M / E / A / N / I / N / G

M/E/A/N/I/N/G

An Anthology of Artists' Writings, Theory,

and Criticism *Edited by Susan Bee & Mira Schor*

DUKE UNIVERSITY PRESS *Durham & London 2000*

Contents

M/E/A/N/I/N/G: Feminism, Theory, and Art Practice
Johanna Drucker ix

Introduction *Susan Bee & Mira Schor* 1

I / FEMINISM AND ART 5

"Post-Feminism"—A Remasculinization of Culture? *Amelia Jones* 7

Appropriated Sexuality *Mira Schor* 24

Why We Need "Bad Girls" Rather Than "Good" Ones!
Corinne Robins 37

Letter on Good Girls, Bad Girls, and Bad Boys *Barbara Pollack* 46

A Conversation on Censorship with Carolee Schneemann
Aviva Rahmani 51

Aesthetic and Postmenopausal Pleasures *Joanna Frueh* 59

just a sketch . . . *Laura Cottingham* 68

A Conversation on Lesbian Subjectivity and Painting with Deborah Kass
Patricia Cronin 79

Monstrous Domesticity *Faith Wilding* 87

II / THE POLITICS OF MEANING AND REPRESENTATION 105

For *M/E/A/N/I/N/G* *Charles Bernstein* 107

Figure/Ground *Mira Schor* 113

The Critic Is (?) Artist *Marcia Hafif* 127

12 Questions of Art *Lucio Pozzi* 131

Some Remarks on Racism in the American Arts *Daryl Chin* 145

The Success of Failure *Joel Fisher* 155

Visual Pleasure: A Feminist Perspective *Johanna Drucker* 163

"I Don't Take Voice Mail" *Charles Bernstein* 175

III / SELECTIONS FROM THE FORUMS 185

On Authenticity and Meaning *Arakawa & Madeline Gins, Susan Bee, Robert Berlind, Jake Berthot, Collins & Milazzo, Maureen Connor, Rackstraw Downes, David Humphrey, Komar & Melamid, Medrie MacPhee, Elizabeth Murray, Yvonne Rainer, Miriam Schapiro, Ann Schoenfeld, Pat Steir, Robert Storr, Lawrence Weiner* 187

Contemporary Views on Racism in the Arts *Emma Amos, Josely Carvalho, Daryl Chin, Tom Finkelpearl, Madeline Gins, Renée Green, Hung Liu, Fern Logan, Juan Sanchez, Robert Storr* 204

Over Time: A Forum on Art Making *Rudolf Baranik, Arthur Cohen, Hermine Ford, Nancy Fried, Leon Golub, John Goodyear, Nancy Grossman, Yvonne Jacquette, Ellen Lanyon, Ann McCoy, Melissa Meyer, Howardena Pindell, Lucio Pozzi, Jacques Roch, Miriam Schapiro, Carolee Schneemann, Richard Tuttle, David von Schlegell, Lawrence Weiner, Faith Wilding* 233

On Motherhood, Art, and Apple Pie *Emma Amos, Suzanne Anker, Susan Bee, Emily Cheng, Stephanie DeManuelle, Jane Dickson, Bailey Doogan, Hermine Ford, Mimi Gross, Freya Hansell, Yvonne Jacquette, Joyce Kozloff, Ellen Lanyon, Betty Lee, Lenore Malen, Ann Messner, Diane Neumaier, Nancy Pierson, Barbara Pollack, Erika Rothenberg, Miriam Schapiro, Arlene Shechet, Dena Shottenkirk, Joan Snyder, Elke Solomon, Nancy Spero, May Stevens, Martha Wilson, Barbara Zucker* 252

Working Conditions: A Forum on Art and Everyday Life by Younger Artists *Lisa Hoke, Julia Jacquette, Rebecca Quaytman, Christian Schumann, Amy Sillman, Hugh Steers, Nicola Tyson, Anthony Viti, Karen Yasinsky* 303

On Creativity and Community *Jackie Brookner, David Humphrey, William Pope. L, Robert C. Morgan, Barbara Pollack, Jerry Saltz, Mira Schor* 317

IV / ARTISTS' MUSINGS 339

Mother Baseball *Vanalyne Green* 341

Bats *Tom Knechtel* 347

The Discovered Uncovered *Nancy Spero* 350

Running on Empty: An Artist's Life in New York *Susan Bee* 352

Reorganized Meditations on Mnemonic Threshold
Joseph Nechvatal 355

The Critic and the Hare: Meditations on the Death of My Rabbit
Ann McCoy 357

September 21, 1989 *Richard Tuttle* 360

Alison Knowles: An Interview *Aviva Rahmani* 362

Media Baptisms *David Reed* 369

V / ARTISTS IN PERSPECTIVE 373

Florine Stettheimer: Eccentric Power, Invisible Tradition
Pamela Wye 375

Cartoons of the Self: Portrait of the Artist as a Young Murderer—Art
Spiegelman's *Maus* *Nancy K. Miller* 388

Nancy Spero: Speaking in Tongues *Pamela Wye* 405

Muse Begets Crone: On Leonora Carrington *Whitney Chadwick* 418

Painting after Painting: The Paintings of Susan Bee
Misko Suvakovic 423

When the Stars Threw Down Their Spears: An Interview with Thomas
McEvilley *Dominique Nahas* 434

Appendix: Contents of *M/E/A/N/I/N/G* 447

Contributors 451

Index 461

M/E/A/N/I/N/G

Feminism, Theory, and Art Practice

Johanna Drucker

In 1986, Mira Schor and Susan Bee founded *M/E/A/N/I/N/G* as a forum for discussions in contemporary art. For the next decade, the biannual journal sustained critical insights and observations that had difficulty finding a platform anywhere else in the current scene. As a noncommercial, artist-initiated and produced publication, *M/E/A/N/-I/N/G* took advantage of this identity to circumvent some of the constraints that usually hamstring a journal's editorial purview (loyalty to a board of advisors, advertisers' interests, or a predefined editorial program).

M/E/A/N/I/N/G succeeded in an intellectual enterprise that was feminist in its foundational impulses and implementation: it largely escaped the controlling determination of market forces and enabled a nonformulaic, heterogeneous discussion. *M/E/A/N/I/N/G* was iconoclastic, nonaligned, and nonprogrammatic in a way that makes it difficult to characterize in any single attribute or descriptive term. This was the strength of its character—it put feminist theory into practice by sustaining a discussion that resolutely refused to congeal into any unified, singular point of view. The journal remained aloof from any or-

thodoxy and thus allowed a distinctly polymorphous consensus to emerge from the ideas it aired. This is not to suggest that the journal was simply open to all comers or that it exercised no editorial prerogatives in positioning itself within the critical field. But the shape of *M/E/A/N/I/N/G* was determined over time, by its inclusions and exclusions, its thematic points of focus and editorial emphasis, rather than being set in advance.

M/E/A/N/I/N/G's significance can best be understood within two traditions and a particular historical moment: the two traditions are those of the independent art magazine and the activities of the contemporary feminist movement, and the historical moment is that period in the mid-1980s when the New York art world was caught up in the inflationary rhetoric celebrating mainstream postmodernism. So, though the importance of *M/E/A/N/I/N/G* is firmly rooted in the ongoing struggles for professional identity and validity given impetus within feminism's recent history, its contribution goes beyond the politics of gender to engage with issues often left only implicit within the field of postmodern criticism. During its ten-year existence from 1986 to 1996, *M/E/A/N/I/N/G* effectively created a zone of critical discussion that was independent of academic or commercial art interests. The journal combined rigorous theoretical polemics and individual artists' voices, and gained respect and visibility that pushed it beyond a local audience of insiders. *M/E/A/N/I/N/G*'s longevity was based on the fact that through dialogue and articulation it succeeded in producing a community for whom it served a vital purpose: *M/E/A/N/I/N/G*-ful exchange around personal and professional issues directly related to the experience of the artists who wrote and read its pages.

Both Schor and Bee are painters and live in New York; they are women who came of age artistically and politically in the 1970s with the energetic development of what is known as Second Wave Feminism. These activities included Judy Chicago and Miriam Schapiro's founding of the Feminist Art Program at CalArts, a crucible for radical transformation of consciousness about concerns central to the professional and personal struggles of women artists. Schor, a student in the program and participant in the 1972 Womanhouse project, absorbed the lessons and attitudes of this environment. As an artist and critic in the 1980s art world in New York City, she was aware that much of the sought-after parity envisioned as the goal of earlier struggles had

proved elusive in the intervening years. Bee, whose feminist conscious-
ness was given its early boost in the context of Barnard College and
Hunter College's graduate art program, likewise experienced the tem-
pering of youthful enthusiasm in the face of the realities of her experi-
ences in the art world. At the same time that Jenny Holzer, Barbara
Kruger, Cindy Sherman, and a handful of other feminist artists had
achieved an unequivocal place in the pantheon of rising postmodern
stars, the Guerrilla Girls began plastering walls in SoHo and other
conspicuous urban sites as the self-proclaimed conscience of the art
world, pointing out persistent structural inequities along gender lines.
Feminism had arrived, but also, not arrived. Bee and Schor realized that
the choice to publish a journal of their own was one way to produce a
base of power and influence for themselves and their peers.

Independent artist-initiated publications have their origins in the
nineteenth century, when their strongly aligned interests joined artists
and poets in publishing enterprises that promoted aesthetic and politi-
cal perspectives not aired in the mainstream press. By the end of the
century, journals had become a significant mechanism for the pro-
mulgation of artists' ideas. Though hardly broad-based in circulation,
publications like *The Germ* (1850), *The Yellow Book* (1894–97), and
Jugend (founded 1896) took advantage of readily affordable print media
fostered by industrialization to make their views available. Following
the precedents of these aesthetes and fin-de-siècle artists, the publicity-
oriented movements of modern art took up the independent journal as
a major instrument of artistic expression. The early-twentieth-century
avant-garde would hardly have produced the ripple effects it did had it
not taken full advantage of publication arts as a means of promoting
radical ideas. In every sector of European, American, and Russian/
Soviet activity in the decades up to and after World War I, artists took
advantage of the capacity of print to inflame bourgeois sensibilities,
provoke outrage, or inflate the image of their movement in the public
perception. The virtual community created by print permitted terms
like Futurism and Dada to circulate way beyond their points of origin,
finding an audience for avant-garde ideas outside the cultural capitals
in which they had arisen. At the same time, a self-consciousness about
books, magazines, and journals and the relations between their form
and their political and aesthetic efficacy produced theoretical ideas that
continue to be germane to artists' publications at the end of the twen-

tieth century as well (the inexpensive multiple, the subversive 'zine, and the capacity to control format and design and production costs).

But if the typographically adventurous, collage-bedecked, and linguistically innovative pages of such publications as *Dada* (1916–20), *La Révolution Surréaliste* (1924–29), or *Merz* (1923–32) are the remote predecessors of *M/E/A/N/I/N/G*, then the productions of the post-1945 years such as *The Tiger's Eye* (1947–49), *Possibilities* (1947–48), and even *Avalanche* (1970–76) are more immediate precedents for Schor and Bee's undertaking. By their proximity in time, such publications established a background against which the necessity of *M/E/A/N/I/N/G* was forged. No feminist of the 1970s or 1980s would bother to tilt the windmills of the outmoded and long-gone avant-garde, but the policies of gendered exclusion, the disposition toward a masculinist art history and critical stance, and the persistently unenlightened boys' club atmosphere of abstract expressionism, pop, minimalism, and conceptualism brought the issues of gender into urgent focus just as Second Wave Feminism was coming into its own. If *The Tiger's Eye* stood for artistic independence of vision and voice, it also embodied the unquestioned assumptions against which feminism had to struggle from the outset: particularly, those which had naturalized the patriarchal terms on which art practice and its validation were continually institutionalized.

Closer to *M/E/A/N/I/N/G*'s own sensibility were the productions of independent poets and writers of the 1960s and 1970s in New York, San Francisco, and elsewhere. In these communities, much of whose activity has been documented in an exhibition and publication curated by Steven Clay and Rodney Phillips, *A Secret Location on the Lower East Side: Adventures in Writing, 1960–1980* (in the Henry W. and Albert A. Berg Collection of English and American Literature of the New York Public Library), there was a successful interchange between poets and painters. Artists and writers such as Frank O'Hara and Larry Rivers continued the tradition of dialogue set by collaborations between Vladimir Mayakovsky and Alexander Rodchenko, Stéphane Mallarmé and Odilon Redon, or William Morris and Edward Burne-Jones in earlier moments. But it was from the immediate precedents of the mimeo, photocopied, and the offset-printed magazines such as *HOW(ever)* (1983–92), *L=A=N=G=U=A=G=E* (1978–81), and *Roof* (1976–79), that Schor and Bee took their inspiration. Bee was both designer for and contributor to *L=A=N=G=U=A=G=E* and published artwork in

HOW(ever) and *Roof,* so she had direct experience with the conversations fostered by venues—those in which ideas about language and art are passionately debated, without obvious commercial concerns. This continuity is evident not only in production terms—but also in the fact that the pages of *M/E/A/N/I/N/G* contain works by individuals whose writings appeared in those earlier publications—Charles Bernstein, Nick Piombino, Marcia Hafif, David Reed, Geoffrey Young, Madeline Gins, Arakawa, Kathleen Fraser, Lawrence Weiner, and others.

Publications within the women's art movement began to appear with increasing frequency in the 1970s and subsequent years. *Women Artists' Newsletter* (1975–1991), where Bee also worked as an editor in 1979–80, *The Feminist Art Journal* (founded in 1972), *Chrysalis* (1977–80), *Female Studies* (1969), and *Heresies* (1977–93) (to which both editors of *M/E/A/N/I/N/G* were contributors) were characterized by nonglossy formats, committed editorial positions, and the variety of viewpoints they published. Questions raised by feminist scholars and critics helped frame the work of women artists as well as to suggest that the policies by which their place in the art world were determined also needed serious attention and rethinking. Feminism became institutionalized within academic programs in the later 1970s, and factions aligned with separatist agendas, militant feminism, and radical academic or critical positions often found themselves at odds. With the publication of *Screen* magazine (begun in 1969) and *Camera Obscura* (founded in 1976), feminist film theory synthesized a relation between gender issues, representation, and critical psychoanalysis. At the same time, the terms of validation on which works of fine art were granted acclaim were being challenged by such figures as Carol Duncan, Arlene Raven, Ann Sutherland Harris, Griselda Pollock, Lisa Tickner, and Roszika Parker, to name only a few of the prominent contributors to the burgeoning feminist discourse in art history. Linda Nochlin's oft-cited essay of 1971, "Why Have There Been No Great Women Artists?" pointed to the cultural conditions that conspired against professional training and advancement for women who aspired to artistic practice—well up into the middle of the twentieth century. French critical theory suggested a semiotic construction of gender in opposition to the essentialist assertions of biology. Activist feminists agitated for transformations in health care, wages, and affirmative action. One debate that split feminist communities into various, sometimes violently opposed, positions in

the 1980s was the contest between assertions of "lived" versus "theoretical" approaches to the gendered experience (the first claiming a positivist knowledge grounded in individual lives, the second suggesting that such claims should themselves be subject to critical deconstruction). Feminism had become *feminisms* in a potent and sometimes contentious way. Neither Schor nor Bee felt completely comfortable defining herself entirely by any single feminist agenda, nor did they wish to exclude other artistic and political concerns from their consideration.

As veterans of art school environments and art world contexts in which these historical and critical assessments were being tested, both Bee and Schor were well situated to experience the ongoing resistance of the mainstream art institutions to make substantive changes in the decade or more between the groundbreaking activities of the early 1970s and the moment of initiating *M/E/A/N/I/N/G* in the mid-1980s. It is in fact a testimonial to the resolute resistance to change that *M/E/A/N/I/N/G* seemed so necessary. So much was different and so much was the same: the expectations of young women artists in the 1980s had been forged by the optimism of 1970s feminist theory and activity. The reality of 1980s professional life was shaped by the social forces of an art world flush with new money, stock market earnings, and a postmodern sensibility. But the agenda of stylish postmodernism was not focused on a feminist agenda, even if many of its critical positions had their origins within feminist interrogations of the structures of patriarchy, authority, autonomy, and truth that were the legacy of modernism in the arts. In the context of 1980s postmodernism the possibility of old-fashioned activism was viewed rather cynically. Aesthetic acts of political critique were frequently posed either in terms of appropriative strategies or else as community-based projects beyond traditional art institutions. The formulae according to which such politics were conceived left little place for hybrid forms whose subversiveness was imaginative and creative, rather than overtly oppositional or slogan-driven. Strategic intervention became a key concept in the struggle for *M/E/A/N/I/N/G* in a broader sphere of public discourse.

As the somewhat depressed, or at least modest by contrast, economy of the 1970s was transformed by a junk-bond, Wall Street–driven upsurge in amounts of available cash in the 1980s, the New York art market thrived. The positive effects of this were everywhere apparent as the SoHo district became populated with galleries, artists acquired star

status, and zones of creative industry appeared in commercial and alternative spaces that spilled over into the East Village and Long Island City. There was an exuberance to this energy that gave art a glamour status that it had seemed to lose after the pop 1960s (the last period in which a surge of affluence had coincided with a high-profile art market and its attendant bonuses). For all their earnestness and pluralist tone, the years of the 1970s had not pumped a revitalizing spirit into the art scene. But the very market-driven character of the 1980s, and the play of terms like *simulacrum, sign,* and *spectacle* that accompanied the sleight-of-hand strategies of postmodernism's arch and often ironic critique of the earnest values of an earlier modernism, resulted in a surfeit of commercialization. There was much that was positive, smart, and successful in the work of the generation that announced itself with Douglas Crimp's 1977 *Pictures* exhibition at Artists' Space in lower Manhattan. But the phenomenon of early postmodernism is inseparable from the economic entrepreneurial spirit of the time. The art object's commodity status was not only not questioned or concealed, it was reveled in as a daring, even titillating, fact. The visual forms of design, mass media, and culture industries like film, television, and popular journalism found their place in the fine art realm through those characteristic gestures of postmodernism: appropriation, the technique of rephotography, and stylistic pastiche. Surface and superficiality were refracted in a critical mirror of endless reproduction in the early 1980s, and though much of this work was focused on a sharp critique of consumer culture, its visual appearance had the slickness of commercial photography and fabricated imagery.

The discrepancies between artists who succeeded in the boom years of the early 1980s and those who did not mirrored the marked distance between have and have-not sectors of the general population that are the legacy of the Reagan/Bush-era domestic policies. The fact that the overnight successes that swelled the ranks of new art stars were divided along generational lines did not ease the sting felt by artists already doing mature work. The demographics of the bourgeoning field of postmodernism was shifted toward just-out-of-art-school celebrities. Suddenly being young, fresh, brash, and daring was an advantage and many artists who had come of age expecting their years of experience to come to fruition through critical recognition and attention found themselves sidelined at just the moment in which they had expected to reap some

fruits of their labors. The unpredictability of historical whims notwith-standing, the 1980s established a paradigm for the emerging artist that couldn't have been anticipated a decade earlier. These changes had their upside—exciting new talent and a stylish, modish hipness permeated the art world—and their downside—some rather superficial values momentarily obscured deeper issues and commitments. But for better or worse, the flashy 1980s were a roller coaster ride of boom-and-bust waves of success in which entrepreneurial tactics were as essential and acceptable as critical insight or artistic integrity.

The decision to publish *M/E/A/N/I/N/G* in a modest format, while initially determined by budgetary realities, marked it as distinct within the slick field of fine art publications that pitted advertising and editorial images in a continual competition for their readers' eyes. Coffee-table allure and newsstand glamour granted mainstream publications a high visibility, while *M/E/A/N/I/N/G,* with its understated typography and simple title, seemed to present itself with the graphic rhetoric of authenticity. It is perhaps this earnestness that put the magazine into such contrast with the mood of the mid-1980s mainstream of the New York art scene. There was a sense that something more was at stake than blatant careerism or flash publicity in a journal that eschewed advertisers and the glossy illustrations and high production values that their monies would have supported. *M/E/A/N/I/N/G*'s editors demonstrated a certain high-mindedness in producing a publication whose values were clearly intellectual and critical. If *M/E/A/N/I/N/G* had its adversarial and contentious aspects, it also served in the best sense as a location in which the meditative, reflective, personal essay (often on issues that were far from the topical fare that formed the monthly columns of *Artforum, Art in America,* or *Flash Art*) could find its place and audience.

Schor and Bee were not alone in sensing a dissatisfaction with the new status quo. From 1980 to 1985, they both participated in a loosely associated group of younger critics and artists (men and women) seeking a collegial context for exchange of ideas that might counter the emerging mood. Thus the precipitating incident for *M/E/A/N/-I/N/G*'s founding was symptomatic of the atmosphere in which critical trends worked their own politics of exclusion and control. In 1985 Schor wrote an essay discussing the misogynist character of David Salle's depictions of women. Titled "Appropriated Sexuality," Schor's essay

made a point of the complicity between Salle's work and the critical views through which it was promoted. The essay was rejected by a series of mainstream art publications and academic journals—all of whom found it out of line with their commercial or critical agendas. This incident provoked Schor and Bee to found *M/E/A/N/I/N/G*, since they recognized the need for a journal in which emerging artists and writers could publish work that was not following the established and often insidiously policed lines of existing critical discourse. Their intention was to create a nondogmatic forum that would counter the overt market orientation of mainstream art magazines and the critical, but remote from practice, attitude of many academic journals. *M/E/A/N/I/N/G* would become the voice of the informed, thoughtful, and creative artist.

Though the independent vision of the journal, its forthrightness of critique, and the editors' capacity to question received ideas were all in some measure a result of their feminist consciousness, the first issues of *M/E/A/N/I/N/G* were heterodox in the scope of issues addressed. Racism, the legacy of modernism, and the shock of the newly felt impact of AIDS in the arts community were all topics in the early issues. The tone of the magazine was in some ways as distant from the assumed community of sisterhood and solidarity that characterized certain feminist journals as it was from the celebratory mainstream. A survey of the authors and subjects of the magazine's first few years demonstrates the degree to which *M/E/A/N/I/N/G*'s editorial stance fostered an autonomous position within the field of publications.

As one of its most sustained contributions to mainstream postmodern critical theory, *M/E/A/N/I/N/G* offered an emphatic insistence on the importance of studio practice as an integral part of conceptual and theoretical traditions. If *M/E/A/N/I/N/G* was distinguished from any other art publication on any single particular point, it was on this continued insistence that there is an authority in the knowledge provided by artistic practice. The struggle was to keep studio work, painting in particular, viable as a form of critically sophisticated and engaged artistic expression in the face of the predominantly photo-oriented practices supported by postmodern critical theory. Photography had so important a place in the appropriative strategies that subverted long-cherished beliefs about originality and authorship that it dominated early formulations of postmodernism (in the work of influential critics

such as Douglas Crimp, Abigail Solomon-Godeau, Craig Owens, and Mary Kelly). But even as the critiques of modernism developed through an engagement with media-centered imagery came to dominate art criticism and practice in the mainstream of 1980s postmodernism, a counterpoint narrative emerged in which painting was "reinvented" in all its figurative potential as a product of male, mainly European painters intent on creating self-consciously historical works. Such art world strategies eclipsed the ongoing and long-standing commitment of many women artists to a figurative and/or painterly tradition. Painting in particular was unfairly (and uncritically) associated with outmoded models of artistic expression, authenticity of gesture, and authorial mark making. Oddly (tellingly), the work of Francesco Clemente, Eric Fischl, or Georg Baselitz could be bracketed by the rhetoric of postmodernism, but the work of Susan Rothenberg, Elizabeth Murray, or Ida Applebroog somehow, at least initially, could not. Painting lived a split identity in which one of its aspects was cast as outmoded and old-fashioned (and performed by women) and the other was perceived as critically sophisticated, ironic, and acceptable (and just incidentally practiced by male artists). *M/E/A/N/I/N/G* became a countervoice within this discussion, contributing an alternative scenario to the postmodern art = photography = theory point of view. Not all of *M/E/A/N/I/N/G*'s writers were painters. But *M/E/A/N/I/N/G* did not put painting and other artistic practice into an opposition with theory; instead, it sought to articulate the theory of and from practice.

Given this stance, it was perhaps peculiar that *M/E/A/N/I/N/G*'s editors chose the format they did: simple typography and design, without illustrations. *Without illustrations?* How could a publication for artists, by artists, and about visual art function without images? The very daring oddness of the choice gave the journal a notorious novelty, but the effect was to emphasize artists' voices and perspectives, to call attention to the materiality of different writing styles and characters. This variety of voices created the verbal "texture" of the publication, instead of editing each piece toward a house style or homogenized and general editorial tone. The noncommodified aspect of the editorial policy was reinforced by the absence of images, as if the very process of reproduction according to which artistic canonization and notoriety are achieved was short-circuited by a publication that only used language. *M/E/A/N/I/N/G*'s essays were read for content, not as a gloss on illustrations, not as one part of a split discourse in which image and

text are always vying for attention through different modes of address to the eye.

The issues that *M/E/A/N/I/N/G* promoted in its pages were numerous, but they clustered around topics such as the importance of visual pleasure, cultural activism and the place of feminism within it, the necessity of heterogeneous and polymorphous discourse, the possible value of anomalous and even eccentric perspectives, the need to reassess historical materials and the work of earlier artists by using contemporary critical insights, and the careful examination of artistic process as a serious undertaking and source of critical knowledge. Instead of being merely subject to criticism, artists found an exhilarating power in writing about their own work or experiences. Topics that would never have been given space in the trendy art world magazines—like the personal testimonials of the challenge of combining artwork and motherhood—found space in *M/E/A/N/I/N/G*'s pages. Nonformulaic in attitude, *M/E/A/N/I/N/G* had a permissive and polymorphous approach, so that wacky, wandering, and even righteously outraged perspectives found a voice. But at the very center of *M/E/A/N/I/N/G*'s motivation was a persistent commitment to the editors' own interests— to painting and sculpture as fields in which traditionally coded practice was in dialogue with contemporary issues in a way often ignored or not recognized in commercial or critical journals.

The effect of *M/E/A/N/I/N/G* as a crucible for the careers of a number of individuals has been one of its most significant long-term contributions. Many artists, myself included, can count their *M/E/A/N/I/N/G* publications among their first significant forays into critical writing. The editorial policy of Bee and Schor facilitated this activity. They used a number of different strategies to generate material in a variety of formats. The forums, always among the most successful of the pieces they ran, allowed artists to write shorter pieces that became significant within a collective discussion rather than requiring that they sustain a writing project through an entire researched or argued article. Interviews became a way of transforming artists' points of view into print without forcing them to the unfamiliar task of writing. Bee and Schor were more personally invested in the content of the magazine than many commercial or mainstream editors are and brought their artistic sensibilities to the task of transforming manuscripts into final pieces. They would frequently challenge an author with a substantive rebuttal penciled into the margins of a draft, asking, "Do you *really*

think this?" And as an author, one would reflect, reconsider, and sometimes—often—find that the position from which the article had been conceived shifted through this productive editorial dialogue. If one was left smarting from editorial comments, it was only to realize that what was at stake had to do with real values in a real life, not just some abstract turn of phrase conveniently lifted from current critical language. Such input is rare; it reflects the most serious kind of commitment to the shared enterprise of trying to sort out what one thinks, what we think, what can be thought *through* and thought *about* in the collaborative space of a magazine.

Just as important, *M/E/A/N/I/N/G* published works that would never have appeared in a commercially supported magazine—because they were too critical, too speculative, too thoughtful, too individually written, or too something else. In other words, *M/E/A/N/I/N/G* exploded the conventional constraints of either critical or academic discourse in the field, allowing more variety of voice and thought than had been tolerated in mainstream venues. Likewise, *M/E/A/N/I/N/G* avoided the academic voice. The magazine never became a site for the kind of jargoned argument that serves mainly to display the command of specialized language essential for professional advancement. Artists' needs were first and foremost in the magazine's perception, and its formats and protocols were always designed with this in mind. The self-taught, polymath artist was a major staple of *M/E/A/N/I/N/G*'s community of writers. Articles reflected artists' heterogeneous reading through a broad spectrum of theory, fiction, anthropology, poetry, popular culture, spiritual texts, and criticism as well as art history. Such a catholic approach counters the parochial quality of more academic discussions in which the field of references is often narrowed to a few canonical works and authors for whom crucial issues are argued in a hermetic space of recirculating references.

M/E/A/N/I/N/G's clear commitment to a feminist viewpoint was never doctrinaire or separatist. From the outset, men were present as contributors and as audience. This policy was reflective of a deeper philosophical vision—that the lessons of feminism, most importantly the commitment to freeing women from the social forces that kept them from professional and personal advancement, were of essential value to all individuals. The idea that men are oppressed by patriarchal structures and attitudes as well (though to different degrees and with

different effects) as women meant that the feminist project was a shared one. The deconstruction of masculinist attitudes within the art world has promoted greater tolerance, respect for difference in sexual and gender positions, and a wider range of approaches to the valuation of aesthetic qualities in a new generation of younger artists, critics, and educators. Feminism's success has in this regard also been its failure: having been absorbed into mainstream positions, having achieved some real goals, it has also lost some of the distinctive profile that enabled its effectiveness. *M/E/A/N/I/N/G*'s legacy (and that of other early feminists) is not always conspicuous or acknowledged in the current climate of diversity it helped to create. The dominant discourses of the art critical and academic world didn't necessarily engage with *M/E/A/N/I/N/G* in return; many a critical salvo launched within its pages remained unanswered.

Still, *M/E/A/N/I/N/G* did become a point of reference in the publishing community. In the last few years, as I became involved in the editorial board of another journal, the image of *M/E/A/N/I/N/G* kept being invoked in our discussions as the quintessentially successful magazine for and by artists. The fact that *M/E/A/N/I/N/G* has been able to do this, and that that image is sustained even beyond the original life of the journal, demonstrates the extent to which it defined a unique space in the general field of art publications. The point of this introduction is not just to place *M/E/A/N/I/N/G* within a historical context, but to point out that the topicality of many of the essays in this anthology is part of their value. The shifts and vicissitudes of focus they record are the traces of a group of individuals living through a shared moment in time. The refraction of that shared experience through the polyvocal lens of their many and different responses is another of the elements that any journalistic record can produce, provided it permits the individual voices enough freedom to express those differences. But with the historical retrospective glance comes another benefit: the recognition of the ways many issues and ideas aren't simply or only historical. Quite the contrary, the central issues of this collection—relations of gender and power, criticism and practice, individual artist and social process— are compellingly with us and will be indefinitely. The insights, partial solutions, and expressions of frustration remain as apt for the next decade as they were in immediate response to the last.

M/E/A/N/I/N/G was not merely a community in some vague, vir-

tual sense. Though there were authors who never met, and artists whose work or lives never intersected with each others' interests, there was at the core of *M/E/A/N/I/N/G* a continually growing network among real people. But beyond this loose sense of community was a more important virtuality, the emergent discourse of *M/E/A/N/I/N/G*, of ways of thinking, that was the result of the editorial policies and efforts of the publication. In the ten years of its existence, *M/E/A/N/I/N/G* recorded the experience of a coming of age with a group of one's peers, individuals not necessarily defined demographically, but defined aesthetically and politically. *M/E/A/N/I/N/G* made it possible to be more than what one could have imagined or achieved within one's own capability by its capacity to push beyond the formulaic clichés and limitations in one's own thinking and attitudes.

The fact that *M/E/A/N/I/N/G* refused to market itself or to participate in any of the more overt aspects of commodification within the art world makes the process of transforming the magazine into an anthology somewhat paradoxical. *M/E/A/N/I/N/G*'s editors were always clear about their desire to avoid transforming their "cultural marginality" into a commodified product. Their self-consciousness about the fact that such a stance of marginality is often simply the first stage of an embryonic entrepreneurial instinct is evident in a response Schor and Bee authored jointly for a forum initiated by John Miller and Joshua Decter, for their artist-run periodical, *Acme:*

> . . . what interests us is how marginality and otherness are actually apportioned and policed. Being marginal and other, let's say fashionably illegitimate, may be a market value promoted by the "alternative," "avantgarde" institutions of the art world; but others remain—well—marginal.
>
> Primary to the creed of the art world is the dominance of fashion, trend, and superficiality and the suppression of eccentricity, oddness, and complexity of affect. Within this culture of Oedipal reversal and shocking the bourgeoisie (and reaping the eventual financial rewards of institutionalized rebellion), of prescribed pushing the envelopes of designated cultural permissions, there is a hierarchy of ins and outs, of correct and desirable infractions of aesthetic values and, incorrect, *really* marginal practices. (Susan Bee and Mira Schor, "What's 'Cultural Permission' Got to Do With It?" *Acme Journal*, vol. 1, no. 3, 1994, p. 14)

But it would take a leap to believe that *M/E/A/N/I/N/G* was ever really marginal in the sense of outsiderness or inconsequentiality. It was

produced in New York, as part of the activity of artists and writers who were part of the current scene, whose work was being exhibited and published. Rather than having been outside of the mainstream, it is one of the independent spaces that reconfigured the mainstream by extending the territory of discussion. Critical aesthetic territory, after all, is not finite; it exists as it is made and in this sense *M/E/A/N/I/N/G* was always conceived and produced as part of the topos of contemporary art, not beyond or outside its domain.

And what of *M/E/A/N/I/N/G* now, here, in this new life as an anthology? Does it lose its marginality, become precisely what it attempted to avoid becoming for so long, another packaged item for art world and academic consumption? Hopefully, it instead becomes recognized as a zone of independent activity within a historical field, a body of articulate thought worth republishing and rereading. While this collection should serve as inspiration, it shouldn't be seen as a mere record of past achievement. It would be far more gratifying if it comes to be a permanent reference in conversations and writing about art, not just women's work or feminist art, but for the broader field of contemporary art and criticism. This anthology will go a long way toward returning *M/E/A/N/I/N/G* to the conversation from which it was generated, and introducing a wide new readership to the work it provoked and published.

Introduction

Susan Bee & Mira Schor

This anthology is a collection of writings on contemporary art by artists, art historians, critics, theorists, and poets. These writings were originally published from 1986 to 1996 in *M/E/A/N/I/N/G*, the journal we founded and edited. *M/E/A/N/I/N/G* was published during a contentious time when critical and political ideas were at issue. Collecting these writings is important now, because just as most individual artists felt left out by the hype of the 1980s art market boom and bewildered by the obduracy and obscurity of some theory language, so too most individual artists today seek a place where issues, including issues of *meaning,* can still be considered seriously and without hype. While the polemic intensity of that period has faded, the shape and the content of much of the artwork currently being produced contains evolutions and devolutions of the ideas so hotly debated in the 1980s.

We felt, as we considered what we should name our publication, that meaning was the concept most discredited by the market-driven postmodernism that dominated art world discourse in the 1980s. While a journal such as *October* had staked out its title on the ground of a specific sense of history, *M/E/A/N/I/N/G* announced an ethical and philosophical dimension. But the slashes (technically, virgules) that separate M from E from A from N from I from N from G not only

graphically indicate our connection to the influential contemporary poetry journal *L=A=N=G=U=A=G=E*, they also break up the possibilities of an uninflected metaphysical belief in *meaning*. We put the concept of meaning back on the table of contemporary art discourse, but with a postmodern twist.

Some background details on how the first issue of *M/E/A/N/I/N/G* came into being provide an example of how interventions into art discourse emerge from serendipitous sparks between personal histories and historical moments, and also of how artists can, on a very small budget and from a space of obscurity, achieve a voice in a large, noisy art world.

The two of us first met when we were children through the acquaintance of our parents, Miriam and Sigmund Laufer and Resia and Ilya Schor, all of whom were artists and Jewish refugees from Europe who arrived in New York City in the 1940s. We met again in the late 1970s, as artists living and working in New York City.

Bee had a great deal of experience in publishing and book design. She has designed, edited, and produced many small press and commercial publications as well as having designed *L=A=N=G=U=A=G=E,* co-edited by her husband, Charles Bernstein. In the early 1980s, Schor had begun to write about gender representation in contemporary art. In the fall of 1986, our disgust with the increasingly overhyped art scene was the final spur to publishing a journal. Over lunch near our studios in Tribeca, we just said, "let's do it," not unlike Judy Garland and Mickey Rooney deciding "let's put on a show!"

We quickly found material for a first issue, invested our own money, and typeset and pasted up the copy ourselves. Bee designed the first issue and all the subsequent issues. We mailed some xeroxed flyers, actually got a few subscribers, and sent many complimentary issues to significant figures in the art world, schlepping our first issues to the post office and local bookstores. We continued to publish regularly twice a year, in the spring and fall, for ten years. *M/E/A/N/I/N/G* was independently produced with both of us assuming all of the editorial and production tasks. Our very minimal funding came from subscriptions, sales, and after two years, from grants from the New York State Council on the Arts and the National Endowment for the Arts. The intimacy of our two-person collaboration had its benefits: we could make decisions quickly without having to adhere to a fixed editorial

policy or get involved with the often time-consuming and stressful collective process experienced by *Heresies,* a publication that we felt close to both politically and aesthetically.

Our issues were assembled in an unprogrammatic manner. We did not have theme issues, at least not on purpose. Rather, we tried to be alert to what people were interested in writing about and, once we had agreed on copy, we tried to be scrupulous in our editing and production; yet we always surprised ourselves when, with seemingly little overdetermination on our parts, an issue could be coherently crafted. In an important sense, the flavor of *M/E/A/N/I/N/G* as an open space where the unexpected occurred and material emerged organically from the art community came from this nondeterminative method of editing.

Our final issue was an all-visual, double issue in May 1996; up to that time, we had not published any photographic reproductions of visual art. We did satisfy our desire for visual pleasure with a simple, elegant design and with distinctive cover colors: the cover to our first issue was solid silver with just the logo and a "#1" on it. Subsequent issues were gold, orange, bright yellow, pale green, salmon, dark pink, copper, mauve, blue, green, maroon, dark yellow, dark purple, watermelon pink, black, lemon yellow, fuschia, and, at last as at first, silver.

This anthology is a gathering of only some of the best and most continuingly relevant of the wide range of writings which first appeared in *M/E/A/N/I/N/G.* We wish we could have included all of our valued contributors but we have had to be very selective. We have many people to thank for their help and support in doing *M/E/A/N/I/N/G:* our families and friends; our editorial board Emma Amos, Charles Bernstein, Whitney Chadwick, Daryl Chin, David Reed, Robert Shapazian, and Nancy Spero; James Sherry and the Segue Foundation; the Solo Foundation; the New York State Council on the Arts; the National Endowment for the Arts; and other individuals who helped us continue publishing with integrity. We want to also thank our exceptionally loyal and devoted subscribers and readers.

We ended *M/E/A/N/I/N/G* before it ended itself through exhaustion and irrelevance. We needed the time for other professional pursuits and we wanted to finish on a strong note. Also we felt that *M/E/A/N/I/N/G* was not a project that could be passed on to somebody else. It was a collaboration between two women of similar background but different personalities, with loosely shared but sometimes

wildly differing aesthetic viewpoints who shared a basic sense of what constituted good texts and what we felt needed to be published. We never wanted to become an institution, either by expanding in a more businesslike manner, or by continuing on in perpetuity, out of habit. We only hope that the spirit of *M/E/A/N/I/N/G* will reappear in another publication and we would be happy if this collection of the best of *M/E/A/N/I/N/G* would inspire such a project. It is possible for artists to fly beneath the radar and still make themselves heard.

I / FEMINISM AND ART

Part I, "Feminism and Art," includes significant writings on debates within feminism, as in the lively polemic produced by Corinne Robins's perspective on a number of feminist exhibitions in the late 1980s in "Why We Need 'Bad Girls' Rather than 'Good Ones'!" (1990) and Barbara Pollack's response, "Letter on Good Girls, Bad Girls, and Bad Boys" (1991). Amelia Jones's "'Post-Feminism'—A Remasculinization of Culture?" (1990) reflects on feminism in relation to postmodernism as a genderless universalist project. Faith Wilding's "Monstrous Domesticity" (1995) and Laura Cottingham's "just a sketch . . ." (1993) track the dangers for feminism of a loss of its own histories. The question of what might be a lesbian aesthetic is explored in "A Conversation on Lesbian Subjectivity and Painting with Deborah Kass" (1993) by Patricia Cronin while an even less frequently discussed topic, that of "Aesthetic and Postmenopausal Pleasures" and representations of the aging female body is the subject of Joanna Frueh's essay (1993). The female body, its pleasures, and its role as "the battleground of greatest intensity" in mainstream culture is also the subject in Aviva Rahmani's lively "A Conversation on Censorship with Carolee Schneemann" (1991), while a feminist analysis of the representation of women by a male artist, David Salle, is the subject of Mira Schor's "Appropriated Sexuality" (1986).

"Post-Feminism"—A Remasculinization of Culture?

Amelia Jones

The most important question . . . is whether . . . feminism is coopted
by being harnessed to other discourses which neutralise its
radical potential.

As developed in the last twenty-five years, feminism and its corollaries,
feminist art and art criticism, are critical perspectives that offer multi-
ple positions and strategies as a means to critique and disrupt patri-
archal practices on political, economic, and cultural fronts. The critical
goals of feminism are thus nothing short of the dismantling of pa-
triarchy's strategies of ideological and institutional repression. Given
these goals, it is clear why patriarchal formations would have a large
stake in repressing or diffusing feminism's various voices.

 I shouldn't have been surprised, then, by the title of a recent article on
postmodern art by critic Dan Cameron—"Post-Feminism."[1] Perhaps
too insulated by my own identification with the theoretical promise of
various feminist positions, however, I *was* taken aback—and since that
time, my dismay has grown as I have encountered this term more and

more frequently in the art and popular presses. What is "post" but the signification of a kind of termination—a temporal designation of whatever it prefaces as ended, done with, obsolete?

To make matters worse, this determination of an end to feminism, most often articulated by male critics who congratulate themselves for their attention to art by women, is revealing itself to be part of a larger discursive project (one that appears to be spreading like a voracious fungus) to appropriate feminism into the larger (masculine) projects of "universal" humanism or critical postmodernism. This subsumption is certainly a strategy of negating feminism's specific political power—its perceived potential to undermine the theoretical certainties that continue to validate American cultural discourses, including, it seems, that of "postmodernism," though the latter defines itself as having left these certainties behind in its modernist wake.

Evidence abounds of this insidious reworking of feminism, which can certainly be seen as part of a broader sociopolitical shift toward a newly entrenched patriarchal formation in the 1980s, "in which the new masculine affirms itself as incorporating . . . the feminine."[2] The texts I examine here work to reinforce and (re)produce increasingly hegemonic patriarchal relations of domination in society at large.[3] They represent the dominant postmodernist cultural discourse, one that continues to empower itself through a modernist "aesthetic terrorism"[4] that hierarchizes art on the basis of traditional categories of value and negates that which threatens its hegemony through various means. These texts operate first to arrogate feminism into a universalist "mainstream" or into postmodernism (as one radical strategy among many available to disrupt modernism's purities); they then work to proclaim the end of feminism altogether, gen(d)erously celebrating its welcomed inclusion into the humanist canon or into a supposedly widescale, already achieved radical project of postmodernist "cultural critique."

While the former gesture is more easily identifiable as coming from a center or right position within art discourse, the other strategy is more difficult to recognize and negotiate, since it often comes from well-meaning critics who position themselves as "left." Even some well-intended arguments articulated from a feminist perspective feed into this dynamic by praising feminism as a useful tool for postmodernism; this allows for the subsequent conflation of the two into an exhausted leftist category of "anti-authoritarianism," with texts viewed as inher-

ently critical if they fall into this category of "radicality."[5] Or feminism is lumped with civil rights and other specific protests as merely a "jargon" taken up as a means of empowerment: thus Fredric Jameson includes feminism as an example of the "stupendous proliferation of social codes today into professional and disciplinary jargons, but also into the badges of ethnic, race, religious, and class-refraction adhesion."[6]

Before discussing the trajectory this move has taken specifically in art discourse, let me submit evidence, from the popular media, of this "remasculinizing" strategy in its visual and textual structuring of gender roles.[7] Using a position offered to me by feminist cultural theories,[8] I will analyze an example of public representations of the feminine and feminism to identify points of rupture where ideological inconsistencies come through in the form of unconsciously gendered language and logical confusion.

What can the *Time* cover story of December 4, 1989,[9] then, tell us about current construals of feminism? "Women Face the 90s," the cover reads in bold yellow letters; it continues, less favorably, in white: "In the 80s they tried to have it all. Now they've just plain had it. Is there a future for feminism?" Our first warning should be the very fact that this mouthpiece of reactionary journalistic "objectivity" posing as middle-of-the-roadism chooses to spotlight (the death of) feminism.

The accompanying image is a further warning sign, but an intriguingly ambiguous one: filling the red bordered cover is a wooden block on which is drawn a very boxy (one could say "masculine") woman's body, Caucasian of course, in a severe business suit. Appended are stubby feet, a blockish head with quite "mannish" features, and crudely carved hands, one tensely clutching a briefcase, the other (attached to a fleshy, peasantlike arm) a child also carved of wood. We are graphically presented with the dilemma of the 1990s woman (that is, the white upper-middle-class woman): the restrictive choice between having a child, and by extension a procreative life of the flesh, and the alternative, a (non) life of the coarse, brutal face and the obliterated body, hidden by masculine clothing—signifiers of what a woman must sacrifice, must *become* in order to achieve (masculine) "success." But this image, a kind of mysticized voodoo or votive figure, is rendered in the folksy medium of handcarved and painted wood that links the two terms: the "feminine" and the atavistically "primitive."

Inside on the title page, there is a photograph of pro-choice advocates

on the mall in Washington with their banners and raised fists, trapped, ironically, behind a chain link fence (the 1990s equivalent of the Delacroixian barricade?). The accompanying caption reads: "The superwomen are weary, the young are complacent. Is there a future for feminism?," and continues in smaller type, ". . . some look back wistfully at the simpler times before women's liberation. But very few would really like to turn back the clock . . ." The second sentence in the smaller type indicates that perhaps the "end" of feminism is not as conclusive as the bulk of the textual and visual codes would suggest. The text naturalizes what is being questioned by preceding its acknowledgment of the possible continuation of feminism with the "weary" and "complacent" attitude of today's women. Furthermore, the assumption that the "pre"-feminist phase was "simpler" goes unchallenged and is doubly insidious by its casual placement. Here the masculine basis of judgment is laid bare, for it is certainly *men* who would find the monolithic dominance of pre-feminist patriarchy "simpler." For women, life under patriarchy has always been complicated by our ambiguous relation to our own domination.

The term "post-feminist" is used here to describe the rejection of feminism by younger generations of women as a result of their realization that women can't (what a surprise!) have it all. To naturalize this rejection as logical, the article confirms for us that "motherhood is back." In this way, hoping to encourage an image of younger women's enthusiastic subscription to American narratives of the familial, the article constructs for these women the desire for a secure position of femininity (remember, it is "simpler"). By presenting these ideas as a priori facts, the *Time* writers avoid the appearance of validating them as right. Yet their language manipulates the reader into accepting these terms that call so innocently for a return to a "simpler" previous state. In the same moment that they appear to "ask" innocently if there is "a future for feminism," they effectively preclude any consideration of this "future" with their term "post-feminist."

Finally the article confirms the sensibleness of the supposed rejection of feminism by explaining that, after all, "hairy legs haunt the feminist movement, as do images of being strident and lesbian. Feminine clothing is back; breasts are back . . . [and] the movement that loudly rejected female stereotypes seems hopelessly dated." So it's all about *looks*, as usual, when women are the question.

The *Time* article is one among innumerable examples of popular

culture text's construction of feminism as a unified, precisely articulated attack on the American family.[10] This in turn produces the necessity for its obliteration—in order to enable the "return" to a previous state of "simplicity," once feminism's shortcomings have revealed themselves. "Post-feminism" in this context, then, means antifeminism—the appropriation of feminism as a theme and then its brutal repression as failed and so implicitly over.

Predictably, there are parallels to this dynamic in art writings of the 1980s, where a similarly motivated discursive appropriation and negation of feminism as "post" has also been pervasively deployed. The decade began with Mary Kelly's article "Re-viewing Modernist Criticism" which showed the potential of radical feminist critical theories and art practices to *dismantle* patriarchal modernist systems of exhibition and interpretation by deconstructing the centered subject from which art historical modernism draws its authority. However, a precedent for discussing feminist art practice as one among several means of critiquing modernism had also already been established. Even Kelly writes of feminism only near the end of her article, positioning it as one possible parameter of a broad "Crisis in Artistic Authorship."[11] In addition, other counterdiscourses maintained from earlier modernisms were already at work, operating actively to recuperate the feminist project back into a mainstream (white, Western, male) humanist or critical theory project.

A discursis on this idea of "mainstream," a notion complicit with the assumption of a masculine "norm," is in order here. A recent exhibition catalogue is entitled *Making Their Mark: Women Artists Move into the Mainstream 1970–1985.*[12] Even aside from the obvious phallic connotations of "making a mark,"[13] and the quite amusing if somewhat horrifying fact that the catalogue and exhibition were sponsored by Maidenform, we can ask: what does the term "mainstream" imply as an ideological field? As revealed in the title of the exhibition and catalogue, the show relied on the premise that women artists desire to enter a "mainstream." And, while not necessarily problematic in itself, the show's bringing together of works by women artists with diverse—even contestatory—positions (from Miriam Schapiro to Sylvia Sleigh to Sherrie Levine) raises the question of the meaning and political efficacy of the category "woman" as a means of grouping art works.

Arthur Danto's review of this exhibition in *The Nation*[14] activates the assumptions embedded in the term "mainstream," making clear the

potential problems presented by the exhibition. Danto recognizes that the show raises as many questions about the "mainstream" as it does about the "artistic relevance of the eighty-seven artists' all being female," but he fails to go beyond this basic acknowledgment. The question for Danto becomes, "whether this particular period, and hence this particular mainstream, was made to order for women, even if the work in question might not have any especially feminine—or feminist—content." For Danto, there must have been "something in the times, in the structure of the art world, that made this female ascendancy possible and even necessary. . . ."

Danto seems to think of women artists in terms of an a priori patriarchal mainstream. This norm, which he calls a "prescribed line," consists of the American genealogy of male artistic "tradition," from the abstract expressionists through to the minimalists and beyond. While he admits that Miriam Schapiro "found a certain liberation from the very idea of this [prescribed line] in feminism," the assumption of a firmly drawn, pre-existing "line" is still intact. For Danto, Schapiro isn't different after all from the (male) artists already in the line: "much the same moral revelation was being made all across the art world, if not through feminism then through the discovery that not only had the old dogmas died but the very idea of dogma was itself dead."

He concludes by *eliding* feminism with any number of "radical" critiques, stating that what *allowed* feminism its efficacy in changing the art world[15] was "poststructuralist philosophy, with its possibilities of ultraradical critique." He continues, "[a]nd from this perspective women did not so much enter the mainstream as redefine it, and the *men* who entered it were more deeply feminist than they could have known."

Danto tells us that feminism required the outside impetus of poststructuralism to make it truly itself but he implies, conversely, that its goal has been *not* to critique phallically invested hierarchies of art history, but merely to fit art by women into the mainstream "line." And, while he allows that women have "redefined" this mainstream, he claims that men are also "deeply feminist." Through this rhetorical strategy, Danto subsumes both male and female artists into a larger (masculine) "critical" project. Feminism does not, for Danto, have a specific critical position vis-à-vis notions of "mainstream"—it is simply one of many refigurings of this mainstream which is thus left more or less intact.

Since Danto's article appeared, *The Nation* has printed a letter by Kathy Constantinides critiquing his piece along with a reply by Danto.[16] Constantinides mentions several editorial slights and personal inconsistencies in Danto's account of the exhibition and she critiques Danto for his tendency "to universalize, which is to say, replicate, the male standard/language."

Danto's reply testifies to his own stake in maintaining his critical authority and dominance over feminist voices. He astutely answers her first complaints, but in response to Constantinides's claim, phrased in extremely gentle terms, that he has unwittingly reinforced gender stereotypes through his language, Danto replies that "it is possible to raise consciousness to a height from which nothing said by males can be other than invidious. This will be the case if the very language we all use is, somehow, 'male oriented.' This may take an extreme form—seeing, for example, in 'universalization' a form of male-centered discourse."

In claiming that language structures "cut across the differences between the genders and touch us in our essential humanity," Danto promotes the reduction and erasure of feminism as a part of a broader humanist project. His seemingly willful misunderstanding of the gendered nature of language and of the bias of a notion such as "mainstream" allows him to imply that women should feel honored to be considered a part of the humanist project, not as subjects capable of producing their own counterdiscourses to it, but as passive objects of its generous ("genderless") embrace.

Another related means of negating feminism is the appropriation of feminist theory as merely one "postmodernist" strategy among many to critique modernist ideologies. Craig Owens's often cited article "The Discourse of Others: Feminists and Postmodernism"[17] is an instructive example here. While Owens presents in a concise and polemical way some of the major issues confronting feminist theory, his discussion places it in the same field as the "postmodernist critique of representation": the two discourses have an "apparent crossing," and his essay is thus a "provisional attempt to explore the implications of [this] intersection." He astutely calls for a recognition of feminist art as explicitly operating to disrupt traditional configurations of sexual difference, critiquing, as I do here, writers who "assimilat[e feminism] to a whole string of liberation or self-determination movements."

And yet Owens's approach is symptomatic of what must be seen as an

ultimately antifeminist appropriative strategy. He begins by placing feminism and postmodernism in the same space, describing "women's insistence on incommensurability" as "not only compatible with, but also an *instance of* postmodern thought" (my emphasis). Owens then further dilutes feminism's specific agenda by appropriating Lyotard's terms to describe its goal of critiquing "master narratives" as commensurate with (and so implicitly included within) the goals of postmodernism: "this feminist position is also a postmodern condition." And finally, he reduces feminism to simply another of the "voices of the conquered," including "Third World nations" and the "revolt of nature," that challenge "the West's desire for ever-greater domination and control." Without seriously questioning his role as male critic, Owens takes up the position he believes to be offered by feminism to empower his own construction of a field of intersection that ultimately subsumes feminism into the postmodernist critique of "the tyranny of the signifier."

There is a complex background for this understanding of the potential of *the feminine* or *feminism* to disrupt "modernist purity," understood in most of these texts as the Greenbergian assumption of the self-sufficiency of the modernist signifier to contain within it transcendent meaning regardless of its context or enunciative situation. This understanding has been primary in American art discourse's self-conscious deconstruction of modernism and construction of postmodernism in its place as a radical, feminized alternative to the phallic closures of abstract expressionist modernism.[18]

Early descriptions of work that would later be labeled "postmodern"—Susan Sontag and Calvin Tomkins, for example, on so-called "neodada" art—are structured by gendered systems of oppositions; thus Sontag, in her well-known article on camp,[19] associates neodada with what she calls the "camp sensibility," which she characterizes as a homosexual sensibility of decadence, artificiality, and effeminacy and opposes to the virile certainties of abstract expressionist ideologies. More recent theories of modernism—some explicitly feminist in their approach—have identified postmodernism with the antiphallic merging of feminized mass culture with so-called high art, interpreting this blurring of boundaries and destruction of dichotomies as a feminist-inspired project.

Andreas Huyssen's article, "Mass Culture as Woman, Modernism's Other" (1986),[20] for example, defines modernism as a "reaction forma-

tion" arising out of a fear of the feminine "other" of mass culture. For Huyssen, postmodernism is a specifically American phenomenon that began in the 1960s[21] and has the radical potential of *dissolving* these boundaries modernism sets up between itself, as "high" culture, and what it perceives as a feminine mass culture. For Huyssen, feminism—as the heir of the "avant-garde's attack on the autonomy aesthetic"—is one of many potential forces to produce a "postmodernism of resistance" (those forces include the ecology movement, new social movements in Europe, and non-Western cultures) that will break apart modernism's hierarchies to allow (male) critics like Huyssen a critical foothold.[22]

While articles such as Huyssen's have been important for feminism's negotiation with modernist art history, unfortunately, these positionings of feminism as a strategy *within* a larger postmodernist project have unwittingly contributed to the incorporation of feminism into postmodernism as, in Owens's words, an "instance of" the latter. And it is this incorporation that has facilitated the declaration of the end of feminism with "post-feminism" rising from its ashes.

What is "post-feminism" in art discourse, then? Dan Cameron, who tends to slide back and forth between the terms "feminism" and "post-feminism," uses the latter broadly to encompass all art by women in the late 1980s that uses "structuralism to critique social patterns in terms of social domination," and sees it as a result, in part, of "the increased commodification of the art world in the late 70s, and the adjustment of world capital to a global order based on information distributed through advanced technology." Under the rubric "post-feminism," he discusses women artists as diverse as Barbara Kruger and Susan Rothenberg. Cameron even claims that "there is by no means a dearth of male artists working from these identical premises," which he defines as the acknowledgment of the contingency of art as language.

One wonders why Cameron references this art through the term "feminism" at all, and, furthermore, why this feminism is deemed to be "post." It seems to prove yet another example of the use of feminism as a term of radicalization to be subsumed into a broader field of cultural critique. Cameron's "feminism," or rather its reincarnation as "post," is increasingly confused—it appears any female can be (and, perhaps, necessarily is) "post-feminist" just by virtue of her sex. But men seem to be able to appropriate this radicality easily too. Cameron also discounts the explicitly feminist in their work by placing these artists in a mascu-

linist genealogy of avant-garde critique: "following on the heels of pop," they then become the "sources" for male artists Jeff Koons, Peter Halley, and Philip Taaffe, whose works, Cameron admits, are—no surprise here—"more vociferously" collected than those of their supposed mentors (matriarchs?), the "post-feminists."

Andy Grundberg's article "The Mellowing of the Post-Modernists"[23] provides another example of the reduction of feminist messages by their identification with generalized or even antifeminist strategies. Here, with obvious signs of relief, Grundberg praises postmodern artists as having "mellowed" such that they are "more willing to allow their audiences some unalloyed visual pleasure" with new works that are "more viewer friendly than those of ten years ago." Lucky for us viewers, then, Laurie Simmons has "polished and refined" her "message" (perhaps that of "hairy-legged" feminism?) to produce "more fully realized" art. These new, "polished" works are her recent photographs of commonplace objects with a doll's clearly *female* legs (which Grundberg identifies only as "humanoid and endearing").

Again, whatever feminist message Simmons is trying to make is elided: the critique of a modernist notion of the female body as commodified object on display is not new, nor is her approach particularly subtle—how could Grundberg miss it except willfully? Grundberg, who prefers to let these "endearing" objects seduce him with their "more fully realized" voluptuousness, refuses to acknowledge their gender specificity.[24] Furthermore, he conflates the photographs of Simmons, which draw directly on gendered codes of representation, with the overtly nonfeminist—the nostalgic macho thematics of Richard Prince's slick fiberglass re-creations of car hoods, and with a work that deals with patriarchy in a more oblique way—a recent piece installed by Louise Lawler at Metro Pictures in New York.

Grundberg is cheered also by Lawler's work, a series of photographs of paper cups labeled with the names of senators who voted to support the Helms proposal to block federal funding for AIDS information and prevention. Grundberg sees this work—which was quite austere to this viewer's mind—as evidence of Lawler's beginning "to shed what some consider an icy conceptual reserve." Whether or not we agree with his assessment of the Lawler installation, we can see that seduction, apparently, is "in"—and the specific political message is erased beneath the overall pleasurable effects the objects provide.

Grundberg seems to deny the possibility of a work of art that is both *sensual* and *conceptual* or politically critical at the same time—a possibility that feminist artists have continually explored and have a high stake in maintaining, since such a work breaks down the rigid divisions required by modernist notions of criticality. As articulated by Grundberg, this emphasis on *seduction* serves to *produce* the (female) artist as sexually manipulative, as a tease who has finally shed her "icy conceptual reserve" (her "strident" feminist ideas?) in favor of acting from her body as a woman should. If the art is seductive, she's seducing. In reading the work this way, Grundberg refuses to acknowledge the difficult conceptual challenges the work poses for patriarchy's formations of power—its critique of the government's hostile stance toward homosexuals as Others of the white male heterosexual establishment.

This process of transforming the woman artist into seductress as a means of opposing her to the cerebral confirms the mastery of the thinking male "analyst"; it has an accomplice in the criticism that deflates feminist art's disruptions of systems of sexual difference by interpreting the art in other terms. For example, Barbara Kruger's pointed interrogations of patriarchy (as in her 1981 images with texts such as "Your comfort is my silence," or "Your every wish is our command") are often interpreted as generalized critiques of the frame, artistic originality, and modernism's claim for the signifying wholeness of the image. And Sherrie Levine's astutely engineered deflations of overblown masculine myths of authoritative creative genius, her deftly phallic appropriations of works by modernist masters and reinscription of them as her own, are reduced to nonspecific critiques of the institution of authorship. Kruger and Levine are claimed only to be using "photography conceptually to ask questions about the source and presentation of images in our culture."[25] And Levine's work is seen as motivated only by a desire to "represent the idea of creativity, re-present someone else's work as her own in an attempt to sabotage a system that places value on the privileged production of individual talent."[26]

Even Cindy Sherman's incisive critiques of the visual construction of the feminine—as em-bodied object, photographically frozen within gendered positions of vulnerability in her untitled film stills; or as, in her more recent works, monstrously overblown in the very clichéed "darkness" of her sexual unknown, barely visible as reflected, for example, in the lenses of sunglasses, lying on dirty ground strewn with nasty

signs of sex and human excretions—these are construed as "universal" laments on the condition of humanity. In Donald Kuspit's words:

> Sherman's work has been interpreted as a feminist deconstruction of the variety of female roles—the lack of fixity of female, *or for that matter any, identity,* although instability seems to have been forced more on women than men. [. . .] But this interpretation is a very partial truth. *Sherman shows the disintegrative condition of the self as such, the self before it is firmly identified as male or female.* This is suggested by the indeterminate gender of many of the faces and figures that appear in these pictures, and the presence of male or would-be male figures in some of them. Female attributes—for example, the woman's clothes in one untitled work . . .— are just that, dispensable attributes, clothes that can be worn by anyone. The question is what the condition of the self is that will put them on. . . . (my emphases)[27]

In this article—aptly entitled "Inside Cindy Sherman," and fittingly reprinted in his book *The New Subjectivism*—Kuspit proves my point with a final flourish. Not only being "inside" her does he know the artist better than she does herself (for how else could he "know" that what appear to be feminine attributes—women's clothing, a female authorial name, and even bloody panties—are really things "that can be worn by anyone"), but also he believes to have penetrated into this interior via a massive set of pre-poststructuralist metaphysical tools: geiger counters for registering the mysterious universal truths that encompass and negate Sherman's feminist themes. (What are "would-be male figures" anyway? And what about Sherman's obsessive inclusions of herself—exaggeratedly as woman—in, or rather *as* these works?) Sherman's insistence on her otherness, as "symptom" of masculinity's uncertainties about itself—is folded back into a narrative of universal (masculine) positivities.

Kuspit seals our confidence in his ability to manipulate brilliantly art history's time-honored methods in summing up: "It is this artistic use—her wish to excel with *a certain aesthetic purity* as well as to represent inventively—that reveals her wish to heal a more fundamental *wound* of selfhood than that which is inflicted on her by being a woman" (my emphases). We women are encouraged to assure ourselves that this bleeding WOUND is nothing for us to worry about— everyone has it. And Sherman is to count herself lucky that, in a great

irony of misreading, Kuspit employs his great (phallic) authority to validate her works as "aesthetically pure." Then he can congratulate himself as well for "understanding" this art not as feminist but, even better, as moving *out of* the narrow strictures that feminism necessarily enforces, to the wide expanse of the universal. This appears to be the final effect of a construction of feminism as "post."

Through the preceding argument, I have examined the insidious project currently at work to disarm feminists, coaxing us into sympathy with the broad postmodernist project by flattery, then extinguishing our tracks behind us. While we are offered a "new subjectivism," this gesture obliterates our sex and antisexism by so generously/genderlessly including us as part of the "universalist" subject of the art of the 1980s (a subject curiously textually determined in Kuspit's article by the pronoun "he"). We must be wary of this gesture of inclusion, resisting the masculinist seduction that produces feminism as subsumed within a critical postmodernist or genderless universalist project. We must refuse what Jane Gallop calls "the prick" of patriarchy, which operates to remasculinize culture by reducing all subjectivity to the "neutral subject. . . . [itself] actually a desexualized sublimated guise for the masculine sexed being."[28]

Notes

The source of the opening epigraph is "Introduction" by Lorraine Gamman and Margaret Marshment, in *The Female Gaze: Women as Viewers of Popular Culture* (Seattle: Real Comet Press, 1989), p. 3. This book contains two essays particularly salient to my topic: Janet Lee, "Care to Join Me in an Upwardly Mobile Tango: Postmodernism and 'The New Woman,'" and Shelagh Young, "Feminism and the Politics of Power: Whose Gaze Is It Anyway."

1 *Flash Art,* no. 132, February–March 1987, pp. 80–83.
2 Susan Jeffords describes the 1980s in these terms in her remarkable study of the gendering operations of popular texts on Vietnam, *The Remasculinization of America: Gender and the Vietnam War* (Bloomington: Indiana University Press, 1989), p. 138. She sees the past decade as a climax of the increasing "remasculinization" of American culture from the late 1960s on.
3 I take this notion of "hegemonic formation" from Chantal Mouffe, who describes it in these terms in "Hegemony and New Political Subjects:

Toward a New Concept of Democracy," trans. Stanley Gray, *Marxism and the Interpretation of Culture* (Chicago: University of Chicago Press, 1988), pp. 89–101. See also the extended study of hegemonic formations in her collaborative book with Ernesto Laclau, *Hegemony and Socialist Strategy, Towards a Radical Democratic Politics,* trans. Winston Moore and Paul Cammack (London: Verso, 1985). Unfortunately, Mouffe weakens her call for resistance to hegemonies by conflating different positions of resistance, including feminism, into a generalized notion of "democratic struggle."

4 In her article "Figure/Ground" in this volume, p. 113, Mira Schor introduces this notion of "aesthetic terrorism," with reference to Klaus Theweleit's theorization of the texts of European Leftist political parties. Theweleit discusses their dependence on *exclusion* to devalue that which threatened their authors' phallic boundaries of subjectivity. See his *Male Fantasies,* vol. 2: *Male Bodies: Psychoanalyzing the White Terror* (Minneapolis: University of Minnesota Press, 1989), p. 418.

5 This is typified by such critics as Hal Foster, who delineates two clear lines of postmodernism based on an implicit attitude of criticality: a reactionary postmodernism of pastiche (usually associated with architecture), and a radical postmodernism of deconstructive strategies. Ultimately his value system is based on circular reasoning. It relies on a notion of criticality implied to be immanent in the work itself, as intended by an absent author, but this criticality is actually determined to be structurally present by the empowered interpreter her/himself. See "(Post)Modern Polemics," *New German Critique* 33, Fall 1984, pp. 67–78.

6 Fredric Jameson, "Postmodernism or the Cultural Logic of Late Capitalism," *New Left Review* 46, July–August 1984, p. 65.

7 One way of viewing popular press constructions (or erasures) of feminism is proposed by Laura Kipnis, who argues that it is the left's abandonment of "narratives of liberation," and its scorning of mass cultural venues as commercial and so presumably complicit with the capitalist bureaucracy, that has enabled the right to appropriate the popular media for its own ends. Thus the right "has successfully fought on the terrain of popular interpellation: controlling the terms of popular discourse, arrogating the terrain of nature, family, community, and the fetus; not hesitating to appropriate and rearticulate a traditionally left rhetoric of liberation and empowerment." See Laura Kipnis, "Feminism: The Political Conscience of Postmodernism?" in *Universal Abandon? The Politics of Postmodernism,* ed. Andrew Ross (Minneapolis: University of Minnesota Press, 1988), p. 164.

8 See, for example, Tania Modleski's discussion of popular culture's structuring of the feminine in her book *Loving with a Vengeance: Mass-Produced Fantasies for Women* (Hamden, Connecticut: The Shoe String Press, 1982).

9 *Time* 134, no. 23, December 4, 1989, pp. 80–82, 85–86, 89.

10 The image of the woman's responsibility to the family is reinforced in the *Good Housekeeping* "New Traditionalist" advertisements displayed at bus stops and in upscale magazines such as the *New York Times Magazine.* In these ads, bold texts—such as "Who says you have to discard your own values to be a modern American mother?" and "More and more women have come to realize that having a contemporary lifestyle doesn't mean that you have to abandon the things that make life worthwhile—family, home, community, the timeless, enduring values"—are accompanied by images of a mother in a domestic setting with one or two children. See also Paulette Bates Allen's strange article, "A Reluctant Education," where she writes of her regret at having been encouraged not to have children by feminism's emphasis on the woman's right to "make choices." In blaming feminism for her desire to develop her writing career instead of bearing children, she naturalizes childbearing as "right," while branding feminism as an ideological imposition on this natural state. *New York Times Magazine,* December 10, 1989, pp. 44, 83, 85, 90–91.

11 Mary Kelly, "Re-viewing Modernist Criticism," *Screen 22,* no. 3, Autumn 1981; reprinted in *Art after Modernism: Rethinking Representation,* ed. Brian Wallis (New York: The New Museum, and Boston: David R. Godine, 1984). Other examples of this optimistic phase of believing in the potential of ideas generated by feminism to question and dismantle modernism's hierarchizations and value systems are: Norma Broude and Mary Garrard, *Feminism and Art History: Questioning the Litany* (New York: Harper and Row, 1978); Griselda Pollock and Rozsika Parker, *Old Mistresses: Women, Art and Ideology* (New York: Pantheon Books, 1981), ideas of which are expanded in Pollock's *Vision and Difference* (London and New York: Routledge, 1988)—see especially "Feminist interventions in the histories of art: an introduction," pp. 1–7.

12 (New York: Abbeville Press, 1989). Curated by Randy Rosen and Catherine Brawer, this exhibition traveled to Cincinnati, New Orleans, Denver, and the Pennsylvania Academy of the Fine Arts.

13 See Jacques Derrida's discussion of the stylus as phallic "spur" in *Spurs: Nietzsche's Styles,* trans. Barbara Harlow (Chicago and London: University of Chicago Press, 1978); or Sandra Gilbert and Susan Gubar's discussions of literary paternity and the penis/pen in "The Queen's Looking

Glass: Female Creativity, Male Images of Women and the Metaphor of
Literary Paternity," in their book *The Madwoman in the Attic* (New
Haven and London: Yale University Press, 1979).

14 *Nation* 249, no. 22, December 25, 1989, pp. 794–796, 798.

15 Although, clearly with his own continued use of notions of a priori
mainstreams, genius, and simplistic notions of innovation he perceives a
system largely unchanged from its Greenbergian modernist state.

16 *Nation* 250, no. 8, February 26, 1990, pp. 258, 288. All citations are from
p. 258.

17 In *The Anti-Aesthetic: Essays on Postmodern Culture,* ed. Hal Foster (Port
Townsend, Washington: Bay Press, 1983).

18 I am currently analyzing this configuration of postmodernism in rela-
tion to Marcel Duchamp, who is often claimed as its origin, in my
dissertation in progress for UCLA—"The Fashion(ing) of Duchamp:
Authorship: Postmodernism, Gender."

19 "Notes on Camp" (1964), in *A Susan Sontag Reader* (New York: Farrar,
Straus, Giroux, 1982).

20 Published in Huyssen's *After the Great Divide: Modernism, Mass Culture,
Postmodernism* (Bloomington: Indiana University Press, 1986).

21 He conceptualizes postmodernism in these terms in his essay "Mapping
the Postmodern," reprinted in *After the Great Divide,* and originally
published in *New German Critique* 33, Fall 1984.

22 "Mass Culture as Woman," p. 61 and "Mapping the Postmodern," p. 220.
Griselda Pollock has also focused on the usefulness of the feminist per-
spective on patriarchy in the project of breaking down notions of orig-
inality and modernist hierarchies that invariably privilege the masculine.
Pollock sees feminism's project to be the use of Marxian tools to critique
modernism as an ahistorical bourgeois and consummately masculinist
discourse. Feminism thus becomes *the* model for postmodernism as a
new avant-garde or politics of rupture. Pollock avoids the negation of
feminism's specificity that Huyssen's text implies by structuring all of her
inquiries in terms of questions of sexual difference; feminism prescribes
the set of concerns by which she analyzes art and art discourse. See
Pollock's essay "Screening the 70s" in *Vision and Difference.*

23 *New York Times,* December 17, 1989, Section 2, p. 43.

24 Grundberg does mention gender as an issue *once,* but quickly negates it
by subsuming it under a larger critical concept: "Here, as in most of her
work, gender is pushed into the foreground: one wonders not only about
the master-slave relationship built into the profession but also about its
repressed erotic content." Why abstract the messages of these works by

referencing "master-slave" relations? These seem to be the only terms by which Grundberg can himself repress their "erotic content," as having to do not with sex but, metaphorically, with economic and/or racial relations of domination.

25 Richard B. Woodward, "It's Art, But Is it Photography?" *New York Times Magazine,* October 9, 1988, p. 31.

26 Thomas Lawson, "Last Exit: Painting," *Art After Modernism,* p. 161. Originally published in *Artforum* 20, no. 2 (October 1981).

27 Donald Kuspit, "Inside Cindy Sherman," *The New Subjectivism: Art in the 1980s* (Ann Arbor: UMI, 1988), p. 395. Originally published in *Artscribe,* September–October 1987.

28 Jane Gallop, *The Daughter's Seduction: Feminism and Psychoanalysis* (Ithaca: Cornell University Press, 1982), pp. 36, 58.

Appropriated Sexuality

Mira Schor

Whoever despises the clitoris despises the penis
Whoever despises the penis despises the cunt
Whoever despises the cunt despises the life of the child.
—Muriel Rukeyser, *Collected Poems*

Rapists make better artists.
—Carolyn Donahue/David Salle/Joan Wallace, "The Fallacy of Universals"

A woman lies on her back, holding her knees to her stomach. She has no face, she is only a cunt, buttocks, and a foot, toes tensed as if to indicate pain, or sexual excitement, or both. A patterned cloth shape is superimposed over her, and paint-tipped pegs protrude from the wooden picture plane above her. Thus, she is dominated by phallic representations.

This image of woman in David Salle's *The Disappearance of the Booming Voice* (1984) may be appropriated from mass-media pornography, but more immediately it is based on a photograph taken by Salle himself. Salle has said that "what's compelling about pornography is knowing that someone did it. It's not just seeing what you're presented with

but knowing that someone set it up for you to see,"[1] and that "the great thing about pornography is that something has been photographed."[2] Salle has even suggested that photography was invented for the enhancement of pornography.

But, cries Robert Pincus-Witten, "clearly your works must be liberated from the false charges of pornography."[3] This sentiment permeates almost all of the vast critical literature on Salle. The issue of pornography is forever raised and laid to rest. But the issue of misogyny is left untouched. Yet, it is the pervasive misogyny of Salle's depiction of woman that is so persistently refuted and excused in favor of a "wider possibility of discussion,"[4] for "in literature of twentieth-century art the sexist bias, itself unmentionable, is covered up and approved by the insistence on . . . other meanings."[5] Salle's depiction of woman is discussed in terms of the deconstruction of the meaning of imagery, and in terms of art-historical references to chiaroscuro, Leonardo, modernism, postmodernism, poststructuralism, Goya and Jasper Johns, Derrida and Lacan—you name it, anything but the obvious. The explicit misogyny of Salle's images of woman is matched by the implicit misogyny of its acceptance by many critics. This complicity is clearly stated by Pincus-Witten: "We're commodifying the object and we're mythifying the makers. . . . I've certainly participated in that mechanism because I believe in the mechanism."[6]

The "mechanism" and Pincus-Witten's belief in it are evident in his earliest interviews with Salle, "up close and personal." He visits Salle's studio in 1979 and meets "a dark 26 year old, impatient and perplexing."[7] "The real content of Salle's painting is irony, or paradox, or parody."[8] *Flesh into Word* (1979), reproduced alongside this text, contains several images of women. The painting is framed on the left by a kneeling nude, seen from behind, near a telephone, and on the right by a headless, upside-down nude. A central, more heavily drawn female contains within her a pleasing, bosomy, sketched-in nude. The central figure is scowling and smoking; a small plane flies into her brain. Thus, the private plane (canvas plane/paintbrush/penis) of the male artist zeros in on the only female in his painting who seems to be trying to think and to question his authority.

Pincus-Witten returns months later, now apparently writing for Harlequin romances. "Complex David Salle—lean of face, tense, dark hair on a sharp cartilaginous profile—the unflinching gaze of the

contact-lensed. A cigar-smoker (by way of affectation?) and a just audi-
ble William Buckley–like speech pattern."[9] The macho positioning is
completed by the specification of locale: "the Salle studio is in that row
of buildings in which Stanford White—shot by Harry Thaw—died."[10]
Thus, the vicarious glamour of a notorious murder committed over the
naked body of a woman is rubbed onto Salle (and perhaps onto his
hopeful accomplice, Pincus-Witten).

Pincus-Witten offhandedly describes the left half of *Autopsy* (1981),
Salle's notorious photo of a naked woman sitting, cross-legged, sad and
stiff, on a rumpled bed, a dunce cap on her head and smaller ones on
her breasts. In *Autopsy,* the naked woman is juxtaposed with an abstract
pattern of blue, black, and white blocks. This type of juxtaposition of
representation with abstraction, as well as any juxtaposition of "appro-
priated" images, seems to be enough to allow for the deflection of
scrutiny away from the sexual content to other, apparently more intel-
lectually valid, concerns, specifically "the uncertain status of imagery,
the problems of representation that infect every art."[11]

Challenged in public forums to explain the meaning of *Autopsy* and
other like images, Salle has stated tersely that it is about "irony." Indeed,
his work is seen by his supporters as an eloquent representation of the
nihilistic relativism that can result from an ironic stance and that is one
of the hallmarks of current "avant-garde" art.

For Thomas Lawson, who does see Salle's representations of woman
as "at best . . . cursory and off-hand; at worst they are brutal and
disfigured,"[12] Salle represents nevertheless one of the hopes for the
survival of painting, painting as the "last exit" before the despair of "an
age of skepticism" in which "the practice of art is inevitably crippled by
suspension of belief."[13]

This school of art accepts and revels in the loss of belief in painting
except as a strategic device. The images of painting are representations
of representations, not of a suspect "reality." Belief in any meaning for
an image in this age of reproduction is dismissed as naive.

However, if all images are equivalent, as indicated by the constant
juxtaposition of female nudes with abstract marks, bits of furniture,
and characters from Disney cartoons in Salle's work, then why are male
nudes not given equivalent treatment, not just drawn occasionally from
the back, but literally drawn and quartered as female nudes are? If
images have been rendered essentially meaningless from endless repeti-

tion in the mass media, what is the motivation for the one choice that Salle clearly has made, which is to mistreat only the female nude? Salle does not mistreat the male nude; therefore, he is sensitive to the meaning of some imagery.

Much is made by critics of the refusal of the paintings to render their meaning. Lawson writes that the "obscurity of the work is its source of strength." "Meaning is intimated, but finally withheld."[14] Donald Kuspit writes of a "strangely dry coitus of visual clichés."[15] In withholding their meaning, the paintings are like Woman, the mysterious Other. In withholding his meaning, the artist is an impotent sadist.

The source of this anger is to be found in the intertwined associations among painting, woman, meaning, and death, which form the core of Salle's work. These are clearly expressed in his 1979 manifesto, "The Paintings Are Dead": "The Paintings are dead in the sense that to intuit the meaning of something incompletely, but with an idea of what it might mean or involve to know completely, is a kind of premonition. The paintings in their opacity, signal an ultimate clarification. Death is 'tragic' because it closes off possibilities of further meaning; art is similarly tragic because it prefigures itself an ended event of meaning. The paintings do this by appearing to participate in meaninglessness."[16] For "the Paintings" and "art" one can read "woman," who can only seem to be "known," then returns to the self-enclosed "opacity" of her sex. The meaning "intuited" is that, in the words of Simone de Beauvoir, "to have been conceived and then born an infant is the curse that hangs over [man's] destiny, the impurity that contaminates his being. And, too, it is the announcement of his death."[17] The opacity of the Mother, the calm enclosure of the promise of his own death seems to incite man to fantasies of the rape of woman, and of art.

It is significant that the illustration to Salle's manifesto is an installation shot of the dunce cap pictures. It is also significant that in response to the seemingly obvious offensive nature of this image (*Autopsy*), Kuspit writes that "to put dunce caps on the breasts as well as the head of a woman, and to paint her with a mechanically rendered pattern . . . is to stimulate, not critically provoke—to muse, not reveal."[18] This brings to mind *Cane* (1983), in which a woman, hung upside down in one of the traditional poses of Christian martyrdom, is impaled by a real rubber-tipped cane resting in a glass of water on a ledge. The cane represents the phallus of the artist, as well as being an art-historical

notation, as the painting and the woman are screwed; as befits a "strangely dry coitus" she may die of peritonitis but she won't get pregnant.

Salle uses woman as a metaphor for death; woman has become a vehicle for the difficulty of painting. Painting, with the potential sensuality implicit in its medium, has become a metaphor for woman, and, also, a vehicle for the subjugation of woman/death. In *Face in the Column* (1983) a naked woman is pressed down by a hand that cannot be her own, by a slice of orange, and by a black band of shadow that straps her down to the ground or bed. A drawing of a woman sitting on a toilet is superimposed so that her ass is directly over the larger woman's face, a further reminder of her disgusting physicality. A white profile of Abraham Lincoln acts as a representative representation of honest male activity distanced from the physical functions of woman, for, to quote Salle, "the ass is the opposite end of the person, so to speak, the most ignoble part of the person and the face is the most noble, the site of all the specificity."[19] As the *butt* of the ironist, woman is "trapped and submerged in time and matter, blind, contingent, limited and unfree."[20]

Carter Ratcliff comes close to grappling with Salle's treatment of women, admitting that "to glamorize cruelty is the pornographer's tactic."[21] *But* "Salle's images of nude women" are "not exactly pornographic. He brings some of his nudes to the verge of gynecological objectivity."[22] Perhaps Ratcliff means veterinary gynecology, because I have only seen dogs take poses remotely as contorted as the one a naked woman is forced into in a 1983 Salle watercolor: flat on her back, her thighs spread apart, her legs up. Footless, armless, helpless, she serves as the base for a set table in a pleasantly appointed room. In *Midday* (1984) a woman is on the floor of a similarly decorated room. Flat on her back, legs up, she holds up her hands as if to help her focus on, or protect herself from, the actively painted face of a man floating above her.

For Ratcliff, Salle is "like a self-conscious pornographer, one capable of embarrassment."[23] A repentant rapist then, who can be excused from culpability. However, Ratcliff continues, "to see his paintings is to *empathize with his intentions,* which is to deploy images in configurations that *permit them to be possessed.*"[24] It is crucial to emphasize that this form of possession implies a male spectator and is condoned by the male art critic. Linda Nochlin writes that "certain conventions of eroti-

cism are so deeply engrained that one scarcely bothers to think of them: one is that the very term 'erotic art' is understood to imply 'erotic for men.' "[25] The hierarchy of erotic art is clear: "the male image is one of power, possession, and domination, the female one of submission, passivity, and availability."[26] Carol Duncan stresses the violence with which "the male confronts the female nude as an adversary whose independent existence as a physical or a spiritual being must be assimilated to male needs, converted to abstractions, enfeebled, or destroyed."[27]

Salle's reduction "of woman to so much animal flesh, a headless body"[28] seems, in part, to be a response to the radical avant-garde feminism that he was exposed to while a student at the California Institute of the Arts in the early seventies. The Feminist Art Program at CalArts, created and led by Judy Chicago and Miriam Schapiro, which I was part of, aimed at channeling reconsidered personal experiences into subject matter for art. Personal content, often of a sexual nature, found its way into figuration. Analyses and quotes (i.e., "appropriation") of mass-media representations of woman influenced artwork. "Layering"—a technique favored by Salle—was a buzzword of radical feminist art and discourse, as a basic metaphor for female sexuality. The Feminist Art Program received national attention and was the subject of excitement, envy, and curiosity at CalArts. Even students, male and female, who were hostile to the program, could not ignore its existence or remain unchallenged by its aims.

The history of this period at CalArts has been blurred, for instance in the curating of the CalArts Ten Year Alumni Show (1981), which excluded most women and any of the former Feminist Art Program students. In Craig Owens's review of that show, he mourned the resurgence of painting by artists nurtured in the supposed post-studio Eden of CalArts. His point may be well taken on the nature of the sellout by certain artists, but he does not probe beneath the given composition of the show to see that the Feminist Art Program, excluded from the retrospective, was truly radical and subversive in daring to question male hegemony of art and art history, whereas post-studio work at CalArts often simply continued an affectless commentary on art history.

Salle's lack of belief in the meaning of imagery is in striking and significant contrast to much work by women artists. From Paula Modersohn-Becker, Florine Stettheimer, and Frida Kahlo to Eva Hesse, Louise

Bourgeois, Nancy Spero, and countless other artists working today, women artists have shown a vitality that shuns strategy and stylistics in order to honestly depict the image of the core of their being. A comparison of two artists' statements speaks to this difference in belief, and, parenthetically, of motivation:

> I am interested in solving an unknown factor of art, an unknown factor of life. It can't be divorced as an idea or composition or form. I don't believe art can be based on that. . . . In fact my idea now is to counteract everything I've ever learnt or ever been taught about those things—to find something inevitable that is my life, my thoughts, my feelings.[29]—Eva Hesse

> I am interested in infiltration, usurpation, beating people at their own game (meaning scheme). I am interested in making people suffer, not through some external plague, but simply because of who they are (how they know).[30]—David Salle

Salle's abuse of the female nude is a political strategy that feeds on the backlash against feminism increasingly evident in the national political atmosphere. The current rise of the right in this country puts issues pertaining to female organs and women's freedom or loss of choice at the top of the right's list of priorities. It is not surprising that in such an atmosphere Salle's theater of mastery of humiliated female *Fleisch* (the title of a Salle painting) is so acceptable despite its bad-boy shock value.

Just as the black leather trappings of the Nazi SS have become trivially eroticized, so too it is possible for some critics to openly succumb to the cult of the artist as magical misogynist. Michael Krüger describes a day spent with Salle in the snow-covered Alps: from a patio, the two consider the "breathtaking scenery" before them, as they drink "a dry Swiss wine from inexhaustible bottles," and Salle smokes "one of those excessively long cigars which cause one to wonder whether they can ever be brought to a successful conclusion." Salle draws an imaginary picture on the view, and then, apparently, a real one in the snow.

> And then he did something that left me completely perplexed. I had always assumed that a painter begins his picture in one corner, for example, top left, if he is right-handed, bottom right, if he is left-handed. But, *without removing the cigar from his mouth*, David concentrated his attention on the center, where he placed the gigantic figure of a woman, naked,

her thighs spread wide apart. And he did all this in such a convincing matter-of-factness that the obsceneness of the gesture with which he had drawn so quickly in the snow only struck me as my view, still dazzled by the sunlight, slowly began to penetrate and rapidly melt. . . . The most obvious explanation that occurred to me was that David was using a symbolic action to liberate the instrumentalized body from the constraints of economy, to *return it to nature.* So there was this splendid body before us, several hundred meters across, and there were the skiers, their tiny bodies wrapped in the most incredible disguises, registering naked shock. . . . The route back down the valley obligated them to *desecrate this naked figure.*[31]

Woman apparently cannot win; either she *is* nature, or must be *returned to it,* in order to be *desecrated,* in a scene that rivals the imaginings of Ian Fleming—a giant cunt, a scenic mountain full of skiers, and the heroic male artist, James Bond/David Salle, cigar/pacifier in his mouth, poker-faced no doubt. One can only wonder what the reaction of the critic and the skiers might have been if an artist had drawn a giant male figure with erect penis, positioned so as to invite castration.

Recent attention has been focused on Paul Outerbridge's photographs of oppressed-looking female nudes posed with the standard trappings of fetishism and sadomasochism, and on Balthus's pedophilic portrayals of little girls who just happen to have their skirts flipped up around their waist. This attention represents an effort to give art-historical validation to present styles and content. A pertinent example of this art historical bolstering, and one that is revealing as to the sources of his misogyny, is Salle's choice of "appropriation" in *Black Bra* (1983), in which a real, large, black brassiere hangs off a peg attached to a large image of a Cézanne-like bowl of apples.

As Meyer Schapiro's "The Apples of Cézanne: An Essay on the Meaning of Still-life" illuminates, still lifes provide Cézanne with a method of self-control, a "self-chastening process."[32] "I paint still lifes. Models frighten me. The sluts are always watching to catch you off your guard. You've got to be on the defensive all the time and the motif vanishes."[33] Indeed, Cézanne's early paintings of nudes are anxious, uncontrolled, and violent, as the thick, gloppy brush marks demonstrate. Through painting careful arrangements of "perfectly submissive things" that have "latent erotic sense,"[34] Cézanne achieves self-possession, posses-

sion of the object of desire, and control of his medium. Needless to say, the comparison between Salle and Cézanne, invited by Salle's appropriation of the apples, goes no further than the original misogyny. Cézanne was able to arrive at a restructured vision of erotic struggle, in which the original violence is transcended and the link between sexuality and death is addressed beyond the target of female flesh. In short, Cézanne grew up.

But, by his quoting of Cézanne, Salle only links himself to the master's subjugation of the uncontrollable forces of sexuality and death incarnated by man in woman. By positing the artwork as being about the self-consciousness of the artist in relation to art history, he deflects the perception of its content for what it is—misogyny, narcissism, impotence. To condemn that content is to betray a misunderstanding of the whole purpose, which seems to be a continuation of a male conversation that is centuries old, to which women are irrelevant except as depersonalized projections of man's fears and fantasies, and in which even a man's failure is always more important than a woman's success. In Laura Mulvey's formulation, "the function of woman in forming the patriarchal unconscious is two-fold, she first symbolizes the castration threat by her real absence of a penis and second thereby raises her child into the symbolic. Once this has been achieved, her meaning in the process is at an end, it does not last into the world of law and language except as a memory which oscillates between memory of maternal plenitude and memory of lack."[35]

If, in a painting as in a dream, all the elements can be seen to represent the artist's psyche, then Salle is the impaled upside-down nude, as well as the rubber-tipped *Cane.* The identification with martyrdom indicates that the artist is subjugating the woman in himself. In subjugating woman, who is historically linked with painting as muse, model, and embodiment of sensuality, he is suppressing the painter in himself. Perhaps he is conquering fears about his virility, for "the victim of rape is not inclined to question the virility of her assailant."[36]

To some extent this essay was suggested by a male artist who explained to me that Salle's work was not misogynist but was a coded message to other men of his own impotence. Well, like the little girl in the old cartoon, "I say it's spinach and I say the hell with it."[37] Whatever the message is—be it homoeroticism, self-hatred, suicidal fantasy—the "desecration" of woman is Salle's expressive vehicle, his "code."

The painting *What Is the Reason for Your Visit to Germany?* (1984), which could also be titled "Bend Over Baby, While I Quote Jasper Johns," seems a temporary summation of Salle's constant themes. In one panel a naked woman bends over, her breasts dangling as she performs for the artist and the spectator. The word "fromage" is written across the center of the panel, at the very least indicating the condescending relationship of photographer to child—"say cheese," certainly a reference to "cheesecake," maybe a derogatory reference to the very smell of her sex. A companion panel of a lead-covered saxophone provides a phallic bulge and a competitive allusion to an older master. Over the woman is drawn, twice, the image of Lee Harvey Oswald being shot; once, so that the physical resemblance to Salle himself is immediately apparent, and then again as his head explodes into paint.

We see in this one painting a conflation of Salle's humiliation of woman, his glamorization and martyrdom of the assassin/artist, as he links woman, death, and paint.

A vicarious suicide, David Salle savages woman rather than savage himself. This is considered appropriate sexuality, and this is a source of his market value.

Notes

I researched and wrote the first draft of this essay in the spring of 1984. The Art Index entries under SALLE, DAVID were then, and are now, composed almost totally of supportive presentations and exegeses of his position. Articles critical of him are few and timid in their scope. There are none that are critical from a clearly feminist point of view. My article could be endlessly updated to include analyses of recent writings on Salle, but the balance of opinion is unchanged.

Some have questioned my use of the word "cunt" to describe female genitalia. I do so advisedly. It is the word that best describes what Salle paints, and it is a word that he himself does not shun.

I have limited my focus to Salle's depiction of women and to the treatment of that depiction by critics, that is to say, I have scrutinized only his subject matter. I have not addressed myself to issues of quality or style. If the question is asked, "Is David Salle a 'good' artist?" I can answer that I feel that he is very good at what he does, which is the manipulation and juxtaposition of appropriated images and styles. It is crucial to offer a critique of his imagery

because he is so effective in his presentation of it, because he is a critical and a financial success, and because his work and his career have epitomized a system of art practices and theories that have dominated the decade of the 1980s.—October, 1986

Muriel Rukeyser, *The Collected Poems of Muriel Rukeyser* (New York: MacGraw-Hill, 1982), p. 484.

Carolyn Donahue/David Salle/Joan Wallace, "The Fallacy of Universals," *Effects—Semblance and Mediation,* no. 1, Summer 1983, p. 4. (It was impossible to ascertain to whom this quote should be correctly attributed, thus all three names.)

1 David Salle, as quoted in Georgia Marsh, "David Salle. Interview by Georgia Marsh," *Bomb* 13, Fall 1985, p. 24.

2 David Salle, as quoted in Robert Pincus-Witten, "Pure Pinter: An Interview with David Salle," *Arts,* November 1985, p. 80.

3 Pincus-Witten, "Pure Pinter," p. 80.

4 Sherrie Levine, "David Salle," *Flash Art,* no. 103, Summer 1981, p. 34.

5 Carol Duncan, "Virility and Domination in Early Twentieth-Century Vanguard Painting," in *Feminism and Art History: Questioning the Litany,* ed. Norma Broude and Mary D. Garrard (New York: Harper and Row, 1982), p. 308.

6 Pincus-Witten, "Pure Pinter," p. 81.

7 Robert Pincus-Witten, "Entries: Big History, Little History," *Arts,* April 1980, p. 183.

8 Ibid.

9 Robert Pincus-Witten, "David Salle: Holiday Glassware," *Arts,* April 1982, p. 58.

10 Ibid.

11 Donald Kuspit, "Reviews: David Salle," *Art in America,* Summer 1982, p. 142.

12 Thomas Lawson, "Reviews," *Artforum,* May 1981, p. 71. In checking quotes for this republication, I find that the full quote is worth noting here because Lawson reworks this passage in "Last Exit: Painting," published in *Artforum* in October 1981, with significant differences. In the May 1981 review he writes: "Most often his [Salle's] subjects are objectified women. At best these representations of women are cursory and off-hand; at worst they are brutal and disfigured. His women are made ridiculous or ugly through juxtapositions with containerlike objects, such as furniture. These juxtapositions disturb on a deeper level than one might at first imagine" (71). In "Last Exit: Painting" he writes: "Often

his subjects are naked women, presented as objects. Occasionally they are men. At best these representations of *humanity* are cursory, offhand; at worst they are brutal, disfigured. The images are laid next to one another, or placed on top of one another. These juxtapositions prime us to understand the work metaphorically, as does the diptych format Salle favors, but in the end the metaphors refuse to gel. Meaning is intimated but *tantalizingly* withheld" (42; emphasis added). This version is significantly more favorable to Salle: he states, misleadingly I believe, that Salle also represents men, although he doesn't make clear whether he does so in the same manner or to the same degree of objectification, which allows him to shift from writing of representations of *women* to representations of *humanity*, a much vaguer and forgiving category; and he now gives the technique of juxtaposition a more positive value as determining a metaphorical reading, rather than as making the women more "ridiculous or ugly," as in his first version. Also significant is the change from, "Meaning is intimated, but *finally* withheld" ("Reviews," p. 71) to the sexier, "*tantalizingly* withheld" ("Last Exit: Painting," p. 42), emphasis added.

13 Thomas Lawson, "Last Exit: Painting," *Artforum* 20, October 1981, p. 45.

14 Lawson, "Reviews," p. 71.

15 Kuspit, "Reviews: David Salle," p. 142.

16 David Salle, "The Paintings Are Dead," *Cover* 1, no. 1, May 1979, unpaginated. A revised version of this statement is reprinted in *Blasted Allegories: An Anthology of Writings by Contemporary Artists*, ed. Brian Wallis (New York: New Museum of Contemporary Art; Cambridge, Mass.: MIT Press, 1987), pp. 325–27.

17 Simone de Beauvoir, *The Second Sex*, trans. H. M. Parshley (New York: Bantam Books, 1961), p. 136.

18 Kuspit, "Reviews: David Salle," p. 142.

19 Salle, "David Salle. An Interview with Georgia Marsh," p. 20.

20 D. C. Muecke, *The Critical Idiom #13—Irony and the Ironic* (London and New York: Methuen, 1970), p. 48.

21 Carter Ratcliff, "David Salle and the New York School," in *David Salle* (Rotterdam: Museum Boymans-van Beuningen, 1983), p. 36.

22 Ibid., p. 35.

23 Ibid.

24 Ibid.; emphasis added.

25 Linda Nochlin, "Eroticism and Female Imagery in Nineteenth-Century Art," in *Women as Sex Objects: Studies in Erotic Art 1730–1970*, ed. Thomas Hess and Linda Nochlin (New York: Newsweek, 1972), p. 9.

26 Ibid., p. 14.

27 Carol Duncan, "The Esthetics of Power in Modern Erotic Art," *Heresies 1: Feminism, Art, and Politics,* January 1977, p. 46.

28 Carol Duncan, "Virility and Domination," p. 296.

29 Eva Hesse, quoted by Cindy Nemser, "Interview with Eva Hesse," *Artforum* 8, no. 9, May 1970, p. 59.

30 David Salle, "The Paintings Are Dead," unpaginated.

31 Michael Krüger, *David Salle,* trans. Martin Scutt (Hamburg: Ascan Crone, 1983), p. 8.

32 Meyer Schapiro, "The Apples of Cézanne—An Essay on the Meaning of Still-Life," in *Modern Art—19th and 20th Centuries: Selected Papers* (New York: Georges Braziller, 1978), p. 33.

33 Ibid., p. 30.

34 Ibid.

35 Laura Mulvey, "Visual Pleasure and Narrative Cinema" (reprinted from *Screen* 16, no. 3, August 1975), in *Art after Modernism: Rethinking Representation,* ed. Brian Wallis (New York: New Museum of Contemporary Art; Boston: David R. Godine, 1984), p. 361.

36 Harold Rosenberg, *Discovering the Present—Three Decades in Art, Culture and Politics* (Chicago and London: University of Chicago Press, 1973), p. 46.

37 E. B. White cartoon caption: "It's broccoli, dear."/"I say it's spinach, and I say the hell with it."

Why We Need "Bad Girls"

Rather Than "Good" Ones!

Corinne Robins

The world has always divided women into good girls and bad. From time to time, women achieve a public bad girl status of being at once admired and mocked. Thirty years ago, Marilyn Monroe, last month, Madonna—the public wallows in such women flaunting their sexuality, rewarding them alternately with love, idolatry, and hatred. And, as has been pointed out by numerous feminist writers in the last decade,[1] such women perform for the rest of us a public affirmation of our female identity: man being the sex that defines humanity; women standing for sex or the gendered other. But, meanwhile, the word "bad" took on new connotations as, in the twentieth century, we learned that women who wanted to be more, who wanted to be artists and makers rather than symbols and muses were begging their assigned role, were not playing the game and by trying to "pass" themselves off as exceptions, were in fact "bad" while, as throughout history, good girls were silent, submissive, and anonymous. (Such good and bad categories handed down to us by men, and which many of us have accepted unthinkingly, still remain to be examined.)

Up until very recently, the few women allowed to participate in the

principal modernist art movements were accepted in a submissive, handmaiden role. The greatest women artists of the first half of the century lived exactly that part, women such as Sonia Delaunay and Barbara Hepworth. Hepworth by way of justifying her second-rung status in English avant-garde circles, said "I think art is anonymous. It's not competitive with men. It's a complementary contribution."[2] Hepworth's generation of women gave up all thought of winning too much attention. Attention would endanger their limited acceptance by male colleagues. Rather, they had to fight hard to remain in the game at all costs, including the cost of self-knowledge.

That was then. After all, the women's movement has been in place now for over twenty years. Nevertheless, the fact is we have just survived, and none too well, the backlash era of the 1980s. I have taught art students at Pratt Institute since 1978. In 1982, I was surprised when a few students came up after a class discussion about feminism and said, "Look, we just want to be artists. Isn't the fact we are women beside the point?" And I thought, my God, is it passing time again? Will we go back all the way to the 50s and the abstract expressionist period when, as art historian Ann Gibson pointed out in her 1990 College Art Association panel on abstract expressionism, "women and black artists were 'othered,' when the famous 'club' for artists begun in 1950 explicitly restricted its membership for the first two years to 'straight' male artists." Once such material is out in the open, it is not surprising to note that during this period women artists like Elaine de Kooning showed her work under the name of E. de Kooning and, for a short while, "the painter Grace Hartigan adopted the painting name of George Hartigan."[3]

The students' reaction in 1982 took place at the height of the neo-expressionist movement in New York, at a time when dealers like Mary Boone, when asked about her all-male roster of gallery artists, replied, "It's the men now who are emotional and intuitive . . . and besides, museums just don't buy paintings by women."[4] The resolutely anti-feminist wave had already receded a bit in 1986 when other students, this time shamefacedly rather than indignantly, came up after class to ask "just how long did I think they would have to be women artists?"

Why is all this still relevant? Why in 1990 as part of the Women's Caucus for Art National Conference titled "Shifting Power" did we elect to put on the exhibition entitled "Bad Girls"? And why was the title of

the show such a draw with the Caucus members, who submitted over 150 sets of slides? And finally, why was the chief complaint of one critic who wrote up the show that "we weren't bad enough?"[5] Obviously, in the 1990s being "bad" isn't enough. Our aim must be to be the "baddest."

First off, this may be because by implication bad girl artists, marginal artists—and most of the best women artists in the twentieth century have unwillingly been just that—are artists who make their own rules. All through modernism the boys—the abstract expressionist boys, the surrealist boys, the cubist boys in their turn set up the rules of their style as being at once exclusionary and universal. In fact, they set themselves up as genius clubs of artists and proceeded to reinforce each other as they set about to convince the world that they alone were the purveyors of their secret, greater vision, and therefore stood first in the canon of contemporary art history—a canon to which girl artists need not apply.

"Firing the Canon" was the title of the major panel jointly sponsored by the Women's Caucus and the College Art Association in 1990. Griselda Pollock, one of the panelists, in her book *Vision and Difference* gives the following example from the writings of George Moore by way of an explanation of what male art historians (and women, too) require from artists who they feel worthy of entering into the canon of art history: "Madame Lebrun painted well, but she invented nothing . . . failed to create a style. Only one woman did this, and that is Madame Morisot, and her pictures are the only pictures painted by a woman that could not be destroyed without creating a blank, a hiatus in the history of art."[6]

This canon of great artists, the CAA panelists agreed, is about "unique" vision as recorded in standard art histories. It was a "canon" from which women artists were totally absent, they also agreed, because it was men who did the recording. Another reason for women's absence seemed to lie in the fact that before 1970, women did not function in groups, but for the most part remained isolated as a nameless subgroup that denied its difference in order to receive some token acceptance from within the art community. These women, grateful to be able to do their work and who made art on the odd chance of being able to show it, were artists who for the most part did not call attention to what they were doing. The uniqueness of some of their visions was something that went undiscussed even by themselves.

The feminist movement changed that situation for artists like Louise Nevelson, Louise Bourgeois, and Alice Neel. Thanks to it, as a recent poster by the Guerrilla Girls points out, one of the advantages of being a woman artist is "knowing your career might pick up after you're eighty." The Guerrilla Girls group, formed in the spring of 1985 to combat sexism and racism, elected to use tactics and strategies appropriate to the 1980s, deciding first off "to remain anonymous in order to draw attention to issues rather than personalities."

The Girls became what was left or allowed to be visible of the feminist movement during the 1980s. Their street signs and posters about the condition of women in the art world sometimes gave younger women a boost, but were of limited value and then only to the already established women. The Girls staged a Contra-Whitney Museum Biennial at The Clocktower that was a media event, offering documentation on the power elite at the Whitney that had some limited effect on Whitney curatorial policies. The show was about being left out of the power structure and was a kind of historical summing up. This is not to denigrate the lone voice of the Girls. But, finally, they carried on in the spirit of an early feminist book project titled "Anonymous Was a Woman." Just how long, I wonder, do we have to be anonymous? In the 1980s, it was the Girls' policy even while they were naming critics and specific galleries not to talk about individual women artists. The fact is anonymity has always been the prescribed behavior role for good girls and good women. In March 1990, the Guerrilla Girls printed a poster consisting of an honor roll of their names. In the 1990s, at last maybe feminist anonymity is over, and feminism is again about to be an issue.

Also, alas, in the 1980s there began to emerge a kind of "Good Girl" feminism, which crested in the person of Mary Kelly and her *Interim* exhibition at the New Museum. *Interim*—divided into four parts, *Corpus* (body), *Pecunia* (money), *Historia* (history), and *Potestas* (power)— according to the New Museum's director, Marcia Tucker, in the show's catalogue, was "examining the woman as subject as she enters middle age, a time when her increasing invisibility and powerlessness in the masculine world may lead her to experience vividly her own constructedness."[7] Tucker begins this essay with a quote from a series of *Good Housekeeping* magazine ads titled "The New Traditionalist," which celebrates the "woman who has found her identity in herself, her home, her family . . . the contemporary woman whose values are rooted in

tradition." Tucker explains that in *Interim* by way of response, Kelly has
set out to examine the question "What is a Woman."[8] In fact, with her
discreet Latin titles, her total concentration on women—ladies talking
among themselves—Kelly's project (I hope unconsciously) like the *Good
Housekeeping* magazine ads represents one more turning back from the
identity women have achieved for themselves in the last twenty years in
the workforce, in the art world, and in politics. Indeed, in its emphasis
on the personal by its use of assembled quotes about the problem of
aging and of women's fading sexuality, it addresses itself to woman's loss
of power in the only area men have ever willingly granted her power.
That women have power in other areas is an issue Kelly prefers not to
address. Margaret Mead, a tough lady of an earlier generation, coun-
tered this kind of lady's day fluff (latin titles notwithstanding) with
her now famous observation "Beware the power of the menopausal
woman."

Throughout *Interim*, but most blatantly and least effectively in the
Corpus section, Kelly uses an object of clothing or its visual representa-
tion to stand in, symbolize "eros," for example. A commodity as stand-
in for a physical (sexual) impulse is by now a classic advertising tech-
nique. Unfortunately, in *Corpus* when Kelly presents three panels of
black lace panties to stand in for stages of desire, one folded, as if in a
drawer, the other outstretched as if inhabited, and the third crumpled,
worn, the visual message doesn't carry. Throughout, Kelly overloads
with symbolic meaning objects such as a black leather jacket (today
every young woman's favorite fashion statement) while simultaneously
relying heavily on language in the form of over-long printed messages
containing her own and other people's writing. While in the work,
clothes may be intended as stand-ins for hysteria about sexuality, for
this viewer it seemed as if the word finally subsumed the visual di-
alogue. The word took the place of the body and *Interim*, full of books,
signs, and greeting card placards, had more to do with time spent in the
library than it had with art.

In contrast to Mary Kelly and her substitution of language for the
object, Hannah Wilke, a quintessential bad girl, from 1968 on has used
her actual face and body, naked and dressed, the specificity of herself as
an art object moving through space and time. Because of the traditional
role of woman as sex object, some of the early feminists questioned if it
wasn't demeaning for women to put their focus on personal erotic

attributes rather than subsume them to the larger interests of feminist art. (The movement of artists using their own bodies in performance, including Carolee Schneeman's *Meat Joy* work of the late 1960s, are almost concurrent with Wilke's own early pieces.) And a few felt Wilke's stance at the time seemed perhaps overly provocative: wasn't she, maybe, giving the men what they want? But Wilke's juxtaposition of her nudity with fashionable philosophical musings by Marx and the like, her awkward parading of (and even at times turning inside out) the age-old cliché of mind versus body struck a nicely satiric note.

In 1984 in the New Museum's show entitled "Gender and Difference," the art world was presented with Kelly's first work, *Post Partum Document*, a 1979 paean to motherhood unlike anything seen since the mid-1950s. In it, Kelly once again put before us all the subject of dirty diapers—diapers and diaper rashes being a mainstay topic of women's magazines of that period. The Kelly work seemed an example in and of itself of a new traditionalism, "drawing heavily on Lacan's analysis to deconstruct the psychoanalytic discourses on femininity and the assumed unity of mother and child in order to articulate the mother's fantasies of possession and loss."[9] Kelly, acting like the most bemused of mothers, obsessively recorded the stages of her son's development from stained nappies (British word for diapers) to his first efforts at writing, "thereby taking possession of the patriarchal word." The theoretical *Post Partum Document* offered viewers little to look at and lots to read. (Looking and reading, i.e. decoding letters, being two quite different exercises.) The point of it was Kelly's experience of raising a male child. To one less favored, in that I reared a daughter, the differences in nappies and early childhood education mores, the process Kelly endlessly displays, are invisible. Perhaps, the poignancy of having to monitor a girl's development might have been more telling. But then, it would not fit in as well with Lacanian and Freudian psychoanalytic theory in which the child remains the woman's consolation and substitute penis, which she gets to insert into the patriarchal order.

By way of contrast, my recent "Bad Girls" exhibition featured Hannah Wilke's 1974–75 *S.O.S. Starification Object* series, which, done roughly in the same timeframe as Kelly's *PPD*, is a photographic record of a series of performances, together with mounted chewing gum signature miniature vulvas which Wilke wore during them. The point of the piece was that the artist, partially stripped, confronted the public

with these dainty vulva chewing gums decorating her body. According to Wilke, the use of chewing gum pieces refers to early primitive rituals of decorating the body—the naked body being what we all have, the communal fact bringing us together. Wilke's work has always been funny, with deadly serious intent. Over the years, a humorous toughness together with a total confrontational attitude have been Wilke's "Bad Girl" trademark.

Today, more and more women artists making visual objects are part of an ongoing backlash to the backlash of the 1980s. The ten other "bad girl" painters, photographers, and sculptors in the exhibit were Nancy Browen, Elisa D'Arrigo, Carol Goebel, Harmony Hammond, Bonnie Lucas, Joyce Romano, Hope Sandrow, Linda Stein, Selina Trieff, and Rhonda Zwillinger, a group who in their work and their mediums were diverse and visually compelling.

Nancy Bowen's large green female butt (women's butts have always been the prerogative of male humorists), and Linda Stein's terrifying array of cutting tools on a kitchen chair with giant shears along the wall (the ultimate castration weapons) were menacing indeed. From Selina Trieff's androgynous pilgrims with mocking pigs (that most "unclean" and antireligious animal) to Carol Goebel's rusting wall creatures, the work was purposefully, visually confrontational. It seems the objects women artists are making today are growing larger, more defiant, and more memorable.

What then is one to make of the spectacle of well-behaved feminist theoreticians in the art world ignoring a vast segment of art done by women in favor of their ongoing conversations with each other? It seems to me doubly ironic that this type of conversation began with the New Museum's 1983 "Representation: Gender and Difference" exhibition; and that Tucker, in a recent article, "Women Artists Today: Revolution and Regression," complains "that lack of change in the intellectual discourse has, except for the occasional woman artist, left things very much where they were. What is certain," Tucker claims, "is that there is at present no agreement even as to what constitutes feminism itself; there is certainly no way of seeing women 'as an unalloyed force for good' or a unified sisterhood or nature."[10]

It seems relevant to note here that throughout the 1980s the New Museum refused to acknowledge that discriminatory practices against women artists might necessitate all-women shows. Tucker in a tele-

phone conversation in 1983 with this author explained that it was the New Museum's principle not to sponsor all women shows since such shows are based on sexual discrimination against men.

Tucker's plaintive words, "from my point of view not much has changed since those early days," shows a pretty shocking lapse of memory. As a one-time curator at the Whitney Museum, she should know better. In 1970, there were maybe four nationally known women artists as opposed to some eighty-seven in 1989 as demonstrated in the recent exhibition and book *Making Their Mark* in which Tucker's essay appears. The problem is a majority of the women artists in the exhibition came to the forefront when the movement was at its most active in the 1970s.

The point still remains that it takes long years before women are regarded or regard themselves as anything but outsiders to the art game. Even now, in the 1990s, we need to be aware of the trap of considering gifted women artists as "exceptionals" rather than as in the forefront of a "minority" power party. It is important for us to acknowledge a commitment to the next generation of women artists, as Bourgeois, Nevelson, Neel, Schapiro, and Spero did. It is to these artists' credit that all of them refused the role that required that they detach themselves from the bulk of women artists. Otherwise we will remain "exceptionals," expected above all to act like "good girls" and to regard any and all approval as somewhat provisional.

As a new decade begins, it seems to this writer a matter of urgency that women artists, critics, and politicians alike unite in the face of the threat of outside control of our bodies' reproductive organs and falling numbers in terms of our overall representation. We must not allow ourselves to again be closeted into wholly "women's issues" but continue to expand our territory. It would seem to be in all our interest to opt to become as "bad" and as visible and perhaps as intransigent in terms of our actual greater numbers as we can be.

Notes

1 Germaine Greer, Griselda Pollock, and Julia Kristeva are three of the large group of feminist writers who immediately come to mind in terms of the 1980s.

2 Cindy Nemser, "Barbara Hepworth," *Art Talk* (New York: Scribners, 1975), p. 15.

3 Ibid., p. 181.

4 "Mary Boone, New Queen of the Art Scene," *New York Magazine,* November 22, 1982, p. 28.

5 Vivian Raynor, "2 Shows, 'Bad Girls' and 'Personal Visions,'" *New York Times,* March 4, 1990, p. 14. Miss Raynor complains about the remaining other artists: "Carol Goebel, Bonnie Lucas, Joyce Romano, Hope Sandrow, and Rhonda Zwillinger—and there's not a Rambo among them."

6 Griselda Pollock, *Vision and Difference* (London and New York: Routledge, 1988), p. 83.

7 Marcia Tucker, "Picture This: An Introduction to *Interim,*" *Mary Kelly: Interim* (New York: New Museum, 1990), p. 17.

8 Ibid., p. 18.

9 Whitney Chadwick, *Women, Art, and Society* (London: Thames and Hudson, 1990), p. 355.

10 Marcia Tucker, "Women Artists Today: Revolution or Regression," in *Making Their Mark: Women Artists Move into the Mainstream, 1970–1985* (New York: Abbeville, 1989), pp. 200–201.

Letter on Good Girls, Bad Girls, and Bad Boys

Barbara Pollack

Why go for second best baby?
Put your love to the test.
Make him express how he feels and
Only then you'll know your love is real.
—Madonna, "Express Yourself"

Smack in the middle of my very own "bad girl" crisis, I find the whole world suddenly in the midst of debating those old categories: "good girls" vs. "bad girls." As a woman artist who is also a daughter, wife, and mother, I find myself in a surprisingly "bad girl" state of mind. Terribly empowering, it is; I have granted myself permission to rebel and act out within the studio, independent of the roles I must negotiate outside the studio.

Yet, in the past month, it also sounds awfully silly and solipsistic. Perhaps, the interview with Madonna on *Nightline* was a turning point. *She* sounded awfully silly and solipsistic. The right to sell yourself as a sex object has always been available to women. The limits of this trans-

action have been thoroughly explored by feminists since the nineteenth century. I find myself wondering why this is such a potent claim at this time and why feminist artists are re-evaluating our position on this issue.

My starting point is Corinne Robins's article "Why We Need 'Bad Girls' Rather Than 'Good' Ones!" in *M/E/A/N/I/N/G* #8. Robins puts forth a definition of a "bad girl artist" for which I am totally supportive, that is, "artists who make their own rules." "Bad girl," however, implies more than flaunting the rules. Being a bad girl has rules of its own. If I remember correctly, bad girls in my high school were not simply rebellious students. They were the girls who experimented with danger by acting as if they were sexually experienced. Specific items of clothing (tight jeans, leather jackets, high heel shoes), very specific make-up (red lipstick, not frosted), and shag haircuts (like Jane Fonda in *Klute*) all made up the bad girl persona. Also, we must not forget this key characteristic—they hung out with bad boys.

In Robins's article, Mary Kelly is set up as the opposition to "bad girl" artists. Kelly is described as a "good girl" feminist ("ladies speaking among themselves") because her work "addresses itself to women's loss of power in the only area men have ever willingly granted her power." Though I am not a fan of Kelly, primarily due to my own bias against work accessible only to highly literate audiences, this distinction is without meaning. There seems little difference in using "sexiness" or using loss of "sexiness" as one's subject matter. Both focus on the female form as totem and both sometimes inadvertently function to re-emphasize this quality. The key problem with Kelly as interpreted by Robins is her focus on the "personal," i.e., only of interest to other women; or to use the vernacular, Kelly doesn't hang out with bad boys.

Exploring female sexual experience has unquestionably served an important role in feminist art. And knowing this subject matter is available to me is liberating as an artist. But, there is something in the label "bad girl" that is even more "seductive" than mere access to sexual material. It carries with it access to men, the marketplace, and the tradition of genius. On one level, many feminists are afraid of being called "prudes." Recently we, or to be most honest, I feel an overwhelming desire to prove that a feminist can look just as good as the next girl in high heels. I have even been known to argue that Madonna is more fun to have for a role model than Margaret Thatcher. However, the

question remains: is involvement in sexual material empowering for a woman artist, does it come from secure parity with the male point of view, or is it only a remake of the old dilemma of the sex symbol?

Being a totem is powerful but limiting. Totems may be worshipped but they are not allowed to go out and change the world. The female experiences power merely as embodying what is forbidden to the male. She is denied her own experience of creating and violating taboos.

The female sharing in the male experience of violation, rather than creating her own, has been a significant undercurrent to "bad girl" art that encompasses many of the artists reviewed by Robins. A side to this discussion not looked at by Robins is that, unfortunately, "bad girl" artists often find themselves in the bind of the promiscuous tomboy, flaunting our adolescent sexuality so we can be "one of the boys." All this gets us, in the end, is a bad reputation. We do not get invited to the prom.

Anyway, Robins's article is itself "ladies speaking among themselves" as long as we only compare "good girls" to "bad girls." To test whether "bad girl" is a truly liberating position, we must also examine what is meant by "bad boys."

Peter Schjeldahl's recent review of the de Kooning/Dubuffet exhibit at Pace brings some interesting information to this discussion ("Female Trouble," *Village Voice*, January 8, 1991). Schjeldahl defines a bad boy as one who desecrates the image of the Woman and then experiences shame at his destructiveness. He uses the term "Woman" but it is clear he is talking about the Mother, in an almost Freudian sense of the word. He states that "A grown-up straight male artist is perhaps a good boy who has made a vocation of maximizing the pleasure of being bad while minimizing its expense." Female artists share the pleasure of being bad. To a surprising extent, our work also involves rebellion against the Mother. The question remains whether it is possible for us to experience "being bad" and escape punishment as male artists do. Can *we* minimize its expense?

While male artists may create objects representing the female that they then violate to play out being bad, we often locate our focus on our own bodies. Some of the most problematic "bad girl" work is not in the realm of painting and sculpture, but performance art. In order to be "bad girls," artists such as Karen Finley set up their own bodies as the Mother and re-enact de Kooning-like desecration on themselves. Even

in a more socially acceptable sense, the need to "be bad" in the sense of "being sexy" often comes from a resolve on the part of a woman not to look like the Mother. There was a time when high heel shoes, lingerie, and make-up were more clearly examined as distortions of "natural" beauty. Today they are being held up as symbols of freedom.

Ultimately feminist artists must face their ambivalence about the need to desecrate the female form in order to live up to a "bad" reputation. Being bad, flaunting sexual knowledge and rebelling against the Mother are inextricably linked for both "bad girls" and "bad boys." The difference for "bad girls" lies in the fact that we are playing dangerous games with our own image. The mother's threat, "Wait until you are a mother" comes true and we grow up to find that we may have unwittingly contributed to new stereotypes for women to overcome.

How can "being bad" be bad? . . . or, as Madonna has recently asserted, in a less articulate fashion, it's her body and her choice to be a sex symbol and isn't that what feminism is all about? The distinction between enjoying our sexuality and "being sexy" seems to have gotten lost in this discussion. "Being sexy" is a historically, culturally determined status. Embracing and enjoying our sexuality is a not-yet-achieved right. "Being sexy" is therefore an enjoyable, but highly problematic experience, much in the way that the compliment "You paint like a man" was once received by women artists.

Madonna would be a truly "bad girl" if, instead of demonstrating to a generation of young women how to make big business from being a fetish, she would be a pioneer and turn men into sex objects. In short, Madonna is no Mae West. Her videos show the variety of ways women play out assigned roles and at best raise the issue that "femaleness" is merely a costume change. She does not deal with the consequences of "playing dress-up"; that we grow up to be who we pretend to be, especially when it comes to male-generated fantasies.

As a woman artist who frankly enjoys using categories like "good girl" vs. "bad girl" myself, it is time for a confession. Most artists, myself included, male and female, were nerds in high school. We were rebellious, yes, but in an intellectual way. Most of us were not successful at the dating game. Male artists complain that they were not jocks and female artists complain that we were not cheerleaders. As adults we enjoy re-creating "high school" in a sense. We enjoy our second chance as adults to join the cool crowd. In subliminal and not so subliminal

ways, we want to flaunt our "sexiness." The last thing we want is the label "good boy" or "good girl."

The bottom line, though, is what does the label "bad girl" really get a woman artist? The cultural understanding of a "bad girl" is a "sexually available" woman and it is a fine line to tread that one is "bad" in her art but not "bad" in her life. Recently Virginia Woolf's myth of Shakespeare's sister has been haunting me. Shakespeare's sister, according to Woolf's allegory, as a tremendously creative woman of her time, found her way to the theater door, but not as a playwright or actor, both forbidden at the time. No, the director finds her spirit enchanting, takes her in, and seduces her. Historically, that has too often been the result of confusing a woman's talents with her sexual persona. Can we honestly state that today we may "choose" to be seduced or seductive, so the results are less diminishing?

This confusion between a woman's art and her self is a key issue for all feminist artists, whether addressed in our work or not. As long as articles, such as *Vogue*'s coverage of Frida Kahlo's eyebrows, appear, I must question whether my art or my "sexiness" are fundamental to my development as an artist. Perhaps this is why I can enjoy calling myself a "bad girl," but I get nervous when it is a category employed for understanding feminist art.

Robins questions the efficacy of "good girl" feminist artists and theoreticians. The answer, quite simply, is that some feminists fight the battle for respect, just as others fight for liberation. Perhaps, "good girl" feminists have figured out that being a "bad girl" has its limits when it comes to achieving respect. Being a "good girl," after all, holds its own form of power—the power of sadistic withholding.

To downplay the sexual and withhold one's favors can sometimes get you more attention than red lipstick. As my mother always told me, her "bad girl," "Why buy the cow when she gives her milk for free?"

A Conversation on Censorship with

Carolee Schneemann

Aviva Rahmani

The following conversations with Carolee Schneemann took place beginning on January 28, 1988. The last discussion was on August 24, 1989, shortly after she had returned from Russia, where her film *Fuses* was to be shown at the Moscow Film Festival. The program for the American Soviet Joint Venture (ASK) was organized by the San Francisco International Film Festival. The program included Philip Kaufman's *Unbearable Lightness of Being* (as a feature) and a side bar of "Sexuality in American Films," including *Trash* by Paul Morrissey, *Working Girls* by Lizzie Borden, *She's Gotta Have It* by Spike Lee, *Beyond the Valley of the Dolls,* by Russ Meyers, *Desert Hearts* by Donna Deitch, *Sex, Lies, and Videotape* by Soderbergh, Mark Huestis's program on AIDS, *Heavy Petting* by Obie Benz, and three shorts by James Broughton. Only *Fuses,* after an opening night unscheduled screening, was canceled from subsequent planned screenings, and was finally screened unannounced after pressure from the USA organizers. *Fuses,* made from 1965–1967, is the first film shot by a woman in which she's also the participant in her own lovemaking. There is no third person—on camera. It's painterly, densely collaged, and all the sequences are in complex rhythms which disappoint pornographic expectations. This was not

Schneemann's first encounter with censorship, and it was being mirrored in Washington, D.C., with Jesse Helm's crusade against the Mapplethorpe exhibit and the NEA.

Aviva Rahmani (**AR**): You've dealt with aggression in your audiences in your career from both men and women. In your recent trip to Moscow you traveled all the way there, they put you up and gave you a translator only to divert your work! That's a tremendous blow to your adrenaline, isn't it?

Carolee Schneemann (**CS**): How about, tremendous spark? Censorship breaks your integrity: it's sinister because the work is endangered and engaged in a falsification of motive. In Moscow I was struggling against invisible powers and was always the fool because I didn't know where my enemy was. The Russian organizers were cordial, gracious, and every day they had increasingly unbelievable stories as to why the showing of *Fuses* was postponed or canceled. I was fortunate to have a translator who became a defender, champion, fighter—very aggressive on behalf of the film. Every time *Fuses* was diverted he would arrange for TV and journalists to be present; we would have interviews about whether or not the film was to be shown.

One TV interview was under the direction of a small round woman in her sixties who arrived at my hotel room with a full crew. She was the head of "Sexual Education in the Soviet Union." She would introduce the interview, then Vladimir, my translator, would translate her questions. He would then translate my response. She was smiling approvingly, looking into my eyes as she spoke into the microphone. "What's she saying?" I asked Vladimir. . . . He paused . . . "She's saying you are a pornographer and a dangerous woman."

AR: Of course, you *are* dangerous. Jesse Helms speaks for a lot of people who intend to resist having their traditional convictions threatened by "dangerous people." But sometimes it comes from unexpected sources.

CS: In Cannes, in 1968, *Fuses* was shown as part of a special jury selection. This sophisticated French audience went berserk. I was standing in the back with Susan Sontag, expecting a pleasurable audience response. Instead, a great commotion erupted in front of the screen. French men were ripping up the seats with razor blades and screaming because it was *NOT* truly pornographic. It wasn't satisfying the predictable erotic, phallocentric sequence they wanted. It was a source of frustration and anger.

AR: Carolee, I feel a great deal of rage and bitterness over this censorship issue that has come up, but not for the reasons I hear everyone else ranting about. I'm furious because this is the art world's equivalent of the one white male heterosexual who gets AIDS and all of a sudden everyone takes notice. It's tremendously hypocritical and self-righteous. The fact that Mapplethorpe was gay and Serrano is black is incidental, in the art world, to their fashionable status. The reason I accuse the art world of hypocrisy on this is that no one stood up to defend or protect twenty years of feminist artists and feminist work that got trashed. And anyone who doesn't think that has economic and self-censoring effects has their head in the sand. In 1968 the backlash against all of us who challenged the established norms of sex and power began.

It seems ironic to me that after twenty-five years, America and Russia have reached parity over censoring your work. *Glasnost* and American conservatism equals out. If the art world had cared to acknowledge what was happening all along and resisted years ago, the right wouldn't have such a podium today. The art world has failed itself by failing those of us who knew all along that we were at war. But at best they were either cowards or indifferent.

CS: So, hey, Judy Chicago puts a sacred vulva—which celebrates a historic woman of unique creative authority—on a dinner plate! And she wants people to sit down, say grace and eat! . . . Hey! We're not going to get approval and funding from the Bridal Registry . . . not even Duchamp's.

We're examining deflected censorship and violent censorship (consider abortion rights); individual and communal censorship (consider AIDS research and care). My experiences with censorship cover a wide range: from the man who attempted to strangle me during the Paris performance of *Meat Joy* (1964); to USA government intervention preventing my anti-Vietnam war performance *Illinois Central* (Chicago 1968); to the manager of a world famous rock group spiking the sangria which was passed out from the dressing room of the Round House to 2,000 participants in the "Celebration of the Chicago 8" (London, 1969); to the local police arresting the projectionist and the projector with *Fuses* still on it (El Paso, Texas, 1985) . . .

My work within erotic and political taboos has been fueled by the constraints of sexism, but my work has offended both men and women, and been defended by both women and men; my work has offended

granting agencies and institutions, and been supported by granting agencies and institutions. I like the margins to slip on . . . the uncertainty. From the margins I've been free to attack, to sniff out the leaking repressions and denial of subordination. Head-on is too much—it's macho, you'll get knocked out of the rink . . . your body is chopped up, head cut off, your children disappear. In male power structures you purchase incivilities for their own self-justification . . . better to run free out here. It's a relatively recent social process in which the good guys *don't* get blown away . . . that they can play with the girls and find meaning, value—a complementariness of action, insight, and force; a repositioning of the old heroic mold. . . . We still build on the underlying pattern that good guys get blown away—that identification with the female, interiority, the unconscious, puts them in jeopardy. . . . The male psyche unearths lost attributes, missing attributes when the female no longer represents the victim-self. Well really it's a privilege to produce work that provokes censorship! Although I don't believe that is my intention, nor that of Judy Chicago, Mapplethorpe, Serrano—even the contentious actions of Karen Finley do not "invite" censorship—rather, controversy, confrontation . . . an unraveling of submerged, denied, latent content. Volatile erotic, sexual denial underlies the self-righteousness of our reactionary censors. Each of our transgressive visions rises from a particular brew, a churning of contradictory values and our insistence to cut through cultural delusion and psychosis. Our lived insights merge with our imagining and materials.

So the real dilemma of the censor is to corral the imagination and the passage of visceral insights into aesthetic and political contexts. Denying a few photographs an exhibit, canceling screenings of *Fuses* only heightens our necessary bite and gnaw—to cut into layers of taboo, denial and projection.

AR: Tell me something about your experience with other artists, writers or journalists in Moscow.

CS: Our conversations were curtailed—not by overt censorship—but by a disparity of analytic precedents. The erotic and political thrust of my work has particular cultural referents which we take for granted: the writings of Artaud, De Beauvoir, Wilhelm Reich were early influences; Freud, Jung, feminist investigations in art history, psychology, linguistics and concepts of the sacred erotic, of an ecological economy; even

the gender constructions of Russian Marxism not implicit in Soviet discussions. Issues of sexuality pivot on authoritarian constructs. Our feminist issues which have assertively dismantled male definitions of female value have not reached into the newly shifting Soviet morality. The intellectual sophistication of my Russian friends—their sharp, ironic perceptions, and the depth of Western influence merges with Russian metaphysical traditions, fueling profound longings—to be released from paranoia, punishing consequences; to express convictions, passions which were punishable by incarceration, exile, repudiation, for the past forty years. It is *impossible* for us to realize Stalinist terror and suppression left not one person, place, or thing unscathed. How do they now contemplate a life of economic scarcity and hardship with the new creative frankness? In an economy in which soap, tampons, condoms, toilet paper, diapers are usually *unavailable*; in a demanding daily struggle which exhausts everyone—how can an examination of erotic intimacy not seem like a luxury? a risk?

Among all the sexuality in USA films, *Fuses* hit a taboo button in Perestroika. But the great achievement was for so many Soviet films which had disappeared to be "off the shelf"—to be shown publicly for the first time since they had been "purged." The issues of women in the Soviet Union were addressed in a remarkable program of documentary films.

Patriarchal gender constructions systematize transference and mythification lurking within the idealization of the arts. We are looking at different forms of denial/censorship: one form instigates public outrage, outcry; the other acts as a slow smothering, a constraint. In the former instance you might have to fight for the immediate fate of your work; in the latter you have to wait it out, persist, live in the basement . . .

It's interesting that this year, twenty-four years after *Fuses* was made it could be both censored and uncensored at the Moscow Film Festival and receive its most intensive structuralist analysis in David James's *Allegories of Cinema*—an analysis in which my deepest motives and methods are clarified.

So, I understand your rage and fury at the dissimilar suppression of works by feminist artists and by Mapplethorpe and Serrano. The only way I ever learn how transgressive my works are—I have this naive, messianic streak and an instinct for the cultural distortions which surround me—the only way I experience the resistance in my culture is by

the denigration, denial, and attempt to obliterate or trivialize my work and its direction. But in the Soviet Union there would have been no chance to ever produce such work! I recognize the measure of society's psychosis when I realize there are only two roles offered me to fulfill: either as a "pornographer" or as an emissary of Aphrodite!

Given our contemporary morality, women artists and gay artists have to fight like guerillas . . . from the edge of the aesthetic encampments . . . from under and over the banquet tables. I think gay men can assume a particular posture—it's often superphallic or metaphallic, to challenge and flush out the underlying grandiosity of male erotic fantasy and its concomitant castration fears. Conservative straights hate to face the paradoxical magnification of their own suppressed desire. Female sexuality incites another sort of proscriptive idealization to ward off detestation, envy, and fear.

AR: In the process of working with sexuality can you describe an evolution in the material?

CS: My exhibit in March 1989 at Emily Harvey Gallery, NYC raised all the same difficult issues about the perception of the body and the body as a source of structuring form. *Infinity Kisses* is a composition of over 160 color photographs displayed in a nine foot by seven foot arc. Over a six-year period I shot in available light close-ups of my cat Cluny's morning ritual mouth to mouth kisses. Because in many of the photographs you can see tongues touching, many people found the sequence obscene.

AR: But by using a cat, you're going even further and making it "non-pornography," taking the erotic issue out of the context of heterosexual mating into eroticism for its own sake. Eroticism becomes a language of communication not necessarily attached to specific organs, actions, people, but simply part of being alive.

CS: I feel I've worked into a big blind spot in the art world. I've been enraged by the sexually negative reactions to so much of my work. I always felt I was doing the obvious next step. In *Fuses,* the necessity was to investigate the absence in my culture of a visual heterosexual intimacy that corresponded to my own experience. If there was no example, could I possibly produce evidence? *Fuses* does. It became a classic work despite resistance; some people used to think of it as this narcissistic jerk-off. The invisibility of "self" that I experience is that I really

don't see *myself* there. I'm an available conscious form that's permeable, that I'm able to use. The culture obfuscates lived experience, the female erotic and the sacredness of sexuality. There's a similar motive in my performance piece *Interior Scroll*. I didn't *want* to pull a scroll out of my vagina and read it in public, but it was because the abstraction of eroticism was pressuring me in a way, that this image occurred, which said, you must demonstrate this actual level . . .

AR: It sounds like you are saying that sexuality as it presents itself in our culture became a form, a metaphysical structure on which to hang the whole issue of human intimacy and the deeper experience of intimacy itself. It's a double-edged sword, of course, because of the baggage our society brings to sexuality and nudity.

CS: I'm using myself in a culture that surrounds me with artifice, lies, obfuscations, grandiosity. Every time a film is made you are cast to act constrained to "represent" someone and something that you're not, or in semiotic structure you are abstracted into a set of propositions to demonstrate something you may or may not believe. In using the actual lived life—that's the only chance for me to see: Is there a sensory and conceptual correspondence between what I live and what can be viewed and seen? It's not normal to be phallicized or de-phallicized! The world is a great vulva that mirrors and imprints the phallic shape, not the reverse! So you see, for me to get clear, I have to make it all inside out and backwards. But there's a way I protect myself from thinking this is "myself."

AR: That sounds like it has a painful aspect.

CS: This is the work and I'm an element in it, the best available material for investigative work. With the cat imagery, I have that same surprise and bewilderment when people say this is "bestiality, obscenity." Their negative response seems a measure of erotic dislocation and cultural deception. Tenderness, sensitivity, yielding, wetness, permeability are all taboo aspects, isolated as "female." The cat is an invocation, a sacred being, profoundly devoted to communicating love and physical devotion.

AR: Quoting from the *Allegories of Cinema* by David James: ". . . in *Fuses* the only stable persona implied is a black (actually grey) cat; its manifest sexuality is a purring correlative to the action." I would say that the cat was more than the correlative, its content was the symbol of a general harmony with nature.

CS: My next film is on the burner—that is—percolating, and it's inspired because *Fuses* continues to raise questions of the essential erotic. As you say, it is "warfare" and the battleground of greatest intensity has been and remains the body—the female body. The taboos are still in place. The transgressive works you mention focus outrage accorded to male sensibility, constructs of male culture. Female creative assaults—with their deep spiritual implications, their attention to gender declivities are surfacing in male consciousness. . . . We are still streaming in from the moon . . . from our planet.

Aesthetic and Postmenopausal Pleasures

Joanna Frueh

Since June 1992, I have been researching and writing about women artists and aging. My focus is contemporary American artists over fifty. I chose fifty because it is the median age at which menopause occurs for Western women and because menopause remains a powerful marker of aging. From June 1992 until January 1993 I sent questionnaires to one hundred women visual artists and interviewed women artists who deal with aging or the body in their work. I received sixty-one responses to the questionnaire, and all subjects were fifty or older. Research continues, and "Aesthetic and Postmenopausal Pleasures" is excerpted from a chapter in a book-in-progress I'm writing on women artists and aging [*Erotic Faculties*, 1996]. In the complete chapter I present a theoretical approach to old(er) women's pleasures and ground it in the art of Bailey Doogan, Claire Prussian, and Carolee Schneemann, among others. My ideas develop from numerous sources, including real old(er) women's self-aestheticization, Yvonne Rainer's *Privilege*, whose hub character is menopausal, and the necessary proliferation of polymorphous perversities. My desire is to make connections between visual pleasure and female pleasures from a position of difference, female aging, that is a largely uncharted territory, outside cultural maps of conventional femininity, and that consequently may provide feminism with new models of female pleasure.

Young(er) women want to be seen; old(er) women are hypervisible, yet, paradoxically, erased by society's alienation from its aging bodies. I question the force of sociovisual conventions—only young(er) women can assume the appearance and postures of sexiness—and the cultural imperative to age gracefully, a euphemism for fading away, lulling lust. Grace derives from the Latin *gratia*, pleasing quality. An old(er) woman who doesn't act her age is not pleasing, unlike a young(er) woman in the guise of femininity, because the old(er) woman exposes her pleasure, which society tries to deny and names indecent.

Women can choose dyed hair, red lipstick, "inappropriate" dress, styles of flamboyance, spectacle, elegance, or "tastelessness" that may be indicators of self-love and lust for living. Love of color and texture is not a crime that old(er) women commit against themselves. A viewer cannot assume that an old(er) woman alive with colors and sensuous bodily and clothing surfaces is trying to mask her age because she hates herself.[1] Old(er) women's self-aestheticization is an autoerotic action that destroys visual pleasure as we have known it, for the postmenopausal woman cannot be the feminine fetish, eroticized by patriarchal womb-worship. The nonreproductive woman's self-aestheticization deaestheticizes Woman as socially constructed femininity.

The erotically disenfranchised postmenopausal woman does not make femininity ugly but rather refuses to accept the exclusive canon of womanly beauty. Her defiance both shatters and expands the aesthetic of femininity and opens the way to new meanings of woman. For even though femininity is misogyny's attempt to sanitize the female body, femininity is also a complex of pleasures that are lived and available and that women can use in order to change them. Postmenopausal eroticism, which includes taking pleasure in the vision of oneself and creating that pleasure, is overt triumph over societal and self-repulsion. What Carolyn Heilbrun calls "the heterosexual plot" has excluded old(er) women from the love story of romance and breeding, and it has no words for women's love of themselves.[2] The woman who grows old gracefully, who is well-preserved, is a dead body, embalmed by a disgusted secularization of women once the culturally sacred womb can no longer bear children.

The postmenopausal body deserves cultural resurrection as a site of love and pleasure.

Without love, there is no revolution, and without pleasure, there is no freedom.

Female pleasure has been theorized in terms of sexual difference but not in terms of women's differences from women. This matters, because patriarchy has determined reproductive woman to be desirable, a site of pleasure, and post-reproductive woman to be undesirable. Young(er) women live the privilege of bondage to the eroticized reproductive ideal. Old(er) women live beyond that privilege.

The Freudian story of the castrated woman lays the groundwork for hatred of old(er) women. A man cannot impregnate a postmenopausal woman, cannot even imagine his creativity visible in her body. Thus menopause is a subversion of female reproductive organs as the origin of male desire (and greed), of erotic symbols and narratives, and of womanhood when spiritualized as the cosmic center of the female body.

Womb privilege operates along with the eroticization of young(er), firm(er) flesh and muscles which represent the phallic symbol, the penis, in its state of power, erection. The old(er) body is the equivalent of detumescence and represents phallic failure. So man must avoid entry into the tomb of his desire.

But the eye is polymorphously perverse and can be trained and lured into diverse pleasures, just as the libido can be. Erotic desire floats, ready for grounding, awaiting direction from a desiring or loving subject. Changing the image of female erotic object from the youth ideal of Western art and advertising demands a change in the parameters and focus of love, the applications of femininity, and the source of female privilege, which has been patriarchy's maintenance of its own empire of desire that has used the female body toward male ends. But pleasures abound in any body and therefore on "the other side of privilege."[3]

Many women artists over fifty say that doing what you love keeps you young. Thus their making art is the practice of love, and underlying the various ways women express belief in art making as fountain of youth, I find erotic motivation. Audre Lorde describes the erotic as rich living and ultimately an involvement in the transformation of self and society.[4] The erotic is pleasure-work, and its practitioner engages in social risk and provides social sanctuary. The old(er) woman's art making as pleasure-work is a provident skill. The results fill a gap in the stories about women's lives with an eros that is self-reliant and resilient.

Bailey Doogan says, "Female pleasure is a Pandora's box. So much goes against your realizing what female pleasure is, but something about female pleasure is connected with a freedom and acceptance of

myself. I find that I often can't talk about the things I care about and the passion for what I care about is reserved for my work."

"I feel more of a going inward as I get older," and perhaps this is associated with a positively narcissistic scrutiny: "The older I get the more I stare at myself." This desire to know one's soul-inseparable-from-the-body through observation is Doogan the artist's pleasure, and she duplicates her visual self-fascination in her paintings of the old(er) female nude. She says, "I feel as if I'm crawling over the bodies inch by inch," as she paints.

Doogan wants to "define the body in relation to culture."[5] As a painter of the female nude/herself seen in her model's flesh, Doogan creates what has been absent in male visual language while using that language to shatter it. The old(er) body, within the conventions of Western art and its vampiric relative, contemporary advertising, represents chaos, because it does not submit to the strictures of domination that have pictured the female body for man's eyes. While the standard female nude, or nearly-nude in advertising, is a sweet that pains a woman's mind-and-soul-inseparable-from-the-body, Doogan's figures in works such as *Mea Corpa* (1992) and *Mass* (1991) are sights for women's sore eyes.

Whereas the conventional female nude is an icon of womb-worship, Doogan's nudes retheorize the canonical female body. Her iconoclasm goes beyond resistance or rejection because she invents a difference from the norm that does not transcend the significance of liminal experience. Although Western culture has construed the female body to be more liminal than the male, because the former undergoes and manifests blood mysteries and has culturally been marked more cruelly than the male body as exemplar of time's ravaging passage, Western art has denied that liminality by shunning age (as well as pregnancy, menstruation, and menopause). Western art's use of the female body to control time—aging and death—contributes to our fear of flesh that moves, wrinkling and even shrinking with age in a dephallicizing process.[6]

As I wrote earlier, the old(er) female body is the tomb of man's desire. To picture the old(er) female nude is to represent the ultimate patriarchal taboo, which is the end of patriarchy. Doogan's female nudes then are models of feminist and female pleasure. They are made by a woman who questions to death the premises of erotic argument—only the young(er) body is desirable, and patriarchy decides that—and the subject who questions experiences pleasure.

She is Mea Corpa, *my* body, standing in the posture of the resurrected Christ, and her flesh moves with the energy of eros. Veins protrude along her calves and feet, skin creases at her ankles and waist and both clings to and bulges at her knees. Light does not caress her, it illuminates her new seductions: heavy eyelids and undereye pouches, bony shoulders, muscled arms and legs worked out in the gym and worked on by the force of gravity over time. Doogan's crawling over every inch results in a body that feels like fluids, flesh, and organs and that recalls Monique Wittig's resuscitation of the female body in *The Lesbian Body*. Like Wittig, Doogan conceptualizes flux and inseparability by using erotic syntax and creating a body—a word that feels too categorical in Doogan's and Wittig's usages—that deserves the name "m/y radiant one."[7]

Naked splendor in *Mea Corpa* offers itself to female eyes and recovers itself from the guilt, *mea culpa,* of not being beautiful or correct enough to be seen. This female figure steps out of the (literal) darkness (of guilt) deaccessorized of conventional erotic props, such as bed, fan, drapery, fruit, or flowers. She displays appetite for herself, *my body,* not the one Western art invented and permutated for Woman, so *my body* has risen, flown from the dystopian eros developed by patriarchy. Doogan puts an end to anorexia of the spirit.

To turn Doogan's phrase, "Female pleasure is a Pandora's box," in her paintings Pandora's box is female pleasure gone wild, the pandemonium loved by some viewers and feared by others. I've heard several people compare her figures to Ivan Albright's. Both artists do present unforgiving spectacles, but Albright's most-remembered paintings depict pathetic specimens of decay. Their flesh mocks them with the futility not only of vanity but of living itself, so the figures, which are rarely nudes, become emblems of dying and death. Their skin looks iridescent, diseased, and worn, and they seem predisposed to growing tumors.

If Doogan's bodies seem like sore sights that frighten women's eyes, this is because they are unaccustomed to "chaos," which is Doogan's assertion of corporeal specificity and individuality, which she says are beautiful. Doogan is friendly to the female body, and "mea corpa," in Doogan's language, reads most significantly as destigmatization, a transformation, from guilt to self-possession, that is responsible to women's real bodies. The nude's face in *Mea Corpa* is tired, but both face and body speak pride, peace, and dignity, unlike the subjects' faces in Albright's *Woman* (1928), *Flesh* (1928), and *Into the World There Came a Soul Called Ida* (1928–30), which are sad and grim.

As Doogan neared fifty—she was born in 1941—bodily specificity began to be present in all her nudes, young(er) and old(er), female and male, and she also focused on female aging. A change in style and content can be seen from 1987 to 1992. In *Femaelstrom* (1987) Doogan paints a female St. Sebastian expressionistically and nonspecifically in regard to age and physical idiosyncrasies. Haloed in gold leaf and pierced by arrows—sticks of wood dipped in red paint—St. Sebastian gazes towards a bevy of bean pods, upon each of which Doogan has painted a young bikinied woman. The femaelstrom is women's confusion over Western culture's splitting of woman into saint and sinner.

Nineteen eighty-nine was a pivotal year of change with three monumental mixed media drawings. Scumbled, scratched, and gestural grounds simultaneously reveal and obscure images, such as book pages, heads, and body parts, but shapes are often indecipherable. The smoky and ashen tones set a ghostly stage for sloping-shouldered, wide-hipped nudes whose large, low breasts and bellies, slack-skinned arms and thighs, and bony chests designate the particularities of bodies worked on by time. Male desire mediates neither them nor the artist's sentiments. For example, in *RIB (Angry Aging Bitch)*, Eve, supposed origin of the Fall, stands in triplicate with stern face and bald head in the "fallen" flesh that signifies women's "fall" into sex, hunger, and age, the desires and inevitabilities of the body. At the figures' head level and across the entire drawing the words "ANGRY AGING BITCH" exist in haunting obscurity except for three scarlet letters, "R-I-B." Doogan twists a knife into the ribs of the idea that woman was born from man and adulterates the notion that woman, as an actual or imagined body, is man's creation. Doogan's bitchy ribbing of convention and her ironic Eve are darkly humorous. By creating a monumental female figure that shows character, unfashionable proportions, and age, Doogan has transformed hypervisible absence into presence.

She sees the old(er) female body as sensuous, and she sees the male body in the same way. In *Mass* a nude man lies over a chair, stomach up. He grips its leg and top edge, as if to maintain the dire tension that exposes his beauty and vulnerability. In a panel to the right a woman stands illuminated in darkness, a cry issuing from her mouth as though she is an unexpected saint enduring an invisible martyrdom. In both bodies veins ripple and flesh seems to pulse with an energy from within and beyond. The chair flames in several spots, but mostly it is charred.

The "chairman," the generic white male authority, has "fallen" from his seat of power, becoming sensuous and moving. Doogan paints his territory turbulent grays, and where his hand grabs the chair back, red flames flow from the dead seat of power and fill a rectangle that reads as burning sky. Mass: the bodies have weight and exhibit the pull of gravity. Mass: the woman prays for reconciliation between self (woman) and other (man), which is the resurrection of love and passion. On the horizon flames signal the destruction of old dynamics of power and the intensity of new erotic heat between old(er) woman and young(er) man.

Femaelstrom and *RIB* are characteristic of Doogan's late 1980s female nude—suffering, melancholy, and (later) aging in monumental resoluteness and inspirational rage. She invests the newer works with reconciliation, the balance in one body, and between bodies, of sensuousness and spirituality, and with a redirection of displeasures sustained from injuries by the fathers to pleasures maintained in service to oneself.[8]

Redirection opens recognition of loss and the necessity of courting unsung, painful, or newly discovered passions. In *Privilege* Jenny, the menopausal hub figure, starts up from the bed where she has just had sex with a male lover, young in this flashback where she is her contemporary fiftyish self, and exclaims, "My biggest shock in reaching middle age was the realization that men's desire for me was the linchpin of my identity." When women of fifty or so have fallen from the grace of womb-love, what do they love in themselves and in their unbecomingly hypervisible because erotically invisible sisters?

A reclining nude in Hannah Wilke's *Intravenous Series* (1992) is an assertion of erotic will. The 48″ × 72″ color photo continues her self-documentation as erotic agent and object. As in *S.O.S. Starification Object Series* (1974), in which Wilke, beautiful in her early thirties, poses in chewing gum "scars" stuck to her body as symbolic display of psychic and cultural wounds that come from living in a body marked "woman," Wilke is a damaged Venus, this time by cancer and its therapies. Intravenous tubes pierce her, and bandages cover the sites, above her buttocks, of a failed bone marrow transplant. Her stomach is loose, and she is no longer the feminine ideal. "My body has gotten old," she said close to a month before the bone marrow transplant, "up to 188 pounds, prednisone-swelled, striations, dark lines, marks from bone marrow harvesting." Although an art historian could cite Renaissance martyr

paintings as sources, she could also understand Wilke's vulnerable Venus, twenty years ago and now, as a warrior displaying wounds and as the dark goddess, Hecate at the crossroads of life and death. Wilke called her work "curative" and "medicinal," and she said that "focusing on the self gives me the fighting spirit that I need," and "My art is about loving myself."[9] The *Intravenous* nude shows Wilke within—intra—the veins of Venus, a lust for living in the artist's blood.

Although Wilke resuscitates the boneless, erotic look developed by Giorgione and Titian, making herself, as usual, into a classical nude, she is not female body as erotic trophy. This is because she characteristically proves that the body's boundaries are liminal and insecure—most recently through vivid and explicit pathos—and because, more than ever, she affirms I AM WHO I AM. Bodily insecurity paradoxically becomes erotic social security, as does the ruin of the classical nude.[10]

The myth of the artist as risk-taker, adventurer, and visionary is embedded in art history's and criticism's language of war and language of miracles, and postmodern critiques have challenged the myth.[11] But it doesn't die. Robert Mapplethorpe and David Wojnarowicz live on in contemporary art lore as heroes whose art and lives held erotic value, and the art press has lionized Matthew Barney, Richard Prince, Jeff Koons, and David Salle, still living exemplars of a masculine ethos, enforcers in their art of the patriarchal plot. Art history's and criticism's romance with them all is a sentimental replay of Western cultural legends in current and easy incarnations of Joseph Campbell's "Hero with a Thousand Faces."

When love is a large hunger for flesh that moves, the terms of romance transform. The art hero with the same old face turns into an actual old(er) woman whose art is known to provide erotic sustenance and activate ever more polymorphous perversities.

Notes

My thanks to the artists I interviewed and to those who responded to the questionnaire are deep. Work on the women artists and aging project was supported by a Faculty Research Award from the University of Nevada, Reno.

1 Kathleen Woodward, *Aging and Its Discontents: Freud and Other Fictions* (Bloomington and Indianapolis: Indiana University Press, 1991), pp. 158–59, tells a story from anthropologist Michele Dacher's and psychoanalyst

Micheline Weinstein's *The Story of Louise: Old People in a Nursing Home*. The book gives psychoanalytic portraits of eight people who live in a French nursing home and focuses also on Louise, a seventy-two-year-old bistro habitue. She had platinum blonde hair, she downed liquor, sang loud, and exchanged obscenities with others, her lipstick was dark, applied beyond her mouth's contours, and she was physically dirty. Woodward writes, "The point of course is that Louise's ferocious excess was a sign of her desire—quite literally her erotic desire for a man named Jean—and a measure of her more general powerful investment in life. Her remarkable appetite and energy, her flamboyance, which had nothing to do with parody, drew these two younger women to her."

2 Carolyn Heilbrun, *Writing a Woman's Life* (New York and London: W.W. Norton, 1988), p. 131.

3 I quote from Yvonne Rainer's *Privilege* (1990).

4 See Audre Lorde, "Uses of the Erotic: The Erotic as Power," *Sister Outsider* (Trumansburg, N.Y.: The Crossing Press, 1984), pp. 53–59, one of the classic feminist writings on the erotic.

5 Doogan's statements were made during a telephone conversation with the author, February 4, 1993.

6 See Joanna Frueh, "The Fear of Flesh That Moves," *High Performance*, Fall 1991, pp. 70–71, for a discussion about the dread and pleasures of bodily liminality.

7 Monique Wittig, *The Lesbian Body*, trans. David Le Vay (New York: Avon, 1975), p. 159.

8 Most of the discussion about *RIB* and *Mass* are in Joanna Frueh, "Bailey Doogan: "Reconciliation," *Artists of Conscience II* (New York: Alternative Museum, 1992), pp. 27–29.

9 Wilke died on January 28, 1993. Statements by her in this article are from telephone conversations with the author, May 11, 1992 and January 9, 1993.

10 Some women artists over fifty deal less paradoxically than Doogan and Wilke with postmenopausal and other pleasures. Examples are Carolee Schneemann's installation *Cycladic Imprints* (1988–92), parts of Barbara Hammer's film *Nitrate Kisses* (1992), and Anne Noggle's *Stellar by Starlight* photographs, begun in 1986.

11 I dealt with this language in "The Dangerous Sex: Art Language and Male Power," *Women Artist News* 10, nos. 5–6, September 1985, pp. 6–7, 11, and have done so more extensively in my performative lecture "The Language of War and the Language of Miracles," first delivered in 1991.

just a sketch of what a feminist art, or feminism, could or ever did mean before or after whatever is implied by the present

Laura Cottingham

A few years ago, I could have discussed feminist art—what it is, what it isn't, what it has been, what it could be—with a greater degree of intellectual confidence than I can today.

I might have suggested that the primary aim of a feminist art must necessarily be based in an overt consciousness of the specificity of female experience as constructed and regulated under the ideology, social customs, and legal apparatus of male supremacy. I might have called "quality" into question. I might have spoken of the need to refuse the delusion of formalism. I might have referred to the myth of genius or the failure of individualism. I might have derided all of European bourgeois art history. Maybe I would have tried to think through the different critical obstacles proposed by some of the dominant feminist-inspired visual strategies of the last twenty-five years: the limits of "body" art; the endgame of appropriation; the failure of assimilation and the dissimilar failure of separatism; or, the perpetual questions that plague painting, women painting . . .

It was easier for me then, only a few years ago, to define, at least, the parameters for considering what is or what could be termed "feminist art." I thought I knew where we stood, even though, then as now, we didn't all stand in the same place. And if I didn't know exactly where we should go, I had suggestions, or at least I remember having them . . .

But then, that few years ago was not so long after the ten years ago when I was freshly graduated from college, where I had begrudgingly graduated with a degree in anthropology, from an institution that only offered feminism as an extracurricular activity. That is, I learned feminism on campus, but outside of any classroom. I "learned" feminism as a member of a student group, the Women's Union.[1] We read the same books that had mobilized the Women's Liberation Movement in the U.S. during the previous decade: Simone de Beauvoir, Shulamith Firestone, Kate Millet, Susan Brownmiller, Valerie Solanas, the anthology *Sisterhood is Powerful,* Redstocking's *Feminist Revolution,* and other early writings from the activist movement. None of these books were ever "assigned" to me in class, nor were they being taught by any members of the faculty at the University of Chicago during the early 1980s to the best of my knowledge—and I would have known. My college advisor, a natty, British-surnamed Harvard man whose father had been the same, was constantly at war with me: I didn't respect the right things, after all. During one memorable session, ostensibly devoted to designing my course selections for the coming year, he screamed at me accusingly: "You're not interested in anything but Marxism and feminism!" Why should I be?

But forget my "interests": like all students, my education was limited by what was available. I studied under one Frankfurt School scholar in the philosophy department, and to him I am still thankful. To others responsible for my formal education, I have less than generous feelings. I endured more than a few lectures where male professors, before delivering their fictional accounts of "fieldwork" gathered during trips to Africa or South America, prefaced their lectures with "And Laura, don't ask me about the women, because I don't have any information." The men in the class would then laugh. This off-the-cuff disclaimer was supposed to be sufficient to explain how someone could purport to have "information" about a "society," while all the "information" was gleaned from observing half of the social group, that is, from docu-

menting the activities of men. It was also meant to humiliate me, to remind me that questions about "women" were not taken seriously, nor would they be tolerated.

The male bias accepted as normative in most anthropological perspectives was only part of the problem: that these white men, from the U.S. and other English-speaking countries, thought they were capable of "knowing" anything worth "knowing" about societies they knew little to nothing about, was the fundamental farce of the discipline. By the early 1980s, the waning of Claude Levi-Strauss's universalist claims and the post-structuralist response put forward by Roland Barthes and others had already led anthropology to its own endgame. Sophisticated practitioners, such as Clifford Gertz, were declaring the death of the field. As an academic discipline, anthropology had originated as a colonial-imperialist enterprise, a genesis that still controls its movements in the U.S. and elsewhere. But institutionalized practices seldom cease just because their methodological efficacy has been either called into question or patently disproved: the anthropology department at the University of Chicago, the first such department in the U.S., lives on.[2]

It seemed to me then, as it does to me now, that if one is interested in investigating how a culture functions, how a society distributes wealth and constructs value, one could best begin by observing one's own. The superstitions and irrationalities that motivate the social movements of members of the U.S. are at least as fascinating as those that mobilize smaller communities elsewhere. And given that the U.S., unlike smaller communities elsewhere, is in the process of vigorously exporting its cultural values abroad, doesn't an examination of those values take on a kind of intellectual and moral urgency?

But maybe Chicago just wasn't the "right" place for a young feminist interested in examining, from a critical perspective, American art and culture. That's what the Whitney Independent Study Program is for—or so I was told by an art historian, a curator, and others who had been following my art writings in student and Chicago-based publications.

Needless to say, I wasn't happy to arrive at a program "made for me" that, like my undergraduate training, didn't include any feminism on its reading list. Again, at the Whitney Independent Study Program, which I dropped out of twice, I had to go "off campus" to satisfy my intellectual interests: in New York I met feminists, theorists, and activists who had been active during the 1970s and I joined one of the few

small feminist activist groups still around in New York City during the early 1980s. Unfortunately, there weren't enough of us in our "group" to make much of a difference to anything. The group eventually folded and most of its members subsequently joined Act-Up, which through the rest of the decade remained the only large-scale direct action group in the nation. Meanwhile, feminism lost its entire radical fringe, leaving behind only the reform groups, like the National Organization for Women or the National Abortion Rights Action League or similar groups devoted to intervention on the electoral or legal levels.

Coextensive with its deference to the reformist arm of the movement, feminism became institutionalized, at least in name, within the academy. That none of the most important theory of Second Wave Feminism had developed out of the academy, or had, in cases such as those of Kate Millet or Mary Daly grown out of *opposition* to the academy, should have remained a permanent point of reference for those engaged in "Feminist Studies." How does feminism advance within a society defined by its belief in and maintenance of women's subordination? How especially can it advance within institutionalized practices such as academia?[3] If you doubt the verity of this politically crude question, witness the evolution of "feminist studies" into "women's studies" into "gender studies." Each subsequent shift in nomenclature is telling: the rhetoric moves progressively away from locating women's oppression as the site of investigation. The shift from "feminism" to "women" is a move from a word that embodies a history of a people's fight for equality to a word that is simply descriptive of those people, women. The move from "women" to "gender" completes the depoliticization, as it suggests that the study of "women" is inadequate or incorrect, that "gender" both male and female is a preferable site of inquiry. The last move, from "women" to "gender" was both logical and inevitable after the first shift, from "feminist" to "women" was made: the only reason, after all, to study "women" is to study our oppression because oppression is, exactly, the defining characteristic of what a woman is, or what women are: we are people who are exempted from the rights given men and victim to specific forms of discrimination, prejudice, and harassment not levied against men.

Women have nothing as significantly in common than our common experience of being part of a group of people historically and presently subjugated to men. But if you don't want to look at that, if you want to

deny, apologize for, or naturalize our inferior status in society, then, by all means, why not dance around in the fiction of "genders." Although I don't mean to condemn the entire academic apparatus or those working for feminist interests who coexist within it, I do think there's enough evidence to suggest that what has come to be termed "feminism" is not necessarily so; there can be no feminism, as Tania Modleski has suggested, in a "feminism without women."[4]

For me, the most simple articulation of what has "happened" during the past few years goes something like this: Whereas in the mid-1980s there was little feminism visible, in 1993 there was something called "feminism" often visible, but too often, I can't find the "feminism" in it. This confusion of terminology—taking place in the academy and other cultural frameworks, such as the art community—has serious political implications for the advancement of women's rights as constructed in theory and in practice. The most obvious example is the work of someone such as Camille Paglia, who calls herself a "renegade feminist" when, according to any intellectual or political analysis, she is clearly antifeminist. Perhaps less obvious is someone such as Judith Butler, who, while misreading de Beauvoir and Wittig, occasions to find the signifier "women" wanting, and therefore suggests we discard it. But without the category "women"—a category imposed upon us and enforced within male supremacist constructions—we are left without the nomenclature that not only binds us together, but binds us down. To suggest that there is no such thing as a "woman" may hold philosophical verity, so too for "race," "homosexual," or "class": all forms of classified subjugations are "false" constructions. But to abandon the categorical imperatives before they are materially eliminated is to play to the conservation of society as it is now: neither gender-, race-, nor class-free.

Whereas during the 1970s and the early 1980s, antifeminism was championed by women such as Marabel Morgan, Phyllis Schlafly and Midge Decter, all of whom articulated their opposition from the "outside" of feminism, since the mid-1980s, the antifeminist front has been led by women who call themselves "feminists."[5]

My definition of feminism is any activity, thought, or deed which assumes both that male supremacy exists and that it must be dismantled. To not acknowledge the existence of male supremacy, or to not advocate its elimination, is to not be engaged with feminism. The

process by which feminism is defined is also the process by which feminism happens. In the 1970s, this "process" would have been termed "consciousness raising"; now, we are looking to establish an intellectual foundation for distinguishing between "consciousnesses," for an intellectual foundation that allows us to argue for the validity of one interpretation of women's experience over another. That the theories of postmodernity that decry the verity of both generalized assertions and subjectivity have put all radical political theory into serious crisis is something that must be worked through during the next decades.

But that the present would have come to pass this way is not surprising: antifeminism in the name of feminism is the most effective way for conservative power to maintain itself, and postmodernity may eventually be considered a reactionary shuffle against the activism demands that hit the industrialized West circa 1968. Because of the mass mobilization of women that occurred during the 1970s, and the successful transformation of the popular consciousness into accepting at least some of the most basic insights of feminism, the demand for women's equality can no longer be easily denounced, at least not in the U.S., and not by the same theories of female subordination that successfully kept women subordinated during previous centuries. Even Orrin Hatch, for instance, refrains from quoting the Bible or insisting on the literal meaning of the word "man" as written into the U.S. Constitution—though his view of women's position in society is derived from the Bible and the social customs of Europe's eighteenth century. But in order to keep women economically, socially, and politically subordinated, new words and fresh explanations are needed to replace, while restating in different language, the old ones. Why not try:

Women are different.
Women enjoy prostitution, it is an act of sexual empowerment.
Women are liberated by *Hustler* magazine.
Women "deserve" to have babies and jobs too.
Just look, Mary Boone shows some artists who are women.
Women are empowered if one of them gets to donate free professional
 services to the federal government, a privilege given to her by virtue
 of her legal marriage to the president.
More men, after all, are doing housework.
This is just a "patriarchy," not "male supremacy."

Things are better now for women.
Motherhood is a "choice."
Female heterosexuality is a choice.
Lesbians and gays are both "queers."
Women are "abjected," not "oppressed."
Women are women because Freud and Lacan explained why.
"Women" are not women because some of us are nonwhite lesbians.
Wife beating is spouse beating.
Women marry and take on their husbands' surnames by "choice."
Women just need to try harder.

There is now a job available for a woman who is willing to occupy the category "feminist" while not practicing feminism, just as there is a job for a black who is willing to sell out other blacks, or for a homosexual who is willing to collude with homo-hatred. In terms of self-interest, either for economic or social survival, it's obvious that to "get ahead" in contemporary America, the best deals to be cut are those made with straight white male centrality in mind. And you don't have to "be" a straight white male; in fact, they especially need you if you're not because you can engage in a signifying practice, a form of representation, that they can not.

So what does any of this have to do with "art," with the idea or practice of a "feminist" art? There are many ways that art can be informed by feminism. At this particular moment, though, I am pessimistic because I don't think it's possible for any significant advancement, in art or in politics, until we synthesize and further elaborate the insights of the 1970s, of the art and politics of the Women's Liberation Movement. We haven't done it. We are still working through—politically, culturally, and artistically—the legacies of Women's Liberation, as well as those of the Black Power and Gay Rights mobilizations.

On the theoretical level, while there is a plethora of material published out of the academy that is inarguably more sophisticated than the early writings that came out of the Women's Liberation Movement, they are substantively not an advancement and, in many instances, they constitute a backlash. Theoretically, the biggest obstacle to the development of feminist theory has been the undue prioritization of psychoanalysis, specifically according to the writings of Jacques Lacan. How curious that the same methodology that ruined the movement in

France has succeeded in becoming the primary intellectual obfuscation of women's position in the United States.[6]

How curious that there is some commercial and museum interest for some contemporary work that evidences feminist concerns—Sue Williams, Janine Antoni, Kiki Smith, for instance—but at the same time, the avant-garde movement that originated the premises of these and other artists, the Feminist Art Movement of the late 1960s and early 1970s, has yet to be given any serious critical, much less financial, support from either critics or museums. Feminist and protofeminist insights have guided the production and reception of American art since the 1960s; many of the women who worked within the pop movement, such as Rosalyn Drexler and Marjorie Strider, produced work already conscious of the need to forefront their specific experiences as women in their art. Pre-1970s performance works, such as those of Carolee Schneemann, evidence similar concerns, and Louise Bourgeois's work from as early as the 1940s often directly takes women's suppression as its theme.

By 1970–78, after feminism had reached critical mass and mass mobilization in the United States, the number of artists working directly from a feminist consciousness was enormous; the movement in the U.S. alone easily included more than a thousand artists. The Feminist Art Movement was decidedly anti-, not "post," modernist. It called high art into question, challenged the absoluteness invested in history, refused to follow the dictates of a formalist proscription, insisted on the importance of content, privileged autobiography, and was perhaps the only true avant-garde movement that occurred in the United States during this century. It was certainly the most ambitious: the Feminist Art Movement, like the radical activist movement which inspired it, wanted to change the world.

Many of the women artists who garnered international attention during the 1980s, such as Laurie Anderson and Barbara Kruger, for instance, were Feminist Art Movement participants during the previous decade. (Kruger was a student under Miriam Schapiro at Parsons in the mid-1960s, but how often is this lineage noted?) That Sherrie Levine, Cindy Sherman, and Jenny Holzer could neither have existed nor been recognized had the 1970s movement not preceded them is obvious. Why then is there so little respect for the diverse and groundbreaking feminist work of the 1970s? Why are so many of the artists

associated with the movement still treated with critical contempt? And by critics and artists and curators who are women who consider themselves feminists? Is it perhaps because white women, the largest sector of the Feminist Art Movement and the largest group of women working in art, are currently the most deluded members of American society?[7] Middle-class white women comprise at least 50 percent, if not more, of the American art apparatus: as art school students, artists, curators, dealers, critics, and collectors. Have we no respect for ourselves, our history, the continual devaluation of our lives? I think not.

While women can continue to produce "feminist" art—and I hope that we do—I do not see any possibility of any serious leap forward until another historical configuration, such as that circa 1968, provides the kind of creative explosion, on all cultural fronts, that significantly changes what kind of ideas and what kind of action and what kind of art is possible. At the present moment I see us as severely compromised: and in ways that we are responsible for, in ways that are neither inevitable nor necessary.

Notes

1 The Women's Union, a student organization at the University of Chicago, had previously been called "the Chicago Women's Liberation Union." The name change took place sometime before I arrived on campus in September of 1979. One of the earliest-formed and most active of the college feminist groups during the 1970s, the Chicago Women's Liberation Union is documented in *Sisterhood is Powerful* with a 1969 statement that ends with: "At the U of C we see the first large action, the first important struggle of women's liberation. This university—all universities—discriminate against women, impede their full intellectual development, deny them places on the faculty, exploit talented women and mistreat women students." *Sisterhood is Powerful,* Robin Morgan, ed. (New York: Vintage Books, 1970), pp. 595–596.

2 How some methodologies and/or political movements "win" while others "lose" is perhaps my fundamental question here; in terms of feminism, we need to know not only what feminism "is" but how its "is-ness" could come into practice, could subvert, deflect and eventually replace the misogyny that currently defines and mobilizes our societies.

For instance, recently I have been trying to trace how psychoanalysis

has come to occupy such a central place in Western intellectual life. It is obvious that economistic Marxism, or other materialist-based perspectives, are inadequate explanations for all of human motivation and behavior, so the introduction, through Louis Althusser, of neo-Freudianism during the 1960s was perhaps inevitable. But the over-prioritization still given to Freudian, specifically Lacanian, thought is appalling, given how inadequate and incomplete the psychoanalytic model is—most especially when utilized to analyze women's subjugation.

One might assume that Lacan was too blindly and hastily accepted when first introduced to consciously-politicized intellectuals in France and in England during the late 1960s and early 1970s. This was not at all the case. In France, the reactionary implications of Lacan and PsychéPo., the women's group associated with Lacanian theory, were immediately discussed and published in everything from the Letters Column of *Libération* to the feminist theory journal founded by Simone de Beauvoir and others, *Questions Féministes*. In England, the film journal *Screen* was one of the primary venues for the introduction of psychoanalysis as a valid framework with which to interpret and explain cultural experience and products, especially cinematic narratives. But, for instance, a 1978 essay published in *Screen*, "Difference" by Stephen Heath (himself an early Lacan enthusiast), reveals and critiques the male supremacist ideology imbedded in Lacan's primary theses, particularly his privileging of the phallus. Heath's essay is extensive and well argued; to me it seems impossible that women who claim to be working from a feminist impetus could submit so dutifully and so loyally to Lacan—and after arguments, such as Heath's and others, were not only made, but made in precisely the "right" publications.

This is just one example, albeit far from a trivial one, of the failure of "information" to transform either opinions or practices. This failure of the enunciative model—"just say it, say it clearly and loudly and it will be heard"—is a more significant flaw in the premises that underlie the liberal, humanist, post-Enlightenment model than any of the lacks so far revealed by the ideas most associated with postmodernity.

3 It might appear that feminism should share similarities with Marxism in this respect. But within academia, the difference between feminist practitioners and Marxist practitioners is crucial. Marxist "professors" are, by Marxist definition, not the agents of change—a professor is socially and economically situated outside of the "working class." Whereas, in terms of feminism, if practiced by a woman or women, the "professor" is still

an agent of change—and therefore, ipso facto, more threatening than her male academic-Marxist colleagues. (I owe this insight to Christine Delphy, in conversation.)

4 Tania Modleski, *Feminism Without Women* (New York: Routledge, 1991).

5 Even a theorist such as Julia Kristeva, who does not consider herself feminist and has never called herself one, is often defined as "feminist" in the U.S. Is this because she is a woman who sometimes writes about women? Is this so that women who are not *doing* feminism can claim to be doing so; that is, they can claim to be involved with the difficult demands of a politically engaged life while basically doing nothing?

6 The history of the MLF in France, specifically the ascension of the group PsychéPo., is either unknown or conspicuously not referred to by American academics who have taken the neo-Lacanian theories associated with that group to heart. PsychéPo. emerged as a consciously antifeminist organization. For a discussion of the activist movement in France, and the problems involved in the devaluation of the word "feminism," see my "Interview with Christine Delphy," *off our backs,* March 1984, pp. 10, 11, 24, 25. For a discussion of how the leader of PsychéPo., Antoinette Fouque, has falsified the history of the French movement and appropriated it for her own (and others') ends, see Christine Delphy, "Les origines du Mouvement de libération des femmes en france," *Nouvelles Questions Feministes* 16, 17, 18, 1991, pp. 137–148.

7 Black women in America, for instance, are not deluded enough to exist in significant numbers in the Republican party. White women, however, are in such sorry shape that they sent a misogynist such as Arlen Spector back to the Senate; Spector could not have won his 1992 race in Pennsylvania without women's support—and it was from white women that he obtained it.

A Conversation on Lesbian Subjectivity

and Painting with Deborah Kass

Patricia Cronin

The following conversations with artist Deborah Kass took place beginning on December 16, 1992 with the last discussion on May 30, 1993. Her series of paintings, *Jewish Jackies* and *My Elvis* were exhibited at fiction/nonfiction gallery, now Jose Friere Fine Art, in New York City in January, 1993. Her appropriation of Andy Warhol "originals" coupled with her Barbra Streisand diva worship make for a riotous and poignant critique of the white male domination of painting. This critique encompasses the complex realities of cultural identity.

Patricia Cronin (**PC**): Why do you think so few lesbians are making lesbian-identified art? I want to see more. How do you see your work in this context?

Deborah Kass (**DK**): You want to see more. I want to see more. But, it is hard to get it supported. As for my work, it is one thing to make queer art, it is another thing to have high modernism, Jewishness, and big-mouth girlness involved, so there's lots to hang on to, enough to relate to and plenty to repress, even if it is as clear as the nose on Barbra Streisand's face. Heteros don't have to see the lesbian content if they

don't want to (their loss). The depressing fact is that until women make a dollar to a dollar and make big bucks, who the hell is going to buy lesbian art. This is one reason people are so uptight about coming out. If Ellsworth Kelly and those guys had known there were gay men who could afford their work and buy it, maybe they wouldn't have been so uptight about their sexual identity. This is just a materialist view. Collectors may have to take their bitter pill at this multicultural moment, a little spoonful of completely distasteful things in order to be politically correct in the 1990s, so they'll buy something queer. But, it better be a boy and it is better if it is a white boy.

PC: And that just adds to your invisibility.

DK: Lesbian visibility and invisibility will be inscribed in the names of Bob Gober, Nayland Blake, Ross Bleckner, Donald Moffet, and Felix Gonzalez-Torres. As Barbara Kruger said, "You make history when you do business."

PC: So how do you do business if your work is lesbian-subject-identified and not queer-boy identified?

DK: How do you make a visual object that someone's going to want to buy that also is as political as you wannabe? How do you subvert something to the point that people don't even know what's happening to them, sneak it into their collection, and then one day they wake up because they have a queer daughter, and she says, "you know, Mom and Dad, I grew up with that piece and now I'm twenty and I want you to know I'm queer." It is very complicated. We're selling art to rich people and we cannot get around this. I feel like I'm fighting a good fight. You can't exist in the world without being aware of the world you're existing in, which is one reason why I use art history. You can't function in art history uncritically. I'm interested in how everything we were taught was "good" came from one particular point of view. Postwar art history has been written by white American men to maintain white American male power.

PC: Then how do you see the role of painting at the end of the twentieth century? Is there "real" room for representing a multiplicity of subjectivities, specifically a homosexual female subjectivity?

DK: Either there is room for a multiplicity of subjectivities in that grand narrative of western civilization—painting—or it is as dead as has been claimed for the last ninety years and deservedly so. Like any language, it is dependent on the voice of the colonized and marginalized to keep

it alive. And, like any language, it will die without it. Where would music be today without the voices of black people, brought here against their will?

So with painting—I'm an existential optimist. I'm stuck with the history, I'm stuck with the language. Adrienne Rich says: "This is the oppressor's language yet I need it to talk to you." If women can write poems and novels, women can make paintings. Can we make painting speak to our experiences? Can we make it represent us? I have to think it's possible. It is certainly what all my work is about. In the last five years, I have been dealing directly with the language of high modernism. My work is about the construction of difference within high modernist art practice. Since modernism is based on ideas of transcendence and universality, it denies specificity or—my specificity. To see high modernism as another language or part of the bigger language that constructs difference in very particular and political ways, is just another way to deconstruct it.

PC: How much do we, as image makers, play into the hands of stereotypes if we aren't explicit about who we are, what we look like, and what we do in bed? Can we produce new ways of seeing or new inscriptions of the lesbian social subject in representation and not purely provide sympathetic accounts or "positive images" of lesbians?

DK: As dykes our responsibility is to be visible. The only way to combat stereotyping is to represent our complexity as clearly as we are able. The complexity of lesbian social relations, within our community, between ourselves and with the world at large and its investment in our invisibility, needs to be represented. These negotiations between our lives and the world, and between visibility and invisibility, take up so much of our lesbian lives. It is our responsibility as cultural producers to try and represent ourselves, whatever that means. Whether this phallocentric culture will dignify these representations is another question.

PC: I know making yourself the subject and exposing your lesbian desire/diva worship with the *Barbra Series* are both central issues to your work. With that in mind and knowing your ambivalent position on pornography—what degree of explicitness of sexual desire/activity do you think is required at this time?

DK: Required? This is a personal choice. Most artists (meaning men in history) have had the privilege of dealing with a range of issues in their work. Courbet, Picasso, Fischl, and Salle, have all been rather sexually

obsessed artists, right? Sexual obsession, or just a robust sexuality, is a part of the myth of the great white male artist. For women all this is complicated (isn't everything?) by the fact that women have been inscribed, in art and culture, as "body" or "nature." If a woman artist wants to deal with sexuality, she has to deal with negotiating the representations of woman within the larger framework of patriarchy, where women do not control meaning or its production. Creating and disseminating our meanings in the area of sexual representation is particularly difficult, since it is about our bodies, the *same* bodies that have been historically commodified and colonized, used as objects of exchange between men. Our bodies have been symbolic vessels filled with meaning for and by men. Again, it is our job as artists to represent ourselves and create meaning. That doesn't mean the world at large will support this activity. As far as sexual explicitness—puritanism, patriarchy, and misogyny make it a minefield of contested meanings. Far too loaded for uptight me. But you, Nicole Eisenman, and Sadie Benning are making really interesting work. I'm not brave enough for it, I don't have the stamina. But I admire it, all the power to you girls! Brava!

PC: How do you see the relationship between perpetuating stereotypical myths about lesbians (what *do* we do in bed/in books/in paintings?) and creating a lesbian subject that is real to your life?

DK: We are told who we are, how we look, and what we are, like all marginalized people. But we are each ourselves, with overlapping identities, complicated, complex individuals. There is no monolithic "Lesbian" subject any more than there is a monolithic "Woman" or "Jew." This is the meaning of stereotype. Our job is to explore and represent our overlapping, usually conflicted, identities. Part of what is real to every marginalized life is the stress of trying to negotiate as an individual in the culture-at-large in the face of these stereotypes.

PC: Both images of Barbra in the paintings display such extreme drag. What is your interest in masquerade and gender construction? And why such butch/femme examples? What is your intent in expressing this desire?

DK: The image of Barbra in the *Jewish Jackie Series* was taken in the early 1960s when Barbra first exploded on the Broadway scene and on television. I was an adolescent then. Her gorgeousness was not universally embraced, especially by first-generation Jews in suburbia busy trying to assimilate—such as my parents. *I* thought she was positively *divine*. Her

"awkwardness," her "nose," her difference, thrilled me. She embraced glamour of a particularly American kind, and did it with a vengeance and great aplomb. That a Jewish girl with wit, talent, and brains could be herself and "make it" spoke volumes to me. And she did it consciously, put it on and wore stardom like the diva she had yet to become. Drag? Absolutely.

As for *Yentl* (Streisand's role from her movie of Isaac Bashevis Singer's story) doesn't it speak for itself or doesn't he speak for himself? Yentl dons male attire to study sacred texts, to realize her desire for knowledge forbidden to her by law. A perfect metaphor for a woman artist.

Butch/femme examples? Clothes make a person mean "male" or "female." As far as I'm concerned, I'm always in drag—artist drag, downtown drag, girl drag, boy drag. I always feel like a drag queen, especially when I put on girl clothes. I even act differently; I can't help it. I put on my fabulous designer "little black dress" to wear twice a year for a wedding or bar mitzvah and I put on my heels, I FEEL different. The transformative power of these fetish objects is very intense. And then there's my collection of men's suits (preferably power suits)!

This work is about coming out as a fan. It is not unlike coming out because you have to tell this incredibly vulnerable thing about yourself that's really awkward, intimate, and embarrassing, that's really about who you are and what you love. Willa Cather said, "Admiration is the way you grow." There is a long history of women opera fans who worshipped various divas. Terry Castle has written a wonderful piece on this and her own diva worship: "In Praising Brigette Fassbaender (A Musical Emanation)." To Castle it is all about women's voice, literally, politically, and metaphorically. I am proud to be a part of this tradition.

PC: Some viewers interpreted your 1991 painting *How Do I Look?*, an image appropriating Picasso's painting of Gertrude Stein and Courbet's painting *The Sleep*, to be an all-encompassing, specifically lesbian image, and were disappointed. This is similar to criticism of early black television programs that were expected to speak to the entire omission/negative representation problem and represent an entire community. How much validity is there in these overloaded expectations or how do *How Do I Look?*, *Jewish Jackie Series*, and *My Elvis* address the difficulties of representing lesbian subjectivity as distinct from both heterosexual female and homosexual male subjectivity? These works seem to be drawing attention to the construction and consumption of

fantasy, whose fantasy and for what audience/community? In locating your own fantasies and erotic investments, how significant is it if the boundary is blurred with other sexualities' fantasies? How do you feel about Barbra's persona being a favorite in some gal male drag venues?

DK: This need for one artist or artwork to speak for an entire community is what Henry Louis Gates calls "the burden of representation." Does a painting by a man speak for all men? My painting *How Do I Look?* is about Gertrude Stein, Picasso's reading of Gertrude, my reading of Picasso's reading, and of Gertrude herself now and when I first saw the Picasso painting at the Met as a kid. It is also about Courbet and his fantasies of women together, these two nineteenth-century guys looking at one real person and two fantasy girls, and seeing, naming, and consuming. And identifying with all these positions as a reader of painting, a painter, a Jewish woman, and as a dyke, searching for representation.

Some criticism that I have heard from women who are feminists and who I respect, has been, "But aren't you just reinscribing the men and their work?" That is the most flat-footed and unsubtle reading of this work. The master narrative of modernism and American painting after World War II needs to be rethought. I am doing this in my work and you can decide if my use of David Salle's images make him important again. I think David Salle's art and his success are crucial to look at from a critical perspective, as are Jackson Pollock's. And if that makes David historically as important as Jackson, fine. From another position, they might be seen as just a couple of white boys jerking off in culturally sanctioned ways. Let the art historians, and I hope they are women, deal with it. The appropriation and critique that I'm involved with is something that has been done in every other area culturally, in the academy and literature. The method has a feminist lineage. My work comes out of Sherrie Levine's work and that is very important to me.

As far as the overlapping of lesbian, fag, and straight girl subjectivities, I expect the boundaries between these categories to blur, since mine are all blurred. We are all created by the culture at large. Our desires, especially, are constructed and manipulated usually, always, to profit someone else. We are all subjected to the same mass marketing of desire. It is actually amazing we end up as diverse and different as we do. It is probably the greatest tribute to what is left of the concept of the individual. Blurring is inevitable, unavoidable, and really interesting. I love my blurs.

PC: Is it important that lesbians write about your work? Or that your work is critiqued by people that are knowledgeable about lesbian literary criticism, queer theory, cultural criticism, art history, and feminist theory?

DK: Yes, will you? Lesbians should write, period. So far, gay men with a strong queer theory bent have been the most visible people writing about my work. But they are men and more visible in general, right? It seems to me that the people who respond to my work are the ones with similar concerns that I have. Isn't this always the case? White straight guys love to see their reflections in everything and have that opportunity. We are all looking for reflections of ourselves in images and ideas.

PC: Your work of the last four years has two distinct directions, the most recent being the *Barbra* paintings, and the earlier work, deconstructing white males' defining position in culture such as *Portrait Of The Artist As A Young Man*. Did you have to critique the boys first before promoting what you wanted to see instead?

DK: I understand the difference between the image of an empowered woman and the deconstruction of a male language and that there is a real difference when you look at them. Just because I did fifteen or twenty paintings that fit into the "deconstruct the hegemony" category doesn't mean I've done enough. Everything is a challenge. Sue Williams's work speaks directly and personally about sexual abuse. One's experience is one's experience. I think our job as artists and women, lesbian or straight, is to represent our experience. And even if it looks negative and if it is violent, I think it is still our responsibility to reflect that experience, though it may not be what the world really wants to see and it is not utopian or "transcendent." Maybe we shouldn't be trying to get past our particular moment, especially if power relations depend on our being invisible and the idea of transcending has been calculated to erase our specific experiences. If one's subject position is writ large culturally, if every place you look looks like you—art, literature, the law and power in general, representing yourself in a world where you are consistently represented would be redundant . . . and it is. What does it look like, representing the absence of women, people of color, and queers? How does it feel? I think this work has to be done.

PC: But I think this work is what the consuming art world wants to see. There's a reason why work of women artists that is sexual in nature and

speaks from a position of pain is supported. People, men, can buy the images that enunciate the injustices of abuse, and still maintain women's inequitable social status.

DK: You mean like the work of Kiki Smith and Sue Williams? I think reducing the complexity of this work to a one-liner about victimization is inevitable in patriarchy and in the marketplace. It then becomes the responsibility of what could too loosely be termed a feminist community to reiterate and insist, over and over again, on a more complex reading. The problem is in the interpretation and not in the work itself.

PC: That is so problematic for me and it is not a criticism of the artists' work but of the art market.

DK: It is problematic, but the art world is always problematic because only rich people can buy work. In late capitalism the only way we know ideas are actually circulating is when they become commodities in the marketplace. The first person to buy Sue Williams's work was Richard Prince. Great. But that doesn't take away from Sue Williams's work. It can't because she is speaking to a larger reality and that's simply more important to me than who buys the work or their motivation.

In some utopian way of thinking, and in the best of all possible worlds, we would only have powerful images of women because women would be equally powerful economically and politically as men. Women, like men, would buy art because they would want to see their own reflections. But we are not there. I understand that the *Jewish Jackies* are powerful because they are positive images of a woman and that my other work is more complicated because it's often about a history written for and by men. I'm interested in both situations. I'm evolving as an artist, I have a long-term view and I have to. I've been doing this for twenty years. It is a big subject, representing me and my absence in representation, that has barely been tapped and I am willing to tap it any place I see I can. Some people can like certain paintings more than others depending on who they are. But, a viewer, a reader is still only reflecting their own specificity. If one is interested in a certain positivism then Barbra as powerful woman will probably be of more interest. If one is interested in how a white Jewish lesbian looks at history, painting, and culture, then one might be more interested in the other paintings. Me, I'm interested in all of it, so what do I care?

Monstrous Domesticity

Faith Wilding

The rooms differ so completely; they are calm or thunderous; open on to the sea, or, on the contrary, give on to a prison yard; are hung with washing; or alive with opals and silks; are hard as horsehair or soft as feathers— one has only to go into any room in any street for the whole of that extremely complex force of femininity to fly in one's face. How should it be otherwise? For women have sat indoors all these millions of years, so that by this time the very walls are permeated by their creative force, which has, indeed, so overcharged the capacity of bricks and mortar that it must needs harness itself to pens and brushes and business and politics. But this creative power differs greatly from the creative power of men. And one must conclude that it would be a thousand pities if it were hindered or wasted, for it was won by centuries of the most drastic discipline, and there is nothing to take its place.—Virginia Woolf, *A Room of One's Own*

To know the history of embroidery is to know the history of women. —Rozsika Parker, *The Subversive Stitch*

The regrown limb can be monstrous, duplicated, potent. We have all been injured, profoundly. We require regeneration, not rebirth, and the possibil-

ities for our reconstitution include the utopian dream of the hope for a monstrous world without gender.

—Donna Haraway, *Simians, Cyborgs, and Women*

1

On a recent visit to my mother, we sat on the couch together talking as she knitted a sweater for my seven-year-old nephew. She complained about her arthritis which was making it increasingly difficult for her to knit. As I watched her, my hands began to itch to knit. She offered to let me finish the sleeve, and I eagerly took it up and began to knit—for the first time in at least ten years. It was as easy as pie: the rhythms and movements of the fingers, the method of keeping the right tension, the techniques of increasing and decreasing stitches, the magic of looping a thread around steel needles and producing a *fabric*—all came back to me. My pleasure in practicing this long dormant skill was so great, that I forgot to count the pattern rows and soon had produced a monstrous sleeve twice as long as the other. It was this "potent limb" which suggested some of the lines of thinking I will follow in this essay.

2

It seems all too likely that only in a feminist art world will there be a chance for the "fine" arts, the "minor" arts, "crafts," and hobby circuits to meet and to develop an *art of making* with a new and revitalized communicative function. . . . Visual consciousness raising, concerned as it is now with female imagery and, increasingly, with female process, still has a long way to go before our visions are sufficiently cleared to see *all* the arts of making as equal products of a creative impulse which is as socially determined as it is personally necessary; before the idea is no longer to make nothings into somethings, but to transform and give meaning to all things. In this utopian realm, Good Taste will not be standardized in museums, but will vary from place to place, from home to home.—Lucy Lippard, "Making Something from Nothing," *Heresies* #4

In February 1995 the Bronx Museum of the Arts mounted *Division of Labor: "Women's Work" in Contemporary Art*;[1] a roughly chronological survey, starting in 1962 and ending in the early 1990s, which examined "artistic production as a gendered practice, and its relationship to a shifting discourse on gender stereotypes and roles within the domestic sphere."[2] When the exhibition's curator, Lydia Yee, asked me to re-create the room-sized crocheted environment I had originally made for *Womanhouse* in 1971, I was very hesitant at first. The historicizing of 1970s feminist art is currently arousing much debate, especially as it relates to what has been deemed the "return" to certain 1970s artistic practices, processes, and subject matter, by both female and male artists in the 1990s.[3] In the past twenty years I have experienced the jolting ups and downs of a heritage of having come of age as an artist and feminist simultaneously, and being identified as one of the founders of feminist art practice in California in the early 1970s—for much of the work done by feminists in the 1970s has been criticized as reinforcing an "essentialist" view of women. Thus I was reluctant to re-create a piece (in a very different context) which might be falsely interpreted as an uncritical celebration of women's traditional culture and handicrafts.

As a practicing artist and activist feminist, my artwork and thinking have been in constant flux. I have been influenced as much by my historical, critical, and theoretical research as by the thorough training in skills and techniques which I had as a child. My work has also been informed by my teaching, and my participation in various cultural, political, and social movements since the 1960s. In the 1970s, I worked in media and forms which grew directly out of the discourses of feminism and 1960s avant-garde art practices—performance, environments, collaboration, mixed media, street works, and the like. I also consciously reworked craft processes which I had learned as a girl growing up in a self-sufficient commune in Paraguay—crocheting, weaving, knitting, embroidery, basketry, ceramics, leatherwork, and woodwork.

Needles and thread and bread dough have done more for preserving nations than bullets, and women who made homes on the prairie, working valiantly with meager tools at their command, did more than any other group in settling the West.—Edith Kohl, *Land of the Burnt Thigh*

When I made my original crocheted environment for *Womanhouse* in 1971, I was motivated by my research on women's work and lives in various cultures. I found that women's work of making homes and domestic environments has been pivotal (though largely unacknowl-edged) in the major cultural inventions of civilization. The transforma-tion of "natural" materials by human activity—variously called "work," "craft," or "art"—has been practiced since the beginning of human history for at least two reasons—necessity (usefulness), and pleasure (uselessness). One distinction usually made between "craft" and "art" is that of usefulness (necessity) and uselessness (pleasure). Craft is gener-ally thought of as unalienated (autonomous) work as opposed to the irksome, forced necessity of labor, while art is related to nonrational work-as-play. Yet, as everyone who has made things knows, this binary is a false one; work, craft, and art are intertwined in complex ways which reflect actual lived experience in which the mundane (rational) is constantly inflected by the transcendent (nonrational). The division of labor not only divides work up by gender and class, but it also separates the pleasurable and necessary aspects of work itself.

In Western patriarchal culture (where binaries rule) domestic craft came to be associated with femininity, and high art with masculinity. In my crocheted environment, I wanted to pay homage to women's useful economic and cultural work, while at the same time producing a piece that was useless (nonpractical) to demonstrate the falseness of the tradi-tional distinctions between art and craft. As Virginia Woolf points out in the quote which begins this essay, women's creative capacities—honed by "drastic discipline"—have been squandered culturally by the restric-tions of separate spheres (division of labor), which condemned middle-and upper-class women to countless hours of "fancy work" or "home decorating" (work which was not taken seriously) while working-class women were exploited in tedious, alienated labor (work which men often refused to do) for which they were paid far less than men.

Obviously, an account of the history of women's work is beyond the scope of this essay, but female labor and the "feminization of labor" are crucial global issues today, and it is no accident that they should appear as important subject matter in contemporary cultural production. As a teacher, I have repeatedly seen female (and, increasingly, male) students revisit the gendered processes of "women's work" as a way of connect-ing to a history of skilled production, of *making*—and *feeling* (experi-ence)—which is all but absent from their lives. These students—often

daughters and sons of mothers who work outside the home and do not practice "homemaking"—usually have no traditional domestic craft skills such as sewing, crocheting, knitting, or cooking, but they evince a strong desire to *make* objects and/or place them in spaces which invoke domesticity with all its attendant meanings and feelings. In a way, what they are representing in this work is a certain loss, the absence of something to which they no longer have the connection of lived experience.

It is important for students to know the lineage of "women's work," and to be familiar with the excellent scholarship which has emerged from several decades of feminist art history and critical theory. It was largely for this reason that I agreed to reproduce the "Womb Room," for little of the actual "women's work" of the 1970s has been seen by younger artists working today. Except for the Bronx Museum show, there have been no major historical surveys of this work, nor are there any significant museum collections of it. *Womanhouse* was demolished shortly after its exhibition in 1972. Many other important works of the 1970s have not been publicly exhibited at all, or not for many years. For example, Mimi Smith's *Kitchen* (1973)—a work which looks highly contemporary and is every bit as complex and accomplished as a Sol Lewitt wall drawing (although it has a very different aesthetic origin and emotional content)—was only shown by a museum for the first time in 1994. Mary Kelly's pivotal work, *Post-Partum Document* (1974), has been shown in its entirety in the U.S. only once.[4] Institutional preservation of such work is important for reasons of history, pedagogy, and access. Though some of the work loses force and meaning when divorced from its original context (this is certainly true for the recreations of the rooms from *Womanhouse*) it gains a different legitimacy and re-enters the discourse in a new way. By bringing together signal works from the 1970s, 1980s, and 1990s, *Division of Labor* encouraged a re-examination of the history of gendered art practices, and a contextualized critique of the 1990s return to the processes, spaces, and subject matter of domestic craft and women's work.

3

... my own artwork addresses the issues of traditional women's handicraft and "sensibilities" in the context of mainstream cultural concerns. . . .

Through my choice of a construction technique (crocheting) that is considered a traditional women's handicraft, this work confronts issues of choice and privilege, as my access to techniques is no longer limited to traditional women's work. The feminine and the masculine are combined and constructed into objects that comment on identity, relationships, and beauty. Additionally, the transcendental nature of the repetitive process of crocheting brings many questions to mind regarding what has been shared by generations of women who silently participated in various states of altered consciousness through enactment of repetitive activity inherent in women's work.—Tracy Krumm, "The Heroine"

In *The Subversive Stitch: Embroidery and the Making of the Feminine*, Rozsika Parker outlines the historical connection between the rise of hierarchical divisions between art and craft and the creation of a code of femininity, "The development of an ideology of femininity coincided historically with the emergence of a clearly defined separation of art and craft."[5] She suggests further that it is precisely because the needle arts are so entwined with the creation of femininity that they are so intractable to redefinition as art. Thus she concludes that the introduction of "craft" into fine arts (painting) has modified masculinity more than it has changed craft (femininity). Many of the avant-garde movements of the twentieth century (Russian constructivism, dada, surrealism) called for an end to the distinction between art and craft, thus opening up a space for women artists. However, since women artists in these movements often worked in "domestic" spaces (artisan workshops, handicrafts schools, designing embroidery patterns and fashions) rather than "high art" spaces (professional studios, art academies, museums), their work was usually not recognized as art, nor did the definitions of femininity and domesticity change—even though some of the male artists became involved with craft processes.

Postmodernity's boom in computer technology, virtual reality, and electronic communications, with its concomitant anxieties about the loss of the body and the "real"—as well as profound global economic changes, changes in the nature of work, devastating biological viruses, and sociopolitical gender, race, and class "trouble"—have contributed in 1990s art practice (by both men and women) to a resurgence of work about gender and the body linked with domestic subject matter, pro-

cesses, and craft techniques—traditionally, women's work. Many artists are "returning" to feminist work of the 1970s without really knowing they are doing so—because so much of this early work entered the art mainstream, and was picked up by influential artists such as Mike Kelley, without acknowledgement of its sources. Much current installation art, as well as so-called pathetic and scatter art, mines the areas of the everyday and the contingent—invoking tropes of home, family, illness, childhood, transitional objects, household detritus, clothing, bodily functions, victimization, love, loss, and the like—in work that strongly recalls the look of much 1970s feminist art.

Feminist artists of the 1970s set out to expose and reclaim the hidden histories of domesticity and women's lives, bringing them into public view in order to examine them, and to open up sites for critical interventions and new meanings. Some of this work attempted to rehabilitate areas of feeling (intimacy, the "sentimental")[6] and experience deemed exclusively "feminine"; but much of it was highly critical of the institution of the family, and of the restriction of women to the domestic sphere—as well as questioning the division of labor, and the conditions of work itself. By contrast, much of the 1990s art (by men and women alike) uses domestic tropes and gendered processes in works which tend to spectacularize, sentimentalize, pathologize, or aestheticize the domestic, rather than offering new critical insights. It must be noted that these artists are usually not working in the context of a strong sociopolitical movement such as the feminist movement of the 1970s.

Whereas when Duchamp placed a urinal in a museum as an art object it was not only an iconoclastic gesture, but could also be seen as a specifically masculine one (which Meret Oppenheim more than countered with her sly, supremely female, fur-lined teacup), in the 1990s, it is by now a truism that the signifiers of femininity can be (and are) freely used in art (and sometimes life) by men, and that the signifiers of masculinity are similarly used by women. But a mere reversal of gender signifiers (while often funny and consciousness-raising) does not seem to be enough to get rid of gender roles and stereotypes—or else we would have entered a nongendered utopia long since. For example, Mike Kelley's reclaimed crocheted afghans, chewed toys, and cloth dolls, scattered about in the Whitney Museum, somehow do more to reify his bad boy masculinity, than to address or change the codes of gender. Kelley's work does not so much read "tough boys can be soft

and play with dolls," as it proclaims "I'm such a tough guy—even when I title a work *Half a Man*—that I can appear pathetic and a failure by working with this stuff." The appropriation of traditionally female and domestic tropes by a famous white male in a retrospective museum show effectively rehabilitates them for high art use (at least by men), but the connection to the feminist project which engendered this work is erased. As critic Terry Myers has written, "The overwhelming generative source for Mike Kelley's work—in historical, aesthetic, conceptual, visual, political, economic, and/or institutional terms—is precisely the painting, sculpture, installation, video, performance, etc., that was made by women artists and art students in Southern California beginning in 1970 (the year in which Judy Chicago began the Feminist Art Program . . .)."[7] The enthusiastic reception of Kelley's work and its considerable influence on younger artists suggest that references to domesticity and traditionally female work are acceptable when presented as signifiers of the "pathetic," "abject," or "failed." These readings do not lead us back to the critical projects of feminism which include re-valuing "women's work" as necessary for cultural and economic survival (and therefore worthy of adequate remuneration), and uncoupling the gender codes of the division of labor.

Important precursors to much of the signal art of the 1970s were the works of Eva Hesse and Lee Bontecou. The hybridization of domestic and industrial (non-art) materials and processes used by both these artists, in works which speak of the replicable and fragmented body and psyche in the age of technological reproduction, were (and are) truly groundbreaking. Bontecou's wire-sutured, lead-bound vortexes lead into (or out of) the abyss of darkness. Hesse's meaning-filled repetitions suggest infinity in materiality. The combination of abstraction with obsessively repeated—*worked*—forms alluding to the body, machines, and nature, in both Hesse's and Bontecou's work, produces suggestive and "monstrous" (in Haraway's sense) new possibilities. This work represents new, nongendered ways of figuring the truth about the body in postmodernity.

4

Labor is blossoming or dancing where
The body is not bruised to pleasure soul,

Nor beauty born out of its own despair,

Nor blear-eyed wisdom out of midnight oil.

—"Among School Children," W. B. Yeats

The subject of *work* (labor) itself is central in much "domestic" art-work. This is often expressed in the charged, obsessional quality given to objects or installations which have been personally worked by the artist. This obsessional quality speaks about the body in time (a life-time) and ceaseless effort. The repetition of bodily gestures and motions produces sameness with slight variations (a mimicry of the conditions of everyday life), and a hypnoid state (altered consciousness) in the maker. An epistemology of *making* develops, which brings into play knowledge lodged deeply in the interaction of hand and material: making fabric, making substance, transforming, linking stitch to stitch, loop to loop, fragment to fragment, forming a web, connecting strand to strand, node to node, repeating, patterning, alternating, repeating—the magic of form coming into being through the "thinking hands" acting with material. The above could be a description of the processes of drawing, painting, crocheting, embroidering, weaving, and the like—and even perhaps of (longhand) writing.

Work which emerges from the desiring body (and affirms the body); which spins out from the laboring (female) body in crocheting, lace-making, knitting, weaving—like a spider spinning webs out of her own body—seems always to have aroused great anxiety in men. Why should this be? And why should drawing, writing, painting—which also emerge from the body—be considered superior (male) practices? Western philosophy posits that art, though grounded in materiality, transcends the everyday (usefulness), and that its meaning outlives the body which produces it. "Domestic" handwork produces useful objects—which are usually as beautiful as the producer can make them—objects which adorn and comfort the body, objects that make life possible. Yet these objects, like bodies, wear out in daily use—they are not immortal or transcendent. Thus they remind us of mortality, and they are regarded as lesser (less human) than art objects. This split reflects a culture which still fears the body (the female), and the life of the body—and which may be perversely embracing cyber technology precisely *because* it seems to vaporize and sanitize the body and distance mortality.

5

Contemporary artists who seek to address gendered work and the do-
mestic in the 1990s need to take into account recent economic, cultural,
and sociological developments, as well as consider how technological
innovations are profoundly altering both public and private work and
life globally. "Women's work," "feminized labor," and "the home work
economy" are intimately entwined with the problems of the assault on
poor women (and children)—through the attacks on welfare, health
care, public education, and abortion—now going forward with such
vindictiveness and cruelty in the United States congress. Recently,
Katha Pollitt called this assault the crucial issue for feminists, because
the situation of poor women in the U.S. as it now obtains will in-
creasingly be that of more and more people in the global technological
society.[8] Thus, ironically, "women's work" has once again become a
central symbol and an image for the worldwide division between the
wealthy and the poor, of those who have access and those who do not.

In her influential essay "A Cyborg Manifesto," Donna Haraway
sketches "one vision of women's 'place' in the integrated circuit" as seen
from the point of view of advanced capitalism: "*Home:* Women-headed
households, serial monogamy, flight of men, old women alone, technol-
ogy of domestic work, paid home work, re-emergence of home sweat
shops, home-based businesses and telecommuting, electronic cottage,
urban homelessness, migration, module architecture, reinforced (sim-
ulated) nuclear family, intense domestic violence."[9] In short, not a
pretty picture—and certainly not the one envisioned by utopian social
activists and sexual liberationists of the 1960s and 1970s.

"Home" has always been a complex concept—especially for women—
and one that appears to be ancient and inescapable, even mythic. As a
newcomer to the Internet, I note the references to (virtual) domestic
architecture, place and process: "World Wide Web," "home page," "do-
mains," "windows," "Netscape." The incommensurability of virtual
space is made user-friendly by such allusive designations (since vehicles
made for physical human travel have always been fitted out with do-
mestic furniture and accoutrements, why not our cyberconveyors?).
Humans seem to need to carry home with them, to make themselves at
home wherever they go. Without "home," it seems, there can be no life.

"Homemaking" has traditionally encompassed many skilled activities passed on from grandmother to mother to daughter. Cooking, sewing, knitting, washing, candlemaking, spinning, dyeing, gardening, weaving, nursing, food preservation, making storage vessels, and the like were usually skills which were taught one-on-one. Accompanying this teaching was a rich tapestry of stories, songs, poems, rituals, and family history, anecdote, gossip, proverbs, recipes, riddles, spells, incantations, secrets, as well as a good measure of "women's" lore—instruction in the codes and arts of femininity.

The survival of skills (and the skills of survival) depends on a lineage of teaching and learning which has traditionally taken place in the private sphere, in the home. Today however, largely because of women's vastly increased roles as family breadwinners,[10] the private home as a pedagogical site has increasingly been replaced by public institutions, especially schools. This means that "domestic" skills are now often not acquired at all by young children, or that they are learned in a "professionalized" and often depersonalized (though not a desocialized) environment. On the one hand, this can have a liberating effect, as the acquisition of the skill or technique is not accompanied by the stultifying lessons of femininity. On the other hand, there is a loss of the context and culture, the history and content, the *feeling* of the skill— part of which, as Rozsika Parker has demonstrated, is how skills have been used by women as secret weapons against their enforced domestic roles. Furthermore, the realms of public and private are undergoing a confusing and alarming shake-up and redefinition, largely to the detriment of both, and with the immediate result of reifying gender roles by intensifying the divisions of class, race, and sexual identities. Increased specialization of skills, consumerism, and a greater stratification in the division of labor have also contributed to a general loss of widely practiced everyday survival and craft skills and a concomitant estrangement from unmediated sense experience.[11] Under such conditions, these traditional "hand" skills are increasingly, and inappropriately, fetishized, and nostalgic sentiments are woven about them, which again separates them from everyday life.

Domestic processes and subject matter have entered the mainstream of art and are used by men and women alike. In this metamorphosis a "feminization" (but not a "feminism-ization") of the art world is occurring, which parallels the feminization of popular culture. Art which

explores "emotional" or "personal" (identity) themes and subjects, such as childhood, AIDS, cultural and ethnic difference, body art, clothing, love, loss, and sexual identity, is ubiquitous—but it has done more to amplify notions of masculinity (men who knit) than to abolish connotations and definitions of femininity as lesser; nor has much improved in the opportunities for women artists. As the 1995 Whitney Biennial attests, there is an effort being made to bring back painting at the expense of all the installation/political art at the previous Biennial. Work which serves as a critical and engaged vehicle for the examination of female experience, gender roles, and feminist analysis of women's lives and work is seen more rarely. I shall discuss two contrasting examples of contemporary re-presentations of women's lives (both in the Bronx show) which draw on past feminist art making strategies, and which raise crucial issues about the "feminization of labor."

6

"In her performance and installation *Hermes Mistress* (1994–1995), Regina Frank succeeds in collapsing the distance between the managerial and labor aspects of postindustrial production. Wearing a beautiful red silk dress, Frank communicates on the Internet via modem, saving fragments of text on her Powerbook computer—some of which the artist later painstakingly transcribes by hand-sewing tiny beads onto the dress."[12]

Frank's piece engages contemporary issues of women's work and the uses of old and new technologies in complex ways. Visually, the work is a stunning spectacle. It replays the fairy tale of the impossible task—spinning straw into gold; sorting mountains of seeds; carrying water in a sieve—given to beautiful girls, upon completion of which they will be freed from evil enchantments to marry handsome princes and live happily ever after. But the artist is already a princess, and a fashionable one at that—as her high-heeled red shoes and handsome silk peignoir, shed carefully in the performance area, attest. Our eyes cannot help but follow her voyeuristically, as she slips into the monumental swirl of luxurious red silk dress, and jacks into the World Wide Web. The fairy tales are a metaphor for women's never-ending task to render the mundane transcendent, and everyday life comfortable and beautiful for others, and here she is doing it again.

Visually, the piece also represents woman as the eternally immobile waiting one, the object of our gaze—a cyborg mistress—who wiles away her time piecing together an endless incantation (gleaned from texts gathered from the Internet) against annihilation and oblivion.[13] Through the Net she has access to the world of thought, text, language, information. But it seems that this profits her no new way of being in the world as she still sits beautifully transfixed, sewing alphabet beads onto her silk dress. If she is a "manager," she is mainly managing her appearance (representation) as a beautiful woman, not her action in the world. Although the piece suggests interesting possibilities, to my mind, the hybridization it represents appears to reify, rather than question, women's traditional role and representation, and to offer a problematic promise of cybernetics as a liberation from the humdrum and limiting aspects of the experience of domestic life and work. On the other hand, it could be argued that the piece represents this cyborg mistress as a pleasure machine—her own pleasure, as well as ours.

A ghost lurks in this machine: the ghost of women's unseen (alienated) work in the global garment and electronics sweatshops—the new "homework economy"[14]—which parallels that of the domestic and factory sweatshop. Haraway points out that "women in Third World countries are the preferred labor force for science-based multinationals in the export-processing sectors, particularly in electronics."[15] Yet access to computers, the Internet, and advanced electronic communications and services is still largely restricted to First World businesses, academics, and middle class professionals and their kids, and electronic technology is still popularly regarded as a male province.[16] Here then, we have the classically alienated position of women producing things which they themselves will never have access to buying or using.

Frank's piece derives in part from her work as a seamstress making beautiful, precious garments for other women. Thus it also relates not incidentally to the fashion business, and by extension, to the global garment industry which is intensely stratified as to class, race, and gender, as well as being among the lowest paid forms of "feminized labor." The use of large amounts of expensive silk fabric (Atlas silk) sets the wearer of this piece apart from the makers of this fabric—the traditional prerogative of managers is that they get to dress better. The viewer becomes an envious voyeur of experiences which are not available to large numbers of people: access to the Internet; luxury materials; the freedom (leisure, money) to make/wear something beautiful and

impractical. This piece aestheticizes and conceals the conditions of many contemporary women's lives and labor—or evokes them only through absence. I miss a more activist and critical component to the work—which could have been supplied by a different kind of performance of the text. But we read the text through the object of beauty offered to our gaze (we also hear/see her read it virtually, in a sing-song monotone, on a TV screen); it flows through her fingers onto the red silk. Though a woman is mediating language here, she is not changing the codes of representation—thus, she becomes again the mediator of someone else's text, not the generatrix of her own. Hermes's mistress serves time here as a silenced messenger of texts which cannot free her (or us) from the spell of enforced femininity and ceaseless labor.

To be feminized means to be made extremely vulnerable; able to be disassembled, reassembled, exploited as a reserve labor force; seen less as workers than as servers; subjected to time arrangements on and off the paid job that makes a mockery of a limited work day; leading an existence that always borders on being obscene, out of place, and reducible to sex.
—Donna Haraway, "A Cyborg Manifesto"

Lynne Yamamoto's installation *Untitled, 1993 (Wash House)* uses a terse text consisting only of verbs inscribed on flat nailheads to drive home the story of her "picture bride" grandmother's backbreaking life of labor as a laundress on a sugar plantation in Hawaii.[17] The verbs replay the monotony of female domestic labor: "cook," "clean," "iron," "wash," "scrub," "fold," as well as tell the secret story of female sorrow "worry," "love," "weep," which is also part of "women's work." The long row of nails on the wall creates an inexorable iron line of demarcation of experience from which there is no deviance. They are nails in the coffin of this stunted life which ends starkly in "drown." Here repetition is not an aesthetic device but rather a semiotic one: repetition is the meaning—and the meaninglessness—of this life. The relentless line of nails is an apt visual image for the "drastic discipline" Woolf speaks of. In the metaphor which encapsulates this particular life, in the spaces between the words, there is room to read the stories of countless other lives. While many of the words refer to gender-specific work, they also

refer to the survival labor still performed in the U.S. by millions of immigrants of various races and classes (and by large numbers of the American working class and poor) as well as poor people (both male and female) the world over. In her eloquent, yet unsentimental, work, Yamamoto reveals a biography of domestic and survival labor which has not vanished from the world in spite of major technological inventions. The piece offers hope in that it makes us conscious of the differences between two generations of women. The granddaughter has become an artist who uses language as well as objects; she can give voice to a silenced past; she moves in a larger world where her work can contextualize and illuminate the lives of her foremothers; her work is not forced, not alienated, not bitter—and she is using it to enlarge our understanding of the (needless) sacrifices of millions of lives.

7

The ideologically charged question of what counts as daily activity, as experience, can be approached by exploiting the cyborg image. Feminists have recently claimed that women are given to dailyness, that women more than men somehow sustain life, and so have a privileged epistemological position potentially. There is a compelling aspect to this claim, one that makes visible unvalued female activity and names it as the ground of life. But *the* ground of life? What about all the ignorance of women, all the exclusions and failures of knowledge and skill? What about men's access to daily competence, to knowing how to build things, to take them apart, to play? What about other embodiments? . . . Race, gender, and capital require a cyborg theory of wholes and parts.
—Donna Haraway, *Simians, Cyborgs, and Women*

In conclusion, I return to the monster sleeve I knitted in my mother's living room that winter afternoon in Vermont. I return to the crocheted "Womb Room" I re-created with two young women artists—to whom I had just taught crocheting. Our hands moved surely, freely, playfully, wielding crochet hooks and looping Woolworth's cheapest "Sweetheart" yarn to make a fanciful, airy, complex webwork full of forms

variously suggesting body parts, domestic furniture, pot cloths, wash-cloths, sweaters, chandeliers, the Brooklyn Bridge, stalactites, chains, grottoes, ladders, cells, umbilical cords, doilies, and lattices. The web invokes the experiences and objects of everyday life and work, yet it is visually abstracted into a three-dimensional "drawing" created by means of the simplest of "domestic" techniques. Because it can never be finished, it speaks of time and timelessness. Because it is "useless" and beautiful, it evokes feeling and the nonrational. Because it is made with cheap materials and easy-to-learn skills, it does not mystify the viewer.

The process of its making provided other surprises, for while we crocheted we became inhabitants of the museum and somewhat re-shaped its daily "life" around our work. As we crocheted, we talked— about our lives, our work, our bodies, computers, machines, feminism, politics, love, our mothers and our grandmothers. Museum workers and visitors stopped by to touch our work and marvel at the spinning forth of substance; they told us stories about their childhoods, their mothers, their families. We exchanged gifts of food, advice, friendship, and solidarity. Working together intimately in a public space connected us in new ways. It created an example of affinity based on unalienated, creative work. None of us lost our autonomy, yet we all learned from each other and made something more various and inventive than one individual could have made by herself. I do not wish to freight this work with too many interpretations, but to me it did become a sugges-tion of new possibilities for my own work, and for collaborations with others.

While thousands in this country flock to Martha Stewart's "hyper-idealized version" of the simulated nuclear family, becoming devotees of her hyper-consumerized activities of "home-keeping" and "garden-keeping" which capitalize on the contemporary "need for balance, the sacredness of family rituals and holidays,"[18] millions of poor workers (all over the world) sleep in shifts in bunk beds, crowded into dilapi-dated urban dormitories. Those of us who have the fortune to resist such sacrificial lives of repetitive, numbing toil must strive to create new models for envisioning the pleasurable, nongendered reconstitution of life and work. I suggest beginning with the lessons of the pleasure of li-bidinal making, the pleasure of daily competence, the pleasure of prac-ticing skills for their own sake—and for the sake of new inventions, new formations, new embodiments. Technology demands learning new

skills, but let's not abandon all those we already know. Let's resist the coercion to overspecialize, to become monoskilled, for then it is too easy to enslave us, or make us obsolete and redundant. Haraway suggests that it is through new combinations of the handmade and the machine-made, new graftings, the regeneration of potent, aberrant limbs, that we will have to negotiate our way in the treacherous world of global economics and re-imagined (work) lives. Let us resist the harnessing of new technologies to old ideologies and mythologies which perpetuate gender roles, exploitive division of labor, and other stratifications. Hope lies in new practices of monstrous domesticity; of potent craft harnessed to a vision of the regeneration of a home for all in the world.

Notes

1 The Bronx Museum of the Arts, *Division of Labor: "Women's Work" in Contemporary Art,* February 16–June 11, 1995. Curated by Lydia Yee. The exhibition opened at MOCA in Los Angeles on September 24, 1995.

2 Lydia Yee, *Division of Labor* (catalog), 1995, p. 6.

3 See, for example, the special issue on feminism *October* 71, Winter 1994; the "Bad Girls" show at the New Museum in 1994, etc.

4 Mimi Smith's retrospective was at the Institute of Contemporary Art, Philadelphia, 1994. Kelly's *Post-Partum Document* was exhibited in its entirety at the Yale Center for British Art, 1984; portions of it were included in New York exhibitions in 1983 and 1984.

5 Rozsika Parker, *The Subversive Stitch: Embroidery and the Making of the Feminine* (London: The Women's Press, 1984), p. 5.

6 Here I am paraphrasing from a talk by David Deitcher, "Compassionate Use," given at DIA Center for the Arts on April 8, 1995.

7 Terry R. Myers, "The Mike Kelley Problem," *New Art Examiner,* Summer 1994, pp. 25–29.

8 Seminar on May 8, 1995, at CUNY Graduate Center.

9 Donna Haraway, *Simians, Cyborgs, and Women: The Reinvention of Nature* (New York: Routledge, 1991), p. 170.

10 According to Tamar Lewin in the *New York Times,* Thursday, May 11, 1995: "More than half the employed women surveyed—including single and married women—said they provided at least half of their household's income," p. A27.

11 "Children of the seventies—whose mothers worked and brought home Chicken Delight and were taught by a newly liberated *McCall's* magazine to make friends with their dustballs—are perversely drawn to Martha [Stewart] and what she represents. In art schools now, crafts and needlework have become subversive media. As seventies feminist artist Faith Wilding told M. G. Lord in an interview in the *New York Times*, "My students are begging me to teach them crocheting, embroidery, and knitting. It's a rebellion." Barbara Lippert, "Our Martha, Ourselves," *New York Magazine*, May 15, 1995, p. 28.

12 Yee, *Division of Labor,* p. 29.

13 In the 1970s part of the show, the continuously running *Womanhouse* film includes Wilding's "Waiting" performance, which critiques such enforced passivity and constriction of women's domestic lives.

14 Haraway, *Simians,* p. 166. "Although he included the phenomenon of literal homework emerging in connection with electronics assembly, (Richard) Gordon intends 'homework economy' to name a restructuring of work that broadly has the characteristics formerly ascribed to female jobs, jobs literally done only by women. Work is being redefined as both literally female and feminized, whether performed by men or women."

15 Ibid., p. 166.

16 In private conversation, Regina Frank told me that very few women artists in Germany had computers or modems, or were computer literate.

17 The film *Picture Bride* (1995), though considerably romanticized, gives glimpses of a history of such lives.

18 Lippert, "Our Martha, Ourselves," p. 28.

II / THE POLITICS OF MEANING AND REPRESENTATION

The essays collected in part II, "The Politics of Meaning and Representation," give an overview of some of the principal issues we confronted throughout our publication: analyses and critiques of contemporary art criticism from the point of view of the artist and of the art object, considerations of painting from a material and theoretical perspective, exploration of art values such as those of success and failure and of professionalism, issues of gender and race in representation and art criticism. Charles Bernstein challenges influential art world figures and institutions in "For *M/E/A/N/I/N/G*," the first essay in the first issue of *M/E/A/N/I/N/G* (1986). In "Figure/Ground" (1989), Mira Schor brings feminist theory and theoretical analyses of fascism to bear on vanguard modernism's fear of flowing, viscous, pigmented matter. In "The Critic Is (?) Artist" (1989), Marcia Hafif reprivileges the artist as a cognizant producer against the encroachment of art critics' claim for themselves as primary art producers. Johanna Drucker also mounts a critique of criticism, in this case of such avatars of feminist theory as Laura Mulvey, in "Visual Pleasure: A Feminist Perspective" (1992). Lucio Pozzi's essay on teaching art, "12 Questions of Art" (1990), is both a graduate art teaching primer and a stringent critique of "consumer orthodoxy" and the concepts of signature styles and professionalism. In

"Some Remarks on Racism in the American Arts" (1988), Daryl Chin finds racist attitudes in some of the supposedly more enlightened segments of the art world, with a particular emphasis on how Asian-American artists are expected to behave. Joel Fisher calls for a reconsideration of the idea of "failure" in art in "The Success of Failure" (1989). The materiality of the traditional art object is explored against the background of the possibilities inherent to electronic media in Charles Bernstein's "I Don't Take Voice Mail" (1994).

For M/E/A/N/I/N/G

Charles Bernstein

. . . It is the part-object
freaked with shadow & trading our body-
bits at a loss. . . . Can this be how we inflate
our meaning presence from our demeaned lives
caressing the part-payments?
—John Wilkinson, *Proud Flesh*

It may be that art criticism is always in a crisis; surely it is in one now, principally on account of its refusal, for the most part, to confront the r(e)adical limitations of its project.

Of course, "art criticism" cannot be treated as a single entity; it should, however, suffice to diagnose such magazines as *Art in America, Art News,* and *Artforum* to make apparent what therapy is needed. The international importance of these magazines in setting the agenda for discussions and evaluations of contemporary visual art should not be underestimated; and it is worthwhile belaboring the point that these magazines are almost wholly absorbed in the process of promotion and inflation of the art market that informs every aspect of their editorial content. This is not to say that no useful or worthwhile articles appear

in these contexts; indeed, the problem is less the fault of individual art writers, or even art critics bunched as a group, than it is the fault of the editorial policies that institutionalize interpretative practices.

The crisis of art criticism is a crisis of representation. For despite the sophisticated perspectives on representational dynamics that engage painters and other visual and verbal artists, the editors and publishers of the major art magazines have rarely allowed any comparable level of complexity into the writing they choose to print. Indeed, the discourse of magazine art criticism is largely carried out in a naively "realist" style of syntax and narration, whether the "content" of such criticism is the "deconstruction" of "logocentric" art or the glamorization of the art (or shoe) collection of Mary "Imelda" Boone.

Certainly, the neo-Marxist claims for "postmodernism" that occasionally adorn the pages of the art magazines are not convincing. The role of criticism in such venues is to decorate, in the sense of providing verbal ornamentation to, the graphics: the "copy" breaks up the procession of images-cum-gallery logos that are the logocentric ("simulated") heartbeat of each issue. Consider *Art in America*'s grotesque forum (June 1986) on museum "blockbusters" (it's not incidental that this term once had currency in reference to an unscrupulous realty practice that created business for speculators by undermining neighborhood real estate values). The most negative of the articles in the forum was about Hans Haacke's critique of corporate art funding, yet made no reference to the fact that the article's "perspective" was being used to legitimize the magazine's "pluralist" approach to issues. The author's exclusive, static focus on corporations obscured and thus defused the role that the article itself, published in the context of an art magazine that is subservient to the financial interests of the major commercial art galleries, was at the very moment playing to bolster the apparatus it claimed to be debunking. It should be rudimentary to expect "oppositional" art criticism to assess who or what is served by the particular discursive forms and contexts of publication in which it appears, and by extension to confront the social organization of the art world, particularly the gallery systems (commercial, multinational, cooperative, "alternative"); in contrast, most "oppositional" magazine criticism reifies its own practice by suppressing these social dynamics and its own participation/complicity in them. This goes beyond biting the hand that feeds; more like, feeding the hand that bites.

Within the pages of the officializing art magazines, both mainstream descriptive reviews and poststructuralist commentary serve the same function: the valorization of certain artists and trends over and against other (generally unnamed) aesthetic tendencies. The "realist" or "representational" discourses of art criticism—all the more effective when they can project an increasingly sophisticated arsenal of theoretical concepts—univocally serve as a mechanism of discrimination. Once this mechanism is operative—formulaic reduction of the aesthetic/visual issues, exclusion based on the formula, implicit hierarchization of the included—the content of the particular discrimination is secondary and in some senses arbitrary. This is why it often seems as if the artwork "represented" by magazine criticism is of secondary importance: it is.

There is no simple method by which writing can adequately represent painting and other visual works. At base, verbal language and visual language interpenetrate synaesthetically. Nonetheless, for practical purposes, the gap between the verbal and the visual poses an almost insurmountable problem of *translation.* Of course, there is a long and distinguished history of visual and verbal artists and philosophers who have found remarkable and suggestive ways of addressing this problem. Some of the "classic" twentieth century works that remain relevant include Kandinsky's *Concerning the Spiritual in Art* and *Sounds,* Moholy-Nagy's *Vision in Motion,* Stein's portraits of Matisse and Picasso, and such philosophical essays as Merleau-Ponty's "Cézanne's Doubt." More recently, to name a well-known representative few from a larger mosaic, there are the imaginative collage/essays in *The Collected Writing of Robert Smithson,* John Berger's ways of informing in *Ways of Seeing* and *The Sense of Sight,* Lucy Lippard's considerations of scale in *Overlay* (a sharp contrast to the formal blandness of her newspaper reviews), David Antin's "talk" pieces, and Madeline Gins's and Arakawa's fundamental rethinking of how to write about the visual arts in *The Mechanism of Meaning.* Regardless of how "positively" these works are sometimes regarded or esteemed, from the viewpoint of art magazine editors and publishers they apparently appear iconoclastic or, worse, "creative," and thus are not taken seriously as methodological models for current art critical writing.

In contrast, normatively descriptive writing styles, such as those mandated by the major art journals, are not promising approaches to

this problem. *Art in America* is reported to require aggressively "normalizing" copyediting of the sort unacceptable to writers who do not take style and tone as negligible or expendable ("we'll take the painting but we're going to change the background color and the title and then we'll . . ."). The sobriety and tonal deadliness of many of *October's* original English-language articles stands in stark contrast to the verbal energy of its many historical and contemporary translations; since the journal is evidently published in the U.S. this is beyond odd—but American scholarly journals are notorious for accepting a level of verbal invention from abroad that they will not broach at home.

I think the failure to engage the issue of the translation of the visual to the verbal (which has been exacerbated by the undigested incorporation of ever new "verbal" formulations into the art critical context), together with the banishment of self-reflection on the interest component of the adopted mode of art critical discourse, combine to exclude from consideration much of the visual art now being created. Since I share an interest in many of the philosophical arguments imported into current art criticism, I am acutely aware that these ideas are too often used as a prophylactic against visual thinking rather than as a means to better engage it. Arguments about the "essential" codicity of art run a high risk of banality; too often they expose a paranoia about meaning—a pervasive suspiciousness that concludes, from the quite necessary questioning of authoritarian and restricted forms of meaning, that all meaning is impossible. Such radical skepticism, lived in the fullness of its implications, would drive one to madness or to an almost unendurable pitch of intensity. As it is, saying such things in the world of art criticism seems merely a cause for tepid celebration of the trace, of simulation, of the coincidence of market forces and fashion that buttress works painted under this Sign. This is not so much intellectual dishonesty as aesthetic shallowness.

Indeed, the valorization of simulation is the credo of shallowness. It represents an effort to sever the internal investigation of visual meaning from the agenda of the visual arts. This process has entailed, first, the attempt to marginalize or discredit painting since its practices continue to resist the Condemnation by Eminent Domain of the Empty Signifier; and second, the replacement of paintings occupied with creating visual meaning in new forms with works that Represent the Codicity of the Sign. Understood in this way, the critical reception of both David

Salle and Peter Halley can be seen as part of the same process—a process fueled by such relatively circumspect essays as Hal Foster's *Art in America* cover story ("Signs Taken for Wonders" [also appearing in the June, 1986 issue]). I focus on Foster's article because it represents a more striking critical trend than the scores of even more routine reviews and commentaries that are as untroubled by the methodological problems of their writing project as they are about the political problems within the art environment they form a part of. In addition, Foster is not only a frequent contributor to *Art in America* but also one of its three senior editors, and his work has appeared in a number of other influential contexts, including *October.*

Foster usefully reiterates that the "new abstraction" as advocated by, for example, Halley, may be understood as a "passive," antihistorical "pessimism" (I would say cynicism); Foster even goes on to note, in passing, that the simulation that this art is said to foreground is a powerful tool for social control in our society. Nonetheless, the effect of Foster's "critical" article is undoubtedly to put an official stamp of approval on these painters and their approach; his hedged reservations are in every sense passing, situating themselves like disclaimers printed in small type on the warranty card that comes with a new consumer product. I have already pointed to several reasons for this: the house style of *Art in America* reduces its contributions to little more than promotional copy, even if, as here, an individual article seems to contradict this; the layout of the article, which is dominated by large color reproductions (creating a visual continuum with the gallery ads elsewhere in the issue) and "call outs"/headlines that range from ambiguously titillating questions to apparent endorsements. There are other problems too: Foster's fundamental suspicion of painting, as such, tends to merge with the simulated concerns of his subjects. Finally, Foster's conclusion—which is buried in the "back of the book" out of the sight and mind of most readers—can most kindly be described as evasive: to say, as he does, that the "processes of capital" are the "real subject" of the "new abstract painting" is to utter a truism of poststructuralist Marxism that could be applied to any cultural production; this underlines the fact that Foster is less interested in particularizing how paintings investigate visually conceived issues in a visual language than he is in making a general, verbally dominant cultural critique. Foster's eagerness to expose the complicity of artworks in the capitalist system

appears hollow in the light of his own unacknowledged complicity, through institutional affiliation and choice of discursive style, in what he purports to condemn.

Of necessity, there is more to contemporary visual art than can be reported in the terms now dominant in postmodern critical discourse. For there is an abundance of work that resists description as "digitalized" codes whose only function is to unmask and expose in their semiotic (catatonic?) indeterminacy: work that, in contrast, labors to deepen the visual articulation of alternatives to predetermined or self-effacing styles of representation and conventional figuration. The most urgent task for critical writing at this time is to explore what is instantiated rather than what is commented on—and in so doing to reject the reduction of the artwork to arbitrary markers that distance everything and inhabit nothing. What needs to be articulated is how works of visual art may resubstantiate rather than evacuate: how they mine the visual field for new spaces and new configurations that measure the imaginary in order to make it visible.

Figure / Ground

Mira Schor

Some people live by what they see with their eyes—light, darkness, color, form. Painters are compelled to express this continuous act of seeing and looking through the application of a liquid or viscous matter on a two-dimensional surface. Despite a barrage of criticism of painting and of representation, even painters who are cognizant of or complicit with this critique continue their preoccupation. I am one of these retinal individuals.

Criticism of the practice of painting emerging from a curious blend of modernist idealism and Marxism may be found in *October* or *Art After Modernism: Rethinking Representation.* While I am reluctant to give this loosely generalized school of criticism a name, "aesthetic terrorism" might describe its adherents' "fundamental commitment to the 'primacy' of 'objectivity' " and their use of "exclusion as one of their principal creative means."[1] In this discourse on art, painting has been described as peripheral, vestigial, an "atavistic production mode," and a "dysfunctional plastic category."[2]

According to this discourse, the linear progression of art history brought painting in the twentieth century to certain "logical" end points, namely abstraction and monochrome, after which representation is always a regression; new technologies emerging out of late

capitalism may be more suited to deal with its ideology; painterliness for its own sake, for the sake of visual pleasure, is narcissistic and self-indulgent.

Meanwhile, painting continues.

If painting needs defending, from these criticisms and from the paintings that may present justifiable targets for such a critique, what method is most effective for a painter to pursue?

I will momentarily defer from resorting to the transcendent, utopian, heroic statement of belief commonly proffered by painters as the ultimate defense of painting. For to argue the validity of painting on the ground of belief is a your-word-against-mine proposition, that is "your word" against "my work." On the ground of words, painting stands to be handicapped, often because a certain critical approach may have already devalorized an entire vocabulary. Another strategy for the painter then is to examine the critic's words—or perhaps, for the imaginary to reaudit the symbolic order.

Since painting can be most basically defined as the application of pigmented matter—which minimally can be understood as Figure—on a surface that is Ground, this reaudition takes the form of an examination of the figure/ground binarism and an analysis of the language used to critique, indeed to condemn, painting. However, I am not merely considering figure/ground as the deployment of positive and negative space or the phenomenon of "push pull." It seems that the formalist concentration on this limited understanding of figure/ground has drained painting of its vitality, and has particularly affected the teaching of painting in this country. Hearing countless students mumble about "trying to push the space around," one *wants* to give up painting on the spot.

The history of avant-garde painting has been oriented toward a demystification of figure (narratives of religion and history, finally representation of any kind) and an emphasis and an amplification of ground: the flatness of the picture plane, the gallery space as a ground, finally the gallery space as Figure, a subject in itself. The history of modern painting—with the possible exception of surrealism and its progeny—is the privileging of ground.

In his examination of the windowless white-walled gallery space, *Inside the White Cube*, Brian O'Doherty develops the aesthetics and ethics of the "myth of flatness."[3] In the twentieth century both the

picture plane and the gallery space have been "vacuumed"[4] of ornament and incident until the wall and the entire square footage of the
gallery space have become the ground for artworks, which as entities or
events functioned as figure. "This invention of context initiated a series
of gestures that 'develop' the idea of a gallery space as a single unit,
suitable for manipulation as an esthetic counter. From this moment on,
there is a seepage of energy from art to its surroundings."[5]

As ground/context are privileged, O'Doherty points to a change in
the identity of the preferred audience: from the "Spectator" to the
"Eye." "The Eye is the only inhabitant of the sanitized installation shot.
The Spectator is not present."[6] The gallery wants to be alone.

O'Doherty points to the "hostility to the audience"[7] that marks modernism and avant-garde movements, and suggests the ultimate dissolution of the art/audience relationship: "Perhaps a perfect avant-garde
act would be to invite an audience and shoot it."[8]

This (presumably) tongue-in-cheek proposal is metaphorically realized in a recent work that functions as a state-of-the-art index on the
status of figure/ground, gallery context, and the inconveniently present spectator. Wallace and Donahue's *Buddy, Can You Spare a Dime?
(Shooting the Public)* (1989), exhibited in the 1989 Whitney Biennial, is a
big blue painting with a vertical row of very bright lights facing out to
blind and disorient the viewer. As an element inserted onto the picture
plane, this figure forces the viewer's eyes away from it and from ground.
The audience has become the figure/subject of the painting, because
the piece contains a surveillance camera focused on the public still
foolish enough to expect to have a private individual experience of
vision. The Spectator and the Eye's desire to *look,* to *see,* is now *scopophilia,*[9] which here is critically transformed into ideology; the viewer is
a voyeur and the artwork is Big Brother.

The privileging of ground is consistent with the utopian ideal often
expressed by modernist pioneers that painting, liberated from representation and reduced to its formal elements, will transcend its end and
evaporate into architecture.

Some contemporary critics are astounded that painters have balked
at this conclusion. For example, Benjamin Buchloh, in his signal essay "Figures of Authority, Ciphers of Regression," links returns to
easel painting and to figuration with authoritarian ideologies, both in
post-1915 works by Picasso, Derain, Carrà, and other cubists and futur-

ists, and in recent painting movements such as German and Italian Neo-Expressionism. The early-twentieth-century vanguard painters, and, by implication, all painters who subsequently replicate their historicist error, are indicted for their "incapacity or stubborn refusal to face the epistemological consequences of their own [earlier] work."[10] The consequence, in this discourse, is spelled out in the title of the essay following Buchloh's in the spring 1981 issue of *October*: "The End of Painting" by Douglas Crimp.

Buchloh's views of painting emerge from postwar German art; however, while the self-conscious flirtation with fascism in Anselm Kiefer's traditionally "heroic" paintings may indeed represent formal and political regression relative to, for example, the oeuvre of Joseph Beuys, Buchloh's frustration is engendered even by traces of mystifying notions about painting in, if not the works, at least the words of artists whose practice is said to (properly) confront the "despair of painting."[11] Excerpts from an interview between Buchloh and the German painter Gerhard Richter serve to recapitulate, in the mode of a Pinter play, what the critic of painting wishes and what the contradictory artist prefers:

> Benjamin Buchloh [B]: . . . And that is really one of the great dilemmas of the twentieth century, this seeming conflict, or antagonism between painting's representational function and its self-reflexion. These two positions are brought very close together indeed in your work. But aren't they brought together in order to show the inadequacy and bankruptcy of both?
> Gerhard Richter [R]: Bankruptcy, no; inadequacy, always.
>
> B: The claim for pictorial meaning still exists. Then even your Abstract Paintings should convey a content?
> R: Yes.
> B: They're not the negation of content, not simply the facticity of painting, not an ironic paraphrase of contemporary expressionism?
> R: No.
> B: Not a perversion of gestural abstraction? Not ironic?
> R: Never! What sorts of things are you asking?
>
> R: When I think about contemporary political painting, I prefer Barnett Newman. At least he did some magnificent paintings.
> B: So it's said. Magnificent in what respect?

R: I can't describe it now, what moved me there. I believe his paintings are among the most important.

B: Perhaps that too is a mythology which would have to be investigated anew. Precisely because it's so hard to describe, and because *belief* is inadequate in the confrontation with contemporary paintings.

R: Belief is inescapable; it's part of us.

R: They [Richter's paintings] have a normal seriousness. I can't put a name on it. I've always seen it as something musical. There's a lot in the construction, in the structure, that reminds me of music. It seems so self-evident to me, but I couldn't possibly explain it.

B: That's one of the oldest clichés around. People always have resorted to music in order to save the foundations of abstract painting.

B: . . . Why is your only recourse that to the metaphor of nature, like a Romantic?

R: No, like a painter. The reason I don't argue in "socio-political terms" is that I want to produce a picture and not an ideology. It's always its facticity, and not its ideology that makes a picture good.[12]

It seems possible that it is precisely its "facticity," its actuality, that is disturbing to those for whom painting is "dysfunctional" and "atavistic." "Aesthetic terrorists" mock "the metaphysics of the human touch"[13] on which defenses of painting depend. Buchloh adds an infantile and animalistic dimension to painting by calling for the "abolition of the painter's *patte*"[14] (French: paw), not just his/her hand but his/her *paw*. The painter's *patte* is an "atavistic production mode" and atavism is used incorrectly as a synonym of "dysfunctional" to signify a "morbid symptom."[15] But something atavistic is a still vital trait resurging from our deep past. Rubbing two sticks together to make fire when a match is handy may be dysfunctional, but the need for, and the fear of, fire are atavistic tropisms. Human mothers, like many mammals, still clean their children's faces with spit. They don't use their tongues, like lionesses, but they do the job roughly, with their "pattes," and the gesture has a function beyond the immediate and pragmatic: it marks a bond, it is a process of marking whose strength is precisely its atavistic nature.

The desire for an art from which belief, emotion, spirit, and psyche would be vacated, an art that would be pure, architectural, that would

dispense with the wetness of figure—Marcel Duchamp calls for "a com-
pletely *dry* drawing, a *dry* conception of art"[16]—may find a source in a
deeply rooted fear of liquidity, of viscousness, of goo.

Whose goo is feared may emerge from a reading of *Male Fantasies,*
Klaus Theweleit's analysis of members of the German *Freikorps,* mer-
cenary soldiers who put down worker rebellions and fought border dis-
putes in the years between the end of World War I and the advent of the
Third Reich, and who were precursors, and often future members, of
the Nazis. The "soldier male" (according to Theweleit's term) has never
fully developed a "secure sense of external boundaries,"[17] a pleasurable
sense of the membrane of skin. He fears the "Red floods"—of the
masses, blood, dirt, "morass," "slime," "pulp,"[18] woman—which he per-
ceives as constantly threatening to dissolve his "external boundaries."
He also fears the liquid forces insecurely caged within his own body
interior and unconscious. The "soldier male" resolves these conflictual
fears by the construction of a militarized, regimented body, by incor-
poration into a desexualized phalanx of men, and by the reduction,
through killing, of all outer threats back to the red pulp he imagines
everything living to be. "He escapes by mashing others to the pulp he
himself threatens to become."[19] The "uncanny" nature of the revolu-
tionary mass, which the *Freikorps* were waging war against, with "its
capacity for metamorphosis, multiformity, transformation from one
state to another,"[20] is akin to the slithery properties of paint. This
capacity for mysterious transformation, appearance, and disappear-
ance "corresponds precisely not only to the men's anxiety images of the
multiple forms and faces of the mass/Medusa they aim to subdue, but
above all to their fears of uncontrollable, unexpected stirrings in their
own 'interiors.' "[21] Against the unregimented flow of paint, some critics
posit the mechanistic one, of architecture, or of language. Buchloh
questions the importance of Newman's painting "because it's so hard to
describe." If words fail, then the visually undescribable must be "in-
vestigated anew," or eliminated. Not surprisingly Buchloh favors the
insertion of words into pictures, especially through collage, where the
binding infrastructure mucilage, the glue, is dried, clear, and hidden
behind the image. Fear of flow also condemns Richter's analogy of
painting to music, which, though invisible, is the quintessential flowing
element through the ear, which offers no protection between interior
and exterior.

A stated desire to "[purge] color of its last remnants of mythical transcendental meaning; by making painting completely anonymous through seriality and infinite repeatability,"[22] and a preference for photography over painting indicates that the problem for some critics is not with color but with pigment. Pigment is matter that interferes with the ideal of color. Its excremental nature makes any individualized manipulation of it distressing, and so it must be bleached out, cleansed, expurgated, photosynthesized onto a laminated sheet of paper on which color has been dematerialized.

Perhaps it is not surprising that many critics who would stop the amorphous flow of paint have most enthusiastically supported women artists who work in photography and video. Clearly, the ranks of post-feminists/postmodernists do include women who sometimes paint, Sherrie Levine, Wallace and Donahue, and Annette Lemieux to name but a few. But theirs is a strictly unsensual, depersonalized use of paint. Their material is always subsumed to mediation.

"We really don't directly experience anything anymore,"[23] says Lemieux. Lemieux's statements often reflect the literalism of the collage aesthetic (or ethic), so indicative of a generally held distrust of illusionism. "When one wants to talk about a helmet, it seems ridiculous to paint a helmet when one can acquire a helmet and present it. It would communicate better."[24] The degree to which painting is a sophisticated process of conceptualization is crystallized by this simplistic alternative.

Robert Pincus-Witten notes in a catalogue essay on Lemieux that "the sheer presence of oil upon canvas seemed too much like painting so Lemieux settled for the expedient of executing [both] works with her feet."[25] On the white ground of a long horizontal painting (*Pacing* [1988]) Lemieux has padded back and forth with black-paint-soaked bare feet. *This* instance of the painter's "patte" is acceptable because the painter's animal tracks are left on a vacated ground (the artist has walked away) for the sole purpose of averting the intentionality of painting (figure).

It is taken as axiomatic by some of its critics and apparently by some painters as well that "painting's own recent history raises barriers to the accessibility of a language with which to represent historical or political fact."[26] This axiom puts two separate questions at issue. Is painting in fact incapable of representing contemporary historical reality? Do historical and political narratives exist *other* than the ones painting

has traditionally represented and that painting now represents to its detractors?

The Neo-Expressionist movement, which spurred the particular critique of painting discussed here, may well have participated in a culturewide conservative reaction. For example, the sexual attitudes displayed by David Salle were consistent with the backlash against feminist activism that has permeated the eighties. Executed with an aesthetic of nostalgia and cynicism, these works did successfully represent some aspects of contemporary reality. Conversely, the "problem" with an artist such as Salle was not that he had soiled his post-studio credentials by selling out via painting, but that he used the format of painting to perpetuate a worldview wholly acceptable to a reactionary establishment. Elaborating the same content in another medium would hardly improve its politics. It is necessary to separate *painting* from the rogue elephants whose practice *is* complicit with regressive ideology.

There can be no question that many paintings refute Buchloh's assertion that the return by painters to representation after cubism, futurism, and suprematism constitutes "figures of authority, ciphers of regression." The Mexican muralists Rivera, Orozco, and Siqueiros combined communist activism and "mexicanismo" (non-European identity) in a populist form of painting. In Germany the works of Grosz, Beckman, and Dix held up an unflattering mirror to corruption and fascism. Currently, the flayed surfaces of Leon Golub's South African racists catch the art audience in a web of complicity and repulsion. Watercolors from Nancy Spero's *War Series* allow no distantiation between male body sexuality and militarist aggression and nihilism. One can look to the peculiar activities taking place under Stalin's nose in the impeccably and absurdly academic paintings by Komar and Melamid. Ida Applebroog's paintings present sinister visions of past and present violence to women, children, sanity, the earth, painted from a waxy red-and-brown palette of toxic waste material and body fluids. Works by artists such as Colescott, Coe, and Richter address specific historical incidents and art history. In all these political interventions, narrative is coequal with formal or art-historical iconoclasm. To say that they "advance" the language of painting would accept the militarist rhetoric of aesthetic progress; one can assert that the language of painting remains functional and mobile.

The evolution of looking into painting may not be able to single-

handedly dismantle ideology. But looking and painting practiced by a politically engaged individual may filter into a politically active stream. This is not to deny that looking and painting by a fascist artist may reflect a fascist ideology. And if the reflective model of painting is critiqued, how can it be argued that photo-collage techniques are anything but reflective of contemporary media culture? And perhaps, by virtue of its self-reflectiveness, of the individualism of its *manu*facture, painting can occasionally provide an effective Other within ideology. The existence of painting that does purvey ideology supports the counterexistence of painting that erodes it.

There may be a gendered dimension to the critique of representation, the fear of narrative, since, historically, what must be excluded from art discourse is tainted by femininity. Painting's presumed loss of access to a language of historical and political representation must be considered in its connection to the equally axiomatic "prohibition that enjoins woman—at least in this history—from ever fancying, representing, symbolizing etc. (and none of these words is adequate, as all are borrowed from a discourse which aids and abets that prohibition) her own relationship to beginning,"[27] as Luce Irigaray writes. For "woman" one can insert "painter" as far as critical language is concerned. Further, woman's presumed lack of subjectivity, of access to self-representation, is the *ground* for the narrative of the One who "must resurface the earth with this floor of the ideal."[28]

That ground was gendered female was never in doubt. Painting in the high Italian Renaissance increasingly became a system for ordering and subduing nature, laying a grid on chaos (femininity), which in the twentieth century became a process of razing and asphalting. For if the ground began to move and "if the 'object' started to speak? Which also means beginning to 'see,' etc. What disaggregation of the subject would that entail?"[29] It might entail the death of the end-of-painting scenario, which should have been played only once according to late modernist critics, and which is to be endlessly resimulated by postmodernists. The narrative of the death of painting is meant to jam the signals of other narratives, that is to say the narrative of the Other.

According to Walter Benjamin, "Death is the sanction of everything that the storyteller can tell. He has borrowed his authority from death."[30] If ground begins to move, if figure rushes back onto evacuated ground, the sanction of death will reassert its authority over the narra-

tive of the death of painting. In this patricidal narrative the artist inevitably sets *him*self up as the next duck in the shooting gallery: the narrative of traditional art history can only admit to a formalist attack on the pa(s)t(ernal). Further, an interdictory relationship to the past is constructed, in which artists are denied functional interaction with art that is not part of the linear "high Renaissance to modernism" art-historical progression. According to "aesthetic terrorists" one *cannot* claim a contemporary relationship to artists such as Sano di Pietro, Hugo van der Goes, or Chardin, only to prescribed artists such as Rodchenko, Duchamp, or Warhol. But, to European patriarchy's Others, patricide may be less of an option and a burden of guilt. The sons kill the fathers, and art history is a graveyard to which they expect and demand admittance. But may not the daughters (and for daughters read all Others in this system), so long denied, now freely roam the "cemetery" (museum), mining the ore of the past, forging different narratives (narratives of difference) on the anvil of painting?

In a melancholic tone, Walter Benjamin, in his essay "The Storyteller," discusses the "new beauty in what is vanishing," "the art of storytelling,"[31] an art of intimacy, of companionship. He notes the role of "boredom" in the transmission of the story, originally heard as people wove and spun. "The more self-forgetful the listener is, the more deeply is what he listens to impressed upon his memory." "Boredom is the dreambird that hatches the egg of experience."[32] This entails a flow, of the storyteller's words to the self, and of self outward to the teller. We have seen that the fear of flow underlies the wish for painting's end. The need to rid painting of all that is "human," the wish for a sanitized, unitary architecture is an attempt to close one's ears to a story or a musical theme—the "death thematic"[33] that has been embedded in femininity, the Other's untold story.

The story condemned and evaded is also the story of pleasure. Contemporary critiques of painting wage war on pleasure. Buchloh, for example, uses the French word "*peinture*"[34] to refer with contempt to paint used mainly for sensual effect on artist or audience. Beyond sensuality, craft is suspect in this wording. Visual pleasure emerging out of the materiality of paint is viewed to be politically incorrect. As the prevailing school of Marxist-influenced art history focuses on social construction and ideological phenomenology in painting of the past, the individual art historian's experience of sensual pleasure is at best a

secret vice or an unfortunate relic of connoisseurship. And because access to the past is regulated by concerns of historicity and historicism, such criticism allows a contemporary painter only cold comfort in the existence of great "*peinture*" of the past.

The contemporary emphasis on the ideological purposes of scopophilia neglects the subversive potential of visual pleasure. Visual pleasure does not rule out politically or psychologically charged narratives. The "Cabinet" paintings by Goya are small, intimate renderings of madness, witchcraft, and misery. In *Courtyard with Lunatics* (1793–95) an eerie light of white paint presses down on a dark courtyard. In a sense, this is a totally "abstract" painting in which enclosure is implicit in the composition. Light is as bleak as darkness. The figures of the imprisoned lunatics barely indicate scale. What is striking in this painting and Goya's other paintings on witchcraft is the motility of the brush, the gentleness of the paint strokes as they construct brutal subjects. These little, soft brush-marks are seductive, but the pleasure they give is the honey that traps the eye of the viewer, seduced by "*peinture*" into looking at images of the most profound anxieties and evils.

However, the emphasis on technique in recent confections of "beautiful" paintings by Ross Bleckner, Mark Innerst, Joan Nelson, and their followers is curiously related to the belief, emerging out of the critique of painting, that painting has become, or will be in the future, a craft. In this country in particular, craft has such negative connotations that there is almost no way of interpreting this fate so that painting would retain intelligence and contemporaneity. And yet easel and panel painting came out of the guild economy of the Middle Ages. The great Sienese painters were craftsmen: Giovanni di Paolo is said to have kept a model book of other artists' compositions, which he freely borrowed from—an early instance of appropriation, or a functional use of more advanced artists' ideas and a respect for his elders. These craftsmen served their communities and respected their discipline. At its best, "craft" might not be such a dread fate.

For a painter there is certainly tremendous pleasure in working out a thought in paint. It is a complete process in terms of brain function: an intellectual activity joining memory, verbal knowledge, and retinal information, is given visible existence through a physical act. But the value of painting cannot rest on any individual artist's private pleasure. Painting is a communicative process in which information flows through the

eye from one brain, one consciousness, to another, as telemetric data speeds from satellite to computer, without slowing for verbal communication. Incidents of paint linger in the working mind of the painter as continuous thrills, as possibilities, like words you may soon use in a sentence, and—in a manner that seems to exist outside of spoken language—as beacons of hope to any human being for whom visuality is the site of questions and answers about existence. The black outline of a rock in a Marsden Hartley landscape, the scumbled white of a shawl in a portrait by Goya, the glaze of a donor's veil in the *Portinari Altarpiece,* the translucent eyelid of Leonardo's *Ginevra di Benci,* the pulsing red underpainting of a slave's toe in a Delacroix, the shift from shiny to matte in a passage of indigo blue by Elizabeth Murray, are only a few of a storehouse of details that are of more than professional interest to me.

In French, *terrains vagues* describes undeveloped patches of ground abutting urban areas, gray, weedy lots at the edge of the architectural construct of the city. *Terrains vagues,* spaces of waves, the sea of liquidity, where the eye flows idly and unconstructed, uninstructed. These spaces are vague, not vacant (*terrains vides*). In such interstices painting lives, allowing entry at just these points of "imperfection," of neglect between figure/ground. Between figure/ground, there is imperfection, there is air, not the overdetermined structure of perspectival space, or the rigid dichotomy of positive and negative space, not the vacuumed vacant space of painting's end, but the "self-forgetful" "boredom" of the area that glimmers around paint, sometimes only microscopic interactions within a color, sometimes the full wonder of the dual life of paint mark and illusionism. Paintings are vague terrains on which paint, filtered through the human eye, mind, and hand, flickers in and out of representation, as figure skims ground, transmitting thought.

Notes

1 Klaus Theweleit, *Male Fantasies,* vol. 2, *Male Bodies: Psychoanalyzing the White Terror,* trans. Erica Carter and Chris Turner (Minneapolis: University of Minnesota Press, 1989), p. 418.
2 Benjamin H. D. Buchloh, "Figures of Authority, Ciphers of Regression," *October* 16, Spring 1981, p. 59.
3 Brian O'Doherty, *Inside the White Cube: The Ideology of the Gallery Space* (Santa Monica, Calif.: Lapis Press, 1986), p. 20.

4 Ibid., p. 36.

5 Ibid., p. 69.

6 Ibid., p. 42.

7 Ibid., p. 73.

8 Ibid., p. 76.

9 That *scopophilia,* the love of looking, sounds like a psychological disorder (along with *necro-* and *pedo-*) seems related to its ubiquity in recent critical texts.

10 Buchloh, "Figures of Authority," p. 42.

11 Benjamin H. D. Buchloh, *Gerhard Richter: Abstract Paintings* (Eindhoven: Van Abbemuseum, and London: Whitechapel Art Gallery, 1978), p. 20.

12 Benjamin Buchloh, "Interview with Gerhard Richter," trans. Stephen P. Duffy, in Roald Nasgaard, *Gerhard Richter Paintings,* ed. Terry A. Neff (London and New York: Thames and Hudson, 1988), pp. 21, 24, 26, 28, 29.

13 Douglas Crimp, "The End of Painting," *October* 16, Spring 1981, p. 77.

14 Benjamin H. D. Buchloh, "The Primary Colors for the Second Time," *October* 37, Summer 1986, p. 51.

15 The epigraph to "Figures of Authority, Ciphers of Regression" is a quote from the *Prison Notebooks* of Antonio Gramsci: "The crisis consists precisely in the fact that the old is dying and the new cannot be born; in this interregnum a great variety of morbid symptoms appears."

16 Marcel Duchamp, *The Writings of Marcel Duchamp,* ed. Michael Sanouillet and Elmer Peterson (New York: Da Capo Press, 1989), p. 130. A republication of *Salt Seller: The Writings of Marcel Duchamp* (Oxford: Oxford University Press, 1973).

17 Theweleit, *Male Fantasies,* vol. 2, p. 213.

18 Klaus Theweleit, *Male Fantasies,* vol. 1, *Women, Floods, Bodies, History,* trans. Stephen Conway (Minneapolis: University of Minnesota Press), pp. 385–409.

19 Theweleit, *Male Fantasies,* vol. 2, p. 274.

20 Ibid., p. 35.

21 Ibid., p. 37.

22 Buchloh, "Primary Colors," p. 48.

23 *Annette Lemieux,* March 18–April 15, 1989, Josh Baer Gallery, New York.

24 Jeanne Siegel, "Annette Lemieux: It's a Wonderful Life, or Is It?" *Arts Magazine,* January 1987, p. 78.

25 Robert Pincus-Witten, "Alien Nature or Art once esoteric and banal or Painting as mise-en-scène or WITHOUT MOVING YOUR LIPS, possible

titles for an essay on Annette Lemieux," in *Annette Lemieux* (New York: Josh Baer Gallery, 1989).

26 Benjamin H. D. Buchloh, "A Note on Gerhard Richter's *October 18, 1977*," *October* 48, Spring 1989, p. 103.

27 Luce Irigaray, *Speculum of the Other Woman* (Ithaca: Cornell University Press, 1985), p. 83.

28 Ibid., p. 140.

29 Ibid., p. 135.

30 Walter Benjamin, *Illuminations* (New York: Schocken Books, 1969), p. 94.

31 Ibid., p. 87.

32 Ibid., p. 91.

33 Buchloh, "Interview with Gerhard Richter," p. 20.

Buchloh: But if one looks at your iconography in the 1960s, I find it difficult to construct a continuous death thematic. . . . It seems to me completely absurd to want to construct a traditional iconography in your painting.
Richter: Perhaps it's just a little exaggerated to speak of a death thematic here. But I do think that the pictures have something to do with death, with pain.

34 Buchloh, "Figures of Authority," p. 59; also, Richter and Buchloh agree on this usage in the interview quoted above, p. 20.

The Critic Is (?) Artist

Marcia Hafif

> It used to be that one could think of "the critic as artist," if not as an actual artist. Now it is inevitable that one acknowledge, however reluctantly—for both critic and artist—that "the critic is artist," in the fullest sense that the eroding idea of "artist" retains.
>
> —Donald Kuspit, *The Critic Is Artist*

I like to think of making art as a many-layered process. The person who digs down into the psyche, using chance, contemplation, or some other method to come upon images that are then put into a physical form and made visible to others is accomplishing the original foundation of the work. That same person (the artist?) lives with those images, having or developing a personal rapport with them in terms of meaning, and exposing those images to the view of others bringing about responses which feed into the meaning process already underway. The artist receives that information which is then incorporated into his/her meaning connection with the work.

In addition the artist is, most often, not an isolated individual, but rather one who lives within a community of relatives, friends, acquaintances, or within the art community. As the layers of meaning proceed the artist is aware of art history (and becomes a historian?), is aware of

currently exhibited as well as unexhibited work of other artists, and inserts her own work into that milieu making a statement as to what is relevant to the larger dialogue (becomes a critic?). The artist knows other artists and tends to be closer to those who are resonant with her own work, often trading pieces with those other artists (becomes a collector?). The artist, being a person who understands the process of art and having a sharpened sensibility to works of art may suggest a specific exhibition of others' work (becomes a curator?), may write about her own work or the works of others (becomes a writer?), and often, as these layers develop, becomes a teacher of the process of the craft, the process of creativity, the history of art and of the theory and criticism related to it. These days this person could function as a (literary critic?) in criticizing contemporary criticism, as a philosopher exploring the meaning of life, and as a religieuse as the work hones and concentrates the soul of the individual and both become quiet and simply there. Or the artist can deal in art, advising and/or buying and selling.

Donald Kuspit, in the preface to his collection of essays, makes a case for the critic not functioning *as* an artist, but actually *being* the artist. "All the weight of meaning in the formula of their relationship is now on the critic rather than the artist" (p. xi).

This I can accept on one level: if an artist can be a complex person it is undeniable that a critic may be as well. The sine qua non of artisthood, however, is usually missing—the initial origination of images together with the putting of them into a visually concrete form. The critic who is confined to working off of art made by others is thus forced into a parasitic position: without the produced art of others the critic has no starting point, no stimulus for flights of fancy. The critic (who does not make art) remains in some inevitable way contingent. The artist keeps the privileged position in that the artist starts at the first level and has the option of working through the layers I have described. Of course, it is possible to reverse the direction; many critics have gone directly to that first layer and become visual artists while others are poets and share a common base in the creative activity. Even so the poet, in writing criticism, wears another hat. I do not deny the interchangeability of the layers but simply want to suggest that differences exist in their definitions.

The artist is one who stands outside the flow of culture and feels it, observes it. The artist is to some degree disconnected from the com-

merce of the world, and is one who, standing back as a kind of voyeur, digests it and returns it in a visual form to represent that world. The artist is a traveler, observer, itinerant worker who moves about the world digesting and regurgitating, commenting in a personal form, making up, inventing, more like the composer than the musician, the choreographer than the dancer, the inventive scientist rather than the "normal" one. The critic can do all this, but becomes an artist (I hate to be dogmatic) only by taking up paint or clay or whatever, words, perhaps, to make his or her own art, rather than making flights of imagination from the compost heap of others, flying merely to explicate a work or state the position of another.

I rather like the term "beholder" to describe the person who looks at art and (inevitably) takes on the creative function of the critic. When this happens the artist has not given up the role of the creation of meaning, but rather additional and often personal meaning is added on to the work. Art, by its nature, is, and perhaps always has been, open and ready to set up a dialogue working as a stimulus for communication with the viewer (see Jan Mukarovsky, *Structure, Sign and Function,* or Umberto Eco, *Opera Aperta*), allowing the viewer to have and to make her own associations and responses. Thus Kuspit underestimates both the artist and the beholder, taking the function of creating meaning from the artist and refusing to allow any independence of imagination on the part of the beholder.

Another way in which the critic attempts to usurp the artist's position is through the argument that it is unnecessary to inquire into the artist's intention, that being irrelevant to the experiencing of the work. For their part most artists accept the idea that the work must stand alone to be read in its silent visuality, however, most do have notions of the meaning they are producing. Disregarding this would suggest that whatever depths of meaning the artist may harbor are simply of no consequence. The artist is doubly silenced: additional meaning which accompanied the creation of work is denied, while the critic behaves as though the artist has no imagination and freely exercises her own.

It feels to me that Kuspit lowers our expectation of art through his notion of its inevitable popularity: "(all art) is condemned to popularity sooner or later" (p. xv). "The only excommunication is not being visible in the media" (p. xiv). If this is the case the responsibility may rest on the shoulders of certain criticism which focuses singularly on media-oriented, popular art and by this focus condemns it, "not ex-

pect(ing) art to be profoundly imaginative" (p. xv). And once that criticism has robbed art of its inherent position, condemning it to either popularity or excommunication, the complaint is made that "criticism takes more risks than art, for it . . . extends imagination into realms of relevance unimaginable to the art it addresses" (p. xviii).

I like to think there is a lot of art being made now—in painting, for instance—which is not either popular or entirely unworthy, which may or may not strive for purity as its goal or strive to be a "high" art, but which appeals to a sense beyond that of entertainment or reflection of the media or celebration of banality or political disaster. Art is still made which can simply Be, which can stand for existence, go beyond our concrete earthly experience of life to suggest a realm beyond the normally visible: that of Beauty, Awe, Terror, the Void.

The balance can tilt the other way. Thomas McEvilley, in his column "Marginalia" (*Artforum*, May 1988) quotes Richard Milazzo: "Speaking in general now the artist's practice has suddenly made the critic's function seem obsolete or superfluous. What exists now is only the critical function, which has become severed from the critic's domain." McEvilley responds with: "The claim that the critic has become obsolete because art had become critical makes as much sense as saying that the artist is obsolete if criticism is written artistically."

There is some kind of circling around the question going on here. Differently from Kuspit, McEvilley retains the idea of the primacy of the artist, but he too does not want to allow the artist a critical faculty. My contention would be that indeed the artist does make a critical statement in producing art. Through the critical and historical awareness that is part of the equipment of most contemporary artists the simple act of choosing to do a certain kind of work, and how to do it, makes that statement. I would have to grant McEvilley's other point, that critical discourse, that is, written and disseminated criticism, does come from the outside, the artist even desiring this other view, while I am not ready to concede that the artist may not speak in her turn. Or that the artist is not the artist.

Note

The source of the opening epigraph is from Donald Kuspit's preface to *The Critic Is Artist: The Intentionality of Art* (Ann Arbor: UMI, 1984), p. xi.

12 Questions of Art

Lucio Pozzi

During the spring semester of 1990, I visited the Yale University Gradu-
ate School sculpture studios for twelve weeks and conducted a Fine Arts
Seminar at the School of Visual Arts in New York City for six weeks. For
both of them I prepared this set of 12 questions and a short introduc-
tory paragraph.

0. Introduction

This workshop is an exploration of the conditions within which we, as
authors, approach the making of art. It consists of twelve questions. We
should consider the questions as open matters and seek neither confir-
mation nor negation of them and expect no specific solutions. Rather, I
suggest we seek only an awareness of the contradictions and references
contained in each.

I shall try often to step away from the "objective," removed position
and speak instead of my personal dilemmas, passions, and desires, in
the hope of prompting equivalent responses. "Objectivity" and its
pseudoscientific stance is often a cause of manipulation in the arts.

The title of my position in Yale is "Senior Critic." Such a title could
imply an objective authority which I consider uninteresting. I prefer

the critic in every artist to be the manager of the permanent crisis creativity cannot but be in. "Critic" and "Crisis" share the same root in Greek: *Krinein* = to judge (to understand) the passing from one condition to another.

1. Style

A misinterpretation of style, originality, consistency, and novelty has become a ruling dimension of artistic exchange. These attributes are thought of as conditions an artist must not only seek but be bound by and more often than not program him- or herself into.

A signature style is often considered to represent a guarantee of aesthetic value for an artist's production. But a signature style is most of the time the result of an artist's censorship of her or his contradictory creative impulses in favor of formulas. These result in the Product Recognition needed to facilitate easy marketability of the art objects.

Formulaic style diminishes the creativity of both the author and the receiver of art because it introduces the apparent accessibility of trade-marked homogeneity into the art.

Rigid agendas for the development and distribution of formulaic art produce the culturally totalitarian regime of Consumer Orthodoxy. Under the appearance of pluralism, Consumer Orthodoxy actually regulates the exchange of visual data at the expense of intellectual research and, especially, of emotional feeling.

All aesthetics sharing Consumer Orthodoxy's practices, even those, such as neo-Marxism, which many believe to be opposed to them, submit to the unregenerative course it ties culture into. Indeed, both Consumer Orthodoxy and neo-Marxism discourage the single experience in favor of generalization and both foster the typecasting of every artist in a specialization.

Only by conceiving of style, originality, consistency, and novelty as unintentional byproducts (recognized a posteriori) of an earnest research which disregards prescriptive rules but favors probing methodologies, can we establish creative discourse in the arts.

2. Exhibiting

The exhibition of art objects, transported from where they were made, assembled, or found to a site where they are put up for public sale, is a

fairly recent development. Before, art was displayed either publicly or privately *after* it had been acquired from the artists.

The current practice of regularly exhibiting artists' new work exacerbates the eternal conflict between private impulse and public stance.

The sites where art is exhibited have become a facet of the media structure which now *media*tes the sharing of aesthetic experience. While the media appear to be democratic means of exchange, they also inevitably prescribe its conditions, thus affecting both the authorship and the receivership of art.

The media, mere instruments per se, are, in this period and in this society, signals of Consumer Orthodoxy, which, like all orthodoxies, represents a specific ideology characterized by specific rules of operation. Within the scope of these rules, exhibiting one's work implies a sort of declaration even when one does not mean to make one. The pieces in a show always seem to have their singular power reduced under a general umbrella statement, at the exclusion of their ramifications.

For the artist, working toward an exhibition often means being prompted on the one hand into an occasionally useful shortening of decision time, and on the other into an undesirable censorship of contradictory creative impulses, so as to comply with orthodox rules of marketability.

The exhibition streamlines contradiction—the very source of regenerative thinking. The selection of what is to be exhibited, whether it follows the gauge of fashion or of an assumed standard of quality, seldom succeeds in presenting the true richness of an artist's art. It resembles the loss of magic engendered by the narration of a dream.

I know many artists who exhibit only a fraction of what they do, so as to keep a chosen image of their art in the public eye. Others lend great importance to timing. They feel artistic value is not so intrinsic in the work as much as a function of when the stance of a certain artistic approach is introduced to the public. A brown painting exhibited today could appear to derive from an obsolete concern to everyone, but, if shown tomorrow, it could be called fresh and new.

The research artists who desire to share with their audience the flow of thoughts, feelings, and inventions they pursue, become like publications unfit to the post office mailing standards. They must either choose marginality or elitism. Maybe both these positions are more desirable than mainstream conformity.

3. Privacy

In the modern movement there has been controversy about the private dimension. Some have promoted the primacy of the public, others of the private. Technology, the machine age, and mass society have been cited as the reasons why the private should be subordinated to the public. Several artists[1] have flaunted depersonalization in their art as a response to modern society's reality. Depersonalized art, they feel, better represents the one-dimensionality of men and women's lives and, by indulging less of the egotistic concerns of an individual artist or the cultural elite, it offers a common denominator of access to mass culture.

In contrast, technology, the machine age, and mass society have also become an incentive for a radical emphasis on private activity by other artists. Their opinion is that as the means of social intercourse become homogenized, private idiosyncracies become more important. As a quantified exchange dominates collective life, quality is to be found there where proof and verification are impossible: in the unfathomable personal sensibility of every individual. These artists[2] purposefully cultivate misunderstandings, mistakes, and incompletion as the mental areas where authors and audience can meet in not completely predictable creative terms.

4. The Social

Everything one does in art has social significance. The questions, however, being discussed about the social aspects of art are mostly about the relevance, impact, or effect achieved by certain strategies, specific actions, or works.

Before modern times, artists were aware of the social content of their art, but would rarely and indirectly address it with the explicit purpose of social reform or improvement—in other words, within an overt and pointed critical agenda. The social fabric was somehow assumed as a given. A challenge to it was considered to be more a task to be carried out, in the theoretical field, by secular and religious philosophers, and by the military in the practical field. Not by the artist, who was encouraged to a stance of detached wisdom. Around the time preceding the French Revolution, the idea of socially active art began to dawn in the mind of many.

We have, since then, witnessed the exchange of innumerable opinions about the social factor in art, and many times seen harsh and even persecutory disagreements in the matter. Polarized, "either/or" thinking has made sure that it would be so.

Now that many of us understand that polarized thinking and the binding setting of priorities feed the short-cycle market of goods and ideas at the expense of intellectual speculation, we are faced with trying to find long-term methodologies of art which might indicate alternative thinking approaches.

The social question is one of many operational dilemmas for the artist today. It is to be singled out and used the same way as mathematicians deal with sets they know no answer to: by giving them a name and operating with their unknown entity as a unit in which unsolvability is implied.

The apparently unbridgeable polarities of activism and contemplation in art are to be dealt with by the establishment of a range of variables between them. Extreme activism for an artist could be: to renounce the making of art and enter social or political work. Extreme contemplation could be: to renounce the making of art and live the ascetic meditating life of the hermit. Between the two are myriads of opportunities offered within their range of variables.

Among these, the artist should allow him- or herself free choice to engage in those s/he desires or feels the necessity of, without privileging either of them. Designing a targeted political poster, for instance, or engaging in a community collaboration might stimulate the artist who designed or initiated them to next make a simple nonutilitarian thing, and vice versa, and so on. A flexible method reaches deeper and achieves in the long run more critical effects than the specialized repetitive production of either applied, sloganistic, or absolute, remote goods. What matters is *how* the art is approached, not *what* approach might be best.

Last year, members of OPUS B (Original Performances in Unusual Settings in Baltimore) invited me to conduct a painting workshop in a nursing home for the elderly, the mildly deranged, and some paraplegics. The mere presence of art in deprived circles can contribute a lot with no need to explain, theorize, discuss, or publicize. I came away with a plan to encourage art students everywhere to contribute a few hours every year, on a voluntary and private basis—to collaborate in visiting projects with any available institution.

5. Play

The puritan dismisses play as an unacceptable component of the creative act. But play is also sometimes used as an alibi for people to reduce the frank exploration of their feelings.

The study of play in religion or in innumerable circumstances ranging from the artist's studio to the jail, from childhood to death, is the subject of too vast a speculation for me to even try to summarize it here. We can nonetheless hint at some of the conditions by which we might want to consider play within our decision-making process in art.

The concept of play can be associated with two contradictory practices: 1) play a game according to consensually accepted rules; 2) transgress the established rules of any set. In the latter case, play is linked to transgression (as caprice, fun, arbitrariness, pun, joke, humor, irony) and to flexibility (as alternative, leeway, range, tolerance, scope). While in past times fulfillment of consensus was sought by art in several societies, the modern movement has favored transgression, but only as a passing from one inflexible methodology to another just as rigid one. In the modern scenario, consensus is found mostly only among members of a restricted group of people who try to supersede other groups as masterful representatives of their societies' aesthetic culture.

The inflexibility of modern transgressive sequences, and the exclusive connotations of their propaganda or promotional actions, have led to the Academy of Transgression, an institution as substantially totalitarian as the Academy of Conservatism. The Academy of Transgression, after a few decades of tangentiality to the mainstream of culture, is now embraced by Consumer Orthodoxy as a reliable, predictable partner for the sequencing of fashion.

In the face of such imperious forces, all the critical artist can do, I feel, is to interiorize both polarities of structure and transgression so that neither ever becomes a rule but both participate as ingredients of the specific decision-making process of his or her art.

To "just play" while making a piece of art is as necessary as it is to acknowledge the limits within which one has chosen to operate. The artist becomes nowadays both the king or queen *and* the jester, the clown *and* the shaman, the sane *and* the fool. Artists who follow this line of thinking oppose to the monolithic and standardized production of art a relativistic network of possibilities among which they play. It is

important however to remind ourselves that play is a matter of method and not of forms: there are no certain colors or shapes nor any arrangements of them one can prescriptively identify as playful. In the creative decision-making process, play is active in the trespassing of expectations (even of the expectation of play, should play have become a norm) and in the mental leaps an artist may trust her- or himself into, while engaged in the making of a work of art.

6. Fabrication

Deus ex machina was the Latin definition of a classical Greek theatrical device by which the solution of a play's quandary would come through the apparition of an all deciding god (*deus*) from the stage's machinery. By the same token, ever since ancient times, many artists have sought the unraveling of their unresolvable contradictions through the use of machines in their art.

With the development of industrialization and now, of electronics, artists have begun not only to legitimize the machine as having artistic validity equal to that of other techniques, not anymore as having a value of escape, but to simultaneously also construct a dichotomy between the machine and the hand as discordant instruments in art-making. The machine has been identified as, alternately, advancing the cause of the future, of progress, mass production, or as furthering dehumanization, one-dimensionality, loss of identity in the arts. The hand has been understood to represent either a detrimental nostalgia for past craftsmanship, for the personality cult and oligarchic uniqueness, or as the saviour of humanistic values, individuality, and spontaneity. The machine has represented democracy for many, while the hand has represented elitism. For some, the machine was alienation while for others the hand was health. There has been futile debate about whether photography, film, television, advertising, or industrial design are complete arts or not.

Today, the question is complicated by a practice common to the production of art once an artist begins to experience a reliable market for his or her work: the fabrication of the whole or of parts of art by others following instructions given by the author. This practice is analogous to that of the architect or of the composer.

Of course, Consumer Orthodoxy nurses the apparent unbridge-

ability of this as of all other dichotomies by encouraging artists to specialize so as to market faster the goods they produce.

How can we find a heterodox model applicable to the question of fabrication? In the last century, at the start of the industrial revolution, John Ruskin bemoaned the loss of group participation in the modern creative process. He recalled how the construction of a Gothic cathedral had been an anonymous collective enterprise, which offered creative opportunities to every individual participant. Nowadays, as well, the fabricator, printer, or assistant can contribute original ideas to the making of art if the author allows it, but, instead of communal ano-nymity, the author's name is the only one finally attached to the work.

I think we can accept art to be made by hand or by machine, by one person or by many, depending on *how* its making is engaged in. It is a matter of ideological and aesthetic approach. After all, most tools used to make art arc primitive or complex machines themselves, and most materials are milled by machines even before we manipulate them (*manus* = hand; *mani-pulate* = handle by hand; *manufacture* = make by hand).

Standardized, linear thinking can be found in both the hand party and the machine party. It can lead to undesirable homogenized results in both.

The artist might do well to entertain no prejudice against any of the tools s/he perceives as being of interest for the setting up of a situation. By developing in him- or herself a form of regenerative critical think-ing, the artist might avoid the prescriptive connotations our civilization presses us to attach to our activities. Even though some of us might react to such pressure by favoring the hand over the machine, we should nonetheless beware of the pitfalls of mechanistic thinking in exclusive favor of either, more than of those potentially inherent in the use of any one technique or other.

7. Situation Specific

Site-specific art has taught us to incorporate contextual ingredients in the making of a piece. But this concept is often understood in too restrictive a manner, because by site we often mean the sole physical plant of the place in which we set up a work. The concept is often used to support an aesthetic negating the validity of less localized practices such as transportable paintings and free-standing sculptures.

I'd like to extend the concept of site-specific art to become that of the situation-specific. Situation-specificity may include not only physical contexts but also wider and important contexts of individual and collective memory, feeling, technique, and social circumstances, with no exclusions.

Rather than privileging the specific environmental scale of a parking lot, for instance, over the apparently less specific intimate one of a small painting, situation-specificity calls for us to pay equal attention to the parkinglotness of the parking lot and to the paintingness of the painting, each inclusive of all the emotional and historical layers and ramifications they imply.

8. Intentions

In a dynamic and critical scenario of creativity, it becomes impossible to statically and hierarchically conceive of intentions as a monolithic, binding component of artistic decision-making. Intentions become mere ever-changing, ever-updated, flexible instruments for the conduction (not the definition) of the art being made. They are a springboard for a flight or fall one never knows the end of. It is impossible to compare works of art to the original intentions of the artist. One may do so only for conversation's sake, but one can not believe such comparisons lead to an explanation of the art. The deeper (departure) intentions and the formal (arrival) meaning of the art are often unknown to the artist him/herself and a matter of continuous, unfinished, unending cultural discourse for its audience.

This opinion runs counter to that of the heirs of Freudian or Marxian positivism, who believe that the referential network surrounding art is not only fathomable but must also objectively, intentionally be addressed in the creation of art. As positivism remains captive to the territorial demarcations which generated it, its careful and justified approach leads more often than not to an unregenerative artistic routine which feeds Consumer Orthodoxy and the short cycle market precisely what they want: recognizable goods whose declared intentions are used as marketing boosts.

While an analytical assessment is useful at the start, it often becomes detrimental once the creative ball is rolling. As an author, jettisoning part of my intentions when they reveal themselves to be of no further use in my creative process, enhances my art. As a spectator, I feel often

excluded by the self-serving explicitness of positivist art, whether it be "splashy" or "neat," while whatever attracts me in it is that which escapes the author's and my descriptions and engages my unexplained intellectual emotion.

9. Ineffable

The ineffable is that which can not be said in words. This could imply the concept that that which can not be said in words can be expressed otherwise. The visual arts and music are among the means we use to probe the dimensions of the ineffable, but also the word arts, like poetry or theatre, seek it.

Since what it is can not be said—since the very word which defines it, defines it in the negative by outlining its territory from the outside as the threshold beyond which description and interpretation can not go—when some written musings such as these are addressed to it as an ingredient of art, they can but be circumstantial (*circum* = around; *stantia* = stand), i.e., standing around its periphery.

We find that our theories stop short when reaching out to the ineffable and that only emotion or feeling or intuition can approach it. It is in the field of the ineffable that metaphysical quandaries such as beauty, validity, and quality should be mentioned as forever a subject of debate, forever unresolvable.

What distinguishes a merely competent rendition of a Webern quartet from an inspired one? Is an audience's consensus about its value an indication of absolute value or is it bound geographically and historically by the social context generating it? What difference is there between a black square painted by a merely accomplished practitioner of contemplative painting and a similar square painted by an intensely lyrical personality?

The concept of the ineffable can be extended to the unfathomable— that which can not even be conceived. Is that which is ineffable or unfathomable for one civilization obvious for another? Should unfathomability be construed as a qualitative attribute of a certain art object, or, because it escapes consensual understanding, should that object be considered outside cultural discourse?

The modern movement, intermixed with the avant-garde, resulted often at first in artistic statements unfathomable for the society at large to which they were presented. This kind of historically bound un-

fathomability, however, is losing power because modern defamiliariz-
ing techniques have now become nothing but selling devices—the sur-
prise factor is of ever shorter duration and many earnest artists avoid it
as much as they can. Also, as we understand better the aesthetic rele-
vance of the myriad cultures now merging in the global network our
ease of information is fostering, many of us have the feeling that, com-
pared to the past, less is now unfathomable.

Yet, even among those of us who fully accept the contextual factors
affecting our creativity, many feel that there is an undefinable, un-
fathomable magic to some art, which is lacking in some other art.

I often find myself tentatively attributing this magic to the *effort*[3]
which every artist has engaged in while in the heat of creativity. This
effort, which is both intellectual and emotional, one may find in any
manner or technique for the making of art—it transcends the specific
conditions within which the art is made, and it creates a corresponding,
as undescribable, effort on the part of the viewer.

10. Professional

To profess, from Latin *profiteri. Pro* = ahead of time; *fiteri* = to avow. To
declare in advance what one is about to do. Is "to profess" a contradic-
tion in terms with creativity? How can the creation of something which
did not exist until it was created be professed beforehand? Is it still
created when its terms are already known?

The professional may avow the direction her or his research is ori-
ented toward and still, within that direction, engage in creative en-
deavors. But how much is the professional submitting to the avowed
confines of his or her exploration to the degree that the explorations
end up not being explorations at all but mere confirmations of that
which was already certified within the scope of an original declaration
of intent?

The arts, like the sciences, have suffered from assuming degrees of
predictability to exist as qualifying givens in their practices. And they
have reduced their possibilities even more by seeking logical, sociologi-
cal, political, or ethical proof and verification for artistic events. Are
there alternative referents we can muster to avoid engagement in a
professional practice dependent on predictable conditions? Or, is it
interesting at all for us to find such alternatives?

Assuming that the decision of producing art and the choice of mate-

rials confine us to a program, and assuming also that everything today ends up becoming an institution, I still find myself attracted by a desire to observe that which happens to the creative mind between those point-of-departure choices and those arrival institutions.

I know the mind does not proceed in a straight line. If it allows itself the opportunity, it stumbles upon personal discoveries which are akin to sheer illumination. These discoveries inevitably divert it from the programmed path it had set for itself. The mind goes from tiredness with the data it has involved itself in to enthusiasm for new data, in an apparently disordered kind of spiral process of growth through which it then returns again to the data it has already touched. What leads the mind to permit itself creative alertness? It is erotic, sensuous, and intellectual desire—the unstoppable curiosity about the next and other steps it envisions.

Through this model of the thinking and sensing process I have attempted to describe above, I have found myself seduced by impermanence and insecurity, as alternatives to the false certainties my culture offers. Conventions have become interchangeable codes for the process of experience rather than rules one should conform to. Analytical structures have become instruments—never binding, never prescriptive—upon which I play the intuitive leaps I trust my desire in. Theories are deduced from art making rather than being its hypothetical guidelines. Art has become for me an emblematic testimony to itself as a personal and social entity, and it is not a goal-oriented activity.

11. Sources

From ancient Greece through Rome and in the Renaissance and beyond, some city artists and intellectuals have drawn, in their poetry, theatre, painting, and sculpture, from an idealized vision of rural or pastoral simplicity. Recurrently, periods develop in which the roughly hewn or the rustic are also revived and revered in architecture and design, because they are believed to echo realities more pristine than the ones entertained by urban decadence.

Today, we have made an ever greater variety of sources for art available to ourselves. We started taking from the realms of the machine, the folk and popular arts, science fiction and colonial exploration, advertising and crafts, and are now bereft of any commonly accepted standards.

We have not only lost the central traditions outside of which we could pursue the exotic (*exo* = outside, in Greek) but also have even lost the reassuring certainties of progress. All that is left is an endless quest for chimeric outer sources. Basically, now all is exotic and nothing is central.

Art has become dial-a-source. Inevitably, all approaches have become quite legitimate and choice derives not from objective conditions, as some of us still would wish, but, willingly or not, from referring to the fluctuating international clubs of taste which are substituting for all previous standards.

The club of taste I find myself sharing the views of is attentive to artistic process as its own source, as Félix Guattari puts it: an organic growth incorporating memory, feeling, society. Process never achieves prescriptive certainty and its results are never fully consumable. I see life as rooted in uncertainty and gauged upon existential aimlessness. I am reassured (not frightened) by this view because from the innumerable orders of experience, in conflict or syntony, derives the creative drive.

Art, to me, is nothing but a testimony of a flow where order and disorder are interchangeable and where the darkness of inspiration and desire fulfill unknown purposes within the appearance of time and space.

12. Quality

row row row your boat, gently down the stream
merrily merrily merrily merrily, life is but a dream

So many voices: the agitating mess of a mass world. It's strange that so many of us live here and don't burst. Why do we take it upon ourselves to call ourselves artists? In the bustling flow, we choose almost at random some substance to activate, and from that first matrix we spin a lifetime of things and words and mysteries.

Looming under or above or behind or in front of it all—maybe actually entwined in it—is a yearning for quality.

We touched upon it a few times in these twelve exchanges, especially when circling around the concept of ineffable magic. Yet I am mentioning quality at the conclusion of our untargeted forays, because it is

perhaps the most controversial topic we could discuss, because it is a subject one can never discuss, because only absolute silence or total noise represents best its infinite constellation of possibilities.

I find quality in a toy made of sticks and nutshells by a child in a valley of the Caucasus and in a pie cooked by an old man in Lima. Quality is found in a gesture a person might address to another in a Beirut cellar under bombardment as well as in a corner of a most vulgar millionaire's apartment in New York.

In Europe, in all the countries being ravaged by World War II, one business which never ceased flourishing was the sale of flowers.

Quality is mourning. It is the celebration of birth. It is to admit the fragility of life and the intensity of passion. Quality can be destructive as well as constructive; it is optimistic and pessimistic. It is a genius, a tutelary spirit, a demon we sense the presence of not in ourselves but as ourselves, and yet ever escaping.

I lace my tragedies and joys with the calm and pressing tide of

Notes

1 For the early part of this century, one could cite, for instance, El Lissitzky or Laszlo Moholy-Nagy. In more recent times there is a whole line of practitioners of depersonalization from Don Judd and Andy Warhol to Peter Halley and Jeff Koons.

2 Giorgio Morandi or Paul Klee could be examples to mention in this regard for the recent past, while maybe Louise Bourgeois, Saint-Clair Cemin, Kathy Muehlemann, or Robert Grosvenor could be counted as such in the present.

3 During the discussions, an interesting objection was made to using the word *effort,* because for many it implied an association with a feeling of burden. It was suggested to use words such as striving or yearning instead.

Some Remarks on Racism in the American Arts

Daryl Chin

About a year ago, I attended a lecture given by Faith Ringgold at San Diego State University. After her lecture, she answered questions from the students. Ringgold had mentioned that, during the past few years, her work has finally received considerable notice. One student asked her if she felt, when her work was reviewed, that her work was not looked at critically, but was categorized as "feminist" or "black" art.

Ringgold replied that, during the 1960s, there was the impression that alternatives to the art establishment could be created. But that was an illusion: there was only one art world. And the New York art world was not endless; it was, and is, a finite system. After a while in New York City, if you've gone to a few openings and the usual circuit of galleries and alternative spaces, you probably have met a large number of the people who comprise the art world. The point is that, if you are an alternative artist (nonwhite, female, gay, etc.), then you have to wait for the art world to acknowledge you. And there's not much that you can do about it. You have to continue working, and wait. When the art world establishment (which is white) decides to acknowledge you, it will.

Ringgold's argument was very provocative. I thought about what she had said during the summer of 1987, when a number of exhibitions

(including the Whitney Biennial) promoted a new "movement" in art, which was being popularly dubbed "Neo-Geo" ("promotion" is the term that is appropriate). Yet, within that discourse during the summer of 1987, including major exhibitions, articles in everything from art journals to daily newspapers, and (perhaps most important in current parlance) the movement of merchandise (a.k.a. sales), there were many omissions. At the end of the summer, the Whitney Museum at the Equitable Building had an exhibition on trends in abstract art, and one omission was rectified, in that David Diao's work was represented. Diao, who, through his work as one of the advisors to the Whitney Museum Independent Study Program for the past decade, has been one of the primary influences on recent painting and sculpture, has not had the public recognition for his part in generating much of the discourse about the visual arts. In addition, his elegant considerations of constructivist precursors have reasserted a discourse about the art object within an aesthetic of radicalization. His practice as a painter during the past decade has maintained a dichotomy between a reaffirmation of the commodity status of art and an acknowledgement of art's dematerialization, all the while resulting in a series of discreet and dynamic paintings encapsulating much of the history of modern abstract art. As artist and theorist, Diao has not had the recognition that he deserves. The quality of his work is not at issue; rather, the admission of the importance of a nonwhite artist in the context of the contemporary art world is one which is exceedingly difficult. Diao's inclusion in the popular discourse of current painting and sculpture is always qualified.

I think it is important to note the part that institutional support plays on behalf of minority artists. The art world is based on the system of the commercial galleries. The attempt to define alternatives, which came about during the 1970s, helped to establish the value of noncommodity art practices. The agenda of the alternative spaces was to provide a forum for art which was disenfranchised from the gallery system, and that included those whose works were not acknowledged within that system. Those disenfranchised included minority artists, women artists, and young artists. As an example, the feminist art movement of the past two decades defined an alternative system consisting of cooperative galleries, journals, courses, and curricula at art schools and art institutes. Many women were able to establish career options through this alternative system. However, aside from a few women who have

been established within the commercial system within the past decade, few women artists have been able to sustain their careers on a commercial level, that is, through the sale of their work. With minority artists, the mandate of many governmental funding agencies requires minority representation in terms of affirmative action. Though minority and women artists often find outlets in teaching, residencies, and grants, the exclusion of most of these artists from the commercial center of the art world effectively effaces their work. The commercial center has always defined a large part of the interest of art in modern times; the price of a work often becomes the factor involved in an assessment of that work. Notice how often auctions are discussed in the reportage on art. Notice, too, how rarely those prices reflect an aesthetic assessment, and how rarely works by minorities or women are featured in those auctions. From these indicators, is the assumption to be made that visual art work of worth is solely the province of the white male? The exclusion of most minority artists from the commercial center of the art world is one reason for the recourse that minority artists must take through the institutional framework. The institutional support to which I refer is part of that system of "alternatives": in short, the "feminist art world" and the "black art world" which Ringgold characterized as qualified in terms of the established art world.

In discussing the racial biases of the art establishment, there are always circumscribed answers, indicative of the ideological stranglehold of establishment opinion. Returning to the situation of the past summer, the ascendance of the "Neo-Geo" painters was highlighted by the fact that many of the artists were able to be represented by some of the most prestigious and the most profitable of the commercial galleries, most notably by Mary Boone and Sonnabend. Just to further the argument: David Diao is represented by Postmasters, one of the more stable galleries in the East Village, but a gallery which cannot command the prices accorded to work represented by Mary Boone or Sonnabend. Now, I am not suggesting in any way that the man is suffering. His position at the Whitney Museum Independent Study Program is secure; he has received numerous grants and awards; when he exhibits his paintings, he has always been able to sell his work for quite respectable sums. Of course, an argument could be made that Diao's work, which questions the ideology of abstraction, is maintaining integrity by the refusal to function in the arena of the inflated art market mentality.

That might be true, but truth might also be served by the acknowledgment that Diao's work has not had access to the most commercial excesses of the art market. To be blunt: if an artist of similar age, operating in the same social system, equally influential for younger artists, such as Ross Bleckner, can achieve prices in the vicinity of $100,000 for a painting, I do not think that David Diao can make the same claim (although his prices are by no means negligible). This discrepancy in terms of economic worth, a sure sign of merit in a capitalist culture, is accountable in one of two ways: either there is a difference attributable to the aesthetics of the work, or there is an ideology involving political and sociological difference which determines how work is seen. The abstraction of Diao's work is not seen as merely a function of abstraction (the neutral "sign" of much "Neo-Geo" work), but is seen as the work of a specific person, and that person is not white. Some recent practitioners of abstract painting, because of their representation by prominent galleries, have the possibility of their work being sold in the six-figure range, while Diao's chances of the same economic potential are much less. I suggest that the reason is not, essentially, qualitative, but racist in base.

As an indication of the changes in the art establishment in regards to race during the past two decades, I would like to note a discussion I had during the summer. I was talking to an artist about alternative spaces, funding, and affirmative action. At one point, we discussed the responsibility of the alternative spaces, since the funding for most of these spaces comes from foundations and government agencies, to make sure that there was minority representation. He said that this was difficult, because that would mean dictating to curators who should be in a show. I said that this was not dictating to curators, but making sure that possibilities for minority artists remained open. The issue is the responsibility of public funding; acceptance of public funding means that the artist or the organization is accepting the mandate of public agencies to equal legal representation. Also being accepted is accountability to the public agencies for any statement made with public funds. For some reason, we wound up discussing the incident of "The Nigger Drawings"[1] at Artists Space in New York City. He felt the brouhaha over "The Nigger Drawings" was very unfair, and that the black artists who protested the show were being opportunistic. He also felt that Helene Winer and the administrative staff of Artists Space were unfairly ac-

cused of insensitivity to racial issues by allowing a white artist to exploit the term "nigger" in relation to an exhibition being sponsored by Artists Space. This artist suggested that artists and administrators such as Howardina Pindell, Lowery Sims, and Linda Goode-Bryant were exploiting the situation, in order to gain greater renown in the art world. Winer and those administrators of alternative spaces since then, he claimed, have been hampered by the idea of accountability. We discussed the direction (or lack thereof) of Artists Space in the past decade, a situation which he felt was due to the vigilance enforced by public accountability, which he viewed as congruent with censorship.

In a related incident, The Wooster Group presented *Route 1 & 9* in 1983. This piece included a segment which involved the performers (who were white) in blackface, exhibiting behavior which can only be considered stereotypical. The piece attracted a great deal of controversy at the time, with accusations of racism being made. The play had white actors in blackface and body paint enacting the most extreme negative racial stereotypes presented without self-reflexive analysis. The defense of the piece stated that The Wooster Group was only being honestly reflective, and that any attempt to have the piece amended would be censorship. In addition, a defense was made that public funding should not bow to community pressures, because the suggestion was made that the piece should not be supported by funds from The National Endowment for the Arts and The New York State Council on the Arts. However, the controversy did cause a decrease in funding from governmental agencies for the 1983–84 season. *Route 1 & 9* has remained in the repertory of The Wooster Group, and, after the initial decrease in funding, The Wooster Group's funding was not just restored to the level prior to 1983, but increased annually over the past three years. One reason for the increase was the budget to tour the repertory: *Route 1 & 9*, without amendation or even an explanatory program note, has now been shown throughout the United States and Europe.

When media arts departments were established in major American universities in the 1970s, there were inquiries to many artists to join the faculties. Obviously, one person who should logically have been invited to teach video art was Nam June Paik. Negotiating with several American universities in regards to teaching, Paik decided to investigate the pay scale for comparable positions. By the 1970s, many artists, such as Allan Kaprow, Ed Emshwiller, and Robert Morris, were involved in

teaching. In his negotiations, Paik asked for a contract with comparable salary and benefits. Paik found that the American universities were unwilling to match the contract conditions which had been accorded to other (white) artists. Paik's credentials, both as an artist and as an academic, were comparable to his white colleagues. Paik was not asking for special dispensation: he was asking for parity. But no American university was willing to grant that. For more than a decade, Paik has been teaching at the University of Munich.

To state that these examples bespeak a racist bias is the kind of statement that minority artists are not supposed to make. Minority artists are always in a bind: if complaints are made, we are made to seem irrational, ungrateful, irresponsible. We should not bring these matters up. (The reason we should not bring these matters up is that the establishment always holds out the hope that an exception will be made in our case. That, in fact, we will be the token selected to participate fully within the arena of the art establishment.) As I write, there has been much advance comment on the exhibition "Committed to Print" at The Museum of Modern Art. This comprehensive survey of recent printmaking is one which has been studiously integrated, so that minority artists and women artists are represented along with the established white male artists. The fact of the exhibition being integrated is one seen to be of great import. But that is the problem: the exhibition should not be so anomalous. Integrated survey exhibitions should be par for the course in the art world. But this is not the case. So minority artists are left in the situation of having few alternatives to the art establishment, no matter what their work. Yet most Asian American artists I know have studied art in the American universities. The agenda of contemporary art, which is taught at most universities and art schools, is one which is familiar to most Asian American artists. Issues of abstraction, of figuration, of originality and appropriation, are issues with which most Asian American artists are familiar. Few Asian American artists work in a way which can be characterized as ethnic; rather, their art reflects an awareness of the mainstream issues of contemporary art. Yet, within a few years of working outside the academic environment, most of these artists find themselves having a problem sustaining a mainstream career; often, when these artists are included in exhibitions, those exhibitions stress the ethnic identities of the artists. The art world, so tied to an ideology of a market economy, reflects the

sociopolitical consciousness of that ideology. And that ideology maintains a hierarchy of stratification, with minority artists lacking a definable place within the structure. For this reason, minority artists must accede to the possibility of alternative systems, specifically institutional.

I should admit that, when I began writing this essay, I worried about the specificity of the examples. Quite frankly: was there a way to generalize, so that the names would not have to be included? I was worried about the proprieties. But that is exactly what the powers-that-be count on. Years ago, when I was in high school (I went to New York's High School of Music and Art), I was transferred from one art class (a graphics and printmaking class) to another (oil painting class). Now, this transfer came a month after the term began. I had already spent more than $50 on supplies for the printmaking class, and I had been planning on certain projects. The whole transfer seemed totally arbitrary, especially since the term was already in its third week. So I went to my guidance counselor to complain, and she was amazed that I was complaining. Since I had already bought all the supplies for one course, I wanted to know how I was supposed to pay for the supplies I would need for the other course. As the term was already under way, I wanted to know why I was selected to be transferred. The guidance counselor replied that the class had thirty-three students, and the class really should only have thirty-two, so one student had to be transferred. So I wanted to know why I was the one to be transferred. Alphabetically, I was not at the beginning, nor was I at the end. Finally, she admitted that I was transferred because I was assumed to be the one student who would obey without arguing. By that point, I was so angry that I yelled, "What the fuck do you mean, I would obey?" And she glared at me, and said, "How dare you say that to me, you, a nice Chinese boy!" In short, since I was the one Asian American in the class, I was assumed to be a dutiful, obedient, docile person. How the hell do you argue with that? So much of the interaction of Asian American artists with the mainstream of the art world seems to be based on a similar idea. The difficulty of assertion in the context of an assumed effacement is always part of the context of Asian American artists.

This is not the case with other minority artists. That is why there has always been such strife in the relationship between other minority artists and the art establishment. The most striking example of this strife is the case of the graffiti artists. The fashionability of the graffiti

artists had the art establishment making attempts to convert the graffiti artists to marketable status. However, soon the interactions between the art establishment and the graffiti artists became problematic, especially when the artists were introduced in the European context. Often, the actions of the artists were deemed inappropriate, outrageous, improper. The comedy of the situation came from the fact that class distinctions, implicit in many art world interactions, became explicit. Within the operation of a postmodern aesthetic, the graffiti artists were able to command an equality of attention. There was always the element of discomfort with this exchange, and the vagaries of fashion enabled the art establishment to eliminate the problematic by a curtailment of acknowledgment. In recent months, a number of articles have appeared discussing the abridgement of the art commerce on the Lower East Side of New York City; many have mentioned the difficulties of the continued market value of the graffiti artists. The racial implications of the situation need not be hammered: the walls have been built to silence a problematic minority.

This is striking in the context of recent events in the art world. The arrogance and the impropriety which have been labeled as problematic for the graffiti artists can also be seen in the behavior of such other prominent artists as Robert Longo and Julian Schnabel. Why is it wrong for minority artists to assume the same stance of egocentricity? I would suggest that the egocentricity displayed by the graffiti artists challenged the ethnocentricity of the white art establishment.

The problem of tokenism is always present in the acknowledgment of minority artists, and, with tokenism, the situation of the fad, the trend, the fashion. In addition, there is the situation wherein one disenfranchised group is used as the token of pluralism, in order to prevent other disenfranchised groups from demanding parity.

I find that the writings of many critics who discuss postmodernism is curiously slanted. In the writings of Hal Foster, Craig Owens, Benjamin Buchloh, Rosalind Krauss, and Brian Wallis, there is an assessment of the ideology of postmodernism as the critique of the sovereignty of the hegemony of Western European culture and its institutionalized aesthetic of the masterpiece. For this reason, there is an insistence on the copy, the appropriated image, the pastiche. Yet, within their agendas, there is rarely a mention of work done beyond the limits of white European-based, ethnocentric culture. When Owens, Buchloh, and

Wallis mention alternative perspectives, their reference tends to be to the work of white women artists. There is rarely any mention of work by nonwhite artists, nor by nonwhite women artists. In Buchloh's essay "Allegorical Procedures: Appropriation and Montage in Contemporary Art" (in *Artforum*, September 1982) and in Owens's essay "The Discourse of Others: Feminists and Postmodernism" (in *The Anti-Aesthetic: Essays on Postmodern Culture*, 1983), a certain aesthetic is defined through the work of a number of women artists such as Cindy Sherman, Dara Birnbaum, Louise Lawler, Martha Rosler, and Barbara Kruger. Yet nonwhite women using similar strategies (and for aesthetic purposes congruent with those of the white women cited) are never mentioned or alluded to or acknowledged. Two artists whose work would fit into those characterizations (and whose work was available in 1982) are Janet Henry and Yong Soon Min and there are, of course, many others. Yet the work of these women remains outside the parameters of the discourse on the aesthetic of the "other" as defined in these discussions of postmodernism.

I do not want to set up an antagonism between feminists and minorities. Divisiveness is exactly the situation being set up by so much of the art establishment. The attempt to aggrandize the self so that the heroic stance is synonymous with the extremities of egocentricity is part of the pathology of much recent art commerce. Careerist behavior patterns have become part of the social intercourse of the art world. Trying to line up exhibitions, trying to line up reviews, trying to line up collectors: people no longer go to parties, people go to work a room. But if pluralism is being advocated, then we have the right to point out that pluralism is yet another exclusionary tactic. During the 1960s and 1970s, so much of the aesthetic of the avant-garde attempted to question the ideology behind aesthetics. We have seen how much that ideology centers on the definition of traditional sexual roles, thus the examples of Schnabel, Salle, and Longo as male artists living out the role of the embattled male egotist as defined by the abstract expressionists. That the ideology behind their work is reactionary need not be explained once again. But we can ask that any advocacy of pluralism remain open to any and all subversions of sexism, classism, and racism. We can ask that the rhetoric of cultural difference actually admit those of different cultures. At a time when reactionary values threaten to regain cultural ascendancy, we can ask that any theory of cultural difference be vigilant

about the qualifications and the exclusions within that theory. If aesthetics remain a function of the imaginative capabilities of mind, we can ask for open minds as opposed to closed minds. Although aesthetics are located in an imaginative realm, aesthetics reflect attitudes grounded in the realities of ethics, sociology, politics, economics, and psychology. When we see that aesthetics are being used to continue attitudes of sexism, classism, and racism, we have the right to point out the problematic we encounter. I should note that the minority can only propose; the majority must allow for accommodation. The minority can only suggest; then it is up to the majority to do something about the situation. But if the majority fails to recognize the exclusionary tactics now being practiced, then the realm of aesthetics is no longer imaginary, it is downright pathological.

Get real!

Note

1 "The Nigger Drawings" was the title of a show at Artists Space in 1978 of (innocuous) abstractions by Donald Newman.

The Success of Failure

Joel Fisher

All things fail save dreams.—Ruth Benedict

The best artist is the imperfect artist.—Wyndham Lewis

I'm not sure that failure exists; that is, I'm not sure it's more than an elaborate fiction. Failure's claim to existence is based on a dualistic separation of the world into areas of success and failure. The word itself—failure—is so loaded with judgment that it draws distinctions like barriers.

Our use of such a word must be conscious, for it adds yet another snare to the discussion of risk. This is a dangerous area. The use of the word *failure* places the discussion in an area that is neither reportage nor strict scholarship.

Most of us realize, of course, that there are no absolute failures, and yet we speak of failure with a kind of confidence and certainty which, in the face of doubt, is a kind of dare. We risk that much. Then we proceed into the inevitable . . .

For the ancient Greeks the idea of success was intrinsically linked to the idea of perfection. In such a worldview, no idea could have been more foreign than that expressed by those dangerous new religions that

glorified the potential of the child or the imperfections of a repentant sinner. The shift in values was profound when, suddenly, it was not the "finished" man who was "chosen," but the imperfect disciple—when the sick, the afflicted, and children were no longer despised. For us, thousands of years later, the conflicting ideas of the ancient Greeks and the early Christians operate within us simultaneously rather than sequentially. This should not be possible, but it is. The result is that sometimes we view success as finished perfection—at other times as the perfectability of growth.

Since failure only exists in contrast to success, it, too, mirrors this contradiction: it can be considered as a kind of incompleteness, or as existence without grace. Paying attention to the way we seem to hold two opinions simultaneously, and to the resultant judgments we make, gives us an opportunity to explore some general attitudes toward human achievement. Given such radical ambivalence, what are the means we use to steer or guide our efforts?

I'd like to propose a new field of study to explore attitudes toward human judgment—a study of the science of failure in which anthropologists or philosophers might usefully engage. It is surprising to me that philosophers have not attended to the concept of failure. The more I think about it, the more I believe that the consideration of failure should exist as a distinct area of study. With some good humor, then (and appropriate Greek roots), I have coined a neologism to encompass a theoretical concept of failure, an analysis of its mechanism, and its consequences in guilt or shame. I propose *anaprokopology,* from *ano,* not, and *prokopi,* success, as a general term to designate that area of existence in which success is not achieved or is irrelevant. This particular study, however, lies within the general literature of connoisseurship and concerns the process of making distinctions. Perhaps it can also be expanded to a broader relevance.

Why are we surrounded by the potential of failure? To what extent is failure imaginary or real? Although we haven't yet any larger systematic study of failure, there is a modest literary genre in which many forms of failure are contrasted to a single instance of success. Probably the best known example is the New Testament parable of planting seeds. The seeds (by implication either us, or the word of God) are destined to failure if, instead of landing on fertile ground, they fall either in the path, on rocky ground, or among the thorns. There are dangers in each

of these places. The seeds might be eaten by birds, trampled underfoot, choked by brambles, or succumb to drought. There are many ways to fail, it seems, but success is singular.

The structure of the parable is not uncommon. I found a similar pattern in an obstetrics textbook which I bought in London shortly before my son was born. It provided a frightening inventory of all the ways a birth could go wrong. There were dozens of chances for disaster in contrast to the essentially unmentioned possibility of a living, healthy baby. Success takes up a very small part of the story. It is easier to consider failure, almost as if the method might be determining the form. There is a hint here, perhaps, that analysis itself is more comfortable with failure.

Such examples would lead us to believe that failure is more common than it is. Manifest failure, however, is relatively uncommon. Often one anticipates failure as the logical end of the path one is following and, when such a situation is sensed or recognized, the path can be abandoned. Perhaps that is why unfinished work used to be seen as a form of failure. In such a resonant example as the story of the Tower of Babel, the unfinished becomes a metaphor for failure itself.

Now, unfinished work is more often accepted as worthy of serious consideration. This shift in values is one on which artists and art historians have had some effect. The metaphor absorbs process in some of Michelangelo's later sculpture (*St. Matthew*, the *Rondanini Pieta*, the *Dying Slave*); we see the figures as bound and imprisoned in the rock. Today the unfinished is considered a convention, and there is general agreement that the Michelangelos are masterpieces. We no longer need to face the unfinished with a negative prejudice or a suspended judgment. We have begun to look at a work as somehow complete at every point in its development.

While it is true that many inevitable failures are abandoned, others get "finished." Sometimes it takes a long time to recognize a problem. Sometimes flaws only appear in retrospect, not having been obvious during the creative process. In such a case the artist might exhibit a work publicly, even sell it, recognizing too late a serious problem in the work. One needs a special kind of judgment here. How can one expect to recognize a failure at a time when one doesn't know or recognize one's goals? Many artists define what they want by observing their own decisions which are often very precise. The sense of "getting it right" is

preverbal and instinctive. The clarity in a work is evolutionary, and the history of its evolution maps an artist's development. With some artists, and in some works by all artists, such clarity never appears. Instead, we feel a chronic, nagging suspicion about these works. We are never certain whether they are the best or the worst things we've ever seen, and we suspend judgment. Most often artists hold back such works for future consideration. Picasso kept *Les Demoiselles d'Avignon* rolled up under his bed for years. The decision to release it may have been prompted by someone else. Sometimes a decision is never made, and the artist never relinquishes the work. I'm sure that it is not unusual for older artists to be more and more surrounded by such questionable failures—their obvious successes long since having left home.

Failure has a curious birth. It comes indirectly, without a trace of cynicism, almost as if it creates itself. Failure is never planned for or organized. It comes from outside intention, and always implies the existence of another separate, more vital concern. A genuine failure cannot be intentional. An intentional failure is no such thing, but an unwholesome, nihilistic form of success.

Once again we are involved with intention. It seems to me that over and over again in different ways it is intention that has marked the way of art in the twentieth century. The recognition of intention implies that, to some extent, an artist is accountable for his or her images or actions. The existence of intention provides an opportunity for failure, ground on which failure can grow.

Failure itself draws a distinction. Where failure occurs, there is the frontier. It marks the edge of the acceptable or possible, a boundary fraught with possibilities. This edge mixes certainty and insecurity. It taunts us to try again and tells us firmly to stay back. The failure tells us clearly where our limitations—at that moment—are. A few minutes later it might be different. This is why the risks of failure add value to success.

The most extreme form of failure occurs when standards are so high, and their satisfaction so unlikely, that the likelihood of success becomes almost fictional. Though such standards guarantee failure, they do not discourage the passionate impulse to strive toward the highest ideals— leading to the realm of almost mystical failure that is akin to the implied and eternal failure of *neti neti* (not this, not that), the ancient Upanishad formula for distinguishing the sacred. The search for the

impossible objective is the most profound and pure manifestation of anaprokopological form.

Other approaches to work are less ethereal: there are works for which there is a kind of "rightness," whether it occurs internally as part of the work or externally in its relationship to the world. In the artists' statements that accompanied this essay, Keith Sonnier explains why it was necessary for him to abandon a whole series of works when he saw the conditions in which the children who would be producing them were working. The impulses of his heart and his sense of compassion were greater than his need to follow through on the pieces he had planned. The means of production would have tainted the art. Similarly, an unseen supporting pipe destroys the spirit of Jackie Winsor's piece, because the work itself implies that it stands by itself. Winsor knew that false implications could undermine the work. The seriousness with which she considered that factor proves that the successful creation of an artwork relies on more than visual standards.

What is appropriate to a given artwork has multiple dimensions. Integrity (an ultimate unity) prevails when something is both internally and externally appropriate, both true to itself and true to its environment. And the work must also follow through on the promise it makes. It can't soften or dilute its purpose at the last moment.

Several years ago I heard a story about a wealthy collector who decided to put a Picasso painting up for auction. He took it to the auction house and was told by the experts that they would not take it because they thought it was a fake. The man was outraged, and after a few rude comments about the credentials of the auction-house experts he took the painting directly to Picasso himself. He explained the problem to Picasso and asked him to verify it as truly one of his pictures. Picasso looked at the painting carefully, and then came back to the collector.

"I'm sorry," he said. "They are right. It's a fake."

"But that can't be!" gasped the man. "I bought it directly from you fifteen years ago."

"Well," said Picasso, "I can make fake Picassos just as well as anyone else."

What we call a sense of timing also has to do with this multiple dimension of the appropriate. Without timing a work may be unintentionally invisible; one cannot make a proper evaluation. Thirty years

ago when Meret Oppenheim painted her picture, she saw it differently than she did when she put it into this exhibition. At that time, instead of seeing the painting in front of her, she saw only what she thought the painting *should* be. Paul Thek's contribution to this show plays with the sense of the inappropriate in contrast to conventions: he proposes a work that reverses sexual stereotypes by changing "Our Father" to "Our Mother." It is a work that probably has more impact now, when sexual inequality is still obvious, than it will have in the future. It deals with what could be called "threshold values." It makes us wonder what distinctions it may be appropriate to make in periods of change.

Corresponding to the different forms of failure are different kinds of obstacles. Except for psychological obstacles, which are mostly a matter of anticipation, obstacles appear unexpectedly or contrast with expectation in the overall plan. When an obstacle stops the action completely, all the energy that has existed as expectation is homeless. What one feels is a sense of loss.

More and more we find instances of things that work in photograph or in reproduction but not in reality. When something works photographically but not actually, one thing that might be wrong is scale or proportion. Scale has a specific, narrow margin of error, and is very sensitive to degree or amount. I take these to be larger issues. Sometimes everything in the recipe can be right except the proportion of the ingredients. We need something more than perfect aim. Our arrow must go far enough to reach the target, and not so far that we overshoot it. In many fields, excess is a kind of deficiency. Twice as much is not twice as good. There is a critical threshold beyond which is error.

Often things fail only in amount—too this or too that. Too aggressive, too argumentative, too arrogant, too arty, too big, too coercive, too confused, too cultured, too dangerous, too limited, too self-conscious, too sentimental, too sloppy, too shy, too subtle, too thin, too little. Too much. The excessive is our preferred value judgment. Which extremes do we value? The kinds of extremes we find objectionable are gauges of our attitudes and values.

Just as all vision has its blind spots, all images have a field of eclipse. Creating the image is only part of the problem. Somehow the image must penetrate the viewer's mind. Images as complex structures are subject to a whole range of snares, traps, and blockages. And they always carry with them a great deal of additional information.

In what ways are we mindful of our failures? Sometimes, of course, not at all. There are times when pain blocks a conscious recognition, when our failure taints our own abilities and what we and others expect of ourselves. It is generally felt that we own our failures in a different sense than our successes. We share success; failure, no matter what, is more private. Thus, we also conspire to protect our friends from their failures. This illusory protection adds another layer to the pain, sometimes even damaging those it tries to protect. This is the failure in failure; by comparison, the original failure is refreshingly simple and minor. The difficulty we have in containing failure is probably the reason some people view it as contagious. And yet the emphasis is not quite right: a failure when recognized is never so serious as when it isn't recognized. A balance is restored. We could even say that an acknowledged failure does not exist.

Inventors, I suspect, have a very high failure rate, but their attitude of try-try-again protects, within society, the freedom to persevere. Edison once said that he failed his way to success. Nowadays we tend to make collective the kind of individualism that Edison represented. Now we do things in groups. Someone gave me a quote from a Silicon Valley executive: "We tell our people," he said, "to make at least ten mistakes a day. If you're not making ten mistakes a day, you're not trying hard enough." Imagine the change if we valued a list of major failures on a person's resumé. If it is true that only failure or anticipated failure is the author of change, a list of failures would be more revealing than a list of successes.

As a scientific method the ideal experimental sequence is to make predictions based on observations and then look for the facts to prove the hypothesis wrong. You look for failure and hope you won't find it. This is a middle-ground alternative to looking only for success, but it is still several steps away from seeing failure as positive.

We may fall short of our goals but, even in our failures, those things for which we strive somehow endure—precisely because we are striving for them. They have an *intentional existence.* We intend (that is, lean toward) a more perfect state, and the goal of that dream or striving locates itself mysteriously in the work. I'd like to suggest that some great works of art might themselves be failures and, moreover, that their failure contributes to their greatness. I also think it is possible that there is more genuine content in failure than in success. Sometimes the

failures of big ideas are more impressive than the successes of little ones. For several years publicly acknowledged success has been more valued than it used to be, and this affects all of us. When failure represents a terrifying possibility, playful experiments in art are more difficult. When every work is called upon to be a success, we lose the option of failure. This is perhaps a more expensive loss than the gain of success.

Note

This is a revised version of an essay written for the exhibition "The Success of Failure," curated by Joel Fisher for Independent Curators Inc., New York. The first "failure shows" originated in Fisher's studio when he lived in London in the 1970s.

Visual Pleasure: A Feminist Perspective

Johanna Drucker

Pleasure in Perspective

It seems astonishing to me that nearly twenty years after the first femi-nist formulations of visual pleasure as the provenance of the male gaze, there has been no coherent way to think ourselves out of the apparent dead end of debates which pit the symbolic construction of gender against the seemingly essentialist insistence on the gendered body in the discussion of feminine sexuality. Critics, art historians, and academics keep taking up Laura Mulvey, Jacqueline Rose, Juliet Mitchell, and other psychoanalytically informed practitioners of feminist theory, as if the basic description of the woman in their models were not patently absurd. The premises of the debate have bogged down the theoretical apparatus in a hopeless mess of nuanced "yes-we-know-the-model-is-flawed-but"–type qualifications.

Meanwhile, discussion of theoretical issues has shifted to topics whose timely significance obscures the fact that part of their usefulness lies in their blocking ongoing consideration of feminist issues. Witness the eclipse of discussions of feminist theory and visual pleasure by the attention to, for instance, post-coloniality and multiculturalism, issues whose currency has been granted more political viability, and whose

appeal is not, I would assert, incidental. It was certainly not necessary for feminist concerns to compete with multicultural concerns as if only one token "other" at a time could be present on the mainstream platform. But it was certainly convenient to cast middle-class white women feminists in the role of careerist opportunists and split the advocacy of "otherness" along ethnic, racial, and class lines. Convenient for whom? Not for any of us who remain in the "other" categories—and all the trendy theory of current conference titles serves to deceive us not one whit about our present status.

Feminist concerns did not fall out of favor because of the ascendancy of the rhetorics of multiculturalism or post-coloniality. If there is still no place for the feminine subject within the patriarchy, then it is because the place of exclusion remains legislated, and the fundamental asymmetries on which patriarchal power gains its legitimacy remain intact. The undoing of this asymmetry is not an academic exercise in theory language, but a subversive attempt to, finally, wrest that order out of its hold on authority. And feminist theory came dangerously close to empowering women on their own terms before it encountered both theoretical and political impasses.

Along the way, the investigation of women's pleasure got dumped on by puritanical feminists as a bourgeois concern and now gets put down as trivial by contrast to other (supposedly more serious) instances of power relations and abuses. But the fact that there is still not a viable theory of feminine pleasure, and of visual pleasure from a feminist perspective, shows all too clearly that women's issues are being written off again. The issue of pleasure is central to the feminist agenda—how we are to become the subjects of our own subjectivity and our own sexuality. The problems that pertain here are those of any disenfranchised, unempowered, abused or colonized class of subaltern, secondary, or "other" individuals whose subjectivity is severely threatening to the terms of hegemonic power.

In addition, the too-comfortable consignment of theory dealing with female sexuality to the mooted (muted) post-feminist domain is perfectly in synch with a general state of cultural affairs in which Anita Hill's utterly ordinary statements of common women's experience are construed as the ravings of a sexually depraved (deprived) female, in which most date rape charges are dismissed by undercutting the credibility of the woman violated, in which Jeff Koons displays himself in the "Hallmark Hall of Porn," and in which Camille Paglia becomes the

spokeswoman of the new right's misogynist condemnation of women's struggle for parity in social and symbolic arenas.

The need for the Christian fundamentalist right to repress female sexuality is just the usual story, and the reinforcement of feminine subservience, of women as the objects, not subjects, of their own language and desire, is part and parcel of the structure of extreme conservatism. But the (surprise?) attack from the supposedly radical leftist arena of theorization of female sexuality takes the form of condemning it as the indulgent preoccupation of privileged, educated, white middle-class women whose chief concern is achieving multiple orgasms within the constraints of conventional (safe) heterosexual relations. This last point misses the distinction between apparent privilege and specific opportunity—that if a certain measure of privilege is required to permit the investigation of fundamental and ongoing forms of repression (oppression) then the attack should be aimed at the repressive structures, not at the liberating investigation.

This essay is intended as an opening to debate, to dialogue and discussion, about the status of visual pleasure in women artists' work and critical theory. It is important to render explicit a hierarchy at work within criticism which continually undermines as nontheoretical the tactile, sensual work of women artists who use manual, rather than fabricated, modes of production while permitting their male counterparts critical legitimacy and authority though they make use of the same means and media for their work. The corollary to this is that women artists who seek and receive status within critical debates are almost always those who have abandoned the canvas/brush for installation, text, theory work. Many women artists have a popular following and high degree of visibility but still don't get critical clout—or if they do, it remains an untheoretical acclaim. Why this should be and what it implies about the operative distinction between the work of actual men and women (vs. the specious categories of "the feminine" and "the masculine") will be the first area of my inquiry. Also, we have to consider what would be involved in vigorously and enthusiastically theorizing exactly this work which seems to remain perennially beyond the pale of the theory language which could be *derived from* (as well as attached to) such artistic practices.

The theoretical vocabulary with which women artists and critics come to describe and represent their own subject position is burdened with the confusions of a patriarchal legacy. The terminology and prem-

ises of that discourse are fundamentally misogynist. Or, they are so steeped in the naturalized sense of women's "otherness" that remarkably, several generations of brilliant and insightful feminist theorists have bought into the "description" offered by psychoanalysis without condemning it as a prescription, and have been unable to think their way out of the dead end which theories of the symbolic construction of gender railroaded us into on the rigid tracks of Lack. Women's artistic practice demonstrates the inadequacy of the theoretical model, as does women's experience. If there is any chance for parity in the decades looming darkly before us, it will come with the undoing of the distinguishing marks of difference and all that they stand for historically through an insistent articulation of our existence as the subjects of our own pleasure and through the symbolic construction of ourselves as subjects, gendered, but not gendered subjects. The order must reverse itself if the *consequences* of *difference* may be understood within a construction of *difference* as a *consequence*, not a *cause*, of gendered identity as a cultural form.

Visual Pleasure and Women's Work

To begin with the discussion of *pleasure* is already to announce the political stakes at the center of my concerns. Women painters' work is rarely *theorized* as visual pleasure—either source of it or evidence of it. Women's work, when it bears clear evidence of the tactile, sensual, handmade, typically receives praise of faint and damning variety: pretty, decorative, ephemeral, or, flowing, stained, and sensual (i.e. receptive to stimulation/response, not capable of generating, initiating it). Male painters, in contrast, have been able to lay claim to a visual practice legitimated not only through praise, but through theoretical validation.

 If we look back onto the relatively recent history of painterly activity (I confine myself to painting for the sake of simplicity here) of the last half century, we find that male painters have systematically been theorized as providing visual pleasure in paint, and that that pleasure is linked to a notion (however misguided) of the possibility of visuality as a plenitude—full, replete, autonomous, and self-sufficient. Certainly the bulk of post-1945 painting by men, especially the Pollock, Newman, Rothko, Tobey, Twombly generation, through to Salle, Fischl, Polke, and Kiefer, and then Goldstein, Bleckner, and Richter is distinguished

by this term of pleasure. The language which gave rise to the fiction of visual plenitude was one which took the value of pleasure as a given within the perception, apperception, of paint, painting, painterliness—this latter term interchangeable with the concept of pleasure—aggressive, indulgent, tactile, phallic.

Again, which women were permitted into this domain? Who are the "painterly" women painters? The women of the earlier generation—Frankenthaler, Hartigan, Elaine de Kooning, Krasner—how are they positioned? Frankenthaler's "unbounded forms" and "flowing stains" carry all the pejoratives of female body imagery and fluids—a kind of she-can't-help-her-flow notion of production. Pleasure? Krasner's anxiety, between intellectual production and tactile pleasure, with Jackson taking up all the space in the barn. . . . de Kooning—who remembers? Hartigan—no, that generation of women didn't rise to pleasure status. The image of Bourgeois, rising slowly in the background, creates an interesting counterpoint, her assured engagement with an iconography of sexual signs, of bodily form, and sexual potency . . . now transposed into the machismo gesture of the big machine.

By and large, the women artists who have recently achieved a place in the mainstream of theorized work have moved far from the handmade, physical, tactile mode of production and squarely into the realm of text, appropriation, fabrication, and photography. It seems that the farther the work is from any trace of or imprint of the woman's body, the more likely it is to achieve a measure of critical success.

Women artists who succeeded in their bid for authority and recognition often did so by claiming an integral relation to theory. That meant text. Visuality per se could not be theorized in feminist terms, but text could play in the high stakes critical theory game. Many women artists renounced any direct engagement with material as pleasure in production and opted instead for a critical stance exemplary of theoretical positions which could be glossed out in critical writing. This was an important achievement, but it left in place a hierarchical set of distinctions according to which women had to work through particular modes, not others, in order to achieve legitimacy in critical terms.

Present Practices as the Source of Theory

The relation between theory and women artists' practice has taken a grotesquely distorted form in the last ten years. Somehow a perceived

distinction between the "theoretical girls" and other artists has come to be grounded in the notion that the former use "typography and Marx" while the latter employ such retro materials as the "paintbrush." This characterization (lifted in this instance out of a Dan Cameron essay,[1] but just as likely to be found almost at random in pages of *Arts, Artforum,* and other mainstream critical journals) unjustly demeans both groups while making it seem that they gain their definition through oppositions of the intellectual/political and the tactile/personal. In a similar vein one has barely to skim the same journals to find painters like Joan Mitchell described as someone who has "continued to paint without relying on critical theory as a buttress for her work."[2] Theory is reduced in such formulations to that which is often expressly political and always necessarily linguistic. Any practice which is bound up in the material aspects of production is deemed untheoretical by definition.

But if we were to look across the many facets of women artists' productions of the past decade—could we not reformulate a concept of theory from observations of such varied practices? If, after all, Pollock, Newman, Reinhardt, and other male painters could be, and have been almost ad nauseam, used as points of departure for theoretical discussion of representation, indexicality, phenomenological, and semiotic models of visual production—then why not Joan Mitchell? Joan Brown? Ellen Phelan? June Leaf?

My point is not to demonstrate a *feminine* mode of production—I frankly don't believe in one—but to demonstrate that *women's work* can be used to generate theoretical discussion on a par with that generated by male artists. Looking at the work of Joan Mitchell or June Leaf, for instance, it is immediately apparent that both women are engaged with a primary form of pleasure—the pleasure of production. With Mitchell this plays out in the open textures of her surfaces, the glyphic rhythm of her forms, and the investigation of relations between bounded and unbounded areas of activity. Her concern with rhythm and boundaries, chaos and limit, is in no way duplicated in the work of her male contemporaries and predecessors; it uniquely contributes to the formulation of these issues in visual terms. June Leaf also makes evident a pleasure which takes the initial rhythmic activity of hand to canvas into the domain of the densely layered surface. Much treated and worked, the surface of a painting like *The Golden Steps* (1985) becomes a field of tactile, physical reality as well as one in which the organization of visual

forms into readable icons insists on the ambiguity of figure/field and mark/sign relations. These are theoretical propositions, as are those of Mitchell, and the evident pleasure of production need not be reduced to a somatic or physical expression linked to female painters. Again my point is not that women's work bears distinct marks of biological gender, but that the one absent feature of the critical reception of women's work has been the understanding that there are theoretical propositions within these visual, tactile, physical activities.

Pleasure of production is one of the most fundamental elements of most painters' work—nothing quite beats the satisfaction of mushing pigment around on a surface in thick, loose impasto or veiling washes. But this pleasure, reductive, even infantile, primal as it is, is not the only production pleasure available in the construction of visual works. Pat Steir, for instance, self-consciously explores the range of ways in which this painterly investigation leads to intellectual and theoretical understanding of issues basic to visuality: how does a mark participate in the production of a meaningful image? If Leaf and Mitchell give evidence of the way in which a painter's being "in" the work can replicate that interiority in the field of visual encounter offered to the viewer, then Steir moves in and out of such field/space/mark distinctions to articulate the range of meaning production in which a painter's strokes participate. The systematic deconstruction of painterly practice in *Blue Sky, Red Tree, Blue Sea* (1984), for instance, makes clear the ways in which Steir's work is overwhelmingly theoretical, and her theory concerns are painting concerns. But if Steir's work has been granted a degree of theoretical credibility and legitimacy, perhaps it is because she herself has claimed such terms; certainly the work of Leaf and Mitchell has not.

Jane Hammond, taking a completely different approach to paint and iconography, allows the tension between critical concerns and painterly production to be worked out in her canvases. A work like *Untitled (141, 257)* (1989), for instance, posing the cliché cut-out silhouette of an "old-fashioned" woman (high coiffure, long skirts, elaborate, bedecked and ribboned garb) in front of an easel while the worked surface, distinctly painterly, sustains the words "defensive" and "jitters," is again squarely involved with theoretical propositions. These are made in visual terms—the image of the silhouette functions through associations of a legacy of femininity, while the pleasure of looking provided by the complex sur-

face works against the pain of identification with the dilemma of the woman painter.

Thus pleasure of production and pleasure for the viewer, not iso-morphic by any means, both function in these works while the works themselves raise issues which are theoretical insofar as they investi-gate the very fundamentals of visuality, representation, and image con-struction. Certain investigations, such as those which work to quote style and reformulate canonical imagery through visual means, can only be worked out through paint and canvas. I am thinking of the works of a Canadian artist, Alice Mansell, whose reworkings in the style of de Kooning, Kahlo, and others, is of a different order of critique than the appropriation/citation work of Levine, Diao, or Fischl. Taking up the brush and reformulating the styles of canonical (not exclusively male) figures, she inserts herself as a female subject of production into a discourse from which she has been historically excluded. Again, clearly a theory project.

Likewise, the eclecticism of Joan Snyder, with its seemingly irrecon-cilable heterogeneity of activity in the frame of a single work, is of a different order altogether than that of, say, Sigmar Polke, whose visual inventiveness is certainly granted theoretical status. And the object/image dialectic of Ellen Phelan calls into question much of the language used to define and delimit the minimalist project in its relentless pur-suit of object status. This enumeration could go on—April Gornick and Joan Nelson enter into clear dialogue with the melancholy and nostal-gia of romanticism precisely as it is coded into paint and understood as a painterly activity; Jaune Quick-to-See Smith interrogates the icons of ethnic identity in both her manner of painting and thematics; and no one more than Joan Brown has challenged a self-constructed sense of identity through a sequence of painted images.

The link to theory in these works seems more logical and insistent than its denial. How, actually, can their theoretical aspects have been overlooked? Partly, I think, through the false opposition, the sense that theory work is language based, and that visual means are inadequate for the direct posing of critique unless they come out of a mass culture, mass media mode of production. The pleasure of production—whether in the physical rhythm of painting, drawing, mark-making, or the tactile satisfaction of working a surface, or in the engagement with the proposition of intellectual concerns as visual issues worked out in as-

semblage, imagery, thematics, or at the level of textural visuality are pleasures well known to any artist. That women engage in this pleasure, are involved in it, unbounded and bounded in it, find subjective identification, formation, expression, and articulation through the visual and material pleasure of such production means would seem to be obvious. The extension of this claim to theoretical legitimacy, and the fact of pleasure in the work and women's clear position as the subject of both that pleasure and the visual enunciation, can be extended to work which is sculpture, installation work such as that of Louise Bourgeois, Maureen Connor, Kiki Smith, Barbara Bloom—the list would be as eclectic and cross generational, cross disciplinary and varied in theoretical stance as the group of painters mentioned above.

However, a curious thing has occurred, if one can generalize (which is dangerous) in respect to the transformation of women artists' practices as they have made a bid for or received and then responded to critical attention of an overtly theoretical variety. That has been the tendency to reduce the handmade, tactile qualities of such artists' work and move toward the hard surfaces, removed production, and synthetic seamless object status of fabricated work. That what is repressed in such manufacture is also the trace of the body in production, is, I think, an effect of the extent to which women's physicality suggests a disadvantage vis-à-vis theoretical credibility.[3]

Visual pleasure from a feminist perspective, and a theoretical formulation which would allow women their real bodies without condemning them to their anatomy, continues to be a nonarticulated area. That we are continually condemned to that anatomy in practical, legal, and medical terms seems not to shake the foundations of a perverse theoretical stance which would wish away the real body as if it could be replaced with a symbolic construction. The difficulty lies in theorizing a symbolic construction of identity, psychic, interior, and represented, within a real body whose identity is socially disciplined on terms which are anything but symbolic. The only way out of this disbalance, I think, is through shifting the terms on which that symbolic ordering is understood—which means, basically, dismantling the role and function of the phallus.

So why theorize this visual pleasure, of all things? Because the conspicuous absence of critical legitimacy for women artists engaged in painting as pleasure is a clear symptom of the current state of theory.

But also because the issue of pleasure, as formulated within psycho-analysis, is at the heart of subjectivity. We know, as women artists, the pleasure of production and production of pleasure—intimately, com-plicitly, complexly, in all the vicissitudes of subject/object relations and their interchangeable configurations of our psychic positioning. That this knowledge has led to practice is abundantly clear. But it has not led to theory.

Feminist Theory and Visual Pleasure

In fact, no theory of female pleasure from a visual perspective has emerged *from* production. Where Pleasure came into theoretical dis-course, it came in terms of reception, critical reception, distanced, arch, and superior. Frankly, that's a limited notion of pleasure—imagine describing the pleasure of eating some disgustingly indulgent food (chocolate éclairs) in the same terms (I was constantly aware that the éclair was a mass culture low level production and my critique of its construction let me enjoy my flirtatious identification with the instance of its consumption . . .)—nobody would buy it.

The women artists who entered the critical mainstream in the 1980s—Kruger, Holzer, Sherman, Kolbowski, Bender, and others—made use of theoretical strategies and, increasingly, fabricated work, to demonstrate the symbolic nature of gender construction. The Feminine was a matter of signs, not essence, and could be critiqued as such through self-conscious manipulation of these signs and their cultural production. Therefore, the body as such, the female body in particular, became highly disputed territory in the visual arts. If men used it they were sex-ist and if women used it they were essentialist. On the one hand, the Body became the site for authority and the legitimating term of critical and artistic discourse—performance artists in particular like Gina Pane, Carolee Schneemann, Karen Finley, and others—used their bodies as a means of insisting on the feminine body and of entering a discourse with means no man could dispute. On the other hand, the body was successfully wished away by the Baudrillardian postmodern simula-crum, where it was evaporated along with all other traces of the "real."

By the end of the 1980s, then, gender was all symbolic, but women were excluded from a place in the symbolic order by virtue of their anatomy—but that anatomy was not real either, bodies having become

conveniently taboo through intersections of post-feminist discourse (women don't exist), taboos against eroticized bodies brought on by the AIDS epidemic as imposed on the artistic community by the moral Christian right, and denial of the reality of either bodies or women by theoretical extremists of the Simulacral.

The root of this difficulty continues to reside in the psychoanalytical model that is at the basis of all these theoretical positions. In psycho-analysis, women cannot have pleasure, cannot be in pleasure, cannot be subjects (to begin with), and certainly not subjects of pleasure. Where Freud was simply baffled, unable to come up with either a narrative of childhood development that permitted women to come into gendered identity through anything but a series of perverse and complicated denials, transformations, and so on, Lacan turned femininity into the truly dark continent.

Lacan declares that since sexuality (hetero, always) revolves around the male genitalia, woman's role with respect to pleasure is always only to provide it. She can't have it, and if she does, she enters the deep space of no return, no articulation, and no subjectivity. While male pleasure (of *having*, not *being* the phallus) is conceived within a subject position, feminine pleasure (a nonexistent category anyway) is conceived of as always outside of subjectivity. In fact, woman disappears in *jouissance*. She can't *know* anything about it, can't articulate it or form it, and can only experience it—but not as a subject.

Enough. There are ad nauseam tons of texts explaining the nuances and details of this position—but they all depend upon the same basic concepts: gender difference in psychoanalytic terms is defined in refer-ence to the privileged term of the phallus. We know this is wrong, incor-rect, absurd. What seems incredible is that such formulations were not only accepted, used, described, but that they persist, and with all kinds of apologies attached to them. Jacqueline Rose asserts, for instance, that psychoanalysis "does not produce that definition. It gives an account of how that definition is produced." But psychoanalysis *does* continue to produce precisely that definition of women as the without-penis-and-thus-lacking-lack-differently gender. The psychoanalytic model of the subject continues to be completely and utterly useful—we do live our lives as psychic beings—but the burden of Lack is one we should have theorized out of existence ages ago. Why? How? Because we have the right to and necessity for the assertion of our subjectivity as women (we

are women—*difference* does exist) and we can achieve this through the theoretical and practical articulation of our own pleasure.

The issue does come down to real women, and to women as such. We are returned to our bodies with a vengeance in the current condition of culture—and to theorize ourselves out of that recognition is to bury our heads in the sands heaped up by conservative forces. The risk of being criticized for essentialist biases is nowhere near as great as that incurred by repression of and self-censorship of the impulse to become the subjects of our own desire and claim a space as subjects within the symbolic. The problem of reinserting the body into both artistic practice and theoretical formulation remains, and has acquired a new urgency. More important, it seems absolutely imperative to theorize gender in terms which both include the body as a real and determining factor and also include the realization that most of what follows from that determination is socially and culturally produced.

Since art remains the least alienated form of labor in our culture, the one domain with at least that mythic idea of work as one's own attached to it, then it seems logical that it would be the first, and most likely place, to look for the manifestation of feminine pleasure as praxis. Hopefully, then, this essay has also made a contribution toward beginning to demonstrate that it may be the most likely place to begin a theoretical articulation of that feminine pleasure as well.

Notes

1 Dan Cameron, *Arts*, April 1986, pp. 37–39.
2 John Yau, "Joan Mitchell," *Artforum*, February 1990, p. 137.
3 In a gross, reductive analogy, one could compare the largely appropriated and fabricated works of the *Plastic Fantastic Lover: Objet*, a show at Blum Helman Gallery, Fall 1991, with the distinctly more tactile, physical work of the *Physical Relief* exhibition at The Bertha and Karl Leubsdorf Art Gallery at Hunter College, Fall 1991.

"I Don't Take Voice Mail"

Charles Bernstein

Before diagnosing the condition of the art object in an age of electronic technology, let me first address the question of the object of art in an age of global commodification.[1] I won't be the last to note that capitalism transcends the technologies through which it operates. So just as today's art world is dominated by marketing, sales, and promotion, so the object of art in the age of electronic technology will continue to be profit; and the values most typically promoted by the art world will continue to be governed by market, rather than aesthetic, formal, philosophical, or ethical values.

Within the art world, as in the corporate boardrooms, the focus of discussion has been on how to exploit this new media, as if cyberspace was a new wilderness from which to carve your niche—better get on board, er, on line, first before the prime sites are staked out. For if the object of art is to sell objects, then the new electronic environment presents many problems but also many opportunities.

But art, if it could speak, might well object to these assumptions. (If art could speak we could not understand it—that's one way to put it; perhaps it's more accurate to say if art could speak it would be poetry and poetry's got nothing to sell.) Art might speak not of its object but its objects; it might testily insist that one of its roles is to resist com-

modification, to use its materiality to push against the total absorption of meaning into the market system, and that's why it got one of the first e-mail accounts on the Net—to talk about it. But you can't sell talk, or not for much, and that can make the Net a vexing place for the purveyors of art.

Today's Internet—a decentralized, largely text-based linking of individual sites or constellations of users—will be superseded by what is aptly called the information superhighway. Just as the old dirt roads and smaller rural routes were abandoned by the megatraffic on the interstates, so much of the present informal, noncapital intensive exchanges on the Net will become marginal back channels in a communications system owned and controlled by Time & Space, Inc. and other giant telecommunication conglomerates, providing new and continually recirculating versions of *USA Today* with up-to-the-minute weather and sports information, sound files offering *Nirvana: The Classic Years* including alternate studio versions, hypertext tours with high resolution graphics of the British Museum collection, plus hundreds of other choices, available at the click of an icon, including items never before available in any media such as *In Her Home: the Barbra Streisand Collection;* a construct-it-yourself simulation of making a Shaker chair; and a color-it-yourself portfolio of the complete appropriations of Sherrie Levine, together with hypertextually linked case dossiers of all related legal suits. All with modest fees for each hour of viewing or receiving (the gaze finally quantified and sold) and downright bargain prices for your "own" personal copy, making available unlimited screenings (but remember, "it is a federal offense to make unauthorized copies of these copies," or, as we say in Buffalo: it's okay to copy an original but never copy a copy). Indeed, much of what is now the Internet promises to become the largest shopping network on earth, and possibly in the universe (even exceeding the Mall of the Milky Way on Galactica B282); those old back roads will be the place to hang out if you are looking for something other than franchise FastImage.

One of the hallmarks of formalist art criticism as well as media theory has been an analysis of the effects of newer media on already existing media. So we talk about the effect of photography on painting, or movies on theater; or how movies provided the initial content for TV before it arrived at its own particular formats (just as the content of the

Net is now largely composed of formats taken from books, letters, and magazines). It is useful to remember that in the early days of TV, many observers predicted that such spectator sports as baseball would lose their stadium audiences once the games were broadcast "live." However, the opposite occurred; TV increased the interest in the live-and-in-person event. In a similar way, art on the Net may actually increase interest in seeing art in nonelectronic spaces.

Formalist critics have wanted to emphasize how new technologies "free up" older media to explore their intrinsic qualities—to do what only they can do. But new media also have a corrosive effect, as forces in the older media try to shift their focus to compete for the market and the cultural capital of what they may see as their new competitors. Within the visual arts, many of the most celebrated new trends of the last decade—from simulationism to multimedia mania to the transformation of *Artforum*—are symptoms of a fear of the specific and intractable materiality of painting and sculpture; such fear of materiality (and by extension face-to-face interaction) is far greater and long-lasting than the much more often discussed fear of technology—a fear so often discussed the better to trivialize and repress.

What are the conditions of visual art in the Net, or art in computer space? We can expect that most visual art on the Net will be reproductions of previously existing work, along the lines of Bill Gates's plan to display in his home rotating CD-ROM images of the masterpieces of World Art, images for which, notably, he has purchased the CD-ROM reproduction rights. The Thing, a new visual arts online service, which has been immensely useful in imagining many possible formats for art on the Net, already features an innovative, in the sense of anachronistic, pricing structure—selling over its BBS (bulletin board system) a numbered and "signed" diskette of an artwork. (The idea of selling a disk is itself no more objectionable than selling a book, but numbering and signing a disk is an attempt to simulate scarcity and limit in a medium in which these conditions do not apply. I wouldn't be surprised, however, if this format was included on The Thing to call attention to the issue and also to poke fun at the Net's prevailing ideology of utopian democracy, a.k.a. netiquette.) In any case, telecommunications systems promise to dominate the distribution of text and image in the near future at a price—though few are now willing to acknowledge it—of more controlled and more limited access (through high user fees, in-

stitutional restrictions, and technological skills barriers) and loss of privacy rights we now take for granted. But technological change—it's a mistake to call it progress—will not be reversed and artists run the risk of nostalgia if they refuse to recognize and respond, the better to resist the communications environment that, for better or worse, they find themselves within.

I want, then, to focus not on how electronic space will actually be used, or how e-space will be exploited, but rather to think about the new media that has been created by technological developments combining computers and telecommunications, and how works of visual art can recognize and explore these new media—even if such works run the risk of being relegated to the Net's backchannels, along with "new mimeo revolution" poetry magazines and psychic readings by electronic Tarot.

The most radical characteristic of the Internet as a medium is its interconnectivity. At every point receivers are also transmitters. It is a medium defined by exchange rather than delivery; the medium is interactive and dialogic rather than unidirectional or monologic. At this moment, the most interesting format on the Internet, apart from the basic electronic mail function, is the listserve: a series of individuals join a list—any post to the list address is immediately delivered to all list subscribers. Individuals can then post replies to the entire list or to the individual that sent the post. Lists may be open to anyone to join or they may be private. The potential for discussion and collaboration is appealing—the format mixes some of the features of correspondence with a discussion group, conference call, and a panel symposium (with the crucial difference that the distinction between audience and panel is eroded).

While many cyberspace utopians speak of virtual communities with much excitement, what is particularly interesting about the interconnectivity of computer space is its difference from other types of group formation; for what we are constructing in these spaces might better be called virtual uncommunities.

The art world remains a difficult place for community or group formations because the gallery system recognizes value primarily in terms of individual achievement. In contrast to poetry publishing and criticism, in which poets play a substantial and perhaps determining role, individual visual artists are largely restricted to (or restrict them-

selves to) the role of producers of potentially saleable objects. Competition among artists is more common than broad-based alliance, with the occasional exception of loyalty to a small circle of friends.

At the national level, there are local communities of artists in every region. Various movements and schools—aesthetic or political or both—can also be understood as art communities. Most recently, the connections of artists within ethnic, gender, or racial groups have been seen in terms of community. But despite these sites of community among visual artists, sustained interaction, dialogues, and collaboration remain rare; indeed, these activities are not generally recognized as values. The Internet provides an extraordinary space for interaction and exchange among artists living in different places and, perhaps more significantly, encourages collaboration between visual artists, writers, and computer engineers. In a way remarkably anticipated by the mail art movements of the seventies and eighties, the Net suggests the possibility of artworks created for their exchange rather than market value—works that may be altered, augmented, or otherwise transformed as they pass from one screen to another. —What I am envisioning here is not art from another medium imported into the Net but rather art that takes the unique constraints and potentials of the Net as its medium.

To begin to delineate this and related computer and telecommunications media, let's start with the "small" screen. We might begin to speak of the screen arts to suggest the intersection of video, TV, and computer art that share the same physical support or monitor. More and more computers are now equipped with video quality monitors and the screen arts—in this broad sense—will be transmitted via modem, cable, and wireless systems as well as plugged in through cassette, CD-ROM, disk, and cartridge.

I distinguish among interactive, interconnected, and presentational screen media:

Presentational screen media is the broadest category. On the one hand, it includes the use of the CPU (computer processing unit) setup as a means to present work realized in a non-CPU medium, such as a videotape or photographs, or read-only text files. On the other hand, presentational screen media also includes work produced and viewed on computer systems that do not require viewer intervention beyond basic directional and operational parameters such as those available on a video recorder. —A hugely important subcategory is works produced

on computer screens but not presented on screens. Word processing, "paintbrush," and "photoshop" programs are some of the tools of this medium, which promises to reimagine the way we read and see text and graphics; moreover, this new medium allows for a greater integration and interaction of verbal, visual, and sound elements than possible with previous printing technologies.

Interactive computer screen art utilizes the processing system of the computer and includes significant viewer participation via keyboard, mouse, or joystick. While video games are the most elaborate visual realization of this medium, works of computer art can be created that are not game-oriented but that use many of the features developed in video games. Still another format for interactivity is often discussed under the general heading of hypertext. Hypertext involves the lateral movement and linking of a potentially infinite series of data pools. It allows for nonlinear explorations of a range of databases; that is, unlike presentational modes, in hypertext there is no established forward path through the data. For example, Jerome McGann and colleagues are at work on an edition of the complete works of Dante Gabriel Rossetti that will include multiple discrepant versions of his published poems along with manuscript versions of these poems, together with his related paintings as well as source material for the paintings and the poems. All of this information will be linked so that one can move through the data in many directions. Claims of many enthusiastic hypertextualists notwithstanding, many of the most radical features of hypertext are technologies made available by the invention of alphabetic writing and greatly facilitated by the development of printing and bookmaking. Such formats as page and line numbering, indexes, tables of contents, concordances, and cross-referencing for encyclopedias and card catalogs, are, in effect, hypertextual. Much of the innovative poetry of the past one hundred years relies on the concept of hypertextuality as a counter to the predominance of linear reading and writing methods. While hypertext may seem like a particular innovation of computer processing, since data on a computer does not have to be accessed sequentially (which is to say it is "randomly" accessible), it becomes a compensatory access tool partly because you can't flip through a database the way you can flip through pages or index cards. (I'm thinking, for example, of Robert Grenier's great poem, *Sentences,* which is printed on five hundred index cards in a Chinese fold-up box.)

Finally—my third category—interconnectivity utilizes the network capability of linked systems such as the Internet and formats such as list-serves, bulletin boards, newsgroups, and group-participation MUDS (multi-user domains) and MOOS and other "real-time" multi-user formats. Interconnectivity allows for works of collaboration, linking, and exchange, as well as the possibility of simultaneous-event or immediate-response structures. Interconnectivity turns the screen into a small stage and in this way combines features of theater with writing and graphic art.

The most static of the three modes I have just defined is the presentation screen mode. Presentational screen media will merge with what is now available via broadcast TV, video cassettes, or video disk and CD. But certain computer features will provide novel methods for searching or scanning material, for example, enabling one to find one particular item or graphic or song or word amidst a large database.

Yet because computer screens are often smaller than TV screens, a class of interactive and presentational screen art can take advantage of the more intimate single-viewer conditions now associated with books and drawings. New technologies for viewing texts may well supplant print as the dominant medium for writing and graphics. Books, I should add, will not be replaced—and certainly will not become superfluous—any more than printing replaced handwriting or made it superfluous; these are different media, and texts or graphics disseminated through them will have different qualities. Nonetheless, it is useful to consider graphic and verbal works created specifically for the intimate presentational or interactive space of the small screen that use features specific to the CPU environment, including scrolling, lateral movements, dissolves, the physical properties of the different screen types (LCD, gas plasma, active matrix color)—an extension into the CPU environment of the sort of work associated with Nam June Paik's exploration of the video environment.

The status of computer-generated films may help to test my typology. Anything that can be viewed on a small screen monitor can also, and with increasing resolution, be projected on a movie screen. Nonetheless, it is still possible to distinguish, as distinct support media, the small backlit screen of the TV and computer monitor and the large projection-system screen of film. Moreover, the scale, conditions of viewing, and typifying formats make video, film, and TV three different

media, just as animation, photography, and computer graphics may be said to be distinct media within film. (Hybridization and cross-viewing remain an active and welcome possibility.) Computer-generated graphics, then, may be classified as presentation computer art modeled on small screens for big screen projection.

Note, also, that I have not included in my sketch nonscreen art that uses computers for its operation (for example, robotic installations and environments)—a category that is likely to far surpass the screen arts in the course of time.

But I don't want to talk about computers but objects, objects obduring in the face of automation: I picture here a sculpture from Petah Coyne's April, 1994 show at the Jack Shainman Gallery, which featured candelabralike works, hung from the ceiling, and dripping with layers of white wax. For it has never been the object of art to capture the thing itself, but rather the conditions of thingness: its thickness, its intractability, its untranslatability or unreproducability, its linguistic or semiotic density, opacity, particularity and peculiarity, its complexity.

For this reason, I was delighted to see a show of new sculpture at Exit Art, also in April, that seemed to respond to my increasing desire for sculpture and painting thick with its material obsessiveness, work whose response to the cyberworld is not to hop on board for the ride or play the angles between parasite and symbiosis—but to insist ever more on the intractability of its own "radical faith," to cite the title of this work by Karen Dolmanish, consisting of a floor display of obsessively arranged piles of broken things—nails and glass and metal.

Object: to call into question, to disagree, to wonder at, to puzzle over, to stare at . . . Object: something made inanimate, lifeless, a thing debased or devalued . . . Whatever darker Freudian dreams of objects and their relations I may have had while writing this essay, nothing could come close to Byron Clercx's witty sculpture, *Big Stick,* in which he has compressed and laminated twenty volumes of the complete works of the father of psychoanalysis into one beautifully crafted Vienna Slugger, evoking both the uncanny and the sublime—finally, an American Freud. Here is the return of the book with a vengeance, proof positive that books are not the same as texts. Go try doing that to a batch of floppy disks or CD-ROMS.

In Jess's 1991 paste-up *Dyslecstasy,* we get some glimpse of what hyper-

text might one day be able to achieve. Collaged from thousands of tiny scraps collected over many years, Jess creates an environment of multiple levels and dizzyingly shifting contexts; and yet in this world made of tiny particulars, it is their relation and mutual inhabitation that overwhelms and confirms.

I long for the handmade, the direct application of materials on an uneven, rough, textured surface. I feel ever more the need for the embedded and encrusted images and glossings and tones and contours of forgotten and misplaced lore, as in Susan Bee's painting *Masked Ball*.

I want to contrast the solitary conditions of viewing a work on a computer screen, my posture fixed, my eyes ten inches from the image, with the physicality of looking at a painting or sculpture in a large room, moving around it, checking it out from multiple views, taking in its tactile surface, its engagement with my thoughts.

On the journey of life, lost in cyberspace, where will we find ourselves: not who we are but who we will be, our virtual reality.

Note

1 This essay was originally presented (with slides) at a symposium titled "The Art Object in the Age of Electronic Technology," sponsored by the Parsons School of Design and organized by Lenore Malen, at the New School in New York, on April 16, 1994.

III / SELECTIONS FROM THE FORUMS

The artists' writings in part III, "Selections from the Forums," were solicited as responses to editorial dialogues based on our personal experiences as working artists. It is fitting that they are at the center of this collection because they were at the core of *M/E/A/N/I/N/G*'s contribution to the art community, inviting artists to voice their opinions on issues close to their hearts. A particular question would stand out from our current practice and life. We would send the question to as many pertinent artists as possible and we published—virtually unedited—all the responses we received. Our first forum, "On Authenticity and Meaning" (1987), set the tone for future forums in terms of the dedicated sincerity and refreshingly varied styles of the responses. "Contemporary Views on Racism in the Arts" (1990), reflects the importance of the issue of racism in the context of the art world.

Our increasing awareness of the new challenges of continued art practice over a greater period of life than the decade or so immediately following art school led to "Over Time" (1991), as we invited older artists to share with us how they renewed their belief in art and in their own work.

"On Motherhood, Art, and Apple Pie" (1992), resulted from concerns about discrimination against practicing artists who are mothers and

the taboos that still exist about discussing this topic. This became our most affecting, intensely personal forum. Some artists found the subject so fraught they couldn't even bear to answer, but even they collared us on the streets of Soho and put their hands to their hearts to indicate how deeply the question of combining motherhood and art had touched them.

In "Working Conditions: A Forum on Art and Everyday Life by Younger Artists" (1994), we were interested in opening up *M/E/A/N/-I/N/G* to a new generation of artists. Two guest editors invited a diverse group of younger artists to write personal statements on their art practice and its sources in everyday life and popular culture.

"On Creativity and Community" (1994) spoke to efforts by artists to break patterns of individual isolation in a highly competitive and yet decisively atomizing art world.

On Authenticity and Meaning

The editors of *M/E/A/N/I/N/G* asked a small group of artists and writ-ers for their responses to a series of questions that reflect the focus of the magazine. What follows are the questions and the responses we received.

Do you see your work, or the visual art of those with whom you are most sympathetic, as involved with the visual expression or articulation of real-ity, meaning, presence, authenticity, originality? To what degree do you see your work, or that of visual artists to whom you are sympathetic, as ques-tioning, undermining, or eroding some or all of these values? Finally, do these concerns play a relevant role in the creation of your work or in your response to visual art?

Arakawa & Madeline Gins

As to what a question of what is going on: Who is forming space and for what? To what extent (O ripe extension!) is blank as original as it would be? Any meaning as a seam of the symbol-making fabric across which daily the fiction of place moves its obstinate, quite-possibly-shining sieve and sieve-making prescience. Oh, not much, if you say so.

Susan Bee

But, yes, I too puzzle over "meanings." What is the work's ultimate meaning or sense? Can we crack the code of the painting till it has no more secrets to withhold? Or are paintings to be understood as shifters, empty signs, that are filled with meaning only when physically juxtaposed with an external referent or object?

The painting as a whole functions to point to the natural continuum, the way the word "this" accompanied by a pointing gesture isolates a piece of the real world and fills itself with a meaning by becoming, for that moment, the transitory label of an event.

I shifted pictures around for days and nights, reeling from the diverse possible meanings the picture possesses when placed in different image relationships. But that is the potency of image making—it's as if we are dense—swamped—image-ridden—we teem with "meanings" constantly.

Everything has a meaning, even what may first seem nonsense. Meaning is so fated for persons that art seems to be used, especially today, not for *making* sense, but on the contrary for keeping it in *suspense;* for constructing meanings, but without filling them in *exactly.* So the "what" is never settled. Of course, it never can be . . . I comfort myself, at times, with the thought that perhaps my whole work is one image anyway. Meaning is never an absolute, but rather a choice of possibilities, with meaning determined by the very terms *not* chosen. By giving everything a name, it strips each sign of its special modality of representation. The enigma remains a silent spot in the rush of meanings.

One does not put one's house in order by getting rid of what one does not have, because that only creates a void, and a void is neither order nor purity. To sum up, I do not create a person or a house, I make a picture. Yet, that the world is out-of-joint is shown everywhere in the fact that however a problem is solved, the solution is false.*

*Some sources: Philip Guston, Rosalind Krauss, Henri Matisse, Alan Davies, Roland Barthes, Theodor Adorno.

Robert Berlind

Reality, Meaning

During the process of painting meanings come and go. I don't find them to be definitive. Meanings, that is, more or less coherent thoughts about the significance of things, occur to me, change, stay, or get forgotten. What a painting means to *me* and *how much* it means to me will be largely a function of how it intersects with other experiences I've had. Others will generate their own meanings, viewing or thinking about the work. All these meanings, however engaging, are certainly not the reason for working nor the point of a painting.

If by "reality" we mean everything that is so, then we must see that *it* doesn't *mean* anything; it just is. Meaning *we* make, individually and culturally. Art's function is at least partly to cut through the received codes of meaning that intervene between us and reality.

Art, as opposed to culture, always has one leg in chaos (where, by definition, there is no meaning). Art has to that extent an implicitly critical role, even when not setting out to disrupt our programming.

Authenticity, Presence, Breath

Since Warhol ushered in an art that was at once revelatory (through the sudden shock of seeing our death-glitz culture in front of us where we had meant to escape it) and enigmatic (just where was *he* in all this?) it has been difficult to know when much art was being socially critical and when it was simply symptomatic. Lately much of the fare seems a study in equivocation, and it is not usually clear whether that effect is deliberate: a double equivocation.

A persuasion in current art and art criticism is that the resources of visual language to express lived experience have been used up. The belief in the authenticity of direct, experientially based art has been eroded, one feels, by a surfeit of disappointments, embarrassments, failures to be understood, realizations of having been conned: growing up in America, or perhaps anywhere, late in this century. There is in the work a very thin line between self-protective irony and heartfelt poignancy or, in their updated versions of recent seasons, sarcasm and sentimentality.

A lot of art out there seems to be gasping for breath. It's not so much that art is over-intellectualized as that the mind, disconnected from senses, emotions, and spirit, runs amok. How could it have presence when nobody's home?

It may be that such art does, in fact, accurately express, as symptom, the condition of society today. Our most alienated and seemingly critical art may in the last analysis be entirely conservative in its essential agreement with the media world of manipulated consciousness.

Polemics

In my own work I'm not interested in polemical issues, that is, in using my work as a deliberate vehicle of protest or propaganda, although there is such work being done that engages me and even sometimes makes me wish I were such an artist. One wants to be effective and useful in the world, and yet it's not given to every artist to do it through the art. In any case the political art that is good does much more than express opinions, and its value as art doesn't altogether coincide with its value as political thought.

Nature/Culture

My painting grows out of other sorts of occasions: moments when glimpses of reality become available, waking dreams where appearances cease to be "mere." I use the word "grow" deliberately here and am aware that it situates painting within the paradigm of Nature rather than of Culture. I don't share the prevailing view that we are, in our consciousness necessarily the hostages of Culture, victims limited to the codes it gives us.

Recently I've been doing large paintings out-of-doors, working directly and fluently from the *motif,* as they used to say, in this case from enormous, ancient trees. As with portraiture the work involves communication between the model and myself and is, finally, a sort of collaboration. My culture-informed sense of painting and my awareness that I am making paintings to be seen elsewhere in an altogether different context are in the service of the project, even as they guide so many choices made along the way.

Jake Berthot

Right now a moment of time is fleeting by! Capture its reality in paint!
—Paul Cézanne

I await the day when a real smart guy with political and philosophical clarity hangs a stretched chunk of linen or cotton duck (even here a decision must be made) on the wall and proclaims the ultimate reality has been reached. . . . There are two choices . . . you can make something that floats around the word or you can make something so that the word floats around IT. Whatever, what's for sure, is that, the closer you get to the heart of the matter the more it shifts. . . . What's real, what has meaning for me is to dream and be awake at the same time. . . . To be in flux—a constant state of transition—to reach for art's life, not its death.

Collins & Milazzo

Country Meaning

Sebastian used to say "Truth is at the bottom of a bottomless pit."
—Elizabeth Taylor (from Tennessee Williams's *Suddenly Last Summer*)

We do not see our work as involved with the articulation of reality. We are more involved with bracketing systems of institutionalized articulation and reality—not only mainstream but the marginal or (so-called) radical systems as well.

 We do see our work as quintessentially involved with meaning. In our view of things, we perceive meaning as a construct, and attempt to bracket it as such, but experience it as otherwise. We do not believe in meaning, or in meaninglessness, but we are presently compelled by its liabilities. At a time when issues of structure, language, information, sign, and ideology dominate critical discourse, govern the fashion industry of criticality and critical ideas, not only superstructural but subcultural as well, we are instead mesmerized by the weakness of meaning, dazzled by its fall from intellectual and academic grace, con-

vinced by its inability to survive the mechanisms of culture, and intrigued by the ways in which its will is so easily compromised by (so-called) "opportunities" to communicate. In all likelihood, we are predisposed to encourage these corruptions in meaning.

Regarding presence and authenticity, we find at this time that the stages of reification which they have achieved resist consciousness. We experience them as a phantom limb.

In light of the reifications operative in art right now—reifications of critique and irony, picture theory, appropriation and critical photography, and, more recently, simulation—originality may be able to sustain, like meaning and Nature, new predicates of inquiry. Originality understood as source of originlessness cannot be reduced or confused with the various expressionisms it ventilates. When pushed to extremes, the unquestionability of the model forces us to reassess the static vectors of mortality that assert what may be considered to be now the radical content of Nature, and which may even bear the markings of a critical existence.

Maureen Connor

Art, science, and religion have, through history, generally represented efforts to deal with the unpredictable. Some cultures, particularly tribal cultures, respected the irrational and made it an important part of their traditions, while others, such as the ancient Greeks, at least in part, tried to deny the existence of the irrational or to exert absolute control over its exigencies. The attitude toward the unknown was, in both cases, an important aspect of positive, productive behavior within each respective culture. Finding a way to confront or control this unknown was to improve the world in some way—to make a significant contribution.

Originality has come to be considered the form or quality of character through which an individual with special access to, or understanding of, the unpredictable makes a valuable contribution to the world. This might take the form of a useful discovery in medicine or mechanics or an alternative way of looking at the world through art or philosophy. Often, the original represents true insight into the unknown or the irrational, but sometimes it is merely superstition in-

tended to allay fears or exert power. However, it seems inevitable that when something is acknowledged as an original contribution it is embraced for a time and imitated by others who also want to do something of value but fear the unknown. Thus, culture, in the form of fashion, quickly places limits on the unpredictable and keeps it well under control.

Some of the early modernists used the irrational as a means to question social and aesthetic conventions. Originality became a force with which to continually undermine society's efforts to control its unpredictable elements. Although, for these artists, artwork did not intervene directly in everyday events, since art was believed to occupy an ideal, pure world that could be separated from the compromises of everyday life, modernism did represent a force for openness, freedom, and discovery. As this art questioned itself on its own terms, with the social challenge embedded in its aesthetic, it had the potential to metaphorically transgress the status quo. While this separation allowed and encouraged much experimentation, it eventually began to create serious problems. In some circumstances, any novelty could take on the status of a challenge to convention and in others the access to the unpredictable became too controlled. Originality, as defined in late modernist terms, began to function in an almost magical way as there came to be a kind of blind belief in its inherent capacity to be subversive.

Currently, artists involved with deconstruction have attempted to undermine these superstitions by asserting that it is more subversive to use appropriated images than invented ones and by trying to "discover" the repressed or denied traditions contained in those works we consider innovative. While this kind of thinking can be productive if it releases us from restrictions and helps point the way toward a new openness and exploration, so far only the opposite has occurred. Although appropriation is valued as a challenge to convention, it actually subverts and further erodes our freedom to explore. Deconstructivist zeal has extended the devaluation of originality far beyond the restricted, late modernist version to the point where it now seems retrograde to actively engage in any open-ended experimentation.

Even if deconstruction, in its present form, is simply another fashion it has insidious implications—that fit well into a world increasingly dominated by statistics and probability and in which the problems of art and philosophy become givens with predictable solutions. Because if deconstruction and appropriation imply that the unpredictable has

nothing to offer us, then they help repress rather than explore the unknown and, with their veneer of fashionable subversiveness, help allow an easy, hardly noticeable transition from an age that values freedom to one that values control.

Rackstraw Downes

"Reality, meaning, presence, authenticity, originality." These words, all placed side by side in a row, make a weighty list.

(1) Reality. My painting process has a lot to do with correcting an assumed reality in my head by continual inspection of what I am depicting. But a depiction can only have the kind of reality proper to itself: its effectiveness consists in how intensely real it is *as a depiction.*

(2) Meaning. An endless number of meanings float through my mind while I work, and some of them will perhaps be present in the finished work, alongside others which I never consciously articulated to myself. I do not manipulate the work to ensure that they get in there, though; that would be editorializing, which I eschew. The actual meaning of a finished work is never definitive—neither with my work nor that of anyone else's; it is a collaboration between the work and the viewer: "A work of art is completed by its audience" Paul Valéry.

(3) Presence. If a work has presence, that means to me that it asserts its own life effectively. I always hope my works will achieve this, and the ones I exhibit are those that I feel do so to a greater or lesser extent.

(4) Authenticity. I believe that all works attributed to me are authentic; I am not aware that anyone has forged a "Rackstraw Downes." I sincerely hope that I shall never be so devoid of energy—or perhaps income—that I am reduced to forging one myself.

(5) Originality. This word is often used with reference to the position of a work in history and, as a quality, was until recently accorded to the kind of work which shouts "This Has Never Been Done Before." I'm not at all interested in achieving that kind of originality in my own work nor is it necessarily interesting to me in other people's work. The kind of originality I value is not so self-aware or so intended; it comes in through the pursuit of quite other goals, and because those goals are pursued in an unself-consciously but intensely individual way. I like to be in a room full of works of different kinds and different periods; history becomes extrinsic, the drone of a docent, and the individual character and relative power of the works come more sharply into focus because of the present-tense dialogues that take place among them.

David Humphrey

Man is soluble in his thought.—André Breton

I have found that the consideration of questions of meaning, presence, authenticity, or reality, while often being an invitation to pretentiousness in social life, are generally quite fruitful to the production of art. While providing a kind of thematic skeleton onto which a work can adhere, these questions also produce an oxygenated ambivalence that circulates throughout the effort. The very existence of these terms often seems determined by a desire for them to exist while the ability to act with authority would seem to depend on a sense that there is a real and whole author who is a master among real things.

I think there is an inspiring incongruity between the apparent unified presence of an artwork and the unruly metastatic swelling of meaning and the unmeant it produces. In a way this dynamic can become a kind of narrative of the body. It often seems that the body (as well as the self) maintains its unity thanks to the internalized constraints of the social in the form of some morality or image, that the body's tendency is to expand out into the environment and the cosmos in a kind of infantile romantic fashion. Artworks, especially those that seek to resist the constraints of a bound meaning, lubricate, promote, and fuel this process. The indolent perversity of the onieric is a good model.

The liquid or ghostly presence of intention in a work, the ease with which it is quoted, repeated, recontextualized, or misinterpreted, seems to render questions of originality and presence less substantial. Yet because these seem to be an important part of how artists and viewers access and relate to artworks they remain as part of a metaphysical love act that develops from looking and interpreting.

Some recent theory has attempted to describe the world of things as an effect of language, thereby shifting the emphasis from reality to be known to texts to be interpreted. This perspective can have the effect of placing the artwork and its interpretation on a volatile and fertile bed in which language, sexuality, power, etc. become the animating terms. The membrane separating the work and the world becomes semipermeable in the exchanging flow of signification. For some this critical self-conscious scrutiny produces an endgame anorexia of the artwork in which its disappearing body satisfies a notion of postmodernity. It is

possible, however, for these perspectives to help nourish and liberate the body of meaning (and meaning of the body) from rigid codification and return to the senses access to the mysterious plenitude of experience.

I am interested in the possibility of an art that animates this somewhat ungovernable sexuality of meaning (including its forbidden, unknown, desiring, or embarrassing character) and that promotes the redirection of thought toward the imperatives of the body and an expansion or resurveying of its boundaries.

Komar & Melamid

All the terms used in your questions are in one way or another relevant to different parts of our work.

But the division of the question into "your work" or that of "artists to whom you are sympathetic" doesn't apply in our case, since more than twenty years ago we began working together precisely because we considered each other the artist to whom we were most sympathetic. But the main thing that brought us together was the belief that we were beginning a new movement founded on "eclecticism"—after all, isn't it true that two artists constitute a movement?

Realistically reflecting the eclecticism of our consciousness, combining together supposedly "contradictory" images, historical and emotional styles, we have gradually moved from chaos to harmony.

If we understand the connection between thought and architecture, we can imagine our memory, our consciousness, as a mysterious city-labyrinth, in which the facades of neighboring buildings and the various floors of the Babylonian tower belong to different styles. In this city "visual expression" coexists peacefully with "erosion." All these facades: "articulation of reality," "presence," "questioning," "meaning," "authenticity," "originality," "creation," and "response," cats and dogs, serious values and bullshit, are forever joined within the framework of our lives by each of our births and deaths.

Medrie MacPhee

I have always believed in the notion of "vision" which is what I think is the embodiment of all the values that are expressed in the first question.

For myself and those artists who I consider kin, vision is a kind of touchstone against which everything that is being explored must be measured, tested, authenticated. By its very nature art making is a philosophical and spiritual position. It does not recognize a compartmentalized self. Work literally is life, a way of fully inhabiting both the territory of one's inner life and outer world. Art making requires a different kind of intelligence from that of a literal, narrative nature. It is kinetic, coming through the body, revealing other dimensions, making imprints of all that is known but difficult to speak of.

Adrienne Rich in one of her poems speaks of the body as being a raft that is continuously in motion between all these abstract worlds. I like to think that that is the state that art making is involved with.

I am not sympathetic to those artists who have elected themselves to destroy and undermine what they consider the myths of art making.

This undermining is accomplished through a celebration of irony, tongue-in-cheek, artist-as-magpie, ambivalence, etc. Many of these artists are career-artists, first and foremost involved in a very narrow debate with the powers-that-be in the art world. Because I believe that it is intolerable for human beings to exist in a state of disbelief, disconnection, and utter banality, I can't consider this trend will last.

Throughout human history the art that has lasted, the art that has meant much to me has been always the work that delved deeply, sincerely into the nature of reality, of time and place, of intimacy. It is that tradition that I think of, that I would like to be connected with.

Elizabeth Murray

I think these questions answer themselves, namely:
(1) Yes. (2) In some instances to a very high degree. (3) Certainly.

Yvonne Rainer

Reality, or the idea of it, is the interplay between private experience and social consensus. Which doesn't mean that it doesn't exist, or is "relative," but that it must be struggled for, and reassessed, like knowledge.

Authenticity and originality are those dubious cornerstones of western (especially U.S.) individualism. The more unequal the distribution

of resources and wealth in the society, the more desperate the search for authenticity and originality in daily life. As a proper "postmodernist" I ceded the latter almost with my first public/presentational gesture. The former, or the illusion of it in representational practice, is useful in establishing credibility and ties to an audience ("real people talking") and is necessary in progressive propaganda. My own postmodernist schooling makes it difficult to go along with this strategy whole-hog, resulting in a tightrope act in which left political conviction appears side-by-side with various kinds of shifts, rifts, fissures, and seizings-up of "authenticity conventions," with the attendant danger of putting a given enterprise into credibility jeopardy. But that's the way I've got to do it.

Miriam Schapiro

I am not nor have I ever been involved with *reality* or *originality*. I am, as Virginia Woolf said, "the loose drifting material of life." All that I see, all that I hear, all that I ingest—I am.

I am involved with *presence* since I need to have my work visible because it speaks for me. I need to appeal to others so that they will be seduced into reading what I say in my painting.

Yes to *meaning*. A signification of my personal politics meant to be yielding rather than flat, posteresque.

"Painting" is my reality, therefore *authenticity* is part of my belief system. I do not simulate anything and the responsibility is enormous, constant, and ordinary.

Reality, meaning, presence, authenticity, originality. Does my work "erode" these values? The question doesn't resonate for me. I want to present my point of view and have parity with those who differ with me.

Ann Schoenfeld

"originality, authenticity, presence, meaning, the visual expression or artic-ulation of reality . . ."

but

my voice has become strangely silent, tensing in my throat when i want to
 speak,

as if some driving impediment's down there
maneuvering a stiff steel lining outward against its walls
flattening my voice, making it disperse then disappear

is this true?

no

but

my voice *has* become strangely silent, whenever i try to speak—loudly or
 not
as if something's wringing it and narrowing its range
this tyrannical constraint is the stranglehold of Theory
squeezing my voice into the axis of Its Authority

". . . representation, signification, reification, the simulacrum, the break-
 down of unity and the Other"

but
so much else comes into my head

Pat Steir

I find this question impossible to answer
because the question is an answer in itself.

For me, a work of art must show a way of seeing
that has not been seen before.

Or show a way of seeing that has always been,
but not consciously seen.

Robert Storr

Deconstructing the myths of absolute originality and authenticity has
been the common purpose of some of the best and most provocative art
of the 1980s. Insofar as inherited notions of "genius" and "aura" have
been the refuge of art-scoundrels of all stripes and splashes this effort

has been tonic—and sometimes genuinely radical. However uncomfortable this critique may make one, simple rejection is at best short-sighted—at worst reactionary.

Over the past several years, however, the efficacy of deconstruction, not to mention the coherence of its motives, has been undermined by its very success. Wide dissemination has led to the near complete vulgarization of its basic concepts—and a corresponding opportunism on the part of many of its supposed practitioners. It is now a cliché producing clichéd art.

It has also become an alibi for the fatalistic acquiescence to or eager courtship of power. "Gee whiz!" nihilism has picked up where the idea of resistance to cultural determinism once flourished. "No exit" has become "Let's settle in for the duration—who's your dealer?" And, fascination with the "hyper-real" has devolved into a convenient excuse for ignoring or second-guessing the experience of others—that mundane and highly inopportune form of the "other"—and a means of avoiding the most disturbing implications of one's own.

In this regard, two incidents of the past year stick in mind.

On a recent panel a colleague, who has written frequently on the theme of the media and the arts, explained that for a while she had lived within walking distance of the Louvre and had regularly gone to see the *Mona Lisa* but decided in the end that there was little advantage to be gained from this exercise since studying the reproduction gave her information she needed. This is a startling conclusion. Granted, the painting is vastly overrated and superficially overfamiliar. And granted there lies over it a patina of irony and in front of it a literal shield of guards and glass that obscure our vision. Nonetheless, like all "originals," even those imprisoned by curators and enshrined by custom, da Vinci's painting remains unique by virtue of the complexity of the relations it synthesizes. Despite everything, it survives in this state because of the density of nuance it contains. No surrogate can match this complexity; likewise no second-hand knowledge can suggest new interpretations as readily as the idiosyncratic engagement of direct and sustained observation. And, one might add, full appreciation of the degree to which a painting has been compromised cannot be deduced from general principles; it too must be witnessed first hand. The question then becomes not whether the original has ceased to exist (it hasn't) but the nature of one's interests relative to its existence—and the measure of one's curiosity and the subtlety and extent of one's appetites.

Next, from art to life—or rather its negation. Some months ago a painter musing on the ideological context of contemporary abstraction put forward this proposition. "Likewise, the poles of life and death collapse into a state of non-life and non-death. No one either lives or dies. The possibility of life is negated by the imposition of mechanical time and by regimentation. . . . Meanwhile, death is replaced by disappearance and is negated by manipulation of time within the recording media."[1] Cribbed from Baudrillard's reflections on Walt Disney, the wizard of the "simulacrum" who lies eternally suspended between life and death in a cryogenic tank, this was once a clever conceit. Lately it sounds astonishingly callow. Death in New York and elsewhere in the art world is too present and too obscene to make anything but nonsense of such sophistry. AIDS is not "disappearance" followed by electronic afterlife, it is misery and definitive loss. Meanwhile, outside that world—among drug users on the Lower East Side and infected members of their families, in the dirt wars of Central America and the Persian Gulf—death is likewise miserable, individual, and final. In this context the discourse of infinite regression into the "hyper-real" is the intellectual equivalent of speculation on the "Star Wars" defense. An intricate futuristic toy, it is the ultimate distraction for insular minds.

In the end, whatever the impediments and distortions created by the general, the social, the "reified," everyone is responsible for and to the authenticity and immediacy of their own experience. Usually what rings true is embarrassing because it must necessarily admit to the tenuousness of its claim to truth. The real test is that of one's tolerance for embarrassment, inconclusiveness, depression, and wonderment.

1 Peter Halley, "Notes on Abstraction," *Arts Magazine,* Summer 1987, p. 37.

Lawrence Weiner

ART IS NOT A METAPHOR UPON THE RELATIONSHIPS OF HUMAN
BEINGS TO OBJECTS & OBJECTS TO OBJECTS IN RELATION TO
HUMAN BEINGS BUT A REPRESENTATION OF AN EMPIRICAL
EXISTING FACT
IT DOES NOT TELL THE POTENTIAL & CAPABILITIES OF AN

OBJECT (MATERIAL) BUT PRESENTS A REALITY CONCERNING
THAT RELATIONSHIP

IF AND WHEN A PRESENTATIONAL SITUATION CANNOT
ACCOMMODATE BY VIRTUE OF SELF PROTECTION (CONFLICT
OF BASIC IDEOLOGIES) A WORK OF ART
IT (THE WORK OF ART) THEN MUST ERECT A STRUCTURE
CAPABLE OF SUPPORTING ITSELF
BUT WHATSOEVER SUPPORT IS FOUND CAPABLE BECOMES IN
EFFECT LEGITIMIZED
PERHAPS THE DIALECTIC CONCLUDES AS THE SYSTEM OF
SUPPORT CHANGES

A REASONABLE ASSUMPTION SEEMS TO BE THAT PROLONGED
NEGOTIATIONS WITH A NONACCOMMODATING STRUCTURE IS
NOT THE ROLE AND OR USE OF EITHER THE ART OR THE
ARTIST

THE OBVIOUS CHANGE IN THE RELATIONSHIP OF ART TO A CULTURE
IS PERHAPS THAT THE EXPLANATION (NOT NEEDED JUSTIFICATION)
OF THE EXISTENCE OF ART HAS BEEN ALLIED TO THE CONCEPT OF
PRODUCTION
THIS READING WHILE OBVIATING SOME FORM OF SOCIAL UNEASE IS
NOT IN FACT THE CASE
ART IS IN RELATION TO ITS SOCIETY A SERVICE INDUSTRY

THE ARTIST'S REALITY IS NO DIFFERENT FROM ANY OTHER
REALITY
IT IS THE CONTENT THAT GIVES THE PERCEPTIONS AND
OBSERVATIONS OF AN ARTIST (WITHIN THE PRESENTATION ART)
A USE FACTOR WITHIN THE SOCIETY

A CONCEPT (IDEA) OF ENDEAVOR (WORK) WITHOUT A
COMMITMENT IS NOT A REASONABLE ASSUMPTION

CONSTANT PLACATION OF PREVIOUS AESTHETICS CONSUMES
PRESENT RESOURCES TO THE EXTENT THAT AS THE NEEDS &

DESIRES OF A PRESENT AESTHETIC MAKE THEMSELVES FELT

(EVEN WHEN THE BASIS IS IN A PREVIOUS AESTHETIC)

THE RESOURCES HAVE BEEN EXHAUSTED

Contemporary Views on

Racism in the Arts

We asked a number of artists and critics from around the country to consider these questions and related issues.

How do race, ethnicity, and class influence art discourse and practice?

Do you feel that enough artists of color are currently having work exhibited and discussed?

Do you think that recent attention to artists of color and to artists of the third world (in articles and exhibitions) is effecting a genuine transformation of mainstream art discourse, or does tokenism remain a problem? And, if so, how does it operate in the contemporary art world?

Are there stylistic double standards at work or a stylistics of "otherness"? Alternatively, is there pressure for an artist of color to assimilate to mainstream ideas and artistic practices?

Emma Amos

In a letter to the *New York Times,* April 23, 1989, I wrote, in part:

It is true that African American artists are doing work that will help all Americans to refocus on our shared strengths, as Michael Brenson so rightly described March 12th (1989) in "Black Artists: A Place in the Sun."

I am invisible as an African American woman artist. I show in February. Thank God for February. I show with other black artists in ghetto month shows that fulfill the funding needs of white institutions. Our few and far between shows seldom get shuffled into the other 11 months of the calendar. And I come from a long line of African American artists, including Mary Edmonia Lewis, Augusta Savage, Horace Pippin, Palmer Hayden, Hale Woodruff, Norman Lewis, Alma Thomas, Nellie Mae Rowe, and Romare Bearden, whose exhibitions also get compressed into the shortest month of the year.

Are there enough black and minority artists whose work is currently exhibited and discussed? No. What would it be like if we heard jazz and the blues mostly in February? Since the early 1989 *New York Times* flurry of written attention to the sculptor Mel Edwards, which prompted me to write that art by blacks was "definitely 'happening,'" I have a feeling that some of the art-viewing public, and some artists as well, think minorities have had "enough" exposure. But "wait-your-turners" can cool out; not much has happened since. A flurry of interest in and resentment against Martin Puryear for his deserved "São Paulo Biennial" outing and an outrageous put-down of black artists in an article by Schjeldahl (*Elle*, 11/89) on the occasion of Basquiat's Baghoomian retrospective broke the usual stay-at-the-rear-of-the-bus silence.

Minorities and women still don't receive press coverage in proportion to their importance or numbers. Reviews and art magazine interviews are hard to come by for every artist, but even more elusive for minority artists. I'm sure much of the progress that has been made is a result of the activities of the Guerrilla Girls ragging on the press, curators, publicly supported viewing spaces, and museums, and not because awareness or scholarship has risen at these institutions.

Artists make the kind of art their experience leads them to. Black people stand outside much of this country's life—schools, churches, advertising, film, etc. Even in fields in which they are central figures (sports, jazz, pop music, style, and fashion) they are often exploited. The experiences of black and nonwhite artists produce art that has a different framework from that of white artists. Why is it that when minority artists are trained along with white artists in Western European male-biased college and graduate art programs, their work still may look "different"? I think it is because black artists know or sense that what art historians, curators, and critics want to write and talk

about as ART is only a fragment of the picture. From the minority artist's position on the OUTSIDE, participation in what we see as an ART WAGON TRAIN FORMED IN A CIRCLE to exclude us is silly at best and apartheid at worst.

Critics and observers of the art scene write about what they experience through their limited Western-European–centered eyes. What has been left out of our school curriculum? If women and black artists are just now appearing in a few art texts, if books are segregated according to race, sex, and the dominant style of the period, then what scholars at which universities are learned enough to teach the total picture?

There is very little criticism of the work of nonwhite artists which relates the content of their work to the work of white artists. Why are black voices only compared to other black voices? Why all this talk about the language of jazz and capturing cultural history in the works of black artists like Romare Bearden, Bob Thompson, Faith Ringgold? Why not look for the language of jazz, cultural history, and other significantly American art forms in the smooth, cold, smug-looking works of Frank Stella, Donald Judd, and Carl Andre? It's as self-contained and off-limits as the Georgia State Capitol was in my childhood. I think minimalism and factory-made art looks like the work of the white man's government in solid form.[1] (Speaking of smooth, cold and smug, the newer gloss-art sensations like Koons and Salle refer to American culture, but filtered through Saturday morning TV.)

Do I think there are stylistic double standards? My answer comes when I just say my last paragraph the other way.

There is NO criticism of the work of white artists which relates the content of their work to the work of nonwhite artists. Why are white voices only compared to other white voices? Why are German, Jewish, Italian, French, and Middle-European Americans allowed to call themselves American artists and given to hold the standard for American art, while Chinese Americans, Native Americans, Brazilian Americans, and African Americans remain always "people of color" or "minority" artists?

When Europe and the East look at this country, they steal our rap and hiphop, our blues, jazz, and country-western, our graffiti, movies, and pop performances, our sneaker-wearing, hard-working women, and our prejudices. Who says the mainstream is blue chip artists? The mainstream is me, baby-darling.

Why am I so concerned since I'm one of those people who seems to be many places at once? Because usually, when you see me, you'll also see Howardena Pindell, Faith Ringgold, Vivian Browne, Camille Billops, Clarissa Sligh, Deborah Willis, Lorna Simpson, and maybe Tyrone Mitchell, Mel Edwards, Jackie Whitten, Al Loving, Houston Conwill, Terry Adkins, Bill Hutson, James Little, Giza Endesha Daniels, James Andrew Brown, Howard McCalebb, and the other hard-working black artists who gather in support of each other. But we know that most gatherings of artists, curators, dealers, and critics at museums, galleries, art societies, and socials are without us. DON'T YOU MISS US WHEN WE'RE NOT THERE?

The following are excerpts from Zora Neale Hurston's essay published in 1928 called "How It Feels to Be Colored Me" and collected by Alice Walker in "I Love Myself When I Am Laughing."[2]

I do not always feel colored. Even now I often achieve the unconscious Zora of Eatonville before the Hegira. I feel most colored when I am thrown against a sharp white background.

I have no separate feeling about being an American citizen and colored. I am merely a fragment of the Great Soul that surges within the boundaries. My country, right or wrong.

Sometimes, I feel discriminated against, but it does not make me angry. It merely astonishes me. How *can* any deny themselves the pleasure of my company? It's beyond me.

But in the main, I feel like a brown bag of miscellany propped against a wall. Against a wall in company with other bags, white, red and yellow. Pour out the contents, and there is discovered a jumble of small things priceless and worthless. A first-rate diamond, an empty spool, bits of broken glass, lengths of string, a key to a door long since crumbled away, a rusty knife-blade, old shoes saved for a road that never was and never will be, a nail bent under the weight of things too heavy for any nail, a dried flower or two still a little fragrant. In your hand is the brown bag. On the ground before you is the jumble it held—so much like the jumble in the bags, could they be emptied, that all might be dumped in a single heap and the bags refilled without altering the content of any greatly. A bit of colored glass more or less would not matter. Perhaps that is how the Great Stuffer of Bags filled them in the first place—who knows?

Notes

1 See Anna C. Chave, "Minimalism and the Rhetoric of Power," *Arts*, January 1990.
2 *I Love Myself When I Am Laughing, A Zora Neale Hurston Reader*, ed. Alice Walker (New York: The Feminist Press, 1979).

Josely Carvalho

Does Culture Have Color?

My art is tightly connected with myself and my hybrid culture. Although I was born and raised in Brazil, I have lived more than half of my life in the United States. I have become more and more aware of the dichotomy of living in a space that is not mine while, at the same time, no longer belonging to a country that I still consider mine. The tension brought about by these dichotomies is further intensified in the art world, which makes me more and more conscious of being viewed as the "other." Questions such as: How am I perceived and seen here as well as in Brazil? What are the stereotypes associated with Hispanics, Latinos, and Latin Americans in this country? What are the consequences of these stereotypes in the survival of an artist? and What are the consequences which are bound to create an impact and to shape one's modus vivendi? What does this do to my identity, my politics, my art? Do I embrace my cultural identity or do I accept a cultural dependency? To accept dependency for me is to accept homogenization. It is to accept labels . . . Hispanic . . . Latina . . . Third World . . . woman of color . . . or any new term that may arise to satisfy a political purpose, an intellectual curiosity, a naïveté, or even a guilt of some. . . . It is to allow myself to become a racial object rather than a subject, a human resource rather than a human being.

A few years ago, "Hispanic" was the standard label to categorize "us." Its racist intention tended to disregard differences in order to facilitate statistics, descriptions, surveys, and comprehension. Most Latin Americans prefer to classify themselves by country of origin rather than the standardized label "Hispanic," because it blurs their historical identity. And yet, a more detached label "Latino" has followed. It still includes

the negativity of homogenization, the lack of incorporating socio-economic class and the failure of understanding historical differences among Puerto Ricans, Mexican Americans, Dominicans, Haitians, Cubans, Central Americans and South Americans, and within Central and South Americans, the distinct nationalities. When classifying, we automatically dismiss certain groups either because of language, color, nationality, gender, or class.

The obsession for categorizing and labeling stems perhaps from a fear of understanding subtleties, layers, and differences. Categorizations tend to stereotype. Where does it come from, this race and color obsession that has been reignited in this country lately? By constantly looking for new classifications as the solution for the discontent with older classifications, rather than fighting classifications per se, it tends to throw us back into the hands of chauvinistic and racist intentions.

In the last year, a new label has arisen: "women of color." African Americans, by uniting through denominations (even if these labels are constantly updated), build pride and self-respect for themselves as a group and as individuals within the group. In this way, classifications can be used positively as an organizing tool. It seems to be necessary to build strength and power. Unfortunately, I don't see that this has been the case for "Hispanics." By deconstructing "colored" and reconstructing into "of color," African Americans empower a once powerless word and have created a terminology that embodies political and personal strength and includes all others that have been marginalized or segregated. Unfortunately, the terminology "woman of color" has a tendency to divide us rather than connect us. It segregates us by race and by sex and it can further separate peoples of different cultures as well as create division within a culture.

I have personally suffered discrimination here in the United States and yet I do not want to be broadly classified and lose my cultural identity. "Woman of color" is a denomination imposed upon us. To accept this label is to give away our history, diverting the attention from a complex cultural subject (where race is a part of it) to that of a one-dimensional color issue.

. . . Do I have to color myself to be with my sisters? . . . or . . . if I keep a colorless memory of my ancestors, do I become "an other" within the "other"? . . . do I have options? . . .

Daryl Chin

Though I have thought about the questions asked by the editors, I find it difficult to answer simply. One reason is that the whole issue of racism and its manifestation in terms of the arts is ambiguous. The complications are many. In the spring of 1989, I participated in a symposium at The Museum of Modern Art, "Contemporary Art in Context," in which the issue of racism was discussed. At that time, I mentioned what I called a "test case." Taking a situation within a "controlled environment," I compared the careers of two young filmmakers. These filmmakers came from similar backgrounds (educated at the Semiotics Department at Brown University), both premiered films on the same bill at The Naked Eye Cinema at Quando on the Lower East Side. Both films received highly favorable reviews from J. Hoberman in *The Village Voice*, and recently, Hoberman listed both films among the fifty significant films of the 1980s in his "End of the Decade" round-up piece. Critics I know who have seen both films have been in agreement that both films are impressive: though radically different, both films are deconstructive accounts of pop music icons. To make a long story short: the white kid became the hottest thing on the experimental film circuit over the past two years, and it took the nonwhite kid twice as long to get even half the bookings. And you can forget about fundraising for future projects, grants, and fellowships. Is this an example of racism? I honestly don't know.

A personal example: the last time my work was presented in New York City, I received a negative review. A few months later, I was at a party, and the critic was there. She came up to me, and apologized for her review. She started to explain that she had misjudged the work, because she had assumed certain things about my work because of my ethnicity. After a number of mutual acquaintances (theater critics, directors, writers) had discussed my work with her, she realized that she had underestimated the formal rigor, the conceptual framework, and the formal radicalism. Because I was nonwhite, she hadn't realized that my work could be as "difficult" as the work of white "avant-garde" artists, but when white people explained the work to her, she understood it. When somebody apologizes, what can you do? I tried to be polite, but it made me feel that everything was hopeless. What's done is done. Is this an example of racism? I honestly don't know.

I took samples of films by Asian Americans to a prominent film programmer. These were "experimental" shorts, of a wide variety. She returned them, with a note saying that she was not impressed with any of the work, and some of the work was horrible: the filmmakers should be ashamed of themselves for denying their Asian heritage. A few weeks ago, I found out that when Isaac Julien showed this same programmer films from the Sankofa Film Collective and the Black Audio-Film Collective from London, her response was the same. Under no circumstance would she ever show such work, and who did these black British filmmakers think their audience was? No one, she informed them, would sit through these films! The message is clear: she does not feel that nonwhites have any business doing "experimental" work. Is this an example of racism? I honestly don't know.

Recently, I was on a panel of the College Art Association, organized by Howardena Pindell. The topic was "De-Facto Racism in the Arts." The point is: in all of the cases cited above, the people were not intentionally racist (not even the film programmer). They were (by and large) "liberals," who, confronted with nonwhites not fulfilling specified tasks, not fitting specified roles, didn't know how to react. In the arts, this is particularly insidious, because of the issue of taste and sensibility. People can always say, I know what I like. But what conditions what they like?

About three years ago, the work of Martin Puryear began to be noticed on a national level. There was an exhibition at the Brooklyn Museum of several recent pieces in 1988; a few months later, his work was included in the Whitney Biennial. When the first reviews appeared, Puryear's work was seen in terms of the scale and texture of postminimal sculpture and in terms of his contemporaries such as Joel Shapiro and Jackie Winsor. However, just before the Whitney Biennial, Puryear's work was included in several survey exhibitions of African American artists. Since then, the critical reaction to his work has changed, subtly but definitely. An example of this might be seen in the writings of Michael Brenson in the *New York Times*. The first times Puryear was reviewed in the *New York Times,* he was reviewed as an example of a postminimal sculptor (such as Shapiro, Winsor, Ursula von Rydingsvard). No mention of race. Suddenly, this changed. Brenson writes in a long essay in the Arts & Leisure section of the *New York Times* of Sunday, October 29, 1989: "Part of what distinguishes Puryear from many other minority artists is his lack of defensiveness about mainstream American

art. He remains something of an outsider, with one foot outside the mainstream, but he has one foot comfortably within it as well." What is Martin Puryear, a Martian? As far as I know, he's an American. What the hell is this talk about "mainstream" and "outsider"? Ursula von Rydingsvard could be considered more of an "outsider" (since she wasn't born in this country), but she's rarely discussed in those terms. Martin Puryear is an American, went to American art schools, where he was taught about American art, and that's what he does.

This point about art schools and training has been made by people as different as the artist Yong Soon Min and the art historian Judith Wilson. And Puryear hadn't been discussed as an "outsider" in his initial reviews. Just as a sculptor. To personalize: I'm an American. People who meet me always ask me where I come from, as if I were born in China or Hong Kong or somewhere. Pardon me: I'm a fourth-generation American. My family came over here in the 1880s. (My father was born in New York City, my mother was born in Pittsburgh, my grandmother, who just died at the age of 90, was born in New York City.) When people talk to me on the phone, before meeting me, they never ask me where I was born. It's obvious the minute I open my mouth (New York City), but when they see my face, suddenly I might as well be the brother from another planet. This is also funny, because one of my best friends is from a Swiss German family. She was born here, but her parents weren't, and she grew up in Inwood, in a neighborhood full of other immigrant (often German Jewish) families. As she once said, her knowledge of American culture was very sporadic, until that fatal day in high school when we became friends.

Another example: Many African American artists (photographers, choreographers, sculptors) get a lot of calls in the winter. Arts organizations are trying to line up African American artists for "Black History Month," which is February (a friend of mine noted, wouldn't you know it, the shortest month in the year). One photographer I know said, I stopped taking those calls. If he's not "good" enough to be shown at any other time, why should February be any different?

I could go on and on, but I'd like to conclude on two points. The first is that I haven't worked as an artist in five years. There are many reasons for that, but I'd like to try to focus on one, relating to ethnicity. My decision to do "theater" was partly formulated on the idea that I would take what Richard Foreman among other theater modernists and post-

modernists had done and subvert it. It was the whole avant-garde aesthetic of negation. You test the limits of the generation before you. I thought this was perfectly fine, but what I didn't realize was that people expect you to be docile if you're Asian.

It's a little like Ralph Ellison's concept of "Invisible Man": no matter what I've done, I'm not white, I'm not African American, and I don't do "Asian American" work, and I won't bullshit about myself in phony Asian American terms, so it's as if I never existed. It's like the Cole Porter song, "It's the wrong time / And the wrong place / Though your face is charming / It's the wrong face." Basically, what people such as the critic were telling me was: you have the wrong face. What did they expect? I'm Chinese American. As we used to say, that's my name, don't wear it out. I'm not ashamed of it. But it has nothing to do with my work. It doesn't even have much to do with my life. Since I was fifteen, I've been hanging out in the art world, and so my work has concerned itself with what John Howell called "performance lining up with art issues." I'm thirty-six now. That's more than half my life. And even before that, my life had nothing to do with immigration, or with laundries, or with Chinese restaurants. And I won't pretend that it had.

All this makes me defensive, and when you get defensive, you get ineffectual, and there's a lot of psychological damage from this guilt people toss at you. What I mean is: "apologies" are also threats. People were telling me, you weren't being a good Asian American, you weren't being what we wanted an Asian American playwright or performance artist to be, it's your fault that we misunderstood your work. My fault? Hey, don't blame me for your ignorance! Don't blame me for your stereotyping! Don't blame me for your (unconscious) racism!

For the last five years I have been primarily involved in art activism, been doing everything to help establish (and reestablish) Asian American media artists. I have helped them exhibit their works, both within the Asian American media community and outside of it. I have alerted programmers and curators to their work. I have tried to help them find funding. It's not easy: I started with the example of the two young filmmakers, one white, one nonwhite. It will take the nonwhite longer to get established. Longer, yes, but it's not never. It's not impossible.

There are many traditional venues for those nonwhite artists who work in a "traditional" vein, for instance, Asian Americans who make documentaries about "the Asian American experience." But there are

others, who are making the claim that, as Americans, they can work as American filmmakers and video artists. It's still not easy: the hot young white filmmaker will get calls from Hollywood. A young Asian American filmmaker will not (and may never get such calls). It will take twice as long to get half as much. And, even there, part of those screenings and bookings will be dependent on the Asian American media community (and if that community is closed, that's it). But these changes are happening, and will definitely happen if we work for them.

One can make a difference, and, because of this interest in new filmmakers and video artists, I've gotten to know the work of people like Lise Yasui, Jon Moritsugu, Gregg Araki, Roddy Bogawa, Rea Tajiri, Tom Yasumi, and Rico Martinez. Obviously, this is (in a way) all displacement: I'm channeling my anger and frustration about my own work into this activism. But, it's something to do. Tom Yasumi (in passing) made one of the funniest comments I've ever heard: he said that when his father first told him that they were moving to California from Japan, he cried, because he was afraid of going to America. But then he realized that if he had stayed in Japan, he would have been one of those kids who wanted to be an American. This way, he is one.

And that's the point: we're not "Asian Americans" or some other species of life form, we're Americans. And that's the way it crumbles, cookiewise.

Tom Finkelpearl

In my mind it is clear that the current art world is racist and sexist. Certainly the statistics compiled by the Guerrilla Girls have proven this beyond a shadow of a doubt. But this should come as no surprise if one considers the art world in the context of popular culture. How often do you see a multicultural cast in a Hollywood film? Or a Broadway play? Or listen to an "integrated" radio station? Even record shops and bookstores segregate African American artists. If you look at the structure of the "mainstream" art world, it is clear that almost all of the positions of power are held by white middle-class men and women. The recent "attention to artists of color" has been within a framework of museums, galleries, and publications that are directed by an elite. Even the phrasing of the question posed for this statement seems to be based

upon the sense that the center is the white power structure: When you inquire about "... recent attention *to* artists of color ..." we must ask where the attention is coming *from*.

A recent study has shown that European anthropologists created history for the Maori of New Zealand, through the questionable discovery of a 1350 migration from Polynesia. The "discovery" of this migration, now accepted by the Maori as historical fact, conveniently fit certain Eurocentric theories about the movements of cultures from the "cradles of civilization." Western anthropologists now believe these findings to be false, but their study of the culture had a lasting effect.[1] While "postmodern" anthropologists are calling for a new cultural relativism, a continuous reinvention of culture, there is still the sense that *we* are studying *them*. Where are the Maori anthropologists to help *us* reinvent *our* culture?

We must recognize our own cultural bias, the bias of the establishment in the "attention to artists of color." As a white middle-class curator, I am not fully prepared to understand all artworks. The cultural bias in my education is astonishing. In the ten art history courses I took in college and graduate school (with an emphasis on nineteenth and twentieth century), I was not exposed to a single African American artist. My wife, Eugenie Tsai, can say the same, and she has finished her coursework toward a Ph.D. in modern art. Everything we have learned on the subject has been self-initiated.

Certainly this does not mean it is wrong for me to exhibit the work of artists of color at The Clocktower. But it is equally important for me to push to make the institution, and its decision-making apparatus, more inclusive and multicultural. To the present, what has happened for the most part is that the mainstream museums and galleries have made an attempt to absorb different sorts of art without changing their character, and the mainstream audience has yet to make a real effort to find new contexts within which to see art. Artists of color are given an "opportunity" to show, but it is on the terms of the establishment. No significant shift of power has taken place. We don't only need artists of color but also administrators, curators, dealers, fundraisers, writers, editors, funders, board members, preparators, registrars, and especially directors. In our current system the museum's role is to be exclusive, the curator's to be selective. We need inclusiveness at all levels to effect a real change.

In the same question, you wonder if there has been a genuine "transformation of mainstream art discourse." This phrase is problematic to me in two ways: First, the notion of a "mainstream" seems to be a barrier in the path toward an inclusive art world. We do not need a transformed mainstream but a structural change, a multifaceted art world more like Jesse Jackson's metaphoric "quilt" or David Dinkins's "mosaic." Second, the "discourse" is not what needs to be transformed, but the course of *action*. Discourse within the structure cannot dismantle the structure. As Malcolm X said, "a chicken cannot produce a duck egg,"[2] and the discourse to which you refer is still among the chickens.

We must address the political *and* social implications of our artistic "practice."[3] Many artists and writers are willing to make political statements in their work, to criticize the "ideology of display." We see show after show at commercial galleries that are purported critiques. But these critiques are presented within the existing system. They are veiled political statements, but the veils are so opaque that the actual function of the objects belies their supposed intent. Jeff Koons is not making his collectors examine the nature of the art object in any way that interferes with the purchase and enjoyment of his luxury items. While Barbara Kruger's critiques may be helpful to inquiring minds within the mainstream, her one-of-a-kind photographic objects are bought and sold in the traditional fashion, even bypassing the monetary and philosophical questions of uniqueness presented by the reproducible photographic print. The galleries these artists show in are high-powered businesses catering to an elite—and the same can be said for the art magazines that are supported by the commercial system.

But I hate to be so negative. There are alternative, positive models. Here are a few, listed in increasing detachment from the current system. *Critical engagement:* Tim Rollins and K.O.S. perhaps present the best example of using the commercial system while engaging in a positive social experiment. There is nothing particularly radical about their final product, except in relation to the nature of its creation: a collective and collaborative project within a community context. It is hard to integrate their context of creation with the context of exchange. *Inside-out critique:* There are a number of African American artists whose work serves as social and museological critique, exhibited within the established system. Renée Green, Fred Wilson, and Daniel Tisdale, for example, have each recently exhibited works that question the traditional notions of anthropological display—the natural history museum.

Participatory projects: The Asian American Art Centre's "China June 4" exhibition and Glenn Weiss's global participatory event "Exhibition Diomede" were both multicultural, politically based, noncommercial, and open to all artists. All work submitted (within the size requirements) was exhibited. These exhibitions set up the model of curator as cultural catalyst instead of exclusive tastemaker. *Self-initiated short-term projects:* For example, David Hammons's five-story basketball hoops in an empty lot in Harlem bypassed the art world to create site-specific work for the community. *Long-term investigation/intervention:* Bolek Greczynski's "Living Museum" at Creedmoor Mental Hospital, and Mierle Ukeles's work within the Sanitation Department show that context can define the meaning of art, and vice versa. These artists, and many more, are taking action rather than engaging in internal discourse. Their model can help us think of new directions rather than dwelling on the shortcomings of the present and past.

Notes

1 John Noble Wilford, "Anthropology Seen as Father of Maori Lore," *New York Times,* February 20, 1990, pp. c1, c12.
2 Malcolm X, *By Any Means Necessary* (New York: Pathfinder, 1970), p. 116.
3 The class connotations of the word "practice" are troubling—doctors have a "practice," carpenters do not.

Madeline Gins

Supplanting Outline for a Preface to "Get the Racist," A Work Never to Be Realized

I. The racist does not want you to be you. It would have been better had you been excluded from being yourself. The racist wants to destroy you for your difference, to begin with. The racist's object is murder. Naturally, too, it is never not a question of economics.

 A. Should racist (or misogynist or elitist) acts against the form that a mind-body has been obliged to start out with succeed in having done with it—that is the killing point.

 1. Failing the complicity of the victim, this could never be accomplished.

2. The victim's full complicity (= defeat) requires after all that to put it as T. Carlyle forcefully did in *The French Revolution*—ordinances of Art [i.e. artful ordinances (read deceits)] become confused with and taken for ordinances of Nature:

"Twenty years ago, the Friend of Men (preaching to the deaf) described the Limousin Peasants as wearing a pain-stricken (*souffre-douleur*) look, a look past complaint, 'as if the oppression of the great were like the hail and the thunder, a thing irremediable, the ordinance of Nature.' And now if in some great hour, the shock of a falling Bastille should awaken you, and it were found to be the ordinance of Art merely; and remediable, reversible!"

B. Between radical, total erasure and some measure of continuance, how many different positions of retreat on both sides; no neutral zone with racism in play . . .

II. For those who play the innocent, saying, "O agony, o racism, o misogyny whatever could that be?"

A. Know that it never comes without a broad-based and definite No, foretelling an exclusion, hard or otherwise.

(It may be too early in this to point out that a soft inclusion is yet another means of assuring a hard [read total (read "to make completely invisible")] exclusion.)

B. To determine the limit of inveterate nastiness, live as the noticeably other in a country not your own.

("But the body, each body, is its own country with which it travels," some might rightly protest.)

III. Contrary to what might be expected, the art world alleviates not at all the hideously dependable agony of all this.

A. This, the art world, is not, as might have been hoped, a more forgiving version of the general case; instead, its main nonattraction is that it is a direct hell. The motives of its members are too mixed and muddy for anything resembling truth or justice to prevail. Not much chance of careful evaluation and weighing of evidence in a world in which the order of the day is manipulate or be manipulated.

1. The resultant asymmetrical relations to "what is to be done" put a dull half-ideological face on discourse or on attempts at discourse.

 a. The artist as theorist will sink into his or her own sodden halfthought.

 b. One protects one's own—nothing different here. The one-man show and the one-man anything and everything.

 (1) If it's not like me and my discourse, it's quite worthless, or, if it is not part of a discourse that I as I recognize, it's, practically by definition, unworthy of attention, or on an arguably less conscious level, simply, if it's not for my (or my country's) pocketbook, then I'd rather it be excluded.

 (2) How to get the point across without coming out with it, or, What might suffice as necessary and sufficient slurs of exclusion.

 (a) "This artist has no critical sense!"

 (i) Wielded unjustly but effectively against an artist of great critical sensibility.

 (ii) Even should this be an accusation that is justified why is it never one that is accompanied by an invitation of some kind into the prevailing discourse—remedial course in critical process; that this be no longer a society without mercy.

 (b) The use of the value-judgement in the casual but definitive dismissal of a work of art.

 (i) Too messy or too clean.

 (ii) Too decorative or too minimal.

 (iii) Lacking X.

 c. Do the members of the art world seriously think that there are no witnesses to these cruel, destructive games?

2. It has been set up in the dominant or dominating culture to have it that all discourse in those countries made up of races nonvalidated for the production of great artists in our time never be taken as in any way corresponding to what are supposedly the main discourses.

 a. A provincial mafia believes, and is continually seeking to convince (rope in) others, that it alone has the right to speak to and for what is international.

 b. Layers of deceit or a glimpse at the extent to which racism might be hopelessly entrenched in the art world.

 (1) A chance meeting with an art critic. I knew her to be

someone who, despite her relative unfamiliarity with the work of a new presence in the New York art world, an artist considered to be important by numerous artists and critics, one who had come from what might be said to be a nondominant culture, had even so gone about letting it be known around town that this was certainly work that was too trivial to play a role in the central discourse. As it happened, this artist's work was being shown that month at a gallery that I knew this critic to frequent. Here then was a chance for evidence to be presented and the case to be reconsidered, it immediately came to mind, if only. . . . I told her that the show was going on, to which she replied that she was aware of that, and then I asked her to go take a look at it. At this point, she fidgeted and appeared distracted; she made it plain how disinterested she was in the subject. "I think you are behaving this way because you are prejudiced!" I cried out. "Well," she snapped back at me, "maybe I am, but isn't everyone?" She's never reconsidered this artist's work; she never even made a try. Ten years later, we find her wanting to be recognized as a critic concerned for the rights of third-world artists, as long, that is, as these are kept off to one side. She has changed nothing about her critical approach, except for the all-too-predictable adding on of hypocrisy to racism. Then, go and fight that.

[To Come to a Stop.]

Renée Green

"I Won't Play Other to Your Same"

Perhaps this is cynicism on my part, but lately it seems as if the "Other" has become a cultural industry. With the casual and ever more frequent use of the term in art discussions, in art journals, and in other cultural contexts, I'm afraid an essentialist category is being created, one which is defined by the trait of absence from the "mainstream." I suggest that a

re-examination of this cultural and political construct is in order, and that its unexamined use can in fact reinforce dominant ideology.

With the repeated mention of the category of "Other," another seldom-enunciated and rather hazy and well-sheathed category comes to mind, that of not-otherness, an insistent centralness that assumes itself to be primary and further assumes itself to constitute the norm. About this category we hear very little.

The notion of the "Other" as a category separate from the "mainstream" (which mainstream?) is a division which may be useful, as neat mental separations are for funding agencies, but which is perplexing for someone who is designated as the "Other." I'd like to turn to fiction to provide an example of this situation as it is encountered by Sarah Phillips, the main character and narrator in a novel by the same name written by Andrea Lee in 1984. A conversation develops between Gretchen and Sarah after they have both been assigned to the hockey team for "athletic pariahs" at the private school they attend, where Sarah is the only black:

> Gretchen stretched out on the grass, propping herself on one round elbow, and peered at me through an oily fall of hair. "My father knows yours," she said. "Your father is James Forrest Phillips, the civil-rights minister. My father is very interested in civil rights, and so am I."
>
> "Don't do me any favors," I said in a tough, snappish voice I had learned from *Dragnet.*
>
> Gretchen looked at me admiringly. "Don't you think it's rather romantic to be a Negro?" she asked. "I do. A few years ago, when Mama and Daddy used to talk to us about the Freedom Riders in the South, my sister Sarabeth and I spent a whole night up crying because we weren't Negroes. If I were a Negro, I'd be like a knight and skewer the Ku Klux Klan. My father says Negroes are the tragic figures of America. Isn't it exciting to be a tragic figure? It's a kind of destiny!"

The next sentence describes the motley pair these two make as best friends, so there is no outraged response on Sarah's part because outrage under these circumstances isn't in order. But annoyance is, and that annoyance with the spoken designation of otherness is apparent in Sarah's "snappish voice." Even though Gretchen is well intentioned, and she is in fact the only girl at the Prescott School for Girls who befriends her and supports her "position," her initial connection to Sarah is

bound to her mythical world of Negroes. This passage underlines the point that "Other" is not a natural state, but rather one which is constructed and which must be designated, and once it is designated it can either be accepted or refused.

Sarah's rankling at being designated as the "Other," even though this position is regarded in a "positive" way, can hint at the problems with the term "Other" (and its implications of monolithic wholeness) and suggests the enabling possibilities of a self-designation of difference. Unlike otherness difference implies the articulation of one's own complex position in relationship to the matrix of cultural, political, and social relations suggested by class, ethnicity, and gender, rather than an imposed naming. I quote Trinh T. Minh-Ha on this point:

> To make things even more complex and more disposed to critical investigation, "western" and "non-western" must be understood not merely in terms of oppositions and separations but rather in terms of differences. This implies a constant to-and-fro movement between the same and the other.

To that statement, I would add that the binarism of "same" and "other" is a frustrating one and in its place I have no new names to offer, but I have instead the desire that with dialogues in which we can discuss differences as well as overlapping concerns that these inadequate terms will not acquire more rigidity.

Hung Liu

Five Terms, Two Letters

My legal term: *Resident Alien*
My professional term: *Artist*
My academic term: *Assistant Professor*
My racial term: *Asian (Chinese)*
My art world term: *Woman of Color (Yellow)*

The following two letters were written in 1989. I believe they pertain to the relationship between artists (and especially women) of color and the academic art world. The first letter was to the chairman of a search

committee for a western university; the second letter was posted in a university art gallery along with my floor installation, "Where is Mao?," which was the object of some confusion by both American and Chinese students.

Letter to the Chairman of a Search Committee

Dear Professor:

With this letter, I would like to withdraw my application for the drawing/painting position in your department. I have based this decision on the interview I had with you at the College Art Association meeting in San Francisco.

To begin with, you didn't have my slides at the interview, and were apparently not familiar with my work. In fact, your comments suggested that you thought I was a traditional Chinese artist with little or no sense of contemporary art. Consequently, the interview was more about my racial and cultural background than my abilities as an artist or an educator, even though I'm sure you believe the reverse to be true.

From my perspective, your questions were arrogant, patronizing, condescending, and full of false assumptions. For example, you continually noted your "concern" about my nationality, as if being Chinese automatically meant that I was unqualified to practice as a contemporary artist in America, or to teach American students. I wonder, was I the only candidate to be asked such questions? Or was I just your token "woman of color?"

While you allowed me a "profound knowledge" of Chinese art and culture, you questioned my ability to "help students survive" in this one. Being a professor in a university, however, does not necessarily involve teaching students to survive. Such a notion has never occurred to me, either here or in China. Rather, I believe, my responsibilities to students involve preparing them to take themselves seriously as artists, as well as to expose them to as many different aesthetic and cultural viewpoints as I can. In fact, diversity is precisely what I can offer American art students, and what is more "American" than pluralism?

But what disturbed me most about our interview was the underlying assumption in your questions that American art and culture is somehow monolithic and uniform, more like "us" than "them." At best, your assumption is merely academic; at worst, it is racist.

Finally, I am left with several "concerns" of my own about art education in your department, and since you seem to have yours as well, I don't wish to add to them by being Chinese at —— University.
Thank you,
Hung Liu

Letter to University Students

Seventy-five years after the famous battle had been fought, the former soldiers, from both the North and the South, gathered together at Gettysburg for a spectacular banquet instead of a battle. Their average age was ninety-three. One of them said: "I am enjoying it more now than I did seventy-five years ago."

In order to understand the past—we call it History—we need to have a distance, a gap between Now and Then.

When I was in China during the Cultural Revolution, I was sent by the government to work in the fields, as were thousands of Chinese students, intellectuals, and artists. At that time—in 1968—I didn't understand what was happening to me and to the whole nation. "We the people" lost families, jobs, health, and sometimes our lives. Bending over in the sun, laboring like a cog in the proletariat machine, I experienced both physical and spiritual oppression. Time seemed endless, but after four years I was able to return to Beijing, my family, and my education.

In 1989, I find myself once again bending, but this time over a gallery floor as I place fortune cookies (which are American–Chinese inventions) on the face of Mao Tse Tung. It reminds me of the rice fields, but from both an ironic and a historical distance. If you understand the difference between a rice field in China and a gallery floor in America, then you may understand the satirical nature of my "memorial" to Mao. After all, I am here, but where is he? And like the Gettysburg veteran, I am enjoying it more now than I did twenty years ago.
Hung Liu

Speaking on behalf of the academic art world, Moira Roth once said: "We should work *with* artists of color, not *on* them." Perhaps there is hope for cultural and aesthetic pluralism in the 1990s. As a classically-trained Chinese artist in the United States, my responsibility is *not* to assimilate, but to express my Chineseness as clearly as I can.

Fern Logan

African American artists still remain in the shadows of American history. This country was built on the blood, sweat, and tears of many different cultural and racial groups. Isn't it time that the "golden door" was opened so that we can benefit from the richness of experience that we all have to offer? Why is it that the best and brightest of our talent have a hard time even making a living at their art? Most of them need to teach to afford the security that advancing age demands. These are people who teach their art to others. Most of these others face no racial barriers. Our artists prime them and let them go on to the great American museums and galleries while the masters try to eke out a living and create their art between classes. Eventually they will accumulate enough of their own work to mount an exhibition somewhere on the fringes of the art world. If they are very lucky, have been around long enough, have gotten to know the right people, their work will be shown in a major gallery. For the most part, the national museums continue to look the other way. Great American artists like Romare Bearden, Jacob Lawrence, and Elizabeth Catlett are still relegated to the back shelves of our major museums, virtually unknown to the masses; this is concrete evidence of a major malaise afflicting our mainstream historians and curators.

Despite the obstacles, the Harlem Renaissance continues to this day. There are writers, painters, sculptors, printmakers, filmmakers, photographers . . . all creating extraordinary works of art. Today we can claim the "African American Renaissance" because these talented people of color are spread across the land from "sea to shining sea." It's time to recognize the fact that we *share* the history of this country; we are Americans. When one discusses or exhibits American art, African Americans are to be included. And we have a long history of masters that were never included. We need to *demand* that Eurocentricity come to an end.

It's hard to talk about the tragedies of artists like Jean-Michel Basquiat. He was adopted by the establishment like a prized pet. He spray-painted graffiti on the street one day and was selling his work for hundreds of thousands of dollars the next. He didn't earn his place in the sun—he was thrust into an inferno, and he was destroyed by it. His remarkable success was even featured on the cover of the *New York*

Times Magazine. He was photographed barefoot and, as I recall, dressed in a suit. I remember being thrilled to see a brother artist featured in such a prestigious publication, but when I studied the visual message being conveyed, I had the feeling that they were telling us that they had let a little savage into their living rooms, how quaint. When will Jacob Lawrence appear on the cover of the *New York Times Magazine*? Here is a genius who has been dedicated to his art for nearly fifty years and he is still creating masterpieces. He is a black man who has had major museum exhibitions, whose work is in the permanent collections of many public and private houses. He tells the story of African Americans with artistic beauty and dignity. Why isn't he showcased on a national level? He is definitely an artist that *all* Americans can be proud of.

Just as the racial barriers fell in the field of sports and African Americans excelled, as the racial curtains lifted on the stage of music and African Americans excelled, and as the lights in Hollywood are beginning to shine on African Americans and they are rising to the applause, everywhere we are "*allowed*" to show our talent, we excel. Yes, it's time. Time for America to understand that by letting all her people share in her heritage we will all rise. No one has anything to lose and we all have everything to gain. It's the American way!

Juan Sanchez

Statement for the De Facto Racism in the Visual Arts CAA Panel Discussion

If art is to create and contribute to the necessary critical consciousness of what is culture and society, in order to assist in the further development and evolution toward change that is humanistic and just, exchange and communication must be established through the participation of all people. That is, all people bridging gender, race, class, political and sexual positions, and nationalities. If art is to respond and take responsibility for the cultural and social fabric of a people, it must extend to the very needs of our time culturally, socially and politically. All people committed to such cultural and critical dialogue must be recognized, invited, involved, and heard. If art is to respond to and reflect yesterday, today, and tomorrow, people of color who have greatly

contributed historically and aesthetically to the creative and artistic processes of art and society cannot continue to be omitted, segregated, and ignored.

APARTHEID in the United States, not only in the so-called art world, but also within the social, political, and economic structure of North American society, continues to exist and has never left. Even when millions of North American whites are protesting and moving forward against apartheid in South Africa; celebrating and contributing to the destruction of repressive and segregating walls in Eastern Europe; and fighting for democracy in Latin America and other oppressed nations; oppression, repression, and racist segregation among other inhumane situations continue here in our own backyard.

The reality, as far as artists of color are concerned, is that we are an invisible people. A people who continues to fight for true representation and recognition in history, let alone in group and one-person exhibitions, art publications, and art history books. Only a handful can claim to be actively exhibiting artists and many fewer than that are represented in commercial galleries in addition to selling and placing their art into important public and private collections. There are hardly any museums, nationally and internationally, that have a fair collection of art by contemporary artists of color. How many art schools in the United States can claim to have a decent representation of African Americans, Latinos, Asian Americans, and Native American Indians, among other people of color, in their faculties and student bodies? The obvious absence is absolute. What is most evident is the fact that we as a people living within the framework of neglect, marginality, oppression, and repression are a censored society. A society who apparently have no civil or human rights—because we are not white—to participate in the definition of American or United States culture. According to Chicano visual artist and activist David Avalos:

> It should be clear that the mainstream of art is less a "legitimate territory" and more a license to exploit taxpayer-supported cultural institutions, creating a racist and undemocratic territory within a nation of democratic ideals. This country's cultural apparatus was created and maintained to showcase the cultural superiority of European-derived values. As designed, they were never intended to support and nurture the cultural values of those citizens conquered by the United States.[1]

Colonialism is an epidemic—a widespread racist disease, an uncontrollable, prevailing condition imposing direct political, social, cultural, and economic control by one nation over another. As the process of colonization moves forward the colonizer moves to destroy the colonized people's sense of their own identity and existence by wiping out the people's history, language, and culture. Native American visual artist, poet, performer, and activist Jimmie Durham brings a very clear perspective to this question of colonialism pertaining to the plight of his people:

> . . . with Indians we're invisible, and that is our discourse, I think that is the main discourse of this country, that Indians are invisible. I think that is the engine that drives the culture of this country, the fact that Indians are denied. We don't exist in this culture, in this history, in the consciousness or the discourse of this country. But it's our country, we're invaded; we're colonized. And if we're that invisible that must be the agenda item, that must be what the discourse is about.[2]

Colonialism, Apartheid, and Sexism are definitely the AIDS and the GENOCIDE of the oppressor. Cultural imperialism is another level of colonialism (a colonialism that has been so persistent in the art world) where the colonizer and descendants aim to rob and reinterpret the culture of the colonized. Artists of color cannot even participate in the dialogue pertaining to their own sense of ethnic and racial culture, history, and aesthetics. The cultural imperialist appropriates, edits/censors, distorts, and exploits the elements that belong to the colonized. Interestingly enough, artists of color are even penalized for using their own ethnocultural aesthetic and conceptualism in their creative expressions:

> Appropriation is a postmodern continuation of Picasso's first use of motifs derived from African sculpture. The birth of modernism is tied up with colonialism. To appropriate is to take what belongs to the "other." To reappropriate is to take back what has been taken from you. Whereas appropriation is fashionable, reappropriation isn't. The former technique is considered an integral part of contemporary trends and mainstream style, while the other is ignored.—John Yau[3]

Liberation takes on many forms in its manifestations. What has become clear to the oppressor is that culture in our music, dance, litera-

ture, theatre, and visual art can have its insurgent effects both physically and metaphysically. Cultural aesthetics has intensity in its subversive potential for freedom. Colonialism cannot permit this, although at present it is happening very much in the same manner that the slave owner prevented his imprisoned slaves from embracing their African culture, language, and identity, enforcing the question of life and death into their enslaved existence.

The outcome of Senator Helms's contemptuous attack on art and his attempt to implement censorship tactics from the most reactionary, conservative, sexist, and racist perspective in the United States is of tremendously grave concern to us all. But I am having great difficulty trying to save a system with its own ingrained sectarian and colonialist structure. Certain sectors of the art community are protesting the potential disruption of a federal, state, and city cultural funding system that is viewed as being "perfect" and as working. But considering the contradictions and deficiencies of this "perfect" system does not leave me much to want to defend. As a black Puerto Rican struggling against second- and third-class status in this country, in addition to colonialism, I cannot see how much more intensely government imposed censorship in the arts will really affect me or my people. That is to say, we have always been a censored people, omitted, and erased from anything and everything that we as a people have contributed to positively. Yet we never really heard a strong enough voice from other sectors of this society about our plight:

> Everywhere I look, TV, talk shows, art exhibitions, newspaper editorials, art forums, and demonstrations all addressing this plague that threatens all our individual liberties. Somehow this demonstration of concern is reminiscent of the reaction to the drug epidemic after it reached the suburbs. I asked myself, "Is this just another fad that will go away once the white community no longer feels threatened?" I ask you my fellow artists and citizens, "where were you during the sixties, seventies, and eighties?" I do not recall this type of outrage regarding the lack of representation of artists of color, although most of us know that African people and all peoples of color were and still are in essence censored out of the art world, let alone United States and world history. . . . I do not see this issue of censorship separate from other social issues confronting America. I personally find it impossible to talk about censorship without

talking about racism, sexism, imperialism, and a declining economy. . . .
The idea of censorship goes beyond Jesse Helms and our elected officials.
In our culture, peoples are censored through the process of omission and
exclusion. . . . These painful truths plus others are the realities we will have
to address in the nineties if we are to solve the problem of censorship. . . .
We are all in the same boat and as Malcolm X said in reference to another
painful time in our history, "The chickens have come home to roost."[4]

This statement by Willie Birch points to the fact that we are still
fighting for our civil and human rights for employment, fair housing,
medical benefits, education, nonsegregation, and equality, not to men-
tion against racist police brutality and other forms of racial violence we
encounter on a daily basis. Our political and social battle against in-
justice in this country is also reflected in the many African Americans,
Asian Americans, Native American Indians, Puerto Ricans, and Chi-
canos as well as progressive whites who are presently occupying Ameri-
can jails as political prisoners.

Now that the whole art world is concerned about government cen-
sorship and repression, where do we people/artists of color fit in? Do
we fight to defend and save a system that has never been perfect, that
has never considered us in the first place, and is still not considering us
in this dilemma? Or do we wage a battle within a battle in the hope that
we can kill two imperialist tendencies with one strong and unified
stone? Killing racism, sexism, oppression, and colonialism while at the
same time helping to resolve the same problems that are now affecting
certain liberal sectors of a colonialist society?

I pray that the answer is a unification and a breaking down of another
wall by the same name, APARTHEID, here in the United States.

Notes

1 *David Avalos Presents Cafe Mestizo "A grind so fine . . . you give in to the
 pleasure,"* Intar Gallery, a multicultural art space, New York City, 1989,
 p. 5.
2 *Jimmie Durham: The Bishop's Moose and the Pinkerton Men,* Exit Art,
 New York City, 1990, p. 32.
3 John Yau, "Official Policy," *Arts,* September 1989.
4 Portions of a statement written by African American visual and perfor-
 mance artist Willie Birch. The text was written and requested specially

for my "De Facto Racism in the Visual Arts" panel discussion presentation, College Art Association, January 15, 1990.

Robert Storr

Is there racism in the art world? Of course. Subtle and crude, it crops up in every imaginable form from Andrew Dice Clay-type "humor" overheard in university art departments to the embarrassed looks of dealers and critics when they fail to recognize the names of established artists of color. Even among the well intentioned, racism manifests itself in language that acknowledges difference but often increases alienation. Habitual recourse to terms such as "minorities," "the Other," "Third World," all beg essential questions of vantage point and connotative bias. "Minority" relative to what majority within which boundaries? "Other" than who? "Third" according to what hierarchy? No matter how neutral or inclusive the words used, misunderstandings still ensue. The generally preferred collective "people of color" itself raises as many problems as it solves, by re-emphasizing skin color as the ultimate criterion and homogenizing all shades that are not pink. "People of culture," one might better say were the phrase not so vague, given that what most distinguishes different ethnic groups from each other is a matter of heritage for which pigmentation is an uncertain code not a certain cause.

These, however, are merely the linguistic symptoms of a malaise which is social and historical—not to mention political and economic— and, as with all such conditions, curing the symptoms is meaningless. Indeed, the discomfort all concerned now feel when choosing their words is a positive sign insofar as it is a constant reminder that we do not easily understand one another. Hence, while we must struggle to overcome a sometimes crippling self-consciousness about what we say, the ways in which our tongues continued to betray us in the 1980s have demonstrated beyond a shadow of a doubt that, like all other segments of American society, the art world has yet to fully comprehend its capacity for implicit or explicit prejudice or fully own up to its habits of ignorance and "benign neglect."

The fact that the issue of racism has at last returned to the fore is thus heartening in exact proportion to the amount of direct and awkward

dialogue it has prompted. The country is in for some rough times and that talk will get rougher too, but we have turned the corner on the public complacency and covert bigotry of the Reaganite years. The outstanding question for all parties to this renewed examination of racism is the same as that which arises everywhere that we confront the damage and dereliction of the neoconservative epoch. Once we begin to rebuild an active Left, how do we prevent its succumbing to the spasms of self-righteousness and short-term thinking that has made the history of social progress in America a series of desperately hopeful episodes and devastating backlashes? So much that needs to be done now is simply a matter of recovering ground won a decade or more ago and since lost. How this time do we make change for the better last?

Over Time:

A Forum on Art Making

We asked a diverse group of artists who have been working for at least twenty years for their responses to the following questions.

How long have you been practicing as an artist? Over the period that you have been working, how do you develop or sustain your art? What keeps you motivated?—or is motivation an active concern at all? Do you find you reuse motifs and styles, or ideas and techniques from earlier work, and to what extent is this a conscious part of your practice? Are you concerned about the ways your work repeats itself over time, or, in contrast, how it breaks from itself?

How has being part of a specific generation marked your work and affected your ability to adjust to changing stylistic and ideological concerns in the world "at large" as well as in the art context? How have the themes, ideas, and goals of your work evolved from your early years to the present?

Rudolf Baranik

Shards

In 1951, while I was studying with Fernand Leger, I had my first one-person show in Galerie Huit (Gallery Eight), a tiny cooperative gallery run by young

American artists on the Left Bank of Paris. It astonishes me that in rereading the first reviews in the Paris press my work was described in very much the same terms it continued to be for four decades later in this century: ". . . a great silence on the verge of turbulence, a formal sensitivity which merges with underlying social concerns." It surprises me because to me the very early work, which I have in photograph, is far from it, but my goals, intuitive and not cognitive, have not changed through the years, even during the Vietnam era, late 1960s into the 1970s, when I did the Napalm Elegy paintings; it remained formalist and poetic, a silent outcry. I think it is stronger that way.

While the above answers in essence most of your questions, I want to give here some fragments of my thinking, done as postscripts after the work is done. These are from statements I read during the years at the long string of panel discussions of which I was part, panels under slightly different titles yet adding up to same, such as Art and Revolution, Social Intent and Formalism, Society and Art, and so on. There I argued with my friends who talk about "political art" and "activist art," limiting art's formalist and poetic prerogatives, and with my friends who talk about the impossibility of "mixing" ideology and art.

Why reclaim the term "formalism"? The answer is not an easy one, and yet it is clear. In the great variety of ways it was used we find one common trait: hardly anyone uses it favorably in self-description. When used to describe others it is always negative.

In art, formalism has been and is the red herring used by those who are opposed to the poetic prerogatives of art. The dictionary definition of formalism ("rigorous or excessive adherence to recognized forms") was used in the Catholic church, in societal mores; but in art it is something entirely different: ideological social realists used it against abstraction as such; "populist" philistines used it against so-called "high art"; know-nothings used it against any art of sophistication. Under the banner of antiformalism, art is being called to task to be clear, serviceable, responsible, useful, and, above all, dependent. Thus it becomes important to take the term away from the detractors, to claim it for all-powerful art, as the term black was taken away from the racists by American blacks who made it their own. At the same time it also takes it away from the stylistic sectarians (Greenberg et al.) from those who are satisfied to build theories on thin diagnostic profiles.

Democratization of society will make art, per se elitist, more democratically available to the people but "democratization" of art will not

change society—it will simply lessen the reason to change society for the better because life will be more impoverished by the loss of a subtle and complex art after the change.

Art is an elite activity, yet to create art is not to be an elitist, though in defense of the activity artists may become so—or perhaps they do not become elitist—just defiant, as did Ad Reinhardt, an abstract artist and a socialist, when he called his magazine "It Is."

"The necessity of art" overshoots the target. Art is not necessary—it is simply unavoidable. In its own dark, uncontrolled, unpredictable way it carries the best and the worst of human expression. It does not "enhance" life as is often said—it churns it, invades it, disturbs it. Therein its power.

To mystify art and to recognize art's mythic force are very different things. In fact those who mystify art do it as a substitute for sensing the myth. Often just describing the myth becomes an act of mystification. Sontag was right when she spoke "against interpretation." . . . Mystification and de-mystification are two activities which feed each other while art pays no attention.

Art lives in the night, in the dark bypasses of dailiness. Concrete analysis of art thinks of itself as a powerful searchlight in the darkness while in reality it is a dying flashlight.

Arthur Cohen

How long have you been breathing? How do you develop or sustain breathing? What motivates it? Or is it (motivation) an active concern at all? Does your breathing repeat itself? To what extent is repetition in breathing a conscious part of current breathing? Are you concerned about the ways your breathing repeats itself? Or, etc., etc.?

How has being part of the human race marked your breathing? Does it change styles? Does changing ideology affect it? How has your breathing evolved? Are you still breathing? *And* most importantly, could you stop breathing for a moment to observe and write about it? We're looking for MEANING, and surely meaning must lie in words and not in life? In living?

Hermine Ford

I've been working consistently for about twenty years. I'm motivated to work because I start to feel empty and lethargic when I don't. The work comes out of what I value the most and feel closest to. I keep trying to get closer. The content has been pretty steady. It comes from spending time in relatively uninhabited places on the planet Earth, and reading about, looking at pictures, maps, and diagrams of same. The various ways of combining this material has endless possibilities, and that accounts for changes—shifts of interest—in the work. I make certain willful changes to keep the making of each painting fresh.

I've been a witness to the art world since the 1950s, so I don't always take seriously each little hiccup in art world trends. I like to be surprised though, so I do pay attention. I think I have a large overview. I don't care much for style or ideology as separate concerns. The work from any age that I like the best is where you feel the humanity of the artist near.

Nancy Fried

What motivates me? That's like asking why I eat so much chocolate—I love it, I feel addicted to the high I get working.

What motivates me? My life motivates me and the work gives dignity to my day. My work has always been autobiographical. Before I called myself an artist, I was a hippie sitting in my kitchen creating scenes of my everyday life in dough. My images are directly affected by my life. My work is about my survival. I don't sit down and say "I'm going to deal with that pain," it's that the image I see is a reference, a symbol for the pain or experience.

The first time that I had breast cancer four years ago I dealt with the fear, loss, anger, and regeneration in my work in a very different way than I am now dealing with having just had breast cancer again. Four years ago I had been making sculptures of full-bodied women using myself as the model. After I had the mastectomy I continued to use my body as the model but the content and form changed. Feeling very fragmented, I made only the torso, with one breast and a mastectomy scar, rather than the full body. Survival was my motivation. The work

helped me to accept my body and to even find it beautiful in its new, altered state. Putting the fear, anger, and pain into the work helped me move through a process of acceptance and regeneration very quickly.

At a point the cancer and mastectomy stopped being a motivation. The torsos continued to have only one breast and a mastectomy scar but that was totally incidental to the content of the piece. For a while I felt obsessed by my niece's pregnancy because she was only nineteen. That obsession became the motivation for my work. Then I became fascinated by the penis as an icon. I put penises in altars, on sarcophagi and on the stations of the cross. In January, just as I was losing interest in the image of the penis, I found out that I had breast cancer again. The penis immediately disappeared. I hadn't planned to have breasts in my work ever again but what was my option? The minute my breast doctor told me that I needed a biopsy I saw a Mexican-type altar with rows and rows of breasts. There was the breast again and the need to make it but now I needed to put it in the context of suffering and spiritual transcendence. The breast, now isolated without a torso, reappeared in Mexican-type altars, on sarcophagi, or in chapels. The pain and fear were the motivation and the work was the relief from the suffering. I made an altar with a cross and nailed a breast to the cross. It felt so great to nail that breast up that I thought maybe I should go into the mail-order business and supply a cross, breast, and hammer to women who had had breast cancer. One altar had a cross with a small breast nailed to it and a mound of discarded breasts at the base of the cross. By transforming and transcending the pain I have had the luxury of never having to say "Why me?"

My work has never been defined by what is happening in the "au courant" art world. I don't censor the images because they're not "cool" or might not be very saleable. I do what I do because I have no option.

Leon Golub

Years as an artist
40
What keeps one motivated?
1. Schizoid splits—desperation to euphoria . . . euphoria to desperation.
2. Daily working practice.

Conscious awareness of the reuse of motifs or ideas, etc. from earlier work
Yes/no/conscious/unconscious.
Concern about work's repetition or innovation
Yes!
Generational location in respect to changing stylistic and ideological concerns
1950s: not an issue. 1960s and 1970s: a towering issue. 1980s: not an issue. 1990s: ?
Ideas and goals into the present
Intended goal: to head into real! issues in real time/media time. Results: ?

John Goodyear

My recent work relates most to my earliest work done in the 1950s. The "middle period" begins to feel more distant. I work in series which change abruptly for unknown reasons. The things within each series look very much alike. Making works which consist of more than one part is a trait that has continued up to now.

I'm sure I'm trapped in a generation. But I'm not sure what that generation believes. As my friends and I grow old together, I notice some tend to stick with ideas for which they became known, others even older than myself have come up with innovations which have helped define the artistic present, still others like myself keep trying new things with different degrees of response. There are other categories besides "generation" which are more delimiting. Being a white male is more of a box than being sixty.

A motivation for my work is the realization that so much is hidden from us. Not only should we try to find out what is hidden, but also we could provide in the work something similar to the life experience; more is given than we can know.

Nancy Grossman

June 28, 1991

This afternoon the temperature has reached a humid 100° in New York City. Very uncomfortable. I've been suffering with a headache all day

but for an interlude when I opened the door of my un-air-conditioned sculpture studio where, a few days ago, I had begun to remove the mitered one-by-twos which framed a 1960s wall construction. Some of the leather in the piece had become dry and needed to be restored or perhaps replaced. Although I had no intention of working on the piece today in the light, airless space, somehow I began to approach it. An hour passed, another—no headache, no worries, no gender, no body. A closed space, a dream space, an ecstatic losing of my care-worn conscious self. That's the way it is sometimes, like going out to play.

I've been a working artist for the past thirty years, showing in New York City galleries since 1963. The greatest interest in my life has been art. I keep going back to it again and again for my excitement and sustenance. It is my way of understanding existence, myself, and other people. And it is the only thing I ever really wanted to do. I made the right choice. Art is my fire, my light, my power to transcend the limitations I was handed as a child. It holds the possibility of expressing the heart of the matter and coming closest to the truth. Because we humans, even at our most formal and pompous, are so puny and so short-lived, we need all we can get—recombinant collage of everything we touch as a representation of so fleeting a reality.

The body of work which I've produced in the last thirty years may simply revolve around my own body. But then I may be, for all intents and purposes, a heavenly body or the Wizard of Oz.

Yvonne Jacquette

1. My mother kept giving crayons and paper to her seven kids to keep them busy and out of trouble. I grew up thinking everyone was an "artist." The others woke up to reality. I just never stopped "working," or "practicing." Thirty-five years ago I quit art school.

2. Most of what I do starts with direct perception. I'm most fired-up by experiences not so commonly found in art: the aerial view, the oblique view, night light. After working from nature I work from drawings.

3. Curiosity keeps me "motivated." The gap between what I want to get and what I do get is interesting. Sometimes gaps found while working on another idea lead to a new direction. Hindsight shows up personal connections I hadn't realized at the time. I've found some stimulation when appreciation is evident.

4 & 5. I'm after paintings that vary quite a bit from each other and especially changes evident from one show to another. The longer I work the more possibilities I have the illusion of having. I like a linkage with former work but I'm after the breaks. From inside the differences are probably felt to be wider than they appear to others, however. An image in black and white is very different to me than when it's explored in color. Scale also alters the meaning. Materials push one further than expected.

6. My generation was the next after abstract expressionism. There seemed to be a fear of self-aggrandizement in the work but not in lifestyle. Astute literalness (rather than mythic concerns) seemed to be a good path for me but now my personal cycle has rotated to more interest in political, allegorical, and symbolic pictures. Starting "tight" is not a bad discipline for later "loosening-up." I can't take credit for my generation being able to change in the world or in the art context.

7. The only "evolution" I can experience about my painting is the way I feel less obsessed with "control" and more interested in opening up to a new set of challenges.

Ellen Lanyon

At fifteen I began working in the drafting department of a foundry equipment company. My task was to disassemble machine parts and draw an exploded view of the entire mechanism. The job demanded accuracy and thus, it dialed my responses to precision and fidelity. My vision became influenced by this process of fragmentation; the floating juxtaposition of objects and how they relate to one another to create a whole.

By nineteen I was in awe of and inspired by Sienese and Florentine predelli, so I began to work in egg tempera and gold leaf. The content was urban Chicago but the exactitude of perspective which was demanded by the machine rendering now became up-ended and distorted. The metaphysical entered the scene and established a permanent position as dictate to all my work from then on. But media changed as did content; to oil, then acrylic and, soon, back to the egg.

My images evolve through a stream of consciousness which suggests the narrative and embellishes the combinations. Old friends, both animate and inanimate, reappear, not as a premeditated scenario but rather as a spontaneous theatric. Transformations, prestidigitations,

and the anthropomorphic universe are all constant players in the drama that unfolds. Motifs do seem to be cyclic but I do not question their reappearance. On one hand I am a very pragmatic person but my art reflects and constitutes my other side, my very private side.

I've now been at it for fifty years. "We," in Chicago, were encouraged to be fiercely individualistic with form and content, to resist the long shadows of New York art which fell across the prairies. More than a dozen years ago I moved East and, as a result, my work has changed. It is still private and devoted to representationalism but it has intensified as it responds to the demands of a more universal language.

Ann McCoy

Houdini said the hardest trick was to get out of bed in the morning. Sustaining oneself as an artist, and making body after body of work is also not without its difficulties. At times I feel as though I have signed on to a whaler. The voyage can be perilous, the search for the whale (the self) taking one through the worst sorts of storms. In times of exhibitions that don't sell, long hours, loneliness, and dull teaching jobs something else is required to renew the task.

Growing up in an adoptive family was not a happy experience, but one that forced me to draw on my own reserves. Living in Colorado and later New Mexico, I had an abundance of nature around me. Being alone in nature herding cattle was always a renewing experience. A second source of renewal was the Catholic church. I read the lives of the saints, the mystics, and visionaries. In rough times the saints are still my support. Not unlike the mystics, the artist makes a spiritual surrender, seeks divine aid. The artistic work is part of an inner process which is in part a spiritual one.

In the Catholic church I first discovered this inner world which has become expanded to include both nature and the collective unconscious, the world of dreams and visions. My work involves psychic interiority and introversion. I work with a Jungian analyst and keep journals of my dreams and visions. The art comes from the dreams. I am the dreamer but the dreams have a life of their own, an intelligence and language of their own. Dreams are for me letters from gods known and unknown, heavenly and chthonian.

As an artist I think of the ancient alchemists who said prayers at the

beginning of their work, and dedicated themselves to the process with complete sincerity. Their work involved an outer task which mirrored an inner process. For the alchemist the secret was to keep an even fire burning in the furnace, the correct attitude of devotion, and to accept the new whether it came in the form of an eagle with two heads or a vision of dismemberment and mortification.

I renew myself through introversion and incubation practices by paying attention to the dreams brought to me by forces I do not fully comprehend. This requires an inner attitude and prayer. I feel more like a midwife than a creator.

Melissa Meyer

Unlike grownups, children have little need to deceive themselves.
　—Goethe

Whoever is not a misanthrope at forty can never have loved mankind.
—Chamfort

All children make art. Since childhood my work has developed and sustained itself from my life, at times difficult but rewarding. I have looked and thought about art and life, and I have tried to put this in my work. My generation does not include very many women abstract painters who are currently visible in the art world. This generation has flourished with other media and other concerns. One reason could be that by the late 1960s abstract gestural painting was devalued and consisted of what Philip Guston called "the empty gesture." In 1974 I was an art student in Provincetown and the artists Leo Manso and Victor Candell would say to me, "you choose your art parents and then you have to leave home again." I chose older art parents—ironically like my own "real" parents.

For an artist, just surviving is a form of success. Stubbornness and the strength to make sacrifices are some important ingredients.

Howardena Pindell

When I was eight I decided to be an artist. I was sent to the Fleisher Art Memorial in Philadelphia for a Saturday class in drawing. I felt very

intimidated as I was the youngest person. I do not remember if I was the only person of color. I continued to take Saturday classes in various programs in the area (Tyler School, Philadelphia College of Art) until I graduated from high school when I was sixteen. I was determined to be an artist and was inspired by the presence of work by Henry Osawa Tanner in the home of one of my friends who was one of his relatives. There were many black artists in Philadelphia plus excellent collections (mostly European art). There was not much of a gallery system. I did not feel it was odd for me to be an artist and was frankly quite amazed at how closed the art world was once I left Philadelphia. Not that Philadelphia was open, on the contrary, but people were working and there was not the massive commercial gallery and art trade publication network we have today. I felt there was always someone to appreciate your work. My first exhibit was in our neighborhood church which was a black church (the Presbyterian church was segregated at the time).

I spent a lot of time in the Philadelphia Museum in the Arensberg Collection. I was very fond of Duchamp's work and landscape painting. There was always a split for me between traditional painting and the avant-garde. I was fond of them both. I was primarily trained in traditional oil painting but gave it up (the use of oil) after becoming allergic from using too much lead white. They never taught about the hazards of lead white until after I graduated. Art hazards are a relatively recent concern.

I sustain myself through sheer tenacity as the art world does not want artists of color to be full participants. I work because it is my life's work. I have no other choice. I do not get bored with it or impatient unless I am overtired. I could have been a classical musician but hated to practice and had terrible stage fright. My work was primarily about process until a freak car accident in 1979. After that my work became autobiographical as part of my desperate struggle to heal myself. I had a brain injury because of a concussion and not everything was working right . . . plus I had severe headaches and had a very short fuse as a result of being very uncomfortable. I also had trouble walking.

Since autobiographical themes are really endless and there are so many things that I want to explore, I find that I am not at a loss for ideas. More at a loss for time. I do a lot of reading and research and now do almost as much writing as I do painting. I have a series that I started in 1988 on war, racism, and foreign policy. I am working on a painting about the Gulf War and have completed a long article about the war

which will be published in Asiba Tupahache's *Spirit of January.* My work repeated itself more with subtle variations when I worked with process in the late 1960s and 1970s. Now there is not that much repetition as each painting is sort of an odyssey or epic. One unrelated tangent I am following is an interest in science. I loved science as a child (biology and balancing chemistry equations) and I am particularly interested in new physics and quantum mechanics and how it ties in with spirituality.

I do not feel a part of the present new generation, I guess, because I was brought up in a different time frame. I was born during World War II, in 1943. I remember the atomic bomb and the dark window shades for blackouts and rationing of food. I remember segregation and the aggressive oppression as opposed to its more subtle form now. I remember the civil rights movement. I was basically brought up on radio not TV. I thought TV was frivolous and can only remember Ed Sullivan, *This Is Your Life,* Ernie Kovacs, *You Asked for It,* and the Mouseketeers, Howdy Doody, and *Flash Gordon.* They certainly had nothing to do with my life. The difference also is that then there was not the massive advertising or the horrendous violence which has been so normalized. The violence of racism was there but there was a silence around it because no one in power wanted to acknowledge it.

Travel has made the big difference for me in that I did not get isolated in the American pathology. I lived in Sweden, Japan, and India and spent time in parts of Europe, Brazil, Mexico, Egypt, Kenya, Nigeria, Ghana, Ivory Coast, Senegal, the Caribbean, Canada, and the U.S.S.R. I have always been concerned about the world at large. I spent some of my summers as a teenager in a kibbutz-like environment that was international in the hills of Pennsylvania. The ideal for me is international cooperation as each culture has so much richness to offer. I also worked in a factory for one summer and got a taste of what could happen if one gave up one's education. I am from a very racially mixed family (some are liberal and some very conservative) and have tried to understand or appreciate this. I have been puzzled by the need for one culture to be obsessed with domination of another.

The goal of my work is to share knowledge. This is the reason I have also been writing as well as painting, teaching, and giving some public lectures. I do not feel very much part of the art world because of the restrictive environment that is brought to it by people who are pathologically indifferent. I do not see art and life as separate.

Lucio Pozzi

As a kid, I was involved in poetry and architecture. Then, around age sixteen, I started with painting. It is thus now about forty years since I began.

I keep wondering what drives me. Even on those sad days when I feel I've wasted my life in insignificant endeavors, something persists in leading me to the surfaces I put paint on. It is what I *must* do, for reasons I can not fathom. I guess it regards approaching and never capturing the mystery of existence. The logistic aspects of art, its sociology, psychology, and technique are all subsumed in that.

I constantly allow the return of motifs and procedures in my work. Sometimes I recycle them consciously, but most of the time they necessitate their return in the spiral process of my mind. In the spiral, the mind leaps from station to station in the most unexpected manner, but it always seems to do so within the terms of its own territory, a territory it does not know beforehand. The mind's continuous attempts to break away from its territory reveal themselves in fact as the means for exploring it. It is by way of its endless movements that the mind both forms and discovers its territory. The stations come to be recognized in time as belonging to families, to groupings, which in turn are found to be linked by some (but not all) of the ingredients they are composed by.

From the start of my consciousness, I have found myself attracted by the kind of critical creativity I see both in resistant dissent and in mystical contemplation. I found plenty of both in the 1960s. I loathe the pedantic conformities binding the right and the left in our culture. I try to keep myself alerted to all alternative private and public probes which might offer themselves on my way. The theory and practice of my work have learned from many ventures in their creative moments and disengaged from them in their institutional phases. It is most difficult to keep connected with the truth of experience in a society dominated by publicity.

Jacques Roch

I was born with the condition of the wide-awake dreamer. I can still feel the wind blowing at the temples of my sixteenth year at a time when I

was living on the back of a camel, crossing long stretches of bumpy desert road in search of the well that doesn't go dry. Painting was my love, but one day I had reluctantly to dismount, as we were in Algeria where there was a war going on with the French army and I was a draftable young Frenchman.

Quietly unwinding in the back of my head during the long period of my reluctant military service was a subversive lasso of satire and derision that would later help me catch and drag through the dirt the crassness and stupidity of the French "petite-bourgeoisie."

It was in Paris in May 1968, however, that the real change took place for me. I was feeling closer to the Situationists than to the art establishment. I remember this marvelous sentence on the walls of Paris at the time—"*Sous les paves—la plage*" ("Under the pavement—the beach"). There was a call for a new poetic energy—the Parisian art world was anemic. The system of the Beaux Arts Academy was ossified and centered around the conservative Prix de Rome. Picasso, already in decline, was hard to shake. Bernard Buffet, catapulted to a *Paris-Match*–type fame, was the prototype of the 1980s New York art-star system. Soulages was no Franz Kline and in his small formats, his black bars were shaking. Georges Mathieu was officially crowned by André Malraux as "at last, an occidental calligrapher" as though Gottlieb didn't exist. Mannessier could be dangerously decorative and Bazaine, as a postimpressionist, lacked the tension of his American colleagues. When the American Painting Show was on view in 1965 at the Musée d'Art Moderne, everything fell into perspective. It was in that artistic context in the years following May 1968 that I started to publish absurdist drawings-cum-cartoons in the new magazines of black humor like *Hara Kiri* and *Charlie.*

At the end of the 1960s, I began painting again. The human figure, which had troubled me for several years, found its way into my paintings disguised as semi-abstract signs and caricatural characters that popped from the painterly ground like knots of light or ghost-like figures concretizing space. The drawn line, clear on a colored ground, held the systems of shapes like a luminous net. The slapstick mood and the lushness of color rendered less threatening my private bestiary of violent instincts, bawdy manners, diffuse fear, contagious glee, and even, sometimes, serenity.

In 1973, consulting a subway map on the Rue du Cherche-Midi, I met

my American wife. André Breton would have appreciated the poetic quality of this chance encounter that would vastly alter my geographic, not to mention cultural, situation. Immigrating, I came to New York with a load of the French artistic heritage that manifested itself most probably in my choice of colors as well as my cultlike penchant for Baudelaire, Gérard de Nerval, and the surrealists. The vitality and rawness of the New World mixed with a certain nostalgia for the old gave my work a new vigor and dimension. The anarchic freedom in New York in everything from the way to dress to the vandalistic and desperate graffiti bombarded me with new ideas but the basic program of my work didn't change.

In my recent work, I have been collaging and silk-screening images from my earlier comic strips. The literal absorption of these earlier drawings into my recent paintings is a way to close a circle that continues nonetheless to widen into a target toward which the trajectory of my work has come like an arrow from the past.

Miriam Schapiro

I have been a professional artist for forty-five years.

I have sustained life by working at waitressing, teaching, lecturing, etc. I have sustained art by reinventing my belief system as I go. Since 1970 I have committed myself to feminism and such politics have inspired me. The art is successful for me when the passion is clear and the sensuous language is available to others.

My earlier work moved from one impulse to another. And looking back I am proud of the variety of my myths and styles. I see how I used to project my imagination and how much freedom I allowed myself. I now have a large resource from which to make selections. And that is a great pleasure like going to Bloomingdales and having all the money I need to spend on what I want.

I have trouble with a question that asks me how I adjust to changing stylistic and ideological concerns in the world. I see myself free in the studio inventing ways to bring out of the hidden crevices of my heart that which is stubborn and which asks for more and more strength and discipline for the extraction. If I make shifts I do not see myself following trends—I see yet another aspect of myself which needs definition.

Yes, my current work reflects ongoing aspects of the expression of a woman who meditates on all her original work and like the movie *Rashomon* tries to give another picture of what happened in her art in the first place.

Carolee Schneemann

I WORK TO
put a crimp in the fabric
a break in the thread
to put a stick in the spokes
a brake on the wheel
sand in the gears
a finger in the dike
a shot in the dark
a cry in the wilderness
a light in the tunnel
sugar in the gas tank
oil on the waters
poison in the well
for a twist of fate
for pearls before swine
a needle in the haystack
a drop in the ocean
a coin in the desert
a pig in a poke
to find a snowflake in hell
a flash in the pan
a crack in the shell
a kiss in the dark
a howl to the wind
to see blood on the moon
tears on the hand
a pebble in the bucket
a black cat in the night
to fan the flames
a notch in the belt
to dance with the dead

Richard Tuttle

Sitting, overlooking Santa Fe there are no leaves on the trees—but there will be soon! Only dark pines "individuate." Planted by humans, they stop just at the valley floor—give energy to the mountain above. It looks like Europe. . . . Tuscana! What *is* the base of this mountain? An idea which, if removed, unifies: makes everything look "American."

Last night, I read a story by Mohammed Mrabet about a man who lived an idyllic life, farming, smoking kif, and watching his slugs by the hour. Some French soldiers broke into his isolated world, and he died. This morning it reminded me of seeing a perfectly contented cat one minute, being pounced on by a vicious dog the next.

The space between the two stories reminded me of the space between me and the mountain, reversed it, and brought it back toward me. This was artist-time.

Crossing the driveway yesterday in my imagination, there was a light which went into the gravel. Today, really crossing the driveway, there was a light which did not. Remembering yesterday, I come toward today. And as I do there is a ghost of yesterday made of gravel that crosses, and as he does I see his feet don't touch the real gravel, and the light that enters here where the feet don't touch and the feet should be, is artist-time.

David von Schlegell

In much of the given world there is an early morning freshness which is forever getting lost. Art, which is all about attention, astonishment, and an alive consciousness, should oppose this erosion.

For me, the lost paradise of myth, or golden age, is simply a surviving intuition of a deep past, when attention *was* supreme.

I have been making art for over forty years. My evolution has been like that of the world, with its seeming illogic and its strange driving force. As gravity begins to dominate, *lightness* becomes crucial.

I have been sustained by art, have tried to learn from mistakes (mine and others'), and now move toward simplification of thought and feeling—toward clarity, economy, and silence.

Lawrence Weiner

I PRACTICE EVERY DAY
(AFTER THE FIRST SOLO PRESENTATION OF WORK : 1960,
 HAVE BEEN PRACTICING IN PUBLIC)

ONE THING SEEMS TO LEAD TO ANOTHER

Faith Wilding

I'm writing this in Vermont just before my forty-eighth birthday. I'm blissfully alone in a new studio mostly built by family members, my husband, and myself. Since 1973, I've thought of myself as a practicing artist. But it all began long before that. What was I painting today, for example?—a diaphanous dress shrouding a thick, brownish-pink pupa/bud/sprout/worm. What was I scratching into the hard red clay floor of my bedroom during the midday siesta when I was eight?—a diaphanous dress (which I imagined to be apple-green) to shroud my thick brownish pink girl-child body.

The pupa/cocoon/mummy/worm/sprout form has appeared and reappeared in my work since childhood. It is a "generative" image for me—an image which never can be exhausted, and to which I return time and again to mine another nugget of meaning. And I still scratch my drawings into the paper with tiny pen-nibs or sharp pencils. The compulsion with which this image recurs convinces me that I'm some-how on the right track for what I am searching for.

It is often hard—even impossible—for me to work concentratedly when I am in New York because I'm working at teaching and other things to earn a living. There are long silences in my work—in Tillie Olsen's sense. But still the work seems to continue relentlessly inside me, a process much like that which I imagine to be going on in the pupa preparing for the great metamorphosis. I'll wake up of a morning compelled to go to the studio and work on an image which has wormed its way to the surface. Because of this I experience my art as a contin-uous process—even when there are fairly radical changes in style or technique. I'm always toiling away in preparation for the great meta-

morphosis, and everything I read, see, experience becomes a secret feeding of the great brown-pink worm.

Now that I'm approaching fifty, there's a great urgency to work—I'll do almost anything to make time. And there's a great conviction that this work is my center—that from this I go out into the world and have my being. The great German artist Käthe Kollwitz said: "Ich will wirken in meiner Zeit." Hard to translate this pun, but it means both "I want to be effective in my time" and "I want to be actively engaged in my time." So do I. The kind of art I seem to need to make was encouraged by the regeneration of feminism in the late 1960s and by the feminist art movement of which I was an early founder/participant. Feminism gave me the permission to explore such themes as female subjectivity, the body, sexuality, desire, and anger. And it also gave me the belief that my experience as a thinking person in the world was important; that I could have deep thoughts about the "big" subjects, heretofore (and according to most art history texts STILL) tackled only by the big boys, i.e. the nature of life and death, nature vs. culture, language, politics, belief, myth, etc. I never think of myself as limited because of being representative of a certain generation or art "movement." On the contrary. And I hate to be classified—as essentialist—as "just a feminist," etc., etc. As an artist I experience the unfolding of my work—and the unfolding of myself—from the inside out, and each change makes sense to me in terms of my engagement with the world. This sense of the unfolding has come slowly, and has been bitterly struggled for. But now I see that this is what has kept me going and has sustained me all these years. *Ich will wirken in meiner Zeit.* I want to be engaged with the world through my work.

On Motherhood, Art, and Apple Pie

We asked a diverse group of women artists who have had children for their responses to the following questions on the intersection of motherhood and art:

Views of motherhood as the primary domain of female creativity have shadowed women's claims to creativity in art. And we live in a society which gives little practical support to women who want to work and be mothers at the same time. While we realize that the topic of motherhood has often been somewhat taboo for women artists to discuss in public, we would really welcome the inclusion of your point of view at this time. We have come up with the following questions, but please feel free to discuss this subject from whatever point of view strikes you as most significant and relevant to your experience.

How has being a mother affected people's response or reaction to your artwork? How has it affected your career? Have you encountered discrimination from other artists, dealers, galleries, art schools, critics because of motherhood or pregnancy? Did you postpone starting your career or stop working when your children were young? How would you describe the differences in treatment of male artists with children or of women artists without children?

Did having children enhance your creativity or affect the direction of your work?

The response to this forum on motherhood is worthy of note. We received by far the highest percentage of response to this forum which grew out of discussions between the editors, one of whom was pregnant with her second child, the other who does not have children. Further, many artists expressed enthusiasm and gratitude for the opportunity to write about this subject: "Your letter went straight to my heart," "Thank you for validating this experience," "I cannot thank you enough for giving me the opportunity to write about my experiences as a mother and an artist," "Bravo to you for providing this forum." However, the subject proved too painful for some artists who couldn't write responses. More than one artist wondered how we'd found out that she *had* a child, so separate had children been kept from art world life.

Finally, it should perhaps be noted that these texts refer to many other aspects of experience including issues of time, economics, child care, prejudice against women in general, contradictory views on women who don't have children, societal expectations of fathers and male artists, and the experiences of the children of artist mothers.

Emma Amos

Raising two children while maintaining my identity as an artist introduced me to the concept of "superwoman." But I am reluctant to talk about the intersection of motherhood and art as an arduous experience lest I betray the reality of the lives of the black and minority women I know and idolize. Unlike southern white women's fabled lives as "ladies of the manor," unlike early TV sitcom detergent-queen moms, my heroines were expected to work outside the home. Black women were either domestics or educated to become teachers or social workers, the main professions open to women. My experiences juggling art, work, and home were no more harrowing than those of my college-educated mother, who was owner and partner with my father in her family's business, a drugstore. Both my mother and I had/have secure and accomplished husbands who participated in parenting more than was called for at the vastly different times of our childrearing.

Motherhood caused me to postpone my career in art for about ten years, and then I had to relearn being a painter. Just after my first child was born, I gave up my painting studio. I couldn't take the baby there

amidst the paint fumes to concentrate on ideas, color, form, and feed-ings. When I was able to leave Nicholas after the first year's nursing, I went back to work part-time at my old job as a textile designer and weaver. I continued making prints in my home silkscreen studio, but gave it up three years later when, pregnant with daughter India, the solvent fumes caused a near miscarriage. It was also at this time that I received a novel brush-off from a 57th Street dealer who visited my studio at the suggestion of an artist friend. The dealer told me I could have a show if I painted a whole new batch of work. (The baby was due in just over a month!)

Managing a toddler and a nursing infant is a full-time job, but it leaves plenty of time for boredom and a feeling of isolation. I sewed, learned to make quilts, taught weaving, and designed crafts kits. Always a printmaker, my sanity was saved by Bob Blackburn's insistence that I come to the Printmaking Workshop as often as I could afford to leave the children with my husband or a sitter. In hindsight the work was not groundbreaking, but making prints was a way to continue being an artist. After the children were in school I went off on an energizing tangent by writing and co-hosting a TV series on crafts for WGBH Educational Television during the big "how-to" craze.

When I talk to young artists on the road or at Rutgers University, I tell them about how my paintings tightened up when my only painting time was after the children were put to bed. I tell about being exhausted, about worrying about fumes and inhaling pigment dusts, about the need for private space and time.

I know few males, artists or otherwise, who talk about their children in connection with their work. Men are taught to seek success by sepa-rating work from family and home. What do male artists say when asked about fatherhood?

The women's movement has made it harder to ignore the unpaid contributions of mothers. A "new male" artist is expected to create income, have shows, change diapers, park-sit, shop, and do laundry. A female artist is expected to do all of the above, plus handle children's illnesses, keep pediatrician's appointments, cook, clean, and keep her figure "just in case it doesn't work out." The woman-artist-mother must buy into being "superwoman" if she doesn't want to make an irreparable tear in the fabric of her exhibition career.

There will, of course, be ragged edges and missing threads—everyone

has them—but there are great rewards. Thanks, kids. Thanks, husband. That Nick and India are attractive, well adjusted, accomplished adults makes choosing and living our priorities worthwhile.

Suzanne Anker

Mothers of Invention

> Cells fuse, split, and proliferate; volumes grow,
> tissues stretch, and body fluids change rhythm.
> speeding up or slowing down.
> Within the body, growing as a graft, indomitable,
> there is an other. And no one is present,
> within that simultaneous and alien space,
> to signify what is going on. "It happens,
> but I'm not there." "I cannot realize it but it goes on."
> Motherhood's impossible syllogism.
> —Julia Kristeva, *Desire in Language*

Within the cultural body lies another corpus, the unwritten textual authority determining the value of flesh . . . its color, pigment, muscular tone, gender, age. As a laboratory defines specimens, so does the power-at-large form a taxon of its constituents, through classification systems of identity and taboo. That great mystery, motherhood, is at once glorified and shunned. Creativity is not shut out by motherhood, nor is it usurped by it. Essentialist arguments defining women by and through their bodies can of course be developed in Wittgenstein's terms: where the meaning of a thing is concomitant with its use. However, when singular definitions are reexamined and opened to include identity beyond biology, identity is revealed as *constructed* rather than deter-mined. Only then is the meaning of women extended to include func-tions of motherhood as well as characteristics not connected with it.

Creativity emerges from everywhere. Everywhere, including mother-hood. Metamorphosis and transformation are not strangers to women whose bodies change several times over the course of their lives . . . the development of breasts, the inauguration of the menarche. As artists we watch our work outwardly transmute, we follow the evolution of our

ideas, its ontogeny. So too as mothers, we experience a recognition of the body, not in terms of vesselized genotypes, but in terms of alterity and transfiguration. Motherhood is not reducible to a single activity. Its nature changes with age, circumstances, culture. Even as an archetype it is mutable. Motherhood is difficult, protracted. So are identity and selfhood, as such, regardless of gender. As individuated subject, woman forms the locus of a career, developing and exchanging systemic controls and expenditures. These activities of motherhood and creative work are certainly more alike than different, more connected than separate.

Both the woman artist and the mother operate in constricted terrains, tracts contaminated by propositions entwined with age-long tales of social and determinist Darwinism. To be a woman artist is *to be* a taboo. Is that not wonder enough? To represent rarity, commodity fetish, *and* anomaly? If such characteristics form the semiotic of aesthetic exchange within political economy then how does it come to pass that these characteristics are of little economic currency when applied to the female of the species? Is it not odd that those very characteristics of the commodity fetish, that is, rarity, unicity, and power do not apply to woman as subject? Answers to these propositions lie in the labyrinth of female identity and its cultural locality.

Women's roles in art production, reproduction, and gender construction operate within a sheltered domain dominated by misogynist fear. "To control women's sexuality and reproduction is the ability to control cultural transmission in general," writes Susan Mizruchi in "Reproducing Women in *The Awkward Age*,"[1] an analysis of Henry James's 1899 novel. With clearcut accuracy, Mizruchi recognizes maternal icons as representations of male desire and control, locates the female voice within an excluded category, which, thus, leaves intact the requirements of culture.[2] To view motherhood within this proposition keeps cultural autocracy in place. To control women is tantamount to controlling the future. To control motherhood, to constrain it into sanctified space, to objectify it as glorious teleological performance, is only one of the means to reinforce the subservience of the flesh . . . women as flesh factories. That is not to say that motherhood is not a glorious experience. It is. But it is not to be the capital of the reigning power as the predominant avatar of female sensibility and being. Patriarchal culture is heavily invested in the myth of motherhood. Like

the beauty myth, the myth of the Madonna is a double agent, self-censoring its practitioners. The pedestal is a prison.

Artifacts, theses, and precepts, the products of civilization, are conspicuously apparent as projections of the body.[3] Double-barreled, ironically, these cultural motifs also form the matrix for agencies of control. As ever present and ambiguous cultural myths, these propositions lie dormant in all cultural institutions and their by-products. By projecting socially constructed values back onto the body, specific power-laden agendas injure science and society, narrowing the possibilities of creativity rather than opening them up. To view women, motherhood, and creativity within this mold is a perversion. Stipulating limited level engagement as a requirement to satisfaction drives, perversion enters functional reality as a meek counterbalance displacing the possibility of a more lucrative quarry of full endowment.

Reproductive technology is swiftly entering the world of motherhood, combining organic processes with electronic and mechanical ones. As power broker, the cultural organ unmistakingly and in its own self-interest infuses the biological body with a viral coup d'état. Capturing the cell's nucleus, the cultural body camouflages its own intent, forcing its biological hostage into false and sometimes tortuous acknowledgments. Whereas motherhood, which once was the domain of mystical and religious ideology, now requires the cultural operation of bio-logic: the control of cells, the engineering of organs, the commodity warehouses of spare parts. If evolution is in part our destiny, by bringing indeterminacy and relativity within postmodern scientific practice, then motherhood must be removed from its mechanistic status. If we take science to be an operational truth, then social systems, which are highly reflective of philosophical ones, can reinvent a notion of motherhood corresponding to actual subjective practice. To the contrary, if we do not take science to be operational truth, if we are wedded to more theological concerns, then the relationship between the body, the self, and spirituality are still fertile territories in this ongoing discussion of life. Regardless of one's particular anatomy of belief, questions around motherhood are becoming increasingly complex. Transgenetic species, recombinant DNA, and surrogate wombs have become operational in reproductive technology. Re-viewing motherhood as machine focuses on a future of the cyborg, a scenario grounded in the invention of nature, fusing the artificial with life science.

Andreas Huyssen activates the metaphor of the automaton in "The Vamp and the Machine," where he writes:

> In 1748 the French doctor Julien Offay de la Mettrie, in a book entitled *L'Homme machine*, described the human being as a machine composed of a series of distinct, mechanically moving parts, and he concluded that the body is nothing but a clock, subject as all other matters to the laws of mechanics. Such materialist theories ultimately led to the notion of a blindly functioning world machine, a gigantic automaton, the origins and meaning of which were beyond human understanding. Consciousness and subjectivity were degraded to mere functions of a global mechanism. The determination of social life by metaphysical legitimizations of power was replaced by the determination through the laws of nature. The age of modern technology and its legitimatory apparatuses had begun.[4]

This modernist drama—the control and surveillance of nature—clearly continues its historical ambition, orienting us towards an Enlightenment construction of medicine. Huyssen goes on to say:

> Just as man invents and constructs technological artifacts which are to serve him and fulfill his desires, so woman as she has been socially invented and constructed, is expected to reflect man's need and to serve her master. Woman, in male perspective, is considered to be the natural vessel of man's reproductive capacity, a mere bodily extension of the male's procreative powers.[5]

Technological fantasy is the amalgam of origination and manipulation. This fabrication turns desire (and motherhood), as a lathe turns wood, into an accessory of powerlessness. Motherhood's future carries with it the fallacy of a "maker," masquerading either as patriarchal religiosity or scientific progress. The formation of a life-begetting organism, the creation of Mother herself, imposes upon us an authoritarian will. The construction of techno-organistic reproduction, not by inheritance, but by deterministic command, employs the sensibility of a militaristic metropolis. (Attention all gametes, roll call!) Egg farming, plastic wombs, in-vitro fertilization, and surrogate habitats are myriad examples of the promise of reproductive technology. By what myths are these covenants propagating and sustaining themselves? Who will benefit from this digitally Darwinized future? Woman must look at this equation to evaluate *her* choice. Who keeps the seeds?

Notes

This article is dedicated to my daughter Jocelyn K. Anker. Special thanks to Christine de Lignieres and Frank Gillette.

The source of the epigraph is Julia Kristeva, *Desire in Language* (New York: Columbia University Press, 1980), "Motherhood According to Giovanni Bellini," p. 237.

1 Susan Mizruchi, "Reproducing Women in *The Awkward Age,*" *Representations* 38, Spring 1992, pp. 101–30.
2 Ibid.
3 See Elaine Scarry, *The Body In Pain* (New York: Oxford University Press, 1985).
4 Andrea Huyssen, "The Vamp and the Machine," *After the Great Divide* (Bloomington and Indianapolis: Indiana University Press, 1986), p. 69.
5 Ibid.

Susan Bee

Breaking Ground

I suppose, thinking back, that in my mind painting and motherhood were always closely associated. My mother Miriam Laufer was a painter and as a child I would sometimes go with her to the studio where I would get a piece of paper and some oil paints and would paint in the corner while she worked. Then, when she started exhibiting in the 1960s in the 10th Street artists co-ops, I would go to the openings with her. So it always seemed to me that the odor of oil paint and turpentine and mother were paired.

Only later when I came to decide myself to have children did I realize how incompatible the rest of the world, especially the art world, find these two phenomena. I think the discrimination against women artists with children is rampant and untalked about. It is assumed that if your womb is active your brain has suddenly shut off. Of course, people expect you to give up your studio (too far away), your work (too physically demanding), and your intellect (not enough blood to the brain). And these assumptions come from dealers, other artists, male and female, and critics and curators. "Surely you're not going to keep

on working now." "You're still painting?" "Well, this will slow you down for sure."

It seems that a woman artist's productivity, imagination, creativity, and strength of purpose are expected to vanish overnight. Unfortunately, these sort of expectations can be self-fulfilling and may force a retreat on women artists with children.

What's not talked about much is a possible opening up of creative energy through procreation. Perhaps instead of being the handicap that it is thought to be, childbearing and rearing ought to be viewed as a source of renewable energy and inspiration. A way to open up to new ideas and viewpoints that you hadn't encountered before. Certainly I've found in my work that a reacquaintance with the imagery of childhood—nursery rhymes, fairy tales, comics, pop culture—through my daughter has infiltrated my paintings and penetrated the veneer of fine art that I thought I had built up. Such influences like those of traveling or illness or new companions and other new experiences seem additive. Rather than closing an artist off from the world—these influences can be an opening to further explorations and experimentation and may be incorporated in the work.

Anyway, I would never encourage anybody to have children (or for that matter encourage anybody to start a magazine like *M/E/A/N/-I/N/G*) since it is surely a demanding, exhausting, and often tedious business. However—I look forward to a time in the utopian future when women artists with children are accorded the same respect and sense of entitlement as is currently accorded to male artists with children.

Emily Cheng

MOTHER, ARTIST, HOMOSEXUAL, LAWYER are all words to indicate roles, preferences, and professions which like magnets, attract stereotyping with relish. The job is to derail the clichés before they lead to assumptions and misunderstandings.

It has been difficult for me to be able to make the distinction between good old-fashioned sexist discrimination and more finite types of discrimination: being a mother, Chinese, or for any other reason.

I had always thought I would have a child after my paintings developed and my career was established. But life isn't always responsive to

your own detailed planning. In my personal trajectory, getting a commercial gallery and having a baby happened to have occurred at the exact same time. Now any woman artist with a realistic sense of what's out there would be concerned with how being an artist who is also becoming a mother will be perceived in people's minds. This is where one has to be hyper-conscious about what and where the pitfalls of stereotyping lie, and take corrective measures. (It wouldn't for example, be too helpful for your own image to show up at an opening wearing a pink flowered baby-doll maternity dress and clutching the arm of the father-to-be.) An awareness of how the semiotics in our culture function is helpful. Stereotyping is a social construction and the individual can take a role in altering other individuals' biases. I withheld my pregnant status until I resolved gallery negotiations. That took five months and I became an expert at the techniques of "Clothes as Camouflage." My opening occurred when I was nine months pregnant (no camouflage there) and I saw twenty some shows the day I gave birth. My concern was if I had a cesarean, I wouldn't be able to see the next round of shows. During my pregnancy the most commonly heard sentiment from other women artists was: "You be the guinea pig. We'll be watching. . . ." then nervous laughter. Half the women who came to the baby shower were so alienated from the reality of a real live baby that there were only a few practical gifts, and many cute, cuddly, comforting stuffed animals, an enchanted forest of the memories of our own childhood. Did I stop working when my child was young? You bet. . . . Two weeks. And working in my studio has never been so ecstatic as the first hour and a half back (the amount of time between feedings). Having a baby in my life was truly amazing and wonderful. Having a baby and having my studio time was even better.

I've never been aware of the difference in treatment between men with children and myself with a child. It's either because I haven't encountered it, (unlikely you say?) or people are very subtle, or I have teflonated myself, unwilling to allow that possibility to enter into my consciousness. Denial can sometimes be useful. Of course one can never know what people think but I do know that when women walk around with a baby, they often look like harried mothers with the hectic burden of child care. When men do, they look like they are adorably accessorized. I also think that people don't question how having children will affect a man's career, but they do think about how it will im-

pact on the woman's work. The inclusion of this subject in *M/E/A/N/-I/N/G* belies this. Perhaps I don't experience difference in treatment because of the equity of child care in our household. No one looks at me as the person whose job it is to take care of the family and the home, because it just isn't. It's a shared attitude as well as a shared responsibility. My parental role models were not neatly and strictly tied to traditional roles either. Having a child has not adversely affected my creativity. It does destroy the notion of an artist working and drinking until dawn and sleeping till dusk. But it makes time more valuable, and it increases my capacity to give.

Stephanie DeManuelle

During my twenties and thirties my focus was on developing myself as an artist as well as (to a large degree unconsciously) struggling to deal with the constraints and definitions imposed on women. So I was really shocked by the issues I was faced with in choosing to be a mother. When pregnant I found myself very self-conscious on the professional level especially where I teach. I felt that I was a representative of pregnant women and was fighting the stereotypes of pregnancy as a handicap, that pregnant women can't do the job, etc. So I made sure that I didn't miss a day of teaching and, between sips of ginger ale and bites of crackers, and after a couple of miscarriages, I had a child during semester break. Being heaped with other people's preconceptions was something that I was unused to—people have them ordinarily but feel free to share them with pregnant women. I was told to do watercolors for a few years until I finished pregnancy and nursing as a way to deal with the problems of oil painting and queried by an acquaintance: "You *are* going to stop painting for a while aren't you?" I think I can group a lot of this material during or after pregnancy under the heading of "this tells me more about the source of the opinion than it does about myself."

As a mother who must work and is an artist, I at times feel like a magnetic field—a battleground where the definitions that are up for grabs are being grabbed at. Women who *did* give up pursuits, interests, voices large and small to raise children often respond to me with ambivalence. I sense the tug in them of "I am glad it's different now" versus

their anger, resentment, jealousy, and uncertainty of whether one can be a good mother, work, and be an artist. I can understand their feelings, but especially when it's a woman connected in some way to my profession I'd rather not be the brunt of these feelings. In my role as an art teacher with students of varying ages, I can see that I'm an exemplar in a very positive sense and I then need to shift to being more open about the complexity of my life—for them. This is a shift from considering the impact of my motherhood on my professional life. I often find myself making sure my child is not visible during a studio visit or being sure I leave him at home when going to an opening, because I still believe that women artists without children are perceived to be more serious. In the past women felt they had to choose family or career and in some peculiar way were respected for that—choosing one kind of creativity over another instead of this unsettling androgyny of being both mother and artist. I do sometimes envy women artists without children, knowing that I'm thinking about painting, dinner, basic design, and the intense connection to my child. I just have to be more focused and more efficient. And it's possible that the complexity enriches my work.

I would say that the direction of my work has definitely been affected by having a child. The intensity of the experience of both pregnancy and childrearing has found its way into my work making it generally more focused and more intense. It has an edge. Until a few years before I became pregnant I had been a painter of still lifes, interiors, and landscapes for almost twenty years. My work had started to shift because of a discontent with what I couldn't get at with those genres. My ideas about the meaning of painting, that it was a reflective activity through which I created ideas of order and essentially a shield *against* the world around me were able to shift through the experience of my miscarriages and pregnancy. I was able to move more strongly into the aesthetic of chaos, disorder, randomness, and ugliness. My work had been moving in a semi-abstract direction for a time but something about this experience led me into a realm of why, of content that has propelled me since that time. Not that I'm painting miscarriages, but the interior/body metaphor, the what-you-can't-see that is beneath the physical surface of reality was the metaphor I needed.

Yes, my life and work have been changed by having a child I am thrilled to have. But it makes me aware of so many issues I was asleep

about and on the professional level complicates things a great deal. I feel uncomfortably like a pioneer when all I want to do is be a mother and artist. There was an article in the *New York Times* recently about women newscasters (by a woman). The drift of the article was that the public's awareness of a female newscaster's pregnancy or children harms her professional career and that women should keep the child aspect of their lives quiet, private. It made me mad. I felt she had it backwards. Maybe the problem really is why don't we know that Dan Rather is out because his kid has chicken pox? I might not have noticed this article a few years ago—this is how my life has changed.

Jane Dickson

Now that my kids are in their first day at day camp I have time to answer your questionnaire.

The issues of work/motherhood for me all center around time and identity. Motherhood profoundly changed how I see myself and how I spend my time—much more than I imagined it would. I now see myself as having two primary and competitive identities, artist/mother, and trying to satisfy both is an eternal dilemma.

I postponed having children to establish my career, as I was less sure of myself as an artist I had to develop that first or I thought I'd be swallowed by maternity and never resurface. (Of course I have been swallowed anyway but it doesn't seem so fearful and permanent now.)

These questions seem to imply discrimination against mothers in the art world. I have not experienced any *increase* in the constant resistance to women being taken seriously since I became a mother. For me the new enemy is time.

An art career requires enormous amounts of time. Thought, re-search, and production of serious work is more than full-time. Then schmoozing/networking/hustling to get the work out into the world is another big job. Kids, even with help, are another *big* job. Successful male artists, or successful male anythings, put their work first. They don't miss a meeting because the kid has mumps. Nonmother women don't have to make a choice, but working mothers, no matter how rich, must juggle their children's needs and their work. I have had fewer opportunities since I had kids because I'm out there less developing

opportunities or following through less and out of sight *is* out of mind in the art world.

I have not stopped working since I had kids, though I teach less. Before I painted mostly at night and fooled around during the day. Now I paint when the sitter is here, or my husband is on duty, in any scrap of time I find. My children are three and six and a half. This is the little one's first day of preschool and I think I see the light at the end of the tunnel, after seven very challenging years of long hours and hard choices. I never guessed how much time and attention loving two more people would take. I often resent their interruptions and demands and they resent my work's demands. And, of course, I feel guilty. They forced me to grow up, make responsible choices, let go of procrastination, and get on with my life.

As for content, I continue to be drawn to macho subjects, but my primary subtheme has shifted, I notice, from alienation and isolation before children, to the complexities and conflicts of interrelationships now. It was no accident that my first postpartum show was demolition derby paintings; as I felt my two lives endlessly crashing into each other leaving me battered and dazed.

Finally, before having kids, I always felt like a misfit—a feeling the role of artist, of course, enhanced. Becoming a mother felt like joining the human race, for better or for worse. It's the most common denominator in the world.

Bailey Doogan

Motherhood and Art—I thought long and hard and kept flip-flopping back and forth between subjective memories and somewhat less subjective observations. The memories later, first the observations: While the images of both Artist and Mother are overly romanticized and revered in our culture, the Artist is construed as complex, sexually potent, and creative, the Mother as selfless, nonsexual, and nourishing. The Mother the boundless giver, the artist the deserving taker. When a male artist has children, it's viewed as an extension of artistic potency and often is used to round out and soften his public image: we're all familiar with magazine photo essays of the artist at home with his adoring family. More often than not it's his wife who takes care of the children. When a

woman artist has children, it's a conflict because usually she is the primary caregiver of the children and despite her creative claim as an artist, it's assumed that motherhood should take precedence over her art. Many women artists see this conflict and choose not to have children. Many have children and do not make that fact very public. Few are able to integrate the lived reality of both roles. With the exception of Alice Neel and several other women artists, how often is an experienced view of pregnancy and motherhood a subject for art? Not that this has to be the exclusive imagery for women artists who are mothers, but I think it is significant that it is so neglected. If a woman artist is also a mother, then there is no difference between the artist and the mother. She is the same creative person.

My life, my memories: I have one child from a marriage that I ended after one year. My daughter's name is Moira and she'll be twenty-two years old this August. Growing up, she always lived with me and I was her sole financial support—a working artist and teacher (a painting/drawing professor in a university art department). I never thought I was a good mother. It seemed I was always too distracted and drained. During the day I was helping between fifty and seventy-five undergrad and grad students and at night feeding and taking care of Moira and the man I lived with for ten years. Eventually my relationship with him ended and it was just Moira and I again. She was with me through my promotion and tenure battles, pre- and post-exhibition anxieties and always the work in the studio.

Two remembrances stand out: The first was when Moira was around eighteen months old and just beginning to walk (more like a barely controlled run forward at a forty-five-degree-angle). I came home late and very drunk from a party. I managed to get Moira changed and into her crib before I staggered into the bathroom and passed out on the floor wrapped around the toilet. I don't know how long I lay there before I was awakened by the soft sound of her bare feet pattering into the bathroom. She covered me up with her tattered security blanket that she wouldn't relinquish to anyone, patted my throbbing head and went back to her crib. As far as I knew, Moira wasn't able to climb out of, let alone back into her crib! I remember laying there feeling like the worst mother in the world and at the same time, amazed by my daughter. Years later, Moira called me at 2 A.M. to pour out her troubles and at one point in the conversation said, "Mom, I tell you things I can't tell

anyone else. You're my best friend." I realize that she is mine. Maybe what I, as an artist, have given my daughter is a life revealed not hidden. Moira is now a drummer in an all-female band in Portland, Oregon called TRAILER QUEEN. Their slogan is "Heavy as a Chevy." I continue to do my work.

Hermine Ford

Your question is two-fold. One has to do with my private experience of being a mother, the other has to do with how I perceive other people's perception of that role. The first is much easier to address: it was very natural for me to marry and have a child. Raising a child was nourishing in every way and the child who I raised is nourishing to me still. The richness of that experience is so much a part of myself that it cannot be separated from the self that is an artist.

The second question is perilous terrain for an artist to discuss in public. So much of what one speculates about in this area may seem like, or in fact is, self-serving rationalizations for one's fate in the art world, and it's often difficult to distinguish between the two. However I will say this: though every single person encounters obstacles in making his or her way in the world, I have specifically encountered in certain individuals, both male and female, a slowness in regarding the wife of an artist as serious in her own right. As roles multiply, in my case, from daughter of an artist, to wife, mother, teacher, political activist, cook, gardener, you name it, the doubt, or the excuse for doubt increases. Most often, I would guess that the reason given would be a question about time spent outside the studio. But I don't believe this is the heart of it. I understand what hard work and concentration in the studio are. Also I'm very familiar with the infinite ways men distract themselves and stay out of the studio. I do believe there is a deep-seated, often unconscious, invisible questioning of the seriousness of a woman's relationship to her work and the more visible her "other" activities, the more easily the suspicion can be rationalized.

It's interesting to speculate on the prejudice against the multiplicity of roles that traditionally have been assigned or undertaken by women as opposed to the romance of the singularity of role and purpose in men. It is a widely and deeply held belief that only extremely obsessive sin-

gularity of purpose produces the best work, and therefore the best work is produced by men. While there are certainly excellent examples of this kind of art making, it does not describe all good, or even great art. It is a myth that is not a reality even for many men. To the extent that multiplicity of roles is most often and most extremely experienced by women and is very visible, it is one more convenient rationale for a dismissive attitude toward women's work. To my mind multiplicity is not a negative, but broadens, deepens, enriches the context for interesting and relevant work.

Mimi Gross

Tip of the Iceberg—Taboo Topics

I. Revolution
Life divided: Before having child/After.
Much later: Revolution/Child leaves.
(early shock)
Soft touch,
Tenderness.
Subconscious education/Travel.
What is another person?
Total respect for: knowing someone best.
Intimacy, relaxed intimacy, physical intimacy.
Looking into: talking about anything, everything.
Infinite references, subtlety: signals.
Recognizing her sturdy courage, humor, intelligence, perspective.
Re-reading childhood.
Knowing, the time(s) of caring.
Consistency of quality.
(I learned to calm down to quality with child, to work at home, see less friends out, see fewer events outside.)
Little child accepts eccentric life: its own world, the work around the house, working all the time.

II. Baby became included as image subject matter. Or baby as papoose working on show installations. Baby radically changed relationship and work relationship with husband/father. He had less/very little time commitment with baby. Always urgent deadlines. Never discussed my

time. I loved baby, baby life. Interruption of daily work cycle noticed after one year: stayed in the country, found many ways to do pickup & putdown painting; kind of filling in colors. In retrospect—did new human depth poetic, overlapping, images. Later, swallowed into newer collaborations with husband/father.

III. 1½-year-old with 3″ wide brush paints bathroom door yellow while no one looks. She makes intentional collage on floor with byroads & stop stations using cornflakes, flour, & other foods: Hailed as prodigy! Baby tot has big table with crayons, scissors, paper, glue, paints. I am inspired by delicacy, details, textures, directness.

IV. Tot has friends: time off. New fun with work, euphoric few hours daily. Baby-sitters (circa '71–'76, urban hippies, performance artists, artists, groupies): huge energies; inspired me, encouraged mother/woman identity; accredited my collaborations with husband/father; questioned worldly emphasis on his work. He became "the father with the kid in the studio" overlooking mother is there, too, any number of helpers are there, too!

V. Husband/father rejects competition/mother/child force. Separation & divorce. Deep sadness. Child is 5–6. Changes house every 2 weeks through high school graduation.

VI. Child grows: School days.
New friends. New influences.
Artwork becomes more self-identified, stronger time discipline, more alone.

VII. Child becomes intimate. Travel together, influences cross. I learn to divide travel time, not only art/architecture/history viewing. Equal time: toy stores, parks to play. While traveling, child criticizes what she sees with excellent objectivity.

VIII. Teen life ok. Meet & love child's school friends. (I meet my life/love/companion through my daughter's friend.) I learn how to teach about art, & about what it is. Independence/dependence. Interdependence.

IX. Adult child becomes peer: After college graduation, makes separation, works far away from root-home: I respect her autonomy. My artwork becomes deeper, less subjective, I stand alone with some new dimension.

Addenda: Ending child care, attending parent care / leaving rare—the spaces between. I try to keep the priorities in perspective & find the spaces between the spaces again.

Freya Hansell

As a child my model was Wonder Woman and that was because she was a warrior, powerful and beautiful. I really believed that I had magical power and in many of my dreams, I flew over the trees and the people below me.

Then I had children of my own. They were beautiful and bright and we were loving together. I had to defend them. I felt fierce and strong. I had much greater strength than before because of the children. When they were both sick, and they were very sick, each of them in different ways, I fought very hard in the kinds of endurance tests required of the circumstances. I felt like a warrior, not conscious of my early model anymore.

The challenge to overcome the events life brings can be fearsome and terrible. My work is about doing battle. My life with my children has brought things together in my art. There is me and the force that pushes against me. Sometimes in my work, the tension elements seem abstract. The images of power I use and the forces and action of paint are the means for my expression. For me, that is what life is about and that is my work.

Yvonne Jacquette

The Intersection of Motherhood and Art

The anxiety about unfettered time for painting pushed me to simplify my work in the early years of motherhood. The first year I discovered that time spent nursing became a period of visual meditation as well. When I could get to work the image was clear in my mind. Generally my paintings were more focused.

I never could bear stopping work for any length of time; luckily with my husband working at home too we could share child care. Another boon: meeting other artist-mothers. Cooperating about baby-sitting

and gathering to talk about art created a network of influences. We were learning to "play" with our art as our kids were learning to socialize. In the late 1960s several of us set out to take slides and photos to dealers hoping to interest them in a ready-made group show. The response was "A women's show? Never." Several years later women's shows became the rage.

Entry-level galleries seemed to be more obvious in any possible discrimination against women who were also mothers. One pregnant friend was told her work if shown would be priced very low because "she would probably be lost from art soon anyway." I encountered difficulty with curators and critics understanding that visits to my studio (then away from home) had to be carefully scheduled so I could arrange coverage at home. One critic stood me up for many hours while Tom was home sick, never even calling.

The positive side is how one's thinking is broadened. Having a child creates an unseen link with history—past and future. Take world events: eventual threats such as nuclear waste stockpiling unsafely catalyzed me to explore my worries in drawings and subsequent paintings.

My use of pictorial space noticeably altered in my paintings as Thomas grew older—from intimate close-up space to vast aerial panoramas. I wonder if fathers (also artists) experienced that gradual widening of space? To me it represented the general distance of the child to the parent.

I also feel that the pace of a child's growth is such a constant reminder of the possible joy in gradual change. Allowing for changes in my work has a perspective from this. The petty frustrations of childrearing disappear in memory when the overall sensation is one of great thankfulness. Can I see my daily struggle in the studio in this way too?

Having a child was for me of great importance and pleasure. One unexpected benefit is that my artist son is one of my strongest critics with a very helpful spirit.

Joyce Kozloff

Giving birth to my son Nikolas, in 1969, was probably the most positive experience of my life. (I used to feel embarrassed to talk this way, but there comes a certain freedom in middle age.) That event also marked

the transition in my work between derivative poststudent painting to the beginnings of what would become my own way of representing things. In retrospect, I believe that he gave me an extraordinary gift.

During my pregnancy, I feared that this child would take over my life and I'd cease to be an artist. After all, this had happened to women I knew. My (male) therapist kept suggesting that I stop going to my studio, because my body was "creating life." This sent me into a work frenzy and an emotional roller coaster. After my son was born, my time was chopped up, but I used it better. I took responsibility for my professional life, as I assumed responsibility for his care. In other words, I grew up. It was difficult: I remember that whenever I was working, I felt I should be mothering; and whenever I was mothering, I felt I should be working. The amount of guilt that our culture lays on women is boundless.

My paintings became smaller, more detailed, more intense, and more expressive. I ceased to worry about whether people called them feminine or decorative, as these adjectives took on a positive meaning for me. I had the great fortune to come of age as an artist and woman coincidentally with the last wave of feminism, and I was in support groups throughout the 1970s. We saw the juggling and struggling as inevitable in a society that does not provide child care, rather than the results of a personal failing. And I discovered other women artists who had experienced a rebirth in their art after having a child. This very interesting phenomenon has not been publicly explored, to my knowledge—and should be.

Ellen Lanyon

I was one of the artist-mother-artist breed of the 1950s. I began to work and exhibit professionally for several years before I married and it was another six years before children were introduced into my life. I had had time, therefore, to establish a very sound base for a highly motivated routine in the studio. I married an artist and it was our whole world. We really wanted to have children and by the time they came we were well prepared for the adjustments that would be necessary. I was house-bound with the studio in the living room, a bedroom or whatever space I could carve out. My work was accomplished during nap-

times or at night and my days were spent in the most ordinary way: Up at six / dress the children / feed the children / off to school / take a walk / buy the food / make the beds / tidy the house / do the bills / plan the meals / take a walk / fetch the children / feed the children / help the children / make the dinner / greet the man / feed them all / clean the mess / tend their lessons / ready the beds / drop dead /

But, being an artist in Chicago was good for me, the heavy hand of male-dominated attitudes was not there as it was in New York. My imagery was always very personal, representational, and metaphysical. The ethnic and cultural climate of Chicago has historically generated and nurtured these sensibilities and a bias against gender was not part of the politics of that art community. Instead the battle raged between the object and nonobjective with the "second city" syndrome resting heavy on "big shoulders." My early work was rendered in egg tempera, the content was drawn from the city that I had always known but after having my two children my territory changed and so did my imagery. The conservatory and the zoo introduced the world of flora and fauna. The impact this had on my sensibilities combined with the most natural effects and changes that had taken place in my body due to two pregnancies was profound. I exchanged oil for the egg tempera and small-scale for a large format. The stroke became very broad and gestural; I was experiencing a new maturity and confidence in the work and I can honestly say that I was content with my circumstances. There were other women artists with children to commune with as well as a lively artist-activist group that generated exhibitions and seminars. We all participated in keeping our work and ourselves visible. Eventually, in 1971, I and a few others initiated w.e.b. MIDWEST and it brought countless women/mothers out of the isolation of their homemade studios. Many of them had small children but the support of the feminist ideology enabled them to find a voice for themselves. Two women's galleries, ARC and ARTEMESIA grew out of w.e.b. I think it is important to the subject of this text to remind young women today that so many in the past struggled with and survived the prejudices of the art establishment. It took all of the 1970s to give women the power, part of the 1980s to diminish their strength, and now with the neobaby-boom it behooves us all to fight for a chance to raise children without giving an inch of ground to those who would dare to challenge the ability of a woman to do both!

In Chicago I had the same dealer for many years. I always knew that, as a feminist, I was somewhat of an embarrassment to him and he accused me of having too big an ego but he was supportive of my work and respected me as a creative person. After twenty years his son assumed partial directorship and found it difficult to deal with my imagery. Needless to say I moved on to find a more compatible place. My current Chicago dealers are two men who are completely unbiased. In New York, I have had five different affiliations, all with women and in all five cases, save one, they closed their galleries due to personal conflicts. While it lasted each one was a very positive experience. I felt, however, that my being a woman who was married with children (although they were on their way to becoming adults) created a different level of casual rapport than that directed towards the male artist or audience. There was more "women talk." Not that I consider this a negative element of my relationship with women, but it does take the edge off of a vital professional intercourse.

The pictorial content of my work has most certainly evolved over the past decade. It has become more universal and more overtly directed toward global and environmental issues. This does have a lot to do with the singular status I have assumed in New York where I spend each winter teaching and working in my own studio. My children now share my adult world and I have no responsibility for them, (my husband is retired and chooses to live in the country where I spend weekends and the summer months) so, at last, I am completely free to connect with concepts that have been dormant, waiting to be tapped. This has encouraged a new confidence in my eccentric, personal vision and an expanded repertoire for my imagery.

I cannot imagine life without my family. I value their input and their camaraderie. I do not, nor have I ever considered giving birth a substitute for making art nor vice versa and I have no reason to believe that art making and motherhood cannot coexist. I must agree that complete freedom to focus on a career would have, most likely, made a difference as to where I stand today. If I were of childbearing age now I can't be sure that I might not decide to remain childless. That decision would be based on so many contemporary variables, the economy, the state of the environment, the mores of the times, and the acceptance of an individual's right of choice. I admire all the women I know who have opted to be childless in lieu of their work because I am sure that it is,

ultimately, a sacrifice for them not to experience having a link to a future generation. I have that connection well established. My body and my art have survived.

Betty Lee

I have never "hidden" the fact that I am mother to a young daughter. I strongly believe in not excluding her from my image making milieu because she is an inherent part of my life and of my life as an artist. That's not to say that my work is about parenthood, and I'm not saying that it is a less than honorable topic in image making. But I am saying this: if we are to consider what informs us as artists, parenthood definitely can be a large part of that process. If we lived on a planet where we did not mate, procreate, and care for our offspring, then it would be a different issue. But here on earth meaningful relationships are very much part of our lives, and that includes the relationship of mother and child.

My parents emigrated from China and started new lives here in the United States. They had developed an extremely tough work ethic because their physical survival depended on it. However, they had children even before they felt their personal finances were sufficiently stable. While my parents worked, my grandfather, the patriarch of the family, took care of us. From all of that I understand clearly about work and about family. The two go hand-in-hand as to what is vital in our lives. I understand completely what I am willing to do to continue in that fashion. Consequently, when my daughter was born, I thought of nothing but of making work and being parent to my offspring. Being a mother did not interfere with work or vice versa. In fact, I strongly believe that working is the best example I can set for my daughter, just as my mother did when I was an infant. Work is vital activity because it realizes empowerment. There was a special form of energy that emerged when my daughter was born, and I made a deeper commitment to my work. I made fewer excuses for myself and plowed forward.

I am extremely fortunate to exist in an extended family structure where children are looked upon as gifts and parents are fortunate because of them. That's the Chinese part of me that helps me function. Even so I am not immune to the swirling sentiments of how difficult it

is to be a mother, Asian culture notwithstanding. I am fortunate to have a lot of support from friends, many of whom are artists themselves. I know it sounds trite as I say this, but knowing that I am in company of those who share and understand needs no further explanation.

I am aware that there are those who view parenting as a totally separate and irrelevant issue from art making, that its inclusion in any form is deemed unprofessional. It almost operates on the same level as listing your hobbies on your cv. But this sentiment has never been articulated directly to me; many of those in charge of spaces in which I have shown work expect my daughter to attend and are surprised when I don't bring her. People seem to take interest in the fact that I have an art career, jobs, and a family. They are interested in the nitty-gritty: When do I go grocery shopping? When do I go into the darkroom? In the same breath I am asked if I use cloth or disposable diapers and whether I prefer Kodak or Ilford photographic papers. When I teach, these types of questions surprisingly crop up often in the classroom. I am happy that young women ponder such issues because I see it as a sign of questioning the validity of those barriers that continue to confine women.

It is extremely difficult for women to be mothers because there is so little support, and on so many levels. Government does not acknowledge women in the work force and the lack of support systems reflects this. And the age-old question of whether to stay home for the benefit of the child or to return to work is more an influence of societal factors than of instinctive ones. You can stay home and be mother. You can go to work and be mother. Somewhere along the line, this issue got blurred with all the arguments of what women ought to be and do. The fact is women work, at home or elsewhere, and are mothers to their children.

I am personally gratified when I read interviews about women who have done meaningful things in their lives and discuss their family life. Artist Elizabeth Murray is an example of this. In almost every article about her there is always some reference to her family. When I read that she has two young daughters, signals go to my head saying, "See, some artists are not from Mars." Normal is not the descriptive word. Full is. When Elizabeth Murray feels free to divulge this type of information about herself, I view it as affirmation for other women artists with children.

Lenore Malen

I became a mother in my early twenties when I was a graduate student in art history at the University of Pennsylvania. Having a child makes for huge changes in one's life and I was truly unprepared for most of them. Except that this juncture was the catalyst for my abandoning a career in art history and becoming an artist.

When I moved to New York after graduate school I continued to teach art history. After teaching and taking care of a baby there was really a minuscule amount of time to make art. I remember painting in my bedroom when Josh napped, and eagerly waiting for those naps! I rented my first studio when Josh was in school all day, rather than one half day. When I wasn't teaching I frequently made two round trips on the subway between home and studio, mornings and afternoons. I remember begging Josh, and bribing him with toys, to come to my studio during school vacations so that I could work. At the same time being a mother required from me a huge amount of patience and letting go of sense of self. Yet it is precisely that sense of self that must be developed if one is to be an artist. And so for a number of years I experienced a very painful deferral of my desires and ambitions. For this reason I always thought it would have been better to wait until I was older (and hopefully more established) to have a child, but there are disadvantages with that choice too.

As for other people's "reaction" to my identity as a mother, I rarely talk about motherhood in the company of artist friends. Most of my friends have forfeited the option of having children, so it seems inappropriate or irrelevant. And I seldom talk about my private life with the various gallery dealers I know because I have sensed the subtle but pervasive stigma of motherhood among the old guard in the art world. Just recently an art world impresario who has been around for a long time asked me: "Was I so-and-so's mother?" I detected in that seemingly innocent question an unmistakable put-down regarding both my age and gender. But there seems to be a real shift in attitude among some younger men and women. This goes for artists, critics, dealers.

Regardless of attitudes surrounding motherhood, the essential problem facing most women artists is an economic one. How does a woman make money, bear children, and still have time to make art? For a

certain number of years there is an inevitable sacrifice somewhere. This
is why few women artists elect to have children.

Ann Messner

Thoughts on Giving Birth, Raising a Child, and Maintaining a Career simultaneously while balancing on the head of a pin

I have a twelve-year-old son. His name is Ben. I have been a single
parent for ten years, since he was two. I have raised him on my own. I
am also an artist.

It has been and is a tremendous commitment to raise a child. No
other animal on this planet takes eighteen years to mature. To take care
of, to nurture, to stay and help someone grow slowly over time is a lot of
work. Even more so as a single parent with a career. Giving birth and
raising a child is similar to the slow process of creating art.

The externals have seemed at times hellish. I have felt myself to be in
the midst of a whirlwind of simultaneous activity; of a phenomenal act
of balancing and a continuous reevaluation of priorities. There is the
ongoing ritual of preparing two people for the day, of negotiating with
teachers and bus drivers when things are not going well, of providing
new clothes for a rapidly expanding body that cannot slow down, of
making do on a budget that is laughable, of being wise and able to
explain the lessons of life, and then . . . to maintain a studio, a place to
work, to keep the focus on this work despite all of the available distrac-
tions, to keep my work in the "public" domain and to participate
socially when there is really so much else to do. Sometimes it has
seemed next to impossible to balance what often feels like two complete
and very different lives—mother and artist. I have had to make many
compromises. Some days I have felt overwhelmed by work and respon-
sibility, engulfed by self-pity.

When my son was very young I experienced hesitation from my
women peers toward my motherhood. None of my friends had chil-
dren. It was uncommon. It was uncharted territory within our commu-
nity. There was unease. I was somewhat in shock myself, at finding
myself with a child. I had never considered this one of my options.
Partly, these were reactions to the external reality of added respon-

sibility (time and money). More importantly was the internal reality. This act of birthing brought up a lot of questions that were perhaps more conveniently left masked. It is easier to address external difficulties than to acknowledge the internal fear. I was afraid my career would slip away. That if I were in fact truly committed to my work I would not have embarked on this escapade. I feared the loss of my creativity; how many times had I heard the statement "my art is my child." I see this today as an extension of a myth of exclusion and scarcity, of a myth that informs us that artists can only be men because the "creativity" of women is biologically channeled elsewhere, of a myth that art need be a restrictive intellectual pursuit, not inclusive of and even threatened by the complete human experience. I can gratefully say that my experience has proved to be very different from these preconceived notions.

My son was born at a time when I did not know any more why I was working or what I wanted to say in that work. I had reached a point of painful noncommitment in my life. Giving birth was a phenomenal experience for me—epic in proportion. Going through it radically changed my life. It was literally as if I had changed the vantage point from which I viewed the world. The experience of giving birth and mothering a child gave me an understanding of who we as human beings are; a direct glimpse of the evolution of the species; of a need to have a future, which, for me, growing up in the drug culture of the 1960s, had been highly questionable. Having a child gave me the knowledge of what I needed to speak about in my life and a motivation to do so that I had not had before. It helped me to see life as something serious and to accept my responsibility for what I say and do. This has been a tremendous gift.

The recurring theme of domesticity in my work would not be there if I had not had that life experience; nor my preoccupation with protection, covering, defining territory; nor would I perceive so acutely the estrangement between the external realities of our culture and the internal stability of the home. If I had not lived life as radically as I have these themes would not have become important to me. It was not so much a conscious decision of mine to work this way. It has become a part of me because being a mother tints the way I look at everything. I am a caretaker, a teacher. I have had to make decisions about what is important to teach, what is better left behind. I have had to learn to

communicate on a very simple level, clearly. I have had to find and learn to participate in a community that nurtures me. This has given me a sense of being a part of society. This has provided a platform for me in opposition to the popular myth of the artist as the estranged, the "madman"—"madwoman"—within the culture. Yes, I am an artist; I am also a woman, a single parent, a person. I have common problems. I have common strengths. The one thing that is unique about what I do is that, as an artist, I take that common experience and use it directly as the material for what I produce.

We live in a very competitive society. We compete for territory and possessions between (and among) the sexes. We are not generous in spirit. We will never have enough. The cavities inside us can never be filled. Our culture is based on the worship of power and the insatiable desire to control. Behind the need to control there is always fear.

I believe that bearing and raising another human being is an extremely empowering act. It takes a deep commitment to being human; to the validation of internal human experience. Ultimately these primal instincts are much stronger forces than the intellectual drive.

Creativity is coveted. I believe women are feared because of the creative power inherent in bearing the young of the species and because men have little control over that power. Within the constructs of the dominant culture this is as much creativity as women dare be given or take—a false myth of the limits of what we are capable of becomes pervasive.

As a woman artist and mother I have not had historical precedents available to me. The most important influences on my work had always been men; certainly none of them were mothers. Within these constructs to have both a career and a child in my life becomes revolutionary.

If art is the telling of the complete human experience it becomes in a sense our responsibility as women artists to use all our experiences, including this primal act of regenerating, as creative fuel. We have a right to a creative process of inclusion in our lives. As artists we are in a unique position to take this internal reality and translate it into the external creatively. One act of creation does not necessarily take away from another. Bearing a child or acknowledging the desire to do so is not a cross to bear, or something that makes us less than men, to be ashamed of. It is empowering. It is a choice that we deserve.

This knowledge is part of what I have come to understand life to be. It is important to me. It is part of my identity as a woman, a human being, and an artist. I also believe that it is knowledge that our culture is very much in need of for its survival not only physically but also in spirit.

In closing I want to say that separate from my experience and opinions about having a child, there is a young boy gathering his own experiences and opinions. And he learns from what he sees in me.

Diane Neumaier

It's August 19, 1992, Family Values Night at the Republican National Convention. Tonight motherhood will be deployed (again) against women. Marilyn Quayle has just been presented to us as a cookie baker, by Major Dad, whom Marilyn says she wishes could meet Murphy Brown. (Is this a sitcom or a sound bite? Hollywood or Washington? Is there a difference?) Marilyn declares women's choices are different than men's. (What's this "choice" business, all of a sudden?) And, she demurs, our rewards are different. Raising happy children is Marilyn's reward. Most women, she says, wouldn't have it any different. (I say we have no "choice.") Marilyn doesn't, as she proclaims liberals do, want to be liberated from our essential nature. (Whoops, where did the "choice" go?) (The camera pans vehemently applauding happy women, presumably happy mothers whose family values made them what they are today—Republicans.)

Well, the truth is, I'm often a happy mother, with an often happy child. In spite of being a mother, I am a productive artist. And, while motherhood, the most distracting condition imaginable, is virtually unrewarded, it feels rewarding. What else can a mother say? Marilyn says, "God Bless America." I say, thank god my kid is out tonight so I can meet your deadline—hopefully not out too late to check my spelling . . .

Nancy Pierson

Two and a half years ago, when I was forty, I had our son Toby. My husband and I had married late, and until then I had never wanted

children, my career as an artist being all to me. Much to my surprise, it turns out to be a wonderful thing to be a mother.

Motherhood is also frightening and isolating. Having fallen out of the L.A. art world, I sought a community of other mothers of small babies to enter into for comfort and advice, and for a buffer against loneliness. It was wonderful for awhile to have so many new acquaintances, but over time our individual personalities, variations in our ages and backgrounds, and our natural female competitiveness began to erode the numbers. Ironically, because our son has lately developed a serious learning disability, I have felt relieved to drop out of the 1990s yuppy competition for the best child. I have recently found a quite different community of parents and teachers who are heroic and inspiring in their love for troubled children.

The community of women, and their attitudes and behavior toward one another, has become the subject of my work now. Over the past year and a half, I have produced a group of large drawings of middle-aged women, many of them mothers. I feel I must now "cover" this group, as I am inside looking out. I feel the double pariahdom of my own position in our culture and wish to convey the emotional gold mine I am discovering here in the outland. The women in the drawings appear in pairs or small groups. They have aging faces, imperfect bodies, are badly dressed or wear Puritan-like uniforms. These are my own invention for a censorious, desexualizing "Mothers Guild." (I am amazed at the process by which motherhood ages and desexualizes women, and by women's complicity in this process.) The women are, in various cases, consoling, supporting, excluding, and reprimanding one another. The grouping schemes are derived from photographs of scenes from opera. I developed an interest in opera around the time Toby was born, as its over-the-top emotionality resonated with my own state.

As a middle-aged woman and a mother I feel my own lack of stature in the art world sorely. I am not a very aggressive person to begin with, so in some ways I embrace the opportunity motherhood gives me to retire from the scene. Because we plan to have another child soon, I will, for the most part, be spending my forties raising small children. Some may consider this a waste of an artist's prime, but I am considering it life experience which I probably need to go through in order to make anything which will be worthwhile looking at. I believe I may be right in this, as this last body of work has received the most excited critical response I have had so far, though the subject matter damns sales.

I can't help but be annoyed by the glamorous magazine ads I see, photographs of middle-aged male artists dangling their tiny offspring. There never seem to be any artist mothers (much less same over forty) given such romanticized treatment! Besides (I am sorry) but we know who's doing the real work of raising that little child . . . the one who's not in the picture . . . (or the Latina nanny)! The male artists I know who have babies or children have never broken stride in the studio.

Artist mothers out there who want to spend plenty of time with their young children and continue to work often find themselves, as I did, trying to work out an almost impossible formula of job, studio time, and child time. In my case, it turned out that I taught to pay the baby-sitter so I could teach. Now I use savings to work in the studio two days a week, and those two days have become much more intensive and fruitful work days for me than any prechild studio days. I am very fortunate to have a supportive husband (who is not an artist), who is willing to sacrifice more than a little financial comfort to see that I continue to have time for my work.

Ultimately, every artist has to put more faith into his/her work than into the system which accepts or rejects it. Having studio time to escape the enormous pressures of motherhood has kept me relatively happy, and helped me fend off some potentially deep despair. On the other hand, my anger, even bitterness, over my situation has turned out to be good fuel for my work. It is too bad that the happier emotions don't seem to inspire such good art; maybe it's because they are so simple, thoughtless, and so very fleeting. The most successful way I manage my own life is to save my unhappiness for the studio, and to give my happier self to my family.

Barbara Pollack

Portrait of an Artist Avoiding the Mommy Track

Rather than join the ranks of Princess Di and Ivana Trump, I will not sell my tragic tale to the tabloids. I may not have jewels or a country estate or even a dealer, but I am a "have," or at least a "having it all." Wife and mother, that's me, revamped by the 1980s into a status symbol, the apex of privilege. So, I'll keep my complaints to a minimum.

Everyone knows that statistically I beat the odds. When *Newsweek*

announced that a single woman over forty has a better chance of being shot by a terrorist than getting married, I had no need to worry. When Dan Quayle attacked Murphy Brown, I did not have to take it personally. If you believe the media, I have no chance of getting AIDS, no desire to see pornography, no need for access to an abortion, and no right to complain. Since politicians from both parties promise to uphold "family values," my biggest worry is how to vote for them all. Right?

When I gave birth to Max in 1988, I had no idea that I was entering a privileged state. As an artist and a feminist, this has meant a major adjustment of my self-image. It is hard to fulfill the expectations of the American Family Association while maintaining respect within the avant-garde. But, this dilemma is my own creation. I can hardly blame the art world for my petty problems.

After all, the art world did not create Demi Moore. When I was nine months pregnant, I could have posed for the Venus of Willendorf, not the cover of *Vanity Fair*. Dealers and critics gave me the cold shoulder, but who could blame them? Such refined sensibilities should not have to gaze on the unaesthetic form of a short, pregnant woman. They had grown accustomed to the signifiers of birth represented in the media; you know, fashion models with pillows in front. The rest of us were what pregnant women had always been—fat. In fact, it was downright rude of me to attend openings in this condition.

Also, the art world did not cause my economic situation. While women make sixty-eight cents for every dollar a man makes, women with children are making forty-two cents. This doesn't worry me because I am an artist, above economic considerations. Nor does it bother me that single women with children are the largest sector living below the poverty level. After all, I have a husband. I used to believe that economic independence was an important factor for my self-esteem. But, I've trained myself not to think about that anymore. It's just too frightening to consider the alternative.

Along these lines, I must thank the Pollock-Krasner Foundation for making me understand that day care is clearly an extravagance. Other women need day care because they have to earn a living. I only needed day care so I could go to my studio. (By the way, the request would have only covered two days a week.) But, I was clearly out of line. It is, after all, much more important for other (male) artists to travel or complete loft renovations. Day care can hardly be compared to those necessities.

And, even if it can, it is wrong for me to ask for government or foundation support for what is clearly a family responsibility. Better yet, since I do what I love—make art—for no money, why shouldn't my baby-sitter, who loves her work, do it for no money? Women usually agree to such arrangements, but I didn't have the heart to ask. So I cheerfully pay more for day care, much more, than I make from my multiple jobs and art career.

At times, this arrangement gets me down. I even think that this is so insane that I should give up. Many of my friends in other professions, even doctors and lawyers, came to that conclusion and are "taking time off" until their children reach school age. But, a true artist never takes time off. Picasso and Matisse did not let children stand in their way, so why should I?

Those friends I just mentioned are grateful that their employers allowed them the option of the Mommy Track. For those unfamiliar with the term, this means they were able to have an extended parental leave and return to work on a part-time basis as long as they agreed to be removed from the partnership track. (A very nice, very legal way of terminating a woman's career.) Frankly, I am so grateful that the art world does not have a Mommy Track. I did not have to apply for a pregnancy leave. Nobody noticed how long I stayed home after I delivered. In fact, nobody noticed that I returned to my studio within three weeks. For years, curators kept saying, "I suppose you're not getting any work done with a small child at home."

Of course, there are times when my fantasies run wild. I imagine quiet days in a studio, uninterrupted hours of concentrated work. At times like that, friends suggest I get away to an art colony. This is a most helpful suggestion. How are they to know that only one—Cummington—provides facilities for children? And Cummington does not accept children under five. But who needs an art colony when she has the idyllic setting of a toddler by her easel? An advertisement for Pampers shows a male artist cheerfully playing with his child in a pristine white studio—the premier example of parenting and creativity. It was obviously a failure on my part that I could not achieve this perfect balance.

Which brings me to Jesse Helms, the man I have to thank most of all. In the final analysis, Jesse Helms got me day care. When Max was an infant, I brought him with me to the studio fairly often. With the onset of the attack on the NEA, I began working with sexually explicit subject

matter. One day my husband visited his wife and child in the studio. The walls were covered with photographs appropriated from porn magazines. He did not wait for an explanation of postmodern strategies. Then and there, he decided that Max needed more time with his baby-sitter.

Since then I have lost my pregnancy weight and I have shown my obscene art. I delight when critics, curators, dealers, and other artists react in surprise, "You're a mother?" At least, they aren't saying that I paint like a man . . . Or are they?

Erika Rothenberg

I don't know if being a mother has changed my work, but it definitely has changed how my work is perceived and how it is made.

As for the former, before my daughter was even born, when I appeared, eight months pregnant, at the opening of my 1989 show at p.p.o.w., strangers came up to me and exclaimed, "Your work is so different now that you're having a baby, so maternal!" Of course, several pieces in the show were created long before I got pregnant.

When my daughter was two, a baby-sitter canceled at the last minute and I had to drag her to the studio, where I was scheduled to show some work to the acquisitions committee of a big university collection. As my kid sat at my desk, drawing, I said to the group, "This will be an interesting test for you. Instead of me trying to put forth the stereotypical image of the brilliant artist—tortured, tormented, alienated from society, giving 'his' entire soul to 'his' work—you have to judge my work while seeing me as I really am, just another middle-class mom." The group tittered. They did not, however, buy a piece for their collection.

Now for the changes in how my work is made: one of the best parts of being an artist and a mother is that I can't work all the time. b.c. (Before Children), I worked constantly. Now, I quit at 5:30 every night and rarely work weekends. The art/life separation has been good for me; it's made my work better.

A last thought: I have been very, very lucky to have been able to afford child care, enabling me to work every day, travel for exhibitions, and so on. I like to think that, without child care, I would still have made the decision to have a child. But would I have been able to have my career too? We need more, affordable child care in this country.

Miriam Schapiro

Rembrandt and Me

Motherhood is a word so fraught with contradictory meanings that to write a personal testament is to face ultimate feelings of love, guilt, isolation, incompetence, and anger.

Little did I realize how anxious I would become when I finally gave birth to my baby. In 1956 I was not in therapy and had no feminist support groups to listen to my grievances and advise and counsel me. Only updated Victorian tenets of perfect motherhood in combination with my Russian, Jewish background reminded me of my duty. More than that—centuries of prohibitions made me guilty for even dreaming that I might be an artist as well as a mother.

Only my mother's wisdom, her fears, her guilt, her trials by fire would compose my education in how to be a mother. It would be learning by friction. My history with her was wrought with emotional tangles and while I admired, feared, and fought her for my own independence—love was whatever happened between us. The irony of all this is that she encouraged me to become an artist. Yet when she found her daughter, the new mother, in tears over her conflict between wanting to be a *good* mother and wanting to leave her baby and go to the studio—she cried out—wishing I had never entered the art field. Too late, the fire had been fanned. I was already a professional artist showing at the Andre Emmerich Gallery when I became pregnant.

Role models were nonexistent as far as I was concerned. Motherhood, the institution, the description of life in the language of patriarchies carried an ancient body of information—invisible—but deeply encoded in me and how tragic it was, that at that time I had no language for my dilemma. Centuries of prohibitions lay behind me and were mobilized against my wish to be both a mother and an artist at the same time.

Try for an image of the Great Mother as she appeared in stone in prehistoric times. She was the primordial archetype not only concretized, as Erich Neuman says, but also existing inwardly as well in the human psyche. She begins the history of motherhood which ultimately finds its way into the depths of me. How will the impasse between my urge toward "duty," and my wish for the "selfishness" it takes to make

art be resolved? I remember my first impression of "duty." As a child I watched my grandmother instruct my mother to remember that her first order of business was to watch over me. I knew that on some days my mother longed to run away, to shop, to go to a movie, to read a book quietly, yet because we were poor, she couldn't afford a baby-sitter and suffered her own disappointment while tending to me. Later this was my own story but I simply wanted to go to my studio which was four blocks from our apartment. Unlike my martyred mother, when duty prevented me from leaving, I would become wretched—possessed by twin agents of desire: wishing to make my paintings and wanting to be recognized as an artist. Even as I write this I can't help asking myself if this was ever Rembrandt's problem?

When I was studying art history for my master's degree at the University of Iowa the image of Mary was incised into my memory. I studied the cult of Mariolatry (the making of Mary into a goddess). I am told that Mary remains the greatest threat to patriarchal Christianity, that people prefer to address their prayers to her and that the greater proportion of churches are devoted to her. With this in mind my future sense of myself as a mother would unconsciously be influenced by the greatest mother of them all. The purity of her love, the supremacy of her selflessness, the mindlessness (and therefore the lack of anxiety) in her face, the adoration afforded by her role in life—what better purpose could a woman have?

Clearly my inner self, my ego—wasn't settled. The self-love required to give love to others had not as yet replaced my narcissistic needs. Paul Brach, my husband, clarified our situation: "Two babies had a baby."

Looking to my Jewish heritage for help was not much of a solution either. Judaism is quite clear about the position of women. When I accompanied my grandmother to the synagogue as a child, she and I were ghettoized with the other women in a small space in the balcony. It has been said that the synagogue was an early men's club. Orthodox Jewish men thank God daily for not having made them women. Of course, times have changed and women now play a fuller role in Judaism but not at that particular time in history—not when I needed validation for wanting to be a mother and an artist with equal fervor.

My mother and her mother and my aunt were a triumvirate when I was a small child growing up. It was a cultured environment and my father, who was a socialist and an artist, supported my wish to be an artist saying that there wasn't much difference between men and

women if the desire was to achieve. Yet the old myths about women's duty toward their husbands remained. Baum, Hyman, and Michel in *The Jewish Woman in America* remind us:

> As long as the woman followed her prescribed course as a devoted help-meet to her husband and responsible household manager and mother, she was accorded great respect. *Should she seek to stray from what was defined as the female role, however, into the male's domain of study and prayer so central to Jewish civilization, she was demeaned and often ridiculed.*

After my baby's birth my struggle was exacerbated by the daily routine of my life. I was lucky to have been aided by my mother and my mother-in-law. Each one for years gave up two days a week to sit with our son so that I could have time to go to the studio for four hours each day. Of course, they reaped the rewards of their grandchild's love which exists to this day (his paternal grandmother is dead but he speaks to his ninety-four-year-old maternal grandmother by phone almost every day). But as time wore on they were not always available. My husband had his routine, he taught extra hours to support our expanded family. As an artist, his hours in the studio were also curtailed but he helped us nevertheless—although the child was (as children were in those days)—primarily in my care.

I also began to teach in order to earn money for a baby-sitter—for studio time. A circular solution. But when I finally reached the studio the devils came to drown me in guilt: "Should I have left him? Is the baby-sitter really a competent, warm, and loving person? If not, will something happen to him?" It was a difficult time for me and for our son. I felt isolated, pressured to spend time in the studio yet I was not always productive there and that felt worse—I was wasting my time and could have spent it better at home. I bit my nails and looked outside the window at 14th Street which seemed to reflect the world as going about its business knowing, at every minute, what it was doing. I asked myself whether my child would suffer from my own ambivalence, drive, and doubt?

Did I suffer from my parents' omissions? Will we continue to ask these questions to our dying day in order to feel less guilty about not being the perfect parent (the way Mary was the perfect parent to Jesus?) (the way the Jewish mother is supposed to be the model mother) and what of the fathers? Was Rembrandt guilty?

I count all the days that are rare, beautiful in the bounty of nature,

and in which I am productive. All the days in which connection with others is warm and rich. On those special days when my son and I have a solid exchange, when he gives me his wisdom and allows me to give mine in return, on those days—I exalt in being a mother.

Arlene Shechet

Six years ago, after realizing that the perfect moment for motherhood would never arise, I became pregnant. I was fearful of becoming a mom. I had been content balancing teaching, studio, and my marriage, and was resistant to change. Motherhood has meant embracing constant change. I am one element in a family that is chaotic, unpredictable, messy, noisy, fragile, and quite wonderful. Over the edge, being stretched, feeling full, I wanted more—I had a second child.

Being an artist no longer defines me. It is now one component of my life. This simple redefinition has been surprisingly liberating. Art and life have become fused and both feel more urgent. I am less cautious. Throughout the life changes of the past six years, I have continued to spend a good deal of time in my studio. There have been some obvious stopping points and lots of shorter unanticipated ones. I am frequently frustrated by not having long stretches of predictable studio time. Though I am a sculptor, I have given considerable time to developing a language in drawing for its more immediate gratifications. I resist using the signs and symbols of motherhood in my work because that iconography strikes me as simplistic shorthand for a complex experience.

My teaching job buys me child care and my husband does a lot. I do not go to openings or many studio visits, phone calls are minimal, wac meetings come at story time. This relative sequestering from the mainstream has taken its toll on my art "career." From a professional point of view it is clear that to be an artist and a mom is double trouble. Two professions requiring lots of work without pay and recognition. Men contributing with chores and child care are heroes. Women can never do enough.

It is no surprise to experience discrimination within the conservative art establishment. I have pretended not to be pregnant and have hid my kids at various low points in my art dealings. I received one day sick leave from my teaching job for each pregnancy. A few women in my

department at school have one child, most have none. Most of the men have two or more. Society seems to say that a man is more complete having fathered offspring and a woman less accomplished. I anticipated institutional discrimination (private dealers included) but it is depressing to encounter condescension from other artists. The taboo against motherhood (and/or speaking of it) seems fostered by the male myth of art as separate from and above all else. This is old stuff. It is sad when women adopt this stance. In my experience art and life have gained spirit and meaning by becoming enmeshed. There are natural lifestyle schisms between those with and without kids but in order for women to be fully empowered, there needs to be a spirit of inclusivity and generosity toward both groups.

Dena Shottenkirk

Motherhood

Like morality, good manners, and a criminal record, motherhood has nothing to do with making art. Its presence neither improves one's ability, nor does it sap one's creativity like Nietzsche's worried model of having one's vital powers drained from sperm ejaculations. Giving birth does not automatically mean giving up.

Having said that, I'd like to retract it. There are limits in the world and nothing proves it like a serious illness or having children.

Wait a minute—that's too vehement. I adore my children. I never knew real passion until I had my first child. The smell that emanated from the deep recesses of her neck literally intoxicated me. I would lean over that crib and bury my face in her neck and inhale her smell until my back gave out or I began to hyperventilate. I don't wonder how it is that wild animal mothers can always identify the smell of their own offspring, differentiating them from the smells of all seemingly identical babies. The smell of your own offspring is more real and potent than any other sensory experience. I doubt that this instinct comes from the more highly developed or intellectual parts of the brain, but nevertheless, I have rarely had more concentrated pleasure.

Private life—not the kind that is spliced into the interstices of public life, not the "quality time" of a few minutes at the end of a distracted and harried day—but the privacy that exists in a hermetic domestic

world that has the luxury to experience the pleasure that comes from spending all day watching the wonderment of a new mind, is a world that has completely fallen out of fashion. The private realm is dismissed as a facet of existence that ought to be farmed out to those who are willing to do it by the hour. However much of the relaxed pleasure that comes from living with children in the natural slow pace of an untimed day gets lost when the private world is subjected to the circumscribed timetable of public life. Demands go up and tolerance for chaos goes down. It is not an algorithm that suits children. Babies and small children have a perverse sense of pleasure in any kind of reaction, whether it is a jack-in-the-box or a glass of milk heaved across the room, it's all equally thrilling for them. They react totally, with every cell in their bodies; peer approval and cool are still safely closeted in the unseen future. Everything is experienced in and for the moment. It is that narrowing of the world to the most private of all realms that is both the bait and the sinker.

If Philippe Aries and Georges Duby ever commission a sixth volume of *A History of Private Life* to cover our own decades, it will surely be issued as a pamphlet. An ironic side effect of feminism has been the denigration of some of the most traditional elements of the female world: the care of children and the elderly; in general, doing anything for others without monetary compensation. Caring for others is now a job for low-paid foreign workers or our own semiliterate citizens. No woman with any education or ambition would relegate herself to the lowly status that our mothers or grandmothers did. We want to do what the boys do. That's okay, but it certainly is worth asking if the boys are really so great after all. I mean, who wants to emulate an asshole?

I've seen a lot of husbands in my life, and have even had a few myself, and noticed a shocking degree of consistence vis-à-vis their child care habits. My mother-in-law maintains that it's all genetic; they're just born that way. It's a depressing thought, but I'm beginning to think she may be right. You may say that tails on rats are just cultural, but if they've *all* got them, the argument is empty. There's a logical imperative here. Husbands never, ever, do anything close to half of the work involved in child-rearing. Now, a few of them seriously believe that they do. I've heard several properly brought up, politically correct men say that they participate fully in the duties and responsibilities of child and house care, but I've never heard a wife concur. Another critic recently

told me that until his wife went out of town for a week and left him with the responsibility for their son, he had always given himself credit for doing thirty percent—a decent and liberal estimation of his own irresponsibility. But he has now been forced to revise that to ten percent. This news may not rally him to new standards of behavior but he's going to be ever so much more grateful.

I believe this universal state of affairs confirms at least one of two things: either women really are more foolish than men, or men really are more wicked than women.

Option one: men don't get themselves suckered into doing any more than the barest minimum of the detailed, shit work like grocery shopping, laundry, chauffeuring to lessons and social events, routine doctor visits, shopping for clothes, cleaning bedrooms, buying toys, setting up play dates, arranging baby-sitting, or conferring with teachers. Women assume these responsibilities independent of their outside workload. Even when a woman has a full-time career, the lion's share of this mountain of details falls to her. The men claim they are too busy or they simply forget, *and they get away with it.* This triumph could easily be viewed as a clear argument for their superiority.

This universal state of affairs may confirm the second option: men are truly scoundrels and women simply are unwilling to stoop to such depths of selfishness and inconsideration of others. Few mothers could "forget" to take their children to the doctor's for routine checkups, or permanently neglect to do the laundry. So maybe the old-fashioned argument for female moral superiority is true.

But regardless of these debates about the ultimate meaning of women's parenting responsibilities, what does it say about the compatibility of having children with being an artist? I believe there are three possibilities. You can have your children when you're still a teenager and living with your mother, because she's the one who's really going to help you out. She won't cheat you on the percentage of work that she does. By the time you're thirty-five, your kids will be grown and you'll have your life back. Or, secondly, you can have lots of money. You'll need lots of it to hire an additional woman to do the things that need to be done so you can go to the studio. It is a rare artist who has the long-term earning potential to span the years of a child's twenty-year dependency. If she is going to rely solely on herself, she would have to earn a minimum of $50,000.00 after taxes, dealer cut, and the cost of produc-

ing the work, e.g., studio rent, materials, and assistants, in order to pay the minimum wage of $20,000 for household help. That leaves her with $30,000 to pay for her living costs. So she's going to have to have sales of at least $120,000 consistently for twenty years in order to be in the studio every day. Or, thirdly, she can do what artists with children usually do: she can run herself ragged, put off washing the dishes, do without to pay the baby-sitter, put off that studio visit to take someone or other to the pediatrician, and make the best of a hard situation, often with a wage-earning husband who also feels ill-used and tired.

"Diamonds are a Girl's Best Friend" is the chorus line that comes to mind in this context. Babies cost money. Add to that a profession like art that is hardly a dependable corporate ladder, and the financial jitters are sure to rattle your night. But it's a testament to the frailty of the human memory when all those worries and fears evaporate into the ether of the forgettable, as that little face puckers up for a kiss. The wonderfulness of children really does make all other practical concerns turn shamefaced away from one's consciousness: money and sustenance issues have no place competing with that sweetness of childhood. Priorities have to assert themselves, and the drab absorption in everyday life must pale next to the moments of passionate love and intense pleasure that children bring. People, in the final autumnal days of their lives, rarely delight in their recollection of a day well worked. It is the small yet significant events that mark the time of one's memories: a day at the beach with one of the silly little ones covered in sand up to their neck; the triumphant day of a first bike ride; the first birthday cake heaved across the room. And so one becomes a mother in much the same way as one becomes an artist: blithely and without regard for the practical consequences. And really, is there any other way to live?

<div align="right">Joan Snyder</div>

Being a Mother

Being a mother and an artist: hard. Being a single mother and an artist: harder. Being a mother is being a mother is being a mother. Being an artist means doing your work. You need time and you need help, years and years of help. It's hard work—hard, creative, time-consuming work. Lucky, very lucky, when your child is healthy. I have a fabulously healthy, beautiful, grounded, wise, centered child who never learned

how to whine. As an infant and small child Molly was always surrounded by an abundance of people who loved her. She still is. So she is lucky and I am lucky.

In answer to one of your questions, I never noticed discrimination from anyone in the art world based on pregnancy or motherhood. Everyone has always seemed very supportive of this aspect of my life. It's not motherhood that triggers discrimination in the art world; it's being a woman.

There is a quote from Hilton Kramer that illustrates perfectly the invidious discrimination against women in the art world:

> The whole phenomenon of Neo-Expressionism, and particularly the American aspects of it—Schnabel, Salle and Eric Fischl, and people of that generation—really has to be understood in relation to minimalism and color-field abstraction, which by the 1970s had established a standard of visual anemia in art. There was a longing for a kind of art that was richer in visual incident. It was an invitation to the next generation to say, We're going to fill up those surfaces with everything we can lay our hands on.

Except that it wasn't the male artists who were working that way then— WE WERE! Women were. Mothers were. Women, who were working in isolation in universities with only male faculty who didn't begin to understand our new language, were. Women all over the country in their studios—again in isolation because very little attention was being paid to them—were. It was women artists who pumped the blood back into the art world in the 1970s and 1980s, not the men Kramer touts. At the height of the pop and minimal movements, we were making other art—art that was personal, autobiographical, expressionistic, narrative, and political. It was women using words, cutting, pasting, building layer upon layer of material, experimenting with new materials, and, to paraphrase Hilton Kramer, filling up those surfaces with everything we could lay our hands on. This was called feminist art. This was what the art of the 1980s was finally about, appropriated by the most famous male artists of the decade. They were called heroic for bringing expression and the personal to their art. We were called feminist (which was a dirty word). They called it neo-Expressionist. It wasn't neo to us.

In answer to another of your questions, being a mother affects your work because it affects your whole being—your body your mind your heart your soul—and of course your work. But what it's really like is that you live two lives, yours and your kid's. Every day. Maybe the hardest

part is the "maintenance" because children keep eating and growing. So every six months or so, no matter what, they need new clothes, new shoes (you have to go through and get rid of the old ones), new haircuts, new dentist and doctor appointments, new play dates, and even new friends. I have done it all for thirteen years. I have gone to every one of Molly's doctor, dentist, hygienist, and orthodontist appointments. I have suffered with her every high fever, headache, stomachache, and earache. I have enjoyed every school play, dance recital, concert, performance, and teacher's conference—alone—for thirteen years. You need lots of help but the help doesn't do that stuff. . . . You have to do it . . . (even friends and lovers don't do it). So it sounds like all of this cuts into my time and work. No kidding. (While Julian Schnabel was painting away.) But I never felt that my work suffered for any of it. Because being a mother is being a mother is being a mother is BEING.

P.S. Saturday, July 18—I have just taken my eighty-six-year-old mother and my ninety-two-year-old father for haircuts, new sneakers, and out to dinner.

Tuesday, July 21—I have just taken my mother to the emergency room of Kings Highway Hospital in Brooklyn. My sister has run to care for my father. I call my brother to tell him about Mom.

Thursday, July 22—My mother is operated on and is in critical condition in the ICU unit of the hospital. I visit her three times a day and run to my father in between visits. My brother telephones to see how everyone is doing.

Sunday, July 26—I put Molly on the bus for camp for three weeks. . . . Mom still in ICU.

Being a mother is being a mother and being a daughter is being a daughter. None of this has anything to do with the art world . . . it all has to do with my work and time.

The bottom line is that you don't have to be a mother or a daughter to be discriminated against in the art world . . . you just have to be a woman.

Elke Solomon

The late 1960s and early 1970s produced an attitude of either/or in me. A child or total concentration on work. By the late 1970s, I could give myself permission to have a child. Women have been trained to stir the

pot, diaper a child, and write a novel simultaneously. When Alex was born my priorities were—he needed to be fed and changed when he needed to be fed and changed. That's it! I became very disciplined. I basically went underground, or midunderground, where I could be both a serious artist and serious parent. I now realize how isolated I was.

I learned from the mothers who were my friends in the late 1960s and early 1970s in the midst of the ardency of the new feminism that as new feminists we were not being sensitive to "their" needs. In the 1990s we are still learning from mothers and other women that there is still not enough real support for day care, mandatory leave, prenatal care, maternity leave, child support, battered women support, planned parenthood, sex education in the schools, single parenthood, and gay and lesbian parenthood.

It's supposed to be "natural" to be a mother if you're a woman. Our bodies are made to be mothers. Only women can be mothers. Men can be caregivers. If you have a child before a certain age, or after a certain age, in the art world, you're abnormal; if you don't have a child, you're abnormal. And men make art. How many men have been told not to bring their children to galleries, or openings, because they would not be taken seriously? Men caring for babies, an additional job to their natural job of making art, are treated as rare and wonderful superhumans, and women artists with families are treated as though it comes with the territory rather than assumed by the free exercise of their will.

I love and hate being a mother. It's positive, enriching, optimistic, and excruciatingly difficult. We care of/for another human for the rest of our lives. I love and hate being an artist. I do not love being a woman artist in the art world. Making art takes time, having babies takes time. As children become more independent, another kind of attentiveness is needed for parenting, and more time becomes available. Alex has taught me, in the most palpable way, that things change all the time—situations, foci, and priorities, that life precedes art.

Nancy Spero

Creation and Pro-creation

We (Leon Golub and myself) have three adult sons, Stephen, Philip, and Paul. The first two were born in Chicago in the early 1950s. My consciousness was not "raised" at the time, but I was acutely aware that

after having an autonomous role at the School of the Art Institute of Chicago and after functioning as a young artist in Chicago, I was treated differently as a wife and mother.

The stigma of motherhood had struck. It seemed even artist friends regarded me differently as if there couldn't be two artists in one household. My work was virtually and sometimes conspicuously ignored in the 1950s (see cv!)—particularly when the male half was honing his skills in theoretical explanations of a powerful oeuvre, recognized as a "young turk." My art was more lyrical and layered, less accessible—coming from a female sensibility? Less accessible meaning the Chicago art world that I knew was unwilling to grant access. The 1950s, like the 1980s, was an era of macho roles. I was hidden behind the nuclear family, and the general denial of validity to women artists, particularly mothers.

Having a primary responsibility with the children—Leon's consciousness needed a lot of raising in that era—I never stopped working and always late at night, proving if only to myself that I was an artist.

In 1959 we went to Paris where we lived and worked for five years. Our third son, Paul, was born there. The Parisian art world opened for me as it hadn't in Chicago. Perhaps because I wasn't categorized as "wife" or "mother." I had three solo shows at Galerie Breteau and exhibited in various group exhibitions in France and Switzerland.

In 1964 we returned to the United States—to New York. The Vietnam War was raging, and I was upset at the U.S. involvement and actions in the conflict. Also I was intensely rethinking my position as an artist. Did I want to reiterate timeless subjects, employing an extended, lengthy process, or did I want to address the excesses of violence in war—its potential for total destruction? Perhaps motherhood was part of a political, personal choice in my changing mediums and content. I started working rapidly on paper, angry works, often scatological—manifestos against a senseless obscene war, a war that my sons (too young then) could have been called up for. Those works were exorcisms to keep the war away.

I felt silenced as an artist, with no dialogue, as there were no venues—other than a few antiwar shows and benefits. The silencing of women's voices in society is pervasive. In the *War Series,* angry screaming heads in clouds of bombs spew and vomit poison onto the victims below. Phallic tongues emerge from human heads at the tips of the penile extensions of the bomb or helicopter blades. Making these extreme

images, I worried that the children might be embarrassed with the content of my art, what "their mother" might be doing as an artist.

They must have realized what I was painting (the *War Paintings* and the *Codex Artaud*). But they were at ease about the art, largely ignoring what both of us were doing, taking us for granted, occasionally as they got older displaying a relaxed acceptance. But I learned years later that they were much more concerned that I didn't appear or dress in more conventional or conservative feminine attire.

In the *Artaud Paintings* (1969–70) and *Codex Artaud* (1969–72), I used fragmented quotes from Antonin Artaud—of his desperation, humor, misogyny, and violent language. He speaks of his tongue being cut!—silenced. I fragmented these quotes with images I had painted—disembodied heads, defiant phallic tongues on tense male, female, and androgynous straitjackets, mythological or alchemical references. I'm literally sticking my tongue out at the world—woman silence, victimized and brutalized, hysterical, talking "in tongues." These descriptions of women fit Artaud's writings and behavior. But as a male character, he is canonized because of his "otherness"—his disrupture of language.

I became an active participant in the art world in the late 1960s and early 1970s, joining women artists' action and discussion groups, such as WAR (Women Artists in Revolution), the Ad Hoc committee of women artists, and A.I.R. Gallery, an all-women's cooperative gallery founded in 1972. We analyzed women's status in the art world, the collusion of power (galleries, museums, critics, collectors, auctions) how the "heroes" are kept on top. (I joke that I joined the women artists groups as I was the only woman in an all male household—even the dog was male!)

We took action, picketing the Whitney Museum (in 1970, women artists represented only 4 percent of those exhibited at the Whitney Biennial), we wrote manifestos for parity and more exhibition opportunities, joined pro-choice marches, and so on.

By different roads, Golub's career and mine have become equal. My art now for the most part has crossed the boundaries from the private into the public domain (from the feminine ghetto into a man's world?). The work that was ignored in the 1950s and 1960s became "relevant" in the 1980s. Leon was consistently critically supportive of my work, and we continued to have an ongoing dialogue. In the early 1980s, I had (gave myself) a three-gallery show (A.I.R., 345 Gallery, and Art Galaxy)—a miniretrospective so that my art was then seen to have a his-

tory. And too, there was the continuance of the dialogues with women artists, historians, theorists (even if women artists were again more dispersed and isolated in the 1980s, the Reagan/Bush years, Kinder, Küche & Kirche—conservative times without much group political action, with the exception of the Guerrilla Girls). Now in the 1990s, with women's political action groups such as WAC (Women's Action Coalition), many women artists are joining together as there is an almost universal anger and frustration with the system.

I have not been too involved with the "problems" of motherhood for well over a decade and a half. I have a step-granddaughter—a young, able businesswoman, and my eldest son and his wife have just adopted a half-white/half-black baby girl. I am a multicultural grandmother now.

May Stevens

How many artists are fathers? How has it affected their work, people's response to their work, their careers? Did Jeff Koons or Frank Stella postpone their careers in order to take their responsibilities as fathers seriously? Did Pace, Castelli, Sonnabend, or Mary Boone discriminate against Schnabel, Salle, or Marden because of fatherhood? What does Gagosian think of Peter Halley's paternity record?

I will be very happy to discuss questions of motherhood after your journal seriously researches fatherhood among artists. In the present, when women bring up children alone and bear primary—often sole—responsibility, financial and emotional, for the next generation, it's fatherhood that needs looking at.

Martha Wilson

How has being a mother affected people's response or reactions to your artwork?
I was the one who thought my career would be over as soon as the baby appeared. It was Ellen Rumm who said, "You're a performance artist—your body is your medium. Why don't you just consider the baby to be an extension of your work?"
How has it affected your career?
I spend a lot more money than I ever thought I had on child care.

Have you encountered discrimination?

No, but I am self-employed.

Did you postpone starting your career or stop working when your children were young?

I'm glad to be an old lady with a baby, even though I sometimes get called "grandmother" on the subway. It would be difficult to baby yourself, which is what starting your career requires, while minding a baby.

How would you describe the differences in treatment?

Don't know.

Did having children enhance your creativity?

All my work is about seeing from the female perspective anyway, and having a baby is one of those things a man can't do. I was interested in the unknown. What do I know now? It's more fun than I expected, more fun than my mother gave me to understand, raising me in the afterglow of World War II. And I suspect that although I "created" a being, he is 100 percent himself and I have perhaps zero influence. Having a baby is how the vast number of women who are not artists get to bliss, the creative "play" state to which art gives us access.

Barbara Zucker

Motherhood's restrictions on my life (and that includes my creative life) came from within, and not as the result of the way I was treated by others. When my daughter was born something inside me, which had long been slumbering, kicked into gear. It has been functioning, neurotically and unbidden, ever since.

In practical, nonanalytical terms I could name this "something" the loss of selfishness, that trait so absolutely essential to those of us who attempt to create. I felt robbed, crazed. Suddenly, I responded as if I were a puppet to the needs of someone else—she came first, I'm still not sure who came second, or whether I was even on third—the game plan had changed entirely, overnight, and to this day I haven't figured out the rules.

There was virtually no support system. My then-husband was not liberated (it was 1969), my parents lived hours away, and my in-laws were completely out to lunch. I identified with my infant: the world was a hostile place, there was no help, and it was my job to protect her, forever!

This attitude did not give me peace of mind. I had access to my studio. I was only working part-time. The problem was me. If my child was sick, or needy, I simply fell apart. I was lovesick and had lost control of my life rhythm. My place was with her, period. Not everyone sees the world the way I did. Some find it friendly, and are capable of trust. They know their child won't die if they go to work and leave her in the care of others.

Besides the new selflessness, the thing which had been slumbering in me was little Barbara, who woke up with explosive force when I became a mother. I had to assuage her/my fears as well as those of my child. My daughter's birth put me in touch with all kinds of repressed childhood fears I'd done just fine without acknowledging.

So what's the good side? All this anxiety and confusion threw me right back into therapy, where I figured out some things. I tried harder than before to get my work out because I needed to prove that motherhood would never stop me from pursuing my career.

My daughter made me ecstatic; my love for her eclipsed any other. She gave me back the parks and the circus and bright colors (was there really anything but black)? She bestowed upon me a set of friends I could never have found on my own, made me a lot less judgmental, a much nicer person, got me to Disneyworld, put me back in touch with my parents and fundamentally connected me to the universe.

The circus became a focus for a long series of sculptures I did from 1976 to 1980 which were called *Harlequin Poles*, and Disneyworld served as the impetus for three animated, mechanized sculpture installations I did in 1978 and 1980—*We See You*, at Artpark in Lewiston, New York, *Holly's Triangle* at The Joselyn Art Museum, and *Use-Reuse* at the Customs House in New York through Creative Time, Inc.

Having a child was a crisis. Crisis is the only thing which creates fast, substantive change. I've never been the same since, nor, by extension, has my work and its process.

Working Conditions: A Forum on

Art and Everyday Life by Younger Artists

In the spring of 1994, the editors of *M/E/A/N/I/N/G* invited Julia Jacquette and Lawrence Lipkin, artists living in New York City, to guest edit a forum. This forum focuses on younger artists and the issues they feel concern them most. The following questions were composed by the guest editors and sent to a diverse group of younger artists.

How do the politics and/or experiences of everyday life affect your work? Is this the subject matter of your work? If not, how do these factors come into play anyway?

How do you feel about being an artist in a culture whose primary forms of visual information are television, movies, and urban advertising?

How confident are you in your work? What gives you confidence?

Do you have a second passion after art making? How does this affect or compete with your artwork?

Lisa Hoke

Vegetables, cast iron, wire, string, shower curtains, magnets, pipes, glass, steel, xeroxes, wax, a stuffed bird, wood, fabric, zippers, ribbon, a drawer, a sandbag, formula cans, circles, mufflers, plastic chair web-

bing, naugahyde, auto windows, brass chains, buttons, silicone, baby-food jars, hangers, shirtsleeves, rugs, netting, rope, labels, curtain rods, grommets, picture hoods, thread, ink, sugar, water, glue, cookie sheets, cake pans, invoices, cardboard, jar lids, shredded text, rolling pin, clothesline, rubber, a broomstick . . .

These are the items in my life and my art. I am witnessing, reliving, and recording the activities of every day, attempting to extend the moment. I seek, in the singular object, to linger over that which is outgrown or too personal or too ordinary. Sometimes in the mundane is the opportunity for me to examine a fragment of an experience, which then becomes a building block or catalyst toward a new structure. Each object is rich with underrated potential and I try to move it from stasis to an active relationship. Often, a discomfort with an engagement to others is revealed. This physical reaction is the sculpture . . . stretching . . . pulling . . . balancing . . . tearing . . . filling up . . . gorging out . . . hanging off . . . ripping open . . . zipped tight . . . unzipped . . . stuck on . . . falling off . . . poured into . . . accumulated . . . stacked . . . glued . . . strung . . . hung . . . cast . . . stuffed full . . . emptied out.

It is the smallness that I want to celebrate and elaborate. I am forever changing my past by my present. The circularity of object to life to art means that I do not have to leave well enough alone.

Julia Jacquette

When I first found I could make artwork about the frustration, anguish, and stupidity of my own life, I wept with relief.

I came upon this realization when I was in residence at an artists' colony in the woods of Massachusetts and was recovering after the breakup of a romance. Although I had always avoided biography in my work I thought, "This bitterness is obsessing me. If I don't get it out of my system I'm not going to be able to make work anyway, so I might as well embarrass myself and spew my bile." But luckily I had metaphor to help me, and I found I could avoid being literal and still speak about this morass.

The key thing seemed to be finding the imagery, the object, the color, the texture that dovetailed with what one wanted to say emotionally. I looked upon Philip Guston's pictures with deep sighs of admiration and tooth-grinding envy; it seemed to me he did this so very, very well.

To use such a vile figure (a hooded Ku Klux Klansman) as a stand-in for oneself, and to make that image simultaneously poignant and humorous, all the while painting it in a simultaneously poignant and humorous way, seemed so painfully perfect to me. For a long time it was hard to see past him (Guston); to see beyond his way of talking about himself. For a while I tried simply using his language, but eventually, thank goodness, found my own.

Important to finding my own language was the realization and acceptance that for me life was an endless black hole of desire. Constant longing for things, people, and situations other than my own. I found that making work about this was the only time I felt some relief from these feelings of yearning and incompleteness. The only time I feel confident about myself is when I am working. And my work is the one thing in my life that I feel confident about—which is ironic since it is about being so unself-confident.

I am happiest when I am painting, with music playing over headphones, and on a sugar high. One of the side benefits of being a visual artist is being able to listen to music, or, dare I admit it, talk radio, while working. And I do so constantly. I'll say, with a little embarrassment, that as I plunge into my thirties, my interest in rock music hasn't decreased one iota. I can say the same for most of my artist cohorts. This has meant access to a large pool of people with which to trade homemade tapes, exchange musical opinions, and see live performance. The conversations about music and art are always inextricably mixed and I see this as one of the most pleasurable parts of my life.

I've noticed that a large percentage of the visual artists I know roughly my age are in rock bands. Something about this kind of music has a grip on us and stubbornly won't let go. Sometimes I think it comes down to the fact that there's a category of people who think that the sound of a heavily distorted guitar is not abrasive and intrusive, but is gorgeous and sublime. We may feel silly for being so representative of our generation ("X"), but we're not going to stop listening or playing—it's too pleasurable.

Rebecca Quaytman

The political and experiential are intrinsically art's source, content, and legibility. What interests me more in the context of this questionnaire is

how political/theoretical viewpoints can determine the mute/passive experience from which we all, as artists, try to extract a voice.

From the viewpoint of a not-so-young-anymore young artist, my education predates the ascendancy of neo-pop/conceptual thinking and production in the "academy." Not choosing to get a master's degree, I have tried to grapple on my own with the threatening and unavoidable questions these theoretical histories have posed for painting. As a "young artist" to whom this issue of *M/E/A/N/I/N/G* is addressed, I am of a generation that has learned a specific politic of experiential inclusion. My work is expected to include ideally "my" but implicitly "our" experience as predicated in a lower-middle-class American pop/cultural politic. Watching artists aggressively transgress art objecthood and authorship with a bibliography-based militancy can erode confidence in my own work, which is often perceived, as one French curator commented, as completely "outside le discours." But it is not the work of these artists that produces this erosion of confidence so much as the brilliant light that exhibitions and critical inclusion sheds on it. Next to the fading future we can imagine so well in this post-1980s climate, much of this work seems to be an honest but symptomatic response to an exhibition and critical situation that functions not unlike the fashion or pop music industry, or, as you put it, "television, movies, and urban advertising."

I want to talk more specifically about painting. As a young artist wanting to make work of relevancy outside of a super-subjective, mystical, or expressionist stance, one enters into a raging battlefield full of people who have devoted their lives to analyzing the position and validity of one's male colleagues, and how the death of "the father" (authorship and autonomy) is implicit in their production. Painting has become pure spectacle losing its power to do harm. It has become like the oppressed feminine: domestic, shallow, empty, ineffectual, fickle, decorative. Our Father Jean-François Lyotard writes:

> virility has its price: life; the body can speak only if it can die and each time it knows pleasure, the body risks becoming lawless and speechless once again capable only of living and laughing. This is why love is for man a struggle in which his virility, that is, culture, is at stake.[1]

I often wonder if the attack via neo-pop/conceptualism on feelings of love (there is no other word for it) toward paintings is not predicated in a desire for virility.

My experience and politics have also led me to be suspect of claims made by critics on behalf of what has recently been dubbed the "new painting": A post-nostalgic/melancholic painting whose claim is to have effectively canceled the figurative versus abstract debate by picturing itself. I think it is interesting to consider the connection between the vernacular use of the word *like*, especially in generation xyz, and the prevailing tendency to distance the self in current art practice. Is it just a coincidence that this "picturing" is the product of a generation that predicates every attempt at verbalizing experience with this word? I don't know, but I think, like, new painting uses, like, what I call, "Presence as Lady Bunny" in which, like, looking at paintings has become a lot like, girl watching, which I will be the first to admit can be, like, great. The only problem is the girl is usually masculine rhetoric underneath all the trappings of painterly facility and decorative detail. In a published dialogue between Michael Corris and Robert Nickas in *Artforum* on the "new painting," Michael "O.J." Corris says:

> A painting of quality is a picture that uses abuse, embellishment, degradation and decoration to generate complex visual malapropisms out of erasure, cancellation, acts of outright destruction of the surface and the picture, the scotomization of vision.[2]

I can't help but, like, sense misogyny at work here. Later in the article Corris comments that, unlike Warhol, this work "admits that a contradiction between the what and the how exists in their paintings."[3] The implication being that these artists use these techniques in their work but not in their life. Hmmm. Do these techniques of abuse, degradation, and erasure come from experience? Apparently not. From politics? I think so. But ultimately it is a rather safe politics, safe in its irony which has become a theatrics of separation from the "academy."

Although I appreciate the insights of appropriation, especially in its relation to feminism, I find that picturing the picture more often than not is an angry gesture at a loss of something I think we all are better off without.

It takes real willpower to scramble out from beneath this suspended tidal wave of theory and try to recall my own short history of looking at painting, of being the subject, in order to understand where I seem unavoidably to be going.

In the 1970s when I was a teenager my experience with modernist abstraction and minimalism was undeniably one attuned to Michael

Fried's notion of "Presence as Grace" even though at the time I had no idea who Fried was. When I first started needing to understand and experience contemporary painting I found it distant, unattractive, and impenetrable. But then on a few distinct occasions I discovered in this lack of spectacle powerful feelings of resonance and understanding/love. It required a certain erotic leap of faith. At age thirteen, fourteen, fifteen I don't think I had the agenda of "legitimating the hegemony of American-type formalism,"[4] which Fried is accused of having. I found out then that the only way to look at art if you want to experience it is with a dual trust in it and in your own perception, whether you like what you see or not.

I remember an inner conflict I had in perceiving this work. In the hygienic museum/gallery space, painting seemed to be under a hyper-focus in which even the faint residue of dust on the paint, smudges on the glass frame, and the uncomfortable awareness of my own body became distractingly apparent. I felt as if I were simultaneously the organism being looked at and the huge eye looking. I was unsure as to what was meant to be experienced and felt guilt for any focus that wandered from the intended target of the painting. I did not have this difficulty with pop art. It was as if these paintings stood in some kind of metaphysical profile in which the subject was peripheral, profoundly outside. If I had known that this is precisely what this work was getting at in its reference to the impotent position of the subject in pop culture at the time, I would have had trust in my response, instead of taking it as a failing on my own part as its audience.

By the time I left college the paternal was not where I was headed. I did not know it at the time, but "discourse" was already saying this with all the paternal authority it could muster. I was noticing how easily painting could be perceived as not having a presence at all, let alone a graceful one. To me however this was never a frightening thing signifying death, it was something else that needed and needs to be examined.

These experiences have led me to a particular place with my own work. I want to realize how to conflate the contradictory experiences of being either in love with or peripheral to a painting. I want to make a painting that knows it is hung on a wall next to other paintings by which its audience walks. To acknowledge that paintings are not immortal, that they die and are forgotten. To acknowledge that one painting does not imply the next. To acknowledge that the only honest way

to know painting's newfound freedom as a lost authority is to disrupt its function as a target. The problem for me is how to make a painting that safely, and not ironically, receives a glance without being a target, without being an authority. To acknowledge that what you see is what you want to get, and to acknowledge that a painting does not exist in the world if no one is there to hear it fall, because it is not an idea, and it is not an object.

Everyone's head is full. They are not hungry anymore. They are not hungry in the face of plenitude. So maybe there is a way to make art that doesn't try to fill, but hangs close to the wall, not to take up too much space. Because it has no choice anyway. Death is not a choice, and emptiness is not frightening. Women and paintings know that "mere objects of visual display" have a life of their own and are included if only in a periphery, which is the space occupied by a painting in a room.

Notes

1 Jean-François Lyotard, "Some of the Things at Stake in Women's Struggles," *Wedge,* no. 6, Winter 1984, p. 25.
2 Michael Corris and Robert Nickas, "Punishment and Decoration: Art in an Age of Militant Superficiality," *Artforum,* April 1993, p. 83.
3 Ibid.
4 Benjamin H. D. Buchloh, *Discussions in Contemporary Culture,* DIA Art Foundation series, no. 1 (Seattle: Bay Press, 1987), p. 86.

Christian Schumann

1. Everything I see and experience affects me in some way and a lot of it ends up in my work. One aspect of my paintings is that they serve as ambiguous diaries whose initial personal subject matter is lost when they leave me but which gain more formal and cultural contexts when they enter into the public world. I am interested in things that serve as both formal critique and personal record.

2. What choice do I have? I'm in it and have undeniably grown up being influenced by it. The important thing is to be able to alert one's self to the mass media's information-control capabilities and tech-

niques. In terms of visual devices, package design and the language of advertising interest me.

3. I have little confidence in a painting until the moment I decide it is finished; when everything has finally come together.

4. Nothing "competes with" but everything "creeps into" my work. I like listening to music and on occasion a song title or swatch of lyric will slip into a piece . . . or maybe part of an old record cover. Writing and books are also diversions that end up being a part of my paintings. Writing/describing things is just as effective to me as drawing/painting them. Words are merely a different form of visual abstraction. . . . Everything is an equal passion.

Amy Sillman

Politics and Everyday Experiences: Being a devotee of the raucous and the rowdy, as well as the sublime and the contemplative, I have the task of integrating the two into one big map of the stream of my consciousness. Everything I love, hate, fuck, fear, wonder at, feel remorse about, dream about, see, eat, and laugh at—or can remember—is there in some form or another. Politics plays a part only to the extent that it comes up naturally in these urge-driven psycho-roadmaps. My work is not instructive. It's basically a story written in the first person. But I hope it functions like corrective politics if women speak loudly about themselves with flourish, expertise, fabulous beauty, raucous humor, and unquenchable, snappy, swinging fearlessness.

In many ways I think my work is about terror management, the control of phobia through humor. An example: I had a nightmare about being raped by a Basque terrorist, a guy with a heavy beard and an ultramasculine demeanor. Later, a macho-looking character with a heavy beard appeared in a painting, but I gave him tiny hands, a huge dangling udder, and a clown suit. After that it occurred to me that I had demasculinized the rapist by making him into an ineffectual clown. That's the kind of therapeutic benefit and autobiography that appeals to me in doing a painting. Also the sort of (associative, dissociative) politics that I can work with.

Television, movies, etc.: I can't stop the flow of stuff that comes pouring in, but I like working with the distraction that arises from it. I

couldn't be less interested in deconstructing, mimicking, mocking, or employing the forms or methodology of mass culture. I often feel like a folk artist, not an uncomfortable sensation.

Passions: Almost everything on the big screen, high and low, mainstream and experimental, including junk, melodrama, vampires, Technicolor, screwball comedies, Sirk, Marilyn, Clint, Satyajit Ray, Jack Smith, Kenneth Anger, Sadie Benning, etc. (There are certain exceptions, like slasher movies, which I hate.) Also underground comics, early *Mad*, Basil Wolverton, R. Crumb, Art Speigelman, the Hairy Who artists, and Saul Steinberg. Florine Stettheimer. Indian painting and Tantric art. Poetry, which I like to read and write. Religions, which I like to read about.

All of these things (and many others) I am passionately interested in, partly for the narratives they contain, skewed or linear as they may be. And anything that requires ardent belief to make and manages somehow not to seem sappy is inspiring to me and feeds my work. I love technique, seduction, stories, ardent belief, magic, beauty, and humor.

Hugh Steers

1. When I came to New York from Yale in 1985, my paintings tended toward allegorical expression of my moral, sociopolitical views. As for my personal experiences, I often used a similar, self-conscious method to convey them. Since 1985 the development of my imagery has been away from this obvious allegorical approach. Now, the process is more about sensing the appropriate imagery rather than imposing it. The images are still allegories but without a fixed moral. They remain intensely felt, personal responses to being human; only as a consequence are they political. I think political issues are transitory and art inspired by them dates quickly.

2. I enjoy pop culture, which actually inspires some of my imagery. One of the aspects of pop culture that fascinates me is how it operates as a site where society's and the individual's hopes and desires are negotiated. I sometimes consider the results of this "negotiation" while working out my imagery. These hopes and desires mix with my own experience and find expression through my chosen medium. Figurative painting is a language with five hundred years of history with all its associations of

authority and truth. I paint without the safe ironic distance of appropri-
ation or neo-isms but rather with a belief in the mastery of technique
and the possibility of carving a unique position in the history of painting
by drawing on artists from Giotto to Rauschenberg.

I also find it interesting how "high art's" embrace of pop culture is
full of condescension. To engage popular culture, artists seem to think
it sufficient to make something that looks ironic, or remote, and back it
up with reams of theory. I believe great examples of popular culture can
have the same resonance as examples of what is commonly agreed to be
"high culture." The best artists in the realm of popular culture—TV,
contemporary music, film, etc.—are comfortable with exploring and
refining personal emotional content in their work. They are not con-
fined by the strictures of the contemporary art academy. In this sense,
the creators of popular culture are way ahead of the art world.

3. I don't think it's good to feel too confident about one's work, but
there's nothing like an exceptionally good passage of paint to make me
feel good.

4. I wish.

Nicola Tyson

Moving to New York from London (where I grew up) has had a crucial
influence on my work. It has enabled me to get a distance on myself and
my cultural baggage (my source material) and process it. Here, how-
ever, I find myself operating in a cultural context that has no distance
on itself (except for the purposes of humor), something I find both
exciting and boring. Art is such a given in New York that no one need
question its purpose too deeply, which results in much shallow work
being produced. But the level of enthusiasm and support for the arts is
for me a relief, coming as I do from a culture where the visual arts are
not particularly valued or even taken seriously, perhaps due to a tradi-
tional English skepticism (or fear of seeming pretentious). Ironically
(. . . being the word), meanwhile, advertising in the UK is supercreative,
unparalleled in pointless sophistication, and completely self-referential.
Hence there seems to be some confusion in the minds of many of my
contemporaries, and I am glad to have escaped advertising's insidious
cultural effect, which can be seen in a lot of contemporary British

"conceptual" art. Now I am presented with a barrage of mostly un-memorable messages about getting and spending . . . which I find I can ignore, probably because most of the cultural references used have no resonance for me as I didn't grow up here. I don't like to feel manipu-lated, I know what I want.

Growing up I wasn't exposed to much in the way of pop culture and didn't really seek it out. So in its most obvious forms it has never been a comfortable or meaningful source material for me. Even now I don't watch much TV and I rarely go to the movies, unless someone makes me. I find it difficult to surrender myself to these media, I don't know why. I get bored quickly. I find the mediocrity of much so-called con-temporary culture more depressing than watching the evening news. History might repeat itself, but culture, generally, is at an all-time low, and passionless. Despite living in an image-saturated culture (which has its exhilarating side), I consider painting a valuable endeavor. In fact, painting is such a *ludicrous* endeavor . . . why even question it . . . especially *figure* painting, which is what I do. A powerful image is rela-tively self-sufficient . . . which is painting at its best. I don't speak an-other language, unfortunately, but I understand the language of images.

Cultural history (anyone's) has always been of absorbing interest to me, not as refuge from the present but as a site of fantasy and imagina-tive adventure. In reading or traveling, I search for clues, resonances. The past is a bizarre place (truth is stranger than sci-fi). I like to famil-iarize myself with the historical context of a country, a city, its architec-ture, a person, a work of art, a thought. I'm very curious but absorb impressions rather than information. Links are formed but are obscure by the time the data re-emerges, in image form. I have recently learned to trust this process, and let the material bubble up, uncensored.

I have always had a certain confidence, an awareness that I have "something," a kind of space inside, that is inviolate. Even in the bleak-est moments when I couldn't work, I always had this place where I was totally free. I carry it around . . . it's like a space with wings, and it's taken me a long time to know how to use it . . . though I've never doubted that I would. It is, in a sense, my essence, and is very strong. However, I was never prepared to settle for just entertaining myself. To hone this sensibility, to use it effectively, has been a long and sometimes painful process. Now that I've found my stride, I am frequently sur-prised by what is available, fully realized. I trained briefly as a commer-

cial artist before abandoning it to study painting. Straight manipulation, its tricks and kicks, doesn't interest me. The language I use is complex, personal, wordless, and slow. And I want to *own* the painted figure, it's mine and I want it . . . it belongs to me and *drives* me. There is so much still to explore, from another perspective . . . that of a woman, which I happen to be. As a child I was a real tomboy, and good at art (I'd do drawings for the girls that I had crushes on at school). It never occurred to me then that when I grew up I wouldn't be valued by society . . . worth as much as a man. I read a lot of contemporary feminist theory as a student, but I decided at a certain point to move away from an analysis of the apparatus of my own oppression. It is empowering but can lead to a kind of self-censorship or self-consciousness that hampers creative expression. (And doing work about why you can't, as it were, is not particularly useful . . . you're just selling yourself short.) I am extremely grateful to those women artists who prepared the ground, who fought for the opportunities that my generation can now enjoy.

Anthony Viti

My work has always sought to explore coming to terms with being gay in a frequently hostile environment that produces feelings of isolation, psychic numbing, and other stressors. My paintings use an abstract language as a metaphor for the effect that the AIDS epidemic has on the communities most severely affected. These are small elegiac paintings. Using my blood as paint I imprint my body on the surface. They are then complexly veiled with thin layers of oil paint and an image of an iron cross as a formal and symbolic element.

With these "Elegies" I seek to equate the experience of communities ravaged by AIDS with communities ravaged by war. The similarities and psychic manifestations are all too similar. Both are isolated communities that undergo abnormal amounts of stress related to witnessing massive amounts of loss and experiencing incessant life threat with an uncertainty about the future. All this lays the groundwork for severe emotional distress. The free-floating anxiety, emotional numbness, and hypervigilance can easily be diagnosed as post-traumatic stress disorder, commonly found among veterans of war.

With this equation in mind I have appropriated Marsden Hartley's iron cross, a symbol often found in his military paintings memorializing a lover who died a premature death in the First World War. This cross was given to soldiers who exhibited distinguished service. I use this as a symbol to express the intense stress that communities are experiencing due to the AIDS epidemic, and as an act of honor for my heroes, close friends and lovers who have died without recognition.

Karen Yasinsky

1. The experiences and politics of everyday life affect my work in sometimes great, sometimes subtle ways. Much "experience" (political/ informational) is supplied by the media, which gives fuel to the formation of my idea of everyday life, including political views. In terms of local news, more crime, more violence, or news of a parade may affect my choices that day or the way I see strangers on the streets and subways. I love to watch faces in New York and the visual information received reappears in the faces I create after being mixed around with other visual thoughts I have about heads and body language and the whole psychology of what one willingly or unconsciously reveals. There is so much to be found on the streets of New York.

My work deals with invented images of women. Humor and discomfort are important components of the images. Being a woman in this city is vastly different from being a woman in Mamou, Louisiana. The experience that gave me this information oddly enough may come out as an image of food in a painting. If I see a mother smacking her child on the subway I won't come home and put my reaction to that in a drawing. The personal experiences that I encounter physically take more time to deal with; the feeling of outrage becomes more complex. My work is personal and more internalized than overt and political. The subject matter is not directly supplied by my experience but my interest in humor and the grotesque, pleasure and pain, and the formation of identity is fed through my experiences—and memories, whose recovery and creation are influenced by who I am today.

2. I am of this culture whose primary forms of visual information are television, movies, and urban advertising. I got away from TV but all the viewing hours of my youth have been irretrievably mixed in with

my visual information bank, which most likely is not kept neat and separate from other things in my brain. Incredible art can be created in film. Movies are a huge inspiration and source for me as an artist. Bad movies I can ignore and as for advertising, its goal of creating desire interests me and I use and subvert images that I find particularly absurd. I find the lowest-common-denominator practice used in TV programming, movies, and advertising depressing.

Artists can create through these forms but the less commercial works are not as widely distributed and are, therefore, infrequently seen in our large country. But the gallery audience is a limited group as well. This is why so many artists are in New York—larger audiences, more opportunities. I haven't pursued any public art projects but the idea appeals to me.

3. I'm very confident in my work in that I'm deeply interested in the subject matter. The images are powerful to me and I trust my judgment. That is all I can say.

4. I would like to know what it's like to be an animal other than a human but my work is all about being human, specifically being a woman. No, nothing competes when I'm working in my studio.

On Creativity and Community

This forum emerged from the editors' initial efforts to stimulate essays on three questions. These questions came from our realization that several of our past issues had focused on questions of difference, art made from positions of gender, race, and age. We wondered if there were other ways of thinking about being an artist today. The questions were:

Speaking of a difference, how are male artists doing today?

Is there a community of artists beyond the polarity of gender, race, and class, the competition of economics and various aesthetic and ideological stances? What are the possibilities for any common interests for artists today?

Are there contemporary redefinitions of creativity? What is keeping art and artists alive in the 1990s? (Is it just because we're all manic depressives, as suggested by recent articles in the *Science Times*!)

Jackie Brookner

A book must be the ax for the frozen sea within us.
—Franz Kafka

. . . and then there's another kind of art, which is related to everybody's needs and the problems existing in society. This kind of art . . . has to start from the molding power of the thought as a sculptural means.
—Joseph Beuys

Sapiens, did someone say *sapiens?*

"**Sapient** adj. [ME I.*sapiens,* prp. of *sapere,* to taste, know: see SAP¹] full of knowledge, wise, sagacious, discerning."

Whoever decided *homo* was *sapiens* must have presciently heard Webster, proceeded to "SAP¹," and noticed that there was also a "SAP²" which could add appropriate complexity to the binomial. SAP¹, a noun (from L. *sapere*—to taste, to know) is about the juice that circulates through plants bringing vital fluids to the tissues and about vigor, energy, and vitality. SAP², a verb and a noun (from MFr. *sappe*—a hoe) means to undermine by digging away foundations, in fact, to undermine in any way, to weaken and exhaust—all useful to the noun SAP², which is an extended narrow trench for undermining an enemy position or fortification.

It's true, we've gotten very good at entrenching ourselves in our own positions, at walling ourselves off, and as of late have been doing a great job of weakening, exhausting, and digging away foundations, the very foundations of life. It's as if we've decided the earth is the enemy we have needed to entrench ourselves—against. Not that we've done this consciously. It's just the unconscious by-product of a culture built upon delusions of limitless power and addicted to satisfying its voracious and endless appetites—a culture that has made greed a virtue and placed it at the core of its economic philosophy. We are all encouraged, programmed, to want more and more—more money, more power, more fame, more stuff, and to be as aggressive in our pursuit as we can. As the 1980s made so very clear, the art world has bought into this American Dream wholeheartedly, and so have artists, despite our postures of critique and marginality in the culture. If Adam Smith was right and narcissism and self-interest are a good basis for community, then artists are off to a running start.

But, it's the 1990s now and perhaps because the crassness of the commercialism and materialism of the 1980s was so clear, perhaps because of the sluggishness of the art market, perhaps because the world's problems seem so insistent, there seems to be another current in the air. As I describe my own concerns, again and again people say, "Me, too. I know so many people who feel that way." What's that way? Many of us feel a hunger to be part of the world beyond the art world, and to have our work and ourselves have more direct social connection. We do not want to be isolated within a system that by cloistering itself

creates an illusion of inclusion within its borders at the cost of defusing the power imagination can have within the world.

The anguish of the world: the silencing of the disenfranchised, violations of human rights, epidemics of hunger and poverty, abuses of women and children, diseases more virulent than we have ever known, and for me the most overriding—the depletion of the life support systems of our planet, cries out for creative, imaginative, and functional responses. This isn't about being politically correct, it's about listening to our hearts and our intelligence.

We "sapiens" have a lot of growing up to do—we are much more primitive than we think—and have a good deal to learn from creatures we have placed lower on the evolutionary ladder. It's interesting to note that the biological sciences are starting to be curious about the role cooperation and even altruism play in the evolution of species. Although there have been rumblings about these ideas for a long time, until recently the competition-aggression model drowned them out.

There's so much to be done, we cannot afford to waste any resources. Artists practice synthetic thinking, live from their imagination and intuition, and are barometers of the unconscious. These are vital resources that should be part of any problem-solving dialogue. In a culture as consensus oriented as our own, where Pavlovian canned laughter triggers audience response and thinking is carefully molded by the commercial interests of the media, people need exemplars of inner-directed thought and action, of individuated motivation. "Individuated" is not the same as self-interested, although certainly among artists the two are often congruent. I don't pretend that artists are naturals at community. This too must emanate from inner need and each artist so motivated must find his or her own access. The possibilities for community among artists reach into the possibilities for community among all people, and across the same minefield of difficulties. Reaching beyond the boundaries we are comfortable in means facing our own prejudices. Trying to hear voices that have been silenced means reorienting one's own assumptions of value. Helping all individuals live lives of dignity requires real humility. Trying to stop the wanton destruction of our planet and learning to value its plenitude means each of us must learn to live within limits bringing our own individual consumption into line with what the planet can bear and accept that humans must take their place within a much larger community of beings.

Artists can be examples of compassionate engagement. There are lots of ways to go about this, be it working within a local community or collaborating with people in other disciplines—physical and social scientists, educators, public policy makers. They may not know that we as artists have something necessary to bring to the dialogue, but we should, and the initiative must be ours. I believe that there is need for solitary work too—that we must keep "practicing" all our faculties and balancing individual needs with those of the collective. Far from being mutually exclusive, they are necessarily mutually inclusive, and we must honor both. That humans are both individuals and social animals creates a fecund tension which sparks our development. It's time we let the juicy fluids flow, and move from SAP² to SAP¹—to bring vigor, energy and vitality to the tissues of our world—and maybe eventually we really will stand upright, sapient.

David Humphrey

Speaking of difference, you ask, how are we men artists doing? I attended a panel in 1993 misleadingly called "Libido" at Exit Art. The panelists spoke on a variety of loosely related subjects at various distances from the all-women show on exhibition there. Afterward, among friends, I was asked how I felt about the panel "as a man." Like the effect of *M/E/A/N/I/N/G*'s question, it felt very strange to try to speak from the point of view of my maleness or to speak for other men. Perhaps the question was asked to determine my relation, as a theoretical beneficiary, to a clearly despised patriarchal order. If I am not always, in some way, speaking as a man, then, perhaps, I could propose a version: to feel it as a role. Should this relate to my preferences or appetites? What kind of sex do I like it? What kind of art?

Different ways of speaking of "pleasure" and "desire" were in the air at that panel. The mobile identifications that occur in masquerade and performance were valued by a couple of the speakers as positive feminist procedures. The process of identifying with others and making representations, however, has also been seen as somewhat troubled by an historically colonizing or acquisitive male gaze. I think these critiques, while rendering negative judgments on some practices, have also reanimated the imaginative potential for the way people picture

themselves and others. The dynamics of power that operate in that space are illuminated. The stakes become raised. Artworks can thrive in this anxious and potentially dangerous interzone. But what really motivates people to make art? It is certainly not a new thing to believe that libido is a big part of it, sublimated or desublimated. An excitable and renewable drive is helpful to overcome the generalized social indifference and lack of support for art. Sexual politics and the politics of having or representing sex liberally flows here. A notion that identity is constructed seems productive, and understandably popular, for artists. So let's construct! Hmm, not so easy. Having the artist's name attached to his or her work already initiates the production of a fictional, theatrical identity in the rhetorics of presentation. But psychological and social restrictions persist.

Perhaps the association of madness and art is a cliché, but it has productive features. Artists can be lunatics in the way their passions are figured in their work. The extraordinary elaborations, evasions, circuitous representations and embarrassingly straightforward declarations give some work a crazy radiance. I completely enjoy encountering the supernatural exuberance or ferocity of these works. Artists and viewers can travel out of themselves. The artist can be both an other and him- or herself. Artists perform this othering for the delectation and interpretation of others. The works provide occasions for what Nietzsche calls "the joy of understanding what another means." Nietzsche notes, however, that artists play a "desperate game" because, in a sense, they do without the present. The artist encounters others only at a remove. Nietzsche describes their suffering as exaggerated "because their ambition and envy are so great." We proceed from estrangement. Appropriately, the art world is itself often felt as a community of estrangements.

How is one to understand tastes, preferences, or inclinations when interpreting artworks? Relationships with art objects seem to proceed into immense complications from the relatively simple vectors preference magnetisms initiate. Impressive rationalizations have been developed by artwriters to sidestep the appearance of a narcissistic orientation. Commerce, meanwhile, distorts these desires by instrumentalizing them; by directing them toward purchasable satisfactions. To allow one's inclinations to develop into something more involved, more unstable, is to risk a loss of boundaries with objects, to experience some of

the reciprocal dynamics usually found in the amorous. Maybe it's time to enjoy the artwork's promise of reconstituted subjectivities. Perhaps a revised notion of the fetish would be useful. If there is a community beyond the polarities of gender, ethnicity, class, ideology, sexual preference, age, or psycho-metabolic character, I think it is dependent on our power to exercise imagination; to dissolve or cross the boundaries between individuals and between groups.

William Pope. L

A low grade fever
Topped off with feelings of impotence
The biting of nails
The gnashing of teeth
Involuntary shrinking and swelling of genitalia
Skin rashes, rashy skin, unreliable melanin-omens
And a disturbing roiling beneath this ersatz calm:
A weird cardboard sorrow
A dogged determination to be somebody
At the center of some great moment
Like a colorful plastic raft floating in a swimming pool

* * * *

The belief that contemporary artists can be a community is mistaken. It would take a massive shift, a revolution or crisis in current ideology, economy, and spirit for such a community to be obtained. This is unfortunate and pathetic. Not because people tend to need a crisis in order to make fundamental changes in their attitudes but because the crisis is now and we are slow to recognize it.

* * * *

What connects most artists is what connects most people. Fear and blindness. We fear because we do not see. We do not see because we fear. The circle is unbroken. Self-perpetuating. We say to ourselves as artists, we say: "I make art for me. No, no I make it for other people. Whatever

the case, if I make art, it will help in some way. Maybe it will help me see. Feel better. Understand more deeply. Or, even if it doesn't I can, hell, I can sell it. Don't look at me that way, I might! Sure anything's possible, right? Sure, sure the money may mess me up even more but that's the price you gotta pay, cause with money I won't have to worry anymore. Cause with money I'll be above that common shit."

<div align="center">* * * *</div>

Few artists make their living selling art. Most lose money making art. Most are in the red. Most are angry, frustrated from living in the red. This is a commonplace for most artists. So why doesn't it bring us together? We're all common folk aren't we? But the art world is not about what's common. Is it? Isn't it? Every artist wants that celebrity carrot. One among but above the many. I am like you but I'm not like you. I am an artist, I make political work.

We, artists, take our lacks for granted. I believe the common ground for artists today is what they lack not what they possess. What we lack is a healthy, proactive and convincing picture of ourselves as a viable political and spiritual body. An economic body. An analytical body.

Meaning: our vision of ourselves, our mutual destiny, as artists, is a matter, to a large extent, of our will to a new self-image. Just because I need isolation in order to make art doesn't mean I have to create my life in isolation from the concerns of the larger community. All acts are social. All social acts are political. In the U.S. the relationship between art and life is confused, not because the relationship between the two is inherently confusing, magical, or difficult, but because we are blinded by the aura of the artwork as commodity. We think: "It is a thing. I can sell it." We tend to not think: "This is my labor. This is my choice. This is another brick in the foundation of my house of destiny. How do I want to build it?"

<div align="center">* * * *</div>

We are more comfortable alone. In isolation. As individuals. We have been socialized to feel this way. To be this way. In art school everybody had his/her own cubicle, his/her own vision, his/her own opinion. All opinions were equally valid yet not all artists were equal in the eyes of our beholder: history. We found solace from the welter of difference and opinion in our solitude. It worked before. Why doesn't it work

now? There is a wind tunnel in our heads. It's at its worst when we are among other artists or when we discuss art (heaven forbid!) or when we are out and about in the art world (having beaten back once again that cultural agoraphobia!). We try to yell above the cacophony, we say to ourselves, inside our heads, at the gallery opening or the gala museum benefit, we say: I am more comfortable by myself. I do not like this milling and frothing and jostling for territory. I can't relate to a group. I am an artist. I make political work.

Perhaps we, artists, feel so isolated today because we refuse to get the message. Our greatest dream, our worst nightmare is to be the uncontestable ruler of our own domain of culture surrounded by our great works and the nonstop applause of our countless admirers. We are locked in our little bunkers of desire. Our biggest illusion is that we have erected this bunker ourselves. Our second biggest illusion is that this will somehow protect us. A gun port is our only access to the outside world. We're always cranky. We have an adverse relationship to almost everything. The gallery dealer doesn't understand us. The collector, the person on the street, our parents, our children, our pets, our stuffed animals, no one understands us. (Secretly, we think: "Maybe David Letterman will understand us?") Intuitively, we can smell our isolation and its concomitant vapors. Highly toxic. Boding no good wind. Something's burning. And it ain't the casserole. We are on the way out.

* * * *

We are on the hit list of culture. We are an endangered species. Last ditch move: zoos for artists. We'll be listed with the parasites. Because basically our relationship to life has become parasitical. A highly specialized subspecies of parasites with no real function except that which we make for ourselves. (In this sense, we are mercenary.) So, how imaginative are we? Well, how imaginative have we been?

* * * *

Multiculturalism is another kind of surrealism. A dream of a universal language which will bind together a universal family. Like European surrealism of the 1920s and 1930s, multiculturalism is idealistic, elitist, and ultimately cynical. Even so, the trend has assisted the careers of minority artists. But it would be foolish to believe that this is its real goal. That its real goal is not consistent with the dominant ideology, i.e.,

to present the facade of inclusiveness while simultaneously constraining minority opportunity. Multiculturalism is a kind of propaganda. The perfect surrealist image: the melting pot.

* * * *

So, how imaginative have we been? Gender issues. Womanist deconstructions of culture. Guys in skirts jumping off of buildings into the arms of the matriarchy: the "B" side of multiculturalism. And I admit I am one of those guys. My skirt is cleaned and pressed (in the closet) ready for another assault on culture for the proper fee. So who am I fooling? Am I slumming to another's drummer? I'm caught in a welter of difference. Constrained by what I've been taught to be while banging into shape the metal that I want to be. Like most men I don't really see it coming. I don't doubt myself enough. Like most men I still hold on to the idea that "real" awareness is possible under the status quo. I'd rather think about how black I am or how male I am. Nothingness is to femininity as obdurateness is to masculinity. Yet here I am a black man with his ass on backward. To me race and gender are a means to a larger community. (Whether this will be a predominantly artist community does not concern me. There are some things more important than art.) How so? Because my essence is dispersed. True my class and position allows me the means and leisure to recognize this. But each person has to choose how to use his or her time. So I've noticed something. Visualize: The raft in the swimming pool is faded and leaking. The water around the raft is a thick, bright red. In this red are chunks of fibrous material that look suspiciously like me. I am all over the place. It is disturbing. I have a choice. To regain wholeness by hanging onto familiar and comfortable outmoded values and ideas or reach out, increase my dispersion until my wholeness becomes the sum of my difference. I don't have to be Babe Ruth or Richard Wright or Toni Morrison anymore. I can be Mary Jane Montalto or Chuck Yuen or Paul Rodriguez or Marty Pottenger or Lowery Sims or Mr. Milk and Aunt Jenny.

Robert C. Morgan

Reversing Paradigms

The problematic of the art world—as a genuine community of artists—has become a profound issue as advanced culture moves toward the *fin*

de siècle. Clearly the emancipatory requirements of artists to actively pursue their respective goals in relation to one another has been sorely lost or dismissed. This was largely the rationalization under the rubric of Postmodernism. In the eighties this term was cited in the art world, often as a means to conceal feelings of desolation and angst among artists and observers of the contemporary art scene.

The eighties was a decade of expropriation and recontextualization; that is, foregoing certain assumptions about the decline of late modernism, characterized by a type of aesthetic formalism, coincident with the writings of Clement Greenberg, and a recycling of earlier twentieth-century art history into a hyperbolic present tense. Given the misunderstandings taught in various American art schools throughout the seventies it was no surprise that the generation of artists who evolved into prominence during the eighties were possessed by the overburdening desire to let go of their collectivist *nom du père* and regain the creative territory of expressionism without the formalism of past decades.

It worked for awhile. It worked until it suddenly became evident that without an operative aesthetic basis things were not going to travel very far nor very smoothly into the horizontal of linguistic ploys about visual expression. Theory was needed—and it came regurgitated. It came hot and heavy. The term "aesthetics" was not particularly useful or extant at the outset of the eighties—at least during the reception of Neo-Expressionism. And for good reason. "Aesthetics" was out then as today. Even the term "intellectual" has been virtually swept from the lexical palette of art writing. What replaced aesthetics was the term "critical theory." To the chagrin of those critics, who entered into a Postmodern discourse in the visual arts at the end of the seventies, it was evident that the ideas were already more or less established in other fields—namely, literature, cinema studies, and architecture.

Critical theory became virtually synonymous with Postmodernism. To speak of deconstructing a text integral to the ideological structure and concomitant ramifications found in a work of art—a hypothetical projection founded on lack—was the fundamental issue beyond all else. Art was no longer about experiencing an idea with any degree of heightened emotional awareness. Art was no longer about a higher (or even lower) sensory form of cognition. Art was—in Postmodern terms—about a lack, a deficiency of the human psyche, a desire that was considered inferior to the informational basis of mind-operations in

the computerized age. Although at the outset critical theory was substantial as a method in coming to terms with the absent "aesthetics" of much of the trendy Neo-Expressionist painting, its use in popular art magazines by the end of the eighties was less about a method and more about an anticanonical canon; that is, a canon used to offset the canon of modernism and its patrimonial heritage.

By the end of the eighties—with the important exception of a minority of feminist theorists, in particular—the popular dilution of critical theory, as it was appropriated for major art magazines, generally implied that one was expected to reduce one's options as to the subject of art in favor of concentrating on careerism by seeking out furtive opportunities in order to gain publicity. Careerism—in social, political, and economic terms—often seemed the complete raison d'être for doing art. In short, one's career became an end in itself. This occurred in a somewhat desperate manner as most careers are forever made, for better or for worse, despite ultimate shortsightedness.

Perhaps these comments are overly compressed and too overbearing in their skepticism; but they are not intended to finalize the experience of art as a cynical art. Quite the opposite. Too often we are functioning less as a community of creative people than as subscribers to a set of taxonomical divisions. Unfortunately, this suggests that the art world community has become unnecessarily insecure about its current direction as a significant cultural force. Too often artists are subliminally put in the position of competing with the more predictable and superficial directives of advertising and the entertainment arts. This results in unnecessary economic and social pressures which are less a reality than an interference with the artist's identity. This is not to imply that social and economic pressures cannot be real, because they are real; it is merely to suggest that, if careerism becomes an obsessive goal, these pressures can become unnecessarily inhibiting in terms of what one does as an artist. To see the opposite of cynicism one must return to the origin of one's emotional strata to see why one is doing what one is doing. What is the purpose of one's art? Why be an artist? What is the motivation?

These are tough questions. I think they have always been tough questions, but, of course, the present always outweighs the past. We are all up against the present. And part of this alienated present—which Postmodern terminology saw as absence—is the failure to trust one another,

to see the common basis that underlies artistic intentionality. This is always for good reason, and the problem will not be ultimately resolved by simply saying that the demarcations between gender, race, and privilege are no longer issues.

They are issues—very important issues. We all know this. So my question is: Why are we pretending not to know? Why are we so possessed by insecurity and denial that every word, every conversation, every panel, every exhibition, every repetitive nonvoice in the American (and now European) critical spectrum has to do with "otherness." The fact is—in reality—we are all "other." Recall the frequently quoted phrase of the symbolist poet Rimbaud: "Je est un autre!" The problem today is that we are not willing to see nor to accept that we are all "other."

I am not talking about careers here. I am talking about what makes an artist function as an artist. It may appear "premodern" to say that we are all "the other." Perhaps it is. But I doubt that Postmodernism has changed the way society in general (the media!) perceives what artists do. What society understands about advanced art is nil. This was true with Fauvism and it is true of Multiculturalism today. Society simply has no regard for the artist—none. Society—as the French Situationist Guy Debord pointed out—wants its spectacles, a diversion from the pain of capitalist exploitation, a diversion from the masochistic lifestyles of a programmed recessionary economy in the late twentieth century.

In reversing the paradigm of Po Mo, I would say that the term today has less to do with art than it has to do with life. When I speak of Postmodernism today I am speaking not so much about theories as I am speaking about the evident conditions of alienation, fragmentation, conflicts without an ideal resolution, the perennial information glut obscuring the trace of historical memory, surreal forms of brutality and violence crossing over between the domestic and public front. These are real life conditions. They are not about art. They have nothing to do with art other than as the necessary and appropriate content that art hopes to reify in some intelligent way, in some specific way. Art will not solve these problems.

Traditionally, art has been able to sustain itself as a conduit of expression, even under the most pathetic and intensely disturbing situations, even in the most unprivileged situations. The individual recourses for

making art happen in such situations are of considerable significance. One cannot ignore privilege, or lack thereof, as a very real situation for many excellent artists who are not being shown, promoted, or advertised in the delimited infrastructure of today's art world. To make art happen as a vital force despite this situation is the beginning of the recognition of community.

Barbara Pollack

What is keeping art and artists alive in the 1990s?

In 1990, I put away Griselda Pollock and Roland Barthes and picked up Norman Vincent Peale and Dale Carnegie.

As silly as it sounds, *The Power of Positive Thinking* and *How to Make Friends and Influence People* have become the seminal texts of my art practice. Lesser known works, such as Peale's *Enthusiasm Makes the Difference,* Carnegie's *How to Stop Worrying and Start Living* and Dr. Joyce Brothers's *How to Get Whatever You Want Out of Life* have also found their way into my studio.

If the 1980s gave artists the cynical illusion of career strategies, the 1990s have brought us the necessity of survival strategies. I am moved to share the wisdom of these texts to assist other artists trying to survive this bleak decade.

Lesson #1: When Life Hands You a Lemon, Make Lemonade

The new definition of creativity rests on the ability to turn rejection into a source of inspiration. In this light, the art world of the 1990s is practically a lemon orchard, offering artists countless moments of encouragement. Some may fear the current situation—fewer exhibition spaces, minimal sales, restrictive grants. I have learned to embrace it as a lesson in self-reliance.

For example, the shrinking art market has given me a much more lighthearted view of dealers and collectors. I keep a file of letters from galleries that have closed. It makes me very happy to know that I am still making art while others, once considered so powerful, no longer retain addresses in Soho.

Plus, I find it much easier to show my work in my studio than in a

gallery. No worries about shipping and insurance. No fears about nega-
tive reviews or lack of recognition. No wine in those little plastic cups.
Just friendly visits with good conversation.

It is no coincidence that an increasing number of artists call them-
selves "independent." Whether it is by choice or not, it is wonderful that
artists can experience a sense of independence from the art market, one
more time.

Lesson #2: Count Your Blessings Instead of Sheep

Insomnia has replaced the Cedar Tavern, according to my answering
machine, which regularly receives messages from friends at 4 A.M.
Artists are staying up all night worrying how to go on. Most worry
about things that are impossible to change—how to pay their rent, how
to support their families, how to overcome discrimination in the art
world. All this worrying only causes lack of sleep and distractions in
the studio.

The surest cure for worry is to remind yourself of the positive aspects
of your life as an artist. First and foremost, artists need to appreciate
that we have unique training for living without money. For years, we
have been taught to ignore economic considerations. This puts us way
ahead of the rest of the American public suffering in the recession. We
believe that history, rather than the marketplace, will prove the value of
our work. I doubt unemployed investment bankers share our optimis-
tic view of the future.

A physicist once said to me, "You and I do the same thing. I go to a
laboratory. You go to a studio. We both explore ideas for years and years
and few people really understand our research."

"Yes," I replied, "but I have to pay for my reactor." He looked shocked.
It was clear he had not worked as a waiter or word processor to support
his research. Artists are so multitalented, so uniquely suited for the
current U.S. economy.

Before this sounds too Pollyannish, I have to insert that Norman
Vincent Peale and Dale Carnegie started writing in the late 1940s to an
audience recovering from the Great Depression and World War II.
Their books are filled with "true stories" of women and men facing
failed businesses, hungry children, and lost homes. "How I Hit Rock
Bottom and Survived" is a typical title.

Artists, who once evaluated their self-worth by their gallery affilia-

tion, can learn a great deal from these stories. A loft in Williamsburg and a fax machine may not seem like a lot, but there are many examples on the streets of New York of others with much less.

Lesson #3: Tell Yourself All the Good News You Know

At times, it seems impossible to do anything but dwell on the obstacles. Discourse has been replaced by a mantra of failure. The danger is that depression can function like a long warm hug, even when it is objectively caused by external forces.

To challenge this state of mind, I propose we change our definition of greatness. In the 1990s, survival should be a sign of genius. To me, every artist managing to live and work in New York City right now is a genius. I am surrounded by artists who are out of work or hold two jobs, are facing AIDS and cancer, must support families or struggle alone. Yet they continue to make art. As far as I am concerned, this puts us in the middle of a city filled with more great minds than Florence at the height of the Italian renaissance. (After all, they had the patronage of the Medicis, so how good could they be?)

With a restructured definition of genius, it becomes easy to find good news. Art world gossip is an endless litany of inspiration. I am not hearing another "hard luck" story. I am discovering another genius.

Lesson #4: Enthusiasm Is Magic

All authors of self-help books from Norman Vincent Peale to last year's bestseller, *Learned Optimism,* talk about enthusiasm—which is probably enough to make most artists run in the opposite direction. However, this is a mistake. In these times, it is essential to value this asset. It does not cost money, requires no education, and does not discriminate.

Enthusiasm simply means that you believe that in yourself is the wisdom, courage, strategy, and faith necessary to deal successfully with all difficulties. Popular culture portrays the artist as a morose, manic-depressive overcome by obsessive problems. Few artists can afford to internalize this stereotype anymore. It may take awhile for us to turn into cheerleaders but remember—if we don't act enthusiastic about contemporary art, Morley Safer never will.

Here are some simple steps to develop a more enthusiastic self-image:
1. The next time someone asks you if all artists are manic-depressive,

ask them what would happen if you locked a lawyer in a room and gave him no money or recognition until he won a Supreme Court case. That should shut them up.

2. Avoid situations that create self-doubts. Artists may have to suffer, but they don't have to suffer humiliation.

3. Keep a file on artists who continued to work against great odds. Art history—especially feminist art history—is filled with them.

4. Develop sympathy for nonartists working in the New York art world. Dealers, critics, curators, and receptionists have to confront creativity all day. It's a tough job and they don't even have an excuse for being manic-depressive. Try to be kind.

5. Think of ways to help other artists, rather than yourself. If you fill a need, you may eventually get paid to fill that need. Then you will have a way of supporting your art. Even if you don't, you will make friends.

6. Remind yourself that you have already made a dream come true. You wanted to be an artist ever since you failed "self-control" on your elementary school report card. Now you are and no one can take that away from you.

If you follow these simple steps, you will be a more productive artist. You will also stand out as original and unique—the genuinely happy artist. Few will comprehend your state of mind, so you will seem intriguing and mysterious. Your self-confidence will inspire confidence in your work.

Norman Vincent Peale would say that this is the road to success, fame, and fortune. All I know is that it will help you continue making art.

Maybe, I should keep these secrets to myself. It's not supposed to be good to leak information to your competitors. However, I am sincerely concerned that the current economic climate is causing some of our best artists to give up. Many have not yet been recognized, have not yet emerged. I want everyone to continue. I look forward to your new ideas, new images, new art forms. I don't have solutions, just pat answers. That will have to be enough for now.

Jerry Saltz

You already know how "male artists" are doing—white "male artists" that is: as usual they're doing better than most. But that doesn't take

away the fact that it's hard for everyone these days. If you had asked "How are critics doing?," the answer would be different. Proportion-ately—I think it's fair to say—that criticism is more equitable than art. Probably because there's no money in it anyway and it's a pathetic way to make a living—but that's another story. People got too used to think-ing of artists as *fat cats*. They're not, and anyway there's nothing wrong with making money. The problem is that it sets up artists as the *bad guy*. Though the ones who do fall near this category can drive you crazy. I saw one very famous male artist walking down Greene Street the other day talking on a cellular phone! How, I wondered, did this artist get so out-of-touch that he assumed he could do this and not be recognized? Maybe he wanted to be seen. Meanwhile an equally famous woman artist—who has been in more than three Whitney Biennials—has to look for teaching jobs because sales are so scarce. You know stories like this too.

It's okay to have a cellular phone, a house in the Hamptons, a Jeep Cherokee or a Saab, it's okay to appear in the Style Section of the *Times* every three weeks, it's okay to hobnob with the super rich, with movie stars, financiers, designers, and tennis stars, it's okay to have your house featured in *Vogue* or a "shelter" magazine—but you better believe that vast segments of the art world will perceive you as—well—flaunting it, a joke or otherwise acting unconsciously. There's nothing wrong with success—the question is *how* are you at being successful? Are you a *Bad Winner*?

Peter Schjeldahl wrote that "in the eighties art and money had sex in public." If that's true you could also say now that money has gone—and certainly it is not in the strata where it is helping to make interesting things happen in the art world—art has been left as its *Battered Spouse*—alone to pick up the pieces and get on with its life. Art may have started out wanting a flirtation—(and who can blame it after the 1970s) it had been living on its own and wanted a bigger "market share," more of an audience; only what started out as an innocent impulse developed into a full blown—some would say self-destructive—obsession. But even here, I have to admit, it was mostly the guys who got the goodies—though *everyone* went along for the ride. The good news is, with money gone, value isn't so tied to money. The bad news is that means it's hard to survive—again.

As to your question about "community"—community is a relative

thing. Mostly the communities I see in the art world reflect those in the real world: they're usually segregated and men tend to have the most power. Narcissism rules. Ideological difference doesn't really keep people apart. On first glance it does but then you realize that everyone wants to get their stuff seen so people show up at everyone else's events—if only to *dish* afterwards. Still communities do tend to polarize into snarling tribes. After all *Self-Importance* stands guard over the *Kingdom of Narcissism*. This all sounds much more cynical than it really is. Mostly what you have are a lot of artists who care a lot about what they're doing.

As a critic I think of myself as having a *skeleton key* to all camps in order to survey the changing landscape. This is where *language* comes in. Why is it that so much art criticism is indecipherable—even to "us"? If art has lost its audience then surely this type of smarter-than-thou "criticism" played its part. Criticism isn't the right word for it anyway. Much of this writing feels cut off from its object. When a critic reports back about what he or she has seen it should be in accessible, clear language and not a lot of brainy gobbledygook that no one understands. A critic should want to be understood. But the price you pay for this accessibility can be dear. You can lose your "pass" into certain academic circles, or it might mean that you don't get asked to be on all those panels that discuss art and its relationship to biogenetic whatever, and it may mean you won't get asked to too many CAA conventions— but that's okay. A critic's job is simply to look and then record his or her responses as honestly and as clearly as possible. That means positive *and* negative response. Look at the art magazines. The reviews are either descriptive or they're positive. Seldom is heard a discouraging word. Is that because of the tacit connection between galleries taking out ads and favorable opinion? I'm not saying they're all in cahoots. The question is raised because of the lack of negative response. Perhaps it's that our critics are not up to it. They—we—are too locked in, too much a part of the art "community." There ought to be an uneasy alliance between artists and critics. You should not want to "love" your critics. For the critic this means not being "loved" by everyone. But a critic shouldn't want love. He or she wants *respect*. If you write negative things you may not get asked to all those sexy dinner parties or you may not be the one to write the juicy catalog essays but at least you'll be doing your job. I don't care what your *taste* is (well, really I do, we all

do) I only want to understand your writing. This formula for this is: the artist is a *transmitter,* the critic a *receiver.* The critic's job is to relay back exactly what they picked up. In the last ten years too many critics have fancied themselves as *transmitters.*

I know critics who only support a handful of artists (I'm told this is more a European model) which is okay even though it seems un-necessarily limited. I also know critics who say things like "I hate paint-ing." To that I would say "Don't hate" and "What do you mean?" Really taste transcends separateness. Whatever your eye leads you to is impor-tant. In other words: If you use a theory or ideology to define your taste sooner or later your eye will betray you, as you find yourself attracted to something your theory says you're not supposed to like. I say "Thou Shalt Have Pleasure."

I'm thinking; now is not such a bad time. True, the money's gone but the air feels clean, the eye feels cleansed, the criteria for success not so narrow. It's hard to get by but that's nothing new. Artists and young entrepreneurs (but especially artists) seem to be coming up with twists and variations on old themes, and in one or two cases whole new approaches. Things always start to happen when artists take matters into their own hands. The art I'm seeing in these newer galleries or antigalleries or nomadic sites or whatever they are may not always be good—usually it's no better than what's in the "regular" galleries—but that's okay; we need the sparks to set the fire.

In answer to your question about "what is keeping art alive?" My advice—not that you asked—is: don't give people the sense they know what you're about; they'll use you up, or think they understand you when they probably don't (plus art isn't about understanding, I don't know what it is about but it's not about understanding. Unfortunately too much art I'm seeing seems to want to be about sociology or biology or philosophy or politics—which is fine [after all, all art is in some way political] but it would be nice to see more sculpture, say, that was about doing things and solving problems only sculpture does). Other advice would be: don't care, but don't care so little that I can't find you. Just don't make it too easy. You don't have to put your art right in my way. It might be interesting to remove it a little from its "normal" house. I'm not sure where or how to put it, but I'm sure you will. There's no "one problem" everyone's trying to solve. That makes for a lot of different fiefdoms. My motto is "Build It and I Will Come." A lot of people don't

have to see your art in order for it to get discovered; plus a show can exist by word of mouth—as things in the imagination tend to be bigger than they are in reality.

Mira Schor

The romantic notion that artists are egoistic, lonely, maybe even mad individualists hell-bent on self-expression is a cliché which some segments of our society, including some artists, may still subscribe to. It may even be a comforting self-image in the face of very real difficulties in being an artist today. Students frequently say their work is about themselves, made for themselves. Significantly, many of my current students are fascinated by outsider artists. But in the next breath they speak of their friends, maybe just the one friend they discuss their work with. That already constitutes an audience and a community, extending their practice away from the solipsistic studio. Their teachers, the confines of a chosen institution organized around the practice of art, these also are elements of a community. This does not even take into account the ghost community in which almost any artist operates, of absent relatives, lovers, artists living and dead with whom they are engaged in vital conversation. Even, maybe especially, the Oedipal system of patricidal response, rejection, conquest, and appropriation which dominates the history of Western male modernism constitutes a community of belonging, although its individual participants personally may be fatally isolated.

Community interpreted in this way is barely intentional. Community, artistic and other—understood as a vision of common identity, common interests, survival strategies that place the individual in the context of a group which needs support so that, in return, it can sustain the individual—must be sought out, recognized, maintained.

Active, articulated communities must be worked at and thus may be sporadic. Groups like the CalArts Feminist Art Program, the LA Women's Building, Heresies, the Guerrilla Girls, Godzilla, WAC, Gran Fury, Coast to Coast, Four Walls, and, for me the past eight years, *M/E/A/N/-I/N/G*, come together, reach out to individuals, bring them together around a cause, a goal, an ideology. One has to be willing to serve, but even just the effort to serve is not only not incompatible with individual

artistic production but it's even a refuge from the stress of carrying one's own ego around. There is a peculiar relief in going outside the self, if only for a moment. It is work that takes precious time away from one's individual art practice, time borrowed also from jobs and rest. Entropy, change, exhaustion, the demands and the effects of individual careers, and the necessities and burdens of personal life undermine the community, and yet the period of intervention leaves a web of friendship, common knowledge, and memory which endures, perhaps in the energy of the next group of activists that comes along.

The purer, the more rigid the organizing ideology is, the quicker the fade. Practically, I've learned to accept the surprising but useful zones of agreement with people I feel are radically different from myself. Politics make strange bedfellows but strange bedfellows are part of the reality of a functioning community. So creating community has involved for me the evolution of a dual system of values, a dual aesthetic standard. One is temporal, contingent, ironic, contentious, rueful, but paradoxically, it allows me to function as an artist more freely than the system of absolute values in aesthetics and ideology which, nevertheless, are the basic inner fuel for my work. Art making is complex so one's sense of community must accept complexity and contradiction.

Feminism has provided me with the most enduring and trustworthy community, not only for the precious support of an actual group of women artists friends, but through the expansion of my sense of self from an individual (often lonely, unhappy, in danger of seeing myself as a victim instead of an agent) to a member of a group with a shared goal: the representation, expression, and inscription into visual and linguistic history of female subjectivity, so long denied and devalued. The analysis of personal circumstance in relation to other women's and to a discourse of power separates what is specifically individual from what is in fact societally based and therefore (more easily) changeable. The buzz phrase of 1970s feminism, "the personal is the political," expressed this liberating dialectic.

What women artists do within this community, how each contributes to its survival is an individual choice, ranging from small groups of like-minded and supportive friends to political action groups like WAC or the Guerrilla Girls. It is the continued, unfortunate necessity of a feminist analysis of power, of feminist strategies and support networks that insures an involvement with community and which paradoxically may

help explain the embattled loneliness of some white male artists. In-dividual men may be "failures" or "successes" but they belong to a dominant group whose basic solidarity is a given, and the long-held dominance of that group makes it hard for its individual members to generate a new sense of community of representation. Of course many male artists see a common cause in political and aesthetic movements. Perhaps it is the most successful artists who don't have a cause except their own success and thus are the loneliest. Picasso, the twentieth-century model of male genius, arguably did his greatest work first when he and Braque formed a community of two in the development of cubism, and, later, when he worked from his sense of spiritual commu-nity with victims of fascism in Spain, in Guernica.

Writing has created a community for me of unknown and sometimes known readers. *M/E/A/N/I/N/G* was born of a community of two, Susan Bee and myself. This intimacy suited me well because I find working with larger groups personally difficult and operationally tor-tuous. Yet now a group of friends, strangers, and institutions are col-lected in a card catalogue of subscribers in a red box in my studio. It holds an abstract network of people, as insubstantial as a spider's web, yet providing connection to the outside world.

My hope is that I can continue to create communities for myself throughout my life. This hope is framed by my concerns about how to find commonality with younger artists who form actual and ideological communities of their own—community is often generationally coded—and my sad awareness that communities ultimately are eroded by the illness and death of their members, as I see in the lives of older art-ists. Thus my hope is that I can identify, create, and maintain cross-generational communities that will enrich my life and sustain my exis-tence in a wider world. It is as important to me as the life of my mind and the life of the studio, and that is saying a lot, given that, of course, I'm one of those individualistic driven loners!

IV / ARTISTS' MUSINGS

Part IV, "Artists' Musings," presents the writings we feel the happiest to have welcomed because each artist so thoroughly dances to his or her own tune. They have everything to do with art even when they least seem to fit the bill of an artist's statement. Tom Knechtel's "Bats" (1987) and Vanalyne Green's "Mother Baseball" (1986) express values about gender, art, and time metaphorically, making clear how the world enters the studio. Other writings include Nancy Spero's wildly angry and funny parody of male career production, "The Discovered Uncovered" (1987); Joseph Nechvatal's fanciful "Reorganized Meditations on Mnemonic Threshold" (1988); Richard Tuttle's offbeat, antiheroic view on materiality and scale in "September 21, 1989" (1990). An interview with Alison Knowles (1991) lets us hear a gentle and wise voice from the Fluxus movement. David Reed discusses his experiences of the fantastic and uncanny in relationship to his painting in "Media Baptisms" (1993). Hear what artists think after the foolish studio visitor has come, misunderstood, and gone. We know the identity of the curator who told Susan Bee, "You have too many ideas" ("Running on Empty: An Artist's Life in New York" 1986) and the critic whose bad vibes may have killed Ann McCoy's rabbit ("The Critic and the Hare: Meditations on the Death of My Rabbit" 1989) but readers will surely recognize these characters from their own experiences.

Mother Baseball

Vanalyne Green

"Did it ever occur to you," I recently asked a friend, "that baseball is played on the landscape of the female body?"

"Yeah, sure," he responded, "all those little men in the middle of a big womb, trying to inseminate the field with their balls, yeah. But you can't reduce it to that, you know."

Oh yes I can, I thought. Why not? Men do it. Baseball, they say, is America; or baseball is the individual versus the universe; baseball is statistics and ordering. Why can't baseball be seen as a pagan spectacle about the cycles of birth and death? Seasonal contests to promote fertility and the ripening of crops underlie most primitive ritual. The word pagan originates with the Latin *pagus,* or country—something to think about when sportswriters reminisce about baseball's pastoral beginnings.

Mother baseball. I enjoy speculating about its bloody beginnings as a fertility rite. Funny that with all the verbiage about the sport no one mentions the obvious structural relationship between a baseball stadium and a womb: in design, a stadium is both a circle and a "Y," two notorious female symbols. The curved and sloping shape of the stands is like a plush endometrium in which we fans cozy up to watch a lone batter square off against the universe. In the bowels of the mother, her

reassuring presence presides over our humble attempts to reconcile the desire to live forever with hard, brutal facts.

But I do not worship at the altar of the Great Goddess. Unlike some feminists, I don't write *wommin* for *women* just to get rid of "men," and I'm not a member of a coven. The remarkable likeness that a baseball stadium bears to a womb means little in and of itself. But 50,000 people sitting in a monolithic uterus is an interesting notion to contemplate. I especially like to think about that when announcers describe players' bats as fast, corked, dead, quiet, live, or as loaded barrels—and pitches as high hard ones.

I went to my first game two years ago, at Yankee stadium. I hiked up the concrete ramps that encircle the stands and as I came out into the open, I saw a beautiful canyon of green, summer green, and light, the way it is at dusk, filling the basin of that space. And it was as if I'd just discovered a secret, but a secret that everyone else knew and took for granted. Why hadn't anyone told me?

Going to Yankee stadium was a more important experience than visiting the Grand Canyon—a fact that has to do with representation and with being a woman. I grew up with textbook photos and tourist snapshots of the Grand Canyon, so when I went there I wasn't moved. The potential shock of its grandeur had been diffused by countless two-dimensional representations; the real thing was like a living postcard. But as a woman not steeped in the history and culture of baseball, going to the game was a revelation. I didn't know its visual terms; I could possess it for myself for the first time.

I've since concluded that being female actually predisposes me to get more value for the price of my admission ticket. Unlike those men who were raised in the game and are more prone to associate it with their own oedipal struggles, I am freer to rethink its structure. Baseball can be the remnants of a sacrificial rite or it can reflect the nation's regressive, nationalistic mood. It can be a postindustrial outlet for cramped urban workers. Or baseball can be, as one woman friend describes it, an aesthetically pleasing opportunity to look at handsome men who don't talk back.

It should come as no surprise that baseball, of all American sports, draws so many female fans. First, baseball historically has attracted marginal people. Crazies. And women are, after all, marginal them-

selves—an economic and social underclass. Also the structure of the game involves elements traditionally associated with women: oral history, storytelling, and gossip. And although baseball has its own arcane language (for example, the box score), it's more accessible than football because the slow pace of the game provides announcers with the time to call up relevant historical and strategic information.

At Yankee stadium, I sit in the "Little Tripoli" section, which is behind home plate in the upper decks. This is where the fanatics congregate, the ones glassy-eyed from the recitation of statistics. Sportswriters are critical of the sometimes dangerous antics of the fans. I certainly don't like the sexism and occasional mean-spiritedness. Yet compared to Manhattan—which is increasingly drained of its neighborhoods and ethnicity by gentrification and corporate hegemony—I find the unabashedly tribal rites at the stadium to be revivifying. I'm amused when men in suits and ties are told to go back to Wall Street where they belong. During the Yankees/Red Sox game, in which Clemens walloped the Yankees, a comatose Little Tripoli fan stripped, then twirled his clothes over his head and threw them out into the fans, I understood: defrocked, humiliated, and demoralized, he was acting out for all of us.

Family. Membership in the sports club is a calling card anywhere the language of sport is spoken. Being conversant breaks down sexual boundaries. To my surprise, most men have welcomed me into that circle where arcane memories of former heroes, great plays, and Freudian dramas are reenacted. And if I don't talk to them about mother baseball, that's all right; I'm a spy in the house that Ruth built.

Watching baseball is an opportunity to decipher the now illegible handwriting of matriarchal culture.

In 1937, an Italian scholar, Gorrado Gini, traveled to North Africa to study a tribe of blond-haired Berbers. The blond strain was believed to be descended from Nordic invaders who had come to North Africa in the Stone Age. Gini was an Americanophile; he noticed that the Berbers played a game that was a remarkable mixture of elements resembling American baseball and earlier forms of European "baseball" (often called "cat" from catapult). The Berbers called their game "the ball of the mother of the pilgrim." When a batter struck out, they said he was "rotten" and "moldy." Considering this in light of the fact that in the Scandinavian game upon which baseball is based, players that were safe

were called "fresh" may lend some credibility to the notion that baseball originated as a ritual battle between dying winter and a burgeoning spring.

In the Berber game the runner's base is called "mother"; in the earliest games the batters were on the "father's side." Compare this with a related game, called "egg-carrying," which was played by women on the Estonian island of Runo. The ball represented seed and was placed in holes in the ground.

At first glance, contemporary American baseball, with its media coverage, advertising revenues, and millionaire players, appears to have wiped out all traces of primeval ritual. But this is not so. Consider the "rundown." A rundown is a kill; there is no other moment like it in baseball. It occurs when a runner is on second, say, and follows a batted ball, such as a ground ball to short. He heads to third, but the ball arrives first, having been picked up and thrown by either the short stop or the outfielder. The runner heads back to second, but by now he's caught in a rundown. His only chance, almost always futile, is to try and beat the throws going back and forth and closing in on him. He will do anything—cheat, look ridiculous, even spastic, run like a doomed animal—to avoid the tag. His motions are wild, out of control, and a disturbing contrast to most of the otherwise routinized, repetitive gestures of the game.

Getting thrown "out" or being made a fool of (*Daily News* World Series coverage designated a "hero" and a "goat" for each game), continues to link baseball with rituals of sacrifice and scapegoating. Indeed the game of tag is "a survivor of rites going back to the labyrinth, to the scapegoat fool or sacrifice," according to Lucy Lippard. In *Overlay* she quotes Francis Huxley: "Tag is an 'endless game' that circulates the touch—a kind of infectiousness, reflected in a similar game in Madagascar where the chaser is called 'the leper.'" He says that "children who end the day as 'it' are truly ill at ease, as if some racial memory of sacrificial victims operated." In this context, such words as "safe" and "out" take on special significance: baseball is a struggle between becoming *it* and returning home alive.

Modern baseball is a game of constantly shifting roles and signifiers, a delicate balance between randomness and order. It is a stage onto which we project our most primitive feelings about the seemingly random events that determine human fate.

A. Bartlett Giamatti, the president of the National League, illustrates

baseball's ambiguities by analyzing the position of the catcher. Although playing defense, the catcher actually dictates the game by signaling to the pitcher what kind of pitches to throw. Further, his position behind the plate offers him the vantage point of the offense. Giamatti says that "part of the secretive, ruthless dimension of baseball is the knowledge that an opposing player, crouching right behind him, signals wordlessly in order to exploit his weakness."

Since players are traded so often, it frequently occurs that a runner and a baseman know each other from a previous team. Yet later in their careers the two friends stand inches apart, each with the intention of causing his former teammate to lose.

Such a moment occurred in the sixth game of the 1986 playoff series between the Boston Red Sox and the California Angels. The game was characterized by miraculous turnarounds and history-making plays. More important, the Angels had only to win this game to take the Pennant. During the eleventh inning, Don Baylor reached first base when Donnie Moore's second pitch hit Baylor on the arm. His old friend and former teammate, Angel's player Bobby Grich, was playing first: "What do you think, Groove?" (Baylor's nickname).

Baylor turned to Grich and said, "This is the greatest game I've ever played in."

"Me too, partner," Grich replied.

If baseball is a game of surrogate kills, duels between men with clubs and men with rocks—primitive in its barely veiled murderous gestures—then moments such as this one may be interpreted as an astonishingly sentimental conversation between an executioner and his victim—because someone has to lose.

I have a diagram on my wall. It's a crude, stick-figure rendering of a baseball drill, printed in a guide for little league players. Looking at it, the tiny narrow line that marks the baseball paths becomes the edge of the world. It's so easy to fall off. Sometimes, I just let my eye follow the base path, tracing all the things that can happen, like chapters in a novel or a person's life, from home plate and back around again.

A player is born when he steps into the batter's box. Once there, his job is to keep breathing. If the batter is able to foul off the ball on a count of two strikes, he is "still alive." He continues to live if he gets on base, where he enters the wilderness of the playing field.

On base, a batter is transformed into a runner. He struggles to stay

alive for himself and his team (his species?). He is dependent upon his teammates to get him home. And if they don't, then he's "stranded," "abandoned," or "picked off."

The outfield is a black universe provoking the same endless contemplation of nature's mysteries that occurs when you look through a telescope. Consider the folklore surrounding the ball that was "hit into infinity." It was a home run that landed in a traveling truck on an adjacent freeway. It is still traveling, they say—the longest home run in the world.

My eye continues, back to the figure coming home. But the purpose of the drill that's being illustrated is to show what happens when the runner misjudges the arm of the rightfielder throwing to home. He will be out. The ball sits in the catcher's glove, waiting. And that, surely, is the greatest tragedy, the most uneconomical of acts: to be thrown out at home plate.

And what is home, anyway? Home is a white surface in the shape of a house.

It's winter, the baseball season is over, and I, as every other baseball fan, go into hibernation. But I'll put myself down with machinations about the coming rebirth. In the twilight between my waking consciousness and dead sleep, I'll ask myself if Lou Piniella will have the horses next year, a twirler on the mound who can get the job done. And about the St. Louis Cards? Will they finally overcome the fatal Dave Denkinger call during the 1985 World Series and come back and be the team they should be? Have they been punished enough for their hubris? Is it possible that Bill Buckner could redeem himself in 1987? As I begin to sleep, the stadium filters into a dreamscape. I see it as from an aerial photograph. It looks like a Robert Smithson earthwork. Claw marks on the earth for space visitors to decode? America's answer to Stonehenge? Mother baseball. To sleep. In April the sun will come out again, and I shall be there to watch men with clubs and seeds stand on a green pasture and coax the sun to stay out.

Bats

Tom Knechtel

for Bernard Cooper

A group of people come to my studio and, while looking at drawings of bats, express bemusement at my choice of models. I explain my fondness for the outlandish by comparing my reaction to bats to the feelings I have while admiring the antlers growing out of a moose's head or a bird-of-paradise flower or a platypus: amazement that anything so eccentric could have found its way past the relentless red pencil of evolution.

I've never seen a bat—not close-up, at least. But it's not really germane to my interest in the animal as to whether I've seen it in the tiny dark flesh. Our appetite for monsters thrives more successfully when fed with our imagination; the Loch Ness Monster will probably appear one day as a large clay-colored blob of a creature, rather than the iridescent sentient being we've fantasized is moving beneath the loch's surface. And the bat is a monster: like the result of a joint experiment between a botanist and a toymaker, it takes the form of a malevolent orchid with balsa wood and tissue paper wings.

I picture entering a cave and seeing the ceiling covered with the lumpy insulation of bat bodies, the air thick with the humid breath of

ten thousand breasts. Lungs no bigger than the pink rubber tip of my pencil expand and deflate—or perhaps I've got it wrong, maybe they need immense lungs to sustain their flights, and so their bodies are nothing more than balloons made of fur and bone. If they fall to the floor of the cave, they pivot and hop until they reach an overhang and can drop into the air, blossoming into flight. The minute brain is firing indescribably small synapses, none of which register on an unresponsive face with glittering pinpoints for eyes and a mouth in a perpetual sneer.

That something so simultaneously ugly and exotic could be among the most numerous species (as someone recently told me) is inspiring. Such self-confidence to push oneself forward, regardless of one's serrated leaf-shaped nose! I'm reminded of a pair of recent conversations. A friend called to say that he had received criticism on a piece he'd written and that he felt a complete collapse of confidence in the piece and in his work. We talked about how he felt isolated, buffeted about by opinions, wandering without an inner compass. Later, describing this to another friend, he and I talked about how we're used to locating ourselves and our work by watching our contemporaries, finding our bearings in the world by bouncing our opinions off our peers, like bats bouncing shrieks off walls to find out where they are. We force ourselves, foist ourselves off on an indifferent environment.

In addition to being an artist, I teach art history. My mind has become so accustomed to plugging everything in western civilization into a time line comprehensible to the student mind that I now find myself trying to fit the bat into art history. The bat does bear a resemblance to another of my enthusiasms—the rococo, a movement itself not so far from the monstrous, with its mad proliferation of explosive form. In the French salons and Bavarian pilgrimage churches of the eighteenth century, in the paintings of Tiepolo, organic form takes ornate flight, rising weightless under its load of draperies and gilt surfaces, spiralling effortlessly away while regarding us with an aristocratic smile. If the bat makes an appearance in these paintings, it does so as a note, a shy gray-blue silhouette fluttering behind Calumny as she's cast down from the skies by a haughty Truth. The actual animal, though, keeps stubbornly forcing itself into my thinking about the rococo, since its anatomy is so delicate, intricate, and artificial, like a decoration out of a perverse version of the Amalienberg. Perhaps it's rococo's dark cousin or even

the opposite pole, with Tiepolo, light and reason at the beginning of the century, and Goya, darkness, the irrational and bats at the end. By Goya's time, the bat has inflated into a giant shape, faceless, but unnerving, who dominates the artist as he falls asleep at his desk. But as I write that, I realize that Goya's bat is as anonymous as Tiepolo's, that the bat is too exquisite to have been captured by Goya, that it is too exquisite even to seal up into an airless dichotomy.

A story I love: A scientist who studied bats had to travel frequently on the plane with one of his pet subjects. The bat was too fragile to put into the hold with the other animals; so the scientist arrived at the solution of carrying the bat in an empty cigarette carton, where it slept hanging from the inside of the lid, while the carton sat in the scientist's shirt pocket. The image captivates me: a man traveling through the air with a miniature monster sleeping over his heart.

The Discovered Uncovered

Nancy Spero

Putz, an extremely young, beautiful[1] California artist—whose recent exhibition of his work and navel[2] is the most significant of these last few years. Along with Creeps, he is in the vanguard of these exciting 1960s (yawn).[3]

I mean Putz's plasticized condoms are extraordinary—the illusion is rendered somehow literal[4]—while at the same time the literalness is dissolved. It is because they are what they are—in spite of their being coated in plastic—a most attractive illusion—(yawn)[3]—that has compelled this young[5] artist.

In this very manner, this viewer[6] gets a feeling of utter amazement—one is compelled to realize[7] that Putz's very rigorous transcendent realizations of a most challenging aesthetic, an extreme nonart, inert object—could be most possibly—and literally realized. The illusion is most *didactically* limited in these shapes (of course, one has to see what one has, of course).

Now, the question[8] arises as to whether or not these literal shapes actually do erect. This is a profound question. Perhaps in essence of "Male Odor" I have not been able to completely follow the projected trajectory to its fullest intimacy—which I feel in this piece the literalness

was somewhat contrived, forced by its ambiguity and physicality at the same time.

Moreover, as I mentioned this artist most intentionally has (as C. so cleverly and prophetically said "they must halt their phoning"[9]) had his assistant making transparencies because their surfaces (and thrust) have become important for the first time.

Finally,[10] and most *didactically*, Putz has produced—for this viewer[6] a projection of a vision—suspended and virile—angled in complete objectivity—yet unmistakably his very own.

Notes

This was written in 1967 and sent to Phil Leider, editor of *Artforum*, with no response.

1 He is very ambitious.
2 At first attached to a dishwasher—now a computer.
3 Of course, the critic's tasks have come to the forefront—and their refusal for the most part to make formalist distinctions has only added the deepest confusion to the entire scene of aesthetic position. So much for the moment for these radical questions critics must provide.
4 I shall write of this plastic problem subsequently.
5 Putz doesn't have one wrinkle—not one.
6 I was the *most* unisex student in my art history class.
7 (See note 6.)
8 This is much too complicated a question to go into now; in another essay I shall delve into the problem.
9 They phone for their work, as they are excessively tired and debilitated.
10 We were intimate for the first time this morning.

Running on Empty:

An Artist's Life in New York

Susan Bee

"You need to build up your stamina."
"Paint larger paintings."
"You need a larger studio."
"Move downtown."
"Rent a basement space."
"Simplicity."
"Just paint; don't think so much."
"You have too many ideas."
"Your work is too complex."
"You painted this?"
"I like the way everything is painted but the area under the chair."
"The images are great."
"It's humanist and psychological."
"It's not narrative enough."
"Put $50 more paint on the canvas."
"Use bigger brushes."
"I like everything but the hair."

"They're very handsome."

"I like them but I can't use them."

"They're quite interesting."

"They're not for us."

"Come back in six months."

"Is this a painting of The Flood?"

"I get it—it's about the blending of cultures that we all live with everyday."

"These should be more well-known."

"They're really funny."

"Don't be bitter."

"The brushwork is not aggressive enough."

"These may be too political."

"We're booked up right now."

"Call us in a few months."

"Your work is a jumble."

"This painting is clearly the culmination of your work."

"Do you do works on paper?"

"Is all your work that size?"

"I like everything but the background."

"You could paint even bigger."

"What's that supposed to mean?"

"How much is it?"

"Are these realistic?"

"Paint ten more like that."

"Don't call us we'll call you."

"Come back when you've got more."

"Your time will come."

"Don't be discouraged."

"Too many colors."

"Loosen up."

"Don't believe what dealers tell you."

"At least you're working."

"It takes time."

"Don't be impatient."

"You're not ambitious enough."

"Your slides are lost."

"Your work's too personal."

"Don't believe what other artists tell you."
"Why don't you paint on the other wall?"
"Too much sexual imagery."
"You're still painting?"
"It's narrative and nonnarrative at the same time."
"Of course, your hand will develop in ten years."
"I get it now."
"So where do you want to show?"
"He can't sell anything."
"Where do you get those images?"
"Send me your slides."
"I like your old work better."
"Come back when you've got six more."
"Keep working."
"Just ignore the outside world."
"Go to more openings."
"Introduce yourself to her."
"I'll recommend you."
"It's too lyrical."
"I get it."
"I don't get it."
"Use your whole arm."
"These seem big enough."
"Just keep working—something will happen."
"Oh."

All quotes verbatim.

Reorganized Meditations on

Mnemonic Threshold

Joseph Nechvatal

Previous cultural forms have been exhausted as self-consciousness has turned into self-enclosure. Self-expression is eclipsed by a field-network of interaction. The next phase in consciousness will only come when all our attachments to the old forms and methods have been obliterated. Everything has become transparent. Information bits flow in a vague whirl while this proliferation, which seems to have no purpose, forms slowly, imperceptibly, bit by bit, into a mass somewhere deep in the gray recesses of the neural cortex; remnant whispers of a once dominant cultural form. Congealed skeletal formation is in a state of information and dismemberment. Fleeting solidity (matter-spirit) rips out and dissolves form from its old content, providing visions of resolve and improvement over dilemmas left behind. Substanceless collectivity reverberates internally, beyond intellect and will, in an inner-external detoxification which breaks pop open and drains mythic consciousness of authenticity. In our media-permeated atmosphere the search is to not repeat what has been learned. The learned form must be cracked open through chaos to make room for other views. Fast-paced

dumbness and reactionary codes are made difficult and resistant to bourgeoisification. The logic of the image, of the whole media society, of postmodernism in general, is satiated in an overabundance and counterfusion. One goes all the way through and comes out the other side, ecstatic and covered in excrement. This hyper-overproduction is the space of refusal today. The only space from which to develop an awareness, a theoretical awareness, of the reification of consciousness. Are we at the beginning of a new metaphor for the system? A Big Bang theory pushing us beyond the vanishing point? A theoretical black hole? The aftermath of the dissolution of form is not a reductive simpli-fication. Rather, an analogy can be drawn to the primordial pleni-tude, subject-object unity, or Benjamin's dialectical image. The money mushroom cloud is seeking repose, as astonished eyes behold the self-cannibalization of nostalgic fetishism. Distorted ideologies bubble and burp their way to the top of the cesspool. Media adulation, commodity consciousness, technocratic mind set, all collide and cancel each other out in an orgy of fazed media mirages, a mindless bombardment of consumption—consumption, resolving itself in an all-round social awareness. Complete self-consciousness is a meta-consciousness. Depth consciousness is formed from the debris of superficiality and fragmen-tation. New neurological circuits are connected, mutating conscious-ness. The characteristics of this new neurological mutation are high velocity, multiple choice, relativity, and the fission-fusion of all percep-tions into alternate possibilities. From Overload to Overmind.

The Critic and the Hare:

Meditations on the Death of My Rabbit

Ann McCoy

The rabbit in question, a black doe named Celeste, for eight years had
provided me with a much needed link to nature in New York City. She
was a forest spirit who instructed me in the mysteries of the animal
realm. In Greek art and mythology the hare was associated with Aphro-
dite, goddess of love and miraculous fertility. Aphrodite's academies
taught the value of sympathy, compassion, and positive human rela-
tions. The rabbit seemed to possess all of these qualities. The hare also
belongs to the moon goddesses, and Hare in the Moon represents the
"other side" or unseen aspect, the unconscious, which, if honored, is
the source of spiritual wisdom—the "light in the darkness" which
guides the traveler. In ancient China, the rabbit was emblematic of the
yin (earthly and yielding) force on account of its lack of belligerence, its
ingenuity in finding ways of avoiding direct attack.

 The critic in question arrived at my studio on December fifth at four
o'clock as scheduled. He spent the better part of two hours looking at
my work and listening as I spoke of the relation of what he was seeing to
dreams, visions, and the collective unconscious. Outwardly polite, a
good listener, this critic, associated with modern ideologies like neo-

Freudianism, object relations, and Marxism, sat patiently as I went on to speak more specifically of my dreams of the vulture goddess Nekhebet and her meaning for the modern woman. As I finished, the critic turned and said, "All animals are children."

This reductionist statement surely didn't apply to vultures, whom the Egyptians emblazoned upon the breastplates of mummies. As "mothers" of the dead, vultures were considered female only and fertilized by the spirit-wind. Four words from the critic robbed the vulture of its numinous power as a symbol in my dreams, thence in my work. I felt robbed of an essential part of my vocabulary.

The critic asked to use my bathroom. I said of course he could but that the rabbit was in there. I could go in and put her in her cage. He blanched at the thought. I said I could go in and take her out. He balked, with hands on the doorjamb and stood rigidly for a second or two. He didn't want anything to do with the rabbit. So, I thought to myself, he's phobic when it comes to animals, and particularly afraid of animals associated with the feminine.

> We are still as much possessed by autonomous psychic contents as if they were Olympians. Today they are called phobias, obsessions, and so forth . . .—C.G. Jung

After quoting Yeats and calling me an "Irish romantic," the critic hurriedly left in search of a safe place to relieve himself.

I went to pick up Celeste. She let out a series of piercing squeals and died in front of me on the rug. To compound the drama of the situation, the moment the rabbit was dying, my husband (born in the Chinese year of the rabbit) got mugged as he entered the building. We took the limp body of the rabbit to be cremated. As she lay on the hospital's metal table, I could not help but think of Joseph Beuys's "Conversations with a Dead Hare."

The artist stands between two worlds—a socially constructed reality which would have us see everything as the effect of physical or physiological forces, and an inner world which presupposes spiritual agencies. The death of the rabbit, as if judged out of existence by the critic, was a synchronic event. Jung defines synchronicity as "the simultaneous occurrence of a certain psychic state with one or more external events which appear as meaningful parallels to the momentary subjective state and, in certain cases, vice versa." The phobic response of the

critic to the rabbit, his dismissing of the vulture, the rabbit's death, and the mugging of my husband produced a chain of events which were cause for meditation.

The afternoon had left me feeling wounded. Not only had I lost a pet, but I had been cut off from myself. I kept remembering a dinner conversation where several women artists had discussed how they too felt misinterpreted, dismissed, even assaulted in the art world. What was it about the feminine that the critic couldn't grasp? To what mummy had the vulture got itself attached?

September 21, 1989

Richard Tuttle

for Karl Hikade

1. Art is temporary in the mind of the viewer—like the vision in the past. It holds the viewer.

2. Anywhere art stands in being relation, art stands alone, "being relation" being solvent upon matter.

3. Whichever way counts like others, is like others. In art the same effort always precedes.

4. Being necessitates givens. Acquiring givens, like art, is past procedurism pluraled.

5. Time threatens back to time-ic wondering, transforms, adjusts, falls, like art, orange on a landscape.

6. Story line coursing laterally, doomed to submission in sand, springs back, clearly echoing art's values.

7. Height frequency zeroes backward to rocks—can I say "purpled"?—purpled, like rocks in art's sister spokesman, here.

8. The range might carry scratched earth, which way the sun decides, touching in shadows as it goes. Art decides whenever it goes.

9. The touch that generates pure space is forward. Can we see it written about? Parallelism, art, come back into your own.

10. Over there, it listens. Art possesses. A rainbow would tell us not art—the edge of issues. In the dryness, I am thinking.

Alison Knowles: An Interview

Aviva Rahmani

Alison Knowles was the only woman member in the original Fluxus group. Fluxus coalesced, in 1962, with a concert at the Wiesbaden Kuntsverein in Germany. It was a group of disparate artists, including Yoko Ono, Nam June Paik, and George Brecht, many of whom had studied with John Cage at the New School for Social Research in New York in 1958. It has continued as a magnet for younger artists particularly in Europe. Knowles has taken her work regularly to Europe since 1962. Knowles and some of the Fluxus artists taught at CalArts in the early 1970s, when John Baldessari, Judy Chicago, and Allan Kaprow were also there. Aviva Rahmani was Knowles's student at CalArts. This interview took place in New York City in the winter of 1991.

Aviva Rahmani (**AR**): We live in a world of chance and the collective unconscious. That's the essential connection I associate with Fluxus. Can you define activism or truth in your own work?

Alison Knowles (**AK**): Making an artwork is an action with its own politics. An artwork has its context. It succeeds or not. By that I mean it communicates from the artist to a world outside and vice versa. Communication, truth, and action are always bouncing off each other! I came to CalArts in 1970. I came from my first performing experiences

and was invited for the first time to teach. As a performer, your availability is limited. As a teacher I felt I had to be available without any limits; my thoughts, my time were always shared. I found many unexpected conjunctions: art as a vehicle of truth and the problems of marketing, design, and professionalism all in one basket. There's nothing inherently evil about marketing; however it's best treated as a kind of game.

AR: I assume you're talking about conflicts around careerism, as opposed to a deeper aesthetic drive.

AK: Yes. Careerism. Art is a calling based on need. It's based on what people need and on knowing. It may be a problem that people go to school to discover that and make art; but then we have to be somewhere to make connections. Art schools provide these resources. At that time, and since, you have made an autobiographical frame and I a local one. Local but not autobiographical. We each notice things so differently, as we examine and touch materials. We each have such different distances from the body, the object and the self. Is it a problem that people go to school to learn to make art? We have to be somewhere. My context is local to my immediate environment, but not autobiographical per se. We look at materials as we walk along the streets, eat our food, look into the woods.

AR: Do you mean local in terms of wherever your body is?

AK: Yes. A bean ritual called Setsubun crossed my path in 1990 and took me and Yasunao Tone to Japan. Once there I framed the time and art into a sound tape for radio and a live performance. Wherever we go we drop a frame around our experience. At a street market in Kyoto I found very unusual bean specimens. The frame was the same as it would have been at home but all the accoutrements of the experience of that transaction were very beautifully different to me. The weighing device was a small square wooden vessel, handmade. The coins exchanged and the language spoken were exotic to me. I was living in a paper factory then. It greatly amused the women there to see me take those beans back home and eat them all up. That maintained my frame!

The best I can do for the ills of the world is to maintain a tight battle with the art. I confess to being totally disengaged from the war in the Persian Gulf. There isn't any way for me to enter that frame.

AR: Can you talk more about this concept of a calling?

AK: I haven't understood how to have a career in art. I arrive by a leap of faith. Art and careerism seem mutually exclusive. I first met careerism

at CalArts. I was bombarded with new ideas and experiences then. Dick Higgins and I had married but were separated at that time and were sharing custody of our twin girls, who were six. I was amazed by the range of approaches to art making I found at CalArts at that time. I had been working alone, as most women artists did then. It was new and exciting to work visually along with others. I tend to work a long time on things and rarely get them finished up until an outside demand forces me to wrap it up. Art making is the hardest work I can imagine and only from time to time does something get completed. At CalArts I saw people working all sorts of ways and with each other and getting work finished quickly. It was an eye-opener.

AR: CalArts then was total heaven for an artist: all the equipment in the world, all the ideas and possibilities in the world, all the people and lots of money to keep it going! A wonderland!

AK: And it gave me access to feminism for the first time. I hadn't had access to women of that stature. All the artists I had worked with were men. This access began at CalArts for me and then I refound it in Hamburg and Amsterdam. I found women working everywhere. It forced me to take a harder look at myself and what my own history had been. I had to make a new balance in my territory of making art: between the feminist art at CalArts that offended me with an aggressive edge that doesn't suit me and a more Taoist view of life.

AR: While I was at CalArts, it always struck me as ironic that I argued with Judy Chicago about the feminism of your work. Chicago felt then that no woman could tap into her full artistic power without tapping into her personal anger at sexism. You were the most supportive of all my mentors there in my research into personal and ephemeral material. The question of anger became a turning point for many women artists.

AK: If one works from a personal anger as the subject matter of the art, it's rare that it becomes excellent. There has to be something over that or with that or any emotion, whether it is anger or fear, or love. All these are primary driving forces into another place, which is where the art comes from. Everyone is free to play an instrument, but do we want them in the orchestra? Ezra Pound said words to that effect. We work together as one orchestra and we sometimes look out at another orchestra. People are drawn to different orchestras, different artworks. No one should push us to one place or another. I'm against activism as a united front in any context. I think there will be terrible conse-

quences, for example, from our meddling in the Persian Gulf. My work looks in another direction completely.

AR: You've spoken generally about what impels art making. Can you talk about what happened around the time you became connected to other Fluxus people? What was your personal catalyst?

AK: I use chance to begin anything, even if it's just folding a cloth to get some creases to know where to start. At the moment, I am printing and reprinting the cloth again and again, each time washing and obliterating the image that I've made. Only fragments remain. That way I always surprise myself. The Fluxus movement was very indebted to John Cage. He has a way of throwing things out and away from himself. He avoids his influences. He doesn't get heavier with his life, but lighter all the time. Fluxus is a first come, first served kind of art; a collision of circumstances and people. I had a chance to do a book and screen prints with George Brecht in the late 1960s and early 1970s. *Notations* was the first of three books I worked on with John Cage starting in 1967. *Notations* was published with Dick Higgins at Something Else Press. Within that same time frame of five to six years, I had babies and I became a performance artist. The Cage class at the New School was central to these events. It was especially central to the origins of the Fluxus group, which blossomed in Germany in 1962. George Brecht has a book coming out soon with Gebruder Koenig Verlag in Germany based exclusively on his notes from the John Cage class. In all these works chance was used systematically, starting with *Notations*. This was at a time when everyone was using the word improvisation.

AR: That juxtaposition of chance and system encapsulates the Art/Life concept which drew me to CalArts in 1971. So many of you teaching and working there then had initiated that development in the late 1950s and 1960s. At that time Allan Kaprow was approaching the same problem a little differently. He has described his relationship to controlling that balance as both more formal and rougher in its parameters of place or time. "The acceptance of Chance is the source of how control slips away from the artist and then life creeps in." How was your early work related to what Allan Kaprow was doing then?

AK: My acquaintanceship with Fluxus started me writing events. Allan was doing Happenings, which are completely different from Events. I participated in a number of them in America. But I met Allan after Brecht and Dick Higgins and Cage. We became friends and I visited

with him and Vaughn Rachel out in New Jersey. He was out in New Jersey doing these strange things! Events reflect back in with a quality of localness and Happenings reflect outward with a large panoramic frame. I remember Allan's wonderful performance, wrapping people in silver paper in Grand Central Station. There was no attempt to make any frame. The frame is a physical context. People are contained by simple elements. Let's say, in my event, "Make a salad," they are contained within that. Nothing else is going on, overtly.

AR: It's irresistible to muse on how two of your better known students at CalArts, respectively, Suzanne Lacy as Allan's student and Barbara Bloom as yours, have taken those structural approaches in very different directions.

AK: My favorite of Allan's works was his apple shrine at the Ruben Gallery. My most vivid memory of that work was finding myself in a small installation space with no one around, so I could enjoy it intimately. That was about 1960 or 1961. Kaprow was in that Cage class where Fluxus blossomed but he escaped and continued with his own directions. I wasn't in the class, my connection was through Dick Higgins but the mechanisms of structure discussed in that class helped me escape the ravening jaws of abstract expressionism. I had graduated from Pratt as a painter and already had my first solo show. The immediacy of these new ideas convinced me to stop painting in the New York style of abstraction. I burned thirty paintings out at my father's house in East Hampton. I met Dick Higgins at a party and then met the other Fluxus people one at a time. We all lived or congregated around Canal Street in George Maciunas's loft. In my loft on Canal and Broadway, I took a piece of cloth and I folded it and I put numbers in the seven areas. Dick was on the phone telling me the probabilities available, given my local visual vocabulary at the time. I made hard divisions on this canvas that I could not overstep. If I threw a two, the area must be blue. I was then twenty-five, it was 1958. In 1966, I made a scroll called, "do you remember," based on a poem by Emmett Williams. We performed this on one of our evenings on Canal Street. I physically stepped on the canvas, spraying around my naked foot . . .

AR: That must have been an incredibly dramatic leap, from abstract expressionist painting to stepping onto the canvas as a proscenium.

AK: This was the first performance in which I showed an exact structure, putting certain small objects I had assembled on the floor beside

me into the scroll as images. I allowed myself to use a range of objects, such as shoe heels and can tops, but they had to go into prescribed places, dictated by the poem. This was my digestion of John's infamous class.

AR: I want to come back to activist art and your work. Horrible things are happening in the world. Some would call your approach frivolous. This lightheartedness seems very Fluxus to me. How does this simplicity tap into something deeper? When we follow the thread of the unconscious, I believe we come to the notion of group politics in the most fundamental sense.

AK: Because these event pieces are so simple the audience projects their own political or artistic frame. Each person must flesh it out. At a recent S.E.M. ensemble concert in Brooklyn, I performed a piece by George Brecht, an example of this. I taped two beans to the keys of a piano. There was no sound at all. I did not try to make a sound. All that was audible was the scotch tape being torn over the toothed edge of the dispenser. These pieces are not in the least frivolous. They are simple and performed in a straightforward vintage no-dramatics style. If they are profound it depends on the perceiver. In the most fundamental sense, you've never heard a Cage piece that sounded like anyone else's work. A personal and lyric style comes across. The spoken texts I am working on, the fish diaries of Barton Appler Bean, or the West German radio texts, are organized, compiled researches, that give me a chance to read. They are found texts that become sound works. If we get to the right attitude, work just rolls along and we can't get enough of it.

AR: I can identify with that more than you might think. After all, I've committed myself to nine years on a remote island to study invisible ghost nets in the sea for the "Ghost Nets" project. I think we're talking about a way of thinking very close to the Native American; that the earth ultimately responds more intensely to the private rituals of a few dedicated people than to all the machinations in all the world's capitals.

AK: I'm perfectly appalled by what's happening in the world. It's another orchestra. Is victory possible in any war? I have been working on a series of cloths about the moons of the American Indian, studying their dependence on nature, their love of the other animals on earth, their respect for all life. We realize too late our loss of connection to the earth.

AR: Rachel Rosenthal talks of that a great deal in her work. I find it tremendously confirmative that many of us are working in these dif-

ferent ways to address similar concerns. To stand outside a dysfunctional system is certainly political and activist in ways that a march may not be.

AK: I marched once against the Vietnam War up Fifth Avenue playing bells with Philip Corner. We performed well and no one noticed. That was the best part.

AR: Have you done anything else that overtly political in recent years?

AK: I was asked to put my name on a Guerrilla Girl poster ("Guerrilla Girls Identities Exposed," 1989) and I did. I'm also a member of NOW. With my strong anarchist tendencies it's quite amazing. Let the rain fall down, the breeze come up. We miss most of what's really going on, projecting our silly selves all over everything.

AR: I think that when you were in California, because of the Pacific rim, people might have been more receptive than here in the East to the haiku style of your work. Do you have anything coming up soon?

AK: I have a chance to publish my spoken texts, so I'm working on that; in May I'm off traveling for a residency in Banff, Alberta in Canada. I'll think of you netting ghosts. I'm sure they'll come when you call.

Media Baptisms

David Reed

When I was in my early twenties I was drawn to the landscape of the Southwestern United States—the deserts and high plateaus of New Mexico, Arizona, and southern Utah. I was drawn by the emptiness of the vast spaces and the freedom which the space implied. I called the Grand Canyon "the home of American painting," recognizing that the unlocated space of Pollock's paintings matched the vastness of the canyon. I thought that through painting vast undefined space I could connect to what I loved in Pollock's and Newman's paintings; learn and grow. This didn't work out as I expected. I discovered there is a dark side to the freedom of that space: isolation and loneliness. In paintings the space can be vast, but how could I prevent it from also being self-contained?

I felt a strange sense of time in the desert. The landscape seemed biblical. It reminded me of landscapes in paintings by Piero and Raphael. The lone tree by a well near my shack seemed the Tree of Knowledge in the Garden of Eden. On the Hopi reservation a friend showed me Max Ernst's studio. The desert also seemed internally familiar from the dreams of surrealism.

But these weren't the only ways that the desert seemed strangely familiar to me. I had several eerie experiences. They were similar to déjà vu experiences, but longer lasting and stronger. I recognized unfamiliar

places and felt I had been there before, remembering events that I was sure had happened—a chase on horseback and a man falling from a horse, the discovery of a well, a wolf that seemed human.

Often I would paint views from my shack but sometimes I would drive out into the desert and choose another view. I had nailed a rough easel onto the side of my small Volkswagen. After painting one morning, to escape the sun, I went to a cave I had noticed nearby for lunch. Just inside the cave entrance there was a small spring of water running down the rock walls. I cupped my hands to drink, but before my hands were filled, I bent and drank directly from the stream. Looking out at the red scrub desert and mesas in the front of the cave, I had an uncanny sense of familiarity. The spring water was an unexpected pleasure. But why did it seem more than just that? After lunch and a nap I explored the back of the cave and found a flue, a crack in the mesa's walls, which I walked through into a small canyon cul-de-sac which also seemed familiar. Many years later I realized that I knew both the cave and the cul-de-sac from a movie, *The Searchers* by John Ford. Martin Pauley and Ethan Edwards take refuge in the cave. Martin fills his canteen under the same stream and drinks with the same gesture that I had made. Somehow my gesture recalled the film image. This recognition made me realize how much CinemaScope westerns had influenced how I thought about the space of the desert. The freedom and loneliness I saw in the space is the theme of westerns. The hero is free in the landscape but he is an angry and isolated outsider and in the end always returns alone to the desert.

Film is especially good at conveying the experience of the uncanny. Stanley Cavell calls the uncanny the "normal experience of film." In a movie the world can look perfectly ordinary, but as the camera lingers one knows that this world isn't ordinary at all.

I realize now that the experience of the uncanny is what drew me to the desert to paint. Not Beauty. Not the Sublime. The category of experience that is explored in my paintings is the Fantastic, from Kafka, to Poe, to B-horror films.

—fear and loss of the self
—division and multiplication of personality
—collapse of the limit between subject and object, mind and matter
—transformation of time and space
—sexual desire in various forms

—biological transformations, especially across gender, from animal to human, or from human to machine

These themes are discussed in Tzvetan Todorov's study, *The Fantastic, A Structural Approach to a Literary Genre*. He describes three requirements for the fantastic.

The first is an unresolved ambiguity between the supernatural and a rational explanation. In my paintings this involves an ambiguity between the physicality of the paintings and their illusionism. I want both qualities and I want neither to deny the other. The paint is very physical and the process direct, but the paint surface looks distanced like a photograph. The painted light can seem like light from film or video. This light, unlike the light in figurative painting, is not directional, but increases the intensity of all colors. The light is technological and not religious. It doesn't come from above. I want to make this technological light human. I want a unified light in the painting, but I want to modify it, let it change from light to dark, change temperature and change hue. I want to make full color, technicolor paintings.

This ambiguity between physicality and illusion affects the sense of movement in the paintings. The gestures are frozen. But because we are used to seeing movement on film and video screens it's easy to imagine a continuation of the movement as we can from a photographic still. I think of this jump of movement as a way to emotionally connect to the work.

The fantastic is a self-conscious genre. I like a sense of artificiality. I want the elements to be blunt and obvious, to *not* be balanced or composed. More and more I find I'm better off not thinking of space and composition but instead of filmic devices such as focus and camera movement. I try to make a screen of paint that has no definable space but which allows one to mutate in size and nature as one moves through it.

Todorov's second requirement for the fantastic is an identification of the reader with the hero's hesitation between interpretations. My entry into the uncanny, while drinking in the cave, was through a gesture. And gesture is the entry into my paintings, but it's a peculiar entry. Most paintings have a tactile entry. But touch won't get you into my paintings. The entry is eyes only. The gestures in the painting are ambiguous in meaning and obstacles put in the way of identification. But they can be identified with, and one's body put into the light of the

painting. I hope the obstacles ultimately cause more identification rather than less. Warhol's paintings work in this way. The illusion of movement one can create and follow in a gesture can open the painting. That is why the paintings are in such extreme proportions vertically and horizontally. When you look at an isolated part of these extreme formats, the other parts which you see out of the corner of your eyes seem to move, because peripheral vision is especially sensitive to movement. But when you look directly at the movement it stops, and peripheral movement starts again somewhere else.

Also the extreme format keeps one from easily putting together the whole of the painting. To make sense of the painting one must put the disparate parts together oneself. My paintings aren't space but an artificial equivalent which is stressed and mutated. I want to take the unity of Pollock's space, the unlocated hugeness of it, and crack it open. I try to control these leaks so they can connect the painting to the world outside itself.

Todorov's third requirement for the fantastic is that the work reject allegorical and poetic interpretations, for if one can interpret the narrative in these ways it loses its ambiguity. I refer to natural forms, architecture, experiences in nature, but they can never be specific. If the reference becomes specific the painting could slide out of the genre of the fantastic and into the genres of either side. If there is a rational explanation (as I feel there is for my experiences in the desert) then the genre is the uncanny. If the explanation is supernatural then the genre becomes the marvelous. Rationality or belief don't work well now for painting. Suspension—doubt, works best.

V / ARTISTS IN PERSPECTIVE

Part V, "Artists in Perspective," presents a sampling of the substantive essays that we published on the work of individual artists. These include essays on artists who at times have fallen to the margins of art history, such as "Florine Stettheimer: Eccentric Power, Invisible Tradition," written by artist Pamela Wye before the latest "revival" of this unique American artist's work (1988); artists whose work's placement in popular culture may have curtailed the serious critical and theoretical attention afforded Art Spiegelman by feminist scholar Nancy K. Miller in "Cartoons of the Self: Portrait of the Artist as a Young Murderer—Art Spiegelman's *Maus*" (1992); artists whose work provokes discussions about the "primitive" such as outsider artist Thornton Dial, who is the subject of the interview of Thomas McEvilley by Dominique Nahas (1994); artists such as Susan Bee as interpreted from the margins of the American art world, by Yugoslavian art critic Misko Suvakovic (1995); and artists such as Nancy Spero and Leonora Carrington whose feminist expressions are sensitively presented in Pamela Wye's "Nancy Spero: Speaking in Tongues" (1988) and Whitney Chadwick's "Muse Begets Crone" (1993). These essays are by artists who have extended themselves generously towards other artists' work or by art historians, scholars, and poets given the opportunity to consider art in the open environment *M/E/A/N/I/N/G* fostered.

Florine Stettheimer:

Eccentric Power, Invisible Tradition

Pamela Wye

Florine Stettheimer is an invisible artist. Invisible by virtue of her near total absence from our collective art historical memory. But her invisibility is not an isolated occurrence. There are other artists who can be thought of as part of a tradition of invisibility. Naive artists, folk artists, insane artists, or minority artists all work outside the field floodlit by art history. Stettheimer, however, was not innocent about the "major" aesthetic preoccupations of her time, nor was she naive about the ambitions of "high art" in general or of her ambitions in particular. Yet despite first-rate artistic power, she continues to circle around the periphery of art history. Stettheimer flirted with the idea of her own invisibility in a particularly striking way: she talked periodically of being buried in a mausoleum with all her paintings. Today, it is only somewhat easier to see her paintings than if her burial plans had been carried out—most of her work is buried in the storage basements and back offices of museums and colleges across America.

Currently three Stettheimer paintings are on view in New York City. Thanks to a revisionist breeze making itself felt in the curatorial sphere of the art world, *Family Portrait No. 2* (1933) is hanging in the Museum

of Modern Art's permanent collection, and *Cathedrals of Broadway* (ca. 1929) and *Cathedrals of Art* (unfinished at the artist's death in 1944) are hanging in the Metropolitan Museum's new Twentieth Century Wing. However, it is tantalizingly frustrating to know that Columbia University is in possession of a bequest of seventy works (including early, transitional, and landmark works) and yet they are without a museum in which to publicly display them. Consequently, they are wrapped and hidden in the storage basement.

Stettheimer was born in Rochester, New York, in 1871 to a wealthy banking family. She studied at the Art Students League between 1892 and 1895, and from 1906 until 1914 traveled and studied in Europe. In 1916 she had her only one-person exhibition at Knoedler Gallery, New York. She joined the Independent Society of Artists in 1917 and participated in their annual exhibitions until 1926. In 1923 Carl Springhorn offered her an exhibition at New Gallery, and in 1930 Alfred Stieglitz invited her to exhibit at An American Place, but she declined both offers. She preferred to show her new work at "unveiling parties" she hosted for such friends and supporters as Marcel Duchamp, Elie Nadelman, Alfred Stieglitz, Gaston Lachaise, and Francis Picabia. In 1929, at the invitation of the composer Virgil Thomson, Stettheimer designed the sets and costumes for Gertrude Stein's *Four Saints in Three Acts.* In 1932 she was included in the Whitney Museum's "First Biennial Exhibition of Contemporary American Painting," and in MoMA's "Modern Works of Art" exhibition. Again in 1939 and 1942 she was included in group exhibitions at MoMA. She died in 1944. In 1946 the Museum of Modern Art mounted a posthumous Stettheimer exhibition for which Marcel Duchamp served as Guest Director.

The "invisible tradition" of which Stettheimer is a part consists of art which, for various reasons, stands outside the mainstream. This art generally is not solidly allied with any one of those major historical movements that occupy our consciousness like armored tanks. Rather, the work stands eccentrically—that is, outside the center—to the art world's prevailing trends. The prevailing aesthetics are either stood on their head, twisted and modified to fit personal ends, or simply ignored. As a result, the work is branded by its singularity. The individual artist's peculiar mixing together of trends and influences is his or her way to personalize form and content. It reveals a predilection for using the individual personality as the major filter and driving force of the

art. This art is so strongly identified with the self that it often functions for the artist as an alter ego.

We can think of these eccentric artists as heroes and heroines of individualism, standing as they do alone and susceptible to invisibility. Or we can see them as careless strategists, heedless of the future—artists so caught up in their private visual dream that they failed to devise strategies for immortality. As a result, first class inclusion in the pantheon of art history has eluded them, even after death. These artists have not got their due by today's standards of recognition. Is it their fault? Is it self-willed? Or did time, once it grasped the essential nature of the artist and the art, take off on its own, elaborating their future from an initial soil impregnated with their eccentricity and independence, and out of which their invisibility took seed and grew and grew, out of the artist's reach? This is a terrifying fate to consider for those with an affinity to this independent sensibility. To be forgotten, misunderstood, ignored, or unjustly left out. What could be worse? Yet it is precisely these qualities, this emptiness, hole, lacuna, and need, which have the power to attract and fascinate. The need for closure, completion, and vindication is, luckily, irresistible for some people; it energizes and galvanizes those who want to overcome it, turn it around. The invisible artist seems to attract the imagination of a few such people, who take up their cause and try to pierce through the thick growth of their invisibility with the fervor of one whose own destiny depended on it.

Florine Stettheimer is an alternately emerging and retreating artist. For years she has been surfacing and disappearing with teasing ambivalence. Today, we are accustomed to bulletins advising us of the immanent emergence of some unknown artist or artists currently working. Stettheimer, on the contrary, is tortuously emerging, not from the haze of that future about which we hear many predictions, but from the clearly delineated and well-lit past. That past, which seems definitively resolved, can prove to be mutable and capable of offering up surprises.

Artists whose work is invisible, by definition, are not important figures in art history. The word "important" is not used here, nor is it ever used, innocently. "Important" is a highly-charged code word that serves as the nucleus around which reputations spin. To be "Important" means not to be overlooked, to be big, serious, and influential—something to write home about—or, quite simply, to write about.

There is an obsessive desire on the part of forces in the art world to jump start art history with pronouncements of "important" new works, shows, artists, trends. It is a treacherous machine that tries to force-feed art history with premature pronouncements of "importance." It often uses the artists it exalts as fuel to keep itself turning—consuming and discarding many of those artists in the process. The mischievous handiwork of this machine is of two sorts. It can puff up reputations that are at best premature, and at worst undeserved; and it can shrink to invisibility art which is inconvenient, marginal, or eccentric by simply and persistently ignoring it. In its attempt to manufacture art history, this machine decides not only how we see, but what we see. Part of Stettheimer's distinction and enigma lies in how invisible, and hence how "*un*important" she has remained.

Supporters of Stettheimer have often returned to the subject of her near nonexistent reputation as though to a conundrum, against which their only resource is to ponder the question of fame and visibility.

In 1931, Marsden Hartley took note of Stettheimer's isolation, and by proposing the sort of sensibility necessary to appreciate her work, spoke of the very qualities that made her work difficult for the art public, and consequently some of the reasons for her "respectable reticence":

> . . . I suppose no painter has been persistently permitted so much of refined obscurity as Miss Florine Stettheimer. . . . In the case of Florine Stettheimer, the reasons are much too personal and special. . . . This artist has wished apparently to remain the property of special friends . . . she has for one reason or another, and, I almost want to declare, not legitimately, elected to remain out of the great parade of esthetic effusion that makes up what is called the art season of New York from year to year. The painting of Florine Stettheimer does not . . . belong to the concert hall, it is distinctly chamber music meant to be heard by special, sympathetic ears; . . . [it] implies a definite degree of cultivation in the spectator in order to enjoy its almost whimsical charm, it implies that one must wish for ultra-refined experience in order to enjoy what it contains. . . . [she is] the one artist of today whose works are permeated first of all with delicate and captivating feminine humor. . . . It is the ultra-lyrical expression of an ultra-feminine spirit, and must be considered as such if one is to enjoy the degree it is meant to convey.[1]

In the catalog accompanying MoMA's 1946 Stettheimer retrospective organized by Marcel Duchamp, Henry McBride wrote:

> Fame is the most uncertain garment man assumes. No one knows exactly how to acquire it nor how to keep it once acquired. . . . Yet fame, apparently, is what the Museum of Modern Art now desires for the late Florine Stettheimer.[2]

And in 1973, on the occasion of a Columbia University exhibition, Hilton Kramer wrote of Stettheimer's work:

> . . . a little campy, a little bizarre, yet extremely powerful in its pictorial effect. . . . One can only hope, indeed, that the Columbia exhibition will turn out to be only the first step in the rediscovery of this remarkable American artist.[3]

So why, in 1988, is Florine Stettheimer still "permitted so much . . . refined obscurity . . ."? One possibility may be that the forces that solidify an artist's reputation are market forces. Stettheimer's attitude toward fame can best be described as one of ambivalence. Her attitude toward the market, in contrast, seems more clear-cut. She didn't need the money that sales could bring; and as Linda Nochlin pointed out in 1980, although a feminist, she cultivated in both her work and her life a language and a persona of ultrafemininity and ephemerality. Neither of these qualities could provide a strong base from which to make inroads into the top ranks of an art world that at best did little to encourage its "lady painters."

Stettheimer's ultrafeminine stance is indicative of the larger picture of her solution to the problem of forging an identity as a woman artist. She and her family were independently wealthy. Her father abandoned the family early on, and later when the two eldest children "abandoned" the family for marriage, the mother and the three unmarried daughters, Florine, Ettie, and Carrie, stayed together in a tightly self-sufficient and nurturing matriarchy—"an inseparable quartet."[4] In life, her persona was something of a cloistered virgin. And in her paintings, the image she gave herself, as well as the devices she used to frame her scenes, reveal a tendency to play with the issues of visibility and invisibility.

Curtains and drapery often frame the scenes within Stettheimer's paintings. In addition to being a decorative framing element, curtains embody a duality. They conceal when drawn, and they reveal when

parted. Revealing and concealing are alternating tendencies that are at work in both the life and oeuvre of Stettheimer. In *George Washington in New York* a feminine hand at the bottom left corner holds back the curtain that frames the left side of the painting to reveal the central scene. In *Spring Sale* (1921) not only is the curtain on the right and left edges of the painting pulled back as on a stage, to reveal the riotous shopping and trying on of clothes, but one woman at the bottom right has wrapped the corner of the curtain around her in a gesture of modesty and concealment vis-à-vis the man who stands just on the other side of the same curtain. In her portraits, Stettheimer often uses the parted curtain as a way to reveal her subject standing on center stage, as in *Portrait of My Sister Carrie W. Stettheimer with Doll's House,* or as a device to frame a distant scene from the past, as the lace curtains frame the young Stettheimer children in the deep background of the portrait of the aging Mrs. Stettheimer in *Portrait of My Mother* (1925).

The subject of many of Stettheimer's paintings are the parties given by her family "which were enjoyed by artists and writers and dancers of their acquaintance. . . ."[5] And in her life as in her paintings "she was frequently inconspicuous."[6] In *Sunday Afternoon in the Country* (1917) the artist portrays herself nearly hidden, deep in the garden in the right-hand background of the painting. With her face concealed by a big hat, she works at an easel which we see only from the back. Distanced from the social gathering, she appears to observe it. Interestingly, according to the writer Carl Van Vechten, a close friend of the Stettheimers and an habitue of their gatherings, she never painted while a party was going on. "She invariably contrived her paintings without visible models. . . ."[7] So this image of her is not a recording of fact, but rather the representation of a persona. Stettheimer frequently made use of analogs in her portraits. She surrounded her subject with people, words, and objects that by association helped to represent something essential about their personality. Therefore it is significant to note that belying the image of modesty, reserve, and professional dedication with which she sought to portray herself in this painting, she has painted a red satyr crouching close by her side. The riotous merriment and lechery with which such woodland deities are associated complicates our reading of her as the aloof spinster, yet supports our intimation of her capacity for sensuality and passion. And since the satyr appears with Florine the painter, one can venture a guess that she is acknowledging to us that painting is the arena for the expression of her dionysian nature.

Stettheimer's spinster image as put forth in her paintings seems to embody something of the self-centeredness of prepubescence. Prepubescence is that pause in late childhood when one is independent of the life-giving mother yet still innocent of that violent yearning for the Other where self-centeredness gives way to self-forgetfulness, and one is drawn to and drowns in the reality of an other being in sexual love. In prepubescence one is self-possessed and untouchable—one's sensuous experience of the world is one's alone. In *Picnic at Bedford Hills* (1918) Stettheimer pictures herself alone and off to the side of the other members of her party which consists of two paired couples—she is literally the odd woman out. Elie Nadelman appears to be wooing a recumbent Ettie while Marcel Duchamp helps Carrie set out the picnic. Ettie is lying flat on her back, with her arms bent up under her head in a pose which, if not exactly provocative, is one of openness, and receptivity. In contrast, Florine is portrayed sitting upright, closed in on herself, her arms hugging her body, her legs pulled up under her, clutching her parasol close, she looks away from the others, alone in her thoughts. She is the picture of self-containment. And again, in *Lake Placid* (1919) we have the picture of many friends of the artist's family clad in bathing suits, swimming, diving, lounging, and water-skiing, clearly given over to the voluptuous pleasures of summer. Florine, in contrast, paints herself in the extreme foreground, fully clothed in what appears a long-sleeved coat and a big-brimmed hat. Again, she is closed in on herself, her arms hugging her body, her face turned away from the joyous crowd. She appears to be sneaking timidly down the stairs, wishing to pass by alone and unnoticed.

Stettheimer knew, and was able to cultivate, the conditions in which her work could thrive—privacy, if not isolation. This is borne out by what we know of her social persona as well as by her peculiar and very personal manner of "getting her work out." Her preferred vehicle for showing a new work was not the impersonal space of a commercial gallery, but the "unveiling party" that she and her family hosted in their home for a select but choice group of supporters. The dinners, picnics, soirees, and unveiling parties that figure so prominently in her paintings were attended by such artists as Duchamp, Nadelman, Hartley, Lachaise, Picabia, O'Keefe, Steichen, McBride, and Thomson. Stettheimer felt her work looked best in its home environment. In fact, the decor of her home and studio was an environmental creation on which she spent much time and energy. The fringed canopies, the elaborate

wall coverings, the drapings of cellophane and lace, the arrangements of crystal flowers, and the white and gold furniture paralleled her paintings in their opulence and eccentricity. "The studio itself was one of the curiosities of the town; and very related, in appearance, to the work that was done in it."[8]

Belying her apparent lack of careerism, however, is the prominence in which she figures in her last major painting, and her ultimate statement on the New York art world, *Cathedrals of Art*. *Cathedrals of Art* is one of the four paintings in the series begun in 1929 known as *The Cathedral Series*, which also includes *Cathedrals of Broadway*, *Cathedrals of Fifth Avenue*, and *Cathedrals of Wall Street*. Together they represent the most ambitious and comprehensive expression of her social/satirical vision. Stettheimer was a gifted and astute writer. She kept journals and wrote poems that evoke the visual world of her paintings as well as elaborate and develop her somewhat hermetic symbolism. A collection of her poems, *Crystal Flowers*, was published posthumously by her sister. Words as visual forms as well as conveyors of meaning also figure prominently in many of her paintings. For example, in the upper left corner of *Cathedrals of Art*, written against the sky are the names of three painters—somewhat obscurely "Bouguereau," "Picasso" (written twice perhaps to reflect his ubiquitous presence), and "Florine St" (written half backwards so as not to be too easily deciphered—as it wouldn't do to be too obvious about one's true ambition and sense of worth). In the lower right corner, Stettheimer has painted herself waving to us, amused and happy, literally off to the side of the busy, preoccupied, and specifically identified art crowd. She is further separated from the scene by her enclosure within one of her characteristic cocoon constructions of rich fabric embellished with gold fringe and intertwining flowers. One could surmise that behind her demure person lies a core of intense ambition and pride.

Further complicating Stettheimer's chances of recognition is that she appears at first glance not to be "serious." People often react to an initial encounter with a Stettheimer painting with a laugh. She entertains us. We can't quite believe what we see. The peculiarity of her forms and her subject matter renders them invisible at first to uninitiated eyes. One might initially brush her off as too frivolous for serious involvement. One can catch in her oeuvre if not an essential core, then a glimmer of a Camp sensibility. Linda Nochlin in "Florine Stettheimer: Rococo Sub-

versive,"[9] directs us to Susan Sontag's seminal article on Camp. In
"Notes on 'Camp'"[10] Sontag says: "The whole point of Camp is to
dethrone the serious. . . . One can be serious about the frivolous,
frivolous about the serious."[11] This Camp twist to frivolity and serious-
ness is borne out in this work. Far from being simply frivolous, her
specific forms, her compositions, and her sensibility as it makes itself
known from painting to painting exude an intense mental, psychic, and
sensual life. In making the fascinating leap from her highly competent
though academic early work to her extremely personal mature style,
Stettheimer embodied another Sontag definition of Camp, "The dis-
covery of the good taste of bad taste can be very liberating."[12]

Humor is a serious matter. Yet, it is something of a taboo in high art.
"It is a fabulous little world of two-dimensional shapes with which she
entertains us."[13] Today the word "entertainment" elicits images of junk
food for the mind and soul—empty, ultimately unsatisfying divertisse-
ment. After a dose of average TV entertainment, for example, one often
feels depleted, irritated, sad. With Stettheimer, on the contrary, one
feels vivified. Like a breeze through the brain, hers is not broad humor,
but rather a sort of visual and mental tickling. Entertainment in the
hands of Stettheimer is a strategy of seduction.

A formal discussion of Stettheimer's work may begin with Sontag's
reference to Camp's "extraordinary feeling for artifice, for surface . . .
[for] the flourish."[14] She could be writing about Stettheimer's lusciously
built-up surfaces, her unearthly sweet colors, her serpentine and wavy
lines that proliferate and intertwine not only in her bouquets and ferns
and foliage, but in the draping curtains, flags, and banners, the elabo-
rate robes and dresses of lace and fringe, and the plumes and tassels and
wrought iron that animate her paintings. This world of artifice is seen
in equal measure with irony and with love. In her work there is "a sense
of the poetry and humor and pathos of what is merely embellishing."[15]
The ironic distance with which she views her world can be thought of as
the result of thinking with the head. However, the cerebral quality is
counterbalanced by a sensuality that could be called thinking with the
body. The subject matter of a Stettheimer painting is never overtly
sexual, and yet despite the androgynous and stylized forms her figures
have taken, they, and the compositions as a whole, seem to be the shape
of desire and yearning. The paint surface, the heightened color, and the
forms combine to create in the paintings hot spots of radiance, of

intense and excessive pleasure bordering on ecstasy, intoxication, and a mystical hedonism. This sensuality is most intense in the enigmatic/ poetic paintings such as *Music* (c. 1920), *Natatorium Undine* (1927), and at its most direct in the *Hearth Screen* (n.d.), presently in Columbia University's storage basement.

In contrast to her social/satirical work, the enigmatic/poetic work stuns by its ultrapersonal, though oblique, content. *Hearth Screen* is a highly refined example of this. The *Hearth Screen* is an actual screen used to hide the fireplace. It consists of a canvas (28″ x 60″) inserted into a standing frame with Chinese carved and gild wood panels. The paint-ing is in oil, with forms built up in plaster and impasto, painted with silver and gold paint, and with tiny beads and sequins (some now missing) imbedded in the paint. The closed, self-contained shapes so typical of Stettheimer are seen here clearly as figures, flowers, and hang-ing forms against an uncharacteristically austere white ground. It is a frontal, direct, and simple piece, without deep physical space, but with the left to right surface space characteristic of hieroglyphics and picto-graphs, or of writing. The composition is spare and eloquent and has a visual tension which results from everything being in just the right place. This appears to be quite different from the overwhelming abun-dance of forms and lines in much of Stettheimer's work, however; it is a pared-down example of the stunning judiciousness of her sense of placement and pictorial coherence. The restraint of this piece under-scores, by its difference, its voluptuousness of feeling and tension paral-lel in feeling to a state of feminine sexual love. Not only the formal aspects of *Hearth Screen* but also the subject matter alludes to and evokes a vision of the way love feels in the body as well as in the soul of a woman. One is struck at first by the organic, implicitly erotic forms of the oversized flowers and shapes that float and hang within the paint-ing. The shapes are very primal in their earthy colors of brown, sienna, gold, and silver, with rich, blood-red interiors and details. They are built up with plaster, which emphasizes their physicality. Connecting all these shapes is a very delicate, quivering, wandering line, seemingly sensitive to the movement of the hand and the soul of she who traced it. Like a single finger tracing a line over a beloved body, it travels a great distance in some places, while in other places it twirls and loops around in playful flourishes. It draws an exquisite tension. The oversized, hang-ing, and floating shapes that dominate the surface of this painting are of

four sorts. The loosely oval flowers with rich red centers; the hanging, drooping lampshade and heart- and bell-shaped flowers; the length of unfurled scroll and fringe that occupy the two upper corners; and the single masculine shape at the extreme right. The distribution of shapes alone suggests a female harem with a single male presence. The swirling earthiness of these shapes speaks of a visceral source; they seem to originate in the body, as approximations of something felt there. Their dripping, bulging, hanging heaviness corresponds to that heavy feeling in the womb that is felt in sexual longing. All these forms are attached to the sensitive tendril/line that wanders through the painting as though to the larger nervous system that connects them to the rest of the body/person.

There are three female figures who stand balanced on this tendril without the least amount of difficulty. Yet the very nature of their perch implies a fragility, a temporary and insubstantial footing. The central figure is shy and self-contained and firmly grounded at the bottom center of the painting. She is shrouded in a black shawl that covers her from head to waist and frames and emphasizes her face and her tremulous, timid, and even fearful eyes. The female at the left, on the contrary, fixes us with a bold, seductive gaze. Dressed in an exotic gold tunic and headdress, with her face framed by a scarf of vibrant red, she seems a figure from a harem in a pose of proud display. The figure at the right is the most active; she appears to be in the thrall of a sensuous dance, her body defines a sort of arabesque. She too is dressed in gold, with harem pants, a high cone headdress with a scarf that trails down to her feet, and the train of her tunic also trails down so that the two trains meet and take on a life of their own, snaking around each other. Most amazingly, there is, balanced at the end of one of these tails, behind the female's back, another oversized shape, which upon inspection reveals itself to be not a round feminine flower with a red vaginal center, but rather a shape highly evocative of a male penis and testicles. And it is toward this shape that the female's head and mesmerized gaze are turned as a partner in a dance. These three female figures propose three different responses to a feminine sexuality—shy self-containment, perhaps even fear and withdrawal; proud self-display, almost objectlike; and active, enthralled engagement. They can be read as three distinct personalities (one hesitates to suggest the three Stettheimer sisters) or possibly as three aspects of one woman.

In concluding, one can step back from the individual works and look again at the problem of Florine Stettheimer's invisibility and note that there is a tremendous amount to be gained by keeping the curtain back on her work for longer than the flash of a glimpse. And despite the obvious charm, for the solitary devotee, of doggedly tracking down her work, one can hope that the time has come for a full-scale, out-in-the-open examination and appreciation of her oeuvre.

Notes

1 Marsden Hartley, "The Paintings of Florine Stettheimer," *Creative Art* 9, July 1931, pp. 19, 22. It is significant that this piece was not republished in the 1982 collection of Hartley's writing, *On Art,* edited by Gail R. Scott.
2 Henry McBride, *Florine Stettheimer* (New York: Museum of Modern Art, 1946), p. 9.
3 Hilton Kramer, "Stettheimer Paintings Are Revived," *New York Times,* February 20, 1973, p. 22.
4 Carl Van Vechten, "The World of Florine Stettheimer," *Harper's Bazaar* 79, October 1946, p. 238.
5 Ibid., p. 354.
6 Ibid.
7 Ibid., p. 355.
8 McBride, *Florine Stettheimer,* p. 24.
9 Linda Nochlin, "Florine Stettheimer: Rococo Subversive," *Art in America* 68, no. 7, September 1980, pp. 64–83.
10 Susan Sontag, "Notes on 'Camp'" (1964), in *Against Interpretation and Other Essays* (New York: Dell Publishing, 1966), pp. 275–292.
11 Ibid., p. 288.
12 Ibid., p. 291.
13 Paul Rosenfeld, "Art: The World of Florine Stettheimer," *Nation* 134, May 4, 1931, pp. 522–23, as quoted in McBride, *Florine Stettheimer,* p. 53.
14 Sontag, "Notes on 'Camp,'" p. 280.
15 Rosenfeld, "Art."

Further Reading

Bloemink, Barbara J. *The Life and Art of Florine Stettheimer.* New Haven and London: Yale University Press, 1995.
Florine Stettheimer Still Lifes, Portraits, and Pageants, 1910 to 1942. With an

essay by Elizabeth Sussman. Institute of Contemporary Art, Boston, Massachusetts. Boston: Institute of Contemporary Art, 1980.

Florine Stettheimer: An Exhibition of Paintings, Watercolors, Drawings. Low Memorial Library, Columbia University, New York. New York: Columbia University, 1973.

Stettheimer, Florine. *Crystal Flowers.* New York: privately published, 1949.

Sussman, Elizabeth, with Barbara J. Bloemink and a contribution by Linda Nochlin. *Florine Stettheimer—Manhattan Fantastica.* New York: Whitney Museum of American Art, 1995.

Tyler, Parker. *Florine Stettheimer: A Life in Art.* New York: Farrar, Straus, 1963.

Zucker, Barbara. "An 'Autobiography of Visual Poems.' " *Art News* 76, February 1977, pp. 68–73.

Cartoons of the Self:

Portrait of the Artist as a Young Murderer

—Art Spiegelman's *Maus*

Nancy K. Miller

A writer is someone who plays with his mother's body.
—Roland Barthes, *The Pleasure of the Text*

Autobiography by women is said to differ from autobiography by men because of a recurrent structural feature. Historically, according to academic critics, the self of women's autobiography has required the presence of another in order to represent itself on paper: for women identity is constructed "by way of alterity." From the Duchess of Newcastle to Gertrude Stein the acknowledgment and "recognition of another consciousness" seem to have been the necessary and enabling condition of women's self-narrative.[1] Unlike, say, Augustine or Rousseau, the female autobiographer rarely stages herself as a unique one-woman show; as a result her performances don't quite fit the models of individual exemplarity thought to be a defining criterion of autobiographical practice.

The number of women's autobiographies that display this construction of identity through alterity is quite remarkable. Yet several recent autobiographical performances by male authors—Art Spiegelman's *Maus*, Philip Roth's *Patrimony*, Jacques Derrida's *Circonfession*, Herb Gardner's *Conversations with My Father*—have made me wonder whether we might not more usefully extend Mary Mason's insight that "the disclosure of female self is linked to the identification of some 'other'" rather than restrict it to a by now predictably bi-polar account of gendered self-representation. What these male-authored works have in common is precisely the structure of self-portrayal through the relation to a privileged other that characterizes most female-authored autobiography.[2]

Self-representation in these memoirs *of the other* is not thematically the designated subject of disclosure. In *Maus* Spiegelman sets out to tell his father's story; his own is necessarily subordinated to that purpose. But the son's struggle with his father proves to be as much the subject of *Maus* as the father's suffering in Auschwitz. In what follows I show some of the ways in which this double paradigm operates at the heart of the *Maus* books as a form of self-narrative. I argue further that the father/son material is intertwined with, even inseparable from two equally powerful autobiographical strands: the son's self-portrayal as an artist and his relation—both as an artist and as a son—to his (dead) mother.[3] (It may also be that along with the entanglements of gender, the project of making autobiography is always tied to this intergenerational matrix of identity.)

From the first pages of *Maus* to the last of *Maus II* the figuration of the father/son relation constructs the frame through which we read (and hear) the father's story. We can think of this frame as *generative*, in the sense that it literally—and visually—produces the material of the "survivor's tale." This frame has a powerful double effect on the reader because it mimes the production of testimony and naturalizes the experience of listening to it. In the frame of narrative time, which is the present of Rego Park, we are lured into the account of a Holocaust past through the banality of American domestic life. The father pedals on an exercise bike in his son's former room and asks him about the "comics business." Art answers by reminding him of his old project of drawing a book about him. His father Vladek protests: "It would take *many* books, my life, and no one wants anyway to hear such stories." But Art

has already incorporated his resistance into his book. "*I* want to hear it. Start with Mom. . . . Tell me how you met." "Better you should spend your time to make drawings," Vladek protests, "what will bring you some money."

These opening panels announce several of the book's themes: the transformation of oral testimony into (visual) narrative, the role of the listener (and then the reader) in that production, the place of his mother Anja in the family imaginary (Art holds her photograph as he speaks to his father), and the failure or success of Art's work as a cartoonist. The generative frame in which these problems about art and life, life and death, death and success, are sketched out also works at allaying the anxiety of the readers and critics who may enter the *space* of the *Maus* project with misgivings about its premises: who wants to hear such stories, and as comics, no less? How could a reader fail to be captivated by such self-deprecation?

The first page of "Time Flies," the second chapter of *Maus II*, lays out the terms of Art's self-portrait as an artist. The top half of the page is divided into two symmetrical panels. On the left, Art, wearing a mouse mask, gazes at his drawing board and thinks: "Vladek died of congestive heart failure on August 18, 1982 . . . Françoise and I stayed with him in the Catskills back in August 1977." On the right, the time flies buzzing around his head, Art comments on his sketch: "Vladek started working as a tinman in Auschwitz in the spring of 1944 . . . I started working on this page at the very end of February 1987." Again, on the left, Art says: "In May 1987 Françoise and I are expecting a baby. . . . Between May 16, 1944 and May 24, 1944 over 100,000 Hungarian Jews were gassed in Auschwitz . . ."; and on the right, Art looks out at the reader: "In September 1986, after 8 years of work, the first part of MAUS was published. It was a critical and commercial success." Below the matching panels is a single frame. Art, in despair, leans on his arms at his drawing board, which now is at the height of a podium. The bottom half of the panel is occupied by a flattened pyramid of mouse corpses, above which the flies continue to buzz. Art complains: "At least fifteen foreign editions are coming out. I've gotten 4 serious offers to turn my book into a T.V. special or movie. (I don't wanna.) In May 1968 my mother killed herself. (She left no note.) Lately I've been feeling depressed." And an agentless bubble of words tries to get his attention: "Alright Mr. Spiegelman. . . . We're ready to shoot."

What does it mean to make (cartoon) art out of Auschwitz, money from the Holocaust? Is it possible to visualize and then represent a world designed to confound and destroy the human imagination? These are the questions that *Maus* rehearses, wrestles with, and displaces through a set of concrete choices. Spiegelman's strategy for crafting his piece of this challenge to the ethics and materials of popular culture is first to personalize the enormity without reducing it. This is done in two simultaneous gestures whose interconnectedness is essential to the aesthetic project: Spiegelman narrativizes the experience of Auschwitz as an individual's trajectory and a family's saga, but the collective horror never ceases to haunt the horizon of a singular history. In retelling that tale as a comic book, Spiegelman binds its meaning to the process itself of rendering that material. This process literally and metaphorically is thus tied to the father/son relation.

The deliberateness of the binding is shown on the back cover of the volumes. In *Maus* a map of Poland at the time of World War II features an insert of a map of Rego Park and a drawing of the father/son story grid: the father in his armchair explaining to an attentive son stretched out at his feet. On the back cover of *Maus II* an insert of a New York/New Jersey map showing a detail of the Catskills is laid down on the plan of Auschwitz II (Birkenau, where Anja was imprisoned); Vladek in his striped prisoner's garb connects the two territories; his head is in New York, his body in Poland.

As Art heads for his therapy session, he dwells painfully on the effects of these simultaneous geographies and temporalities on him as a son and an artist. (If his father, as Art puts it, "bleeds history," the son draws blood.) Climbing onto the chair in the body of the child the interview session seems to have reduced him to in his own eyes, Art complains about his creative block. (In the show about *Maus*, held at the Museum of Modern Art, is a drawing placed in counterpoint to the "Time Flies" panels that literalizes that metaphoric state: a self-portrait of the artist as a slightly warped child's playing block, under which Spiegelman has written: "My projections of what others now expect of me from *Maus* have bent me out of shape. . . . They're not meetable." The block looks a little the worse for wear.) This crisis has to do in part with the effects of commercial success, in part with the nature of the project itself: "Somehow," he explains, "my arguments with my father have lost a little of their urgency . . . and Auschwitz just seems too scary to think about . . .

so I just lie there . . ." Pavel, the therapist, who is also a survivor of the camps, zeroes in on the father material: "It sounds like you're feeling remorse—maybe you believe you exposed your father to ridicule." "Maybe," Art replies, "but I tried to be fair and still show how angry I felt."

In the therapy session Art rehearses the ambivalence inherent in his project: being fair and staying angry. In the therapy panels the son gets to justify his anger: "Mainly I remember arguing with him . . . and being told that I couldn't do anything as well as he could." "And now that you're becoming successful you feel bad about proving your father wrong." "No matter what I accomplish, it doesn't seem like much compared to surviving Auschwitz." As a good therapist, Pavel works to undo that bind: "But you weren't in Auschwitz . . . you were in Rego Park. Maybe your father needed to show that he was always right—that he could always SURVIVE—because he felt GUILTY about surviving. And he took his guilt out on YOU, where it was safe . . . on the REAL survivor." Art leaves the session cheered up, ready to work on the next panels—his father's stint as a tinman at Auschwitz—but his "maybe" lingers unresolved.

The anger Vladek inspires in his son is palpable in the narrative frames in which Vladek's post-Holocaust manias are thoroughly detailed but it also shapes Art's representation of the Holocaust testimony itself. In "Of Mice and Menschen: Jewish Comics Come of Age," Paul Buhle makes the important point that one of the "less discussed, but more vital" reasons for the extraordinary success of *Maus* (beyond the brilliant decision to render the insanity of the Holocaust as a cartoon) "is the often unflattering portrait of the victim-survivor Vladek." The father, Buhle goes on to argue, "was not a nice guy, ever"; and (as he observes that Spiegelman commented to him) "the mainstream critics seem to have missed this point entirely, quite an important one to the artist. Perhaps they can't accept the implications."[4] The *Nation's* reviewer, Elizabeth Pochoda, flagging Buhle's review, emphasizes his "political point . . . that more sentimental critics have missed: Vladek began as a typical selfish bourgeois with no politics and no ideals."[5] In the *New Yorker*, Ethan Mordden offers one case of this mainstream "sentimental" reading: "Through his increasingly astonishing composure in retelling these adventures, Vladek becomes oddly heroic. . . . Perhaps this is the reason Art is so forgiving of a father who was overcritical when

Art was growing up and is now, not to put too fine a point on it, a real pest."[6]

Despite these differences of interpretation, both Buhle and Mordden identify the panels I've described above as emblematic of the *Maus* project. Buhle chooses them to illustrate his remarks: "The reflexive work of Art Spiegelman probes the perils of success and the burden of survival"; Mordden to make his point about the father/son relation and its classical pedagogies: "the son trying to learn from the father." Mordden, I think wrongly, separates "Art . . . a man wearing a mouse mask" from "Art, son of Vladek." He distinguishes between the son and "Art Spiegelman, artist, passing himself off as some kind of Jew—huddled over his drawing board on top of a heap of mouse corpses." The work of a son, or the work of an artist? This question of genre played itself out in the best-seller lists of the *New York Times* when Spiegelman himself challenged their categories and had *Maus* moved from fiction to non-fiction. The man in the mouse mask is precisely the figure of the *son as the artist* and nothing makes the difficulty of that dual identity more visible than his representation of Vladek as Art's father.

The success of *Maus* is due to a double audacity. The first is the choice to represent the Holocaust as a cartoon; the second to cast its star witness as a victimizer in his own world, a petty tyrant at home. In *Maus II* Spiegelman, who is an acutely self-conscious artist, agonizes over this problem of representation in a conversation with Mala, his father's second wife. Mala and Art discuss Vladek's stinginess. Art tries to exonerate his father: "I used to think the *war* made him that way . . ." "Fah!," Mala succinctly replies, "*I* went through the camps. . . . *All* our friends went through the camps. Nobody is like him!" If Vladek's cheapness is unique to him and not due to the war experience, then what is its justification? Art comments: "It's something that worries me about the book I'm doing about him." "In some ways he's just like the racist caricature of the miserly old Jew." Art adds, "I mean, I'm just trying to portray my father accurately! . . ." But the relationship between accuracy and caricature for a cartoonist who works in a medium in which accuracy is *an effect of exaggeration* is a vexed one, especially if the son is still angry at his father: not a nice guy, ever.

He then suddenly invokes his mother: "I wish I got *Mom's* story while she was alive. She was more sensitive. . . . It would give the book some balance." But the mother's story is doubly missing here. Although

Vladek tells the parts of Anja's wartime experience which overlaps with his, what's missing is her own self-narrative, her chance to refigure herself. Anja, we learn earlier, killed herself in Queens in 1968. Art has already published his cartoon version of her suicide as "Prisoner on the Hell Planet: A Case History" (1973) in, as Art puts it, "an obscure comic book." He reprints it thirteen years later *en abyme* in *Maus*. Why?

In the course of the frame narrative Art discovers that his father (who, Art complains, "doesn't even look at my work when I stick it under his nose") has just read "Prisoner." Drawn in a neo-expressionist style resembling a primitive woodcut, the cartoon depicts in four stark black pages the aftermath of his mother's suicide.[7] When we as readers of "Prisoner" return to the world of *Maus*, Mala, who says she found the "personal" material of "Prisoner" shocking when it first came out, now grants approval: "It was . . . very accurate . . . objective." Vladek says he read it and cried because of the memories it brought him of Anja. The invocation of Anja in turn leads Art to inquire about her diaries. This exchange tells us something about why Spiegelman might have decided to reproduce the early work and what his relation to his mother and *her* story has to do with the emotional effectiveness of the full-scale memoir.

The father's narrative in *Maus* ends with Anja's and Vladek's arrival at Auschwitz, but the framing text—the conversation between Art and Vladek—concludes the volume itself. The discussion of the couple's separation at the camp leads Art to ask again for his mother's diaries so that he could discover "what she went through while you were apart." At this point he finally learns that in a second holocaust his father has burned Anja's notebooks: "these papers had too many memories." Acknowledging that Anja had expressed the hope that her son would be interested in her recorded thoughts, the father blames the depression that followed Anja's suicide for his actions.[8] To his son's enraged questions he has no real answers. In the last panel of *Maus*, Art walks off, smoking his eternal cigarette, and thinking a single word: "Murderer."

"Murderer" is the epithet Art assigns to the man who has destroyed his mother's memoirs without reading them (he only, as he puts it, "looked in"). But we have seen this interpellation before. At the end of "Prisoner on the Hell Planet" Art draws himself in jail, calling out to his mother: "Congratulations! . . . You've committed the perfect crime. . . . You *murdered* me, Mommy, and you left me here to take the rap!!!"

Now immediately after the scene in which Art and Vladek discuss the early comic strip, Vladek lies when asked about the diaries, claiming he couldn't find them. When Art learns the truth, he can't believe that his father, who saves everything (string, nails, matches, "tons of worthless shit"), would throw these notebooks away (in *Maus II*, Françoise, Art's wife, acidly remarks that Anja must have written on both sides of the pages, otherwise Vladek would never have burned the blank ones).[9] The importance of Vladek's "murder" is underlined again in the credits page of *Maus II* where Spiegelman notes: "Art becomes furious when he learns that his father, VLADEK, has burned Anja's wartime memoirs." The highlighting of that act not only points to the ways in which the question of Anja's story has haunted the *Maus* project from the start but also serves to guide the reading of its second installment.

Art's quest for his mother's diaries punctuates the dialogue with the father out of which Vladek's testimony is produced. The inclusion of "Prisoner of the Hell Planet" connects the enigma of the suicide—the mother left no note—to the violence of destroying the diaries. Both gestures entail the suppression of a maternal "text." As a son and an artist Art's response to this erasure is complexly layered: in "Prisoner on the Hell Planet" he blames himself and his mother for her death; in *Maus* he attempts to provide a measure of reparation for "murdering" his mother by putting into images what he could know from Vladek of life during the war; throughout the volumes he indirectly links his task as an artist to her body by representing as a crucial piece of the *Maus* recovery project his own doomed and belated attempt to figure out her reality.

In the penultimate episode of "Prisoner," "Artie" turns away from his mother's plea. "Artie . . . you . . . still . . . love . . . me. . . . Don't you?" and fantasizes that this rejection makes him responsible for her suicide. The image of his mother in pained retreat locks him literally into the jail of his guilt, fed by the imagined "hostility mixed in with [the] condolences" of his father's friends. "Arthur, we're so sorry." "It's his fault, the punk." But in a single panel Spiegelman also renders the impossibility of ever knowing the answer to "why." At the top of the panel Anja lies naked in a tub, under which thick capital letters spell out "MENOPAUSAL DEPRESSION." A triangle of concentration camp iconography—barbed wire, piled up human corpses, a swastika—under which HITLER DID IT! is scrawled—separates the body in the tub from

the jarring scene below in which three images are juxtaposed: a mother reads in bed with a little boy dressed in miniature prison garb by her side, MOMMY!; a forearm with concentration camp numbers on it slits a wrist with a razor blade, BITCH; and finally, diagonally across from the body in the tub, the prisoner sits on his bunk and holds his head. The mosaic of images proposes the pieces of truth to which no single answer is available.

Replaced in the *Maus* books, the mother's suicide is given not an answer but other images through which to locate it. What more would the son have learned about his mother from her memoirs? After Vladek has told the story of the hanging in Sosnowiec of four Jews for dealing in goods without authorization, Art asks what his mother was doing in those days: "Houseworks . . . and knitting . . . reading . . . and she was writing always in her diaries." "I used to see Polish notebooks around the house as a kid. Were those her diaries?" "Her diaries didn't survive from the war. What you saw she wrote after: Her whole story from the start." "Ohmigod! Where are they? I *need* those for this book!" But the book will get made without them. In the absence of his mother's auto-biography, Art writes his father's. He also writes his own; or rather, through the father's murder of the mother's texts, the son seeks to repair his own monstrosity: the fatal unseemliness of surviving the victims, but not without violence of his own.

As *Maus II* opens, Art and Françoise drive from Vermont to the Catskills where Vladek has summoned the couple to his aid. In the car Art agonizes over the presumption of doing his book: "I mean, I can't even make any sense out of my relationship with my father. . . . How am I supposed to make any sense of Auschwitz? of the Holocaust?" He then asks: "When I was a kid I used to think about which of my parents I'd let the Nazis take to the ovens if I could only save one of them. . . . Usually I saved my mother. Do you think that's normal?" Although Françoise replies reassuringly that "nobody's normal," the question hangs fire.

In the panels about the incredible success of *Maus* which appear in the next chapter, Art, the man behind the mask, puts his head down and remembers: "In May 1968 my mother killed herself. (She left no note.) Lately I've been feeling depressed." In the Vermont frame narra-tive it is Françoise's question "Depressed again?" that leads to Art's reflection about the enormity of his book venture. Toward the end of the therapy session about survivors' guilt, Pavel, the shrink, says: "Any-

way, the victims who died can never tell *their* side of the story, so maybe it's better not to have any more stories." Art, reminding himself of Beckett's comment that "Every word is like an unnecessary stain on silence and nothingness" (and the fact, as he puts it to himself, that nonetheless Beckett *said* it!) seems to feel compelled as an artist to try to represent the words otherwise condemned to silence. It's as if at the heart of *Maus*'s dare is the wish to save the mother by retrieving her narrative; as if the comic book version of Auschwitz were the son's normalization of another impossible reality: restoring the missing words, the Polish notebooks. Though Vladek tries to shrug off the specificity of Anja's experiences: "I can tell you," he gestures disparagingly, "I can tell you. . . . She went through the same what me: terrible!"—that isn't good enough for Art, who keeps the question of Anja alive from the beginning to the end of the memoir.[10]

What is the relation between creating *Maus* out of his father's words and restoring the maternal body? For the reader of the autobiographical collaboration at the heart of *Maus,* who wants to find the place that might exceed the artist's recorded self-knowledge, there's not much to do beyond playing second-hand shrink (and he's already got a great therapist!). But if the outrageousness of comic book truth is any guide, and what you see is what you get, then we should I think understand the question of Anja as that which will forever escape representation and at the same time requires it: the silence of the victims. Perhaps that impossibility is what keeps Art forcing his father back into the memories he has tried to destroy. In one of the framing sections of *Maus II* Chapter 3 (which bears the heading that is the subtitle to the volume: "And Here My Troubles Began"—and which narrates the final scenes at Auschwitz[11]) Art asks Vladek about a Frenchman who helped him in the camps, whether he saved any of his letters. "Of course I saved. But all this I threw away together with Anja's notebooks.[12] All such things of the war, I tried to put out from my mind once for all . . . until you *rebuild* me all this from your questions."

For Vladek, "rebuilding" memory means reviving the link to Anja; Anja cannot be separated from the war: "Anja? What is to tell? Everywhere I look I'm seeing Anja. . . . From my good eye, from my glass eye, if they're open or they're closed, always I'm thinking of Anja." But this memory is by now the artist's material as well and despite Vladek's protest, Art finally extracts the images he needs from his father's reper-

toire in order to close his narrative, including Anja's last days in Sos-
nowiec and their reunion: "More I don't need to tell you. We were both
happy and lived happy, happy ever after." The tape recorder stops.
Vladek begs for an end to stories and in his exhaustion from the past
brought into the present, calls Art by his dead brother's name, Richieu.
The last drawing in *Maus II* is of the tombstone bearing the names of
Art's parents as well as their birth and death dates; beneath the monu-
ment the artist signs the dates that mark the production of his book:
1978–1991. The dates on the tombstone give the lie to Vladek's "happy
ever after" since Anja killed herself some twenty years after the war. Did
she live happy ever after? Mala, Vladek's second wife, doesn't mince
words: "Anja must have been a *saint!* No wonder she killed herself." The
dates also point indirectly to the fact that Art's text keeps his father as
well as his mother alive: Vladek died in 1982. Both volumes of *Maus*
were published—and critically acclaimed—after the death of the man
who thought, after looking at some of his son's early sketches of the
Jews hanged in Sosnowiec that he might some day "be *famous,* like . . .
what's-his-name?" "You know . . . the big-shot cartoonist . . ." "What
cartoonist could *you* know. . . . Walt Disney??" "YAH! Walt Disney."[13]

Throughout the frame narrative to the survivor's tale Art forces
Vladek back into the past of suffering and the double loss of Anja. In
the corners of the pages Art presses Vladek to continue with his narra-
tive, and Vladek pleads: enough. Vladek dies before *seeing* himself
"comically" reunited with his beloved Anja, and before seeing his words
and deeds in some ways turned against himself (though given his inca-
pacity for self-criticism and his talent for self-justification, he would
probably have missed the bitter ironies of his portrait). And before
seeing his son become the Walt Disney of the Holocaust.

The frame narrative displays an acute self-consciousness about what's
at stake psychologically for the son in telling his father's story. The
Museum of Modern Art show in turn emphasized the *work* involved in
the process. Located in the "Projects" room the exhibition illustrated
the detail of the Spiegelman method. In one display case the process by
which life becomes art is broken down and narrated. "An incident from
V. Spiegelman's transcribed memories becomes a page of *Maus.*" A
typed page of the transcript describing the long march out of Auschwitz
is displayed and marked. The episode involves the shooting of a pris-
oner, which Vladek likens to a childhood memory of a mad dog being

shot by its owner: "And now I thought: 'How amazing it is that a human being reacts the same like this neighbor's dog.'" The commentary in the display case deals with Spiegelman's technical process: "The incident is broken down into key moments, first into phrases, then into visual notations and thumbnail sketches of possible page layouts." "Phrases are rewritten, condensed, and distilled to fit into the panels."

The exposition of the myriad details involved in the transformation of the father's narrative of lived atrocity into the son's comic book underscores the degree of re-presentation involved in the *Maus* project and the skills required for its realization. Although the son claims that he became an artist in part to define his identity *against* his father's— "One reason I became an artist was that he thought it was impractical— just a waste of time.... It was an area where I wouldn't have to compete with him"—the boundaries between them turn out to be more permeable than distinct. Vladek, for instance, also draws: early in *Maus* Art reproduces Vladek's detailed sketch of the bunker he designed for hiding in Sosnowiec: "Show to me your pencil and I can explain you . . . such things it's good to know exactly how was it—just in case." The exhibit lays bare the literal dexterity entailed in the "comics business." It materializes the challenges posed to an artist committed to rendering what was never meant to be seen again. Art had to learn to *draw* what his father had faked in the camps: how, for instance, to be a shoemaker when you're a (fake) tinman.[14]

This is part of what Art's self-portrait in the mouse mask preparing to render Vladek's stint as a tinman also points to: the work of "rebuilding" Holocaust memories. There's also a specific issue here about the ethics involved in converting oral testimony—"the ruins of memory" to borrow Lawrence Langer's phrase[15]—into a written and visual document (let alone a comic strip!). This leads us to a final question about the making of *Maus*: what happens *between* the father's voice and the son's rendering of it as text?

In the exhibition, a tape of the father's voice was made available to the listener curious to know what Vladek sounded like. The desire to hear his voice is intensified by the inscription throughout the frame narrative of the tape recorder—both as the mark of their collaboration (even after Vladek's death)—"Please, Pop, the tape's on. Let's continue. . . . Let's get back to Auschwitz"—and of the testimony's authenticity. The reader of *Maus*—especially one with immigrant parents or grand-

parents (me)—is also made (uncomfortably) aware of the foreign turn of Vladek's English; the tape offers the possibility of hearing what she has been reading.

What surprised me when I listened to the tape was an odd disjunction between the quality of the voice and the inflections rendered in the panels. For while Vladek *on tape* regularly misuses prepositions—"I have seen on my own eyes," "they were shooting to prisoners," mangles idioms—"and stood myself on the feet," pronounced "made" as "med," "kid" as "ket"—the total *aural* effect, unlike the typically tortured *visualized* prose of the dialogue in the comic balloons, is one of extraordinary fluency.[16] It's almost as though in "distilling" his father's language to fit the comic strip the son fractured the father's tongue. By contrast, the voice on the tape has the cadences of a storyteller: it is smooth, eloquent, seductive. Is breaking the rhythms of that voice an act of violence or restoration, or both at once?

What the show allows to happen which the text *as representation* necessarily forecloses is that the reader of *Maus* gains momentary access to the voice that survived the event, freed from the printed voice of the frame. In that moment (and listeners greedily listened to every word of the tape, unwilling to relinquish the headphones), one is tempted to say, the father performs unmediated—to the world.[17] But this would also be to miss the crucial function of the listener in the production of testimony. As Dori Laub writes in *Testimony: Crises of Witnessing in Literature, Psychoanalysis, and History:*

> The listener . . . is a party to the creation of knowledge. . . . The testimony to the trauma thus includes its hearer. . . . The listener to trauma comes to be a participant and a co-owner of the traumatic event. . . . The listener, however, is also a separate human being . . . he preserves his own separate place, position and perspective; a battleground for forces raging in himself, to which he has to pay attention and respect if he is to properly carry out his task.[18]

Paradoxically, then, the reader's experience of the father's voice returns her to the son's task and its realization. As "co-owner" of his father's trauma the son cannot fail to map out those places and those wars.

By forcing Vladek to "rebuild" his memory, Art becomes both the *"addressable other"*[19] necessary to the production of testimony and the

subject of his own story. In the end the man in the mouse mask moves beyond his task by fulfilling it, by turning it into art, and replacing it in history. This is not to say that his losses, any more than those which define the survivor's life during and after Auschwitz, are erased by that gesture: Anja will not return to explain herself. Rather, that by joining the murderers he also rejoins himself. If after the Holocaust violence and reparation can no longer be separated, perhaps this is also the form postmodern forgiveness takes.

Notes

Since the original publication of this essay, I have pursued the implications of these thoughts in "Representing Others: Gender and the Subjects of Auto-biography," *differences* 6, no. 1, Spring 1994, 1–27. I have also included an expanded version of "Cartoons of the Self" in my book *Bequest and Betrayal: Memoirs of a Parent's Death* (Bloomington: Indiana University Press, 2000).

1 Mary Mason made the case over a decade ago in a pioneering essay from which I have been quoting, "The Other Voice: Autobiographies of Women Writers," and her analysis has been important to the mapping of women's traditions, so often neglected in the formulation of theories of cultural production. The essay is included in *Life/Lines: Theorizing Women's Autobiography,* ed. Bella Brodski and Celeste Schenck (Ithaca: Cornell University Press, 1988).

2 In a revision of Mason's model, Susan Stanford Friedman has shown that women autobiographers tend to locate the self of their projects not only in relation to a singular, chosen other, but also—and simultaneously—to the *collective* experience of women as gendered subjects in a variety of social contexts. "Women's Autobiographical Selves: Theory and Prac-tice," *The Private Self,* ed. Shari Benstock (Chapel Hill: UNC Press, 1988). Here again—with the inevitable measure of asymmetry that gender com-parisons always present—the men's texts echo the female paradigms. In *Maus* (and to a lesser degree in *Patrimony*) this collective identity—the other Other—plays a crucial, indeed constitutive role in the elaboration of the autobiographical subject. This socially situated identity, however, is not so much a generalized masculinity as specified Jewishness. It could even be argued that the father/son relation, and more broadly the famil-ial scenario, finds meaning primarily when plotted against the cultural figures of Jewish identity. This double proximity may mean either that at the end of the twentieth century the autobiographical model is becoming

feminized, or that we need to reconsider the original theoretical assumptions of the canonical model itself. After all, one could easily see Augustine as constructing his autobiographical self in relation to his mother Monica, and Rousseau elaborating his in relation to the other constituted by his imagined reader.

3 There is from the start a tension about whose story it is. On the cover of *Maus* is the father/mother (mouse) *couple* whose joint destiny gets summarized in the singular "survivor's" tale. Although the son clearly distinguishes the two parts of the couple by asking specifically about his mother, he is limited finally by his father's plot.

 Maus also conforms to Catherine Portugues's account of recent autobiographical films by contemporary women filmmakers (primarily postwar European directors). "These films share as a common gesture . . . the desire to create an intergenerational testimonial for the benefit of parents or children and to recount a story formerly repressed, silenced or distorted. . . . It is the desire to make restitution for pain inflicted, real or imagined, and to see the other as a whole individual with a separate identity that infuses these films, rather than the 'manic defense' more typical of the work of male autobiographical filmmakers." "Seeing Subjects: Women Directors and Cinematic Autobiography," in *Life/Lines*, p. 343. I think we have to complicate these patterns of gender differentiation and to articulate them with the historical demands of postwar representation. See also in *Lear's* (June 1992) the striking photograph of TV newsreporter Charles Stuart *with his mother* (the story is about her unsolved murder) and described as a *self-portrait taken by himself.*

4 *Tikkun,* March/April 1992, p. 16.

5 "Reading Around," *Nation,* April 27, 1992, p. 560.

6 "Kat and Maus," *Nation,* April 6, 1992, p. 96.

7 In the upper left-hand corner of "Prisoner," in its title frame, a hand holds a summer snapshot of Anja and Art dated 1958. It's hard to make out the expression on the mother's face, but her little boy is grinning at the camera. In the lower left-hand corner of the page in *Maus* on which "Prisoner" is reproduced, Spiegelman has drawn in the same hand, as if to mark the place of his own rediscovery of the earlier work. The representation also ties the hand as signature to the mother/son bond. In the photo, Anja rests her hand on her son's head; the hand that a few panels later will hold the razor blade.

8 The tension between obsessional saving and impulsive throwing away is rehearsed earlier in *Maus*. After a session with his father on the pre-Auschwitz days in Sosnowiec, Art looks for his coat only to discover that

Vladek has thrown it away: "It's such *shame* that my son would wear such a coat!" His father offers one of his old jackets as a replacement (having brought a new one for himself at Alexander's). The chapter ends with Art verifying that his coat is indeed in the garbage, and walking home alone in shock (as in after his father's revelation): "I just can't believe it . . ."

9 The whereabouts of the diaries are associated with the saving of junk much earlier in *Maus*. Art interrupts a conversation with Mala about the roundup of the Jews in Sosnowiec to track down a vague memory of having seen the notebooks on Vladek's shelves in the den. He catalogues the kinds of things Vladek saved: four 1965 Dry Dock Savings Calendars, menus from cruises, hotel stationery, etc. There's a question here about what part of this saving can be seen as a specific effect of surviving the Holocaust and what belongs more generally to a diasporic identity. I was struck by the remark in Susan Cheever's memoir of her father, John Cheever, the ultimate chronicler of *goyish* sensibility: "My father never saved anything. He scorned all conservative instincts." (*Home Before Dark* [Boston: Houghton Mifflin, 1984], p. 53.) Like Vladek, my father always had tea bags drying on the stove (the degraded transformation of the perpetual samovar and the tradition of what he called "sens"—the essence, presumably, of tea) and saved rubber bands, jars, broken pencils, old flower pots, plastic containers, until the apartment overflowed from the hoarding. Was this the aftermath of the Depression? A way of always being prepared—the "you never know" of survivors?

10 In the scenes of Auschwitz following the therapy session Art has his father describe Birkenau (Auschwitz II) where Anja was interned. Here Vladek relates what he managed to learn of Anja's fate, including a letter reproduced in one of the panels: " 'I miss you,' she wrote to me. 'Each day I think to run into the electric wires and finish everything. But to know you are alive it gives me still to hope' . . ." Despite the "reproduction" of the letter—the only instance of Anja's written words—we are necessarily left as readers with the mother's voice in translation: into Vladek's English, into his idealized version of their couple, into Art's comic strip. Nonetheless, the disembodied voice delivers the message of despair that seems to have been hers from the start. At the beginning of her narrative we learn that Anja has a nervous breakdown after giving birth to Richieu and is sent to a sanitarium.

11 In *Holocaust Testimonies: The Ruins of Memory* (New Haven and London: Yale University Press, 1991), Lawrence Langer comments on the status of this phrase in survivor interviews: "Asked to describe how he felt at the moment of liberation, one surviving victim declared: 'Then I

knew my troubles were *really* about to begin,' inverting the order of conflict and resolution that we have learned to expect of traditional historical narrative" (p. 67).

12 Toward the end of *Maus II* Vladek presents Art with a surprise, a box of snapshots: "I thought I lost it, but you see I saved." This raises for the last time the matter of the memoirs: "*Mom's diaries?!*" The snapshots— redrawn as photographs—mainly show other members of Anja's family, including a brother, a commercial artist Anja said he resembled and who like his sister killed himself. The photographs record what was left of her family after the war. In "Family Pictures: *Maus* and Post-Memory" Mar- ianne Hirsch analyzes the role of photographs in *Maus* and their crucial role in the "aesthetic of post-memory" that Spiegelman elaborates. She also emphasizes the ways in which the *Maus* project represents an attempt to reconstruct the missing maternal legacy (*Discourse: Journal for Theo- retical Studies in Media and Culture* 15, no. 2, Winter 1992–93, pp. 3–29).

13 The epigraph to *Maus II* is drawn from a German newspaper article of the mid-1930s linking the "Jewish brutalization of the people!" to the miserable "Mickey Mouse . . . ideal."

14 In *Maus II* Vladek explains how in the camps he justified his boast that he had been a "shoemaker since childhood" (in reality he had watched his cousin work in the ghetto shoe shop). He describes repairing lace-up boots in need of resoling. Art illustrates this task with a complicated drawing. In the show above the comic drawings is mounted the technical drawing of shoemaking from which Art derived his cartoon version. Vladek draws the moral of his successful gamble: "You see? It's good to know how to do *everything.*" Art's insistence on his impracticality—not knowing how to do anything—is undone by his accomplishment as an artist in figuring out how to *draw* anything. The survivor's skills honed in the camps pass on to the next generation as a matter of artistic survival.

15 It's the subtitle of his book.

16 A portion of the tape corresponds to the transcripted account of the march out of Auschwitz and thus it becomes irresistible to compare the aural and written voices.

17 There's no escaping the effect of the frame since the taped passages are just as *chosen* (out of the twenty or more recorded hours) as the illus- trated ones.

18 This book is coauthored with Shoshana Felman (New York: Routledge, 1992), pp. 57–58.

19 Laub, *Testimony,* p. 68.

Nancy Spero:

Speaking in Tongues

Pamela Wye

Tongues, gaping mouths, stuffed mouths, gagged, suppressed, exterminated, mother tongues, speaking, uttering, screaming, liberated, joyous, purposeful, active, text, codex, testimonies, speaking in tongues, glossolalia, glossitis, glossaries, tongue-lashings, knife, knife-cuts, betongued, be tied, be tongue-tied, give tongue, kiss, lick, defeat, tickle, bootlick, lickspit, tongue-less, limp tongues, stiff tongues, swollen tongues, snake tongues, wise tongues, glib tongues, wagging tongues, but no, no tongues in cheek.

An abundance of tongues exist in the art of Nancy Spero. They appear in many guises and contexts, and they sport widely varying meanings. Spero has made of them a powerful body language.

The muscular structure known as the tongue resides in the head, the seat of the mind and the intellect, yet it is particularly animalistic, wet, enclosed, if not hidden, and primitive in its shape. It is at once a personal organ, identified with pleasure, eating, and sexuality, and a public one, as the instrument of speech. It forms the link between the inner and the outer, the private and the public, the self and the world.

But who was this artist? Me! That's why all these tongues; in French "tongue" is "langue," tongue and language—I was sticking my tongue out and trying to find a voice after feeling silenced for so many years.—Spero[1]

Excesses are often the reaction to extreme denial. Silence or the denial of a voice can be imposed from without as the silencing of whole groups of people through political repression ranging from the denial of the vote to torture and murder. Or through social prohibitions/conventions like the "seen but not heard" adage functioning as the preferred state for women and children. A voice can be rendered inaudible and eventually silenced through a systematic lack of interest in those who have the power to hear or ignore it. The history of art, as a reflection of our culture, shows us that woman is "seen but not heard"— her presence is that of object not artist. Or, silence can also be imposed from within by the internalizing of the muzzles of convention, or from psychological trauma, as in shock, which also lends its name to the institutionalized silencing of the "mad" through shock treatment. Or in a combination of these, as in the mystic's denial of bodily needs including speech. Spero, in her dense and far-ranging work, speaks of all these silencings, and she uses the tongue to do so.

Logorrhea combines "logo" (word, speech, discourse) with "rrhea" (stream, flow, discharge) to mean excessive, often uncontrollable talkativeness. The obsessive proliferation of tongues as instruments of speech in Spero's work is her long-overdue reaction to her lack of a voice as a woman and as a woman artist. The tongues are not only building blocks in the creation of her language, but also the symptoms of the need that precedes the finding of a feminine language within a patriarchal culture.[2] Glossolalia, more commonly known as "speaking in tongues," is "an ecstatic or apparently ecstatic utterance of unintelligible speechlike sounds, viewed by some as a manifestation of deep religious experience."[3] Spero's work is not religious through her adherence to any dogma or institution, but rather because she is concerned with power or powers—both human and divine—as the creators and the rulers of the universe. Her involvement with the mythical dimension is a way for her to speak of "first and last things."

Spero's art resists our easy grasp, but we don't easily elude hers. When one is captured by her work, one is in a potent and perplexing snare: of myth and fact, words and images, contemporary poses and ancient

archetypal figures, poetry and Amnesty International torture reports, spiritual yearning and sexual devouring, suicide and dance, insanity and love. This art does not fit into a neat little package. Rather, it hides and resists lest we not know how to deal with it, but expands and deepens on sustained viewing. Her impulse to resist being easily grasped is a positive one—it gives her work a better chance of living, of being alive, of resisting death. Why such talk of life and death? Because that is the territory that Spero, in her art, has staked out. Over time, the images in her words have evolved, transformed, and proliferated, and in so doing, have brought about new births from old deaths. That is both the form and the content of her work.

Spero's relationship to the archetypal imagery of myth is complex. Myths are more than explanations that give forms and names to what otherwise is experienced as chaotic—namely life. Myths embody emotionally charged systems of belief through which one "sees" the world. When mythical characters are created or eliminated, or when details of mythical events are tampered with, the meanings imbedded within those mythical constructs are revolutionized and reborn. Spero snatches figures and abducts meanings from ancient mythology, religion, art history, contemporary media, scholarly texts, and her own earlier work; she redraws them, prints them, dismembers and rearranges them, cross-fertilizes, and makes of them a new community.

Spero exploits the printing process to help weave meaning. Images are printed over other images; the surfaces of some figures appear scarred, weathered, or distressed, giving them the look of images that have "been around"; others are blurred or smeared as though disintegrating, losing their identity. Some figures carry echos of other figures on their "skin" and evoke indwelling presences—past or future powers that live through the present figure.

> All true language is incomprehensible, like the chatter of a beggar's teeth . . .—Artaud[4]

Simple linear narratives are not what Spero's work is made of. Her work is multilayered, symbolic, seemingly enigmatic, and experienced as expanding just a little bit out of one's reach, in a perpetual state of prenarrative tension. It encompasses and refers to something that is at the same time equal to but greater than oneself. And it is this which gives her work its poetry. As her images are pieced together from far-

ranging sources and her juxtapositions bear that mark of seeming ran-
domness, a close reading of her work can lead one into an ever-
expanding room of mirrors that transforms the willing spectator into
an active questor after the truth, a protagonist on a dangerous and
transformative journey of understanding.

Spero's use of the mythological process is not an escape into a fanciful
past, but a vehicle on which to ride deeper into the grinding tensions,
clashes, quests, and frailties of the world and the underworld. In this
way, her work is not narcissistic, but political.

> The hero . . . is the man or woman who has been able to battle past his
> personal and local historical limitations to the generally valid, normally
> human forms.[5]

> I've moved increasingly away from the ideas of Western art toward some-
> thing less individualistic and personalized.—Spero[6]

To defy, protest, bear witness, counteract, or sometimes simply to
speak, is to be political. As such, political content is a constant in
Spero's work though its expression is neither didactic nor propagan-
dizing—its dose of ambiguity is an homage to the complexity of the
world. Fragmented, nonlinear morality plays, stitched together from a
world in which there is an overabundance of information, and in which
all systems of belief are created equal, Spero's concoctions yield potent
stories about struggles for and struggles against.

An early use of the tongue in *Les Anges, Merde, Fuck You* [The Angels,
Shit, Fuck You] (1960) hints at struggles that will reach full force in later
works. Like the figures in her Black Paintings (from the 1950s and early
1960s), the angels in this work are delineated from a painterly ground
by only a sketchily drawn line. Figure/ground separation is not yet
pronounced here as it will be in later work. Rather, the three angels are
one with the all-over ground except for their white mask-faces. Spero
employs the convention of depicting an angel with a head and shoul-
ders, but no gendered body. These strange angels are subversives who
strew disorder, wreak havoc in the status quo, and ultimately provoke
new life through change. The middle angel is sticking out a red tongue
which, though small, is emphasized because it is the only spot of color.
The tone of defiance is reinforced by the scrawled obscenities "merde"

and "fuck you." These obscenities and the small tongue prefigure Spero's later use of more elaborate texts and more ghastly tongues as her agents of outrage, irreverence, and change. These insurgent angels refer back to the Christian "bad" or "fallen" angels (the same derogatory terms used to debase a sexualized woman) who offended God-the-Father through pride in their own intelligence by not accepting on faith the divine mysteries. Spero's angels, however, do not believe themselves fallen. Heads high, they stick a tongue out at the notion of their "badness" and continue to fly straight ahead, not down. They are prototypes for Spero's later female rebels with a cause of empowerment and non-submission.

Tongues shoot forth from the mouths of helicopters, bombs, pilots, and victims alike in Spero's *War Series*, produced between 1966 and 1970 in reaction to the Vietnam War. In 1966, Spero became involved in the peace movement, and she stopped working with oil on canvas. Small in scale, many of these drawings have a sketchy, manic line and the urgency of political graffiti. War as a form of madness. Madness as an uncontrollable, destructive force of nature. The rawness, the irreverence, the absurdity, and the scatological transformations push these works into the realm of black humor, cousins in sensibility to the monologues of Lenny Bruce. Black humor is no laughing matter. It can be a weapon, and has its targets and its victims.

> These are ugly and dirty images but exact as metaphor. The most ferocious and repulsive image is that of victims who lick the Bomb, also victims who lick the chimney, the swastika-marked crematorium. . . . On occasion, the effulgent Deity or Christ rides the Bomb, appears apparitionally or uncertainly presides or remonstrates over the scenes of carnage and havoc below. . . . Planes and helicopters are similarly anthropophagous, pitiless, gluttonous. . . . The helicopter ingests its victims, regurgitates and shits out blood and entrails, drags and smashes bodies.[7]

Pilot, Co-pilot, Eagle, Victims (1970) is a *War* drawing whose structure is totemic and whose forms are solid and enclosed rather than sketchy and loose. Three images are stacked in the middle of a vertical rectangle. At the top of this "totem" is the profile of a pilot like a primal demonic deity with a hugely open mouth from which a thick tongue is thrust like a fist. This tongue/fist has also a small head at its end which in turn has an open mouth and a hissing tongue. In addition, the fist

has a bomb stuck out in the position of a hand on a throttle. This tongue/fist/man is the co-pilot, appendage to the pilot. The middle figure of this totemic drawing is an abstracted eagle with head down and wing outstretched as though surveying the ground for prey. The bottom figure, the skull of a victim in profile, rendered in a very pale gray wash, faces down toward the ground, disintegrating and ephemeral compared to the hardy physicality of the bronze pilot, the co-pilot, and eagle. The victim-skull too has a huge tongue, but it is dangling from its broken jaw like a dried bone. These figures function as signs in a hierarchical configuration (where the winner is on top), and could be a logo for the business of war.

> So after completing the War series I felt the necessity for using language, texts, and Artaud's own sense of social victimization opened up a way for me to externalize my position as an outsider. . . . I was so far out in the art world—on the edge, if not actually over it—that by using the language of Artaud I could expel my hostility and resistance. . . . The voice of the other (though masculine), provided a vehicle for my silenced voice as an artist.
> —Spero[8]

The Artaud drawings from the late 1960s and early 1970s differ in scale and format from the later room-sized scrolls. They are rectangles of white, uniformly-sized sheets of rice paper that have the look of self-contained "pages." This suits a series in which she "collaborated" with the poet, playwright, actor, Antonin Artaud, by using excerpts and translations of his writings as major components of her drawings. Spero makes other references to the idea of the "page" by collaging torn corners and scraps of other pages on which she has drawn and written. In some drawings, she hand-prints Artaud's text much smaller than the image so that the text reads as a concentrated aside. In other drawings, her scrawl of Artaud's text dominates and engulfs the image, and claims as much presence as the physical bodies that are depicted. Thoughts are freed from the claustrophobic space into which they are born (the head), and are given voice in the palpable, physical realm of the written word. The world as depicted in the Artaud drawings (as well as much of her later work) is made up of words and thoughts as much as it is made up of bodies.

> For the ego and the male, the female is synonymous with the unconscious and the nonego. . . . The womb of the female is the place of the origin

from whence one came, and so every female . . . threatens the ego with the danger of . . . self-loss—in other words, with death and castration.[9]

A tongueless, wide open mouth in sexual terms is woman who lacks a phallus but possesses a void: the womb, that primordial emptiness synonymous with the abyss, the grave, death, and perdition. "The human face in effect carries a kind of perpetual death with it. ARTAUD," appears in a 1969 drawing. A head at the right of the page is that of an even-featured youth, and a head at the left, without features except for a small black eye socket and an enormous cavity of a mouth, is that of death's skull which looms larger than the youth's head. They face in toward each other and the hand-written text that fills the great divide between the living and the dead. The head of death is tongueless. Its strong, wide-open jaw emits a silent scream that reveals to the youth that this mouth of death into which he stares resides within himself, is his own life consuming itself. As the sex of woman "devours" and "consumes" the phallus during sexual intercourse, the image of death as devourer and consumer of life can not but have sexual references. Artaud's words, which speak of death as the ultimate self-fulfillment, resound between these two heads in that space "between our eyes and the grave."[10] It is the moment of a horrifying revelation, the loss of innocence.

"Je suis suspendu à vos bouches. . . . Artaud" [I am hanging on your every word . . .] (1970) has white handwriting on white paper, giving the words the effect of a visual whisper that becomes so low (pale), that we are unable to "hear" the last few words. In the bottom half of the drawing is a Classical head in profile with a huge tongue coming out of its mouth like a person being born. Artaud replaced "lèvres" (lips) with "bouche" (mouth) in his use of this idiomatic expression. The hole of death is also the canal of birth. The mouth, out of which the tongue/voice is born, is the site of an emerging identity. In place of the eye of this head there appears a tiny head with a long projecting tongue facing in and reaching toward the temple (mind) of its host head. Voice, words, reading, a collaboration with a dead poet. This image of a head with another person's head/tongue in place of eyes evokes the idea of seeing the world through the words/ideas (voice) of another. Love is cannibalism: we want to merge with the other, take into ourselves what the other has to offer. In a review of Marguerite Duras's *The War*, Francine du Plessix Gray writes: "Duras's women identify so totally

with the male object of their obsessions that their loyalty is ultimately a form of fidelity to the self."[11] Spero's relationship with the work of Artaud has some of these qualities of a love relationship. In this work, the utterance of the other (Artaud) is visually and mentally absorbed (read), to the point that the other's words become her eyes—the lens through which the world is seen. Artaud helped Spero to begin to speak to the world. She used him as a guide, as someone who has gone before and so could help her give birth to a new form of herself. He was an unknowing midwife.

Speaking is an imposition on silence. It is the active penetration by the self of the world which surrounds it. Intercourse. In more than just its shape, the tongue is phallic. Spero proposes an image of the tongue as phallus in a detail of *Codex Artaud XVII,* a panel in her first scroll work that is comprised of thirty-three separate panels (1971–1972). In this panel, a small woman is penetrated, as though impaled, by the reddish tongue of a huge male head. She is anatomically complete except that she is cut just above the knees. As a result, she does not stand on her own two legs, but rather she is grounded by the tongue/phallus of the man, and as such appears as the permanent appendage of his appendage. Her head is tilted back as though in an ecstatic trance and resembles photographs of heads of ecstatic/hysteric women which appeared in surrealist publications.[12] The surrealists held that the irrational is the domain of the feminine, and they mined the "feminine" ecstatic/psychotic discourse for their own artistic purposes. Woman was the muse, men were the artists. Consequently, "feminine" discourse entered the art of this century on the tongues of men not women. This discourse, this "speaking in tongues" is that of Spero's male tongue in *Codex Artaud XVII* and it is that of Artaud himself:

> Why couldn't it have been some world without numbers or letters
>> yam CAMDOU
>> yan DABA
>> Camdoura
>> yan CAMDOURA
>> a DABA ROUDOU
>>> ARTAUD[13]

What Artaud returned to Spero was femininity, but femininity in a different light, and paradoxically in the accents of a man empowered to

speak his sexual fluidity, madness, marginality, and curious passivity: a subject able to sublimate his pain in language.[14]

Tongues also figure prominently in *Codex Artaud VI*. This panel contains two distinct groups of images separated by a large blank which functions like a long pause between the signals in a message of Morse code, or the lull in a conversation. Both groups combine typewritten words and cut-out painted images. One speaks about the silencing of a voice, the other speaks about the seizing of a voice. On the left is the cut-out figure of Artaud the madman. Painted in gold metallic paint, this figure is on his knees, arms straitjacketed to his body, forcibly subjugated. His head is hairless—shaved as to erase his identity and to further the process of rendering impotent and dependent (feminizing) the institutionalized. The tongue of this alienated figure is shoved like a stick in his mouth. Rather than as an instrument of speech, this wooden protrusion reads as a stopper, preventing him from speaking for fear of the chaos that will spew forth. The insane fracture and violate the coherence of our existential order; we, the "sane," consequently feel compelled to treat them as subversives to be deadened into manageable silence.

> . . . I am vacant through the paralysis of my tongue.—Artaud[15]

In the other half of the *Codex Artaud VI* panel, we see one of Spero's key constructions, the "Sky Goddess," in her prototypic form. In an effort to right the imbalance of power between the masculine and the feminine, Spero goes back to symbolic sources and attempts to re-envision history through a refeminized imagery.

> Thus all great Myths are dark and one cannot imagine all the great Fables aside from a mood of slaughter, torture, and bloodshed, telling the masses about the original division of the sexes and the slaughter of essences that came with creation.—Artaud[16]

Spero reenacts the mythic motif of the splitting into opposites of the androgynous Original One that was at the origin of the universe. Her figure, bent and on all fours, in the posture of the Egyptian sky-mother, is headless and hermaphroditic. Spero has endowed it not only with numerous breasts, but a phallus as well. This figure has straight vertical legs, it is bent at the waist with a horizontal back, and its arms reach

down to form the hieroglyph of a flat-roofed house (the sky). At the point where the waist bends, Spero has positioned a female head with a wide open mouth on the verge of swallowing the phallus—poised to seize its power. She is cannibalizing and taking into herself male powers by swallowing the phallus, the Word, the godhead, the divine. She seems to be trying to possess a symbol of the Logos as creative power associated exclusively with a patriarchal god-the-father. "God . . . 'speaks' his creation into being. His realm is the realm of the spoken, his word. . . . Creation, unlike procreation, depends on conceptualizing."[17] By swallowing the phallus, the female head in this work will castrate the hermaphroditic figure, thus freeing its femininity from the androgyny in which it is trapped. This foreshadows the later (1976) transmutation of this hermaphrodite figure into the strictly feminine incarnation of the "Sky Goddess."

A tongueless morsel of a woman appears in *Knife Cut* (1974), originally part of a series of tiny works called "licit exp"—a cut-up variation of "explicit explanation," but which was later absorbed into, and made a part of, the huge scroll installation *Torture of Women* (1976). Huge yellow block letters spelling "Knife Cut" form the background, and a big male head in profile with a thick, but sharply pointed, tongue is at the right edge of the paper. Two pieces of a female body fall into the void between the words. She is decapitated and what's left of her is only belly and upper thighs, the region of her sex. Her mouth is open as in a scream, but her tongue has been excised, so she can neither voice horror nor cry for help. The large man, anchored firmly on the right edge of the page (of history), dominates the words "Knife Cut" which read like the tabloid headline of this grisly crime. The female victim disappears unanchored into nonbeing. The man's tongue was the instrument of punishment used to cut her down to size and out of the picture, before she could cut him off, interrupt him, with a voice just as remarkable as his, only different.

Spero's art from 1974 on focuses exclusively on the issues of women. *Notes in Time on Women* (1976–79), is a room-sized, multipaneled, paper scroll installation which surrounds the viewer like an embrace or a womb. One detail of panel eighteen is that of a small head in a field scattered with blocks of text. Compared with some of the tongues in other pieces, the one sticking out of this profiled head is only slightly larger than a normally proportioned tongue. Printed over the top half

of the head and ending above the mouth is a sentence that reads: "Throughout male literary history, gorgons, sirens, mothers of death, and goddesses of night represent women who reject passivity and silence."[18] Here the tongue embodies a woman's right to expression without, as a result, her being perceived as, or being thrust into the role of, an aberration, a monster, a harpy, or any other negative personification.

A turning point for the tongued head occurs in Spero's series *To The Revolution*. The same tongued head (discussed above) undergoes a healing transformation in the double portrait of the Greek goddess Artemis in *For Artemis that Heals Woman's Pain* (1979). Spero has printed twice an image of Artemis with her left arm raised and bent. Within the crook of the arm of the Artemis figure on the left, Spero has nestled the tongued head. She has placed this troubled head in direct line with the sympathetic gaze of Artemis, "guardian of women of all ages."[19] The tongued head has found in her a haven, a healing protectress. We are witness here to a "talking cure" inspired by the sympathetic listener. For finding a voice is only half of the problem that faces women in a patriarchal society. Finding a listener is the other half.

> . . . I wanted to continue depicting woman as activator, to get away from this lack—the loss and castration of the tongue. I wanted to depict women finding their voices, which partly reflected my own developing dialogue with the art world, that somehow I had a tongue . . .—Spero[20]

With Spero's *To The Revolution* series, her work becomes increasingly celebratory and unabashedly "carnivalesque."[21] In a work from this series, also entitled *To The Revolution* (1985), the tongue has become untied, and its voice is shouting in joy and expansiveness. Modeled in black and white, and with her back to us, a classical female figure tiptoes almost sheepishly. She is surrounded by three versions of a running "primitive" female. These three are defined linearly, without modeling; one is orange, one blue, and one red. They leap a leap that enjoys itself. Two of them have, superimposed on their otherwise featureless faces, the delicate linear face of the tongued head, still sticking out their tongues, but for joy. These light-footed spirits surround the timid classical figure as though to incite her to abandon her restraint and join them. With this raucous threesome, we come full circle from the three angels of *Les Anges, Merde, Fuck You.*

Spero's tongued figures have gone down to the depths and they have

come back up energized. In these celebratory works, Spero's women hoot and holler in pride, and jabber for joy. It is a sign of life. I am here. It was not always so, and it will not always be so. But while I am here, I am going to make a noise, yell my lungs out, speak till I'm out of breath. Because, who knows, maybe this voice will continue to echo through space long after I am gone. So, by all means, these works seem to say: babble, gossip, and utter, discuss, confess, shout, and disclaim. Converse and articulate. Talk back, talk big, talk off the top of your head, sing if you can, sing if you can't, talk to yourself, talk through your hat, speak up, speak clearly, mumble if that's all you can do. But do it. Now.

Notes

1 Nancy Spero, as quoted in Jon Bird, "Nancy Spero Inscribing Woman— Between the Lines," in *Nancy Spero* (London: ICA/Fruitmarket Gallery/Orchard Gallery/Foyle Arts Project, 1987), p. 24.

2 For in-depth discussion of feminine language with numerous source references, see Lisa Tickner, "Nancy Spero Images of Women and La Peinture Féminine," in *Nancy Spero*, pp. 5–19.

3 *Webster's New World Dictionary of the American Language*, Second College Edition (Cleveland and New York: William Collins and World Publishing, 1974), p. 595.

4 Antonin Artaud, "Here Lies," in *Antonin Artaud: Selected Writings*, ed. Susan Sontag (New York: Farrar, Straus and Giroux, 1976), p. 549.

5 Joseph Campbell, *The Hero with a Thousand Faces* (Princeton, N.J.: Princeton University Press, 1973), pp. 19–20.

6 Spero, as quoted in Bird, "Nancy Spero," p. 36.

7 Leon Golub, "Bombs and Helicopters: The Art of Nancy Spero," in *Nancy Spero: Works Since 1950* (Syracuse, N.Y.: Everson Museum of Art, 1987), p. 39. Originally published in *Caterpillar* 1, 1967.

8 Spero, as quoted in Bird, "Nancy Spero," pp. 24–25.

9 Erich Neumann, *The Great Mother* (Princeton, N.J.: Princeton University Press, 1963), pp. 157–158; as quoted in J. A. Phillips, *Eve: The History of An Idea* (New York: Harper & Row, 1984), p. 181.

10 Campbell, *The Hero*, p. 206.

11 Francine du Plessix Gray, "The Power of Our Obsessions," *New York Times Book Review*, May 4, 1986, pp. 1, 48–49.

12 See photographs from *La Révolution Surréaliste*, no. 11. March 1928.

13 Antonin Artaud, in a 1969 drawing by Spero. See Nancy Spero, *48 Works*

on Paper Excerpts from the Writings of Antonin Artaud (exhibition catalogue) (Cologne: Galerie Rudolf Zwirner, 1987), p. 18.

14 Tickner, "Nancy Spero Images," p. 12.

15 Antonin Artaud quoted in Martin Esslin, *Artaud* (London: J. Calder, 1976), p. 65.

16 Antonin Artaud, *The Theatre and Its Double* (New York: Grove Press, 1958), p. 21. Originally published in *Antonin Artaud: Oeuvres Complètes,* vol. 4 (Paris: Editions Gallimard, 1964).

17 Phillips, *Eve*, p. 13.

18 Susan Gubar, "The Female Monster in Augustian Satire," *Signs,* Winter 1977, p. 393, as quoted by Spero.

19 C. M. Bowra, *Classical Greece* (New York: Time, 1965), p. 180.

20 Spero, as quoted in Bird, "Nancy Spero," p. 34.

21 For in-depth discussion of "carnivalesque," see Jo-Anna Isaak, "Nancy Spero: A Work in Comic Courage," in *Nancy Spero: Works Since 1950* (Syracuse, N.Y.: Everson Museum of Art, 1987), pp. 24–37.

Muse Begets Crone: On Leonora Carrington

Whitney Chadwick

In *The Hearing Trumpet,* Leonora Carrington's comic parody, female endurance brings its own rewards. The novel, written in the early 1960s, recounts a fictionalized and feminized quest for the Holy Grail undertaken by Marion Leatherby, a ninety-two-year-old English feminist held captive in a medieval Spanish castle turned into a nursing home.[1] Marion has long since given up catering to the social expectations of others. Stone-deaf and toothless, her sight remains keen, and she is far from ceding the spoils of life to those who will succeed her. Though her grandson characterizes her as a "drooling sack of decomposing flesh," she herself finds her short gray beard "rather gallant."

With her companion, the red-haired Spaniard Carmella Vasquez (loosely based on the figure of Carrington's close friend, the painter Remedios Varo), Marion sets out to recuperate the powers taken from women over centuries of patriarchal oppression and masculinist revisions of history. Carrington's readers are invited to suspend belief in the rational order of things in order to enter a world in which the male god is displaced by a female, and Christian and pagan symbols and sites are interchanged. Finally, the elixir of life is revealed hidden in the tomb of Mary Magdalen. "You may imagine the transports of delight which overcame me," reports Marion, "when I learnt that Magdalen had been

a high initiate of the mysteries of the Goddess but had been executed for the sacrilege of selling certain secrets of her cult to Jesus of Nazareth."

Critic Susan Suleiman has noted the contradiction between the humorous intelligence of the novel's narrator-heroine and the absolute denial of intelligence—indeed of subjecthood—to which her age, and her physical condition, reduce her in the eyes of her family. "Only by having the old 'senile' crone tell her own story from the start is this contradictory effect achieved: Marion's sharp wit counteracts her 'decomposing flesh,' and her dependent status is belied by her narrative mastery."[2]

Carrington was in her early forties when she wrote the novel. She was born in 1917. As a young woman beloved by the surrealists, and in particular by Max Ernst with whom she lived for two years before World War II, she had a personal familiarity with the fraught relationship between muse and male genius in twentieth-century vanguard art. Indeed her flight from France in 1940, and her subsequent mental collapse, have often been depicted as the first stages of a feminist pilgrim's progress toward autonomy and female agency that would lead her from Europe to New York and Mexico.

Carrington had taken up the fictional subject of aging at least once before embarking on *The Hearing Trumpet*. The short story titled "My Flannel Knickers" was written in Mexico in 1950.[3] It revolves around the adventures of a "saint" (gender unspecified) who, dressed in a tweed golfing jacket and gym shoes, has taken up residence, not in a desert cave, but on a traffic island in the middle of a busy boulevard in a city— one that sounds very much like Mexico City. The saint, known far and wide for a habit of hanging its flannel knickers on a traffic light pole each day to dry, has come to its present circumstances as the result of a misspent life abusing a beautiful face by wasting it on the social expectations of others. After a complicated series of adventures, and misadventures, the saint's cosmic destiny is played out on the traffic island. In a final meditation, the saint muses on a narrow escape from the world of social intercourse:

> Here I might explain the process that actually takes place in this sort of jungle. Each face is provided with greater or smaller mouths, armed with different kinds of sometimes natural teeth. (Anybody over forty and toothless should be sensible enough to be quietly knitting an original new body, instead of wasting the cosmic wool.) These teeth bar the way to a

gaping throat, which disgorges whatever it swallows back into the foetid atmosphere.

The bodies over which these faces are suspended serve as ballast to the faces. As a rule they are carefully covered with colours and shapes in current "Fashion." This "fashion" is a devouring idea launched by another face snapping with insatiable hunger for money and notoriety. The bodies, in constant misery and supplication, are generally ignored and only used for ambulation of the face. As I said, for ballast.

My first meetings with Leonora Carrington took place in New York, beginning in 1983.[4] "I'm only interested in three things," she told me firmly during one of our early conversations, "illness, old age, and death." When I congratulated her on her foresight in having chosen to write about such subjects from an early age, she replied, not without acerbity, that the earlier stories and novels "didn't count." "Because," she added, "I wasn't old when I wrote them."

I had taken Marion Leatherby very much to heart when I first read *The Hearing Trumpet,* several years before meeting its author. Now I was forced to concede that perhaps time, and age, would transform my own reading. At the same time, the fact that Carrington firmly rejected the notion that the character of Marion had anything to do with "real" old age led me to reconsider the function of the particular representations of aging in Carrington's oeuvre.

The fictional process of transforming the female body into one in which psychic and spiritual powers replace patriarchal constructions of femininity around physical beauty and sexual desirability is an important one. It represents a critical stage in a process of visualizing, and generating, images which may help fill the hole created by the lack of representations of old women in contemporary western culture. In one sense, these images served as the means to the embodiment of femininity in new forms. I also came to see them as integral to Carrington's belief that psychic and spiritual development require flexing the boundaries of material reality, a process which is an inevitable part of the physical deterioration of aging, and which underlies all of her work— whether painting or writing.

While living in Mexico, Carrington began to produce complex paintings whose psychic and spiritual content was created through manipulation of size and scale, the fusing of conscious and unconscious

sources in a fabulist narrative, and the gradual dematerialization of objects and images. During the 1980s, as she approached her own seventh decade, she began to paint with acrylic, a technique that resulted in subtle colors and thinner surfaces. Her recent paintings have a transparent feeling perfectly in keeping with subjects that increasingly revolve around a community of ancient figures. These old men and old women, their sacklike bodies lending them an androgynous air, travel in the company of animal companions, which are like the witches' familiars of Anglo-Irish legend and the *nagual* of Mayan culture. Nocturnal beasts such as the badger, known as a fierce protector of its young, inhabit subterranean realms, and hybrid chickens and geese roost among cabbage roses.

The figure of an old woman looms over many of these paintings. She is the Crone, who dates to the earliest goddesses, the spinners, and the furies. Exuding great strength and mystery for Carrington, she represents not wisdom or old age but the female who has passed beyond conventional expectations and models of femininity. Accepting her aging body—the collapse of the social face with the loss of teeth, the changing bodily looks and scents—she produces herself with little help from anyone else.

Reading Doris Lessing's *The Diary of Jane Summers,* Carrington found valuable support for a concept of woman who is beyond the conventions of imaging. She fits neither the cultural stereotype of the witch, nor that of the wise and benign grandmother. Abandoning nostalgic ideals of the invincibility of the physical body, and the serenity of old age, Carrington turned instead to the powerful *brujas* and *espiritualistas* of Mexican culture, the exiled prophetesses of early Christianity, and the goddesses of Celtic Ireland.

It is this image which dominates Carrington's most recent paintings. In one, *Kron Flower* (1986), an old woman detaches her eyeball to peer at a red flower that has mysteriously burst from a pavement as cracked as her own face. In another, *The Magdalens* (1986), old women exchange malevolent glares with their crystals. The dry-brushed surfaces of paintings like *Kron Flower* and *The Magdalens,* the restoration of knowledge and power to the elderly, the painting of aged and wrinkled faces, are perfectly in keeping with Carrington's belief that unless women reclaim their power to affect the course of human life, there is little hope for civilization.

Carrington's late paintings are an integral part of a decades-long attempt to capture moments marked by great psychic and spiritual clarity. "Living is a process," she said recently, "now I'm in the process of learning about dying." Yet there is nothing despairing about these recent works. Like the overturning of patriarchal narratives that accompanies Marion Leatherby's journey in *The Hearing Trumpet,* these paintings subvert dominant artistic mythologies. And they do so with earthy, often mordant humor. Unlike the heroic and timeless images of male spiritual vision we have come to expect from the experience of viewing the late works of Titian, Rembrandt, and other "old masters," they remain rooted in the mortal, as well as in the immortal.

Notes

1 *The Hearing Trumpet,* first published in French, was published by Virago Books (London, 1991). I would like to thank Moira Roth for her helpful comments and suggestions on this manuscript.

2 See "The Hearing Trumpet: Marion Leatherby and the Holy Grail," in *Subversive Intent: Gender, Politics, and the Avant-Garde* (Cambridge and London: Harvard University Press, 1990), pp. 169–180.

3 It was republished in Leonora Carrington, *The Seventh Horse and Other Tales* (New York: E. P. Dutton, 1988), pp. 165–168.

4 Unless otherwise indicated, all quotations of Leonora Carrington are from conversations in New York, Oak Park, Illinois, and Mexico City between 1983 and 1993. Notes from these conversations are in the author's possession.

Painting after Painting:

The Paintings of Susan Bee

Misko Suvakovic

Susan Bee's painting (like her collages and her color xerox and photographic books) is generated out of "the end" of painting. In the place (edge, puncture) where the history of modern painting ends, her painterly interventions begin.

1. Borders, Edges, Punctures, and the End of History

Bee's altered photo books from the 1970s (*Photogram,* 1978) and early 1980s (*The Occurrence of Tune,* 1981) close down and deconstruct the power of representation that photography took over from painting. Photograms take away the power of representation from photographs, returning to the concreteness of the surface (relations of black and white, plane and form on the surface). Photograms take away the power of producing the meaning by means of representation, leaving to the gaze the realized surface of possible associations. Possible associations are not symbolic but are based on the signifier's ability to anticipate potential meanings.

There is a photo in *The Occurrence of Tune* that shows the artist with

camera. Her face is framed by a square, drawn with photo-chemicals. The painterly motif of the artist's self-portrait becomes the photo-document (iconic sign) that is, by means of the painterly intervention upon the surface of the photo, brought to the edge of gestural painting. This edge *tells* about the end of painting, signifying borders of face, figure, and form on the plane.

The end of painting, which in different ways happened in photography, film, video, performance, and conceptual art, had the nature of a performative act. That is to say, the end of painting gained its meaning and sense by abandoning painting, and not by creating representation or by producing artifacts. The act of ending painting obtained its sense and its meaning by its own realization. The material power of representation in painting transformed itself into the concept of representation and into the logic of representing. Deconstruction of representation is based upon the transformation of the sign of painting (that which it shows: picture, text, scene) into the signifier (that which precedes representation). The signifier was the ideal zero degree of painting. Bee's photograms tended toward the zero degree of photographic surface as the zero place of painting.

2. After the End of Painting

Bee's paintings, beginning in the 1980s and the early 1990s, raise questions about the nature of painting by transforming modernist and high modernist signifiers and signs of painting, as well as the visual codes of mass culture, into new signs and texts for painting after the end of painting. She shows how one signifier from the history of painting or from advertising designs of the fifties becomes the new sign or structure of sign (text of painting). Her paintings are the *other* in relation to the history of modernism, although they are made out of signifiers of modernistic representations. Her paintings posit for us the exact material scene for the representation of the signifier's transformation into sign and sign's transformation into the text of painting.

Bee's paintings are the *other* in relation to the history and scene of modernistic painting. Where can we find the nature of this *otherness* of her paintings? This otherness is to be found in the asymmetry that is established at the visual and semantic planes: (1) between the sign structures of modernism that her painting takes over as signifiers and

(2) their transformation into new painterly signs and structures. This asymmetry is analogous to the asymmetry that exists between language and the subject. The asymmetry between language and the subject who speaks or writes creates the relation of otherness. Language is always unfamiliar to the subject and language always drops out the subject. Asymmetry creates a discrepancy between the subject of language and the existential (biological) being. Similarly, Bee's paintings, by fragmenting the modernist visual structures of painting's and advertising's signs, build an asymmetry between: (1) herself as the subject of the act of painting, (2) painting as the ordering of signifiers that transforms itself into the new painting, and (3) the Other that could also be the strong subject of modernism as well as the weak subject of postmodernism (which could be painting's laws, political dogma, models of sexual intercourse, styles of social consumption, the gaze that interprets the painting, feminist critical discourse, fatal strategies of seduction). Her paintings are about the asymmetry of the subjectivity of representation and about the relation among signifier→subject→sign→Other. Equally by her figures and by her characteristic signs of painterly procedures (her use of Jackson Pollock dripping or advertising and cartoon iconographies of the 1950s), Bee introduces sexual and political connotations into the play of painting. She shows that the function of the painting: (1) is not anymore the ritual transcendence of the plane of the canvas into the sacred (European tradition), (2) is not the aesthetic transformation of this plane into immanent subjective experience (European figurative expressionism, American abstract expressionism, modernist autonomy of the aesthetic into which the artistic work is transformed), (3) is not the destructive, analytical, and deconstructive act of performative transformation of this plane into the existence (performance) or into the cognition of art (conceptual art). She shows that the function of painting is based upon the other practice: it has its foundation in the sexual-political net of production of asymmetry between painting and the Other as the theme of painting. The Other of her painting is not the transcendental Other, but the Other of the sexual-political net of pictoral images.

How can this sexual-political net of production of asymmetry between painting and the Other be recognized? Let us look at the painting *Otranto* (1984). At the plane's surface there is the "floating" or "lying" statue of a man's head as if gazing at the nude female figure below. The

painterly procedure and compositional solution are close to the Italian transavantgardia: (1) classicist compositional relation between figure's head and figure of the body (pseudoclassical pose), (2) the modernist relation of the head and the figure on the plane, (3) the postfuturist and postcubist modernist solution of a reduced figure of the body and head (the body and head are transformed into iconic signs). The way the scene is represented by the painting produces a range of narrative relations that could be recognized as a "sexual-political net":

(a) She, as he would wish her.

(b) He, as she should wish him.

(c) She, as he would like her to be seen.

(d) He, as he would like her to see him.

(e) She, as he would like her to see herself.

(f) He, as he for her would like to be seen by her.

This chain between Her and Him is a chain of failure in the sense of sexual relation and brings asymmetry to the representation of gender-political relations. In the painting, he looks at her, and she doesn't look at him. He sees her, and she imagines him (or she doesn't see him). The difference between perception as an act of fulfilment of (man's) wish and imagination as the producing of (woman's) wish is a political-sexual difference that the painting produces for us by representing it. The represented failure and the asymmetry of her and his gazes (it is possible for him to see her and by seeing her to dominate over her and her ability to imagine being looked at) could be determined as what is sexual and political in every human act. Every failing act—here we think of gazes that don't meet one another—has some connection with sexual motivation and with political consequences. The sexual motivation is represented by the relation of the two figures and their objectification. This objectification of the gaze (the relation between subject and object) is universal in Western tradition of representation. The political consequences are inscribed in the relationship between subject and Other—a relationship that is represented in this painting as the relationship between outer and inner. Outer is represented by the male as symbol of transcendence (there is no body, just the master's gaze), of law (he floats above her), and of ethos (he is the one who looks at and who gives criteria for the gaze). Inner is represented by the naked female figure (which is the object of wish, fetish, the place of wish, the invitation to be looked at, the invitation for the imagining Other who looks at her). His transcendence is universal and grasps the power of

symbolic law (in Levinas's words, transcendence is not negative). Her transcendence is only personal and grasps the power of imaginative experience (it is always negative because it does not grasp the universal symbolic order).

The sexual-political net of the represented figures' relations is always the expression of nonwholeness. Theoretical psychoanalysis shows that the constitution of subject, culture, and society is nonwhole and that the system of human relations always shows some lack (defect, failure, asymmetry of gaze, and wish out of which power comes into existence). The idea of nonwholeness arises out of the "fact" that nature (woman) and culture (man) are not two circles that could in any way come together in one circle ("There is no intercourse!"). Bee's painting shows that there is no intercourse, that there are only differences in desire and the ability to wish with open eyes (symbolic order) or with closed eyes (imaginary order). Teaching about nonwholeness subverts the last two hundred years of the Western ideology of complementarity (of male and female, of wish, gaze, political power, sexual division of values, of matter and spirit) of wholeness and consistency. The idea of non-wholeness shows that speaking (writing, painting, looking, thinking) is gender determined. The representation of nonwholeness through the asymmetry of the figures reveals what is important: the knowledge about taking over of one's own gender in speaking (looking, writing, painting, living).

3. Wish, Painting, Figure, Device, and Transformations

Bee's painting—made out of diverse, appropriated signifiers—produces an asymmetric pictorial order of signs and shows that it possesses neither itself nor the neutral metalanguage by which its meaning and pictorial relations could be codified. It immediately invites analysis. But where should the analysis start, where are the points of support, when in front of us there is the order of: (1) asymmetric figures, (2) open noncoherent compositional solutions, and (3) fragmented narrative mechanisms?

Asymmetry of Figures

A figure is always a trace, and a trace is always a trace of absence, a trace of Other. A figure (of a woman, a child, a doll) is not a sign of the

presence of a woman's, child's, or doll's being on the painting but rather
is a trace that points out that there is no being. A figure speaks (shows,
represents) what is not on the painting and what could not be in the
painting. An image in the mirror is always symmetric to the body in
front of it. A figure in painting is always asymmetric to all persons and
bodies of the world revealing itself as being the trace of representation
of what is already represented. Bee works with the clichés of figures; for
example, some figures from her paintings are paper dolls cut out from
girls' magazines from the 1950s or decals. Her figures seem to want to
tell us: "Yes, we are imaginary asymmetric figures: we are not figures of
the persons made of flesh and blood!" Her paintings always point to a
context of appropriating out of "one possible world" and removing
into "the other possible world."

How to become the figure of the painting? A figure becomes the
figure of the painting when the already existing figure is removed and
becomes the element (trace) for a new context of transformation of
signifier into the sign and of sign into the visual pictorial text. The
figure removed from one possible world (of advertisement, of toys)
into the pictorial world of painting is inscribed in a literal, material
manner. Inscribing the figure in painting is both material and bodily.
Figures from advertisements or from girls' magazines are impersonal
representations (metaphors) of possible persons; that is, they are actu-
ally metaphors for a girl or a woman. When that figure is inscribed in
the painting, it becomes a material body in a material pictorial paint-
ing's world.

Open Noncoherent Compositional Solutions

When a figure is inscribed into the painting, it is brought into it: it is
inserted into a new material relationship with the painting elements
that determine, or at least make possible, the potential meaning of the
figure. In these paintings, a figure is never given in a simple way, for
instance: (1) a figure is inserted in an artificial collage-montage manner,
so that it is noncoherent with its plane and all other solutions (*Gray
Matter*, 1993); (2) the figure floats, in other words, it is not determined
by conventions of spatial representations of the body in the picture
plane (*Swiss Miss*, 1993); (3) the figure is covered by layers of color, lines,
stains (*Little Girl Lost*, 1993 or *Greetings*, 1993); (4) several figures are

mutually connected by organic shapes (*The Gaze*). The fact that the figure is not given in a simplistic "natural/conventional way" emphasizes the act of pictorial inscription through acts of taking-over, insertion, and classification. The figure is always brought into the broader pictorial product.

It is possible to differentiate three levels in the painting *Little Girl Lost*: (1) the colorful plane, (2) the figure on the plane, and (3) the Pollock-like dripping grid that covers the figure. The situation of the painting *Greetings* is more complex: two figures (which represent two girls in a hug) are situated in a pictorial scene that is covered by a grid of Pollock-like dripping and little vignettes with texts. In relation to other compositional elements, the figures do not appear as the human center (the represented human being around which the composition is built and which gives sense to the composition). The figure is a signifier for the painting, but a signifier that is in relation with other signifiers (the picture plane, the dripping grid, the other figures, the vignettes with texts, or with three-dimensional objects that are introduced into the painting). The figure also presents the painting's subject. This figure will be the figure that causes all other figures to represent the subject. But the subject that is built into the painting at the same time is the figure that is in relation to the figures (signifiers) of painting as art. This chainlike branching out of the relation of figure and representations of subject is potentially endless—it is never finished or stable.

Bee's painting surfaces are material scenes that subvert the idea of a transcendental signifier. Every single painting's signifier is changed in relation to the other pictorial signifiers without establishing a coherent meaning order. Her paintings subvert the idea of transcendental signifier because they prevent finding the first signifier (first signifier = transcendental signifier) with which painting is started and that builds a continuum between the painting and the world or between painting and spirit. The serial character of these paintings is a consequence of this subversion of the "first" or transcendent signifier.

Many of Bee's paintings are made in series; for instance, several paintings point to different moments of one narrative (semantic level) or procedural (formal painterly level) flow. Some of Bee's paintings are made in layers so that over time the layers are changed, covering precursory traces or representations into planes. Let us consider, for example, a series of paintings and collages that represent two women fighting

with one another while floating on the painting's surface. The same figural relation of two women (taken from a nineteenth-century wood engraving) is given three treatments: (1) with stains around the figures, (2) with stains around the figures out of which a square spiral that frames the figures is drawn, and (3) with dripping lines that cover the figures. In the first case, figures and stains have the same pictorial signifier's function of floating in pictorial space (creating a floating illusion on the surface). There is no defined space. In the second case, the square spiral establishes spatial relations between figures, with the stains and surface building a defined pictorial spatial world. In the third case, the figures are situated in a dripping whirlpool that covers them by suggesting the depth in which they are situated. In all three cases, empty signifiers introduced into the painting's space (on the painting's surface) anticipate different meanings that may not necessarily be clarified and clearly defined. This series, just through the anticipations of different meanings it creates, points to the inseparable relation of the figural and linguistic, because language not only establishes codes, but also opens endless potentials of meaning.

These works, as well as most of Bee's paintings, contain an atmosphere of humor (of possible laughter), although we never exactly know what it is that produces humor. Maybe it is the multitude of asymmetries that show that among the painter's different viewpoints and different stylistic solutions (iconographies, compositional possibilities of one and the same painting and of narrative fragmented citations) there is no correspondence in meaning, but a multitude of often opposite indexes that point to fear, pleasure, or unsafeness, i.e., to the forms of visualization of skillfulness, spontaneity, chance, ironization, self-reflectiveness, transfer, countertransfer, tenderness, craftiness, seduction, innocence, language games, and children's games. The hidden laughter that hums behind the paintings is the laughter of a puzzle.

Fragmented Narrative Mechanisms

All of Bee's paintings made between 1991 and 1994 contain narrative fragments. Fragments of narration are connected with the relations of the figures. They are elements of a story that is out of the picture. By introducing the figure into the painting, narration is announced, promised, or quoted. Nevertheless, fragments of narration never start

or finish the story. The story as a continuity of pictorial narration and representation is unapproachable. The narration is always out of the painting. It is the object of the wish that represents the Other. But the story of the Other cannot be told or represented by the painting. The story remains an announcement and pictorial promise. The Other is, for painting as well as for language, always that which cannot be described by metaphor, allegory, or by speculative transcendences.

Let us consider the painting *Swiss Miss* (1991). The gesturally painted, richly-colored surface is in the tradition of abstract expressionism. Two female figures (paper dolls) are introduced into the painting by collage. Their floating relation on the plane is arbitrary in the spatial sense. In the stylistic sense it corresponds, for example, to the use of "floating figures" in the work of Marc Chagall. The banner (the cloud in which the text is placed, for example in a cartoon) is the hole that yawns in the plane making the illusion of the space behind the plane. In the banner there is a horse's head. The banner with its peak, which is usually put near the figure's mouth that speaks in a cartoon, is placed toward the female figure's genitals. None of the described figural relations has a specific meaning, or a fixed narrative motive.

What are the narrative promises of Bee's paintings, what are the figural relations based on? First, there is the absence of one fixed narrator; for example, the author-painter who by the use of pictorial tools speaks and shows a possible event. As a painter, Bee doesn't have defined stylistic, iconographic, gender, and metalinguistic position in relation to the figures, composition, and narrative promises. She changes her moods in the frame of one and the same painting by changing the stylistic, iconographic, gender, and metalinguistic positions of her gestures, colors, and forms. She promises, but doesn't declare, pictorial truth.

Second, there is the absence of imaginary and symbolic identification with a coherent narrative flow and with the subject that is identified with a narrative structure and that builds a pictorial voice of narration. Imaginary identification, for example the Lacanian stadium of the mirror, is subverted. There is no identification with represented characters. Represented characters are figures that are in fact traces of the figures of mass media production. Bee does not identify her painfulness with the painfulness of the painted scene. That is why her expressionism is para-expressionism (she represents the expressionist atmosphere of painting

but she doesn't represent inner soul moods by expressionist modes). Neither at the iconic level (of the identification of her character with the figure) nor at the symbolic level (of the identification of her gesture with inner moods) does she define the subject. Her identifications lead toward a representation of the represented, and her emotions are in relation to the emotions of perception and to the usage of the already represented. They are not stable, but are changeable to the extent permitted by every shift from the original context of the figure (advertisements, magazines, paper dolls) to the new context of placing figures in the painting's plane.

Third, Bee's recent paintings work by shifting the viewpoint at the level of narrative promises as well as at the level of formal pictorial solutions. With her pictorial iconic signs, the painter tells neither a fairy tale nor a folklore anecdote, maiden's dream, woman's wish, nor obscene game. All these she promises, pointing to the fact that the drama of the painting is not to be found in the obscenity of a psychoanalytical myth about the relation of the body to the language, but in the drama of the gesture of the painter who opposes figure to language. Yet it is as if Bee evades language also: (1) by gestures that take away the sense from the figure (gestures that refute established, recognizable, and valid "grammatical" figures) and (2) by inserting the figure into a field of gestures, an insertion that takes away from the gesture the pure senselessness of painting, promising a language that is not there in the picture.

Note

This essay originally appeared in *ProFemina* (Yugoslavia, 1995). It was translated from the Serbo-Croation by Dubravka Djuric.

Sources

Bee, Susan (Susan B. Laufer). *The Occurrence of Tune*. Text by Charles Bernstein. New York: Segue Books, 1981.

Bee, Susan (Susan B. Laufer). *Photogram*. New York: Asylum's Press, 1978.

Biti, Vladimir, ed. *Suvremene teorije pripovedanja (zbornik)*. Zagreb: Globus, 1992.

Deleuze, Gilles. *Francis Bacon, Logigue de la Sensation*. Paris: Editions de la Différence, 1981.

Derrida, Jacques. *The Truth in Painting.* Chicago: University of Chicago Press, 1987.

Drucker, Johanna. "Susan Bee: Arcane Painting" and "Susan Bee: Six Paintings." *Sulfur* 28, 1991.

Felman, Shoshana. *Don Juan avec Austin ou la séduction en deux langues.* Paris: Editions du Seuil, 1980.

Lacan, Jacques. *Ecrits: A Selection.* New York: Norton, 1977.

Levinas, Emmanuel. *Totality and Infinity—An Essay on Exteriority.* Pittsburgh: Duquesne University Press, 1992.

Miscevic, Nenad. *Bijeli sum—studije iz filozofije jezika.* Rijeka: Dometi velika edicija, 1978.

Morgan, Robert C. "After the Deluge: The Return of the Inner-Directed Artist" in *After the Deluge—Essays on Art in the Nineties.* New York: Red Bass Publications, 1993.

When the Stars Threw Down Their Spears:

An Interview with Thomas McEvilley

Dominique Nahas

This interview was conducted with Thomas McEvilley during several sessions starting on November 19, 1993 and continuing through July 5, 1994. Its impetus was the publication of *Thornton Dial: Image of the Tiger* (Abrams Books, 1994) written by Amiri Baraka and Thomas McEvilley, in conjunction with the exhibition of the work of Dial curated by McEvilley at the New Museum of Contemporary Art and at the Museum of American Folk Art in November 1993.

The exhibition *Thornton Dial: Image of the Tiger* raised anew the issue of what it means in today's art world to be labeled or to consider oneself an "outsider artist."

Thornton Dial, a self-taught artist born in 1928 in Sumter County, Alabama, was employed for over thirty years at manual labor and started to pursue art making exclusively at the age of fifty-nine in Bessemer, Alabama, the town he has lived in and around since the age of ten.

In 1992 McEvilley's long-standing interest in Third World, non-Western, and nonwhite art and culture led him to Dial's work. Reflecting on the remarkable oeuvre, he felt that it focused a clear light on certain fundamental oppositions that were long accepted but have come into question

lately. One is the dichotomy between the insider and the outsider, the other the separation between the black and white art worlds in the United States.

In the outcome, the event proved controversial. Mass media from CBS to *The New York Times* were drawn into discussions of subjects such as: race, exclusiveness, market manipulation, white exploitation of black culture, and more. In this interview we discuss Dial's work and the various issues surrounding it.

Dominique Nahas (DN): You have a widespread international reputation as a leading art critic but I believe this is your first curatorial undertaking—and it's a controversial or risky one. Why did you decide at this point in time to curate a show of an unknown artist?

Thomas McEvilley (TM): Past invitations to curate have seemed less interesting than this one in several ways. Usually it's just a matter of re-arranging things that are already well-known and making tiny, nuanced changes in attitude toward them. But the Dial show seemed of historic importance to me. It's not just that this major oeuvre is almost completely unknown—at least in the contemporary art world—it's also that it intervenes in a timely way with the ongoing postmodern process of questioning and rethinking the exclusionary categories of modernism. I feel that Dial is as great an artist as anyone I know of who is working today. Yet his work would have been dismissed, in the modernist period, by putting it in some pejorative category such as "naive," "outsider," "folk," etc. But that is no longer so easy. Dial at this moment can cause us to question whether there *is* anymore an inside and an outside. His work overflows the category of folk art to inhabit the category of contemporary art perhaps even more naturally. What I am after is a situation in which contemporary art viewers will be able to attend to this work with the same curiosity about its ongoing development with which we regularly attend to the work of favored contemporary artists. And in order to attain that situation the work has to be shown to transcend those traditional exclusionary categories. That's why I put the show simultaneously in the Museum of American Folk Art and the New Museum of Contemporary Art. This bilocation implies the major historic point that is being made.

DN: What would you say to the question whether, by claiming overlap between Dial and such contemporary artists as Schnabel and Kiefer, you are doing the same thing that you criticized William Rubin for

when he asserted an affinity between Picasso and African artists? I'm referring, of course, to the so-called "primitivism controversy" that attended and followed the show *"Primitivism" in Twentieth-Century Art* at the Museum of Modern Art in 1984.

TM: There are two points for which Rubin was criticized. First, he based his claim on affinities or formal qualities alone, without consulting the contents and purposes of the non-Western artists involved. He assumed that if the forms were similar the underlying contents and purposes must be too. In other words he treated esthetic form as a set of trans-cultural universals and he dismissed the non-Western artists' under-standing of their own contents and purposes. In comparing Dial with certain contemporary white artists, on the contrary, I compare not only formal aspects but also the artists' own expressions of the contents and purposes of their work. What I say about Dial's work I have not deduced from any supposed universals but have heard from him personally.

Second, Rubin made his comparisons between members of widely separated different cultures, so once again in order to account for the similarities, he had to invoke transcultural universals of pure form. His argument was not historical but transhistorical. In comparing Dial and certain contemporary artists, on the contrary, I am comparing artists produced by the same society, at the same time, occupying the same flows of media awareness, reacting to the same historical events. My argument is a specifically historicized one that does not depend on an invocation of metaphysical principles.

DN: Some would say—and have said—that it's not the look of the work that makes it contemporary art; "contemporary" means that it was generated out of a more or less informed reflection on recent art history.

TM: That's a great example of a modernist exclusionary device. It works by separating out the threads of history and isolating them—so that art history, say, is seen as autonomous, separate from history as a whole. But seen in a broader context Dial's work comes from the same history that white contemporary artists' work comes from, just a different angle of entry into it. They are not from different cultures or times. They were shaped by the same broad history, though with a different English or spin on its impact. The fact that Dial's work is not based on an awareness of what has happened in Soho in the past ten years is trivial. His oeuvre is deeply historicized in somewhat the same way as

Kiefer's is—meaning they arise from a keen sense of this historical moment in society. It has as much to do with the end or revision of modernism as much prominent work by famous white contemporary artists. This is enough to qualify it as "contemporary."

DN: In *Thornton Dial: Image of the Tiger* there is a lot of discussion of detailed references to the black American experience in Dial's work. How frequently does one come across an untutored African American artist using such specificity in his or her artwork?

TM: The African American art scene has several groups in it. One is the so-called "self-taught" group, the group that Dial has been placed in so far. It's unusual, in this group, to see the degree of explicit focus on historical events and black history that Dial has. If you look, for example, at the work of Bessie Harvey you could argue that there are ways that it refers to African American experience; similarly the work of Hawkins Bolden refers to the black experience in terms of general ideas such as bondage. But my impression is that Dial is unusual in the explicitness of his historical focus. The painting *Graveyard Traveler–Selma Bridge,* for example, is about the walk across that bridge by Martin Luther King in 1962. And there are a number of recent pictures that refer to the 1992 South Central L.A. riots.

DN: What is the single most important difference in Dial's work that makes it stand out from other nonacademically trained or outsider artists?

TM: One thing that to me makes it different from the work of other so-called "self-taught" or "folk" artists is the clarity of this commitment to the idea of history that I have mentioned. Again, this work is as deeply committed to history as, say, the work of Anselm Kiefer. In fact there are a number of relationships between the work of Dial and Kiefer which are discussed in the book. Dial's work, like Kiefer's, strikes me as being intensely focused on history from the position in which he was born into it—that is, in Dial's case, from an African American slant on history. His work not only focuses on what one traditionally calls "black history," it also has a deep commitment to making a constructive contribution to that history. When Dial talks about the tiger the word that comes up most often is "struggle." The tiger is about struggle, and struggle is about history. It's about black people struggling through the medium of history to attain dignity and autonomy in alien societies. This is an extremely Hegelian view of history—history as the

struggle toward self-advancement through reversing, and subsequently annulling, the master–slave relationship.

DN: Dial is evidently an extraordinary phenomenon who, by virtue of the quality and breadth of his work, leapfrogs over traditional art categories. It was not one of your intentions however, from what I understand, in presenting Dial's work, to propose the elimination of these categories. Is this a fair statement?

TM: Yes. One thing that I'm *not* saying is that "contemporary" simply means "living today," and hence, that the distinction between folk art and so-called contemporary art is meaningless and should be put aside. There *are* artists whose works I regard as "folk art"—artists such as Mose Tolliver, Howard Finster, and the no-longer-living Bill Traylor. And the fact that these people may be, merely in a chronological sense, contemporaries of "contemporary artists" doesn't by itself make them contemporary artists. I do agree that there are differences between contemporary art and folk art. One of them is the involvement in history that I referred to, though restricting it exclusively to art history in the narrow sense robs the idea of real meaning and treats history like a formal game.

DN: What are other qualities in Dial's art that set it off from the work of other "self-taught" artists?

TM: Another important point is his treatment of space. Folk artists—those who I believe are legitimately called "folk artists"—generally have a preperspectival rendering of space. Either the space is not defined at all or if there is an attempt to define it in the depth axis, the artist has not yet reached the Renaissance system of linear perspective, where, let's say, parallel lines in the depth axis converge at a vanishing point and so on. Now this is a very touchy point—because in terms of Piaget's theory of cognitive development the preperspectival rendering of space is typical of children under the age of nine, so this trait seems to associate folk art with the art of children. And this is something that is very offensive to people who specialize in the folk art field. They continue to point out that someone like, say, Mose Tolliver, is seventy years old. That he is not a child, that he is full of experience, that he has this life wisdom, he's lived a full life . . . and so on. They feel it's pejorative to compare him with a child, and, of course, they have a point.

But, still, look at this drawing by a child—and compare it to this work of self-taught artist Clementine Hunter. Fundamentally space is treated

in the same preperspectival way in both works. Now late modernist and contemporary art treats space in what I would call a postpcrspcctival way. Some great examples are Jackson Pollock, Willem de Kooning, and Franz Kline. In their work the surface is treated as a metaphor for primeval configurations of energy. To me it's just obvious that Dial's treatment of space is postperspectival. He activates the surface of the painting as a metaphor for pure energy in much the same way that these great late modernist and postmodernist artists have done.

DN: You've identified two modern elements in Dial's work: the explicit layered focus of history as struggle, which is very Hegelian, and the postperspectival treatment of space. Is Dial, then, a contemporary artist?

TM: It's not an either/or situation—that he's either a folk or a contemporary artist. There are other concretely identifiable elements in Dial's oeuvre which are legitimately connected to folk art. I'm not saying that his work is entirely NOT folk art. I'm saying it straddles or conflates these categories. But in terms of its relationship to history and to space and the treatment of surface—it is essentially a late modernist or postmodernist type of art.

DN: One of the elements in his work that gives it a folk quality is that there are story lines in his work, or at least, this is what I'm led to believe. What are your observations on this aspect of the work?

TM: Folk art, not always, but very frequently, is involved in storytelling—a somewhat naive . . . I hate to use that word . . . let's say nonironic approach to iconography. Now, late modernist art in general is not involved in storytelling (if we think of the New York School, for example, Pollock, Newman, and so on). There are postmodernist artists whose works *are* involved in storytelling, for example, Nicholas Africano's *Battered Woman Series*. The difference is: in postmodernist storytelling art there is always an ironic stance toward either the manner in which the story is told or the content of the story or both. In folk art, per se, there is often a simplistic, earnest, and nonironic storytelling. Dial does, in many of his works, tell a story, and those works have a narrative iconography which legitimately connects the work with folk art. However, right after Dial has finished a picture he'll have a very clear idea of what the narrative line is but two or three months later he may have forgotten the story line and the details of the iconography and then he'll say the picture is just a picture.

DN: What's the extent of Thornton Dial's formal education? Can he write?

TM: My understanding of it is that Dial's education ended in the fourth grade. And at this point in his life all that he can write is T period Dial. Yesterday I watched him sign someone's book. It was just like a second grader. He signed v-e-r-y carefully [here McEvilley acts out a slow act of writing]: as if he had been taught to put the dot over the i but doesn't know why. He's learned how to draw his name not write it. He grew up in an environment where you don't really need to read. Maybe you're even discouraged from it.

DN: His production has been going on for a surprisingly short amount of time, hasn't it?

TM: He started painting seriously in 1987, seven years ago. Let me point out that the entire artistic career of Yves Klein covered seven years. So we have accepted in our white Western art world that it is entirely possible to create a major oeuvre in the first seven years of one's productiveness. (Klein also, by the way, was "self-taught.")

DN: Let's talk about the expressionist tendencies in the work. Are the majority of the works leaning in this direction and, if not, how would you categorize them?

TM: Well, some of them are. My impression is that sometimes he starts a painting in a purely expressionistic way by intuitively making some marks. Then, as he gazes on them he begins to get an iconographic association. And then, that in turn helps to shape the next marks and then those next marks create another iconographic association and then the two aspects develop together in this type of intuitive collaboration. However, there are pictures that could not have been done this way. In *Wondering About Life: Proud Stepping in the Flowers* at the New Museum, for example, I think that Dial obviously had to have thought this piece out entirely in his head before he began. That's why I'm not convinced that all the works should be called expressionist. Some of them, I think, were thought out entirely beforehand.

DN: What are some possible explanations for the work's visual or material sophistication?

TM: I'd like to mention four factors. One is that a lot of vocabulary elements of so called "high art" have passed into design. For example, you see linoleum patterns that look like a Pollock or a Mondrian. So that Dial, just by looking at design elements around him, in stores or on

TV, could have picked up a certain amount of that vocabulary. Secondly, there's the fact that (and this is one thing that hasn't been explored significantly enough yet) a lot of those elements of so-called "high art" vocabulary may have been present in the African American tradition before they actually entered the white art tradition.

DN: In your book on Dial you mention Robert Rauschenberg. You bring out the question of whether he happened to have seen any black funk assemblage while growing up in Port Arthur, Texas, which could have led directly into his great early works such as *Monogram.*

TM: Port Arthur is in the area where such things are seen. Probably he did, you know? Or to use another example: the Pollock drip-and-splatter style is something that is seen in certain areas of African American so-called "folk art" at least as far back as the thirties—and it probably extends as far back as the nineteenth century. This is a style of decorating things in the southern black community—the area that W. E. B. Du Bois called "the black belt." The black belt is a world unto itself and our scholars of art and art history have hardly begun to deal with it and its relationship to white art practice. Amiri Baraka says that there are hundreds of artists in the black belt and that the white world has no idea that they are even there. And Robert Farris Thompson has convincingly traced some elements from that area of so-called "folk art" back to Africa. It's a tradition that has been existing right alongside our tradition with certain elements of cross-fertilization that have not been art historically worked out yet because it's something we don't want to look at. We don't want to imagine that Pollock might not have been the genius that figured it all out, you know? That maybe he saw it in some black guy's work. Thirdly, and this is a point that is clearly associated with the last one, we call these artists "self-taught," but I don't think they're "self-taught" at all. They *are* taught; there's a tradition down there. And whenever you have a tradition you're liable to have sophistication develop.

The fourth point is that, even without invoking romantic ideas of genius, we have to admit on the most down-to-earth level that some people are more talented in certain areas than others. There are children who are immediately recognized as musical or math prodigies or great chess players. In every grade school class there's always someone who can draw so well the other kids can't believe it. Well, Dial's one of them.

DN: You haven't mentioned that Dial had made patio furniture for a living since his retirement, which is evidence of a talent and skill with materials and design.

TM: Absolutely. And for thirty or thirty-five years he worked as a steelworker at the Pullman Standard Boxcar plant—it's obvious he gained a lot of discipline there. As you say, just the sense of how you methodically and intelligently go about making something figures into this.

DN: What's the iconographic significance of the tiger in Dial's work and how do the various materials in his work tie in with this image?

TM: The tiger is associated with primal energy and beauty and the jungle. The tiger represents Africa. The tiger in his jungle is precolonial black African society presented as a very harmonious contented state. Then there are other works that show the tiger being taken out of the jungle. There's a painting, for example, called *When the Tiger Leaves the Jungle He Gets a Monkey on His Back*. The money refers to the problem of drug addiction in the ghettoes. It also represents the white slave master, the white factory foreman, and so on, all the seemingly unnecessary and irrational white authority figures that have plagued African Americans. The tiger—I've suggested, and Dial has agreed with me—involves an expanding series of meanings. On one level it represents Dial himself—the struggle of his life. On another it represents all African American males and their struggle for dignity and autonomy in a truly alien society. In a still larger sense it represents the whole African American community: the diaspora black community. Finally, it represents all humans struggling to survive, indeed all creatures struggling to survive on earth. The tiger means struggle and the struggle means history. Dial puts this together in a very coherent way.

DN: There are interconnections in Dial's work between the overall theme of struggle and the themes of labor and displacement. What are some of Dial's works that typify this approach?

TM: There's a painting called *Roosevelt: A Handicapped Man Got the Cities to Move*, which gives you a good idea of Dial's acute sense of history. What this painting and several other paintings focus on is the moment that Nicholas Lehmann has called "the Great Black Migration," when black people had been picking cotton in the South and then, in about 1942 I think it was, the invention of a cotton picking machine eliminated all those manual jobs. Consequently, literally millions of African Americans migrated from the rural South to the indus-

trial citics of the North. The point of the Roosevelt work is that Dial feels that FDR's New Deal urban policies created job opportunities that these blacks, who were migrating up from the South when the cotton-picking jobs were eliminated, were able to find. In Dial's eyes FDR created opportunities for black Americans to better their position through the struggle of history. (Ralph Bunche has argued that New Deal policies were applied with racial bias, though I don't know if he would attribute such bias to FDR himself.)

Another picture that relates to the FDR theme is a painting called *Heading for the Higher Paying Jobs*. This commemorates the moment when African Americans shifted their place of employment from the cotton fields to the steel factory. Dial shows the tragic dangers of the steel plant: on-the-job injuries and so on—steel plants are notorious for this. He shows these dangers as the price you've got to pay to better yourself through struggle.

A theme in Dial's work which I respect enormously is his reverence for labor. As I said he worked for thirty-five years in the steel plant, which is a hell of a long time—it's a punishing job. He's a workaholic now. When you see him there at the house he works all the time. He's the most gentle and meek man but he works ferociously. And when he's not working he doesn't know what to do with himself, and you can see this in the works themselves: they're so laboriously constructed and so sturdily put together.

DN: The themes of labor, struggle, and history in Dial's work are closely interrelated as you have taken great pains to point out in your book. How do the actual materials in the work reflect his concerns?

TM: I'll give you a few examples. In the Martin Luther King picture and in the FDR picture and in a lot of other pictures the tiger is made out of carpet—used carpet. The reading is: black people have been down, stepped on, trod upon, but they will rise up again as this old bit of carpet has risen again and been transformed by Dial's struggle through art. There are other materials that Dial uses such as mop strings and pieces of broom and these things represent the menial jobs to which black people have been relegated. But at the same time these materials represent reverence for honest labor. They also have to do on another level with the redemptionist approach to black American history that is set forth in, for example, Nathan Huggins's book *Black Odyssey*, where the idea is that American society carries at its very core the wound of

the guilty secret of slavery. And that African Americans who are re-deeming themselves through the struggle for dignity and autonomy will cleanse and redeem the whole society. This is also what the mop and the broom refer to: that blacks will clean society through redeem-ing themselves through the struggle of history.

DN: Have you made these linkups for Dial or with Dial or has he expressed these meanings to you himself, unassisted?

TM: More than once Dial has heard me give talks about his work, and I've asked him if he agrees. And he has enthusiastically affirmed that he does. That's not surprising since a good deal of what I say I heard from him in the first place. In addition some of my remarks are based on the iconographic readings that Paul Arnett has provided, which are all based on what Dial said to him. Paul has made a practice for years of questioning Dial about each painting as it was made and writing down his explanations. Furthermore, I've talked with Dial enough about these matters to feel confident that Arnett's reportage is correct in terms of Dial's attitude.

DN: Let's confront the issue of the packaging of an illiterate black artist by a sophisticated, privileged, white milieu. You, Bill Arnett, Paul Arnett—"white boys"—who could be accused of categorizing inappro-priately. I'm surely not the first to raise this sensitive issue.

TM: Of course not. There are two questions that are involved here. First of all did these white guys direct Dial's work? For example did Bill Arnett, who's Dial's major collector, at a certain point show Dial exam-ples of, say, Julian Schnabel's work and say: build up the surfaces. My impression is: absolutely not. I've been around Dial and Bill Arnett a lot. Bill doesn't try to direct Dial's work at all. He simply receives it. Dial notices which one of his works his collector likes. And like any other artist he is apt to be influenced by that perception. So there is a certain interplay there that isn't illegitimate at all. After all, when Peggy Gug-genheim liked a certain work by, say, Jackson Pollock, he was apt to be encouraged to make more in the same vein. And that doesn't seem to bother anybody.

The second question is, maybe these white guys didn't influence the work itself, but did they influence the interpretation of the work? Again, I would have to say "no." Paul has had great integrity about this and the stuff he's written down is all or almost all what Dial has said to

him, with the probable addition of some inferences or deductions that Paul has put together on top of it, which I don't think is illegitimate. So: if the artist made his own work and if the meanings attributed to the work are his own—then what's being packaged? Except that we put him in our museums. And those who would say we shouldn't put his work in our museums are dangerously close to saying that black people should be kept in their place.

DN: Aren't you leaving yourself wide open to criticisms of contextualizing an oeuvre primarily for the sake of commodifying the work for a mainstream, that is, white public, thereby disregarding the intentions of the artist?

TM: Again I think there are two points—one about intentions and one about commodification. In terms of the artist's intentions, to repeat, I've consulted Dial's expressions of his intentions, which are discussed in the book, and certainly haven't disregarded them. Further, Dial doesn't feel that the context of the white art world is inappropriate for him. He has expressed great satisfaction at the idea that his work will exert its influence in the same arena in which Picasso's work operates. In terms of the commodification issue I think—again—that anyone who objects that the work of self-taught artists should not be sold for prices comparable to those of art school graduates is dangerously close to saying that such people should be kept in their place and not be allowed a chance to improve their lot in life.

DN: What was your first-time experience as a curator like in working with the Museum of American Folk Art and the New Museum of Contemporary Art? Were there differences?

TM: The experiences were as different as night and day. The New Museum treated the role of guest curator as autonomous and helped me to realize the show I wanted. The Folk Museum was, to put it mildly, less professional. The in-house curator, for example, was far more obstructive than helpful. It was a bit of a nightmare ...

DN: What do you think about the CBS *60 Minutes* segment on outsider art, aired on November 21, 1993, in which Morley Safer implied that Bill Arnett was exploiting Dial?

TM: Again, I raise my eyebrows. It strikes me as possibly racist, and certainly paternalistic, to suggest that Dial needs to be protected as if he were a helpless child. He's a sixty-five-year-old man with considerable

experience and sophistication. And he has the right to choose his own associates. In any case, my relationship is with the artist and his work. I have often written about artists whose dealers are rumored to engage in disreputable business practices. But as a critic that isn't my subject matter. I'm not approaching Dial as an accountant, and whether the books are straight between Dial and Arnett I couldn't possibly know. I do know that Dial is happy with Arnett's friendship and feels he was exploited by the ruthlessly manipulative interviewing and editing of *60 Minutes* rather than by Arnett. He's free to choose his dealer after all, and it's not my place to criticize his choice, any more than I would criticize his choice of a lawyer or a doctor. But all that is not the point, you see. The *60 Minutes* people were much too cavalier in their dismissal. Here you have a great artist, two reputable museums—the Museum of American Folk Art and the New Museum of Contemporary Art, two serious and committed writers—Amiri Baraka and me—and an established art book publisher—Abrams—who have all considered these matters carefully and decided the project was legitimate. Yet *60 Minutes* doesn't say a single word about the artwork! If Dial has in fact been exploited, then hopefully this coverage will help him to get better protection. But in the meantime let's not lose sight of the power and significance of Dial's work, which *is* the point.

Appendix:

Contents of M/E/A/N/I/N/G

No. 1, December 1986: an essay by Charles Bernstein; memorial tributes to painters Porfirio DiDonna and Rene Santos; "Appropriated Sexuality" by Mira Schor; "Mother Baseball" by Vanalyne Green; also essays by Susan Bee, Mimi Gross, and Johanna Drucker.

No. 2, November 1987: responses to questions on the nature of meaning, authenticity, and originality in art by a diverse group of artists and critics including Arakawa, Rackstraw Downes, Komar & Melamid, Yvonne Rainer, Ken Sofer, Robert Storr, and Lawrence Weiner; also essays by Mira Schor, Tom Knechtel, Nancy Spero, Pam Shoemaker, and Johanna Drucker.

No. 3, May 1988: "Florine Stettheimer: Eccentric Power, Invisible Tradition" by Pamela Wye; "Some Remarks on Racism in the American Arts" by Daryl Chin; "The Poetics of Basketry" by David Guss; "The Art School as Research Workshop" by Lucio Pozzi; also essays by Charles Bernstein and Corinne Robins.

No. 4, November 1988: "Representations of the Penis" by Mira Schor and "Nancy Spero: Speaking in Tongues" by Pamela Wye; an interview with Richards Jarden by Robert Berlind and a critique of Allan Kaprow by Johanna Drucker; also a "theoretical fiction" by Joseph Nechvatal.

No. 5, May 1989: responses to "What Is Repressed in Art?" by twenty-four

artists and critics; a section of art book and catalog reviews by artists; also essays by Joel Fisher, Marcia Hafif, and Charles Bernstein.

No. 6, November 1989: an interview with Carolee Schneemann; "Figure/Ground" by Mira Schor; an essay by Daryl Chin; an article on Elie Nadelman by Brandt Junceau; and articles by Ann McCoy and Faith Wilding; book reviews by Whitney Chadwick, Johanna Drucker, Geoff Young, Ilan Stavans, Joseph Nechvatal, and others.

No. 7, May 1990: a forum of views on racism in the arts by twelve artists, critics, and curators; also Amelia Jones on "Post-Feminism," notes by Gil Ott and Richard Tuttle; and reviews of books by Trinh T. Minh-ha and Jean Dubuffet.

No. 8, November 1990: three articles on teaching, including "12 Questions of Art" by Lucio Pozzi; essays by Mira Schor and Janet Kaplan; statements on symbolism by Lenore Malen, Ellen Lanyon, Peter Schjeldahl, Nancy Spero, and Robert Storr; essays by Corinne Robins and Johanna Drucker.

No. 9, May 1991: articles by Charles Bernstein, Joseph Nechvatal, Robert Jensen, Daryl Chin, Amelia Jones; also book reviews by Robert C. Morgan and Liz Willis.

No. 10, November 1991: "Over Time: A Forum on Art Making" with twenty-four artists; an essay by May Stevens; an interview with Alison Knowles; book reviews by Robert C. Morgan; a letter from Kathleen Fraser.

No. 11, May 1992: a round table on art criticism with Saul Ostrow, Robert C. Morgan, Jeremy Gilbert-Rolfe, Klaus Ottmann, Pat McCoy, Jeanne Silverthorne, John Miller, Sidney Tillim, Joshua Dechter, Marjorie Welish, Mira Schor; also essays by Joseph Nechvatal and Collins and Milazzo; book reviews by Daryl Chin, Robert C. Morgan, and Jessica Prinz; and a letter from Yve-Alain Bois.

No. 12, November 1992: "Motherhood, Art, and Apple Pie," a forum by thirty-two women artists; "My Murderer/Myself: Portrait of the Artist as a Young Murderer—Art Spiegelman's Maus," by Nancy K. Miller; and "The Drunken Conversation of Chaos and Painting," by James Elkins.

No. 13, May 1993: Curtis Mitchell's "Working the Park"; "The Comfy Chair" by Jo Anna Isaak; Jordan Crandall's "Transactional Space"; essays by Mira Schor, Stewart Buettner, David Reed, Daryl Chin; also book reviews by Barry Schwabsky, Robert C. Morgan, Steven Harvey, and Susan Bee.

No. 14, November 1993: an interview with Deborah Kass; essays by Laura Cottingham, Amelia Jones, Joanna Frueh, Whitney Chadwick, and Sheila and Jack Butler; also book reviews by Robert C. Morgan and Joseph Nechvatal.

No. 15, May 1994: "Forum: On Creativity and Community"; an essay on Japanese artist Yayoi Kusama by Pamela Wye; essays by G. Roger Denson and Dena Shottenkirk; and book reviews by Charles Bernstein.

No. 16, November 1994: a forum guest edited by Lawrence Lipkin and Julia Jacquette, and devoted to concerns of younger, emerging artists, with thirty-eight artists; an interview of Thomas McEvilley by Dominique Nahas; essays by Charles Bernstein and Johanna Drucker; a book review by Misko Suvakovic.

No. 17, May 1995: essays on popular culture by G. Roger Denson, Daryl Chin, Barbara Flug Colin, Charles Alexander; book reviews by Nick Piombino, Robert C. Morgan, Daniel Barbiero, Barbara Einzig; also two letters.

No. 18, November 1995: remarks from the 1995 conference "Brave New Art World"; "Monstrous Domesticity" by Faith Wilding; "The Stranger," by Pam Longobardi; "Painting as Manual," by Mira Schor; "The Visual-Verbal World of Johanna Drucker," by Nick Piombino.

Nos. 19–20, May 1996: a special, double, final, tenth-anniversary issue featuring original artwork by one hundred twenty visual artists who had written for past issues; also a valuable, complete, detailed index to issue nos. 1–20 arranged by subject as well as by author.

Contributors

Emma Amos is an Atlanta-born artist living in New York. She is Professor of Art at the Mason Gross School of the Arts, Rutgers University, and a governor of the Skowhegan School.

Suzanne Anker is a visual artist and theoretician working with genetic imagery. She is Chair of the Department of Art History at the School of Visual Arts in New York City.

Arakawa is a coordinator of life or poet-artist-architect. *Reversible Destiny,* his joint exhibition with Madeline Gins at the Guggenheim Museum Soho in 1997, won the College Art Association's Artist Award for Most Distinguished Body of Work.

Rudolf Baranik's (1920–98) last painting, *The Evening After,* dedicated to his parents who were murdered by Lithuanian fascists in 1940, was exhibited at Exit Art, New York, in 2000. *Poetics and Politics in the Art of Rudolph Baranik* by David Craven is forthcoming in 2001.

Susan Bee is an artist, editor, and designer who founded, coedited, and designed *M/E/A/N/I/N/G* magazine. She showed her paintings at A.I.R. Gallery in New York City in 1998 and 2000. Her artist's books include *Little Orphan Anagram* (1997) and *Log Rhythms* (1998). *Bed Hangings,* with poems by Susan Howe, is forthcoming in 2001.

Robert Berlind is a painter who lives in New York City and Cochecton, New York; he is represented by the Tibor de Nagy Gallery. Berlind also writes on

art and teaches at the State University of New York, Purchase, where he is Coordinator of the MFA Program in the Visual Arts.

Charles Bernstein's most recent books include *Republics of Reality: 1975–1995* (2000) and *My Way: Speeches and Poems* (1999). He is Director of the Poetics Program at the State University of New York, Buffalo.

Jake Berthot lived and worked in New York City from the early 1960s until the late 1990s, when he moved to the Catskill Mountains in upstate New York, where he now lives and works. He is represented by McKee Gallery in New York and the Nielson Gallery in Boston.

Jackie Brookner is an environmental artist who is collaborating nationally and internationally with ecologists and earth scientists on bioremediation/public art projects. She was guest editor of the 1992 issue of the *Art Journal* on "Art and Ecology" and teaches at the Parsons School of Design in New York City.

Josely Caravalho is an artist living in New York City.

Whitney Chadwick is an art historian who writes on surrealism, feminism, and contemporary art. Her recent publications include *Mirror Images: Women, Surrealism and Self-Representation* and *Framed* (an art historical crime novel) (both in 1998).

Emily Cheng is a painter who exhibits in the United States, Europe, and Asia. She lives in New York City.

Daryl Chin is associate editor of *PAJ: A Journal of Performance and Art. Shigeko Kubota*, his monograph on the video artist, is forthcoming in 2001.

Arthur Cohen is an artist living in New York City and Provincetown, Massachusetts. He shows at the East End Gallery in Provincetown and Susan Teller Graphics in New York.

Tricia Collins has been an independent curator and art critic. She also taught at Yale University. At present she has a gallery in New York City, Tricia Collins Contemporary Art.

Maureen Connor is a video and installation artist who exhibits her work internationally. Recent exhibitions took place at the Laznia Center for Contemporary Art in Gdansk, Poland, and the Queens Museum of Art. She teaches installation, video, and sculpture at Queens College, City University of New York.

Laura Cottingham is an art critic who lives in New York City. She is the author of *lesbians are so chic . . .* (1996) and *Seeing Through the Seventies: Essays on Feminism and Art* (2000).

Patricia Cronin is an artist who lives in New York City, works in Brooklyn, and teaches in the Visual Arts Division at Columbia University. Her work has been exhibited in New York and across the country, and has been reviewed in numerous publications.

Stephanie DeManuelle is a painter who lives in New York City. She teaches at the Fashion Institute of Technology.

Jane Dickson is a painter living in New York City. Her work is in the collections of the S.F. MOMA, the Whitney, and the Metropolitan Museum of Art, among others.

Bailey Doogan is an artist living in Tucson, where she has been teaching painting and drawing at the University of Arizona for thirty years. Recently semiretired, she now devotes most of her time to her work, which has been exhibited widely.

Rackstraw Downes paints his surroundings on site in New York, New Jersey, and Texas.

Johanna Drucker is a writer, artist, and scholar who has published and lectured widely on contemporary art, visual poetry, feminism, and digital technology. She holds the Robertson Chair in Media Studies at the University of Virginia.

Tom Finkelpearl is Program Director at P.S. 1 Contemporary Art Center. His book *Dialogues in Public Art* was published in 2000.

Joel Fisher is a sculptor, and what he learns from this work he applies to his other activities. He divides his time between his studios in Brooklyn, New York, and northern Vermont.

Hermine Ford is a painter living in New York City and Canada.

Nancy Fried lives and works in New York City. She has received a National Endowment for the Arts grant in sculpture and a Joan Mitchell Foundation grant, and her work is in the collection of the Metropolitan Museum of Art and the Brooklyn Museum.

Joanna Frueh is an art critic, art historian, and performance artist. Her most recent book is *Monster/Beauty: Building the Body of Love* (2000).

Madeline Gins is a coordinator of life or poet-artist-architect. *Reversible Destiny,* her joint exhibition with Arakawa at the Guggenheim Museum Soho in 1997, won the College Art Association's Artist Award for Most Distinguished Body of Work.

Leon Golub's current exhibitions include *While the Crime Is Blazing,* a traveling exhibition organized by the Bucknell University Art Gallery, and a

retrospective organized by the Irish Museum of Modern Art in Dublin. Both shows are traveling from 2000 to 2001.

John Goodyear is an artist living in Lambertville, New Jersey. His work was the subject of a retrospective exhibition in summer 2000 at the Michener Museum, Bucks County, Pennsylvania.

Renée Green is an artist based in New York. *Shadows and Signals,* which accompanies her exhibition of the same title, was published in 2000.

Vanalyne Green is a video artist and professor at the School of the Art Institute of Chicago. She was a student in the first feminist art programs taught by Judy Chicago in Fresno and Sheila de Bretteville at Cal Arts. Since then she's won numerous awards and has been included in such shows as the Whitney Biennial.

Mimi Gross's most recent dance set design was for Douglas Dunn & Dancers, *Cocca Mocca,* St. Marks Church, New York City, in 1998. She had a one-person exhibition at Salander O'Reilly Galleries in New York, March–April 2000.

Nancy Grossman is an artist who lives in Brooklyn. She is represented by the Michael Rosenfeld Gallery and showed her work in a one-person exhibition in September 2000.

Marcia Hafif has had painting shows in Germany, Austria, and Switzerland; in connection with a show of video and photographs at the Kunstverein Grafschaft in Bentheim, Germany, she published a new book: *Letters to J-C.* An exhibition of her paintings from the 1960s took place in April 2000 at FRAC Bourgogne in Dijon, France.

Freya Hansell is an artist living in New York City.

Lisa Hoke is a sculptor living in New York City. She is represented by Holly Solomon Gallery.

David Humphrey is an artist who lives in New York City and writes regularly for the journal *Art Issues.* He has shown at the McKee Gallery since 1984.

Julia Jacquette is an artist living and working in New York City. She recently designed paper plates, cups, and napkins for the Museum of Modern Art Project Series and was included in the *Greater New York* show at P.S. 1.

Yvonne Jacquette is a painter enamored with aerial views from airplanes or high buildings, often at night. In 2000 she showed at DC Moore Gallery in New York City; in 2001 a retrospective organized by the Stanford University Museum will open at the National Museum of Women in the Arts in

Washington, D.C.; it will then travel to Colby College, Maine, and to Stanford, California.

Amelia Jones is Professor of Art History at University of California, Riverside. She organized *Sexual Politics: Judy Chicago's Dinner Party in Feminist Art History* at the UCLA/Armand Hammer Art Museum (1996) and is the author of *Postmodernism and the En-Gendering of Marcel Duchamp* (1994) and *Body Art/Performing the Subject* (1998).

Deborah Kass, an artist who lives and works in New York City, has exhibited her work nationally and internationally. *Deborah Kass: The Warhol Project* is touring university museums from 1999 to 2001. Her work is included in numerous collections.

Tom Knechtel is an artist who lives in Los Angeles. He is represented by Grant Selwyn Fine Art.

Alison Knowles. My page making is another kind of performance. Using familiar content, size and type are varied. We hear voices whispering at the ear or far away.

Vitaly Komar and Aleksandr Melamid are Russian émigré artists living in New York City. They exhibit their collaborations at Ronald Feldman Fine Arts.

Joyce Kozloff lives in New York City and is represented by the DC Moore Gallery. She is a 1999–2000 Rome Prize recipient.

William Pope. L is the dim inside the dark which is Yves Klein's asshole. He teaches performance, film, and theater at Bates College.

Ellen Lanyon is a former Chicagoan, now painting in New York. She recently had a three-decade retrospective at the National Museum of Women in the Arts and is working on a major ceramic mural for the city of Chicago.

Betty Lee is an artist living in Los Angeles.

Hung Liu, born in Changchun, China, is a Bay Area artist and two-time NEA fellowship recipient who exhibits nationally and internationally. She is Associate Professor of Art at Mills College in Oakland, California.

Fern Logan is a fine arts photographer and graphic designer. She is the official photojournalist for the spiritual leader Swami Chitvilasananda and is Professor of Photography at Southern Illinois University in Carbondale, Illinois.

Medrie MacPhee recently completed a five-city national touring show of her paintings in Canada. She was featured in an article in issue 21 of *Contemporary Visual Arts*.

Lenore Malen is an artist and writer whose project, *The Disappearance,* appeared in the fall/winter 2000 issue of *9/9 revue d'art practique,* Paris. She is working on a project about Franz Anton Mesmer and the New Society of Universal Harmony.

Ann McCoy is a painter, sculptor, and printmaker living in New York City. She has received the Prix de Rome, the D.A.A.D, and other awards, and teaches at Barnard College.

Thomas McEvilley is the author of *Sculpture in the Age of Doubt* (1999). Forthcoming works include *After the Deluge* (on conceptual and performance art) and *The Shape of Ancient Thought: Comparative Studies in Greek and Indian Philosophies.* He lives in New York City and teaches at Rice University.

Ann Messner is a visual artist whose work continues to explore, although not exclusively, a feminist experience. She lives in New York City.

Melissa Meyer is an abstract painter living in New York City.

Richard Milazzo is a curator and critic. Forthcoming works include two books of essays on the art of the 1990s, *According to What* and *Caravaggio on the Beach,* as well as monographs on Malcolm Morley and Saint Clair Cemin.

Nancy K. Miller is Distinguished Professor of English and Comparative Literature at the Graduate Center, City University of New York. Her most recent book is *Bequest and Betrayal: Memoirs of a Parent's Death.*

Robert C. Morgan is an artist and critic who lives in New York City. He writes for many international publications and is the author of *The End of the Art World* (1998).

Elizabeth Murray is an internationally known artist living in New York City. She is represented by Pace Wildenstein Gallery and her work appears in numerous museum collections.

Dominique Nahas is a New York–based critic and independent curator. He writes regularly for *Art in America, Flash Art, Art on Paper, Review,* and Artnet Worldwide and teaches at the Pratt Institute and Montclair State University.

Joseph Nechvatal has worked with ubiquitous electronic visual information and computer robotics since 1986. He was artist-in-residence at the Louis Pasteur studio and at the Ledoux Foundation's computer lab in Arbois, France. He teaches at the School of Visual Arts in New York City and at the Institute for Electronic Arts at Alfred University.

Diane Neumaier is an artist who combines photographs with whatever occurs to her; she is also a writer. Neumaier frequently works in Eastern Europe.

Nancy Pierson is an artist who lives in Los Angeles.

Howardena Pindell is an artist who lives and works in New York City. She is Professor of Art at the State University of New York at Stony Brook and a visiting professor of art at Yale University.

Barbara Pollack has exhibited with the Holly Solomon Gallery, Thread Waxing Space, A.I.R., and other galleries. Pollack (who is forever in debt to *M/E/A/N/I/N/G* for publishing her first articles on art) is now a regular contributor to *Art News, Village Voice, Art & Auction, Arts Monthly*, and *Flash Art*.

Lucio Pozzi is an artist living in New York City. He likes to paint and to pursue his painterly concerns in other media as well. Pozzi teaches at the School of Visual Arts.

Rebecca Quaytman is an artist living and working in New York City. Her work has been exhibited internationally since 1992. Her work has been discussed in *Artforum, Art in America, Art News,* and *Review*.

Aviva Rahmani recently completed the *Ghost Nets Project* (1991–2000), a work of restoration ecoArt. She is codirecting a program in environmental art at the College of the Atlantic, Maine.

Yvonne Rainer made dances from 1960 to 1975 and films from 1975 to 1996. She is currently making one more dance.

David Reed has lived and painted in New York City for the past thirty years. Recent exhibitions include *David Reed Paintings: Motion Pictures*, organized by the Museum of Contemporary Art, San Diego, which traveled to P.S. 1 in New York City, and *Notorious*, organized by the Museum of Modern Art, Oxford, England.

Corinne Robins, art critic and poet, is author of *The Pluralist Era: American Art 1968–81* (1984) and the poetry collection *Marble Goddesses with Technicolor Skins* (2000).

Jacques Roch is an artist living and working in New York City. He shows at Kim Foster Gallery in New York City.

Erika Rothenberg is an artist who lives in Los Angeles.

Jerry Saltz is an art critic living in New York City. He writes regularly for the *Village Voice*.

Juan Sanchez is a painter and photographer who explores his Puerto Rican

heritage and the issue of colonialism and Puerto Rican independence. He lives in New York City.

Miriam Schapiro currently has two traveling retrospectives: one of works on paper and another of her paintings. Thalia Gouma Peterson's book, *Miriam Schapiro: Shaping the Fragments of Art and Life,* was published in 1999.

Carolee Schneemann's *Vespers Pool,* a seven-channel video projection installation with a wall of artifacts manifested by paranormal events, was exhibited at ArtPace, San Antonio, and the Emily Harvey Gallery in New York City. Her forthcoming book is titled *Imaging Her Erotics—Theories, Interviews, and Documents 1980–95.*

Ann Schoenfeld writes for several publications and teaches modern art and design history at the Pratt Institute and at the State University of New York, Purchase. She lives in New York City.

Mira Schor is a painter and the author of *Wet: On Painting, Feminism, and Art Culture* (Duke University Press, 1996). She is a cofounder, with Susan Bee, of the journal *M/E/A/N/I/N/G.* She is a recipient of a Guggenheim Fellowship in Painting and the College Art Association's 1999 Frank Jewett Mather Award in Art Criticism.

Christian Schumann is an artist currently residing in New York City. His work can be seen at Postmasters Gallery in New York City on occasion.

Arlene Shechet is an artist living and working in New York City. She is represented by Elizabeth Harris Gallery in New York City and Shoshana Wayne Gallery in Santa Monica, California. Her latest writing project was a conversation with Kiki Smith concerning the late work of Elie Nadelman (Salander O'Reilly Galleries, 1999).

Dena Shottenkirk, a visual artist and practicing art critic, is also currently finishing a dissertation in philosophy in the field of epistemology.

Amy Sillman is a painter who lives in New York City. She is represented by Brent Sikkema Gallery in New York City and teaches at Bard College.

Joan Snyder is a painter who lives in Brooklyn and Woodstock. Her daughter Molly is now a junior at Bard College majoring in film.

Elke Solomon is an artist living in New York City.

Nancy Spero is an internationally known artist living in New York City.

Hugh Steers's (1962–95) paintings deal with his sexuality and HIV as well as eroticism and illness. His fictive alter ego, "hospital man," is depicted wearing a hospital gown and high heels. He studied at Yale and is represented by Richard Anderson Gallery in New York City.

Pat Steir is a painter living in New York City. She is represented by the Marlborough Gallery.

May Stevens divides her time between New York City and Santa Fe. Her most recent exhibitions were *May Stevens: Images of Women Near and Far* at the Museum of Fine Arts, Boston, and *Works on Paper* at the Mary Ryan Gallery in New York City.

Robert Storr is an artist and critic, and Senior Curator in the Department of Painting and Sculpture at the Museum of Modern Art, New York City. He writes for many publications, lectures, and has taught painting, drawing, art history, and criticism at colleges and art schools in the United States.

Misko Suvakovic teaches aesthetics and art theory at the University of Arts in Belgrade. He is the author of more than ten books on theory, including *The Postmodern* (Belgrade, 1995), *Aesthetics of Abstract Painting* (Belgrade, 1998), and *Vocabulary of Modern and Postmodern Visual Art and Theory After 1950* (Belgrade and Novi Sad, 1999).

Nicola Tyson was born in 1960 in London, England. She has lived in New York for ten years and shows at Friedrich Petzel Gallery in New York City.

Richard Tuttle thinks language may be visually based.

Anthony Viti's work explores themes of sexuality, mourning, and AIDS. He lives and works in Brooklyn, New York.

David von Schlegell (1920–92), American abstract sculptor and painter, was director of the Yale Sculpture Program from 1974 to 1989. Influenced as much by his experience as an aircraft engineer as by New York minimalism of the 1960s, his public sculpture can be found from Saudi Arabia to Sacramento.

Lawrence Weiner: IF IT FITS IT FITS BECAUSE IT FITS
NOT BECAUSE IT FIT BEFORE

Faith Wilding is a multidisciplinary feminist artist, writer, and activist. She is currently working on a multimedia project about sex and gender in the biotech century with her artist collective, subRosa.

Martha Wilson is a performance artist and founding director of Franklin Furnace, a museum for temporal art that became a "virtual institution" on its twentieth anniversary, and now presents live art on the Internet.

Pamela Wye is an artist and art critic. She shows her paintings at Luise Ross Gallery in New York City.

Karen Yasinsky uses drawing and stop-motion animation to explore human fragilities. Humor, sadness, and awkwardness are important to her

nonlinear narratives. She is represented by Casey Kaplan Gallery in New York City.

Barbara Zucker is a sculptor living in Vermont and New York. She is a cofounder of A.I.R. Gallery in New York City.

Index

Academia. *See* Education

Activism, xiii, xiv, xix, 120, 134, 362–368; and feminism, 71, 120, 273, 337; and race, 214

Advertising, 41, 61–62, 312–316

African American artists, 204–209, 211–216, 222–226, 243, 434–446

Africano, Nicholas, 439

Age/aging, xv, 41, 59–67, 282–283, 338, 418–422. *See also* Younger artists

AIDS, 16, 201, 314–315

Amos, Emma, 204–207, 253–255

Anderson, Laurie, 75

Animals, 56, 412, 442. *See also* Bats; Cats; Rabbits

Anker, Suzanne, 255–259

Anthropology, 69–70, 215–216

Antoni, Janine, 75

Applebroog, Ida, 120

Appropriation, 24–33, 79, 83–84, 307

Arakawa, 109, 187

Artaud, Antonin, 54, 299, 410–412

Art criticism, 8, 11, 14, 28, 33n, 107–112, 115, 119, 123, 127–132, 165, 176, 189, 333–335, 357–359; and race, 206, 219–220. *See also* Art publications

Art history. *See* History, art

Artistic concerns, 233–251

Artists of color. *See* African American artists; Asian American artists; Race/racism

Artists Space, 148

Art market, x, xiv–xvii, xxii, 1, 15, 86, 107–112, 132–139, 147–152, 175–179, 318, 321, 323, 328–333, 363, 379, 444–445

Art objects, 182

Art publications, x–xiii, xvi–xxi, 2–3, 107–112, 205, 216, 327, 334. See also *M/E/A/N/I/N/G; October*

Asian American artists, 150–151, 211–214, 217, 260, 275–276

Audience, 115, 183

Authenticity, 187–203

Autobiography, 236–237, 243, 310, 388–389, 401n. 2, 402n. 3

Bad girls, 37–50

Baraka, Amiri, 446

Baranik, Rudolf, 233–235

Baseball, 341–346

Basquiat, Jean-Michel, 205, 225–226

Bats, 347–349
Baudrillard, Jean, 201
Bearden, Romare, 206, 225
Bee, Susan, ix–xxii, 1–4, 183, 188, 259–
 260, 352–354, 423–433
Benjamin, Walter, 121–122, 356
Benning, Sadie, 82, 311
Berlind, Robert, 189–190
Bernstein, Charles, 107–112, 175–183
Berthot, Jake, 191
Beuys, Joseph, 116
Birch, Willie, 229–230
Black artists. See African American
 artists; Race/racism
Blackburn, Bob, 254
Bleckner, Ross, 123, 148, 166
Bloom, Barbara, 170
Body, representation of, 9, 16, 24–33,
 42–43, 56, 58–66, 92, 95, 118, 163,
 172, 236–237, 255–257, 263, 341,
 405–416, 420–421
Bontecou, Lee, 94
Boone, Mary, 38, 108, 300
Bourgeois, Louise, 44, 75, 167, 171
Bowen, Nancy, 43
Brecht, George, 365, 367
Brenson, Michael, 204, 211–212
Brookner, Jackie, 317–320
Brown, Joan, 168, 170
Buchloh, Benjamin, 115–118, 120, 122,
 155–153
Butler, Judith, 72

Cage, John, 365–367
CalArts (California Institute of the
 Arts), x, 29, 336, 362–365
Cameron, Dan, 7, 15–16, 168
Camp, 14, 382–383
Career. See Professionalism
Carnegie, Dale, 330
Carrington, Leonora, 418–422
Cartoons, 388–404
Carvalho, Josely, 208–209
Castle, Terry, 83
Cats, 56

Censorship, 51–58, 229–230
Cézanne, Paul, 31–32
Chadwick, Whitney, 418–422
Chagall, Marc, 431
Cheng, Emily, 260–262
Chicago, Judy, x, 53–54, 94, 364
Childhood, 260–261
Children. See Motherhood
Chin, Daryl, 145–154, 210–214
Classism, 152–154
Clercx, Byron, 182
Clothing, 41
Cohen, Arthur, 235
Collins, Tricia, 191–192
Colonialism, 228–230
Community, xxii, 3, 127–128, 135, 178–
 179, 185, 317–338
Computers: and art, 179–183. See also
 Electronic technology; Internet
Connor, Maureen, 171, 192–194
Constantinides, Kathy, 13
Corris, Michael, 307
Cottingham, Laura, 68–78
Courbet, Gustave, 83–84
Coyne, Petah, 182
Craft, 88–92, 123, 137–138, 183
Creativity, 317–338
Critical theory, xiii, xvii–xviii, 165,
 326–327
Cronin, Patricia, 79–86
Cultural history. See History, cultural

Danto, Arthur, 11–12
Debord, Guy, 328
Deconstruction, 193, 200
de Kooning, Elaine, 38, 167
de Kooning, Willem, 48, 170, 439
DeManuelle, Stephanie, 262–264
Design, 440
Dial, Thornton, 434–446
Diao, David, 146–148, 170
Dickson, Jane, 264–265
Domesticity, 21n. 10, 40, 87–104, 279
Donahue, Carolyne, 34. See also Wal-
 lace & Donahue

Doogan, Bailey, 61–65, 265–267
Downes, Rackstraw, 194–195
Drexler, Roslyn, 75
Drucker, Johanna, ix–xxiii, 163–174
Duchamp, Marcel, 53, 93, 118, 243; and
 Florine Stettheimer, 376, 379, 381
Duncan, Carol, 29
Durham, Jimmie, 228

Education, x, xiii, xvii, 306, 326, 336,
 363, 437; and race, 149–151, 205–
 206, 212, 215, 222–224, 227; and
 women, 29, 69–72, 76n. 1, 77n. 3.
 See also CalArts
Edwards, Mel, 205, 207
Eisenman, Nicole, 82
Electronic technology, 175–183
Ernst, Max, 369, 419
Erotic(a), 29–30, 51–61
Exhibition of art, xiv, 11–12, 115, 132–
 133, 146–150, 178, 243, 306, 308, 316,
 329, 334–335, 352–354, 381, 398–400,
 434–446; and gender, 38–39, 120,
 271, 299, 320, 327; and race, 215–216,
 227
Expressionism: abstract, 38–39; neo-,
 38, 120, 327

Failure, 155–162
Femininity, 60, 412, 420–421
Feminism, ix–xxiii, 7–23, 29–30, 37–
 43, 55, 68–78, 88–104, 120, 163–164,
 247, 251, 272–274, 287, 292, 297, 320,
 336–337, 364, 418
Feminist artists, xi, 49, 53, 55–56, 68–
 78, 88–89, 93, 146–147, 251, 284, 295,
 307, 364, 379
Feminist Art Program. See CalArts
Feminist theory, xiii, 13, 43, 163–174,
 314, 327
Film, 17, 51–58, 176, 210–214, 310, 315–
 316, 370–371, 402n. 3
Finkelpearl, Tom, 214–217
Finley, Karen, 48, 54, 172
Fisher, Joel, 155–162

Fluxus, 362–367
Folk art, 435–441
Ford, Hermine, 236, 267–268
Ford, John, 370
Formalism, 234, 326
Foster, Hal, 20n. 5, 111, 152
Frank, Regina, 98
Frankenthaler, Helen, 167
Fried, Michael, 307–308
Fried, Nancy, 236–237
Frueh, Joanna, 59–67
Funding, 148–149; and race, 229

Galleries. See Exhibition of art
Gallop, Jane, 19
Gay artists, 56, 314–315
Gaze, 28, 163, 423–426
Gender, x–xvi, 13–23, 55, 71, 93–94,
 97–98, 121, 163, 256, 267, 325. See
 also Feminism; Male artists;
 Women artists
Gibson, Ann, 38
Gins, Madeline, 109, 187, 217–220
Goebel, Carol, 43
Golub, Leon, 120, 237–238, 297, 299
Goodyear, John, 238
Gornik, April, 170
Goya y Lucientes, Francisco José de,
 123–124, 349
Graffiti artists, 151–152
Green, Renée, 216, 220–222
Green, Vanalyne, 341–346
Grenier, Robert, 180
Gross, Mimi, 268–270
Grossman, Nancy, 238–239
Grundberg, Andy, 16–17, 22n. 24
Guerrilla Girls, xi, 40, 205, 214, 300,
 336–337, 368
Guston, Philip, 242, 304–305

Haacke, Hans, 108
Hafif, Marcia, 127–130
Halley, Peter, 111, 300
Hammond, Harmony, 96
Hammond, Jane, 169

Hammons, David, 217
Hansell, Freya, 270
Happenings, 365–366
Haraway, Donna, 94, 96
Hartigan, Grace, 38, 167
Hartley, Marsden, 124; and Florine
 Stettheimer, 378, 381
Harvey, Bessie, 437
Hatch, Orrin, 73
Heilbrun, Carolyn, 60
Helms, Jesse, 52, 229, 285
Henry, Janet, 153
Hepworth, Barbara, 38
Hesse, Eva, 30, 94
Higgins, Dick, 364–366
Hispanics, 208–209
History: art, xii–xiii, 15, 29, 39, 61–62,
 66, 113–114, 120–123, 326, 348, 375–
 378, 436; cultural, 120, 437, 439,
 442–444
Hoke, Lisa, 303–304
Holocaust, 388–404
Holzer, Jenny, xi, 75, 172
Homosexuality, 16–17, 314–315
Humor, 315, 430
Humphrey, David, 195–196, 320–322
Hurston, Zora Neale, 207
Huyssen, Andreas, 14–15, 258

Intention, 139, 158, 161
Internet, 98–99, 175–181

Jacquette, Julia, 303, 304–305
Jacquette, Yvonne, 239–240, 270–271
James, David, 55, 57
Jess, 182–183
Johns, Jasper, 33
Jones, Amelia, 7–23
Judaism and art, 79–86, 288–289,
 368–404
Julien, Isaac, 211

Kahlo, Frida, 50, 170
Kaprow, Allan, 365–366
Kass, Deborah, 79–86

Kelley, Mike, 93–94
Kelly, Ellsworth, 80
Kelly, Mary, 11, 40–42, 47, 91
Kiefer, Anselm, 116, 166, 435, 437
Klein, Yves, 440
Knechtel, Tom, 347–349
Knowles, Alison, 362–368
Kollwitz, Käthe, 251
Komar, Vitaly, 196–197
Koons, Jeff, 66, 164, 206, 216, 300
Kozloff, Joyce, 271–272
Kramer, Hilton, 295, 379
Krasner, Lee, 167
Kristeva, Julia, 78n. 5
Kruger, Barbara, 17, 75, 80, 216
Krüger, Michael, 30
Kuspit, Donald, 18–19, 27, 127–130

L, William Pope, 322–325
Labor. See Professionalism
Lacan, Jacques, 74, 77n. 2, 173
Landscape, 369–370
Language, 109, 195–196
$L=A=N=G=U=A=G=E$, xii, 2
Lanyon, Ellen, 240–241, 272–275
Laufer, Miriam, 2, 259
Laufer, Sigmund, 2
Lawler, Louise, 16, 153
Lawrence, Jacob, 225–226
Lawson, Thomas, 26–27, 34n. 12
Leaf, June, 168
Lee, Andrea, 221
Lee, Betty, 275–276
Lemieux, Annette, 119
Leonardo da Vinci, 200–201
Lesbian artists, 79–86
Lessing, Doris, 421
Levine, Sherrie, 11, 17, 75, 84, 119, 170,
 176
Lipkin, Lawrence, 303
Lippard, Lucy, 109
Liu, Hung, 222–224
Logan, Fern, 225–226
Lorde, Audre, 61
Lyotard, Jean-François, 306

Machines, 134, 137–138

MacPhee, Mcdrie, 197

Madness, 321

Madonna, 37, 46–49

Male artists, 12, 48–49, 166–167, 317, 320–322, 325, 332, 350–351

Malen, Lenore, 277–278

Mansell, Alice, 170

Mapplethorpe, Robert, 53–55, 66

Marginal artists. *See* Folk art

Marxism, 77n. 3, 113, 122. *See also* Neo-Marxism

McCoy, Ann, 241–242, 357–359

McEvilley, Thomas, 130, 434–446

McGann, Jerome, 180

Mead, Margaret, 41

Meaning, 187–203

M/E/A/N/I/N/G, ix–xxiii, 1–4, 260, 336, 338

Media arts, 119, 149, 213. *See also* Film; Photography; Video art

Melamid, Aleksandr, 196–197

Menopause, 41, 59–67

Messner, Ann, 278–281

Meyer, Melissa, 242

Michelangelo, 157

Milazzo, Richard, 130, 191–192

Miller, Nancy K., 388–404

Min, Yong Soon, 153, 212

Minh-Ha, Trinh T., 222

Minority artists. *See* African American artists; Asian American artists; Race/racism

Mitchell, Joan, 168–169

Mitchell, Juliet, 163

Modernism, 13–16, 38–39, 81, 113–115, 140–141, 424, 435–436, 439

Morgan, Robert C., 325–329

Motherhood, 42, 252–302

Multiculturalism, 163–164, 324–325

Mulvey, Laura, 32, 163

Murray, Elizabeth, 124, 197, 276

Music, 206, 305–306, 310; and painting, 117–118

Myth, 407–408, 421–422

Nahas, Dominique, 434–446

Narrative, 430–431, 439

Native Americans, 227–228, 230, 367

Nature, 190, 192, 241, 258, 319

Nechvatal, Joseph, 355–356

Neel, Alice, 40, 44, 266

Nelson, Joan, 170

Neo-Expressionism, 120

Neo-Geo, 146–148

Neo-Marxism, 132. *See also* Marxism

Neumaier, Diane, 281

Nevelson, Louise, 40, 44

Newman, Barnett, 116, 118, 166, 369, 439

New Museum, 40–43

Nietzsche, Friedrich, 291, 321

Nochlin, Linda, 28–29, 382–383

Nude, 25–33

October, 1, 110, 113

O'Doherty, Brian, 114–115

Oppenheim, Meret, 93, 160

Originality, 187–203

Outerbridge, Paul, 31

Outsider art. *See* Folk art

Owens, Craig, 13–15, 29, 113–115, 152

Paglia, Camille, 72, 164

Paik, Nam June, 149–50, 181, 362

Painting, xvii–xviii, 26–33, 110, 113–124, 306–309, 369–373, 423–433

Pane, Gina, 172

Parenthood. *See* Motherhood

Parker, Rozsika, 92, 97

Peale, Norman Vincent, 330–332

Phelan, Ellen, 168, 170

Photo-collage, 121

Photography, xvii–xviii, 16–17, 24–25, 31, 423–424

Picasso, Pablo, 83–84, 158–159, 246, 338, 436, 445

Pierson, Nancy, 281–283

Pincus-Witten, Robert, 25–26, 119

Pindell, Howardena, 207, 211, 242–244

Poetry, xii, 178

Politics, 16, 17, 121, 368; and art, 80, 199, 121, 190, 216–217, 230, 234, 307, 311, 323, 336–337, 408
Polke, Sigmar, 170
Pollack, Barbara, 46–50, 283–286, 329–332
Pollock, Griselda, 22n. 22, 39, 329
Pollock, Jackson, 84, 166–168, 369, 425, 429, 439–441
Pop Art, 75
Popular artists, 129–130, 133, 137
Popular culture, 40, 303–316; feminism in, 9–11
Pornography, 24–25, 28, 51–52, 56, 164
Post-feminism, 7–23, 119
Postmodernism, x–xviii, 1, 8, 13–16, 19–22, 119, 152–153, 196, 198, 326–328, 439
Pozzi, Lucio, 131–144, 245
Prince, Richard, 86
Professionalism, x, xiv, 141, 327, 329–333, 363, 382; and Florine Stettheimer, 375–386; and motherhood, 263–265, 275–276, 285–286, 290
Psychoanalysis, 76n. 2
Puryear, Martin, 205, 211

Quaytman, Rebecca, 305–309

Rabbits, 357–359
Race/racism, 78n. 7, 145–154, 204–232, 243, 324–325
Rahmani, Aviva, 51–58, 362–368
Rainer, Yvonne, 198
Ratcliff, Carter, 28
Rauschenburg, Robert, 441
Reed, David, 369–372
Reinhardt, Ad, 235
Religion, 155–156, 192, 288–289, 418, 421
Rembrandt, 287–289
Reproduction, 160, 177, 200–201
Rich, Adrienne, 197
Richter, Gerhard, 116–117, 120, 166
Ringgold, Faith, 145, 147, 207

Ritual, 341–346
Robins, Corinne, 37–45, 47–48
Roch, Jacques, 245–247
Rollins, Tim, 216
Rose, Jacqueline, 173
Rossetti, Dante Gabriel, 180
Roth, Moira, 224
Rothenberg, Erika, 286
Rubin, William, 435–436

Salle, David, xvi, 24–35, 84, 110–111, 120, 153, 206
Saltz, Jerry, 332–336
Sanchez, Juan, 226–230
Schapiro, Meyer, 31
Schapiro, Miriam, x, 12, 75, 198, 247–248, 287–290
Schjeldahl, Peter, 28, 48, 205, 333
Schnabel, Julian, 435
Schneemann, Carolee, 42, 51–58, 172, 248
Schoenfeld, Ann, 199
Schor, Ilya, 2
Schor, Mira, ix–xxii, 1–4, 24–36, 113–126, 336–338
Schor, Resia, 2
Schumann, Christian, 309–310
Serrano, Andres, 53–55
Sexuality, xvi, 17–18, 24–37, 41, 47, 55–58, 79–86, 120, 163, 165, 321, 407, 425–427
Shechet, Arlene, 290–291
Sherman, Cindy, 17–19, 75, 153, 172
Shottenkirk, Dena, 291–294
Sillman, Amy, 310–311
Simmons, Laurie, 16
Site-specific art, 138–139
Sleigh, Sylvia, 11
Smith, Jaune Quick-to-See, 170
Smith, Kiki, 75, 86, 171
Smith, Mimi, 91
Snyder, Joan, 170, 294–296
Solomon, Elke, 296–297
Sonnier, Keith, 159
Sontag, Susan, 52; on camp, 14, 383

Spero, Nancy, 44, 120, 297–300, 350–351, 405–417
Spiegelman, Art, 311, 388–404
Steers, Hugh, 311–312
Stein, Gertrude, 83–84, 376, 388
Stein, Linda, 43
Steir, Pat, 169, 199–200
Stella, Frank, 300
Stereotypes: of artists, 331; of gender/sex, 81–82, 93, 160, 261–262; of race, 208–209, 213
Stettheimer, Florine, 311, 375–387
Stevens, May, 300
Stewart, Martha, 102
Storr, Robert, 200, 231–232
Streisand, Barbra, 79–86, 176
Strider, Marjorie, 75
Success, 155–162
Suleiman, Susan, 419
Surrealism, 412, 419
Suvakovic, Misko, 423–433

Technology, 92, 96–102, 257–258. See also Electronic technology; Machines
Television, 176–177, 310, 315
Theater, 212–213
Thek, Paul, 160
Theweleit, Klaus, 20n. 4, 118
Tiepolo, Giovanni Battista, 348–349
Tisdale, Danny, 216
Todorov, Tzvetan, 371–372
Tolliver, Moses, 438
Trieff, Selina, 43
Tucker, Marcia, 40–41, 43–44
Tuttle, Richard, 249, 360–361
Tyson, Nicola, 312–314

Ukeles, Mierle, 217
Uncanny, the, 369–372

Video art, 149, 214
Violence, 120
Visual pleasure, 123, 163–174

Viti, Anthony, 314–315
Voice, 405–406, 412
von Rydingsvard, Ursula, 211–212
von Schlegell, David, 249

Wallace & Donahue, 115, 119
Wallace, Joan, 34. See also Wallace & Donahue
War, 118, 120, 298–299, 314–315, 409–410
Warhol, Andy, 189, 307, 372
Weiner, Lawrence, 202–203, 250
Westerns, 370
Whitney Independent Study Program, 70, 146–147
Whitney Museum, 40, 44, 299, 376
Wilding, Faith, 87–104, 250–251
Wilke, Hannah, 41–43, 65–66
Williams, Emmett, 366
Williams, Sue, 75, 86
Wilson, Fred, 216
Wilson, Judith, 212
Wilson, Martha, 300–302
Winsor, Jackie, 159
Wittig, Monique, 63
Womanhouse, 90–91
Women artists, 8, 11–12, 15, 17, 29–30, 38–44, 46–50, 59–66, 83, 85–86, 98, 119, 121, 146–147, 153, 165, 242, 253–254, 259–260, 272, 276, 280, 295, 297, 299–300, 314, 337, 358–359, 364, 379, 406
Woolf, Virginia, 50, 90, 198
Wooster Group, 149
Work. See Professionalism
Writing, 310
Wye, Pamela, 375–387, 405–417

Yamamoto, Lynne, 100–101
Yasinsky, Karen, 315–316
Yasumi, Tom, 214
Younger artists, 303–316

Zucker, Barbara, 301–302

Library of Congress Cataloging-in-Publication Data

M/E/A/N/I/N/G : an anthology of artists' writings, theory, and
criticism / edited by Susan Bee and Mira Schor.
p. cm.
Includes bibliographical references and index.
ISBN 0-8223-2534-9 (cloth : alk. paper) — ISBN 0-8223-2566-7
(pbk. : alk. paper)
1. Art, American. 2. Art, Modern—20th century—United States.
3. Women artists—United States. I. Title: *MEANING.*
II. Bee, Susan. III. Schor, Mira. IV. *M/E/A/N/I/N/G.*
N6512.M378 2001
709'.73'09045—dc21 00-034089